OCT 1 2 2011

Also by Jonathan Raban

Soft City
Arabia
Old Glory
Foreign Land
Coasting
For Love and Money
Hunting Mister Heartbreak
The Oxford Book of the Sea (editor)
Bad Land
Passage to Juneau
Waxwings
My Holy War

Surveillance

Driving Home

JONATHAN RABAN

Driving Home

An American Journey

Pantheon Books, New York

Mahomet Public Library

Copyright © 2010 by Jonathan Raban

All rights reserved. Published in the United States by Pantheon Books, a division of Random House, Inc., New York, and in Canada by Random House of Canada Limited, Toronto. Originally published in Great Britain by Picador, an imprint of Pan Macmillan, a division of Macmillan Publishers Limited, London, in 2010.

Pantheon Books and colophon are registered trademarks of Random House, Inc.

Pages 495-96 constitute an extension of this copyright page.

Library of Congress Cataloging-in-Publication Data

Raban, Jonathan.

Driving home: an American journey / Jonathan Raban.

p. cm.

Originally published: London: Picador, 2010.

ISBN 978-0-307-37991-7

Raban, Jonathan—Travel—United States.
 Raban, Jonathan—Homes and haunts—United States.
 Raban, Jonathan—Knowledge—United States.
 Authors, English—20th century—Travel—United States.
 Authors, English—20th century—Homes and haunts—United States.
 United States—Description and travel.
 Title.

PR6068.A22Z375

828'.91408—dc22

2010054090

www.pantheonbooks.com

2011

Jacket illustration by Stephen Shore Jacket design by Linda Huang

Printed in the United States of America

First American Edition

246897531

For Julia, a native of the Pacific Northwest

Contents

Introduction: Readings	3
Driving Home	16
Mark Twain's Life on the Mississippi	76
Philip Larkin	82
I'm in Heaven	95
Mississippi Water	104
On the Waterfront	132
Julia's City	144
Why Travel?	155
The Waves	159
Walden-on-Sea	165
Last Call of the Wild	174
Seagoing	185
Homesteading	192
Keeping a Notebook	201
Julia and Hawaii	205
The Turbulent Deep	213
White Warfare	223
The Unsettling of Seattle	236
The Last Harpoon	244
Battleground of the Eye	255

The Strange Last Voyage of Donald Crowhurst	271
Gipsy Moth Circles the World	280
Too Close to Nature?	289
A Tragic Grandeur	293
Surveillance Society	306
September 11: The Price We've Paid	310
Guantánamo Bay	317
A Postregional City	332
Indian Country	340
The Curse of the Sublime	352
Good News in Bad Times	358
I'm for Obama	364
Going, Going, Gone	373
An Englishman in America	376
Second Nature	393
Cyber City	418
An American in England	423
Cut, Kill, Dig, Drill	432
Election Night 2008	445
The Golden Trumpet	450
Metronaturals	462
American Pastoral	471
At the Tea Party	483
Acknowledgments	495

Driving Home

and the state of t

Introduction: Readings

MY MOTHER taught me to read in the summer of 1945, between VE Day and VI Day, when I was turning three. Time lay on her hands: my father, a major in the the Territorials, was away in Palestine, battling Irgun and the Stern Gang in the latter days of the British Mandate, and wasn't due to be demobilized from the army until the end of the year; and I was a pushover for her deck of homemade flash cards and a game I found more fun than our previous sessions of Animal Snap. In the cluttered, narrow-windowed living room of our house in the village of Hempton Green in Norfolk, my mother and I progressed from letters to words to sentences, stopping the game at intervals to listen to the BBC news crackling from the wireless, its fretwork grille sawn to represent an inappropriately Japanese-style rising sun. By the time we reached sentences and the cards had given way to headlines from the day's *Times*, Japan had surrendered to the Allies and the wireless was reporting that our troops in the Far East were fighting "pockets of gorillas"—an idea that excited me much more than anything in my father's letters home from Transjordan. Gorilla warfare was something that any three-year-old could warm to in his imagination: I sought out colored pictures of gorillas to feed my understanding of the conflict, and it was years before I realized that I was the victim of a deceiving homophone—an early case of the linguistic misunderstanding to which I've been prone all my life.

I squandered my mother's gift of so much time and patience. Proud of my new skill, I showed it off to anyone who'd listen—my grandmother, an indulgent aunt, an illiterate woman called Mrs. Atherton who was my mother's "daily," and, most unwisely, to my few contemporaries in the village, who beat me up for my intolerable conceit. But the capacity to read brought with it no corresponding advance in intellectual curiosity. I rested

lazily on my laurels, taking as long as anyone else of my age to venture beyond the conventional diet of Beatrix Potter, Winnie the Pooh, *The Wind in the Willows*, and Enid Blyton's Famous Five. By the early 1950s, I was tearing at speed through the middlebrow best sellers of the time: John Creasey, Nevil Shute, the wartime adventures of British officers who'd escaped, or tried to, from German POW camps, like *The Wooden Horse* and *The Colditz Story*, along with a stream of books about fishing. The nearest I came to reading "literature" for pleasure, aside from an early passion for *Huckleberry Finn*, was my discovery, at eleven or twelve, of H. E. Bates, whose *Fair Stood the Wind for France, The Jacaranda Tree*, and *Love for Lydia* seemed to me unsurpassably fine in their emotional eloquence and the transporting power of their natural descriptions. For a long time, I couldn't imagine the existence of a greater novelist than Bates.

In adolescence, my reading predictably widened in its range, but it hardly deepened. Joyce, Hardy, Dickens, Camus, George Eliot, Hemingway, Henry Miller, Lawrence Durrell, D. H. Lawrence, Scott Fitzgerald, Keats, Byron, Auden, Pound, T. S. Eliot . . . At sixteen I was a chain-reader, on a steady three library books a day when not in school, but my style of reading remained much as it was in my Enid Blyton period. I sucked and sucked at books for the precious juice of vicarious experience they contained, and as soon as they were finished, I discarded them like squeezed-out grapefruit skins. In the course of twenty-four hours, I might be Nick Adams, Paul Morel, and sitting in one of the dives on 52nd Street, uncertain and afraid, as the clever hopes expired of a low dishonest decade—but these were less acts of serious reading than experiments in identity, made by somebody who very much feared that he lacked one of his own and hoped that he might find a suitable off-the-peg identity in a book.

As it turned out, I eventually found one on a bus—a green double-decker owned by the Hants and Dorset company. On my first summer vacation from university, in 1961, I got a temporary job as a conductor, ringing the bell and issuing tickets on various routes through the New Forest between Bournemouth and Southampton. I was kitted out with a serge uniform to which age had given a bluebottle sheen, a heavy silver ticket machine to wear around my neck, and a blackened leather satchel to hold the predecimal small change of halfpennies, pennies, threepenny bits, sixpences, shillings, and half crowns.

Except in the early mornings and late afternoons, business was generally slow. Often, I was second-in-command of an empty bus, sprawled on the triple back seat, with ample time to read. My favorite run was the

2 p.m. back-country route from Lymington to Southampton, by way of East End, East Boldre, Beaulieu, Dibden Purlieu, Hythe, Marchwood, Eling, and Millbrook, on which the only passengers might be two or three elderly women from Lymington and a couple of gypsies from an encampment near Hatchet Gate. The jolting bus ambled along the B-roads, resting at intervals at deserted stops, and made a sleepy epic of the round-trip, which was little more than forty miles. I begrudged even the very few passengers we picked up on these slow trawls through the Hampshire countryside, because they interrupted my reading of William Empson's Seven Types of Ambiguity, in its blue-barred Peregrine paperback edition, which lived for weeks inside the leather satchel, becoming steadily more grimy from the stash of greasily fingered old coins whose company it kept.

The book was a revelation to me. It made me learn to read all over again. Looking at the book now still brings back the old-bus smell of cigarettes, fish and chips, sweat, Polo mints, and ineffectual disinfectant, and the excitement with which I first heard Empson's voice speaking from the page. It was a voice utterly unlike that of any of the literary critics whom I'd begun to read in my freshman year as an English student (F. R. Leavis, L. C. Knights, A. C. Bradley, E. M. W. Tillyard): plain spoken, peppery, disputatious; here talking in cheerful, offhand slang, there rising to lyrical and unforgettable descriptions of passages he most admired. In almost every paragraph was a joke or an arresting surprise.

Briskly disposing of the woolly idea of poetry as the beauty of Pure Sound, Empson made me giggle when he quoted Virgil's line in the sixth book of the *Aeneid*, "*Tendebantque manus ripae ulterioris amore*," as "the stock line to try on the dog,"* but went on to make a subtle analysis of its sound, before dismissing the general theory as bunkum:

[The line] is beautiful because *ulterioris*, the word of their banishment, is long, and so shows that they have been waiting a long time; and because the repeated vowel-sound (the moan of helpless sorrow)

^{*}Empson flattered his readers with unexplained allusions, expecting them to be as well read as he was himself. The line from Virgil translates roughly as "each stretching out his hand in longing for the far shore," and describes the dead souls in the underworld awaiting transport across the Styx by Charon, the ferryman. It had been cited by A. C. Bradley in his 1901 lecture, "Poetry for Poetry's Sake," for the untranslatable beauty of its sound (hence, "the stock line to try on the dog"). I hasten to add that I found all this out in 2009, forty-eight years after reading it on the bus, when my O-level Latin wasn't up to more than dim guesswork about hands and riverbanks and love.

in *oris amore* connects the two words as if of their own natures, and makes desire belong necessarily to the unattainable. This I think quite true, but it is no use deducing from it Tennyson's simple and laborious cult of onomatopoeia.

In territory more familiar to me than Latin poetry, Empson brought his inspired common sense to bear on poems that I knew by heart, yet had never properly read. Keats's "No, no, go not to Lethe, neither twist..." took on a startling new life when Empson gruffly pointed out that it "tells you that somebody, or some force in the poet's mind, must have wanted to go to Lethe very much, if it took four negatives in the first line to stop them." Of course! It was obvious—but it took Empson to bring the obvious to light.

In what has become the single most famous passage in *Seven Types of Ambiguity*, he anatomized the fourth line of Shakespeare's 73rd Sonnet, which begins:

That time of year thou mayst in me behold When yellow leaves, or none, or few, do hang Upon those boughs which shake against the cold, Bare ruined choirs, where late the sweet birds sang.

Of the comparison between the lover in the autumn of his life and those bare ruined choirs, Empson wrote that "There is no pun, no double syntax, or dubiety of feeling."

But because ruined monastery choirs are places in which to sing, because they involve sitting in a row, because they are made of wood, are carved into knots and so forth, because they used to be surrounded by a sheltering building crystallised out of the likeness of a forest, and coloured with stained glass and painting like flowers and leaves, because they are now abandoned by all but the grey walls coloured like the skies of winter, because the cold and Narcissistic charm suggested by choir-boys suits well with Shakespeare's feeling for the object of the Sonnets, and for various sociological and historical reasons (the protestant destruction of monasteries; fear of Puritanism), which it would be hard now to trace out in their proportions; these reasons, and many more relating the simile to its place in the Sonnet, must all combine to give the line its beauty, and there is a sort of ambiguity in not knowing

which of them to hold most clearly in mind. Clearly this is involved in all such richness and heightening of effect, and the machinations of ambiguity are among the very roots of poetry.

The temporary bus conductor read this paragraph over and over again, ravished by its intelligence and simplicity. *Of course!* again. After all, Shakespeare was born in 1564, barely twenty years after Henry VIII's dissolution of the monasteries, whose fresh ruins were scattered around the landscape, as raw and brutal as the bomb sites of my own childhood. The totalitarian vandalism of the mad king, as he tried to erase Catholicism from the land, was in plain view, and echoes of the sweet birds' singing still remained in the ears of the elderly when Shakespeare wrote his sonnet. The jostle of meanings that Empson exposed in the line made me giddy with a sense of extraordinary discovery—not only of the deeper implications of Sonnet 73, but also of what reading, *real* reading, might be if one could only learn how. If a new passenger got on the bus then, I doubt that I gave her a chance to pay for her ticket.

The first lesson Empson taught was to drastically slow down; to read at the level of the word, the phrase, the line; to listen, savor, question, ponder, think. This was easy because his own writing enforced it. A single paragraph in Seven Types of Ambiguity was like a street closely punctuated with traffic-calming speed bumps: you had to study the relationship between one sentence and the next—and often one clause and the next—to see the logic that connected them, and if I tried to read them in my usual skimming style, I instantly lost the thread.

The second, more general lesson required one to greatly enlarge one's understanding of what writing is and does—all writing, not just poetry. Empson illustrated his arguments with sentences from novels, book titles, newspaper headlines that had caught his eye, and so forth. On this, he was inexplicit except by inference, but as a fisherman, I saw it in angling terms. Every piece of writing was like a pond, sunlit, overhung by willows, with clustering water lilies, and, perhaps, the rippling circle made by a fish rising to snatch a dying fly. This much could be seen and appreciated by any passing hiker. But the true life of the pond lay below the surface, in deep water where only the attentive and experienced eye would detect the suspended cloud of midge larvae, the submarine shadow of the cruising pike, the exploding shoal of bug-eyed small fry. It was with the subaquatic life of literature that Empson—a scientist by early inclination, whose interest in science is a recurrent feature of his writing—was concerned.

Beneath the clean line of type on the page lay the muddy depths of the living and changing language, a world of stubborn historic associations, swarming puns, suggestive likenesses and connections (as between trees and carved choir stalls), meanings that were in a continuous process of evolution and decay, sometimes enriching the word in print, but as often subverting it. (Spare a thought for Coleridge when he penned the line in "Kubla Khan," "As if this earth in fast thick pants were breathing." Writing in 1797, he wasn't to know that, very shortly after his death in 1834, pants would become a popular abbreviation for pantaloons, and by 1884 a word for men's drawers.)

Empson's preternaturally sensitive ear and eye for the deep-water workings of the language enabled him to share with his readers a myriad subtleties, shades of meaning, richnesses, in lines they might otherwise have skated over, in ignorance of this buried treasure. He was equally alert to how language so often betrays the writer, revealing what is really at the back of his mind when trying to assert its opposite. (In *Some Versions of Pastoral*, Empson unmasked the complacent and reactionary political conservatism that lies just beneath the surface of Gray's "Elegy," and in *Milton's God*, he demonstrated how, in the course of writing *Paradise Lost*, Milton came to detest the God whose ways he was devoutly trying to justify to Man.)

Seven Types made it clear that I'd been a casual day-tripper on the beach of literature and that my supposed skill at reading was so primitive and rudimentary that it had never progressed much beyond primary-school level. Embarrassment mixed with wonder when I faced up to the fact that Empson's astounding book had been written when he was twenty-two, and had begun as an undergraduate essay written for his Cambridge supervisor, I. A. Richards.

Cats may look at kings. It was certainly possible to learn from Empson—"Kill Your Speed," as the traffic signs say. But it would be fatal to attempt to mimic his precocious scholarship, his eccentric brilliance, or his quirky and quick-witted, table-talking prose style. After my Empson summer on the buses, my reading measurably improved, with my own fortnightly essays for my tutor coming back to me with Alphas at the end instead of the Betas, plus and minus, that had been standard in my first year. Had I been at all religious, I might have lit candles in Empson's honor (something that would have greatly annoyed him, for he was a militant atheist). Since then, I've made a living out of reading, one way or another. For reading, of the kind

that Empson preached and practiced, doesn't stop at books, but goes on to make the larger world legible.

Trying to understand the habitat in which we live requires an ability to read it—and not just in a loose metaphorical sense. Every inhabited land-scape is a palimpsest, its original parchment nearly blackened with the cross-hatching of successive generations of authors, claiming this place as their own and imposing their designs on it, as if their temporary interpretations would stand forever. Later overwriting has obscured all but a few, incompletely erased fragments of the earliest entries on the land, but one can still pick out a phrase here, a word there, and see how the most recently dried layer of scribble is already being partially effaced by fresh ink. From the embanked, bulletpath road through the valley—relic of Roman occupation—to the new fifty-turbine windfarm on the hill, every feature of the landscape belongs to an identifiable phase of sensibility, politics, and language.

We're in England, let's say, on the same hill as the windfarm. In the far distance is the gray smudge of a cathedral city whose housing developments have spread untidily beyond its 1960s ring road, and whose office parks contain dozens of small companies in the "knowledge-based industries." The course of a narrow, crooked river, marked by a double line of trees, diagonally connects the city to the village at the foot of the hill. This village lost its post office in the 1990s, and its only surviving commercial enterprise, besides the pub and the shop selling "gifts and country antiques," is a Shell station-cum-minimart. Old farmworkers' cottages, built from the nearest and cheapest materials to hand—rocks, pieces of old timber, plaster made from mud—and roofed with bundles of wheatstraw or reeds from the local swamp, have long been prized as weekenders' second homes. These people, who dearly love ancient brick windmills with skeletal sails, but not their modern descendants, mounted the Stop the Turbines campaign of 2001, and continue to grouse vengefully over their defeat. Sixty or so permanent residents live on "the estate" of semidetached council houses, which is itself semidetached from the village on the main road. The fifteenth-century church gets half a page in Pevsner's The Buildings of England but has been locked against vandals for years, though a communion service, said, not sung, is held there on the fourth Sunday of every month, and it's still used for weddings and funerals (after which the corpses are transported by undertaker-led motorcades to the crematorium on the city's edge).

Between the village and the city are fields, vastly enlarged since mechanized farming came in after the Second World War, mostly arable (wheat,

barley, oilseed rape), with one big dairy farm, a member of an organic milk cooperative that is under contract to Dairy Crest PLC. The redundant farmhouses, stripped of all their surrounding land except pony-sized paddocks, are owned by commuters. The tree-shrouded Georgian hall in the middle distance is now a combined hotel, restaurant, golf club, and health spa. Twin lines of pylons, erected in the 1930s, carry high-voltage cables across the landscape, a flight hazard back in wartime when the Americans ran an airfield here. After that was decommissioned, its runway drainage systems left it too barren for agriculture. Following a brief period as a refugee camp, it became a motor-racing circuit, then a truck maintenance center, and is now in the early stages of deciduous broadleaf afforestation.

These are just a few of the changes to the landscape on which the ink is still drying, on the uppermost layer of the palimpsest. Beneath them, the ink color alters slowly from blue or black to sepia, and the handwriting to copperplate, then italic, then Gothic black letter, as it registers how use and ownership of this stretch of land has been continuously contested. The windfarm dispute, in which the quarrel spread to include the district council, a multinational power company, a farm corporation, the Ministry of Defence, English Nature, the National Farmers' Union, and the Campaign to Protect Rural England, echoed, in a minor key, the great battles of the past-from the hopeless fight put up by landless peasant farmers in villages against landowners at the time of the enclosure acts, to the long war between the church, the crown, the landed aristocracy, and the wool merchants. In our collective rural nostalgia, we like to think of the countryside as settled and placid, not as the scene of perpetual conflict involving class, power, and money, but there's hardly a feature of any real landscape that doesn't stand for somebody's triumph, concession, or defeat.

Landscape historians can read the palimpsest more skillfully than I, but any attempt to see it like this helps to negate the brain-curdling effects of degraded Late Romanticism, which still shapes the way in which most of us instinctively think about landscape and place. In Britain, it's led to the cult of the antique-picturesque, in the United States to the parallel cult of "pristine" wilderness. Devotees of both practice a highly selective, self-induced blindness, canceling from their view, and all claims to their sympathy, anything that intrudes on their preconceived pictures of how landscape ought to be. This sort of mental bulldozing tends to bring real bulldozers in its wake, in fits of Cromwellian zeal to erase whatever offends the eye and taste of the temporary beholder. Better by far to learn to value the landscape for its long accumulation of contradictions and ambiguities—an accumulation to which we're constantly adding by our presence here.

I moved from London to Seattle on impulse, for casual and disreputable reasons. I met someone . . . the usual story. A writer's working life is dangerously easy to transport from one place to another, and in 1990 I thought that possession of a fax machine would be enough to bridge the inconvenient distance between the two cities. As for anxiety about displacement and culture shock, I had none: I cockily thought America was my oyster. I'd taught its literature at two British universities and was about to begin the last chapter of my second book of American travels. I confidently began to make myself at home in my new surroundings in the only way I knew how, by reading them. More than a year went by before it began to dawn on me that I was floundering out of my depth.

The first time I went sailing on Puget Sound—with a copy of Vancouver's account of his 1792 voyage through these parts open, facedown, on the cockpit seat—I was taking in the landscape of low, built-over hills, rising fir forest, and mountains white with glacial ice and snow in June when I glanced at the electronic depth-sounder. It showed a steady 11 feet of water, though we were more than a mile from the shore and I'd seen no shallows when I'd checked our course against the chart. I immediately brought the boat's head through the wind, sails clattering, and started back in the direction from which we'd come. From 11 feet, the digital readout went to 10, 9.6, and abruptly down to 6.0—giving us just eighteen inches of clearance between the keel and the sea floor. Starting to panic, I grabbed the chart and guessed at our most likely position, a patch of white paper (a reassuring sign, since shallows are colored blue or tan) marked with three-figure numbers: 114, 125, 103 . . . and this in fathoms, not feet. The water beneath the boat was as deep as it is at the abrupt cliff-edge of the Continental Shelf.

The depth-sounder was lost. Programmed to accurately read down to fifty fathoms, or 300 feet, it was hunting for the bottom and, failing to find it, was seizing on false echoes and familiarities—drifting kelp fronds? shoaling salmon? plankton?—in a vain effort to regain its footing in the world and make itself at home again.

Its owner was doing much the same. On one level, my new city and its hinterland felt deceptively homely. Their similar latitude gave them the angular light and lingering evenings I was used to. Their damp marine weather, blowing in from the southwest, came from the right direction. When the mountains are hidden under a low sky, one might almost imagine oneself to be in Britain.

At first glance, too, the palimpsest appeared to be a lot more easily legible,

with many fewer layers of script running at cross-purposes to one another. The first white settlers had arrived here in 1851, and were of the same generation as my great-great-grandfather. Between Henry Yesler, who in 1852 saw the fortune to be made from cutting down the stands of gigantic Douglas firs on the neighboring hills and feeding them to his steam mill, and the founders of Microsoft, Starbucks, and Amazon was a stretch of time little longer than one old person's range of memory. There must have been people around in 1960 who could remember Yesler (d. 1892) from their teens and had bounced the infant Bill Gates (b. 1955) on their arthritic knees. After living here for twenty years, I've already experienced at first hand one-eighth of Seattle's history since the whites drove the Indians from their tribal land and forced them into a reservation on the far side of Puget Sound.

What I saw on arrival was a disorderly free-for-all: tract housing and industrial parks swarming over farmland, farms established on logged-over forest, loggers shaving mountainsides bare of trees, dead and dying mill towns, environmental organizations litigating to save what was left of nature, and in every direction barbed-wire fences marking out the fronts between the contending armies. The acrimony between city and rural hinterland was coming to a boil, with urban-based conservation groups like the Sierra Club and liberal politicians confronting the newly formed Wise Use coalition of free-marketeers, property owners, timber and mining interests, farmers, and the construction industries.

I'm still a trespasser on this battlefield of old resentments and fresh indignations, whose inequities glare more obviously than they do from any landscape I can think of in Western Europe. It's a hard place in which to feel at home. From its designated "wilderness areas" (themselves the result of much human ingenuity, conflict, legislation, and policing) to the latest crop of shopping malls and condo blocks sprouting from behind screens of trees, it feels provisional and volatile, as if its entire character might drastically alter with the next shift in the political or economic wind.

For an English-born reader, America is written in a language deceptively similar to one's own and therefore full of pitfalls. The word *nature*, for instance, means something different here, and so do *community*, *class*, *friend*, *tradition*, *home*. (Think of the implications beneath the surface of the peculiarly American phrase "He makes his home in . . . "). These I've learned to recognize, but the longer I stay here the more conscious I am of nuances to which I must still remain deaf. The altered meanings and

deep-water associations of American English, as it has parted company from its parent language for over four hundred years, reflect an experience of the world that has been every bit as different as that between, say, the Germans and the French, but in this case the words are identical in form and so the difference is largely lost to sight.

Reading an American novel, I can usually persuade myself that I'm a native speaker of the language in which it's written. But reading a western landscape, or an American political campaign, I hanker for a dictionary that would explain the difference between *nature* and *nature*, *home* and *home*, and chart their separate paths of evolution from their common roots. Talking with Americans, I still battle with the static interference, as on a bad long-distance line, caused by the buildup of slight differences of definition and assumption between our two national vocabularies. My grasp of American is a thousand times better than my lousy French, but there are sometimes moments at Seattle dinner parties that remind me of trying to follow street directions offered by a voluble stranger in a Calais bar-tabac.

Still. it's always the business of the patient reader to learn to live in a language not—or not quite—his own. Empson made himself extraordinarily fluent in seventeenth-century English by immersing himself in controversies—social, political, and theological—that had long been lost to view, and by digging deep into the private lives of writers who excited him, like Donne, Marvell, and Milton. His visits to the England of the 1600s were not made in the spirit of conventional historical or literary scholarship, but as a fierce partisan. He took sides. He relished battles. In a tribute to I. A. Richards, he wrote that "The main purpose of reading imaginative literature is to grasp a wide variety of experience, imagining people with codes and customs very unlike our own." He treated the writing of the past as a foreign country—every bit as foreign as Japan or China, where he taught in the 1930s and 1940s—in which he established himself as a model traveler, acquiring the local dialect, adapting himself to the local codes and customs, and returning with fresh and invigorating news of a world three hundred years distant from his own.

In 1971, ten years after first reading *Seven Types*, I met Empson in London. He'd recently retired from his chair at the University of Sheffield and was living with his wife, Hetta, at Studio House, Hampstead Hill Gardens—in a setup described by Robert Lowell as a "household [that] had a weird, sordid nobility that made other Englishmen seem like a veneer." Empson's idea of making lunch was to place an assortment of unpunctured cans of Chinese vegetables on the gas cooker, where they tended to explode.

Ancient rashers of fried bacon served as bookmarks in his disintegrating copy of Marvell's Collected Poems. He stirred his tea with the sole remaining earpiece of his glasses. After an alarming lunch, he and I would set off in my car to raid the Wallace Collection, the Sir John Soane museum, or some unsuspecting country house in Buckinghamshire or Hertfordshire where, Empson had found out, a family portrait of an ancestor distantly connected with Marvell hung on the walls. Doorstepping a secluded mansion, deep in its landscaped park, at the end of a long and gated drive, he displayed an imperious persistence, refused to take no for an answer, and forced our entry past nonplussed butlers and feebly protesting dowagers. I delighted in the disquiet that Empson gave such people. During the time I knew him, his luxuriant moustache varied in cut from Fu Manchu to Colonel Blimp; he was, always, legendarily scruffy, but his commanding, high-pitched, singsong voice announced his lapsed membership of the landowning classes, and the dowager and butler were clearly uncertain as to whether they were confronting Lord Emsworth in his cups or an unusually determined Kleeneze salesman.

At this time, he was engaged in a campaign to prove that Marvell, late in his life, had married his London landlady, Mary Palmer. This is a question that has interested nobody very much, before or since. But it greatly concerned Empson, who needed to know the full character of the author of "The Garden" and the "Horatian Ode Upon Cromwell's Return from Ireland": not knowing would be to leave Marvell's moral identity in a state of ambiguous incompletion, and Empson meant to get to the bottom of the matter. Delving into the knotted tangle of Marvell's legal, sexual, and financial affairs in the 1670s—freely speculating and imagining whenever documentary evidence was lacking—he was simply expanding his reading of the poems into a larger reading of the man, the times, and the language in which his subject lived and spoke. He was the best close reader of literature alive, but his definition of "reading" was infinitely more generous and catholic than that of the New Critics who were his immediate contemporaries and with whom he skirmished, often furiously.

He remains for me a touchstone figure. Faced with a book for review, a poem, a picture, a movie, a stretch of inhabited countryside, a speech, a staged event, I instinctively wonder how Empson might have read it, and think ruefully of how much he would have discovered in it. The pieces that follow are readings—most of them of the American landscape, literature, and politics, along with some backward glances to England that may betray a lurking nostalgia for a society more settled in its shape, more instinctively known, than the one I live in now. I haven't tried to corral them under the-

matic headings but have left them in more or less the same order in which they were written. It would be nice to think they can be read as the unfinished chronicle of my attempt to make a home in a place I continue to find fascinating, bizarre, ugly, beautiful, repellent, and generous and whose language I'm still trying to learn.

Seattle, October 2009

Driving Home

IN THE SPRING of 1990 I packed up as much of my life in London as would fit into a suitcase and four large plywood boxes and flew to Seattle to set up house. It was a selfish and irregular move. I had "met someone" and liked what I'd seen of the Pacific Northwest during a two-month stay there the previous autumn. I liked the aquarium lighting, the sawtooth alps forested with black firs, the compact cities encrusted in dirty Romanesque stucco. Most of all, I liked the place's wateriness. At forty-seven I felt cracked and dry. My new home territory was as rainy as Ireland, puddled with lakes and veined with big rivers. Seattle was built out on pilings over the sea, and at high tide the whole city seemed to come afloat like a ship lifting free from a mud berth and swaying in its chains.

We took a house on the wrong side of Queen Anne, the innermost of Seattle's hilltop suburbs. The tall wooden house, built like a boat from massive scantlings of Douglas fir, carvel-planked with cedar, had been put up in 1906, in the wake of the Yukon gold rush, when the hill itself was logged. It had warped and settled through a string of minor earthquakes: the floors sloped, doors hung askew in their frames, and on a silent night it groaned and whiffled like a sleeping dog.

Barely a mile from the new banking and insurance skyscrapers of downtown, the house felt as if it were hidden away in the woods. Shaggy conifers, survivors of the original forest, darkened the views from every window. The study looked down over the Ship Canal, where trawlers stalked through an avenue of poplars on their start to the Alaskan fishing grounds, eight hundred miles to the north. From the top-floor deck one could see out over the pale suburbs, like shell-middens, to the serrated line of the Cascade Mountains, still snow-capped in May.

For someone fresh off the plane from London, it was a vast prospect in

which making oneself at home would not be easy. It had been fine to be a tourist in this landscape, when I had been enjoyably awed by its far-western heights and distances; but now that I'd signed up as a permanent resident, the view from the window seemed only to reflect my own displacement.

Even the very near-at-hand was strange. I kept Peterson's Western Birds and the Audubon Guide to Western Forests by the typewriter. I made lists and pinned them to the wall. Cedar, cypress, dogwood, laurel, madrona, maple, I wrote, trying to distinguish individual personalities in the jumble of damp and muddy greens framed by the window. I took the tree book down to the garden and, wary of attracting derisive looks from the neighbors, matched the real-life barks against their close-up color pictures; the peeling, fish-scale skin of the lodgepole pine, the frayed hemp rope of the western red cedar. It took a month, at least, to be able to see the black-crested Steller's jay in the madrona with something like the comfortable indifference with which I'd used to notice a song thrush in the sycamore in Battersea. It took a good deal longer to adjust to how adeptly the rufous hummingbird, like a tiny thrashing autogyro, redisposed itself in space, zapping from point to point too fast for the eye to follow. Glancing up from the typewriter, stuck for a phrase, I'd catch sight of a bald eagle slowly circling on a thermal over the Ship Canal, its huge wings still and ragged, and lose the logic of the sentence to another half hour of involuntary ornithology.

The German word for "uncanny," as in Freud's famous essay on the Uncanny, is *unheimlich*—unhomely. The tourist thrives on the uncanny, moving happily through a phenomenal world of effects without causes. This world, in which he has no experience and no memory, is presented to him as a supernatural domain: the language of travel advertising hawks the uncanny as part of the deal. Experience the *magic* of Bali! The *wonders* of Hawaii! The *enchantment* of Bavaria!

But for the newly arrived immigrant, this magic stuff is like a curse. He's faced at every turn with the unhomelikeness of things, in an uncanny realm where the familiar house sparrows have all fled, to be replaced by hummingbirds and eagles. The immigrant needs to grow a memory, and grow it fast. Somehow or other, he must learn to convert the uncanny into the homely, in order to find a stable footing in the new land.

Hunkered down in the second-floor study of the comfortingly old and memorious house on Queen Anne, I tried to read my way home. My best guides were fellow aliens in the Pacific Northwest, from the early explorers of the region to such relatively recent arrivals here as the poet Theodore Roethke and the novelist Bernard Malamud. From the late eighteenth cen-

tury to the late twentieth, they kept striking the same note of shock at the stupendous unhomelikeness of this landscape.

It drove George Vancouver into a pit of what now appears to have been clinical depression. Between May and June of 1792, as he probed the inlets of Washington and British Columbia, he went from dizzy elation to sullen melancholy—and wrote his changing moods into the permanent nomenclature of the region. To begin with, he was high on his discoveries: this was "the most lovely country that can be imagined." He saw the Pacific Northwest as a kind of unusually verdant Devonshire, and imagined orderly villages with churches and manors laid out between the wooded hills. At this stage of the voyage, the names he gave to the headlands, bays, and fiords were upbeat: Discovery Bay, Protection Island, Restoration Point (the most beautiful and useful features, like Mount Rainier and Port Townsend, were named by Vancouver after his relations, friends, and patrons).

May turned into June. As Vancouver sailed north, the mountains grew steeper, the inlets narrower, the woods more impenetrable. His lieutenant, Peter Puget, who kept a parallel journal, was increasingly excited by the romantic sublimity of what he saw: a few years younger than Vancouver, he was much more in tune with the rising generation's taste for wild nature. For Puget, the unfolding landscape was "majestic" and full of "grandeur"; for Vancouver it was increasingly "dreary," "unpleasant," "desolate," "gloomy," "dismal," and "awful"—the words pepper his descriptions, often being used twice in the same sentence. Five minutes north of the fiftieth parallel, Vancouver brought his ship to a "dreary and unpleasant anchorage": "Our residence here was truly forlorn; an awful silence pervaded the gloomy forests, whilst animated nature seemed to have deserted the neighbouring country..." He called the place Desolation Sound.

Thirteen years after the Vancouver expedition, in the autumn of 1805, Lewis and Clark reached the Columbia River valley from the continental interior, after climbing to the headwaters of the Missouri and crossing the Rocky Mountains in what is now Montana. William Clark, with his botched spellings and childish exclamation marks, was a resoundingly lively presence on the page. He was an original vernacular narrator as he confided his discomforts, Dear Diary–style, to his journal. "O! how horriable is the day—" he wrote when the tidal Columbia cut up rough in a westerly gale and waves drenched the explorers' camp. "We are all wet and disagreeable." Clark had grown up in Virginia and Kentucky, and, like almost every newcomer to the Northwest, was incredulous at the monotonous fall rains that

soaked the country west of the Cascades. It rained day after day, hour after hour—with the fine-sifted thoroughness and regularity of a gigantic lawn sprinkler. "This morning Cloudy and drisley." "Rained all the last night we are all wet." "Rain as usual." "Rained without intermition." "A blustering rainey day." "A hard rain all the last night we again get wet." "Rained verry hard." "Confined on a tempiest coast, wet." The swollen river carried with it the trunks of uprooted trees, "maney of them nearly 200 feet long"; as they spun around and around on the current, they often came close to capsizing the expedition's canoes. "Those monsterous trees—" wrote Clark, summoning the vocabulary of the uncanny to convey the gross abundance of this landscape.

In 1947 Theodore Roethke came west to Seattle, drawn here by the offer of a job in the English department at the University of Washington. The city itself ("a kind of vast Scarsdale . . . no bars for anything except beer and light wines in the whole of Seattle") was tame and provincial, but the surrounding landscape roused Roethke, as it had roused Vancouver, to flights of concentrated pathetic fallacy. Before 1947, his poems had been full of emotional turmoil projected onto a vivid vegetable world of crocuses, geraniums, cyclamens, peaches, butternuts, pear trees, and spiders—a world enclosed by the same fences that bordered his father's market garden and nursery in Saginaw, Michigan. In the Pacific Northwest (" . . . the peaks, the black ravines, the rolling mists / Changing with every twist of wind . . . ") Roethke found a nature that was extravagant enough to give physical body to the extremes of his own morbidly dishevelled nature.

His new poems mapped a wild, volcanic, thickly forested region of the heart and mind. In the geological melodrama of the Washington landscape, he found a spectacular objective correlative to the upheavals of his mental life—the uncontrollable ascents into mania, the whiskey, the compulsive womanizing. His last collection, *The Far Field*, posthumously published in 1964, is an inspired gazetteer of places that are simultaneously states of mind and visitable destinations within easy reach of Seattle. "Journey to the Interior," for instance, is both a fine description of driving on a logging trail in the Cascades (Roethke bought his first car, a Buick, in 1950, when he was forty-two and was thereafter an enthusiastic—and alarming—motorist) and a lightly encoded account of a life spent skirting the edge of insanity:

In the long journey out of the self, There are many detours, washed-out interrupted raw places Where the shale slides dangerously And the back wheels hang almost over the edge... As the mountains represented the menacing heights, the rivers, lakes, and sea afforded renewal and balm. Roethke wrote beautifully about water, its movements and stillnesses. In the mental hospital, he spent long hours in hydrotherapy; sane, he found another kind of hydrotherapy, fishing for coho salmon from the Oyster River resort on the east coast of Vancouver Island, watching birds on Lake Washington, walking on the rocky margin of Puget Sound, watching small waves break. From "The Rose":

I live with the rocks, their weeds,
Their filmy fringes of green, their harsh
Edges, their holes
Cut by the sea-slime, far from the crash
Of the long swell,
The oily, tar-laden walls
Of the toppling waves,
Where the salmon ease their way into the kelp beds,
And the sea rearranges itself among the small islands.
Near this rose, in this grove of sun-parched, wind-warped madronas,
Among the half-dead trees, I came upon the true ease of myself,
As if another man appeared out of the depth of my being...

It was exciting to watch Roethke making himself at home in western Washington by discovering that western Washington had always, as it were, been inside himself. To the view that I could see from my own window, Roethke attached names and meanings that went far deeper than Vancouver's. Of all the incomers to the Northwest, who had put this landscape to use and made cognitive sense of it, from fur traders and timber barons to aeronautical engineers and Dutch bulb-growers, Roethke was the most generous: if a stranger had as baggage nothing except Roethke's *Collected Poems*, he would have a solid imaginative foothold here.

In 1949, Bernard Malamud left New York to take a job as an instructor in the English department at Oregon State College in Corvallis, lately an agricultural school. In 1961, he returned to the East Coast, where he had been appointed writer-in-residence at Bennington College in Vermont—and published his third novel, *A New Life*, a bitter comedy about a New York Jew, an English instructor, who finds himself stranded in a narrow-minded town in the wide-open country of the Pacific Northwest. Malamud's

revenge on Oregon (as it was generally perceived by Oregonians) had for a long time been my favorite campus novel—though for years I believed that it was set in an invented landscape, a fabulous Far West that Malamud had cooked up in his Manhattan fastness.

I had come across the book in 1964, in the paperback carousel at the new service station at Newport Pagnell on the M1 motorway. The cover was suggestive. Above the blurb, "He found strange refuge—love with another man's wife," was a drawing of a young woman reaching for the zip of her Levi's. The man in the background was small and wore a hat. I knew Malamud's name from the stylized short stories of New York Jewish life in *Idiots First*. I hadn't heard of this surprising novel.

I read it in a sitting and have owned three separate copies since, but it wasn't until around the beginning of the second copy that I woke up to the fact that Malamud's "Cascadia" was Oregon, not an urban Jewish fantasy of some Eden far beyond the range of the road atlas. I hadn't then been to the United States, and the landscape described by Malamud—a green paradise infected by the encroaching spectre of Senator Joseph McCarthy—rang no specific bells for me. It read like the landscape of allegory, and worked so well in those terms that I wasn't tempted to go looking for its latitude and longitude.

In the book, Marathon, Cascadia, is a rigidly conformist college cowtown, with a winning football team and a paranoid contempt for Reds, misfits, and intellectuals. Seymour Levin, "from the East," "formerly a drunkard," an admitted liberal with a beard, is destined for a painful roasting in this 1950s version of a Puritan township enjoying a witch trial. At every turn in the story, the philistinism and uncharitableness of town and college are set against a landscape of mountains, forest, and ocean so ironically magnificent that any reader bred to the landscape of Newport Pagnell must have doubted its literal existence. A New Life seemed to me to be written in the freehand, fantastic tradition of the Jewish folktale: Malamud was painting the richness and promise of the idea of America—and its betrayal by a mean-spirited citizenry, people too small to deserve to inherit their gigantic land.

It slightly diminished the novel to learn that there were "originals" (or so my knowing American informant claimed) of the Fairchilds, the C. D. Fabrikants, the Buckets and Bullocks, and that Malamud's poisoned Arcadia was drawn directly from the life—that Marathon was Corvallis, sixty-five miles down the road from Portland. This American, a Berkeley professor, thought I was offbeam when I claimed the novel was a work of ambitious

fabulism. No, he said, the landscape of the Pacific Northwest was in itself an unrealistic stretch of country—it was just naturally fabulous.

The uncanny again. Twenty-five years on, I sat out on the deck of the house on Queen Anne on a sunny day in autumn when the visibility was good, rereading *A New Life* for the umpteenth time. To the right lay the Cascades, to the left the raised and snowy edge of the Olympics, and in the middle the mixed woodlands of the rolling suburbs of Seattle. A big ketch was sliding through the poplars. The sun made the print jump on the page, but now I very nearly had the opening of the novel by heart:

... They were driving along an almost deserted highway, in a broad farm-filled valley between distant mountain ranges laden with forests, the vast sky piled high with towering masses of golden clouds. The trees softly clustered on the river side of the road were for the most part deciduous; those crawling over the green hills to the south and west were spear-tipped fir.

My God, the West, Levin thought. He imagined the pioneers in covered wagons entering this valley for the first time, and found it a moving thought. Although he had lived little in nature Levin had always loved it, and the sense of having done the right thing in leaving New York was renewed in him. He shuddered at his good fortune.

"The mountains to the left are the Cascades," Pauline Gilley was saying. "On the right is the Coastal Range. They're relatively young mountains, whatever that means. The Pacific lies on the other side of them, about fifty miles."

"The Pacific Ocean?"

"Yes."

"Marvelous."

Just off to the side of the page margin, there was a flittering disturbance in the holly tree in a neighbor's yard. I shifted my attention from Cascadia to Washington, from the 1950s to the 1990s. A big flock of yellow-bellied waxwings had settled on the holly and were distributed on its branches like so many ornaments on a Christmas tree.

High over the city, above the muffler shops and 7-Elevens and steep streets of pastel-colored frame houses, an eagle wheeled, sublimely.

I was with Seymour Levin. My God, the West-

November 1992, and the snow level, said our TV weatherman Harry Wappler, was down to 3,500 feet and dropping fast. In a week the mountain passes would be tricky and the back roads closed for the winter. I dug out of storage my never-used box of tire chains and set off on a wide swing around the neighborhood.

It was high time to make the trip: though I had been living in Seattle for more than two years, I was still confused as to its whereabouts. I knew the city better than its cabdrivers (a very modest boast), but I'd barely begun to work out how Seattle fitted into the larger story. A long drive, on empty western roads where it's still possible to think with one's foot down, would, with luck, thread the oddly assorted bits of the Pacific Northwest onto one string and set them in narrative order.

The afternoon rush hour had started by the time I got away, and heading east on Interstate 90, the cars were locked bumper to bumper on the floating bridge over Lake Washington. The sky was lightless, and the windshield wipers scraped on the glass in the fall moisture, typical of these parts, that was something more than mist and less than rain. The traffic jam, too, was typical: a ceremonious and orderly procession, like a funeral, of VWs with ski racks on their tops and I'D RATHER BE SAILING stickers on their rear ends. A great deal of higher education was stuck on the bridge that afternoon. The names of the universities from which the drivers had graduated were posted in their back windows—faraway schools, mostly, like Stanford, MIT, Columbia, U. Mich.

My own car, a low-slung, thirsty black Dodge Daytona with a working ashtray, marked me out as a Yahoo among the Houyhnhnms—too old, dirty, and wasteful to pass, even in this bad light, as a member of Seattle's uniquely refined middle class. Stuffed into the book bag beside the work of the Northwestern writers whom I had brought along for the ride (Richard Hugo, Ursula K. Le Guin, Raymond Carver, Katherine Dunn, William Stafford, Norman Maclean, James Welch, James Crumley) was a bottle of Teacher's, two-thirds full, which would have seemed OK to the Northwestern writers but thought a very low touch by these Northwestern drivers. In Seattle, a triple shot of nondecaffeinated espresso was thought to be pushing the boat out farther than was wise.

In shifts and starts, we lurched into Eastside Seattle, Houyhnhnm country, where the VWs started to peel off onto the Bellevue exits. Bellevue and its satellites were not suburbs so much as—in the rising term—an Edge City, with its own economy, sociology, and architecture. Things made on the Eastside were odorless, labor-intensive, and credit-card thin, like com-

puter software and aerospace-related electronics gear. They were assembled in low, tree-shaded factories, whose large grounds were known as "campuses"—for in Bellevue all work was graduate work, and the jargon of school and university leaked naturally into the workplace. Seen from an elevated-freeway distance, Bellevue looked like one of its own products: a giant circuit board of color-coded diodes and resistors, connected by a mazy grid of filaments.

During the presidential campaign, Bill Clinton had jetted around the country calling for the advent of the "high-growth, high-wage, smart-work society"-a fair description of Bellevue, with its lightly rooted, highly trained workforce, its safe streets, its scented malls sprayed with composerless light orchestral music, its air of bland good conscience. Bellevue was the new and hopeful face of American capitalism, and it had a strongly Japanese cast to its features. The one- and two-storey campuses with their radial walkways reflected a style of business management that was closer to the industrial collectives of Tokyo than to the moribund hierarchies of Detroit and the American Rust Belt. They housed entrepreneurial teams in which more or less everybody appeared to be an equal player. In Seattle, I kept meeting people from Microsoft, the biggest of the Eastside corporations, and it was interestingly hard to figure out who was whose boss: as in the layout of the buildings on the ground, all the distinctions appeared to be lateral ones, between division and division, rather than vertical ones between layer on layer of management.

The place looked like somebody's utopia, more a model city than an actual one, and it appeared to be inhabited by the kinds of people whom architects like to place as strolling figures in the foregrounds of watercolor sketches of their projects. Wherever the eye wandered in Bellevue, it lit on another 31¾-year-old, with a master's if not a doctorate, dressed for work in hiking shoes and fleece. Thousands of these diagrammatic people were housed along I–90 in white-painted, shingled, faux-New England condo blocks called "villages." Lakefront Village . . . Madrona Village . . . Olde Towne Village . . . communities in which the villagers met in the evenings at neighboring exercycles in the village health club or at a prebreakfast session on the village driving range.

Eastside Seattle was a new kind of American city, though it had a lot in common with the long-established retirement paradises of Florida and Southern California. People in their twenties and thirties were now moving (as their parents had done only toward the ends of their lives) for the sake of the climate and the natural amenities of a place rather than just for the jobs on offer there. They were coming to Seattle much as people had gone to Venice, California, and Miami Beach; the difference was that they were coming at the beginnings of their careers. They arrived as kayakers, hikers, balloonists, birdwatchers, skiers, and mountain bikers who also happened to have degrees in math and marketing and computer science. Their Pacific Northwest was really a civic park, roughly the same size as France, equipped with golf courses, hiking trails, rock-climbing routes, boat-launch ramps, ski lifts, campgrounds, and scenic overlooks. This great migration of open-air hobbyists (which dated from about 1980—the early Reagan years) had won Seattle a curious niche in urban history, as the first big city to which people had fled in order to be closer to nature.

As part of the migration, I was in no position to affect a haughty tone about it, but it was tough to see one's own bold and original move so nakedly mirrored by the Bellevue villagers in their hand-crafted Peruvian wool outfits and their radical crusades on behalf of the wolf, the whale, and the spotted owl. There was a bad smell of metropolitan imperialism in the way in which all of us, from London as from the burned-out urban hulks of Brooklyn and Queens, were moving in on this working landscape and bringing the news that its traditional rural industries must stop forthwith. Of course, it was the enlightened mission of the incomers to save the planet; of course, the loggers and mill workers saw the mission rather differently, as an attempt by strangers to rescue the Pacific Northwest as an unspoiled recreational site for themselves and their children.

Sixteen miles out of Seattle, the eastward march of the city was stopped in its tracks by the foothills of the Cascades. Beyond Issaquah the black cliffs of the forest began, and the social character of the road abruptly changed when the last of the VWs melted into the last of the white condo blocks. Up till now, I'd been in the fast lane; no longer. Mud-slathered pickups with jumbo tires charged past the Dodge wearing angry slogans on their tailgates. JOBS BEFORE OWLS. SUPPORT THE TIMBER INDUSTRY. SAVE A LOGGER—SHOOT AN OWL. Behind the glass of a cab window, a Zippo lighter flashed in the gloaming.

Small charcoal-colored clouds were snagged in the firs. We were climbing steadily now, the road wet, the light failing fast. At just over 3,000 feet, Snoqualmie Pass was much the lowest of the Cascades' passes, but it was a long slow haul to reach it with the highway weaving up through the contour lines, shouldering the hills aside. Each bend in the road opened on another wall of Douglas fir, the trees as dense and regularly spaced as the bristles on a broom.

This wasn't true forest, though it had the enormous blackness of the forest of German fairy tales; it was a "tree farm," a second- or third-growth planta-

tion now ready for "harvesting." The terms were those of the industry, and after two years of seeing them in use, I still found myself putting quotation marks around them in my head. To me, farm and harvest meant a two-acre wheatfield in Essex, with rabbits scarpering from between the cornstalks, and the words refused to stick when I tried to attach them to mountains with hundred-and-fifty-foot trees, where bears and cougars ranged instead of rabbits and twin-rotor helicopters served as baling machines. But my perspective was altering: each time I thought of the seventeenth-century farmhouses of the Dengie marshes, their checkerboard crops neatly hedged and ditched, they looked less like farms and more like cottage gardens.

The road veered sharply left around a dripping wall of rock and disclosed a harvest. *Harvest*? It was like seeing a dynamited factory chimney, or a disused housing project blown to smithereens. It was magnificent. A rectangle of forest a mile square had been shaved from the face of the mountain: the straight lines of the clearcut were contemptuous of the natural bulges and fissures of the landscape; they sliced through gully and ridge as cleanly as if someone had done the job with a steel ruler and a Stanley knife. Every tree was gone.

In close-up, where the bottom edge of the clearcut grazed the next hairpin turn, one saw the mess of it: the blackened stumps and upended root systems, the yawning mud craters, their outlines softening now with a healing overgrowth of blackberry and salal, with, here and there, the green spike of a sapling fir breaking through. It looked like photos of the Flanders battlefields in 1918. A whole world of burnings, explosions, amputations, random excavations, it wanted only the tin hats of the dead to be hung on the blasted stumps. Then it was gone, this enormous combat zone between man and nature, borne away by the fast-swerving road.

Not long ago I saw the word "clearcutting" in a list of wanton evils that culminated in "genocide": utter abhorrence is the politically correct response to the miles of razored forest. Yet it was only yesterday afternoon that the logger was the greatest of all American folk heroes, his activities hymned as the moral triumphs of civilization over the unruly wilderness. Even now, American children are being raised on the stories of the craggy giant Paul Bunyan, with his lopsided lantern-jawed grin, whose blue ox, Babe, measured forty-two axe handles and one Star tobacco tin from eye to eye. I imagine, though, that these stories are being drastically rewritten or withdrawn from circulation: Paul Bunyan, the first clearcutter, is too vulnerable on the character issue to remain for long in his position as a demigod in the American nursery.

Bunyan is the embodiment of unbridled masculine power. In Wisconsin

one December he felled "a hundred million feet of lumber" to find a suitably tall Christmas tree; he logged Minnesota with a saw half a mile in length. On a detour from his walk from Fargo to Seattle, he dragged a spike behind him and created the Grand Canyon. After meeting the Seattle timber barons (Paul habitually sides with the industrial bosses) he harnessed Babe to a plow and dug out Puget Sound. Tramping in the Cascades (he walked from Seattle to Minneapolis in an afternoon), he went swinging an axe with a sixteen-foot cutting blade on the end of a woven flexible handle fifty feet long. This cleared a path conveniently wide for him and his ox, and the trees fell symmetrically in a perfect corduroy.

The clearcut was a true-life Paul Bunyan story—exuberant, exaggerated, so far out of fashion that it was criminal. It stood for an American way of thinking and feeling about nature that was not easily going to be wiped out by a generation's worth of environmentalist education. For more than four hundred years of white settlement, this was what you did with the wild—taming it with bold rectangles and straight lines. There was a stirring kind of American poetry in the rifle-shot road; the ambitiously projected grid of the infant city, its numbered streets-to-be laid out across the swamp; the single-file march of power pylons over a mountain; the rigid outline of the clearcut. This was order, reason, and discipline imposed on an adversarial and unregenerate nature. By the last quarter of the twentieth century, Americans had come within sight of the end of wild nature—but the habit of mind, bred in cold Protestant theology, was now as deeply embedded in the national character as an instinct. If I were a logger, I thought, I'd be brimming with pride at what I had done to that mountain, and I would hate with a passion the whining townies who were trying to demonize my kind. Save a logger, shoot an owl!

The road got darker and darker as it climbed toward the blue snowfields on the peaks. The tree farms dripped. The car's automatic transmission kept on flubbing its gear changes as the gradient steepened. At the top of the hour, on the top of Snoqualmie Pass, National Public Radio, lost since Issaquah, returned with the news that John Major had carried the motion on the Treaty of Maastricht in the House of Commons by the skin of his teeth. In England, I realized with as unexpected twinge of homesickness, it was "Bonfire Night."

Bowling downhill east of the summit, I ran out of the rain into a cold dry night with a waxing lemony quarter moon overhead. The trees began to shrink in height and there were lightsome spaces between them, for the climate of eastern Washington, in the lee of the Cascades, is arid. At one side of the state there's a rainforest, at the other a desert, and the Cascade Ridge splits the state in two, giving a kind of geographical reality to Washington's schizoid personality, its fierce divisions between wet liberals and dry conservatives.

At Cle Elum, down near the foot of the range, I pulled off the highway and stopped for a drink. The small town's too-wide main street was empty of people. The air was icy. But there was a good bar: in the rancid fog of cigarette smoke, a line of broad-brimmed hats, broad bums, and red plaid jackets. Conversation, which had been brisk when I walked in, stopped dead when I hoisted myself onto the only vacant stool.

"Hi. Mind if I-?"

I got a fishy stare for an answer. Then the man resumed the interrupted sentence he'd been speaking to his neighbor: "...like I was saying, they got some over in Wenatchee..." I was caught in the crossfire of the war between the country and the city. Too late in the season to be a hiker, too early to be a skier, I was a likely member of that most despicable of all urban species, the birdwatchers.

It wasn't so much that the spotted owlers were the direct cause of the closed sawmills, the bankrupted log-hauling companies, and the rest of the miseries of the timber industry. What rankled most deeply in the depressed towns of the Cascades was the righteous triumphalism of the owlers as they rejoiced in the industry's decline. That the owlers came (or so the timber interests surmised) from the environs of Bellevue, which appeared to grow fatter, richer, and smugger by the day, was the final affront.

For Seattle had always used to be a timber town, and there had been a continuous and productive intercourse between the city and its rural hinterlands. Seattle's first industry was Henry Yesler's sawmill, established in 1853 on Elliott Bay at the foot of the original Skid Road; and most things that were manufactured in Seattle—paper, pulp, furniture, ships, and boats—had started life as trees. The aircraft industry had roots in the forest: William Boeing's factory was a bankrupt boatbuilder's yard, and the first planes had boatlike skeletons constructed from local fir, pine, and Sitka spruce.

It was only lately that the city's economy had broken free of its dependence on the countryside. The new Seattle, where babyfaced entrepreneurs from out of state trafficked in semiconductors, was as remote from the local concerns of places like Cle Elum as Tokyo itself—while for tourists from the city, the world they found on a short drive out of Seattle was as alien as

that of rural Appalachia. The loggers and the urban tourists had come to regard one another with an intense bafflement and dislike.

Sipping without pleasure at my beer, I saw in the bar mirror the man who was sitting on my stool—a fern kisser, a prairie fairy, a watermelon (green on the outside, red on the inside). A sumbitch preservationist. The Dodge Daytona parked on the street outside was marginally in my favor, but the copy of Peterson's Western Birds parked on its passenger seat was definitely not.

In a week or two, when the snow settled on the slopes, the skirmishes would begin. The preferred winter sport of the Houyhnhnms was cross-country skiing, and they came to the eastern side of the Cascades because the snow was drier here (the west side of the range was known as Slushqualmie). The Yahoos went in for snowmobiles. Astride 750cc Yamaha Vmaxes, Super Brute 440s, Thundercats, and Exciters with psychedelic purple-and-silver custom paint jobs, they roared through the woods, guzzling gas and scaring the owls into Canada.

The big sleds could go 120 miles an hour on the flat, and an enthusiastic snowmobiler could run through a hundred gallons of high-octane mix in the course of a good day. The language of snowmobiling was untainted by sissy environmentalism. *Snowgoer* ads were phrased in a virile prose that I thought had died in the 1960s: "Hammer the throttle for a split-second response and that menacing 581cc liquid-cooled snarl tells you it's got the cc's to take on all comers"; "It's raw power. It's pure adrenaline . . . There's really only two things you have to remember about the SX. One, it comes from Yamaha. And two, it goes like hell."

So family parties from Seattle would go telemarking silently through the trees with bird books and binocs—and be met by families from Roslyn and Cle Elum putting the pedal to the metal and making their banshee winter music. There were "incidents" and "altercations": the nature-loving townies, offended by the technology-loving country folk, came back with their own kind of machinery in the form of injunctions, ordinances, filed suits, and hitherto unnoticed regulations in the small print.

I left the bar and returned to the highway, slowing in front of the Cle Elum snowmobile dealership, a Yamaha outfit with a display of Exciters and Phazers. They had condom names and looked like cheeky cocks-and-balls, their protuberant scarlet nose cones supported by pairs of fat pistons over abbreviated, wide-apart skis. Paul Bunyan might have been equipped with something similar.

I lacked the cojones to stay the night in Cle Elum. Half an hour down the

road lay Ellensburg, the farm metropolis of central Washington. One of the many cities of the Far West that had had great expectations when its founders laid it out as the coming Chicago of the Yakima Valley, Ellensburg had 1890-ish yellowbrick shoebox buildings with grandiloquent stucco facades. It had a college, a J. C. Penney's, and an Italian restaurant. Next to the lingerie shop on Pearl Street was Giovanni's, and it was open.

That night, the restaurant and the lingerie shop had confusingly joined forces. Before an audience of a dozen diners, mostly men and apparently unprimed for the event, a fashion show was taking place, and what I took to be the menu was full of descriptions like "Jackie, last but not least, in our Lacy, Romantic, Sassy, Sexy chemise of poly-lace chiffon, \$49.95." The Chicken Cacciatore and Veal Parmigiana turned out to be on a separate sheet—though the procession of young women in intimate apparel added a note of powerful double entendre to the sassy and romantic restaurant-English of the menu.

Giovanni himself waited on my table.

"Sorry about the dreadful music," he said. "It's not our usual thing at all. It's for the fashions." His voice wasn't from Italy, or Ellensburg. Giovanni was John, from Monmouthshire, between Newport and Pontypool.

Later, after I had eaten and Jackie had swirled past in her chemise to a Mantovani accompaniment, John and I talked. An old North America hand, he'd sailed from Liverpool to St. John, Newfoundland, in 1964, settling first in Canada, then in Seattle. Like a Hollywood Englishman, his public-school accent had become more rather than less pronounced in the nearly thirty years he'd spent out here. Trim, pink, and beginning to grizzle at the edges, he was the kind of affable Britisher who put one instantly in mind of country pubs, thatch, hollyhocks, and Alistair Cooke on *Masterpiece Theatre*.

He had been Giovanni since the fall of '89, when he moved from Seattle to Ellensburg to set up shop in a defunct restaurant then known as the Carriage House. I said that he seemed a strange bird to discover in an eastern Washington cattle town.

"Oh, do you think so? I feel comfortable here. I'm getting to know people now, I'm becoming accepted, I think. Ellensburg's a nice-sized town—a market town, really. I was getting tired of the hassle of the big city, and going to Ellensburg was sort of like a homecoming for me."

"But the landscape . . . I've been here nearly three years, but it hasn't begun to look *normal* to me. I sometimes wake up in the mornings, forgetfully, and think I'm in London, and then I see the mountains and the forest, and I wonder what on earth I'm doing here. That never happens to you?"

"I hear what you're saying," John said. "But no, I don't think so. We're in quite a small valley here, with hills on both sides. And the fields are small. Relatively small. Well, I mean, compared with *Texas*, it's restful. It's ... bucolic."

For a moment, I saw Ellensburg as I imagined John did: the Cascades somewhat squashed, to about the size of the Black Mountains, the Yakima River leaking into the Usk, Pearl Street narrowed and given a dog's-leg twist to it. This was how people with a real talent for expatriation organized the landscapes in which they lived. They cultivated a benign astigmatism toward all the *unheimlich* aspects on which I dwelled with morbid interest. When I was in Bahrain a dozen years ago, I used to drink at the British Club, whose members were all under the (to me wild) delusion that they had just dropped in for a snifter at the saloon bar of the Dog and Duck in East Molesey; and Giovanni–John had a similar knack for making himself improbably at home. Had he been placed on the lip of a crater on the moon, he would probably have said that it strongly reminded him of Wales.

"It's nice," he said. "I like the countryside 'round here. Whenever I can, I go for drives. I get in the car and take the first right, first left, first right... you know. And wherever I land up, that's fine by me."

I went on poking and prying. I wanted him to confess homesickness, alienation, something more in my line. He had tried returning permanently to Britain once, ten years ago, but it hadn't worked out, and he had been back in Seattle after eleven months. "Now I'm resigned to staying here. I don't have much to go back for, really, not now. To be frank, I can't afford to go back. I couldn't afford to buy a restaurant over there. Right now, I'm in the middle of buying some land here. A nice house, with a garage and a workshop, on three acres of its own land, just outside town. I'm paying seventy-six thousand dollars. That's—what? Forty, forty-five thousand pounds?"

"People pay that for dinner in London now-"

"I *like* it here," he said, with just enough emphasis to allow me room to doubt if he entirely meant it.

Next morning, a kindly fog filled the valley. It shrouded the outline of the Super 8 Motel, built and furnished like a low-security prison, where I had spent the night, and hid the worst of the blood-and-mustard gas-station architecture around the highway. I tucked the Dodge behind a slow-moving truck with Pennsylvania plates (I–90 is an epic that starts in downtown Seattle and finishes at Boston Harbor) and followed it blindly into the gray.

As the road climbed and the fog turned shallow and silvery, bits and pieces of the landscape started to show through: outcrops of shale, balding rye grass, chain link fencing, a stationary group of beige-colored cattle. It wasn't nymph-and-shepherd country, the "bucolic" pastoral of Giovanni–John's Cwmbran-on-the-Yakima; it was an irrigated desert, tan not green, stony, a congenial habitat for the rattlesnake and the coyote.

The last rags of fog faded into the air and suddenly one could see for miles: a huge tract of unrelieved ochre under an empty ice blue sky. At Vantage, the road crossed the mile-wide Columbia River, yet even here there was no vegetation to speak of. The river, bigger even than my memory of the Mississippi, ran through a cutting of frost-crumbled rock. Furrowed by a wind I hadn't noticed until I saw the water, the Columbia was breaking like a sea. Until that moment, I had thought that someday I'd like to ride a boat down the thirteen-hundred-mile-long river; an ambition canceled on sight. It was the most inhospitable-looking stretch of inland water I'd ever seen—no shading trees, no riverside bars, no islands; nothing but wind and shale, and between the two an enormous and bad-tempered black canal.

The bluffs on the east side of the river had the texture and color of a cracked Cheddar cheese after the mice had been at it. From a short distance, they looked quite bare; close-up, they turned out to have a thin covering of sagebrush. It was not much of a vegetable. More dead than alive, its twiggy, burned-out stalks shivered in the wind.

I left the highway for a blacktop road, straight as a compass bearing, that led across the plateau to Ephrata and Odessa. On the car radio, the airwaves seemed to be drying out in sympathy with the landscape. National Public Radio had drifted into a tindery crackle miles ago. Then I found a country music station, with an early-period Merle Haggard song: "... Fever caused my momma's loss of hearing / And Daddy Frank was born without his sight..." But that went too after I'd crossed the Columbia. I tried the AM band and got a phone-in exorcism program. The exorcist, who sounded as if he was moonlighting from a regular job of promoting sales of cars at unbeatable giveaway prices, was casting out the evil spirit that had taken possession of a female caller. She wept and moaned down the line. The exorcist ordered the spirit to speak its name—and got an answer, from a ventriloquist's bogeyman voice, half-way between a chuckle and a screech.

"I can't hear you. Say it again!"

"My-name-is-Satan-"

I switched off. I'd run into this show before, and it was the kind of thing

that I used to find amusing in the United States before I lived here but was hard to bear as part of the everyday furniture of home.

The plateau was dead level from horizon to horizon; the road tapered evenly to a dot in the middle distance. Half a dozen small farms went by. Although this land was parched, its soil was rich. It had been a desert until the 1940s, when the building of the Grand Coulee Dam on the Columbia enabled a network of water pipes and irrigation ditches to spread across eastern Washington and homesteaders moved in on the unlikely, monochrome terrain.

I kept on driving past the same farm: same trailer home parked on the same dusty plot; same Chevy pickup; same chained yellow dog; same great tilted silver satellite dish collecting messages from the heavens. The best-kept farms announced themselves from several miles off with a lone poplar tree, four times as tall as the telephone poles that were otherwise the most commanding feature of the landscape. The plateau was dotted with these flagstaff poplars, each one a signal of someone's long-standing residence and patient husbandry.

It was a big thing to raise a tree here, where nothing grew naturally except stunted sagebrush. A Seattle friend who'd visited eastern Washington since his childhood in the 1940s told me these were known on any of these farms as the Tree; whenever the dishes were washed or a bath was taken, the dirty water was carried out and fed tenderly to the Tree, whose inch-by-inch growth was monitored as carefully as a child's.

Rusty "walking johnnies" littered the landscape. Quarter-mile-long water sprinklers on wheels, they were permanently tethered at one end to a spigot, the free end attached to a tractor so as to be trundled over the ground, making a disc of wetted soil. I'd noticed these circular fields from the window of an overflying 747; they were dark and granular, like treacle tarts randomly scattered in the desert.

It seemed an extraordinarily grim method of farming. Every sprig of green on the plateau represented an elaborate circumvention of nature by technology and labor. In a summer heatwave or a winter wind, this would be a horrible place to spend time in the vintage trailer houses that passed for farmhouses, and nobody seemed to be making a fortune out of the struggle. Schafer . . . Reiser . . . Krupp . . . Weber . . . the names on the map matched those on the mailboxes. Where, I wondered, had these German subsistence farmers been before, that they could consider this dry butte hospitable and promising?

On a road so straight, through a landscape so flat, distance dissolves

into time and time decelerates to the speed of a watched kettle. The farms seemed to come to a standstill as the car got stuck beside the same telephone pole. Looking down to find the radio on/off button, I noticed that the speedometer needle was securely lodged between 105 and 110. I lifted my foot from the gas pedal and watched the needle drop slowly through the numbers: at 55, the next mailbox appeared to be slightly receding, as if the car were failing to keep up with the rotation of the earth.

At the next townlet (a straggle of prefabricated bungalows along the side of the road, with six poplars constituting a civic park), I stopped at Somebody's Chuckwagon Diner—Eddie's, or Bill's, or Kurt's. I was the only customer, and I hadn't finished seating myself at the counter before the woman in charge started to argue with me.

"And *another* thing he's for," she said, glaring at me from behind big lavender-tinted spectacles, "is family leave. And that's going to do the most tremendous amount of harm to small businesses."

I didn't know what my problem was. Perhaps I was wearing a liberal Democrat shirt. At any rate, I wasn't prepared to ride to the defense of the new president-elect before breakfast. I nodded and smiled and muttered that I liked my eggs over easy. The woman stared through me. Her permed silver curls were wound as tightly as springs, and her lips were rouged in a cherry-red Cupid's bow. Her whole demeanor was about order, control, the smack of firm government. I had somehow managed to locate the Margaret Thatcher of the western plains.

She stood over the griddle, cracking eggs as if they were the pates of noodle-headed lefties. *Splat. Splat.* Her head swiveled briefly round in my direction. "You know they've got more Christian mandates now in *Japan* than what we have here? *That's* what this country's coming to."

For a moment, the irrigated flatlands of eastern Washington merged with the irrigated flatlands of Thatcher's native Lincolnshire, another hardline, subjugated landscape where nature had to be dominated for humans to live in it.

She overcooked the eggs and petrified the bacon.

"Catch up!" she snapped.

"Sorry?"

"Ketchup?"

It was not a happy meal. I ate one egg that tasted like a dried-up scone, then paid the check. Turning, I saw there was another late-breakfaster in the diner; a very small old man with a shrunken jaw was in the booth behind me, hiding behind the Spokane morning paper. He wore a faded

Oro-Wheat baseball cap and looked inoffensive enough, but he must have been the notorious tax-and-spend bleeding-heart socialist of Grant County.

This was the landscape of the Christian Right. In the 1988 primary season, east-of-the-Cascades Republicans had made the televangelist Pat Robertson their first-choice presidential candidate, and Washington was the only one of the United States to back him. In the small towns I was passing through—Stratford and Wilson Creek, Odessa, Harrington, Lamona—the smartest, most important buildings were the churches of the Adventists and the Assembly of Godders. White-painted, picket-fenced, and made of cinder blocks, with late-model parish minibuses in their parking lots, these bunkers of Christian fundamentalism looked as efficient and well capitalized as the software outfits of Bellevue.

Religion was in the air here. The FM band was packed with local gospel stations, and the satellite dish in everyone's yard could bring in hellfire preachers from Chattanooga to Seoul.

And the desolate land shall be tilled, whereas it lay desolate in the sight of all that passed by. And they shall say, This land that was desolate is become like the garden of Eden; and the waste and desolate and ruined cities are become fenced and are inhabited. Then the heathen that are left round about you shall know that I the LORD build the ruined places, and plant that was desolate: I the LORD have spoken it, and I will do it. Thus saith the Lord GOD . . .

Ezekiel, chapter 36, verses 34–37. The land itself, a miracle in its own right, was sufficient testament to the piety of the homesteaders. It was no wonder that the farm families of eastern Washington were inclined to see themselves as an army of light, marching to the beat of God's own drum.

On both sides of the Cascade Range, the ultramontanes were regarded as forces of darkness—as the battalions of the Devil, or of ignorant bigotry, depending on whether you saw things from the eastern or the western point of view. Much of Washington state politics consisted of the angry exchange of ballot initiatives between opposite sides of the mountains. From the urban corridor of western Washington, one of the great liberal enclaves of the nation, came measures to protect gay rights, the right to choose, and the right of the terminally ill to die. The east responded with initiatives designed to combat "homosexuality," to ban abortion, to rid

the syllabus of blasphemous and immoral teaching materials, to promote creationist lecturers in high schools. The west of the state tried to apply a brake to the ethical authoritarianism of the east, while the east felt its mission was to curb the ungodly and licentious tendencies of Seattle and its fellow-traveling cities.

Politicians attempting to represent the interests of the whole state had to fudge. The House Speaker, Tom Foley, was a Democrat who stood for an eastern Washington congressional district; his power base lay in the city of Spokane, but he needed a proportion of the farm vote. On most issues, he was thought of as a generally liberal figure, but on gun control he was a live-free-or-die National Rifle Association man. Washington had a death penalty, and used it—but with an odd twist. Sentenced to die, you were accorded the right to choose the means of your execution. Death by hanging, or by lethal injection? Take your pick, loser.

A little short of Spokane, the farm road was fed back onto I–90 and the car sailed over the top of the city on a viaduct, past a sixth-floor roofscape of billboards, clocks, and the shell-like aluminum cowls of air-conditioning systems. Spokane, on the hinge between the plain and the Rocky Mountains, was a dense five-minute metropolis, and it was already gone before I made up my mind to stop for it.

In 1883, a rich lode of silver was found at Coeur d'Alene, Idaho, and Spokane Falls, fifty miles to the west, was the nearest railroad terminus. Spokane boomed, burned down, and boomed again. Unlike the loggers and farmers who settled most of the Northwest, the silver miners, along with their attendant mineral brokers, engineers, assayers, and lawyers, were predominantly urban people with raffish big-city tastes. Finding themselves far out in the sticks, fresh from San Francisco, St. Louis, or New York and flush with ready money, they brought to the wilderness a Sodom-and-Gomorrah style of plush velvet, gilt, and crystal chandeliers.

From Spokane on, the highway wound through old mining country. Each crevice in the hills had a small, gothic brick town squatting in it. Smelterville. Silverton. The pretty name of Coeur d'Alene was high-rolling French for *drill-bit* (as I found out later with the help of a dictionary). After the fundamentalist white rectangles and circles of the plain, the Idaho hill towns were happily jumbled, full of nooks and crannies and powerfully redolent of that disreputable culture of the assay office, the dance hall, the saloon, the whorehouse-hotel, and the player piano. Where the farming communities were founded on abstemious virtue and steadfast labor, the

mining towns were founded on luck and a thin blue streak in a knob of rough quartz. The Bible was full of awful warnings about silver: "Howl, ye inhabitants of Maktesh," said Zephaniah, "for all the merchant people are cut down; all they that bear silver are cut off." Hard on Zephaniah's heels came Zechariah: "And Tyrus did build herself a stronghold, and heaped up silver as the dust . . . Behold, the Lord will cast her out, and he will smite her power in the sea; and she shall be devoured with fire."

The road climbed again into pine forest, with shaved patches where the harvesters had been; and on an exposed bend the car filled with the familiar, unwholesome stench of a pulp mill, like a malfunctioning chemical toilet. The snow level was dropping steadily until, all of a sudden, it had slipped below the highway, and the road surface was a mess of yellow slush. At Lookout Pass, just under 5,000 feet up, the white trees had icicles dripping from their branch ends and the windshield was spotted with the asterisks of singleton snowflakes melting as they hit the glass.

The Idaho-Montana state line crossed the pass, and it was nice to enter a state whose license plate honored a distinguished local novelist. *Montana—Big Sky Country* was a salute to A. B. Guthrie Jr."s *The Big Sky*, published in 1947; and every logger's pickup now advertised the work of a lyrical and indignant conservationist. Guthrie, born in 1901, had lived in the small town of Choteau until his death in 1991—and through the 1980s, in his eighties, he had denounced the timber industry for its careless demolition of his native landscape. It must have given Guthrie some waspish pleasure to see his many enemies driving around the state with plates blazoning his novel's title like a huge, unwitting fan club.

For more than a hundred miles, I–90 ran up the back side of the Bitter-root Range, skirting crags and shale falls, switching promiscuously from river course to river course in its search for the low ground. As dusk settled, the hills dissolved into clouds of swirling soot. Light from my headlights spilled over the wet road, making driving a tense and headachy business. The car plowed through the dazzle at a breakneck forty-five. Trucks rolled past like speeding ships, leaving the Dodge floundering in their wake. I ate the remains of a cellophane-wrapped ham sandwich, bought before the beginning of Idaho, and counted down the miles to the safe haven of Missoula.

It took a long time coming. Then it was there—a sackful of lights scattered over a broad, flat valley bottom below the highway. I was tired and roadshocked, and it seemed that there was something not quite right about the place. As soon as the car passed under the railroad bridge that marked

the beginning of the town, one could taste the complex industrial flavor of carbons in the air. The streetlamps all wore smoggy haloes and the dark brick architecture was slightly out of focus. Expecting a winter resort town—something along the lines of Aspen—I had the powerful impression that I had driven deep into the Rocky Mountains and somehow arrived in England's industrial West Midlands.

Berthed in a motel room, with a finger of Teacher's in a plastic tumbler, I called home. The five hundred miles between Seattle and Missoula felt as vast as if we were talking across a continent. We were in different time zones. The temperature here was in the twenties; on Queen Anne Hill it was in the fifties and there was still a tomato red sunset over Puget Sound. I was saying *The mountains! The desert! The Christians!* like any traveler in a foreign land, and it was disconcerting to discover that my wife, Jean, seemed to think I was just around the corner.

"If you're coming back through Portland, can you stop by at Powell's?" Pick up a pint of milk at the shop on your way home, will you?

For in the expansive terms of American regional geography, Missoula was well within our neighborhood. The industry I knew best reflected that. Publishers' reps, based in Seattle and given the Northwest as their beat, went at least as far east as the Continental Divide, which I–90 crossed a hundred miles farther down the road at Elk Park Pass; and there was a lot of to-ing and fro-ing between Seattle and Missoula, with Montana writers showing up regularly in Seattle to give readings and decorate parties, and Seattle writers hitting the road for expenses-paid weekends in Montana. As the book trade traveled, so, presumably, did the rest of the commercial world. Driving to Missoula, an adventure for me, was for a true Westerner no more than a routine commute.

I dialed the number of one of the Missoula writers whom I'd met at a Seattle lunch, the Montana-born novelist Deirdre McNamer. She was out, teaching a writing class at a university in Ohio (how these people *moved*); but her husband, Bryan Di Salvatore, *The New Yorker* essayist, was in, stumped for his next sentence, and keen to come out.

We suppered at a barnlike restaurant with a roaring clientele.

How, I wanted to know, had Missoula, this mountain mill town of forty-three thousand people, managed to establish itself as a national literary asylum?

"When Montana divided up the stakes, Helena got the capital, Deer Lodge got the prison, and Missoula got the university." Di Salvatore lit a cigarette and wagged it at a particularly loud gang of fellow-diners. "Missoula got the flakes. This is the wobbliest, the *strangest*, town in the state."

Di Salvatore was tousled and burly, with a mighty Grover Cleveland moustache somewhat improbably attached to an outdoor face that had begun to set along its laughter lines. When William Shawn edited *The New Yorker*, he appointed Di Salvatore as the magazine's man in the social wilds. He wrote, at length and affectionately, about long-distance truckers, bears, dynamite blasters, country singers—and in each of these subjects one could see a portion of Di Salvatore himself . . . a sort of singing grizzly bear, with a taste for travel and big bangs.

"People come here for the university—some as students, some to teach. They stay because it's cheap and it's addictive. If Jim Crumley was here, he'd say it was because writers need to live in deep smelly places. Missoula's on the bottom of a prehistoric lake that used to go all the way to Spokane. You're down in the sediment here. In the ooze . . ." He looked out the window at the haloed streetlamps. "You can see clear across the street tonight, which is unusual for Missoula this time of year. When the fog's down, it's easy to stay home and write."

We talked about the writing that had come out of Missoula, from Norman Maclean's A River Runs Through It and the poems of Richard Hugo, to the work of Richard Ford (who moved to Missoula in 1983 but left in 1990) and current residents like William Kittredge, James Crumley, and James Welch. People wrote fondly about Missoula and, in my view, oddly. The usual fate of the small industrial town in literature is to be abused and escaped (rather as Malamud abused and escaped Corvallis). But it was the fate of Missoula to be loved half to death. A line in A River Runs Through It set the prevailing tone: "... my brother and I soon discovered [that the world outside was] full of bastards, the number increasing rapidly the farther one gets from Missoula, Montana." Foggy-bottomed Missoula was the small town as womb.

"It's a hard-drinking, raucous town. Sexist, but getting less sexist than it was," said Di Salvatore, himself a transplant from Southern California. "It's a blue-collar town, a very traditional town. A *narrative* town. Go to a party with a bunch of writers in Missoula: people get shitfaced and tell *stories*. They laugh. You get good jokes here. It's very unpretentious. People don't talk literary theory in Missoula."

I said: "Seattle's a theory city. There are deconstructionists in town. You can get into fights over Paul de Man. Last week I had to read two postmodernist novels in manuscript. Not novels, *texts*."

"There's none of that stuff here. Missoula people go to Seattle for football games. We pretend we haven't heard of Paul de Man."

Missoula's *genius loci*—at least in the writing line—was Richard Hugo. Hugo grew up in West Seattle, in the working-class suburb of White Center. Born in 1923, he served with the air force in Europe during the Second World War, then studied at the University of Washington under Theodore Roethke.

Teacher and student, fifteen years apart, were eerily alike. Photos of Roethke and Hugo, taken when each was in his forties, show the same jowly fat man with the blurred features of the dedicated drinker. Each has the same anxious *How am I doing?* smile and the same weepy eyes. Each owns a car of the same make—a Buick—and writes poems about driving dangerously through the landscape of the Northwest.

Hugo's early poems, written when he was working at Boeing as a technical writer, read like first-draft Roethke. He had learned from Roethke how to describe the rough terrain of the self by seeing it as a place much like Seattle and the surrounding countryside. His tumbling salmon rivers, running free through jungle green, are relatively shallow tributaries of Roethke's Oyster River. The poems most his own are the ones set in the city, in abandoned rooming houses and rundown immigrant neighborhoods: an urban landscape of loss and defeat in which the solitary drunk weaving down the street is Hugo's double.

In 1964, a year after Roethke's death, Hugo went to the University of Montana at Missoula to teach writing, his marriage at an end and his drinking out of control. He found both a home and an office in the Milltown Union Bar. In another university and a different town, Hugo would probably have had his salary stopped at the end of the first month, but Missoula took to this warm, unbuttoned, gregarious man. When he was too depressed and drunk to teach, his departmental colleagues filled in for him and his paycheck kept coming. Very much as Roethke had been protected at the University of Washington, Hugo was regarded by the University of Montana as a precious civic asset, like a picturesque ruin. (Though in 1964, Hugo, with no teaching experience, had published only one book and had no great literary reputation.)

He was a beloved drinking and fishing buddy, an accessible teacher who showed by example that the most ramshackle life was fit material for poetry. Given sanctuary by Missoula, he wrote more freely and intimately than he had ever done in Seattle. He abandoned the gestures of elevated lyri-

cism that he had picked up from Roethke and wrote with increasing plainness about bars and bartenders, fishing trips, mountain drives, the deserted homesteads and down-on-their-luck towns of rural Montana. He wrote about being shitfaced and told stories.

In a prose piece, he described an old man he'd met in the Milltown Union Bar:

Like many Montanans, the man, who had never seen me before, immediately started talking about his personal life. In Montana, many people assume that with the scarce population, 735,000 people in a state bigger in area than any except California, Texas and Alaska, loneliness is the norm and when you meet someone else you have license to speak intimately simply because you are two people in a lonely, nearly uninhabited landscape.

That was exactly Hugo's own manner in his writing. In his worst poems he is the man on the next bar stool, muttering half to himself and half to you, trading on your indulgence and on the reasonable certainty that your life is as much a mess as his. Why else would you be in this bar? Why else would you be reading this poem?

Once more you've degraded yourself on the road. The freeway turned you back in on yourself and you found nothing, not even a good false name. The waitress mocked you and you paid your bill sweating in her glare. You tried to tell her how many lovers you've had. Only a croak came out. Your hand shook when she put hot coins in it. Your face was hot and you ran face down to the car.

His best poems are candid, but soberly so, disciplined by meter and the close observation of externals. In Philipsburg, a depopulated silvermining town southeast of Missoula, Hugo found a mirror to his own condition:

You might come here Sunday on a whim. Say your life broke down. The last good kiss you had was years ago. You walk these streets laid out by the insane, past hotels that didn't last, bars that did, the tortured try of local drivers to accelerate their lives. Only churches are kept up. The jail turned 70 this year. The only prisoner is always in, not knowing what he's done. The principal supporting business now is rage...

By the time he died, in 1982, Hugo had mapped a large chunk of Montana in his poems and named it Vancouver-style after his own desolation: a sad, dark landscape, brightened, at long intervals, by the welcoming lights of bars. Yet the tenor of Hugo's life in Missoula was jollier than his poems might lead one to think. He attracted a convivial crew of colleagues (some of them his ex-students) to the writing course and gave the university a great name for the interdisciplinary study of fishing and drinking and poetry. He made a happy second marriage. A photograph of him in June 1982, four months before his death from leukemia, shows him capped and gowned, receiving an honorary doctorate at Montana State University; laughing, rubicund, and puckish, he looks like the Pillsbury dough man.

Next morning the air was clear and thin; seen in cold sunshine, the buildings of Missoula seemed to have drifted apart during the night, the huge spaces of the Montana landscape having infected the architecture of the town. Courthouse, bank, and department store were like lonely mountain peaks, with low-lying plains between them, while the snow-dusted sides of real mountains rose almost sheer above the city, boxing it in around the Clark Fork river. The overall effect was oddly unsettling; the streets were too open for comfort, the town itself too closed-in, inducing mild claustrophobia and agoraphobia at the same time.

The river that ran through it was quick and trouty. It spilled noisily over boulders and the trunks of fallen trees, baffling the sound of the traffic. I sat on a rock and read the beginning of James Crumley's *The Last Good Kiss*, in which Richard Hugo appears under the nom de guerre of Abraham Trahearne, poet and drinker.

When I called Trahearne's ex-wife, she told me that she had received a postcard from him, a picture of the Golden Gate and a cryptic couplet. Dogs, they say, are man's best friend, but their pants have no pockets, their thirst no end. "Trahearne has this odd affinity for bar dogs," she

told me, "particularly those who drink as well as do tricks. Once he spent three weeks in Frenchtown, Montana, drinking with a mutt who wore a tiny officer's cap, sunglasses, and a corncob pipe. Trahearne said they discussed the Pacific campaign over shots of blackberry brandy . . . "

It was easy to imagine Hugo-Trahearne being happy in Missoula: it was a place where odds and ends naturally collected and cohered. On the far bank of the Clark Fork lay the pleasantly nondescript campus of the university that had taken Hugo in—a mosaic of oddly assorted pieces of "collegiate" architecture. There was a bit of Oriel College, Oxford, a bit of Harvard Yard, quite a lot of '60s New Brutalist, a touch of corrugated egg carton, and something that might, from a distance, have been taken for an ivory tower. More formal-minded cities would have turned up their noses at this scruffy gang of buildings, but they'd found acceptance in this liberal-hearted mecca, and looked as if they belonged.

The same principle held for human oddments. The walkway along the riverbank was busy with promenading hobos. Men with bedrolls and sun-bleached beards strolled in ones and twos, reclined full length on public benches and studied the river with the narrowed eyes of anglers watching for the pewtery underwater wink of a feeding fish. The gravel shore was littered with the neat remains of small driftwood fires.

The hobos rode in on the boxcars of the Northern Pacific railroad, drawn to Missoula by its reputation as a kindly town. A hot meal, a shower, and a bed for the night could be had at the Poverello Center on Wyman. Word had gone around that transients could find work here. Other Montana towns, like Butte and Helena, were said to be sewn up tight by the labor unions, but since Missoula was still "open," the hopefuls kept showing up, despite the fact that homelessness and unemployment were by now endemic. Winter was coming, and I wouldn't like to be caught with a backpack and a bedroll in a place where the January temperature was likely to sink to twenty below or worse. Yet famously kindly towns are few and far between in the United States now, and the presence of these shambling, amiable men said a lot for Missoula as a place to which you could still take your misfortunes and have a sporting chance of redeeming them.

It had all the useful amenities that go with low wages and hard times: cafes with coffee for 25¢ (refills free); thrift stores on every corner, with J. C. Penney business suits at \$7.50 a throw; a dozen pawnshops, stacked to their ceilings with accordions, farm tools, fob watches, and stereophonic junk. Standing in front of one of these dusty treasure houses, eyeing an

elderly Bausch & Lomb microscope and trying not to give in to the impulse to rescue it, I was joined at the window by a hobo. He looked like a man with nothing to pawn and no money to spend. Maybe he was making a sentimental visit to one of his own old possessions. Together we stared wordlessly into the window until the silence seemed rude.

I said, lamely: "Whole lot of pawnshops in this town . . . "

"Yup," he said. "You want to buy an old guitar or a gun, Missoula's the place to be."

Over the river, past the university, a dirt road led up a smooth and snowy hillside that had once formed the bank of the great emptied lake. A red-tailed hawk (the bird book was back in play again) was crouched on top of a telephone pole, looking down into Missoula, waiting for a rat to break cover on the lake floor. I opened the car door as gently as I could, but the hawk took fright, scrambled untidily off its perch, and sailed away on braced-flat chestnut wings. Minutes later, it was still in sight, quartering the air over the town in patient circles, ready to drop like a thunderbolt out of the sky on the next thing that moved.

From up here, Missoula looked more like an oversize trailer park than a city, with a few thousand little pastel-colored houses loosely strewn across the valley. A minor tremor in the local geology—a slight resettling of the crust, a rise of a few feet in the level of the river—would be enough to wipe all of it clean off the map. Above and behind the town, mountains climbed on mountains' backs in a succession of shelving snowfields and walls of black rock—and these enormous fractures and upheavals looked dangerously raw, as if there might be more of them later today or early tomorrow morning. I thought: if I lived here, I'd lie awake at night listening to the earth creak.

The valley trended westward. After a couple of miles or so, the squat buildings of Missoula petered out, and then there was just the intermittent glint of the river, like a twist of wire, running into haze and distance. It was a long, long way down there to Seattle, yet that was Missoula's big city. If you needed the London papers (two days old) or a bone-marrow transplant, wanted to see a major-league baseball game or eat dinner in a French restaurant, you had to make the journey to Seattle. Its nearest rival was Minneapolis, a thousand miles back over the Rockies and in another regional world.

People took the plane or skipped a night's sleep to make the drive. They

went for the Seahawks, the Mariners, the Sonics; for the Seattle Symphony, the Rep, the Pacific Northwest Ballet. Every big city is sustained by its hinterland: it offers services that are too specialized and expensive for even a concentrated metropolitan population to support on its own. Seattle had a gigantic hinterland for such a small big city. It was the provincial capital of places like Missoula, as of all the charmless one-gas-station towns and lonely farms halfway up mountainsides that lay in between; and, in their turn, the places like Missoula strongly colored Seattle with their own expectations and daydreams of what a big city ought to be.

Squinting into the haze at the far end of the valley, one could almost see Seattle-at least, one could sense its faint but definite magnetic tug. And from this distance I got the point of Seattle's habit of grandiloquent self-advertisement, its preoccupation (which I had taken to be merely neurotic) with structures that were the biggest, or just the damnedest, things of their kind "west of the Mississippi," in the cant phrase. Its romance with the monumental had begun with the timber-baron Roman Empire style of the downtown architecture, with the now-dainty office building that had once been the tallest building W of the M, with the absurdly haughty expressions of the terra-cotta walruses who condescended from the facade of the Arctic Club. It was a city of bizarre novelties and grandiose follies. Its sports stadium, the Kingdome, was famous for defying the laws of physics and the canons of good taste. Its most arresting landmark, put up for the 1962 World's Fair, was the Space Needle—a stout radio mast whimsically surmounted by an intergalactic flying saucer, drawn from a 1950s sci-fi comic. Living with the Space Needle on the other side of Queen Anne Hill was rather like having to put up with a black-velvet portrait of Jesus on one's living room wall; but here on this hillside, five hundred miles off, I thought I understood what the Space Needle was for. It was designed to beam the message of Seattle's capital status across the hinterland—and for the message to reach out to Missoula, the signal had to be inordinately strong.

It turned out that Missoulians were a lot less worried by the prospect of their town being swallowed by the Rocky Mountains than they were by the arrival of the dentist from San Diego.

Everybody knew somebody who'd met him, though not everybody agreed that he was from San Diego. Several people swore he came from Santa Barbara, and one or two clung obstinately to the opinion that he came from Beverly Hills. He had first shown up in Missoula nearly a year

before. He and his wife had been observed dining at the Depot one Saturday night; they washed their meal down with two large bottles of mineral water. He was next seen the following weekend, aboard a mountain bike and wearing skin-tight orange Lycra shorts. The weekend after that he was in a new Jeep Wrangler, with lightweight carbon-fiber fly rods piled in the back. He was dressed out of a Patagonia catalogue.

The dentist had bought a house out at Hillview Heights, on one of the "-view" streets—Mainview, Skyview, Grandview, Cloudview, Clearview, or Longview. He'd paid two hundred and eighty-nine thousand for the property. *The asking price!*

Every Friday night, he was on the Delta flight that got into Missoula at 10:40, and every Monday morning he was out on the 7:00 plane. Sometimes he was with his wife (if she *was* his wife); sometimes he came alone; lately, he had been coming with two buddies in tow, and they, too, had now been sighted in the company of a prominent Missoula realtor.

The dentist was bad news. The buddies were worse. They were going to send house prices in Missoula through the roof, and as house prices went up, so would property taxes. Ten more dentists from San Diego, and the place's entire character would be spoiled. Until now, the town had been famously out of the way; its cheapness and its liberalism, its amiably scruffy air, its renown as a shelter for such misfits as tramps and writers, were dependent on its geographical remoteness. But nowhere was truly remote anymore. The dentist's itinerary was proof of that. At 7 a.m. on Monday he flew from Missoula to Salt Lake City, where he changed planes. Crossing from Mountain to Pacific time, he gained a useful hour and touched down in San Diego at a quarter of ten. By 10:30 he was in his surgery, masking-up for a root-canal job.

I tried to track him down. In the Old Post Pub that evening, Bryan Di Salvatore introduced me to a woman whose hairdresser had a customer who'd done work on his house—"and he's not a dentist. He's an eye doctor."

While the phantom dentist was real enough, that he was even *possible* was already altering things in Missoula. The town was beginning to think differently about itself, as any place must that is only a zip away from San Diego.

A windey dark raney disagreeable morning. The wind and rain lashed at the fast-food pagodas and bunting-hung car dealerships of suburban Missoula and flung around the overhead stoplights on their wires. With a full tank,

a pint of gas-station coffee, and a Merle Haggard tape to ward off the FM evangelists, I drove out of town on U.S. 93. The swish and slap of the windshield wipers kept good time with the banjos as Haggard and his combo sang lachrymose patriotic songs in exaggerated stereo. Both weather and music seemed right for a day on which I meant to follow the route taken by Lewis and Clark on their journey from the Continental Divide to the Columbia River in the fall of 1805.

This expedition was the crowning detail of Jefferson's grand design for the westward expansion of the United States. Though he himself never got much farther west than Staunton, Virginia, on the edge of the Appalachians, Jefferson devised the western landscape in which I now lived. He wrote the original draft of the Land Ordinance of 1785—the document that was responsible for the checkerboard rectangularity of the western states. He drew the grid.

It was a construction typical of his rationalist, Enlightenment-philosophe habits of thought. No one yet knew how the land lay beyond the Mississippi. Jefferson believed that North America was probably made up of two matching halves, like a spatchcocked hen split open around the breastbone of the Mississippi basin. So there should be a range of mountains in the western territories much like the Alleghenies in the East—up to about 5,000 feet high, with a narrow watershed and a short portage between the rivers that ran into the Gulf of Mexico and those that emptied into the Pacific. This was Jefferson's imagined West, but his grid could cope with any topographical eventuality since it was grounded in a magnificent disregard for empirical geography.

It started at an arbitrary point on the north bank of the Ohio River on the western edge of Pennsylvania, on the river's high-water line. From here, Jefferson projected a north-south meridian and a westward-running baseline as the master axes of the grid. He then spread over the undiscovered country a ghostly reticule of six-mile squares named "townships." They stretched away across an infinity of western space, imposing a tight social order on what had been (until the passage of the Ordinance through Congress on May 20, 1785) a speculative void. Every township was subdivided into thirty-six "sections" or "lots," each a mile square, or 640 acres, and the lots were numbered from No. 1 in the northeast corner of the township to No. 36 in the southeast. Lot No. 16 (the northwesterly of the four central squares) was reserved for the building of a school or college, and Lot Nos. 8, 11, 26, and 29 were set aside for agencies of the U.S. government. The remaining lots were to be sold by auction at not less than \$1.00 an acre in

hard-money currency, and the 640-acre section was to be the smallest land unit sold by the government.

Even then, even on the frontier, 640 acres was a big parcel, and few settlers could raise the \$640 minimum to buy a lot. To Jefferson, who farmed 10,000 acres of prime land in Virginia, both the size and price of the lots must have seemed paltry. America was destined to be socially as well as geographically symmetrical: beyond the mirror-Alleghenies, Jefferson could see a mirror-Virginia populated by gentleman-farmers of means like himself.

Deserts, mountains, swamps, and prairies, as yet unknown to white explorers, turned into a patchwork of shadowy townships, each with its unbuilt school on Lot 16, adjacent to the unbuilt post office on Lot 11. Years before the first covered wagon came bumping over the sagebrush, the town was already there, lying in wait for its founding citizens.

Jefferson's majestic style of Platonism in regard to the West quickly rubbed off on the American real-estate business. In *Martin Chuzzlewit*, Dickens has Martin purchase a fine lot from the offices of the New Eden Settlement, where he is shown a detailed plan of the city:

A flourishing city, too! An architectural city! There were banks, churches, cathedrals, market-places, factories, hotels, stores, mansions, wharves; an exchange, a theatre; public buildings of all kinds, down to the office of the Eden Stinger, a daily journal; all faithfully depicted in the view before them.

"Dear me! It's really a most important place!" cried Martin, turning round.

"Oh! It's very important," observed the agent.

"But I am afraid," said Martin, glancing again at the Public Buildings, "that there's nothing left for me to do."

"Well! It ain't all built," replied the agent. "Not quite."

This was a great relief.

"The market-place, now," said Martin. "Is that built?"

"That?" said the agent . . . "Let me see. No: that ain't built."

When Martin goes to New Eden to take possession of his property, he finds that the city consists of a few log cabins scattered over a mosquito-ridden marsh on the edge of the Ohio River.

By 1800, when Jefferson was elected president, the Rectangular Survey was moving steadily over the ground, with townships and lots staked out as far west as the Ohio–Indiana line and south into the Mississippi Territory.

The Far West was now a habitable idea. What it lacked was contour lines, weather, soil, flora, mineral deposits, birds, animals, and Indian nations. In June 1803, Jefferson commissioned Lewis and Clark to furnish the West with credible detail as they sounded out the best route from St. Louis to the Columbia River.

Jefferson was the West's idealist architect; Lewis and Clark were its pioneering realists. The Rockies were so horribly unlike the Alleghenies that the travelers could hardly believe their eyes at the loom of the distant mountains over the Missouri valley. There was no narrow watershed, no short portage. Lewis and Clark had boils, dysentery, septic cuts, skin eruptions, and sore feet. Men on the expedition suffered from syphilis and doses of clap. They dragged their tons of gear up the headwaters of the Missouri and over the Continental Divide at Lemhi Pass. On September 9, 1805, they camped at a place they named Travelers Rest, ten miles south of Missoula.

The name Travelers Rest hadn't stuck. It was Lolo now, with a conspicuous gas station for the truckers on U.S. 93. When I looked in, the truckers were working intently on a line of Vegas-style slot machines, and there was a counter display of a dozen rival brands of stay-awake pill. I threw out the colored Missoula water with which I'd started and replaced it with a pint of black and bitter truckers' coffee.

Across from the gas station, U.S. 12, the Lewis and Clark route, branched off from the highway—a narrow blacktop road on a straight-arrow course through a bedraggled landscape of sawn-off stumps and sapling firs. Mine was the only car in sight. In ten miles I met one logging truck and, with my thoughts elsewhere, was startled by the disapproving myopic glare of its headlights in the rain. The road began to wind and climb on its way up to Lolo Pass through the Bitterroot Range.

4 miles assend a Steep ruged mountain passing over high Stoney knobs maney parts bare of timber [the Indians] having burnt it down. None of the early white visitors to the Northwest were struck by the Indians' special reverence for their environment; on the contrary, they were impressed by the amount of damage that the Indians, despite their limited numbers, had managed to inflict on it. On Puget Sound, George Vancouver watched "eighty or one hundred men, women, and children... busily engaged like swine, rooting up this beautiful verdant meadow in quest of a species of wild onion." James G. Swan, a mid-nineteenth-century settler on the Olympic Peninsula, wrote that coastal navigation in late summer and early fall was made extremely difficult by the pall of smoke that lay over the

water from the Columbia to Nootka Sound, caused by Indian forest fires that had run out of control. Driving through the slash-and-burn operations of the timber industry, I found myself clinging to the fact that even in 1805 this was not virgin forest. When William Clark rounded this bend in the trail, he saw opening ahead an acrid wasteland of black stumps and sodden ash. My view exactly.

The road steepened. Rain turned to snow and the dark landscape paled and turned white as the altitude increased. There were no tracks on the road except for those in the Dodge's rearview mirror, and it was exhilarating to have this gaunt and haunted route to myself, with the box of tire chains in the back seat, in case. It was hard, though, to keep securely in touch with the ghosts: our time scales were so far out of kilter. The coffee bought in Lolo was still warm. Four long days in the lives of Lewis and Clark had slipped past in the last twenty-five minutes. In this undignified, fast-forward mode, the explorers shot up hill and down dale, jabbering in chipmunk voices, while the Dodge trundled comfortably through soft snow at a steady 15 mph.

Emince Dificuelt Knobs Stones much falling timber and emencely Steep... Several horses Sliped and roled down Steep hills which hurt them verry much... The crossing of Lolo Pass was even tougher than the crossing of the Continental Divide. The climate was much colder then than now: in mid-September the snow was already deep here... we are continually covered with Snow, I have been as wet and as cold in every part as I ever was in my life, indeed I was at one time fearfull my feet would freeze in the thin mockersons which I wore...

Beyond the summit, I pulled into a broad paved overlook, a Lewis and Clark rest area with a brown metal historic marker. Though the road was empty and hardly wider than a lane, it was punctuated with these huge rest areas, each big enough, in summer, to take a couple of tour buses and a dozen cars at a time. Their size was a measure of how Lewis and Clark had been granted heroic status in the highly selective pantheon of American popular culture.

Of course their journey was important—it made the West real—but there was more to it than that. No other figures in American history were as endearing as Lewis and Clark. Partly it was their language, which jumped off the page with its undated plainspokenness. You could imagine bumping into them at a bar and getting along just fine—whereas George Vancouver, say, would strike you as a very weird old windbag with an accent. Most of all, though, it was the relationship between them that put them so easily

within reach. Lewis and Clark were America's foremost male couple. Before Queequeg & Ishmael, before Huck & Jim, there were Lewis & Clark.

When Lewis asked Clark to join him as joint commander of the expedition, he phrased the invitation like a proposal: "If therefore there is anything under those circumstances, in this enterprise, which would induce you to participate with me in it's fatiegues, it's dangers and it's honors, believe me there is no man on earth with whom I should feel equal pleasure in sharing them as with yourself." Clark accepted him: "My friend I do assure that no man lives whith whome I would perfur to undertake Such a Trip."

Their joint command was an extraordinary success. There seems never to have been a cross word between them. When one fell ill, the other solicitously nursed him back to health. Sometimes Lewis fussed over Clark ("Capt Clark is . . . still very languid and complains of a general soarness in all his limbs. I prevailed on him to take the barks which he has done and eate tolerably freely of our good venison"); sometimes Clark fussed over Lewis ("Capt Lewis out all night, we arrived at his Camp to brackfast, he was without a blanket").

Each was protective of the other's weakness. Lewis, who'd served as Jefferson's aide, was the brainy one, Clark the better woodsman. Lewis had a smattering of formal natural history and liked to turn a fine phrase on occasion. When they named a Montana river after the president, Lewis wrote:

We... determined that the middle fork was that which ought of right to bear the name we had given to the lower portion or *River Jefferson* and called the bold rapid and clear stream *Wisdom*, and the more mild and placid one which flows in from the S.E. *Philanthropy*, in commemoration of two of those cardinal virtues, which have so eminently marked that deservedly selibrated character through life.

Clark, an enthusiastic cartographer, could draw a beautiful map, but that kind of thing was far beyond the reach of his literary skills. When it came to writing, he was all fists. He couldn't spell, and the grammar of the simplest sentence had a habit of raveling itself up on him in a bird's-nest tangle. So he got help from Lewis. Where the two journals run in daily parallel, one can see exactly how they were composed. Lewis wrote his entry first, then passed the elkskin-bound notebook to Clark, who copied what was written there into his own journal. Even when Clark disagreed with Lewis, he borrowed Lewis's vocabulary and grammar to phrase his own dissent.

So Lewis, the more adventuresome eater, wrote:

our party from necessaty having been obliged to subsist some lenth of time on dogs have now become extreemly fond of their flesh; it is worthy of remark that while we lived principally on the flesh of this anamal we were much more healthy strong and more fleshey than we had been since we left the Buffaloe country, for my own part I have become so perfectly reconciled to the dog that I think it an agreeable food and would prefer it vastly to lean Venison or Elk.

He finished the entry and handed it to Clark. Clark, who felt squeamish about eating dog (and must have thought that Lewis's last sentence went right over the top), wrote:

our party from necescity have been obliged to Subsist Some length of time on dogs have now become extreamly fond of their flesh; it is worthey of remark that while we lived principally on the flesh of this animal we wer much more helthy Strong and more fleshey than we have been Sence we left the Buffalow Country, as for my own part I have not become reconsiled to the taste of this animal as yet.

Lewis and Clark set the exemplary pattern for friendship in the western wilderness—a landscape in which male friendship took on an intense, sometimes overheated importance. Almost everything difficult and dangerous in the business of clearing and settling the land was done by men working in couples; like the pairs of "fallers" who managed the long saws from a position high above the ground on the trunks of the firs, and formed year-in, year-out partnerships that were as close as marriages. The term "pard" or "pardner" is still used in the West as a term of man-to-man intimacy. I used to think it was merely jocular—Tex Ritter, "howdy pardner" talk from low-budget Westerns; but it's not. To call someone "pardner" is to make the significant announcement that you are on close *tutoyer* terms, and the first and best of pardners were Lewis and Clark.

In Idaho now, the road began to tumble through the forest like the river whose course it followed, swerving away at the last moment from vertical chimneys of gray rock, eddying out and doubling back. My ears popped as the car lost height. The river grew—like everything else here—prodigiously. One minute, it was a crack of light in the rocks beside the road; the next, its white-water rapids were louder than the Dodge's engine; the next, it swirled

darkly from deep pool to deep pool, dimpling over sunken boulders, its surface scored with lines of current, like penknife doodles in the wax polish of a tabletop.

Clark had a bad time here. For a frontiersman, he had an unduly sensitive stomach, and the combination of broiled dog and unspecified "roots" got from the Indians was too much for him. I am verry Sick to day and puke which relive me. Lewis, raking the trees with his spyglass, found a strange bird:

of a blue shining colour with a very high tuft of feathers on the head a long tale, it feeds on flesh the beak and feet black, it's note is cha-ah, cha-ah. it is about the size of a pigeon; and in shape and action resembles the jay bird.

...a Steller's jay—the same bird that perched on a dead branch of the madrona tree outside my study window. Lewis was a careful birdwatcher. He was a poor hand at describing the landscape, though Jefferson had asked him to report on "the face of the country," its "volcanic appearances" and "mineral productions"; it was perhaps simply too big and strange to find words for. So Lewis concentrated on details that were within the range of his descriptive powers. Faced with the bewildering novelty of the West, he dealt with it by focusing in close-up on western birds. Several he described, like the Steller's jay and the varied thrush, were new to science. He gave his own name to one species—Lewis's woodpecker—and it was he, not his partner, who first saw a Clark's nutcracker.

I eate much & am sick in the evening, Clark wrote.

The road leveled as it entered Nez Perce Indian country. The river grew broad and placid enough to float a ship on. Fir gave way to stands of ash and maple in soggy, unkempt meadows by the water's edge. The most prominent building in many miles was a sky blue shack, padlocked for the winter, with Wild Bill's FireworKS painted on it in careful four-foot-high letters, each i dotted with a circle like a halo. Standing alone in the deep sticks of Idaho, the blue shack looked like a gesture of crazy hopefulness on Wild Bill's part. The grass and thistles surrounding it were untrodden: no one had yet beaten a path to its door.

All over the Northwest, Indians exploited their separate-nation status by dealing on reservations in goods and services that were prohibited to their white neighbors. Where the reservations were near big towns or abutted major highways, there were Indian casinos and bingo halls and pungent

open-air firework markets, each called Boom City. You could buy only the most puny rockets and Catherine wheels from the state-licensed white dealers, but at a Boom City you could get fifty-foot strings of firecrackers and three-inch-mortar skyrockets that would climb 2,000 feet before going off like something out of the Gulf War.

This reservation, though, was seventy miles from the nearest city, U.S. 12 was hardly a major highway, and bingo and the firework trade, both good moneymaking stunts for suburban Indians, would be of little avail here. A bend in the road past Wild Bill's, I ran into Kooskia, a muddy, one-storey brick village with a rail siding and a lumber mill. Its fringe of Indian homes—peeling prefabs, old trailers, huts knocked together from sheetrock and pieces of two-by-four—was grim even by the unexacting standards set by the reservations on the outskirts of Seattle. It looked like a TV picture of one of the poorer quarters of Soweto, without the mollifying sunshine. I ate lunch at a slovenly diner. The burger might as well have been made of dog.

Jefferson to Lewis: In all your intercourse with the natives, treat them in the most friendly & conciliatory manner... allay all jealousies as to the object of your journey, satisfy them of it's innocence, make them acquainted with... our wish to be neighborly, friendly & useful to them. For Lewis and Clark, the West was an unexplored wilderness and they were full of the novelty and drama of their own first footsteps in the landscape; yet wherever they went they were moving across a grid whose lines, though wavier and more irregular, were far more substantial than those of Jefferson's projected checkerboard.

As Lewis and Clark passed from one national territory to the next, they changed guides at each frontier. Even on the roughest passages, they were led, or directed, along paths which they referred to in their journals as "roads." I found great difficulty in finding the road in the evining as the Snow had fallen, wrote Clark, starting down the budding track of U.S. 12; road bad as usial. There is a big difference between a country with poor roads and one with no roads at all; in Lewis and Clark's Northwest, the roads were bad but they were definitely there.

At Lolo Pass, the explorers crossed from Flathead to Nez Perce territory and met a band of Nez Perce men who were looking for stolen horses. Clark gave the Indians fishhooks and tied a colored ribbon in each man's hair, which appeared to please them verry much. Lewis gave them a Steel & a little Powder to make fire. In dumbshow, the Indians explained that they lived in a village in a valley to the west, "five sleeps" away; a six-day hike. (This was the original of the shanty-and-trailer town of Kooskia.) From

there, the men said, they had convenient access to the Columbia, which was safely navigable to the Pacific.

Lewis blew his nose, and the Indians were excited by the sight of his handkerchief. It was, they said, almost exactly like the cloth given to some relatives of theirs by an old white man who was camping on an ocean beach near the mouth of the Columbia.

This talk of handkerchiefs took place four hundred and eighty miles as the crow flies—more than six hundred miles by crooked trails and looping river courses—from the Pacific, and it takes some thinking about. Who in, say, Oxfordshire, in 1805, would have been able to gossip knowledgeably about someone seen in Genoa or Turin? Yet Lewis in his journal doesn't seem overly impressed by his conversation with the Indians; he records it without comment before going on to describe the men as being of large stature and comely form.

Lewis and Clark had arrived in a country that was already well mapped and traveled. Goods and news were transmitted across an immense geographical space and over a large number of heavily policed tribal boundaries. When the caravan of trinket-bearing white men came stumbling down the main road from the mountains, no one seems to have been much surprised: since 1792, at least, the Indians had been getting increasingly used to the presence of eccentric tourists with designs on their homelands.

I put my foot down.

The Dodge Daytona was a measure of my shaky grasp of the basic grammar of American life. Leaving London, I'd sold my two-year-old VW on my way to Heathrow and bought the Dodge in Seattle the next day. It was black; it started smoothly; the stereo worked; I liked its bucket seats and the flip-up eyelids on its headlights. I didn't think about it from a semiotic point of view until too late. That evening, I was talking on the phone to a Seattle woman whom I'd met on my first visit.

"You bought a car already? What make?"

"A Dodge Daytona."

She laughed, and not kindly.

"What does it say?"

"Uh, uh-midlife crisis."

"So who drives them?"

"Kids. Black teenagers. Gang members. They like to total them on Alki Beach."

After a couple of years in my hands, the car developed a malevolent scowl when its offside eyelid got stuck permanently open. Unwashed, with a missing wheel trim and some bad scars on its paintwork, the one-eyed Dodge looked as if it should be doing time in some automobile correctional facility; but it had the knack (vital in a narrative vehicle) of being able to render large tracts of landscape as an undifferentiated green blur.

So, with the pedal on the floor, it shot from the valley of the Lochsa River to the valley of the Clearwater to the valley of the Snake at a steady cruising speed of five miles a word. Slowing as it reentered the state of Washington, it climbed into the bare and rumpled hills of the Palouse, their sides as smooth as gray suede. Their baldness led one to expect nothing of the summit except sagebrush and snow, but as the Dodge crested the last hill at 3,000 feet, it came out onto a steppe of rich farm country. I stopped to stretch my legs and take in the surprise of it. The sky was an empty duck-egg blue, but the soil was damp from recent rain, and the colors of the land had the unreal paintbox freshness of the last few minutes before a fiery sunset. Between an enormous undulating field of buttery corn stubble and an enormous undulating field of emerald winter wheat there marched a herd of twenty piebald cattle in single file. It was so quiet and still that one could almost hear the cows moving, half a mile off. In the far distance, steepling aluminum grain elevators did the job of churches, landmarking and subordinating the sprawling patchwork of the plateau.

There were no other cars on the road, and the only tractor in sight, up to its axles in chocolate earth, had a sleepy and forgotten look. The big, lonely geography of the Northwest made it easy to succumb to Lewis and Clarkery—to the sensation of being the first to discover an already well-discovered land. Even here, on territory so obviously occupied and cultivated, the natives of the place seemed to have only a skin-deep tenure of it. In England, all land looks owned. Hundreds of years of continuous possession, of wills and entailments and codicils, are visibly there in the fabric of the place, where most of what you see is the work of dead people and their builders, gardeners, plowmen, and lawyers. In Washington State, the land looks squatted-on, as if tomorrow it might have quite different tenants putting it to an altogether different purpose.

More than in any place I'd ever lived, it felt all right to be a stranger here. I was happy in the Northwest not because I felt at home but because no one else much seemed to be entirely at home either. When people said that they went "way back" in Washington, they meant two generations, three at most. Though they liked to affect a proprietorial air toward the landscape, they hadn't yet had time to really make it their own. I liked their gimcrack

townships because they looked as if they'd been built inside the reach of my own memory, and built by people whose skills as architects and carpenters were not much better than my own. Driving through Pomeroy ("The Key to Friendly Family Living," pop. 1,716), I could recognize it as exactly the sort of town I might construct myself, if I were doing it in the evenings and weekends and paying for it as I went along.

For as long as whites had been coming here, the Northwest had tended to attract last-chancers in their forties and fifties: it was a region where unsettledness and solitude were part of the normal fabric of things. In their turn, the migrants had written their own morose character onto the face of the country, with lonely, inward-looking houses, hedged, ditched, and electric-fenced against unwelcome advances. Set far back from the road in acres of land for land's sake, they looked less like homes than gun emplacements. The Dodge was going too fast for me to read the names on their mail-boxes, but I could make some fair guesses: the Angsts, the Weltschmerzes.

It was dark when I reached Walla Walla, a big farming town with a college and a state penitentiary where Westley Allan Dodd, the serial child-killer, was waiting to be hanged in six weeks' time. Because Dodd gave regular television interviews from the prison (in a creaky and pedantic voice he argued the case in favor of executing people like himself), the townscape of Walla Walla had recently become picturesquely famous in a small way. From these broadcasts, I knew its wide dusty streets, its baseball diamond, its old brick grade school, its cinema, its swimming pool. The producers of the Dodd interviews liked to show Walla Walla as the kind of quiet country town to which every parent would like to move; the ultimate safe place to bring up kids. Then they'd cut to the interior of the penitentiary.

It was quiet. Not even a TV crew stirred. Though it was a Saturday night, there was only one other diner in the restaurant of the Whitman Motor Inn, and I was wary of the look of determined interest that showed on his face when I arrived. He looked like a man from whom several diners might have already fled, and I did my best to bury myself conspicuously in the large gray slab of Volume 5 of the University of Nebraska Press edition of the journals of Lewis and Clark. I had just folded the book back on the right page (it had taken the explorers five weeks and two days to get from Lolo to the Walla Walla River), when the catechism started up. That looks like a good book. You like to read? Who's the author? You ever read Stephen King? He's a good author.

He was fortyish, with a narrow, sallow face and a limp moustache like a drowned vole. He held out his loneliness in the manner of a derelict exhibiting an open sore; and, having made me meet his eye once, he was a relentless anecdotalist. Through the slowly changing seasons of bread rolls, green salad, and rib-eye steak, I nodded, abjectly, while the man recalled his past in the timber industry, his conversion to environmentalism, and his recent, successful attempt to get in touch with his inner self. It was the search for this lost self that had brought him to Walla Walla, which was a fine town, a college town, an educational town. He had taken some wrong turnings in his early life, the man said, but now he was on the right track. In Walla Walla, he was going to take some courses.

I pushed the remains of my steak to the side of the plate. "What courses?" He evidently thought my interruption rude. "It's like they say: it's never too late—"

"What courses?"

"Hey?" His eyes were wary now. I was pestering him.

"What courses are you going to register for? I'm interested. What courses are you going to take?"

Irritably, he said: "Courses in . . . machinery. And flagging."

... The water was agitated in a most Shocking manner boils Swell & whorl pools, we passed with great risque.

Buffeted by a strong headwind, the car sped west along the bare, ribbed valley of the Columbia. Lewis and Clark's river, with its Indian fishing lodges and canoe-swallowing rapids, lay many feet underwater now. Locked and dammed since the 1930s, the Columbia had been turned into a staircase of epic lakes. The surface of the water was chipped and furrowed, streaked with windrows of scud. By the side of the road (another deserted blacktop, Route 14, on the Washington shore), stalks of dry sagebrush stood quivering on the stony ground. This miserable, gale-tormented plant had been new to the explorers, who referred to it, doubtfully, as "whins" and "wild Isoop."

The feelings of the early settlers here, as they tried to find words to express the extraordinary barrenness of the valley, were plain from the names on the map. To the north lay Sand Ridge; to the south, Poverty Ridge. There was a hamlet called, with a grimly literal eye for the land-scape's salient feature, Sage. Beyond Sage was Dead Canyon. Beyond Dead Canyon was Golgotha Butte.

The West was named, in English, at a time when almost every frontier sod house and log cabin contained a copy of *Pilgrim's Progress*, resting next to the Bible. Huckleberry Finn notices the book in the Grangerford house:

There was some books too, piled up perfectly exact, on each corner of the table. One was a big family Bible, full of pictures. One was "Pilgrim's Progress," about a man that left his family it didn't say why. I read considerable in it now and then. The statements was interesting, but tough.

The fur trappers, farmers, fishermen, and loggers were comfortable with Bunyan's landscape of allegory. (Was Paul Bunyan's name meant as a respectful nod to John Bunyan? Certainly the Bunyan stories have a distinct *Pilgrim's Progress* flavor.) The settlers were used to a topography in which places had names like the Slough of Despond, the Hill Difficulty, the Delectable Mountains, Lucre Hill, the River of the Water of Life, the Valley of the Shadow of Death. Western names! Migrants to the West found themselves living in a dramatic and exaggerated landscape that must have seemed more like the country described in *Pilgrim's Progress* (or the Book of Revelation) than anywhere in the conventional realistic world. It looked allegorical, so allegorical names were attached to it: Damnation Peak, Mount Despair, Lucky Canyon, Starvation Point. When Lewis called the Jefferson River's twin forks Philanthropy and Wisdom, he was beginning to create a world in which the pilgrim Christian might wander as he does through Bunyan's book.

When Lewis and Clark reached the Columbia it was already named (after the ship in which Captain Robert Gray sailed into the river in May 1792), which was a pity since it meant so much to them. The river, surging west through these biscuit-colored hills, was a joy and a deliverance. From here, the explorers could almost smell the ocean. Every day now, they came across tangible signs of the end of the road: an Indian wearing a sailor's peajacket over his short hide skirt; more handkerchiefs; an English copper tea kettle in a lodge house; a musket. They saw what were probably harbor seals (which live happily in freshwater) and called them "sea otters" to bring the Pacific closer. With each overnight variation in the level of the river, they fancied they could see the influence of the tide. It was a measure of their raised spirits that they now began to lay on regular musical entertainments for the Indians, with Private Pierre Cruzatte on the fiddle.

Pete Crusat played on the violin which pleased the Savage, the men danced.

Past Golgotha Butte, the windsurfers began. The Columbia Gorge gathers in the westerly winds of the Pacific and focuses them like a nozzle. It is one of the great wind funnels of the world, and its effect is exaggerated because the sun-dried desert land east of the Cascades forms a pressure vacuum that sucks in the cool wet oceanic air. So an almost continuous westerly gale blows through the lower Columbia valley, burnishing the rock bluffs and keeping the sagebrush down to a thin and close-cropped fur. It made the going rough for the explorers. Wind hard from the west all the last night and this morning . . . a verry windy night . . . a windey morning . . . a Violent wind . . . Their canoes lurched and pounded through the lop on the river, often taking on water.

But the windsurfers loved the windiness of it. They came from all over. I first heard about this roaring chasm in the bar of the Isle of Man Yacht Club, where a windsurfing bank clerk told me it was his ambition to spend a long season crisscrossing one short patch of water on the Columbia River. He showed me a picture of the place in a magazine; I barely glanced at it, but nodded politely, thinking him an amiable madman who required humoring.

Now I saw his point. Each wetsuited windsurfer had the rigid crouch of a toy gladiator as he skidded hard across the wind on his psychedelic wing. These people made sudden, happy sense of the harsh topography: for a moment, they made the Columbia look homely, in a solitary, Northwestern manner. There were at least a dozen of them in view, but there was no apparent relation between them. They weren't racing, it wasn't a regatta. Everyone was striking out on a freelance course of his or her own, each at a different angle to the wind, sailing exactly as people seemed to live here, unsociably and at cross-purposes.

I thought of the Manxman, slow-spoken, somber, and dreamy. During the year I spent on the island, he quit his job at the bank and broke up with his fiancée in order to devote himself to his sailboard. Driving on the coast road to Douglas in the dead of winter, past a sea of blown spume and boiling milk, I'd catch sight of a triangular scrap of rainbow in the storm—the ex-bank clerk at his devotions. This beef-pink, horse-faced loner was made for the Pacific Northwest: put him in a shack at the mouth of Melancholy Canyon, and he'd pass as a native.

As the Cascade Mountains began to crowd around the river, the landscape slowly changed from tan to green. The first fir tree came and went, sparse woodland thickened into forest, and National Public Radio was back on the air, broadcasting from Portland. For the past few days I had been living in a chronological fog, and it came as no particular surprise to learn that the man in the news today was Warren Christopher—a name I hadn't heard for so many years that it sounded as if it belonged to the historical archives. Go driving long enough in the deep sticks, and you might tune in to find Cokie Roberts interviewing John Quincy Adams.

The road ran abruptly and unambiguously into the fall of 1992, with a lumber mill pumping steam into the overcast, some muddy acres of building lots and model homes, a tangle of concrete ramps and two freeways straddling the Columbia on high bridges. The whole landscape was permeated with the flatulent reek of the timber industry. I had meant to stop in Portland but took the wrong ramp and found myself headed north on Interstate 5, bound for Seattle and Vancouver, and at the next exit I kept on going.

Even on this Sunday afternoon I-5 was clogged. The main Mexico-to-Canada highway west of the Rocky Mountains, this thirteen-hundred-milelong concrete duct had been a marvel in its time but was now an almost continuous end-to-end traffic jam. I made a slot for myself in the slow-moving stream and settled in. It was restful to have no more land-scape to look at for a while, just the weather-stained back of a big milk truck, like a grimy blank page.

When Lewis and Clark returned to Washington in 1806, each was looking for the classic ending to a nineteenth-century story of a young man's adventures. To go with the worldly honors they'd won with their expedition, they needed two weddings, two budding families. President Jefferson had given Lewis the job of governor of the Louisiana Territory and had promoted Clark to the rank of brigadier general and made him territorial agent for Indian affairs. Lewis was thirty-two, Clark thirty-six: by the standards of the time they were both unusually long gone in bachelordom, and they were in a justifiable hurry to be married.

Clark went back on a visit to his native Virginia, to the hamlet of Fincastle, near Roanoke, just off Interstate 81, where he proposed to Julia Hancock and was immediately accepted. Lewis wasn't so lucky. For several months, he hung around the social honeypots of Washington and Philadelphia, making advances to likely young women, all of whom turned him down. Lewis was used to hard going and uphill climbs, and he seems to

have tackled the business of courtship in much the same spirit as he'd tackled the Lolo Pass. He wrote to a friend: "What may be my next adventure god knows, but on this I am determined, to get a wife."

But he got nowhere. He was America's newest and brightest cultural hero, yet when it came to lovemaking he simply couldn't put himself in luck's way.

Charles de Saint Mémin drew a ceremonial crayon portrait of Meriwether Lewis in Indian dress in 1807. It's no great work of art, nor is its subject, who stares out of the picture with undisguised pathos. His deep-set, doggily soulful eyes are full of trouble. Jug-eared, with a great conk of a nose and a small mouth like a credit-card slot, fantastically crowned with a twin-tailed coonskin hat, Lewis looks a more likely candidate for the comedy circuit than the drawing room.

Poor Lewis. In 1808 he went out to St. Louis, still wifeless, to take up the governorship. The newlywed Clarks had already set up house in the town, and Julia was pregnant. The ugly bachelor found that the one dear companion of his life was lost to him. He felt miserably excluded.

Lewis got drunk. He hit the whiskey with methodical deliberation, looking to the bottle for anesthesia, and almost every day drank himself into oblivion. St. Louis was a hard-drinking place in a hard-drinking period, but the governor's drinking was a scandal even on the frontier. Pickled in alcohol, he got into shouting matches with the secretary of the territory, who wrote: "Gov Lewis . . . has fallen from the Public esteem & almost into the public contempt." He alienated Jefferson by failing to send any reports back to Washington. Sunk in depression and booze, he began to buy large tracts of land, paying for them with unsecured lines of credit.

Julia Clark had her baby—a boy. The Clarks christened him Meriwether Lewis Clark.

Traveling, like whiskey, was a means of escape. In early September 1809, the governor, who'd been summoned back to the national capital under a cloud, left St. Louis to go to Washington via New Orleans—first by flatboat down the Mississippi, then by ship to Chesapeake Bay . . . a voyage of nearly three thousand miles. The flatboat drifted slowly southward on the current. Lewis drank. After eleven days of drifting and drinking, the travelers were in sight of Fort Pickering, where Memphis would eventually be built, only two hundred and thirty miles south of St. Louis as the crow flies. Lewis changed his mind. He would ride cross-country to Washington.

He was incapacitated with liquor. Captain Russell, the Fort Pickering

post commander, forced him to stay and dry out, allowing him to drink only claret and some white wine. After five days of this—it seems to me—tolerant regime, Lewis gave Russell his promise that he would lay off whiskey and saddled up for the ride to Washington.

He was accompanied by two servants, an Indian agent, a slave, an interpreter, and a group of Chickasaw Indians; but Lewis liked to ride alone and went on ahead of the rest. Cantering through the Tennessee wilderness on dreadful roads, bottle back close to hand, Lewis perhaps found some relief from his goading furies. He was high on motion and whiskey. On October 10 he was on the Natchez Trace, heading north for Nashville, when he pulled in to Grinder's Tavern.

Grinder was away, but Mrs. Grinder was home. Later, she would describe how Lewis called for whiskey, smoked his pipe, and paced the floor talking agitatedly to himself "like a lawyer." Then she heard shots from his room. At dawn next morning, the governor died of wounds to his head and stomach.

Exactly what happened at Grinder's was never properly unraveled. The official reports said suicide; gossip said murder. At the time of Lewis's death, Clark was also en route to Washington, traveling on the main road from St. Louis with his wife and infant son. The news was brought to him on October 28, and Clark, who knew Lewis better than anyone alive, responded with grief but without much surprise.

I fear O! I fear the weight of his mind has overcome him.

After Lewis's death, Jefferson wrote of his one-time secretary, "He was much afflicted & habitually so with hypochondria'—a word used by Jefferson in its original sense, to mean acute depression or melancholia. In Jefferson's sympathetic diagnosis, Lewis had managed to keep his illness at bay with the "constant exertion" of his western travels, but that the "sedentary occupations" of the governorship had led him to succumb to "these distressing affections."

In 1813 Clark was given the job that had broken his partner and became governor of the Louisiana Territory; he lived until 1838, when he was two years short of being seventy. His baby son grew up to work on the Rectangular Survey that Jefferson had begun: in June 1849, Meriwether Lewis Clark became surveyor general of Illinois and Missouri.

My wrong turning had left me with a day in hand. I quit the interstate and headed northwest for the Olympic Peninsula and the Pacific coast. The road was a dead-straight furrow through rolling plantations of black firs—an enormous canopy of darkness held up by bare gray tree trunks, standing as thick on the ground as stalks of wheat. The trees were of the kind that timber industry people call "pecker poles"—all height and no circumference, like hundred-foot broomsticks. Over their tops was spread a smothering sky of oily-looking rain clouds like a dirty eiderdown. These were the foothills of the razor-edged Olympics, but from the road one could no more guess at the existence of the mountains than one could tell the time of day. Mile after mile slid by of the same dank, unpeopled lightlessness, relieved by the occasional patch of clearcutting.

Great tracts of the Pacific Northwest, like this one, resembled the interior landscape of manic depression. They ran through the same exhausting cycle. For days on end there'd just be gloom and dripping water in this natural dungeon where things grew like some fungal runaway mold. Then, without warning, the sky would clear and you'd find yourself suddenly open to the high white heights, and watch as the world changed color in an instant, from vegetable black to brilliant moss green. The character of the region seemed strangely well matched to the characters of the people who had first discovered and best described it: Vancouver, Lewis, Roethke, Hugo. By commission, choice, or birth, they'd all managed somehow to gravitate to this mood-swing country, where their own disturbed, roller-coaster temperaments seemed to be bodied forth in the objective physical geography.

Foot down through the forest, I kept going until at last the ocean showed, like the ultimate clearcut, as a lightsome vacancy beyond the trees. I parked the Dodge and walked down to the beach. The sky was higher and thinner here, and there was even a meagre ration of evening sunlight, enough to make the big, half-sunken driftlogs cast distinct shadows on the sand. Though there was barely enough wind to keep the pine needles in motion, the sea drummed and rumbled like the traffic on an overhead expressway as the incoming swell broke on the beach.

I sat on a log and listened to the sea.

The Sea which is imedeately in front roars like a repeeted roling thunder, wrote Clark; and have rored in that way ever Since our arrival in its borders which is now 24 Days Since we arrived in Sight of the Great Western Ocian, I cant say Pasific as Since I have Seen it, it has been the reverse.

The Pacific rollers came bursting onto the beach like exploding snowdrifts. Each one started off as an unambitious crease, a pencil line on the smooth water a quarter mile out, where the swell tripped on the shallowing sand bottom. With ponderous slowness, the crease sharpened and built into a translucent crest, through which the dying sunlight showed as through bubbled green bottle-glass. Now the whole wave was really on the up-and-up. Sixty or seventy yards off, it sprouted a thin white handlebar moustache, which widened rapidly along its lip. It kept on climbing. And climbing. The force of gravity appeared to have been suspended to enable its magnificent ascent. The arched wave hung in space, as thick and viscous-looking as a tower of treacle. Then came the break—a ground-shaking crash you could feel in your bowels—as the sea collapsed into powder, then reformed itself back into water again.

I shut my notebook and pocketed my ballpoint. My log was now an island, and both my shoes had sprung serious leaks below the waterline.

That night I put up at a motel in Forks, twelve miles inland, on the slope of the invisible Olympics. It was a timber town, and a minor classic in its genre. I had been driving through timber towns all day and seen them at every stage of their evolution. Forks was the most highly evolved version so far.

The lowest form of timber-industry social life was a camp of trailer homes parked in a line along the roadside. It became a town with a name when the trailers were joined by three or four prefabricated ranch-style bungalows and a 7-Eleven convenience store with a gas pump out front. The next stage up the ladder required the addition of a full-blown gas station with a "deli," which in these parts meant not a delicatessen but a basic horseshoe-counter diner, serving steak-and-egg breakfasts and sandwiches. Serious civic ambitions set in with the arrival of the video store and the motel. After that came the sculpture.

This was nearly always as formalized as the statue of the bronze infantryman atop the war memorial in a small English market town. I'd seen a dozen variants of it in Oregon, Washington, and British Columbia. Carved from a section of old-growth Douglas fir of massive diameter, it represented, in heavy relief, sometimes painted and sometimes in bare varnished wood, a logger with an axe cutting down an old-growth Douglas fir.

The example outside the motel was a beauty, for Forks was the metropolis of the logging camps—a mile-long strip of neon business signs, with three stoplights and a string of tenebrous beer joints. But the carved and painted logger, a figure of heroic pastoral, was distinctly out of tune with his real-life counterparts, who gloomed disconsolately over their drinks in the bars. None were Paul Bunyan types. The loggers were journeyman employees of billion-dollar outfits like the Weyerhaeuser Corporation, and

they gave off the sour smell of years of negative profits, evaporating cash flows, and hard bottom lines.

Mills were closing all over the Northwest, and for many reasons. The powerful Japanese buyers wanted whole trees, straight out of the ground, not American processed lumber. With the economy in recession, fewer new houses were being built and domestic demand for timber was unusually weak. Now, in November 1992, the industry was alarmed by the results of the election. The vice president-elect had been tagged by the outgoing president as "an environmental extremist," "up to his neck in owls." For many decades, the timber companies had been cutting down the national forests with hidden subsidies from the federal government to help them do so. In 1937, when President Roosevelt toured the Olympic Peninsula, his car went past a clearcut just south of Forks. Roosevelt was reported to have turned to the congressman sitting beside him and said, "I hope the son-of-a-bitch who logged that is roasting in hell." Disgust at the ravages of clearcutting was nothing new, but even on federally owned lands it had gone unchecked through the Reagan and Bush years. Now, after years of governmental paralysis and laissez-faire, things were changing. With Gore as vice president and Bruce Babbitt (another notorious environmental extremist) at the Department of the Interior, the federal government looked as if it was about to swing to the side of the spotted-owlers. The industry accountants, who did their sums in heartless cities a world away from places like Forks, were already ordering layoffs and closures, and every week more loggers were going out of work.

They were now the endangered species. They put up homemade signs on their lawns that said this family lives on timber dollars—and I'd find myself peering through the windows of these houses as if, indeed, I might glimpse some owlish birds pecking at a tray of timber dollars while Wheel of Fortune played in the background.

The sculptures I saw all looked recently carved and were part of the counterpreservationist movement. They owed a lot to the carved totemic ravens and thunderbirds with which the local Indian tribes announced their special status, and they asserted that timber-industry workers, like the Indians, had, in one of the hardest-worked American phrases of the late twentieth century, a unique and historic *culture*. Deny me my job, and you deny me my culture, my past, my ethnic identity. So the logging communities were busy manufacturing craft objects that gave them a tribal history and the right to be regarded as yet another beleaguered minority threatened with extinction.

It took some imaginative effort to identify the Weyerhaeuser forklift operators and helicopter crews with the carved figures of a brawny woodsman wielding an axe. The sculptures seemed to me to be self-defeating: sentimental tributes to a past so long gone that it was far beyond the reach of preservation.

I picked at a meal in an overlit, almost empty restaurant. The view through the window was of pickups and logging trucks plowing through the wet and dark. The chicken and french fries tasted of sawdust and wood pulp. The only other customer removed his teeth and pocketed them after he'd finished dining. Forks in the rain was resolutely unlovely.

An elderly blue VW Beetle was stopped at the light, its back end pasted over with slogans that looked misplaced here: antinuke, Clinton/Gore, and, with the brightest piece of folk wisdom that I'd yet seen on the tribulations of the timber industry, SAVE A LOGGER & A WHALE—SINK A JAPANESE SHIP.

The north shore of the peninsula, a hillocky strip of mixed woods and farmland, looked out over the hazy Strait of Juan de Fuca to the stranded thundercloud of Vancouver Island. A big ebb tide was running: one could see the westward drift of the level, tan-colored water, frosted with cats'-paws of wind.

This land had been settled at the turn of the century by handy and versatile people. First they had been loggers. They cleared their plots and sold the timber to the mills in Port Angeles. Then they pulled the stumps out of the ground and planted it with grain, or turned it over to cattle pasture. When the salmon were running in the strait, the settlers became fishermen and supplied the canning factories. As hunters, they sold venison to the Seattle butchers. They lived much like the Makah Indians whom they had supplanted, except that the whites lived, penny-wise, on their surpluses, selling everything they could chop down, raise, catch, grow, pick, or shoot.

These busy small capitalists—lately the poor of Sweden, Germany, and the British Isles—had left their names on the map. Bagley, Charley, Herman, Macdonald, Morse, Petersen, and Sadie were creeks; Dan Kelly, Dempsey, Durrwachter, Grossett, Liljedahl, and Pearson were roads; Snider, Stolzenberg, Ellis, and Muller were hills. The landscape was dotted with derelict farms—barns and windowless houses going down on their knees, their timbers splayed, their roofs collapsing under a heavy thatch of

moss. A plantation of future Christmas trees had risen spontaneously in what had once been a kitchen garden.

In this climate, where things both rotted and grew at a rate that struck me as belonging more to science fiction than to the ordinary process of nature, it was hard to guess how long the farms had been standing vacant. They seemed to have been abandoned for years, but here it maybe took only months to slide from working order into ruin. Possibly their owners had just gone away for the weekend.

As the farmhouses sank into black mulch, new retirement homes rose on "view lots" overlooking the strait. Leisure was now the big industry; farms were fools' games beside marinas and resorts, and the smart descendants of the settlers had long ago quit farming and moved into real estate and property development.

Few of the names on the map now matched the names of living residents, but Schmidt Road, by Whiskey Creek, still led to the Schmidt house. Turning down the unpaved trail, I disturbed a pair of skinny coyotes, who loped unhurriedly away from the Dodge, heads down, tails at half mast. At the road's end was a small sandy bay with a cathedral-like cedar A-frame perched on the edge of the water. Bud Schmidt was home.

We'd been introduced a couple of months before, when I came through with a friend, an ex-towboat captain, who knew everybody in those parts. We'd stopped here for tea, and Mr. Schmidt had delivered an eloquent and memorious tirade that made me ache for a pen and notebook. I'd therefore asked if I could return sometime, professionally equipped.

I told him I'd seen the coyotes—my first at such close quarters.

"Coyotes," Mr. Schmidt said, pronouncing the word as one might say crack dealers. "Oh, you'll see coyotes. The coyotes will be cleaning up when every last damn thing is gone." He led me into the house. A bulky septuagenarian in baggy overalls, he was stooped with arthritis and moved with the stealth of a burglar, trying to hide his intentions from his own easily alarmed joints.

The Schmidt living room was un-Americanly cozy. It was full of ordinary things, slowly accumulated over the best part of a hundred years. Though he'd built this house quite recently, Bud had been born "on the property," and the room, warmed by pine logs grumbling in the potbellied stove, felt as old as the century: an easygoing, patched-at-the-elbows place, full of old photographs, old papers, old tools, with a loudly ticking clock and the kettle on the stove just coming to the boil. Its big picture window gave onto the bay—the woods crowding to the water, the ruffled

strait, the gulls doing aerial stunts in the clearing blue, the far loom of forested hills on the Canadian shore. A brassbound telescope on a tripod pointed out to sea.

Standing by the window, I exclaimed about the view, and heard myself sounding like an out-of-control realtor. Mr. Schmidt, settling himself cautiously into a rocker, allowed that it might look pretty to an uneducated eye.

"People now, they talk about how clear the water is—how you can see right to the bottom. Used to be it was all *milky* here. You couldn't see more than a few inches down. Then you'd look a little closer, and you'd see that milkiness was life. It was things swimming. It was all kinds of small sea life. Now all that life's gone. It's getting clearer all the time. Used to be, you'd look out there on a day like this and all you'd see would be salmon jumping. Any one moment, there'd be a thousand splashes out there—many, many more than you could take in with your eye. That whole sea was alive with salmon. Now . . . "He matched a sour, small, knowledgeable laugh with an audible shrug, showing no amusement at all.

Out on the strait, the tide was starting to break against the building wind. I couldn't see a single leaping fish.

"It's so quiet now. The beach is quiet. Dead quiet. Used to be, when the tide was out on a calm day, it was making all kinds of noises. There was rustling and squirting and gurgling and crawling . . . The fox terrier we had, he'd run across the beach ahead of us, and he could make more clams squirt than we did. He'd start a vibration going—well, it'd make all the clams squirt. And there'd be crabs running around; stuff like that . . . Now you go out and there's nothing in the sand. It's silent. If you didn't know, you'd think it was peaceful."

Mr. Schmidt's hands moved impatiently in the lap of his overalls. His fingers were swollen and knotted. He looked at them rather than at me and spoke in a voice as insistent and repetitive as a rusty hinge.

"We had a tremendous lot of little animals and birds that aren't here anymore. We had bluebirds—there's none. We had killdeer snipe—he's gone. We had whip-poor-will—he's gone. We had a huge amount of woodpeckers—they're all gone. We had grouse, we had quail, we had rabbit, we had several different kinds of weasels. We had mink, we had otter, we had muskrats. There was swamps then—they hadn't built the road ditches back then—and we had birds in the swamps. Ducks. We had peregrine falcons eating off the ducks, we had ospreys eating off the salmon. We had God knows how many little parasite-animals like mice, and different things like

that—they're all gone. We had two different kinds of skunk, the spotted one and the striped one. They're gone. We had frogs, we had toads, we had salamanders, and we had some of those green tree frogs, and in the last few years they've all disappeared—"

Mrs. Schmidt had come in from the kitchen, where she was cooking lunch. She listened to her husband for a moment, as if to check which part of his recital he had reached so far, and said: "Not all of them, Bud—not quite *all*..."

"We had bears in the creek, and they're all gone."

Now Mrs. Schmidt was gone.

"Everything seemed to gang up on the wildlife, and it's getting worse and worse and worse." He stared at his crippled hands, and I was struck by how out of keeping they were with his lips, which were unusually full—like Mick Jagger's had been in the 1960s. Bud's lips made his age seem like an undeserved affront, like the environmental disaster that had overtaken Whiskey Creek.

He blamed the timber industry for most of what had happened. Clearcutting in the hills above Schmidt Road had destroyed the natural drainage pattern. Water either poured off the sides of the hills in flash floods or the creeks went dry. Floods washed away the gravel shallows where the salmon used to spawn, and there was rarely enough water in the creek for the fish to swim up from the sea. It had been thirty years since the last good salmon run in Whiskey Creek, "or any other creek around here."

"When you do one thing, it takes a very around-the-house way. Like you get hit from several sides, not one blow on the head. When they cut down on the creek so you didn't get many fish, that meant there wasn't a whole lot of dead salmon coming out into the strait. Well—there went the crabs, see? When the salmon went down it disposed of a whole cycle of food: it wasn't just fish that went, it was bear, it was coon, it was eagles and seagulls and crows and mink and otter and skunk and weasel . . . "

His tone was sorrowing, but not entirely so. It was tinged with the modest satisfaction of the prophet who has correctly foretold the earthquake, the plagues of hail and scorpions, the frogs coming out of the mouth of the dragon, the sea of fire—and who still has the scarlet whore of Babylon up his sleeve.

"When did this breakdown start?"

"We knew things were wrong by the 1950s—we knew it then. But it wasn't until the 1970s that people began to say that we should turn this

around. And then it was only talk. Now..." He vented his unamused, prophet's laugh. "It's sad. But that's the way the world is."

I was back at the window, looking out.

"Used to be, you'd see as many eagles out there as you can see gulls now." This time, I laughed.

"Well—something like that. Something like it."

Lunch was ready. As Mrs. Schmidt brought the dishes to the table, I saw that she'd been mounting her own counterargument in the kitchen. The meal said *Not all*, *Bud*. *Not quite*... Everything came from the Schmidt property, from the venison and the vegetables to the apples in the apple pie. It was a meal to write home about—the great American meal, which provided the main substance of thousands of letters home to Europe at the turn of the century. This was how the emigrant cousins were rumored to live—like noblemen, on oysters, smoked salmon, game, and strawberries. It was tales of meals like this that made the rural poor of Europe pile into the steerage sections of the transatlantic steamers.

When the railroad line reached Puget Sound in 1883, the railway companies leafletted the Old World with brochures in English, German, Swedish, and Norwegian. The Pacific Northwest was The best MONEY MAK-ING country in America . . . Farming and Mineral Wealth in Great Profusion for MILLIONS OF PEOPLE! ... Whenever the plow is freely used, and the seed planted, the growth of grain and vegetables becomes luxuriant (Northern Pacific Railway guide, 1883). The soil and climate of the region guaranteed rapid growth and extreme fruitfulness. Grape cuttings will yield the first year; peaches and apples the second and third year, and the young limbs need propping up to keep from breaking under the weight of the fruit (Great Northern Railway guide, 1889). Remember that word pictures often portray feebly, warned a guide writer, struggling to convey the groaning table of the Northwest. From the Great Northern Railway guide, 1902: Past, present and future, there is no region under the sun that can be recommended more strongly, honestly and safely than Puget Sound. From a guide jointly produced in 1924 by the Chicago, Burlington & Quincy, the Northern Pacific, and the Great Northern: On the horizon of the Pacific Northwest men with vision read, in letters of fire, a single word—Opportunity.

Tucking into Mrs. Schmidt's lunch, you'd have a hard job trying to persuade yourself that it came from a brutalized and dying land. It was squarely in the tradition of the brochures—a royal spread, thriftily put together from whatever bits and pieces came to hand at the back door.

Eating like a king, Bud Schmidt nodded at the strait where no fish jumped, at least not at that precise second. It wasn't so long ago, he said, since the gillnetters used to form a continuous boat-to-net-to-boat fence across the strait from here to Vancouver Island. You'd watch them lying lower and lower in the water until only a few inches of gunwale amidships showed above the surface; then they'd peel off to the canning factories on both the American and Canadian sides of the water. He remembered one boat slowly going down, in a flat calm, under the preposterous load of eleven thousand salmon, the three fishermen shouting and splashing in the bloody welter of dead and dying fish. He himself had used to gaff a hundred salmon in a night at the mouth of the creek. In season, the Schmidt family smokery was kept continuously burning for weeks on end.

He was seven years old when he was given his first hunting rifle, a .22, and at eight he went out grouse shooting on his own. His first pin money was earned killing seals for bounty. At high tide, he'd lain hidden in the grass by the creek mouth and shot the seals as they came inshore to feed on the shoaling salmon. When the ebb tide beached the carcasses, the boy dragged them above the tideline, where he hacked off the whiskers, eyes, and nose from each animal for the \$3.00 government bounty, then pared away the blubber with a flensing knife and boiled it up to make seal oil.

Oil for what?

"Used it for shoes, for harness oil, for wood preserver. You could get a good price for seal oil then."

He made a clean plate and clasped his hands in front of him on the table. Eyeing his swollen finger joints, he said: "The creek now, it's this *puddle*. And no life in it."

Mrs. Schmidt, slicing into the apple pie, said nothing, but Mr. Schmidt turned on her as if she'd contradicted him. "Even the loons are gone."

Back on the road, laden with lunch and homeward bound, I tried out the wizened view for size and saw coyote country. The dozen miles between Port Angeles and Sequim were turning fast into a continuous strip of car dealerships, chain drug and hardware stores, Kmart plazas and hamburger drive-thrus. A few hundred yards ahead there was a happy thing—a sun-bleached timber grain silo, rising like an ancient church tower over the one-storey slum of pastel cinder block, sheetrock, and aluminum cladding. As it drew closer it showed itself to be a grain silo no longer: it had been

colonized by a Mexican restaurant chain and now it was all-you-can-eat tacos and nachos. A sign flashed past: WILD BIRD SEED—CHEEP! CHEEP! 25 LBS \$5.50. Even the birds—those that remained—were on fast food here.

Halted at a stoplight, though, I found my gaze drifting: to the left, and the strait, like a bolt of green shot silk; to the right, and the Olympic mountains, their snowfields turning rosy in the afternoon sun. The strip of development appeared to be no more than a long scratch—not even a flesh wound—on the face of the country. If you searched the sky, you'd see eagles circling there; if you went for a walk in the high woods, you'd find the scat of mountain lions and black bears. If the people were to leave, the trees would cover the scratch tomorrow: Kmart's concrete roof would craze and split open as the spear-tipped Douglas firs poked through, and Walgreens Drug would sink gracefully into mossy ruin. *Tomorrow*.

I thought of Mr. Schmidt. When he looked out from his fastness in the deep countryside, all he saw were absences and all he heard was the incriminating silence of the sandy beach at his feet and the empty branches over his head. Yet it was no less true that when I looked out from our upstairs living room in the city, I marveled, time and again, at the profusion of nature in the Northwest. The list of birds watched from our urban deck now ran to ospreys and eagles, cedar waxwings, red-shafted flickers, pine siskins, varied thrushes, nuthatches, ruby-crowned kinglets . . . Who sees this in Manhattan Isle?—thinks Seymour Levin in a Cascadian wood—None but the gifted. Of course Mr. Schmidt was right; but so was I. Hopefulness is always callow when it rubs up against well-informed pessimism, though I couldn't kill the stubborn gut feeling that—abused and damaged as it was—this was still, just, the most possible landscape in which I'd ever traveled.

Not all, Bud. Not quite. Not yet.

Past Sequim, the road bent south, back into the inky green of fir and hemlock, and dusk returned the tree farms to the towering darkness of original forest. The northern spotted owl might disdain it (too few dead branches in which to set up home, too few voles and flying squirrels on which to dine), but a plantation of forty-year-old trees after nightfall is as deep, and looms as witchily, as any forest in a German fairy tale. A harvested break in the woods framed a sea of creased black oilskin, under the low and growing moon.

I caught the 7:40 ferry from Bainbridge across Puget Sound to Seattle seconds before it was unshackled from the dock. Up in the overlit lounge, a sprinkling of commuters sat in withdrawn silence like subway passengers. For them Puget Sound was a time, not a place: it was twenty-five minutes, and the ferry was six minutes late. The ship—far too big for this light eve-

ning task—trundled over the water, its engine churring like a tumble dryer. I went out front, onto the cold and windy lip of open deck, where two smokers, a man and a woman, were huddled with their cigarettes in the inadequate lee of a steel girder.

The wind was blowing out of the south and a lumpy sea was running. Seattle, five miles off now, was a sweep of light, like a spontaneous bloom of luminous plankton in the water, a phosphorescent city. It had a watery depth and brilliance—a great floating exhibition of glowing silver office towers and glowing amber streets. After the miles of woody darkness, I found myself quite unprepared for the city's dizzy splendor, climbing and spreading around the ferry as it plowed across the Sound at eighteen knots.

Seattle was a western city, built in a wilderness and designed to dazzle. To get it right you were meant to approach like this, as a fisherman back from the Gulf of Alaska, a logger coming in from the forest, or a salesman returning from his huge and far-flung territory, and you were meant to feel an explosion of pride in the sheer brazen unlikeliness of it—this sky-high glittering metropolis in a hilly clearing in the firs.

Country life in the West, around the mill, the cannery, the logging camp, was slovenly, and most settlements were ramshackle affairs, thrown together in a hurry because people needed to live on the job. Seattle was intended as a spectacular proof that western life could be dignified, cultured, *permanent*; everything that the country was not. Wood was the material of the rural outback. Seattle (after the fire of 1889, which destroyed the first, mainly wooden city) craved marble, granite, sandstone, and brick—as it craved height, to set itself apart from the single-storey villages of its hinterland. A heroic attempt to create, in a wild and remote place, all the appearances of a long civilized past, it was a jumble of allusions—to the storybook history of classical empires, to the famous monuments of Europe, to such fragments of the recent past as a favorite park, a chophouse, a New York apartment block.

It was a homesick city, full of memories—of Stockholm and Copenhagen, as of the high life of Manhattan—with its most basic tone that of a determinedly bright letter home. We're doing fine here. We eat with knives and forks... we go to the theatre and see the very latest things from the East only a few months after you... You would be amazed by Henry's office—on the 28th floor... We're kept so busy here!... Honestly, we're doing fine!... Please, write soon...

The smokers had retreated to the lounge. As the ferry passed from the Sound into Elliott Bay, the city lights closed around it, enfolding the ship

in their ambit, and I was proud of Seattle as one was meant to be. I followed the swarm of house lights up Queen Anne Hill, to the TV towers on the summit with their slowly winking red aviation beacons. The lights of our house were just out of sight, over the brow of the hill, and it seemed, in the moments before the ferry locked into its berth, that this was always how it was out here, to be so far abroad, so nearly home.

Independent on Sunday, July/August 1993

Mark Twain's Life on the Mississippi

LATER IN LIFE, Twain would claim *Life on the Mississippi* as his own favorite among his books, but in the winter of 1882, when he was struggling to finish it against a deadline, it was his millstone and his albatross. From his desk in Hartford he plagued his friends with weary bulletins: "The spur and burden of the contract are intolerable to me. I can endure the irritation of it no longer..."; "I never had such a fight over a book in my life before..."; "... this wretched Goddamned book."

Yet when he put his signature to that accursed contract, the job of writing a book on the Mississippi must have seemed a breeze. The guts of the project were already to hand, in the seven articles, totaling thirty-five thousand words, which he had published in the *Atlantic Monthly* in 1875, under the title of "Old Times on the Mississippi." The articles had come to Twain in a single fluent burst of work, while he paused in the writing of *The Adventures of Tom Sawyer*, and their portrait of the artist as a young river pilot had already earned him a round of invigorating critical applause. All he had to do now was to capitalize on their success and expand the series to book length.

The Atlantic Monthly pieces were suffused with the roseate style of Tom Sawyer. The "white town drowsing in the sunshine of a summer's morning" in "Old Times" is set in the same key and the same tempo as "The sun rose upon a tranquil world, and beamed down upon the peaceful village like a benediction" in Tom Sawyer. Both the magazine series and the boys' book represent the river as an idyllic playground. In both, Twain re-created his own youth and wrote of a lost age when America itself was still young.

In fact, only thirteen years intervened between May 1861, when Twain, aged twenty-five, made his last trip on the river as a pilot, and October 1874, when he sat down to write "Old Times"; it might as well have been a

century. War had changed the world beyond recognition or repair. Before the war, the Mississippi had been the arterial mainstream of midcentury American life; after the blockade of Memphis in 1861, the river was broken in two, its trade killed for the duration. It was the end of the culture of the steamboat and the river town. When peace eventually came, the railroads took most of the traffic that had once gone by water. Twain at thirty-eight was able to look back at his own young manhood as if it were ancient history; his memories—both in *Tom Sawyer* and in "Old Times"—have the hauntedness, the glowing remoteness, of those of a man in his nonage.

Between the New England *now* of his writing and the Missouri *then* of his fiction and reminiscence lay a personal as well as a national cataclysm. When the war put an end to his career as a river pilot (at which he was by all accounts extremely happy), he enlisted in the Marion Rangers, a band of Confederate guerrillas based in Missouri—a state that remained loyal to the Union despite the secessionist stand made by its governor. The next few weeks were spent in hiding or on the run. Then Twain, in the company of his brother Orion, who had been appointed secretary to the Nevada Territory, fled west—first to the gold diggings, then to the San Francisco newspapers, where he quickly established himself as a famously droll columnist. In *Life on the Mississippi* he vilifies the Confederate South in a tone of wise, and seemingly age-old, contempt; it's worth remembering that he began the Civil War as a Rebel volunteer and spent the rest of it in a state of what amounted to internal exile.

He emerged in 1865 with a new name, a new profession, and a new political view of the world. The young humorist Mark Twain was an entirely different kind of animal from the young pilot Samuel Clemens; and Twain would commit himself to so befogging and mythologizing the past of Clemens that it would turn into the best and most glorious of the mature writer's inventions. The "Old Times" pieces were fiction—a fiction made credible, in every sentence, with autobiographical fact. From the makeshift and muddy raw material of western life in the 1840s they created a golden age of innocence and harmony as pure, and as unreachable, as that pastoral world of nymphs and swains on which the poets of the Jacobean court used to dote.

It was a fiction that could not be indefinitely sustained. Even before he finished the *Atlantic Monthly* series, there were signs that Twain was beginning to scrape the bottom of that particular barrel. Article 7 (Chapters XVI–XVII of *Life on the Mississippi*), with its steamboat-race statistics and its limp anecdotal ending, is not a patch on Twain's portrait of his boyhood and his apprenticeship as a cub pilot under Horace Bixby. To make a whole

book out of the river, he needed to construct a bang-up-to-date modern (even modernist) frame for his idealized picture of the past. He would pit the antebellum Golden Age against the postbellum Gilded Age.

In April 1882, he went back to the river. It was a triumphal grandee's return. Twain took with him Charles Osgood (his literary agent and the manager of his publishing house) and Roswell Phelps, who was signed on as a stenographer to take down the great writer's small talk. He at least toyed with the idea of taking on an assumed name; as C. L. Samuel of New York—a rich Jewish East Coaster—he might eavesdrop, like Huck Finn, on people speaking of his younger self as if he were dead.

The Twain party arrived at St. Louis, rode down the river to New Orleans, then up the river again to Minneapolis. A month after setting out, Twain was back in Hartford, where he quickly found that the book, far from being an easy assignment, was the most mulish and immovable project that he had faced in his entire writing life.

Reading *Life on the Mississippi*, it is not the river one sees first but the writer's desk—a desk littered with magazines, books, brochures, writing pads. There is the stack of seven-year-old issues of the *Atlantic Monthly;* a pile of recently acquired guidebooks, bland and boosterish then as now; several American travelogues by such British authors as Frances Trollope, Captain Marryat, Captain Basil Hall; a copy of *A Tramp Abroad*, published two years before, from which some overspill material (like "A Dying Man's Confession") might be filched for the Mississippi book. Most important of all, there is the half-finished manuscript of *Huckleberry Finn*.

Few books expose the halting progress of their own authorship so plainly as this one does. You catch the rhythm of Twain's working days from it—the bad ones along with the good ones. A day of plodding journalism will be succeeded by a day of happy inspiration; sometimes Twain nods over the work, then, suddenly, he quickens and takes wing. When his energy flags, he goes back to the books and papers on the desk, searching for a quotation that will fit or an idea that will move the manuscript along for another thousand words.

Chapter XXXVIII, "The House Beautiful," provides a nice example of Twain at work, doodling and improvising his way around the river. It begins with a steamboat run, quotes Dickens on steamboats, and then, triggered by little more than the mention of Dickens's name, launches into a brilliant Dickensian pastiche. Twain, diverted into thoughts of Dickens's animated London interiors (or so I surmise), begins to apply Dickens's patent brand

of telegrammatic syntax to a childhood memory of his own—his visits to the farmhouse owned by his uncle and aunt, John and Patsy Quarles, in Florida, Missouri. The result is a wonderful exercise in rapt memoriousness. A whole society is brought to life in an epic inventory of its household effects. It is at once the cleverest imitation of Dickens ever written and a magnificent original in its own right. Later, when he returned to *Huckleberry Finn* (and all the internal evidence suggests that the passage in *Life on the Mississippi* came first), Twain used this chapter as a quarry from which to extract material to furnish the Grangerford house. The second time around, Huck does the seeing, and gets it poignantly wrong.

The chapter loops back to steamboat architecture and, a page later, Twain—on what is evidently a dull morning—is down to one of his regular ploys-of-last-resort and quoting Mrs. Trollope. Both the roller-coaster motion and the essential literariness of the method are typical of *Life on the Mississippi*. Like the river itself, the book is labyrinthine, a succession of meanders, chutes, and cutoffs; it turns digression into a structural principle, as Twain wanders downstream, then up, branching off at will into recollections, swoops of fancy, lectures, fictions, facts, guided tours, meditations, and sly parodies.

It is a palimpsest, with one style of writing laid slantwise on top of another, and it is a book obsessed with the meaning and consequence of writing. When Twain blames the Civil War on the South's fatal weakness for the romantic prose of Sir Walter Scott, he is joking, but only just. *Life on the Mississippi* is profoundly charged with the insight that, in Wittgenstein's happy formulation, the world we live in is the words we use, and that the United States in the late nineteenth century was living in a language that had become corrupt and stale. The book begins in newspaperese—a slather of routine statistical journalism, as if the great river might be netted in a mesh of facts and figures; it ends in a tongue-in-cheek pastiche of varnished guidebook prose, full of tired lyricism and spurious Indian legends. En route, Twain keeps up a continuous—and often very funny—attack on the language of romantic cliché.

Twain's real opponent is not Scott, or Poe (who is mocked and imitated in Chapter XXXI), or the New Orleans *Times-Democrat* journalist who is given a dressing-down in Chapter XLV, but himself. He suffered from what he labels "the artificial-flower complaint," and his own prose (in *Innocents Abroad*, in *Tom Sawyer*, and in the "Old Times" pieces) had strong Confederate leanings. The passage he quotes from the New Orleans journalist ("On Saturday, early in the morning, the beauty of the place graced our cabin . . . ") sounds very like the kind of sentence in his early work to which Twain himself might, with hindsight, have posted a rejection slip.

He had already created, in manuscript, the clear and powerful voice of Huckleberry Finn: a voice without literary precedent. *Life on the Missis-sippi* counts the cost of that creation. It shows Twain in the act of wrestling with the demons of the language—battling, in parody and pastiche, toward a new way of rendering the world in writing. Style after style is tried out on the river, and found wanting. All Twain's literary ancestors, from his journalist-brother Orion to Dickens, are mimicked, some in homage, some in excoriation. This is a far more anarchic book than has generally been acknowledged.

Its emotional and stylistic heart resides in Chapters LIII to LVI, where Twain goes back to his old home in Hannibal, and the tone throughout is conventionally fond ("this tranquil refuge of my childhood . . . "). It is the required tone of a man revisiting his past and finding it at once sweetly evocative and changed almost beyond recognition. It is a cunning mask, for the memories that the town brings to mind are violently at war with the style in which they are recalled. Fondly, at leisure, he dwells on the story of his schoolmate who was taunted to his death by Twain and his playfellows, on the tramp who burned himself to death in the town jail, on the man who fancied himself a serial murderer, on the woman driven insane by another childish prank, and on the town's chief tourist attraction, the pickled body of a fourteen-year-old girl. He laments the passing of the slaughterhouse and discovers Tom Sawyer's sweetheart, Becky Thatcher (for it is surely she), in the person of a raddled and promiscuous crone. Every page is littered with the town dead; the unmathematical reader will rapidly lose count of the corpses that form the main punctuation points in Twain's story of his homecoming.

It is an extraordinary performance. Manner and matter are played against each other, tenor and descant, in a brilliant and unsettling black comedy. Here, as almost everywhere else in the book, Twain is working on the edge of parody. The model in these chapters is Washington Irving's "Rip Van Winkle," and the connection between Irving's story and Twain's reworking of it is precise and suggestive. Van Winkle slept through the American Revolution; Twain has, as it were, slept through the American Civil War. Wakened at last, he is a very old man indeed—far, far older than the forty-six-year-old who made the literal return to Hannibal.

He might have called the book *Death on the Mississippi*. When he came to pick up the threads of the "Old Times" series, in Chapter XVIII, he built the book up to its first climax—the story of his brother Henry's death in an explosion aboard the steamboat *Pennsylvania*. The scene of the "death

house" in Memphis ("Two long rows of prostrate forms—more than forty, in all—and every face and head a shapeless wad of loose raw cotton") is the last we see of the antebellum Mississippi, and the bodies of the people killed in the explosion, viewed as in an improvised field hospital, foreshadow the bodies of those about to be killed in the Civil War.

Thereafter, Twain can't keep his pen away from the subject. He jokes about it. He spins out morbid gothic tales. He records it as a matter of important fact, and, when he reaches the last page of the book, he drags death in by its heels, in a facetious metaphor:

A dead man could get up a better legend than this one. I don't mean a fresh man either; I mean a man that's been dead weeks and weeks.

As he wrote to his wife, Livy, when he was on the river in May 1882:

That world which I knew in its blossoming youth is old and bowed and melancholy, now; its soft cheeks are leathery and wrinkled, the fire is gone out in its eyes, and the spring from its step. It will be dust and ashes when I come again. I have been clasping hands with the moribund . . .

In the same letter, he called his return to the past "this hideous trip," and when he settled down to write his book, he wrote compulsively of dead people, dead cities (like the town of Napoleon, Arkansas, washed away by the river), a dead civilization. The brightest, funniest moments in the book are shot through with a kind of jaunty necrophilia.

It is the conceit, and necessary premise, of the "postmodernist" writer to believe that he or she has somehow survived into an era without precedent, beyond history—that the world in effect died sometime between the time he or she was born and the time in which he or she is writing. No one in the late twentieth century has subscribed more fervently to this belief than Twain did in the late nineteenth. The Civil War was his Holocaust and his nuclear bomb. *Life on the Mississippi* shows him dealing with that predicament in a typically postmodernist way—in pastiche, in parody, in writing (as John Barth described Borges) "postscripts to the corpus of literature." It is a strange, untidy, uncomfortable, and secretive book, and it is no wonder that Twain, having sweated blood to make it work, should have been so proud of it long after its publication.

Philip Larkin

TO LIVE IN ENGLAND in the age of Larkin was like having a famous bleeding statue on the premises. Once in a blue moon, word went out that a poem was about to surface in the next issue of the *New Statesman*, *Listener*, or *TLS*, and within days of its appearance people would have it by heart and be quoting it over the dinner table. I can name precisely where I was (subway, friend's kitchen) when I first read, on its publication day, almost every Larkin poem between "Dockery & Son" in 1963 and "Aubade" in 1977. Those grimly beautiful later poems are still solid facts of their period, like the three-day week and the falling pound. Larkin's great subject was his own declining bachelorhood, but it seemed that somehow, mysteriously, he had found a way to speak directly to the condition of England as no poet had done since Tennyson. If Larkin's muse (unlike Tennyson's) was usually out on strike, that too was a measure of how perfectly in tune he was with his time.

His writing had a Victorian regard for fine (and sometimes ostentatious) craftsmanship. No literary training was required to see that a vast amount of highly skilled labor had gone into the construction of a Larkin poem. Every last tiny piece was an exact fit. Like a brassbound ship's chronometer, the thing ticked and chimed and kept strict Greenwich time. Larkin started out as a novelist, with *Jill* (1946) and *A Girl in Winter* (1947), and his most despairing poems had the comfortingly busy texture and dependable shape of fireside tales. They swarmed with glistening realistic detail: in a line or two, Larkin would re-create a stuffy railway carriage, a vacant room, the wide landscape of a flat county in high summer, and make you see and smell it on the page. He was expert at the resplendent, transfiguring ending—the ending that sweeps the reader aloft on a rising thermal of grave and formal language:

... as the tightened brakes took hold, there swelled A sense of falling, like an arrow-shower Sent out of sight, somewhere becoming rain. ("The Whitsun Weddings")

-or,

The traffic parts to let go by Brings closer what is left to come, And dulls to distance all we are. ("Ambulances")

When it came to the bitter innards of the poems, Larkin had a genius for making his readers feel vicariously brave as they entered a life of such enforced solitude, such unfulfilment, such concentrated horror at age and death, that their own lives grew sharply brighter for being lived for a few minutes inside Larkin's. Just as you assented to the intolerable truth of—

Life is first boredom, then fear. Whether or not we use it, it goes, And leaves what something hidden from us chose, And age, and then the only end of age

—so you were reassured by your pleasure in the lines' own patterned eloquence that they were not true; at least, not in your case; not quite yet.

Larkin, the son of an accountant, was a famously tough agent on his own behalf and a shrewd promoter of his literary reputation. Recognizing his scarcity value, he ensured that people never got enough of him. Every once in a long while, he granted an audience to an interviewer. The journalists who traveled up to Larkin's eyrie in Hull were met by a well-scripted character whose tone was pitched midway between the reactionary acerbities of W. C. Fields and the self-deprecating complaints of Eeyore the donkey. Pale and flabby, carrying his 230 pounds like a shifting liquid cargo, Larkin was kitted out with two hearing aids and thick specs that served as windows to a house whose interior was hidden in gloom. Each interview was a studied performance, furnished with all the comic business and split-second timing of an old music-hall turn. Larkin would pay off his interrogator with at least one original burnished *mot*, like "Deprivation is for me what daffodils were for Wordsworth"; asked about politics, he'd profess to "adore" Mrs. Thatcher, as on modern fiction he would solemnly advance his admiration

for the early and middle-period work of Dick Francis. He was a lugubrious tease. Whenever he struck a memorably philistine note ("Foreign poetry? No!") or came across as a blimpish Little Englander, his remarks were treasured as vintage Larkinisms. Had they been made by, say, Enoch Powell or Norman Tebbit, the literary establishment would have deplored them; made by Larkin, from that dark space deep behind his glasses, and in a voice of mournful plainsong, they were thought ironical and droll, pure Philip.

He died in 1985, a beloved national figure. At his memorial service in Westminster Abbey, I was surprised to hear a burbling dean posthumously enroll him—the poet of all our disbelief—into the ranks of the Anglican faithful. Larkin (who called religion "That vast moth-eaten musical brocade / Created to pretend we never die") was, according to the cleric in the pulpit, if-not-in-fact, blah blah, a deeply human man, a deeply spiritual et cetera. This cheeky act of Assumption did at least fairly reflect Larkin's extraordinary centrality in the culture: a man so plainly for England and Saint George would surely be for God as well.

So things rested until the publication in London last October of Larkin's Selected Letters, when the miraculous trickle suddenly turned into an ugly hemorrhage. The letters are snappishly funny, full of gossip and lively reports from the home front (the library, the literary committees, the lonely evenings with the gin bottle) and, toward the end, harrowing. They're also petulant, smutty, and inexhaustibly self-concerned. Even the expected pleasure of seeing Larkin wipe the floor with his contemporaries wears thin when spread over this length and in this quantity: Iris Murdoch—"unreadable"; English poetry since 1960—"horse-shit"; Vikram Seth-"load of crap"; Thom Gunn-"what an ass"; Theodore Roethke-"phoney"; W. D. Snodgrass—"dopy kid-mad sod"; Donald Davie—"tosh"; Geoffrey Grigson—"rotten"; Ted Hughes—"no good at all. Not at all. Not a single solitary bit of good"; Robert Lowell—"never looked like being a single iota of good in all his born days. Lord Hairy's Arsehole. Gibber gibber." The graceless denunciations far outnumber the pretty wisecracks, like Larkin's verdict on Greene: "Good old Graham, always the saham."

In 1978 he wrote to Robert Conquest: "We don't go to Test matches now, too many fucking niggers about." The letters to male friends like Conquest and Kingsley Amis are salted with terms like "wop," "coon," and "wog," just as they're salted with nursery ruderies like "bum," "piss," and "shit"; and in context the childishness of the words counts for a good deal more than their tiresome spraygun racism. Larkin's alternative Conservative manifesto ("Prison for strikers, Bring back the cat, Kick out the

niggers—How about that?") and his ditty addressed to HM the Queen ("After Healey's trading figures, After Wilson's squalid crew, and the rising tide of niggers—What a treat to look at you") have all the political heft of a preschooler showing off his hoard of dirty words to *épater* the aunties and get in with the big kids. No word was dirtier than "nigger," and Larkin used it extensively to his boys'-room cronies, for the usual boys'-room reasons.

To the many people who think that no art goes into art (it's just the spontaneous effusion of the personality), it has come as a shock to find that the Larkin of the letters was so much sillier and more mean-spirited than the eloquent and plaintive character whom they had met on such intimate terms in Larkin's poems. The sorrowing voice of England-on-the-slide turns out, in 1942, when he was an undergraduate at Oxford, to have been a sneaking admirer of the Third Reich: "men who can see the right must hold clear from the mass of writhing filth that threatens to engulf us all ... If there is any new life in the world today, it is in Germany . . . Germany has revolted back too far ... but I think they have many valuable new habits." The poet of doleful solitude for whom "Sexual intercourse began / In nineteen sixty-three / Which was rather late for me—" turns out to have been a good deal less deprived of female company than his poems suggest. It emerges from the letters that Larkin's solitude was precariously maintained by the old Don Juan trick of always keeping two, and sometimes three, women on, as it were, the go. When things got too intense with one, he found another to play off against her. In 1966 he wrote to Conquest: "Life is pretty grey up in Hull. Maeve wants to marry me, Monica wants to chuck me." This was how Larkin was usually placed—not quite married and not quite chucked, his precious loneliness threatened but intact.

The most off-putting letters are those that deal—in a tone of dismal giggliness—with Larkin's addiction to illustrated magazines depicting the corporal punishment of schoolgirls. With Robert Conquest, a fellow devotee, he scoured the Soho bookshops for suitably arousing stuff, and traded titles by mail. "Bamboo & Frolic are the tops, or rather the bottoms: do pass on any that have ceased to stimulate." "MINUIT CINQ has some good rears in it now and again, and I've taken out 12 months' sub." "I got the pictures—whacko. I admired the painstaking realism of it—I mean, the teacher did really look like a teacher, & I greatly appreciated the school-like electric bell on the wall . . . "

But even these letters say only what the poems had told us all along: that life for Larkin was a sorry business, mitigated, at increasingly rare intervals,

by his gift for recasting it in verse. His poems are triumphant evidence that it is possible to make a silk purse from a sow's ear—and it was always our luck that we could read Larkin's life without having to live it.

Now comes another sort of silk purse—Andrew Motion's measured, intricate, and quite beautifully written biography. When teaching English at Hull in the 1970s, Motion became a close friend-but not a crony-of Larkin's. A couple of months after they first met in 1977 (Larkin was fifty-five, Motion twenty-five), the subject described his biographer-to-be as "like a latterday Stephen Spender-very tall, sissy voice, gentlemanly, good-looking, all that. I quite like him." Motion is a poet (most recently, Love in a Life), novelist (Famous for the Creatures), critic (Edward Thomas), and biographer (The Lamberts); he is also an executor of the Larkin literary estate. Thirty years younger, well to the left of Larkin in politics and far too modernist a poet for Larkin's taste, Motion is an ideal foil. He is close enough to write intimately of the man, and some of Larkin's best lines here were spoken to Motion in private, and in a voice he never allowed his interviewers to hear. Yet he is sufficiently distant to keep Larkin in sharp focus, and his book brilliantly amalgamates the warmth and understanding of the good friend with the necessary cold reckoning of posterity.

Larkin always wanted life both ways—fame and obscurity, sex and solitude—and his chronically ambivalent personality doesn't easily fit the sequential requirements of conventional narrative. There was precious little and then... and then in his life; an inordinate amount of despite... and however. Motion solves this problem by approaching his subject much as an Empsonian critic might approach a particularly dense and ambiguous poem: he uncovers the paradoxes and contradictions in Larkin's life, cherishing its contrariety. Doing justice to Larkin's doubleness leads Motion to a style of very nearly continuous antithesis. So, on Larkin's engagement to Ruth Bowman (in 1948), Motion writes:

In two minds himself, he would keep his mother and fiancée in two minds as well. By promising his life to both of them, he hoped he might be able to keep it for himself.

The twin-bladed eloquence of that phrasing is typical of the book—and as Motion teases out this life of unhappy evasions and denials, he proves himself to be a wonderfully subtle and psychologically acute writer in his own right.

The biggest paradox uncovered by Motion is one that no reader of Larkin's poems could possibly have suspected: that the author of "They fuck you up, your mum and dad ... " was quite such a chip off the old block. Sydney Larkin, the Coventry borough treasurer, was eerily like the Hull University librarian—a forbiddingly antisocial man, with a well-developed sense of humor; a compulsive flirt who pressed his advances on his female office juniors; a great reader whose library in the early 1930s ran to Lawrence and Joyce. Sydney Larkin's greatest literary enthusiasm was Thomas Hardy—the presiding genius of his son's poems. Politically, he was on the extreme right wing: probably a member of the British Nazi organization the Link, he certainly decorated his city hall office with Nazi regalia and kept a statue of Hitler (it saluted at the press of a button) on the mantelpiece at home. At an age when most sons are in revolt against everything their fathers stand for, Philip Larkin was-lamely-supporting his father's pro-German views and—passionately—discovering his father's favorite author. "They fill you with the faults they had," says the poem—and not just faults in Larkin's case, but tastes, opinions, and attitudes that until now we had thought eccentrically personal to him.

Larkin's mother, Eva, was a snobbish, sick-headachey doormat; unintellectual, lacking in everyday vitality (or perhaps just saving it up, since she lived to be ninety-one), her twin driving forces appear to have been a belief in the Larkins' social superiority and a terror of thunderstorms. Growing up in the genteel gulag of his parents' marriage, Philip Larkin acquired his father's ideas, his mother's sense of hereditary specialness, and a pathological loathing of family life. It was a mixed glass of blessings; it at once guaranteed Larkin a lifetime of unhappiness and gave him his essential identity as a poet.

From early on, the ordinary pleasures of life made a habit of eluding him. At Oxford, he made passes at girls, but—

Every encounter was a disaster. Margaret Flannery, for instance, "edged towards him but made him giggle." Hilary Allen of St. Hilda's upset him by beating him at table tennis. Another girl, when he took her a bunch of flowers, alarmed him so much merely by opening the door to his knock that he was literally unable to speak to her; he thrust the flowers into her arms and fled. A fourth, when he tried to kiss her in a punt, told him, "I'd sooner not, thanks." After this string of defeats Larkin retired hurt, sheltering behind the antagonism which had protected him in the past. "Cunt and bugger Oxford women," he wrote to Sutton...

He had no better luck with boys. He tried to make love to a medical student at his college (St. John's), who reported to Motion:

"There were a few messy encounters between us, yes. Nothing much. Philip's sexuality was so obscured by his manner of approach and his general diffidence that frankly I would be surprised to hear that he ever had sex with anyone."

Larkin came closest to experiencing requited passion in the solitary pursuit of art—in listening to Count Basie and Sidney Bechet records, as in reading Lawrence, Yeats, Auden, Hardy. Even in his fifties, when he was having convoluted (and consummated) affairs with Monica Jones, Maeve Brennan, and Betty Mackereth, his preferred form of sexuality was masturbating alone over pictures in magazines.

One of the several themes of Motion's book is how cunningly Larkin came to contrive and sustain his lonely exclusion from the world. It was often hard work to stay so alone and so unsatisfied, but it was work for which Larkin had an extraordinary talent: from the time he left Oxford in 1943, to take up a magnificently obscure position in the urban district public library at Wellington in Shropshire, he always managed to give himself reason to grieve over being in the wrong place with the wrong person in the wrong era—and, conversely, to be haunted by the brilliant prospect of the counterlife he had thus sidestepped, the happiness he had ensured would not be his.

In "The Importance of Elsewhere," Larkin wrote: "Lonely in Ireland, since it was not home, / Strangeness made sense." The poem is dated June 1955—three months after Larkin left Belfast (where he was an assistant librarian at Queen's University) to take up the job in Hull, where he would spend his remaining thirty years. The last line goes: "Here [in England] no elsewhere underwrites my existence."

This wasn't strictly true. His poems are possessed by the idea of elsewhere. Their disappointment with the here-and-now is a rankling home-sickness compounded with amnesia: there's no telling where home was, precisely, but it is not here. Again and again, they point to the other country of the past, that misty elsewhere in which things were done differently, and better.

In Ulster, Larkin's true-blue brand of Toryism led him to become a Loyalist, and while there he wrote a curious poem, "The March Past," about an Apprentice Boys' parade. This annual show of Protestant force rouses in him:

... a blind
Astonishing remorse for things now ended
That of themselves were also rich and splendid
(But unsupported broke, and were not mended)

His nostalgia is couched in terms so inexplicit that these lines might summon almost anything, from William of Orange trouncing Catholics at the Battle of the Boyne to a mild repining for the glories of country-house life in the heyday of the Anglo-Irish Ascendancy. The essential logic seems to be that things were rich and splendid *because* they are now ended—a thought that often drove Larkin to crocodile tears. In "An Arundel Tomb" he wrote a tender hymn to marriage (an institution that he treated as hell on earth in most contexts), the couple in question having been safely dead for six centuries. In "Church Going," the church becomes an object of fond reverie only after Larkin has emptied it of people, stripped it of its roof and filled it with sheep and mildew in four stanzas of loving ruination.

When Larkin wants to make us feel warm about something, he turns it into history, gangster-style, at gunpoint. The sepia photo of grinning young men standing in line to enlist for service in the Flanders trenches ("MCMXIV") brings out an upwelling of sweet sorrow ("Never such innocence, / Never before or since . . . ") because we know the men are very shortly going to be blown to smithereens—as in "The Explosion" we weep for the miners, seen in the fullness of their lives just at the moment when the fatal tremor shakes the pithead village. As the young man opens his fist to show a clutch of unbroken larks' eggs, he's—history.

The mysterious and lovely ending to "The Whitsun Weddings" delivers more death on a grand scale. Motion reveals that the image of the "arrow shower / Sent out of sight" was prompted by a visit to the cinema (with Monica Jones) to see Laurence Olivier's *Henry V.* We're at Agincourt, the English archers have just loosed their bows, and a lot of French peasants are going to snuff it when the shower turns into rain at the other end of the battlefield. So the luckless honeymooners are in for it, their great day made poignant by the doom that is being planned for them in the poem's final lines.

One can't help being reminded of how Larkin felt about people like this when they were alive, with no immediate prospect of extinction. "I want to see them starving, / The so-called working class, / Their wages weekly

halving, / Their women stewing grass..." Dead, they became legitimate objects of sentimental feeling, material for Larkin's peculiar kind of taxidermal elegy.

His rare attempts to find something to celebrate in contemporary England tend to fall flat. The 1973 poem "Show Saturday," for instance, is like a big, crowded, somewhat overcolored canvas of a Suffolk horse fair by Sir Alfred Munnings; a craftsmanly re-creation of a county show, complete with farmers, craft and produce stalls, pony-club children, wrestlers, chainsaw contestants, and "mugfaced middle-aged wives / Glaring at jellies" ("wives" always get it in the neck in Larkin's work, like the "unspeakable wives" in "Toads," the "grim headscarved wives" in "Here" and the "bearded wife" in "The Dance"). The show is the backbone of rural England, the Tory party taking a well-earned day off, and Larkin here is in an uncharacteristically expansive mood as he shepherds the poem to an uplifting envoi:

Let [the show] stay hidden there like strength, below Sale bills and swindling; something people do, Not noticing how time's rolling smithy-smoke Shadows much greater gestures; something they share That breaks ancestrally each year into Regenerate union. Let it always be there.

It's a rhetorical collapse. Motion suggests that the passage is charged with a private double meaning: Larkin visited the Bellingham Show in Northumberland with Monica Jones, and the "regenerate union" is as much his and hers as it is that of the good people of England. Yet even if one glosses it with this in mind, the last sentence strikes a wan and hollow note. The show, with all its bright and noisy quiddity, simply won't perform the solemn function that Larkin assigns to it, and the end of the poem only serves to remind one of how very deeply affirmation goes against Larkin's grain.

What he excelled at was a kind of acrid self-cancellation. In the conduct of his life, whenever he made an emotional move, he as quickly rescinded it. Motion's account of why Larkin began an affair with his secretary, Betty Mackereth, in 1975, shortly after Maeve Brennan, a library junior, had at last consented to go to bed with him, is to the point here (and read as if these were characters in fiction, it is also extremely funny):

As Maeve finally yielded, her romantic elusiveness was destroyed and his attraction to her was bound to diminish. Furthermore, the sacrifice of her religious principles raised again the spectre of marriage—for Larkin at least, if not for Maeve herself. He felt that he had set in train a series of obligations which were likely to lead to the altar. There were other kinds of frustration as well. Because he and Maeve went to bed—even in their new, revitalized relationship—only on "very rare and isolated occasions," Larkin's sexual appetite was stirred but unsatisfied. By turning to Betty he was therefore taking for himself while giving of himself—not only gaining his pleasure but securing his independence. Betty reactivated the dramatic struggle between life and work on which his personality had always depended.

One can watch Larkin going through the same canny hoopla in his letters: a warm and appreciative letter to X is followed, often on the same day, by a warm and appreciative letter to Y in jeering dispraise of X, and so on. Bad faith was a form of good faith: it meant that Larkin was still keeping his options open. As he wrote in "To My Wife" (1952), "Choice of you shuts up that peacock-fan / The future was . . ." Even as the fan faded from peacock to moulted starling, Larkin set great store by refusing to close it.

Something very similar happens in the work. From early on, the shit-and-piss talk with which Larkin regaled the boys in his letters began to enter the poems as the language of life, nasty, brutish, and four-lettered, to be set against the solemn Tennysonian idiom of art. In many of his best poems there is an exquisitely delicate balance between an interior voice, thinking aloud in the rarefied silence of the lamplit study, and the demotic voices—rude, inconsequential—of the street outside. Art is pitched head-on against life, and there is the teasing possibility in all these poems that art may lose—that the poem may become swamped in chatter, or scatology. When "The Whitsun Weddings" was about to be broadcast on the BBC in 1959, Larkin warned the radio reader:

Success or failure of the poem depends on whether it gets off the ground on the last two lines. It is asking a lot of a reader, I know, to achieve a climax in so small a compass, but unless this image succeeds with the listener I am afraid the poem will seem no more than pedestrian.

The narrowness of the triumph—the against-the-odds transcendence of art over life in that last-minute swoop—made the poem. Larkin here was playing a dangerous game brilliantly.

By the time his last collection, *High Windows*, was published in 1974, it had ceased to be a game. The poems had turned into battles—between a life that was increasingly frightening and disgusting and an art that was increasingly fine-spun and febrile. One after another, the poems start in low demotic—the language of intolerable life: "When I see a couple of kids / And guess he's fucking her and she's / Taking pills or wearing a diaphragm ..."; "What do they think has happened, the old fools, / To make them like this?"; "Jan van Hogspeuw staggers to the door / And pisses at the dark ..."; "They fuck you up, your mum and dad"; "Groping back to bed after a piss ..."; "Sexual intercourse began / In nineteen sixty-three"; "My wife and I have asked a crowd of craps / To come and waste their time and ours: perhaps / You'd care to join us? In a pig's arse, friend ..." From these desperate and squalid beginnings, the poems climb, against all likelihood, to heights like the tragic serenity attained at the end of "High Windows" (which begins, "When I see a couple of kids ..."):

Rather than words comes the thought of high windows; The sun-comprehending glass, And beyond it, the deep blue air, that shows Nothing, and is nowhere, and is endless.

Poems don't get much closer to miracles than that.

Andrew Motion, however, has some unsettling news about "High Windows." Larkin finished the poem in February 1967, working from a draft he had written in the spring of 1965. The draft ending ran:

Rather than words comes the thought of high windows The sun pouring through plain glass And beyond them deep blue air that shows Nothing, and nowhere, and is endless

and fucking piss.

The three words jeer desolately at the lines immediately above them on the page. Larkin—horse shit. Gibber gibber. His later work bears the message that poetry can be made out of a sour and unsatisfied life, but it comes with the self-lacerating caveat that no poetry is so secure that it can escape the suspicion of being a rhetorical trick, a phony prettying-up of the life it purports to transfigure. In this tormented mistrust of his own art, at least, Larkin was an exemplary modernist.

After his death, two women each believed that the poem "When first we faced, and touching showed . . . " was meant for her alone, and one of them, Maeve Brennan (who worked with Larkin for thirty years and whose affair with him lasted for seventeen), said to Motion, "I wonder whether I really knew him at all. He had feet of clay, didn't he? Huge feet of clay." The author of *The Less Deceived* maintained his sacred privacy behind a fence of interlocking betrayals and evasions—and it was no wonder that he came to fear that the person most deceived by these stratagems had been himself.

The solitude that he spent a lifetime dodging and lying to keep intact was always solitude for art's sake—time "repaid / Under a lamp, hearing the noise of wind, / And looking out to see the moon thinned / To an air-sharpened blade." For the bargain to work, there had to be an unfinished poem under that lamp; but after the publication of *High Windows*, the desk was nearly always empty, and the poems that did occasionally appear there were rarely among Larkin's best. The strikes and counterstrikes of life and art in *High Windows* had taken Larkin to the brink of paralyzed silence. Out of this impasse came one magnificent poem—"Aubade," begun in 1974 and finished in 1977.

An aubade (dawn serenade) is an early morning poem in which the writer parts with his mistress after a last night of love. Larkin's 4 a.m. aubade is a desperate and hungover leavetaking from life and art.

... this is what we fear—no sight, no sound, No touch or taste or smell, nothing to think with, Nothing to love or link with, The anaesthetic from which none come round.

The poem makes plain that, more than almost anyone alive, Larkin knew what being dead was like. It was in writing that he was able to think and link, and death presented itself to him as a kind of eternity of writer's block, a state of unbeing with which Larkin had long been miserably familiar.

Most things never happen: this one will,
And realisation of it rages out
In furnace-fear when we are caught without
People or drink. Courage is no good:
It means not scaring others. Being brave
Lets no one off the grave.
Death is no different whined at than withstood.

In a letter to Barbara Pym, Larkin described "Aubade" as "The death-throes of a talent," and though the phrase is meant to come across as mournful-jocular, Larkin in his Eeyore mode, it tells the exact truth about what the poem accomplishes.

Larkin was always scared that the bargain he had made was a bad one. As early as 1966, he was confessing to Monica Jones:

I feel I am landed on my 45th year as if washed up on a rock, not knowing how I got here or ever had a chance of being anywhere else . . . Of course my external surroundings have changed, but inside I've been the same, trying to hold everything off in order to "write." Anyone wd think I was Tolstoy, the value I put on it. It hasn't amounted to much. I mean, I know I've been successful in that I've made my name & got a medal & so on, but it's a very small achievement to set against all the rest.

Fifteen years later, or thereabouts, he told Andrew Motion: "I used to believe that I should perfect the work and life could fuck itself. Now I'm not doing anything, all I've got is a fucked-up life." Both these verdicts cry out for contradiction, but the reader, balancing Larkin's poems with the letters and the life, is likely to find them wretchedly hard to gainsay.

New Republic, July 1993

I'm in Heaven

A YEARNING FOR ELSEWHERE, for a life beyond the one we're leading, is universal, but America is unique in giving the idea a specific geographical location in the West. Though the West is a slippery and mobile entity. When Miles Coverdale goes to Blithedale to try the "life of Paradise anew," he has only to ride a day's journey inland from the smoky city of Boston; Hawthorne crowds that day with topographical and meteorological incident, laying on a snowstorm and a tempest and depopulating the countryside, so that by nightfall Coverdale is able to reflect, "I felt that... we had transported ourselves a world-wide distance from the system of society that shackled us at breakfast-time." Blithedale, like its model, Brook Farm (in West Roxbury), may have a Massachusetts zip code, but it is located in spirit in that Far West of the American imagination where all utopias belong.

Now that California is elsewhere no longer, its problems as insistently *bere* as those of Roxbury itself, the utopian burden has been taken up by the states to the north, Oregon, Washington, Idaho, Montana, where population density is lighter and the impact of recession has been less severe. The Pacific Northwest, with its dramatic and metaphysical geography of mountains, forest, desert, ocean coast, and inland sea, is still, just, West in the old sense; a worthwhile, if not a worldwide, distance from breakfast-time society.

Recent arrivals, like J. Z. Knight, who channels the spirit of Ramtha, the hedonistic thirty-five-thousand-year-old sage from Atlantis ("I give you the strength to find joy") on her New Age ranch at Yelm, near Tacoma, have fitted easily into the region. Yelm is just another dot on a map already thickly dotted with the names of old utopian communities and schemes of salvation and revelation. Already Yelm has shown signs of following its predecessors down the dusty Brook Farm road of dissension and breakup.

Shirley MacLaine & Co. have packed their bags, the Knights are now divorced (after an extensive hearing on the daytime TV circuit), but Ms. Knight goes on filling the thousand-seat arena at Yelm for "dialogues" with her old man of the sea.

On the far side of Puget Sound from Tacoma lies Home, a turn-of-the-century utopia where "the kingdom of heaven," in secular lowercase, was to be established within the liberated self. Home was founded in 1896 on a wooded inlet-within-an-inlet named Joe's Bay on the Key Peninsula. It grew out of Glennis, a bankrupt utopia thirty miles south of Tacoma, and was based on a merry conglomeration of principles, including single-taxism, anticlericalism, anarchism, socialism, nudism, and free love. By the time people reached Home (most came from the East Coast, some from Europe), they were well to the west of conventional radical thought, and the place became a famous shelter for all sorts of very far-western doctrines. Several members were Koreshans, holding that the accepted view of the world was inside-out and that the earth was not a globe but the interior surface of a sphere.

The community produced a succession of newspapers and magazines. Its first regular publication was *Discontent: Mother of Progress*, in one of whose early issues the laureate of Home, C. L. Penhallow, set out the somewhat spongy ethos of the place in a poem titled "Joe's Bay"

I there a promise feel,

That in a future great,

I'll find a realm that's truly free

From taint of church or state.

Where each will live for all;

Where all will live for each;

And in an atmosphere of love,

They'll practice what they preach . . .

Interestingly, the poem itself is profoundly colored by the taint of church that it tries to disavow: the literary tradition of C. L. Penhallow can be found in its entirety in the Methodist hymnal. Home—proud of having no church in its precincts—was at heart a congregation of staunch non-conformists bent on turning the form of the Sunday School picnic into a permanent way of life.

Syndicated articles by—and homegrown articles about—Emma Goldman were a staple feature of *Discontent*, and when Goldman was on a swing of the western states in 1898, she was talked into making a last-minute

appearance at Home. (She came again in 1899.) The colonists were thrilled by her ("a jolly comrade, a good looking, sensible girl, who is even not averse to a little flirtation"), though she found them to be a bunch of happy cranks, too lightweight for her large designs on the world. They showed her their asparagus plots and their poems; then they went skinny-dipping. Goldman said Home was "the anarchist graveyard."

What now remains of Home are the swelling rhododendrons, the gnarled apple trees, and bird-haunted spaces between houses—the square one-acre plots, the perfect balance between communitarian neighborliness and deep country isolation. The last relic of communal ownership is the broad village beach, which no houses directly abut. Home slowly evolved from utopia into suburb, with the last of the founding anarchists surviving into the 1950s. Heaven on earth became a dormitory suburb of Tacoma that reminds the passerby of how utopian was the original suburban urge; it has turned out to be not so much the graveyard of anarchism as the nursery of the upper-middle-class planned community.

The Pacific Northwest continues to be a magnet—the strongest regional magnet in the country, I would guess—for hopefuls and new-lifers of every imaginable cast. It feels like the last surviving corner of the United States to be widely promoted, in Blithedale terms, as "the one green spot in the moral sand-waste of the world." People like to think of themselves as undergoing not mere relocation but full-blown resurrection here in the smoke- and cholesterol-free city of Seattle, where eternal life is thought to be a viable alternative to two packs a day. In the enlightened Northwest the recycling and saving of things (water, owls, paper bags, whales, urban neighborhoods) elides imperceptibly into the salvation of the self (the Self section in bookstores here is impressively larger than the History section). In this far-western stronghold of the second chance, second family, second career, it's easy to find yourself beset by the thought that you have somehow passed over and entered the afterlife.

Embraced by the Light is an unusual travel book by Betty J. Eadie, a Seattle woman, in which she describes her journey to heaven and what she saw there. It has been steadily climbing the New York Times nonfiction best-seller list for the last several weeks and its paperback rights were recently sold to Bantam Books for "more than \$1.5 million," according to a Times report, which also carried a brief interview with Bantam's president, Irwyn Applebaum, who praised the book for being "remarkably affecting and thorough."

It is a pity that Curtis Taylor, Mrs. Eadie's co-worker on the book (in this context, one hesitates to call him a ghost), has licked her prose into professional shape and given it a style of machine-turned simplesse which fails to do justice to the very personal nature of the experience reported here. For even before her death and brief ascension, Betty Eadie had a story worth telling—a western story, in the footloose, hardscrabble Raymond Carver mold; *Embraced by the Light* gives one the facts of it but not the voice it needs to come alive.

She was born in Nebraska in 1942, the seventh of ten children. Her mother was a Sioux Indian, her father a "Scotch-Irishman." She was four when her parents separated and she was posted off to a Catholic boarding school, where the nuns were brutal and she nearly died of whooping cough and double pneumonia ("I found myself in someone's arms. I looked up and saw a man with a beautiful white beard looking at me..."). She met kindlier treatment on the Rosebud Indian reservation in South Dakota, where she was cared for by Wesleyan Methodist missionaries. At fifteen, she quit school and married; at twenty-one, she was divorced with three children (a fourth had died in infancy).

Her second life began in Reno, Nevada, where she met Joe Eadie, an air force technician who was himself recently divorced. (These bones are very bare. What was she doing in Reno? Living on welfare, waiting on tables? Had she gone there to get her divorce? We're not told.) Joe and Betty married ("From the beginning it seemed almost too good to be true") and moved on to San Antonio, Texas, where the air force put him in training as a computer operator. Two more children were born in Texas. "We were living a dream come true . . . But still, I knew that something was missing."

She was twenty-five when Joe retired from the air force in 1967 and they and their five children, soon to be six, embarked on life Number 3.

[Joe's] training qualified him to begin a new career just about anywhere he wanted. All we had to decide was which side of the country we wanted to live on. We finally chose to move to the Pacific Northwest, where Joe would take a position at a large aerospace corporation. We felt that the climate would be a welcome contrast to the hot, dry weather we had become accustomed to in Texas...

Rosebud to Reno, Reno to San Antonio, San Antonio to Seattle... these mighty hops are comparable, where I come from, to flitting from London to Marrakesh, Paris to Moscow, or Rome to Damascus. Betty Eadie describes a lightly rooted, quintessentially western American life, in which

the great distances she travels help to underscore the enormous, empty gulfs between scenes of Dickensian deprivation and reports of dreams come true. Journeys themselves turn into a kind of narrative explanation: how do you get from servitude to bliss? You take the road from Rapid City to Reno, via Rock Springs and Salt Lake City. How do you signal a change in your life and perform a rite of passage? You hit I–10 West out of San Antonio. (I wish we knew more about that journey—the make and vintage of the car, if they drove; the behavior of the children, all under the age of ten; the motels stopped at; the flat tire in New Mexico—and would be sorry to discover that it was made by plane, tickets courtesy of Boeing.)

It seems inevitable that such a life should have come to rest in Seattle, from where there is nowhere farther west to go, in the hilly, arboreal suburb of White Center, where several thousand Boeing workers live within spitting distance of the aircraft plant. White Center's undulating avenues, lined with shingled houses set on tidy plots, with Pacific rain clouds marching overhead, must have seemed a world and more away from the miseries of Betty Eadie's childhood on the edge of the Badlands. Settled in Seattle, she took home-study courses to make up for her lost years of high school—tough going for a mother of six, turning thirty.

In November 1973, when she was thirty-one, Mrs. Eadie had a partial hysterectomy in a Seattle hospital. Sometime during the night that followed, she died and then began her longest journey yet, to that undiscovered country from whose bourn no traveler ordinarily returns.

I felt a terrible sinking sensation, like the very last drops of blood were being drained from me. I heard a soft buzzing sound in my head and continued to sink until I felt my body become still and lifeless.

Then I felt a surge of energy. It was almost as if I felt a pop or release inside me, and my spirit was suddenly drawn out through my chest and pulled upward, as if by a giant magnet. My first impression was that I was free. There was nothing unnatural about the experience. I was above the bed, hovering near the ceiling . . .

After a short surveillance of her own dead body, she was off on a rapid power glide ("I was only vaguely aware of trees rushing below me") to her home suburb, where she saw her husband "sitting in his favorite armchair reading the newspaper" and two of her children engaging in a pillow fight. She flew, or was flown (the pleasurable passivity of postmortal travel is given repeated emphasis here), back to her hospital room, from where she made a nonstop supersonic ascent into heaven. Mahomet Public

It was a night flight. The noise on takeoff ("a deep rumbling, rushing sound") was terrific, but quickly diminished as altitude was gained. Mrs. Eadie was made to feel luxuriously comfortable:

I was in a reclining position, moving feet first, head slightly raised. The speed became so incredible that I felt that light years could not measure it. But the peace and tranquility also increased, and I felt that I could have stayed in this wonderful state forever...

She entered heaven through a dark tunnel with a brilliant light at its end. At the celestial terminal, Christ was waiting for her. While admiring his magnificent halo (gold paling to incandescent white), Mrs. Eadie noticed that she had acquired a halo of her own, though hers was of much humbler wattage.

In an understandably breathless sequence, she describes how Christ gave her a crash course in universal cosmology and the meaning of life. ("As more questions bubbled out of me, I became aware of his sense of humor. Almost laughing, he suggested that I slow down . . . ") Under divine tutelage, the answers to all her questions come whizzing at her, as if by magic.

The word "omniscient" had never been more meaningful to me. Knowledge permeated me. In a sense it *became* me, and I was amazed at my ability to comprehend the mysteries of the universe simply by reflecting on them.

She comes into possession of a teleology that owes something to Plato and more to Emerson (an ever-present influence on American religious thought, from Mrs. Eddy to Mrs. Eadie). Christ explains the relation between heaven and earth in a nicely up-to-date simile:

I was told by the Savior that the spirit creation could be compared to one of our photographic prints; the spirit creation would be like a sharp, brilliant print, and the earth would be like its dark negative.

Here I do wonder if perhaps Mrs. Eadie hasn't got the analogy the wrong way around; the idea that heaven is a print made from the negative of earth rings with a truth that I cannot believe she quite intends.

In her state of omniscience, the whole of human history is unfolded before her: she watches as the world is created and "our spiritual brothers and sisters" take their turns at incarnation. Every child born is a spiritual being, dispatched to earth for a divine purpose. (*Roe v. Wade* puts all heaven in a rage.) She witnesses a sort of living-hologram cavalcade of great events; significantly, she is particularly interested in seeing the settlement of the West.

I distinctly remember watching the American pioneers crossing the continent and rejoicing as they endured their difficult tasks and completed their missions. I knew that only those who needed that experience were placed there.

Though Mrs. Eadie's descriptions of her ascension and her interview with Christ may tax the reader's credulity, what follows is in a more comfortable and familiar genre. On a guided tour of the world above, she proves herself to be a seasoned and unflappable traveler, with an eye for heavenly architecture ("Buildings are perfect there"; they have translucent walls of "very thin marble"), fashion ("soft pastel gowns"), and the wonders of nature. She is tactfully curious about politics and industry. She visits a factory where a strange fabric ("like a mixture of spun glass and spun sugar") is manufactured on handlooms, and stops at the celestial equivalent of the Pentagon, from where warrior angels ("giant men, very muscularly built, with a wonderful countenance about them") are sent out on covert operations against the legions of Satan.

Her tone here is matter-of-fact to the point of being blasé. She has knocked about the enormous and variegated spaces of the West, has lived in Nebraska, South Dakota, Nevada, Texas, and Washington; heaven presents itself as one more state on her life's itinerary. (A double meaning lurks in her discovery that "When we 'die' . . . we experience nothing more than a transition to another state.") Nor is it surprising that she seems to be so at home there, for heaven, as it turns out, is much like western Washington. Any Seattle resident would feel at ease in this landscape of "mountains, spectacular valleys, and rivers in the distance," where the grass is "crisp, cool, and brilliant green." The river that flows through the garden at heaven's center is "fed by a large cascading waterfall of the purest water . . . A melody of majestic beauty carried from the waterfall and filled the garden . . . " The Seattle resident will be put in mind of Snoqualmie Falls on the western flank of the Cascades and a favorite Sunday-brunch destination (these are the falls that used to figure in the *Twin Peaks* credit titles).

Heaven, like Seattle, is in the forefront of advanced information technology. Besides the quaint handloom weavers (themselves well represented in western Washington), there are computer geeks in the form of angels who

enjoy creating devices that are helpful to others—both here and there. I saw a large machine, similar to a computer, but much more powerful. The people working on this too were pleased to show me their work.

Mrs. Eadie is given a taste of what the geeks are up to when she is taken to "a large room similar to a library":

It seemed to be a repository of knowledge, but I couldn't see any books. Then I noticed ideas coming into my mind, knowledge filling me on subjects that I had not thought about for some time—or in some cases not at all. Then I realized that this was a library of the mind. By simply reflecting on a topic . . . all knowledge came to me.

This sounds much like a system now under development at Bill Gates's Microsoft Corporation, where it goes under the code name Cairo; Microsoft's sublunary version, however, running a generation or two behind the heavenly model, will still require the user to be seated at a terminal.

As Mrs. Eadie travels through heaven ("I could do whatever I wanted, go wherever I desired, go fast—incredibly fast—or go slow. I loved the freedom"), her book grows to resemble one of the guides for prospective immigrants to the Pacific Northwest that were put out by the railroad companies between about 1880 and 1930. There is the same boosting of landscape and lifestyle, the same chatty and informal peeking at the major industries in which the immigrant is likely to find work. The authors of the railroad guides habitually reached for the language of supernatural revelation to convey the marvels of the region: "Picture your own ideal of a place to live on this earth . . . On the horizon of the Pacific Northwest men with vision read, in letters of fire, a single word—Opportunity" (from *The Land of Opportunity Now*, 1924). Or as Mrs. Eadie says of heaven: "Plans, paths, and truths await us there . . . " All aboard!

Embraced by the Light is a western production in every sense. Gold Leaf Press of Placerville, California, was set up by a Sundance, Utah, businessman for the express purpose of publishing Mrs. Eadie, and the main bulk of the book's sales have been in the Far West—in Washington, Oregon, Idaho, Utah, and California. (Some 590,000 copies are in print; about half that number have been sold so far.) It has been a triumph of regional word-of-mouth, with no reviews to speak of and with the powerful Christian bookstores handling the book gingerly or not at all. Mrs. Eadie has

taken to the road, drawing large crowds in small towns, and the book has been promoted on backcountry radio stations. It has been walking on winged feet from the chain bookstores in the malls.

As I write, Mrs. Eadie has just shouldered past Bill Moyers on the *Times* list and is now within reach of Rush Limbaugh. Yet the disconcerting rise and rise of *Embraced by the Light* cannot simply be put down to the novelty of the adventure. Mrs. Eadie is by no means the Columbus or Marco Polo of the afterlife: accounts of postmortem flights to Elysium are such standard stock items in New Age bookstores (which themselves lean to distant-travel names like Quest and Odyssey) that they are known wearily in the trade as "ascension material."

It's the homely and well-trodden aspect of the book that distinguishes it—the six children at age thirty, the rootless pilgrimaging across the states, the succession of fresh starts. The Taylor–Eadie prose style, tepid and banal, works to the book's advantage here. It's so unparticular that this life might belong to almost anyone who's trailed a string of kids around a supermarket in an unfamiliar town.

On her zigzag trek from Nebraska to Seattle, Betty Eadie covered what still remains of the crumbling Manifest Destiny trail. Now—and for a largely western audience—she brings back a report on a territory of unlimited travel across vast spaces, with romantic scenery, fertile soil, and full employment . . . that old story of the Far West which has always really been a tale of the hereafter. It's in the dictionary: "Go west . . . a. to be lost or destroyed irrevocably, b. to die."

New Republic, August 1993

Mississippi Water

FLYING TO MINNEAPOLIS from the West, you see it as a theological problem.

The great flat farms of Minnesota are laid out in a ruled grid, as empty of surprises as a sheet of graph paper. Every graveled path, every ditch, has been projected along the latitude and longitude lines of the township-and-range survey system. The farms are square, the fields are square, the houses are square; if you could pluck their roofs off from over people's heads, you'd see the families sitting at square tables in the dead center of square rooms. Nature has been stripped, shaven, drilled, punished, and repressed in this right-angled, right-thinking Lutheran country. It makes you ache for the sight of a rebellious curve or the irregular, dappled color of a field where a careless farmer has allowed his corn and soybeans to cohabit.

But there are no careless farmers on this flight path. The landscape is open to your inspection—and to God's—as an enormous advertisement for the awful rectitude of the people. There are no funny goings-on down here, it says; we are plain upright folk, fit candidates for heaven.

Then the river enters the picture—a broad serpentine shadow that sprawls unconformably across the checkerboard. Deviously winding, riddled with black sloughs and green cigar-shaped islands, the Mississippi looks as if it had been put here to teach the God-fearing Midwest a lesson about stubborn and unregenerate nature. Like John Calvin's infamous bad temper, it presents itself as the wild beast in the heart of the heartland.

When people who live on the river attribute a gender to the Mississippi, they do so without whimsy, and nearly always they give it their own sex. "You better respect the river, or he'll do you in," growls the lockmaster; "She's mean—she's had a lot of people from around here," says the waitress

at the lunch counter. When Eliot wrote that the river is within us (as the sea is all about us), he was nailing something true in an everyday way about the Mississippi. People do see its muddy turmoil as a bodying-forth of their own turbulent inner selves. When they boast to strangers about their river's wantonness, its appetite for trouble and destruction, its floods and drownings, there's a note in their voices that says *I have it in me to do that . . . I know how it feels*.

When I went down the Mississippi in 1979, I met a woman, born in 1880, who'd grown up in the town of Milliken's Bend, a name I couldn't place. "Nothing left of the town now," Miss Lily said; "the river took it." She spoke as if it were common knowledge that you had to feed whole towns to the Mississippi every so often in order to placate it. Within her memory, the river had sluiced many places clean off the map, as it had taken chunks of Illinois and moved them over to Missouri and left busy grain ports stranded high and dry in the fields, miles distant from its new channel. It had drowned a score of Miss Lily's friends and relations. She began to tick them off on her fingers for me, but lost count. She grinned—new teeth in an old alligator face. "In a boat, huh? Well, just you take care," she said, adding me with obvious relish to the roll call of the dead.

Since that trip I've often found myself back on the river in dreams of helplessness and foreboding. My subconscious is addicted to the lower reaches—the miles of open swamp and canebrake, the water like diarrhea, the current moving fast in greasy swirls and boils, the dead trees circling around the lips of whirlpools. There's a skiff in the dream but the motor's toast, and the boat slews on a boil like a braked car on ice. Leeches, mosquitoes, cottonmouth snakes, and catfish are grubbing for carrion. The boat leaks, the water's up to my knees and rising higher. This is not so much a dream as a somewhat faded and diminished memory, for the real river, in all its horrible splendor, is more than a match for one's nastiest fantasies. There are parts of the Mississippi so deathly and cloacal that they get censored even in bad dreams.

When the river climbed out of its banks last summer, I felt a surge of vicarious pride as it spread like a stain over Iowa and Illinois and tangled with the swollen Missouri in the suburbs of St. Charles and St. Louis. The TV pictures showed a power of darkness on the loose as the Mississippi rolled a trailer house over in its current, squashed someone's summer cottage flat against the hull of a moored barge, liberated caskets from a graveyard, filled a restaurant kitchen with a moving tide of sludge, got up streets and inside marriages.

Ignoring the pleas of hypocrite TV reporters for "gawkers" to stay home and not interfere with the troops and the sandbaggers, I flew to Minneapolis, rented a car, and followed the river downstream for a thousand miles.

After nearly fourteen years away, it was difficult to get my bearings. So many landmarks had gone. Where sandbars should have been, there were none. All that was left of the islands I remembered were some sprigs of green shivering in the current. There should have been a towboat coming around the bend, pushing a fleet of shovel-fronted barges, but there were no boats of any kind.

The sunlit water was a yellowish purple, the color of a ripe bruise, and the water sounded like fire as it crackled through a nearby wood. At my feet, a shoal of minnows in the long grass exploded when a bass charged at them from behind a clump of drowned buttercups.

This was below Red Wing, Minnesota, nearly three hundred miles up from the real trouble, which didn't begin until Dubuque; yet even this far upstream, in the infancy of the floods, the river had annexed farms, killed the grain trade, ruined the tourist industry. I watched as the river wrestled a navigation buoy underwater. It was a big red can, about five feet in diameter, and no easy pushover; but the current laid it flat. Braids of turbulence, like thick rope, trailed from it for thirty yards on its downstream side and a V-shaped bow wave was breaking whitely from its leading edge. Inch by inch, this barrel full of air sank into the Mississippi. The water closed smoothly over it, and for a minute at least the buoy was gone. Then it came splashing back on station, riding upright for a few seconds before the river seized it again, shook it from side to side, and dragged it under. The struggles of the buoy, as it weaved and shuddered on its mooring chain, gave one a powerful idea of what this current might do to something less resilient, like a grain elevator or a house.

The upper Mississippi is supposed to be a staircase of artificial lakes, with only a trickle of current in the channel. Between St. Paul, Minnesota, and Alton, Illinois, just upstream of St. Louis, there are twenty-six locks-and-dams, built by the U.S. Army Corps of Engineers in the late 1930s and early '40s. In normal times, these enormous military installations, each with a lock chamber big enough to hold a multistorey apartment block, lord it over the river like castles. Every twenty-five or thirty miles, you see them looming in the distance, blocky and turreted. This river has been conquered, they assert; it's under army control.

Not anymore. At Lock and Dam 7, above La Crosse, Wisconsin, the

great roller gates of the dam had been cranked clear of the water and the Mississippi was pouring unhindered through the piles. "It's just cruising right on by," the lockmaster said. "It's what we call open river right now. The gates are as high as they can go. It's been like that since March."

Below, where the dam should have been, the river seethed in a noisy shambles of steep pyramidical waves and quaking scud. One had to shout to be heard over its hiss and rumble.

"We had a tow through here yesterday," the lockmaster yelled. "He had a load of empties—he'd been rounding up loose barges above Dubuque. We probably won't see another all week."

Meanwhile, he gardened. Mr. Jessesski ran the only lock on the river whose gaunt lines were softened by a flower show. Using railroad ties, he'd built a row of stout three-tier grandstands along the side of the basin and packed them with regular columns of marigolds, snapdragons, phlox, and scabiosa. While the Mississippi swirled at his feet and thundered in his ears, Mr. Jessesski kept his private patch of nature in good military order. Reviewing a line of saluting marigolds, he found a weed in the ranks and threw it to the flood.

"How fast is the river moving?"

"Normally this time of year you'd expect anything between 20,000 and 30,000 cubic feet a second. Latest figure we have, it's coming through here at about 130,900 cubic feet a second."

About? I looked at the drifting chaos of the Mississippi and failed to make it fit that nigglingly precise figure.

"How on earth do they come up with a number like that?"

Simple, said the lockmaster. Take an exact sectional profile of the river at a given point. Divide it into, say, thirty vertical segments. Into each segment, dangle a Price current meter, then read off the speed of the current at one-fifth of the total depth and again at four-fifths of the total depth. Multiply this by that, cube it, square it—and you get 130,900.

The flood was breeding its own obsessive numerology. The more nature got out of control, the more people measured it. Across the enormous drainage area of the Mississippi and Missouri rivers, people were stationed with rain gauges, rulers, hygrometers, knotmeters, probes. In the cities of St. Paul, Rock Island, and St. Louis, people fed the data into computers. Each day at noon, the Corps of Engineers faxed out a new sheet of numbers. The sheet would tell you—among many other things—that the Mississippi was due to crest at Hannibal, Missouri, on Thursday at 1:30 p.m., at a height of 31.4 feet.

Each day, these sheets were posted in city halls and riverside bars. They

were treated exactly as opinion polls are treated in a neck-and-neck political campaign. Spin doctors interpreted them. Strategies were changed by them. "Thirty-one-point-four!" people said, and the number alone would excite fear or relief.

At noon the next day, the number would be revised, by a foot or more—and it wouldn't be Thursday, only Saturday or Tuesday. Yet people still clung to it. "Twenty-nine-point-six!" they said, as if the prediction was itself a victory worth celebrating.

I asked Terry Jessesski how much advance warning he'd been given. Had he known about the flood for ages before it arrived?

"They didn't forecast it until it happened," he said.

In March the river was high with normal spring runoff after the melting of the northern snows. One by one, the dams were raised—as usual—to give the Mississippi a free run to the Gulf of Mexico. Then the rain began.

"It just kept on coming and coming. It was unreal. In April, they were saying it would be all over by May. In May, things were getting real tight, but they said we'd be dry by June. And all through June, it rained and rained. And rained."

As we spoke, five inches of rain had just been forecast for Nebraska; two or more in South Dakota; it was due to rain tomorrow in Minnesota, Wisconsin, Iowa, Illinois, and Missouri. A *disaster* is a disorder in the heavens: *dis* + *astrum*, an unfavorable aspect of the stars or planets. Few "disasters" are really *disasters*, but this one was—in 1993, the heavens were all to hell.

With each new town, the level of the river grew noticeably higher, the boils of current more pronounced. As the flood rose, the towns got emptier. "It's not this bad in *January*," said the waitress in Lansing, Iowa. There were no cars, no tourists, no fishermen, no houseboaters; shops were closed, roads were closed, and in the cafe where I remembered a merry breakfast crowd on my last visit, four Iowa ancients in plastic baseball caps sat silently in line, staring out at the Mississippi like an audience at a movie. The river unscrolled like a movie: in the middle distance, an uprooted tree sailed slowly past from left to right. It was followed by an oil drum, a tractor-trailer wheel, another tree. The ancients watched closely, awaiting the next twist in the plot—a vagrant skiff, an outhouse, an interesting box. For half an hour I watched them watch the river, hoping to see them scramble for the boat that was pulled up on the street above the landing, but I and they were out of luck. Something over 235,620,000 cubic feet of Mississippi water slid past the window, bearing nothing worth the bother of salvaging it.

I crossed to the Wisconsin side, for I had a visit to make. Skirting the water in the streets of Prairie du Chien, the tangled hoses, the litter of chattering two-stroke pump engines that were trying to get the river out of people's basements and back into the river again, I found Kaber's Supper Club. It used to be several blocks uptown; now it was right on the Mississippi. I asked the barman if Rex Kaber was around.

"That's my dad," the barman said. "Yes, he's here—"

The Kabers had been kind to me in '79. I'd stayed in their spare room and sat up late with Rex, talking and drinking. On Sunday, after Mass and a memorable sermon by the asperitous parish priest, I'd taken the Kaber family (though surely not this almost-middle-aged son?) on a river picnic on my boat.

"Dad's not that well right now," the barman said.

When Rex appeared, he was shuffling slowly through the gloom at the end of the bar, pushing a silver cylinder of oxygen on a trolley.

"Me and my shadow," he said with a blanched smile. Lengths of plastic tubing were taped to his nose and upper lip. He put his hand on my shoulder, but the effort that it cost him was painful to see.

We were much the same age. Rex was skeptical, funny, boundlessly inquisitive. He read a lot and thought a lot. In this small river town he was thought of as dangerously intellectual; a subversive.

"What happened, Rex? You never smoked—"

"Got it secondhand," he said. He spoke in short puffs now; words were expensive. "All those years—tending bar."

I had spent the day watching the river grow steadily bigger and stronger, hugely outstripping my memory of it, and this somehow made Rex's emphysema all the more shocking. He was in the grip of another current, eddying away on the stream but struggling to get back. I wanted to talk about him, the floods, Prairie du Chien; he wanted to talk about my writing—not its style or subject but the business nuts and bolts of it.

"Agent—percentage?" "An article like this—you get an advance?" "You go to them—or they come to you?" He leaned on his cylinder, nodding, full of interest, as I spun out the details for him. He was hungry for worldliness—for any distracting gossip one could bring him about tangibles like contracts, deals, dollars and cents. "You get translated—into Japanese?"

"I love. Talking. With you." Again he put his hand on my shoulder. "What I'd like. Sit down to dinner. Bottle of wine. Talk—"

"My turn to pay this time-"

He shook his head. "I tire so easy. Slightest thing."

The bar was beginning to fill with diners. Rex labored to construct a

maître d' smile to bestow on the guests; I watched it being hoisted into place, in sections. He turned back to me. "But Jo-Ann's *great*. You'll see her. She's *fantastic*. I'm so proud of her."

Thunder woke me—a series of grumbling explosions directly overhead that made the second-floor room shake and waver in its flimsy timber frame. It was still dark. I found the switch on the bedside lamp, but the lamp was dead. The sound of thunder gave way to that of rain on the parking lot outside, like gravel pouring from a long chute. I groped for the window frame, then watched bursts of sheet lightning flicker over the roofs of the darkened town. My watch said that it was 8:50.

Soaked to the skin by a ten-yard dash to the car, I drove around to the candlelit motel office. The woman at the desk took my key and checked her ledger by flashlight to make sure that I'd paid. "Come back and see us sometime," she said indifferently. "Have a nice day." No mention of the storm, the lightning, the power outage, the candles at midmorning. This was evidently how summer days usually began in Prairie du Chien in the year of the Deluge.

The roads were awash. A truck cruised slowly down U.S. 18 like a clipper ship with a bone in its teeth. On the car radio, a tiresomely upbeat, top-of-the-morning announcer was enjoying himself, reading out flash-flood warnings for Crawford, Grant, Clayton, and Allamakee counties. "Seek higher ground," he said, as I crossed the river back into Iowa and struck out south on a low-lying minor road that kept close company with the Mississippi. Having told everyone to run for the mountains, he then told them to head for the Free Sweet Corn Boil at Johnson Market. "Go on!" he urged. "Brave the rain! Take the kids! It's going to be a whole lot of fun!" If we were thinking of spending the day in Illinois, he said, we must be sure to dial a 1-800 number: "They'll tell you if your favorite tourist destination is underwater."

By 10 a.m. the rain was thinning and the sky took on the appearance of a wintry dawn. The Mississippi was like an enormous sheet of dirty gauze, spread flat across the landscape. It was now impossible to guess where its banks might have been, and hard to tell where the river left off and the unflooded land began. Fields of short corn ("knee-high by the Fourth of July") brimmed like ponds, and as the Mississippi rose to meet them, there was a kind of fluid commingling between this river full of earth and this earth full of water.

I stopped for breakfast at a grocery store on a low hill, a mile or two

inland, and was shocked by the heat of the day as I stepped out of the car. It looked like November, but the temperature was over ninety degrees and the rain on my scalp was warm as sweat. The same four ancients, first seen in Lansing, or their first cousins, were seated at the breakfast counter.

From them I learned—slowly and with some difficulty—that

- (1) The floods were caused by paving. *Paving?* Parking lots. Malls. Condo blocks. Community colleges. People from the cities were covering the land with concrete and there was nowhere for the rain to go.
- (2) The water table was rising. It was now so close to the surface that crops were rotting from the roots up.
 - (3) Things were going to get worse. Much worse.

"You think it's bad now, you better come back next year. Then you'll see floods. I'm telling you. What we got now—that's nothing to what's coming. You wait till the year 2000. Where they've got cities now, there'll be just swamps then. Levees won't hold the river in, not with the water table where it's at—no way." He looked as if he was going to make damned certain that he stayed alive until the year 2000, if only for the sour pleasure of seeing his prophecy come true.

When I went back to the car, the rain had turned to steam. Visibility was down to less than half a mile. The river smoked, the bluffs were shrouded in hot fog. The road ran along the edge of the flood, which had recently dropped a little, exposing a margin, ten or twelve feet wide, of shiny black goo—a compound of rotting grass and cornstalks, drainwater, fertilizers, oil, and dead fish. The smell was of the sort that glows in the dark; a lighted match, tossed from the car window, would have made it go off with a bang.

The mayflies were doing well in it. A huge hatch was in progress, and the big clumsy flies pasted themselves against the windshield, hundreds at a time. The wipers made a crunching sound on the glass and were caked solid with bits of wing and thorax. The stink, the insects, and the bubbly, sewagey look of the uncovered ground were the result of a drop of just a few inches in the level of the river. When the Mississippi really went down, it would leave a margin of fetid slime miles wide on either side.

In 1979, an Iowa farmer, Harvey Schwartz, showed me the precious soil of his bottomlands between Davenport and Muscatine. He powdered it between his forefinger and thumb, and made me do the same. It was soft, brown, moist, and pungent—almost as rich in nutrients as dung itself.

"Taste it," he said.

I parked a few grains on the tip of my tongue.

"That's some of the richest soil in the entire world," Harvey said, as if the grains were caviar.

Now the river was only doing what rivers are supposed to do on their floodplains: enrich the soil with the long, slow work of regular flood, siltation, and decomposition, coating the fields with smelly glop. At present, all the talk was of how the Mississippi had "devastated" the land around it. Actually it was nourishing it, though with scant respect for the barns sunk to their eaves or the farmers' homes where the river was now in possession of the bedrooms on the second floor. When Governor Branstad of Iowa spoke on the radio of the tragedy that had befallen his state, with eight million acres of land underwater, he might have added that most of this land was being improved by the experience. When the flood finally went down, there would be a foot or more of fresh topsoil on the bottoms—a fine-sifted mulch in which the wheat would stand as thickly as the bristles on a brush.

At Le Claire, I saw a fisherman sitting in the picnic gazebo in the middle of a children's playground, and waded across to talk to him on his island. He'd brought sandwiches, Gatorade, and a transistor radio to while the day away. He watched his rod tip. His bait, a plump night crawler, had been cast far out; it lay between the slide and the swings.

"Ain't nothing doing," he said. "I don't know why. I think it's because the fish don't like the river going down. Beginning of the week, when it was coming up, the fishing was real good—right over the road there..." He pointed to where I'd parked the car.

"Catfish?"

"Big catfish. And perch. And crappies. It was good fishing." He reeled in. His worm hung in a limp U from the hook, looking stressed out by the heat and humidity. He took a fresh one from the can, threaded it past the barb, and flicked it out toward the jungle gym.

His radio, on the picnic table, was full of advice and instructions. Volunteer sandbaggers were being given assembly points. They were told to bring plenty of mosquito repellent and to swab down thoroughly afterwards. "Remember," the announcer said, "this is tough, hot, smelly work." For about seven seconds I toyed with the idea of becoming a volunteer sandbagger in Des Moines—a two-and-a-half-hour drive to the west—but the only thing that I could seriously imagine doing out in the open air was steaming asparagus in it.

As the Mississippi spilled untidily southwards, it added more and more new rivers to the flow. There were the Wisconsin, the Rock, the Iowa, the Des Moines, and—before the river reached St. Louis—the Illinois and the Missouri. There were Indian rivers: the Maquoketa, the Wapsipinicon, the Kickapoo. There were animal rivers: the Turkey, the Fox, the Bear, the Skunk, the Buffalo. There were the Apple and the Plum, the Cedar and the Root, and smaller rivers by the dozen and the score, all piling into the Mississippi—and every one of them in flood.

According to the Corps of Engineers and their Price current meters, the Mississippi was moving at a speed and volume of 130,900 cubic feet per second at La Crosse; 400,000 cubic feet per second at Rock Island; 1,000,000 cubic feet per second at St. Louis. Over the same stretch of river, the current was quickening from about 3 knots to about 10 knots.

The trouble with these figures is that they make it sound as if the Mississippi was traveling downstream with the concentrated energy of a train. But its actual motion was more like that of the contents of a washing machine. It spun and tumbled, doubling back in swirling eddies and countercurrents. The friction of the water against the river bottom put a brake on the stream, making it somersault over on itself like an ocean wave tripped by a shelving beach. At the surface, the friction between a fire-hose jet of deep, free-flowing water and the slow-moving shallows to the side generated a string of whirlpools, some big enough to swallow a small boat. Wherever one looked, the water was moving like smoke in coils and wreaths.

Just below the bridge at Davenport, I passed ten minutes watching a few thousand spent mayflies performing a sort of quadrille. I focused on a tiny scrap of the river's surface, about twenty feet square. Within this area, dead insects were drifting in every conceivable direction—upstream, downstream, across; describing lazy S's on the current; pirouetting like tops. Some shot past and were out of view almost as soon as spotted; others dawdled, lolling on columns of water that seemed fixed to the bottom. I narrowed the focus, settling on a single fly, one veined wing standing proud of the water like a windsurfer's sail. It would . . . but it didn't. It feinted, sashayed, zigzagged, confounding my predictions over every inch of the course.

From Davenport on down, cities began taking on water in earnest. Muscatine and Port Madison were in the river up to their middles. Their downtown shopping streets had become canals. Parking meters had turned into convenient mooring posts for the aluminum skiffs that served as gondolas in these strange new Venetian times. The boats moved silently. There was a ban on the use of outboards, whose wake might have toppled the sandbag walls, so people rowed and punted, as if they were doing it for the scenery and the exercise on this broiling Saturday afternoon. It's said that a change

is as good as a rest, and most of the flood victims were in a larky holiday mood.

"Start your own business! Be your own boss! Fax machines! Answering machines...," sang out one jolly ferryman over the water, as he paddled a cargo of office equipment to higher ground.

The bottom end of each town petered out into a semiotic playground of signifiers, now divorced from their referents and sticking out of the flood. Turn right for U.S. 61. Stop. Railroad Crossing. Business Loop. No Parking. No Left Turn. Straight Ahead for the Museum. One Way. Yield. Exit Only. Some of the signs had been knocked sideways by the current and leaned at forty-five-degree angles to the water. Others were completely submerged. The river ran placidly through the slough of messages from before the flood, making braids around every post.

All the shutterbugs in town were out with cameras, and the jumble of signs was everybody's favorite subject. People shot the signs wide-angle, like a crazy maze of fishing stakes. They got out zoom lenses and snapped Speed Limit 25 or West 92 brooding emptily over its own reflection, with an out-of-focus liquid sunset in the background. In private albums, as in the special souvenir editions of the local papers, pictures of the signs would become one of the two or three key images of the Great Flood.

Happy pictures, they show the river making monkeys of City Hall, the Highway Department, Burlington Northern, and the rest. They show authority wittily subverted by the water, which has robbed every imperious command of its meaning. They are beautiful—surefire candidates for the Camera Club annual exhibition. They catch something important, about which little was said at the time: the glee that people felt as the river came up and played this gigantic practical joke on their world.

In Fort Madison at dusk, with the mosquitoes beginning to sound like a string band, I was loitering at the edge of a flooded street, watching a line of sandbaggers build a wall around a threatened gas station. An elderly woman with a camera stood nearby, her Oxford shoes islanded. She was waving the bugs away with a handkerchief and smiling hugely. When she saw me notice her smile, she felt called on to explain it. "Well," she said, "everybody's got to look at the water, haven't they?"

On Sunday morning, wanting to catch a good sermon about Noah and the waters that prevailed exceedingly upon the earth, I stopped at the sinking town of Montrose and joined the congregation at the Church of the Nazarene. The piano plonking out the tune of "The Bee Eye Bee Ell Ee" (a hymn new to me) was no match for the crotchety rumble of the pumps outside. When the pastor stepped forward to give the address, he began rattling off texts like crossword clues. "John, Three-sixteen!"; "John, Ten-ten!"; "Romans, Six-twenty-three!" You were supposed to get them before he quoted them, but I was no good at this game, and I could hear the water rising. Certainly the chatter of the pumps appeared to be getting louder by the minute. "Hebrews, Ten-thirty-one!" This was all very well, but the Mississippi was at the door and Pastor Klinger had nothing to say about Noah, his Flood, or this one. I could see him grinding on about sin and redemption even as the river boiled around the knees of his business suit. I slid out of the pew, gained the car, and headed inland.

By Missouri, the thing looked like a war. Each tributary river ran higher and faster than the last. Big creosoted barns were pasted flat against trees, like stoved-in cardboard boxes. Lines of oddly foreshortened telephone poles led out to isolated farms that were sunk to their roofbeams. From a distance, they looked like bivouacs pitched on the water. Things were so bad in towns like La Grange that even the National Bank was in the river. U.S. 61, the main highway to the west of the Mississippi, led down a hill and ran slap into the river. At every turn, soldiers in battle fatigues and camouflaged armored cars manned roadblocks, lounged, smoked, and talked importantly into antique two-way radios. With the sodden fields, the National Guardsmen, and the pensioned-off military equipment, it looked as if one had stumbled into the making of a movie set in Vietnam, circa 1968.

The National Guard was there to deter looters and turn sightseers away. But the sightseers were locals—farm families, still dressed for church; shrunken grandpa figures in straw hats and oversized pickups—and the soldiers shrugged and let them through. Me, too. At one checkpoint, I pulled up and prepared to spin a story, but the sergeant in charge said only, "We're going to have to start charging admission soon."

The families formed a slow promenade in the heat, leaving their cars to walk out to the end of a graveled road that was now a pier. The sheet of water ahead, dotted here and there with roofs and treetops, stretched to the horizon, an inland sea. People said very little. There was some nervous joking among the adults, some roughhouse capers from the kids, but the prevailing atmosphere was that of the church that most of us had just left. We squinted at the flood in silence. We might have been at prayer.

Water not only finds its own level; it makes itself perfectly at home. The winding contour line of the edge of the flood had the natural authority of any coast. It looked so *right*. It wasn't the water that was in the wrong place, but the strange, angular things that poked impertinently out of it. Wherever the water impinged on the man-made—on a road, or a city parking lot—it described a sweet curve across a surface that one thought was flat. The flood redefined the land, and the dangerous thought came, unbidden, that the work of the flood was a spectacular improvement.

Was this why people were so quiet—because the water roused feelings that were better kept to oneself? I knew that if I said what I really thought, I'd be in trouble.

All the bodies were on the right-hand side of the road. They looked like cuddly toys from an infant's crib—dead opossums, raccoons, coyotes, chipmunks, fawns. They had all fled west to escape the rising river, and fleeing nature they'd been felled by technology in the form of cars and trucks.

On the whole, nature was doing well out of the flood. The fish were thriving, with even morose professional fishermen admitting to record hauls of carp and catfish. The birds that ate the fish, like herons and ducks, were everywhere, and people said they couldn't remember a time when so many birds were in residence on the river. The mosquitoes were in heaven, and the lower orders—bacteria like *E. coli* and tetanus—were enjoying a rare taste of freedom from the constraints of civilization, breeding by the billions in the stagnant swampy water on the fringes of the flood. For the wandering tribes of freshwater plankton (Gr. *planktos* = *drifting*) on whom the whole ecosystem of the Mississisppi depended, life had never been better than in the summer of '93.

The flood was making many humans happy too. Door-to-door insurance salesmen were working around the clock, selling dubious policies to frightened homeowners in low-lying areas. On the Chicago stock market, commodity traders were making a killing on wheat and soybean futures. In St. Louis, panhandlers were putting on their best clothes and representing themselves as charities collecting for flood victims.

It was a wonderful time for prophets.

On the car radio, Randall Terry, of Operation Rescue, the antiabortion outfit, was being interviewed by Terry Gross on NPR's *Fresh Air.* The floods in the Midwest were, he said, "The first Call. The first Blast of the Trumpet." There was a triumphant I-told-you-so squeak in his voice, and

his tone was that of the mad lounge-bar logician who can *prove* the moon landings never took place and Richard Nixon was a communist spy. We had, according to Mr. Terry, seen nothing yet. "God has a *hundred* hurricanes, a *hundred* droughts, a *hundred* floods . . . " and in His wrath over abortion, He would cast them at America one by one.

Ms. Gross pointed out that God's choice of the Midwest as the locus of His vengeance seemed a little unfair: had He not picked on the most God-fearing region in the whole United States? Why was He so punishing His own home team?

"When God judges a nation, innocent people suffer," Terry replied with frank relish. "Innocent people suffer—for the sins of the child-killers, and for the sins of the homosexuals..."

A few days later, CNN financed a poll which found that one in five Americans—the same percentage as had voted for Ross Perot in the presidential election—believed that the floods were God's judgment on the sins of the citizens.

At Louisiana, Missouri, that Sunday evening, a Free Supper for Flood Victims was advertised on the noticeboard of the Masonic Temple. The Masons' wives had been cooking all day, and the trestle tables in the temple basement were stacked with chicken wings, barbecue ribs, bowls of slaw and tuna salad, cookies, bran muffins, jugs of Kool-Aid, and bright red humpback turtles made of Jell-O. This feast was being scarfed up by six perspiring National Guardsmen, each attended by a Mason's wife looming with another dish.

I was barely inside the door before I was fending off an avalanche of ribs and wings. I explained I hadn't come to eat, but that I would like to meet a flood victim if any would be willing to talk to a stranger.

"There aren't too many flood victims here right now, but you *must* try these cookies—"

"Are you a vegetarian? We could make you up a special plate—"

I could see the Masons themselves were all men of impressive substance, whose most noticeable clothing items were their belts and suspenders. One man wore a particularly fine belt of strange devices which proclaimed him to be a member of the Ancient Arabic Order of Nobles of the Mystic Shrine—an organization with curiously lax security for a secret society.

"You have to be in the photograph," he said, and I was hustled into the group of waiting brethren. The picture was for a forthcoming issue of a Masonic magazine. In it, the Shriner and I have our arms around each oth-

er's shoulders; I'm grinning weakly and billed, I fear, as a visiting Knight Templar from London, England. The reason for the picture is that we have all been helping the flood victims.

When the photography was done, I asked the Shriner about the flood victims.

"Those people," he said. "Most of 'em, they just don't want to be helped." How many people had been washed out by the flood in Louisiana?

"Oh, not too many. Down in the flats . . . must be about thirty families, maybe?"

How were they coping?

"Oh, those people, they cope pretty good. They're used to it. They're the same people got flooded out in '73. They just move right back in. Hang out the carpets to dry, hose down the furniture, and they're back in there happy as clams."

"Are these people black?"

"Oh, no. Some of 'em are—it's pretty much of an even mixture down there in the flats. Between you, me, and the gatepost, most blacks in this town have got more sense than to live there. The smart ones all live up on the bluff, as far away from the river as they can get. And good luck to 'em!'

The Masons' wives began, reluctantly, to shroud the bowls of food with plastic wrap, while their husbands folded up the tables and the Guardsmen returned to their roadblock on the flats.

I went for a stroll in the dusk. The cabins of the flats-people were deep in the river. The current skirled through bedroom windows that had been smashed by floating railroad ties. At the corner of Alabama and 6th, a catfish was rootling down the center of the street, its progress marked by the bursts of small bubbles that it sent up at steady intervals. Farther down, where someone's yard shelved steeply into the river, I spotted what appeared to be a large pale halibut. It turned out—disappointingly—to be a submerged satellite dish.

The flats were on a back eddy of the Mississippi, a natural assembly point for drifting junk, and wherever the river touched dry land, it returned a broad selection of objects to the civilization from which they had been thrown away. On the little beach at the end of one quite narrow street, I counted more than twenty tires, a propane cylinder, a torn-out car headlight, a fishing float, a fifty-gallon oil drum, a glove, several super-economy-sized detergent bottles, numerous soft-drink cans, old lightbulbs, a clutch of aerosol cans, a badly mauled yellow plastic tricycle that was encrusted in gobs of tar, some broken honeycombs of polystyrene packing, and enough lumber to build at least one new cabin on the flats.

In the Downtown Lounge, a spry black man in his seventies was half-telling, half-miming a flood story to two younger white men.

"... And Duval—you know Duval... has that purple house down there? Duval's up on the levee takin' pictures ... "The storyteller was being Duval, prancing on tiptoe, his right hand curled into the shape of a view-finder while his left cranked on the imaginary handle of an old-fashioned movie camera. His head jerked to one side; he'd been interrupted in his filming. "Oh, I ain't baggin', 'says Duval; 'I'm too busy takin' pictures of the water—'They're piling up the sandbags, fast as they can go, but Duval's busy. He's walking around his house, around and around, taking pictures. 'I ain't baggin'!" The storyteller was wheezing with laughter. "I ain't baggin'!" He stopped to sip his beer and brushed his forehead with the back of his hand. "And the river, he's risin', right into Duval's purple house. The river's through the door. Duval, he didn't get nothin' out of there, he's takin' pictures on the levee. And when it's too late and the water's come right up, you should heard him! 'My TV! My couch! My rug! My clothes!' That Duval!"

He returned to his stool and hoisted himself up on it, shoulders shaking. "'I ain't baggin'!' "

I asked the storyteller if his own house was safe. Did he live down by the river?

"Where's my house? Oh, my house is fine. I live way up the hill."

At St. Charles—in normal times—the Missouri River tucks itself behind a wide and leisurely bend of the Mississippi. For more than twenty-five miles, the two rivers swing in consort, first north, then east, then south, before they tangle violently with each other twelve miles upstream from downtown St. Louis. Now their separate floods met on the northern edge of St. Charles and washed across the flatland of trailer communities, industrial parks, farms, and townships—a hazy shimmer of water, the same color and texture as the sky.

I had wanted to reach Portage Des Sioux, once on the Mississippi, now ten miles out across the lake but still connected, just barely, to the mainland by a road that was only a few inches underwater. I was turned back at the first roadblock: only residents and emergency workers were allowed to tackle this amphibious route, where jumbo pickups crawled like a line of ants traversing a mirror.

People here looked mugged.

In the small towns along the Mississippi where I'd been stopping, the flood was the cause of a sustaining outbreak of Blitz humor. People knew one another and—more importantly—they knew the river. Having grown up in the company of a famously temperamental monster, they weren't entirely surprised when the monster roused itself and shambled, on muddy paws, into their living rooms. Many could remember the floods of '73, '65, and '47; some could go back to the legendary flood stories of their grandparents and great-grandparents, in which the river changed its course, swept towns away, ran backwards for a day and a night.

It was different in the Greater St. Louis suburbs, where the river was little more than a glint of brown water with a towboat on it, seen out of the corner of one's eye from a car on the expressway. Tourists, doing the Gateway Arch thing, saw more of the Mississippi than most native St. Louisans, for whom the river lay on the far edge of the known world, a convenient barrier between St. Louis proper and the desperate no-go area of East St. Louis over in Illinois. You could live in St. Louis without giving the river a second thought from one year to the next; you might not even be aware that you had a river on your doorstep at all.

So when the Missouri, the Mississippi, and the little Des Peres ganged up and moved into the suburbs, their arrival was a horrible surprise to people who had no memory or mythology to help them cope with the flood. The little one was the nastiest of the three. The Des Peres backed up from its junction with the Mississippi, turning its earthen levees into piles of wobbly sludge. The levees bulged; the river burst through and made itself at home in the middle of residential South St. Louis. Headline writers renamed it the Despair.

I passed high over the Des Peres on a freeway bridge. The river was being carried down evacuated streets on a leaky aqueduct of sandbags and plastic sheeting through an area surrounded by troops. Meanwhile, policemen were stringing an orange screen along the side of the bridge to deter motorists from slowing for the view. The sight of a nice quiet neighborhood spectacularly engulfed was bringing rush-hour traffic to a honking standstill.

The region around St. Louis was also suffering from an inundation of journalists. The world's TV crews had set up command positions in all the best hotels and were fanning out across the countryside in search of stories. At Kimmswick, on the Mississippi, I reached the roadblock in time to catch the tail end of an altercation between *Time* magazine, the *Houston Post*, and a captain of the National Guard. No one, said the captain, was to be allowed through: orders of the mayor.

"What about Good Morning America?" said Time. "You let Good Morning America through."

The captain allowed that an exception had been made for *Good Morning America*.

"It's typical," said the *Houston Post*. "This is what we're finding everywhere—discrimination against the print media. The breakfast shows are reporting from the levee, while national newspapers have to put up with 'briefings' in City Hall—and here we can't even get to City Hall."

"It's not me," said the captain. "I'm here to carry out the instructions of the mayor. And that's what she says. No journalists beyond this point."

"I want to speak to the mayor," said Time.

The captain spoke into his radio. The message from downtown was that the mayor was out of her office and would not be back until the evening.

"But we have to file our stories by six," said the *Post*, "in the print media." "And they know that," *Time* said. "That's why she's out of her office. Can we reach her at home?"

The best the captain could do, he said, was to report that the newspapermen had filed an urgent request for access. He spoke into his radio again. "... I've got *Time* magazine and the *Houston Post* and—" He turned to me. "Who are you with?"

"Oh, I'm not exactly . . . Granta," I said.

For a moment, the captain looked at me with a flicker of significant interest.

"That's Time, Houston Post, and Greta," he said.

Ste. Genevieve was lapped in a cloud of hot gray dust. This dust was everywhere: it turned the grass gray and grayed the faces of the people on the streets. In the town center, the high-school yard had become a sandbag factory, where dozens of small squads of volunteers were shoveling dust among the mounds. Dotting the yard were more small squads, of cameramen and reporters, filming the sandbag brigade.

The dust was "screenings" from the local lime-producing plants, whose trucks, laden with fist-sized chunks of limestone, rolled through town en route to the levees. The noise of their passage blended nicely with the sound of an enormous orchestra of two-stroke pumps. From end to end, Ste. Genevieve rumbled, coughed, and snuffled in the dusty air while the river drifted past.

The Mississippi had already taken a large slice of the town, but a winding line of inner levees had so far stopped it from swamping the antique heart of

the place—a pretty grid, five streets by five, of freshly painted antebellum houses, gift shops, restaurants, and hotels. The river was on the rise. The water was now within a very few inches of the top of the sandbag parapet and was also coming up from below, puddling the streets and making ominous dark stains on the dry ground.

That day, Ste. Genevieve was where the story was. CNN was in town, with ITN and Swedish television hard on its heels, followed by a brilliant rabble of scribes and photographers, conspicuous in their Florida beach-vacation wear. Along the balcony of one old hotel had been strung a banner:

Ste. Genevieve—Doing It Again Beating Ole Man River

TV reporters were taking turns being filmed in front of the banner as they delivered their to-camera pieces about historic-town's-heroic-cliffhanger-battle-with-mighty-Mississippi. Up on the levee, cameras slowly panned from the rooftop-islands in the river on one side to the quaint gift shops on the other, via the chain of sweating sandbaggers in the middle. They fight a foot at a time. They fight a day at a time. They fight with grit and determination . . . and you could almost see the levee bulge and quake as the river threatened to sweep away this precious, candy-colored piece of early Americana in a tide of foaming slurry.

It was a good image, and a valuable one to the town. Ste. Genevieve had always wanted a "federal levee"—a top-of-the-range model, built by the Corps of Engineers, with a solid clay core encased in layers of earth and rock. When the river eventually went down, there would be a tremendous contest between the flooded towns for federal money. In Ste. Genevieve, whose experience in the tourist industry had equipped it with more worldly cynicism than most towns of its size, it was thought that the money would flow naturally to those places that had been most prominently pictured on the evening news and on the breakfast shows.

Trying to catch the attention of senators and congressmen, Ste. Genevieve went fishing for journalists. Its little city hall was like the head-quarters of a political campaign—and in fact it was. Under the slogan WE CAN DO IT! the walls were decorated with convenient factoids, written out in a big, round hand that put one in mind of an infants' school classroom. "40,000 Sandbags Are Needed Every Day"; "Number of Sandbags Used So Far—800,000"; "Ste G. Annual Budget, \$1.4m—Estimated Flood Expenses, \$15.3m and Rising." Every journalist was supplied with a map and an attached fact sheet, which proved beyond any reasonable doubt that

floods in Ste. Genevieve were usually caused and always exacerbated by the construction, in the 1940s, of federal levees on the Illinois side of the river.

The city had appointed a media coordinator—Jean Rissover, a local woman who had once been editor of the *Ste. Genevieve Herald* and now ran her own PR firm—and it was hard to figure out quite how Ste. Genevieve had managed to contain Ms. Rissover before the flood. She had the metropolitan knack of being able to efficiently maintain three conversations at once; she knew how to hobnob with purpose; she smoked; and she nourished the story of Ste. Genevieve, as it was told on the networks and in the national press, adding just enough to it each day to keep it alive for many days on end. If there was a weak spot on a farm levee or a dip in production at the sandbag factory, the fact—and the name Ste. Genevieve—would appear on the ten o'clock news and in next morning's *New York Times*. Given the geographical extent of the floods and the intense competition for time on television and space in papers, it was extraordinary how Ste. Genevieve managed to keep itself in the public eye. That was Ms. Rissover's responsibility.

Under her direction, the National Guard took the journalists off on helicopter rides, and the Coast Guard ferried them around in boats. She kept a team of local historians at the ready, to brief the journalists on the unique nature of the national treasure that was threatened by the flood. For Swedish television, she found a Swedish-speaking local historian.

Ms. Rissover thumbtacked newspaper stories datelined *Ste. Genevieve*, *Missouri* to the wall around her desk. They hung there in fat bunches of wilting newsprint, and the wall was fast growing too small for them. Some day soon, the city administrator would cash them in for a correspondingly thick pile of tax dollars and a new federal levee.

For *Granta*, Ms. Rissover (who took the democratic line that a medium was a medium was a medium) laid on a boat trip. In the company of a photographer from FEMA, the Federal Emergency Management Agency, and another from the AP wire service, I got afloat on the flood, in a silver aluminum dory piloted by two Coast Guard reservists.

Even right by the levee, two miles from the course of the Mississippi as shown on the map, the current was running fast. Though there was no wind, the treetops shook as if in the grip of a gale and a street lamp oscillated wildly on its stalk as the river tried to bend it double.

"Dancing light pole," said Petty Officer Mobley.

The boat gained slowly on the current, the 50-horsepower motor on tickover. If Mobley made a wake, he risked knocking sandbags off the levee. He was also navigating without a chart or local knowledge, for this Coast Guard detachment came from Louisville, Kentucky, and neither Mobley nor his crew, Seaman Felicia Berbar, who sat up front with a five-foot boathook, had ever visited Ste. Genevieve before the flood. So we moved gingerly, in doubtful water, over foul ground, with the seaman sounding for chimney pots, parking meters, heating vents, rock gardens, sheds, power lines, trailers. Though there were plenty of roofs and utility poles in view, it was surprisingly hard to make out the safe deep channel of a street.

The current, spooling through the shallows of an orchard, made the boat slew.

"Lot of eddies here," FEMA said.

"About the time you get that current figured out—forget it," said Mobley, weaving the dory between a gable end and a submarine garage. "Snake," he called out, "snake in the water." It moved like a spring, in quick spasms. Berbar, sitting next to me, screwed up her face in pantomime disgust.

"What sort of snake is that?" I said. "It's not a water moccasin—"

"They got more snakes in this river than I ever heard of," said Berbar, "and any kind of snake's a bad snake to me."

"Snake..." said Mobley. "Snake in the tree." It was dangling from a branch, apparently trying to make up its mind as to whether to take the plunge. It plopped neatly into the water as we went past, ten feet clear.

After a few minutes of this, Mobley stopped alerting us to snakes; it was too like shouting "Fly!" on a warm evening in a barnyard. There were a lot of snakes. Ousted from their homes on the islands and wooded riverbanks, the mammals had fled inland, but the snakes were happy with any dry lodging they could find—a windowsill or chimney did nicely; an upstairs deck was snake heaven. So the flooded half of town had filled with copperheads, cottonmouths, rattlers. There were snakes sunning themselves on roofs, snakes on couches, in drawers and closets, in beds. The snakes—so sinuous and riverine in shape—were natural emblems of the Mississippi itself, and nothing so well represented people's sense of being violated by the river as the image of the cottonmouth in the child's crib. When people talked about going back to their houses after the flood, it was the snakes they mentioned first, and with good reason. The snakes were real, were deadly, and were in residence.

Pacing the current, Mobley opened the throttle, and immediately the boat ran into something soft and substantial. The boat reared, slid sideways over the obstruction, and nearly tipped Associated Press into the snake-infested river.

"I never hit that before," Mobley said.

Berbar, leaning over the bow, prodded about with the boathook, but it went cleanly down into deep water.

"It wasn't hard enough for a shed," Berbar said.

"It felt something like a dead cow," I said.

"The things people have in their yards."

From the perspective of the river, the surviving levee was a shallow rim, no more than six inches high in places, of gray sandbags and torn plastic sheeting. We coasted to its edge and looked over at the flimsy streets below—at the pumps, the limestone piles, the dark wet patches on the ground. It was as if someone had tried to patch Holland together overnight: the whole scene appeared to be held in place by prayers and string.

Ducking to clear telephone lines, skinning a couple of shingles from a roof, we nosed out into open water. As we headed for the main channel of the river, Mobley ran the motor on full thrust, and the dory began to kick up a steep and curling wake. It slammed and bounced on the water as it climbed onto the plane, but the fringe of trees alongside barely moved. The engine roared, the wake streamed in a white vee behind us, the boat pounded—but the land remained obstinately still.

We skidded from boil to boil as the Mississippi poured southwards under our feet. The surface of the river was a lacework of rips and swirls: oily mushroom heads, a hundred feet or so across, bloomed and spun; little whirlpools raced away on private zigzag tracks; everywhere the water was dividing, folding in on itself, spilling, breaking, spitting, and sucking.

It was only when the downdraft from its rotor blades began to disrupt the patterns of the current that I saw the National Guard helicopter overhead. Associated Press was photographing it. I could see the picture he was taking, and it was a good one: the Coast Guard afloat, alone, on the raging flood; and, over his left shoulder, a military chopper on a rescue mission.

"Oh—" said AP, and put his camera down. "It's full of journalists."

At the same time the copter, having spotted the same problem, wheeled away into the sky.

"People taking pictures of people taking pictures," said PO Mobley.

I was on the levee, making a sketch of how the river moved as it tried to flow through the middle of someone's house, when a small, rawboned man

in sunglasses approached me. "Got all your notes?" he said, and put out his hand. His handshake was of the kind that people go to evening classes to learn. There was a lot of technique in it—the modulated pressure of the thumb; the palm-to-palm interface; the finger lock; the terminal wrist flip. It was a prolonged and multilayered assertion of confidence, frankness, solicitude, and firmness of intent.

"John Kasky," the man said, with an intimate cough.

I took him for a traveling evangelist, possibly drumming up customers for a mass baptism, and noticed that his limp moustache was interestingly out of character with the powerful handshake.

"R. & H. Service & Supply."

He was a pump salesman. He was shortly going to demonstrate a pump to the city administrator; in the meantime, he rehearsed his patter on me. The pump stood at the bottom of the levee and looked like a shiny red tractor.

These were flush times in the pump business. Mr. Kasky could not recall exactly how many pumps he'd sold in the last three weeks, but it was between thirty and forty. These were not tinpot two-stroke jobs but big industrial pumps that cost from \$20,000 to \$50,000 apiece, and Mr. Kasky was selling them, on commission, to cities up and down the river. The excitement of all these done deals had worked on him like speed. He was elated and twitchy, and it would not have been surprising to see him break out into a hornpipe on the levee.

This particular pump was a Godwin Dri-Prime 6-inch, 65-horsepower model, with a throughput of 2.1 MGD.

"Million Gallons a Day," said Mr. Kasky.

"That's a lot of water."

"Oh, we go way up. Take a twelve-inch pump, for instance. That'll give you a throughput of nine MGD—and that is a lot of water."

I was curious to find out how much water had to be pumped out of Ste. Genevieve every day.

"You'd be talking hundreds of millions. Close to a billion. But don't quote me." He snapped open his briefcase and got out the literature on the Godwin. "We just took on this line a little while back. Pretty fair timing . . . " He gazed appreciatively over the levee and its lines of pumps, each with a hose poking over the top of the sandbags, spewing dirty water back into the flood. Beside the spanking-new Godwin, they looked a sorry collection of rustbuckets.

Mr. Kasky explained to me the poetry of the dry-prime system. A wet-prime pump—he flapped his hand dismissively at the hardware nearby—is

a source of never-ending tribulation. It must be constantly tended. If you allow your wet-prime pump to suck dry, it will probably break its seals. With broken seals, it won't pump. And in any case, you'll have to reprime it.

On the other hand... Suppose you go the extra mile and invest in something like the Godwin Dri-Prime... When there's water to suck, it sucks. When there's no water to suck, it quietly hums along, waiting for the next leak to spring. It requires no adjustment and no priming. Its seals don't break. If you wish, you could go away on vacation to Hawaii, leaving your trusty pump to do its work unattended in your absence. Everybody should have one.

"And it's made in England." He read the name of the place, with some difficulty, from the promotional sheet: "Cirencester, United Kingdom."

"How much?"

"Twenty-three . . . just shy of twenty-four thousand dollars."

I was still puzzled as to why, in this drowning and pump-hungry city, Mr. Kasky had chosen to spend time selling his shiny red tractor to me.

"You're the media. It's like everything else—you need to get media coverage in this business if you're going to succeed. You never know: you could be doing yourself a favor if you work in a reference in your article to the Godwin Dri-Prime Pump."

I have done my best.

I hung around for the demo. The pump worked. I saw water coming out of the other end. The city bought it.

At his house on South Gabouri Street, Mr. Ish Scher had fifteen pumps, and they all ran out of gas at different times, so he spent the day going from pump to pump with a two-gallon gasoline can. It was hard enough to keep the pumps supplied with fuel, but they were old and temperamental, and every day at least one pump would cough and die, and the water would begin to climb. Even when all the pumps were smoothly churring, the basement of the Scher house was ankle-deep in floodwater, and a bit of muck in an impeller would bring the level to knee height in a few minutes. If one stood in the sopping basement, the river was just above one's head, held off by a homebuilt wall of sandbags. Water dripped and bubbled through the cracks between the bags, and the bigger leaks were miniature cascades.

"It's a beautiful house," said Mr. Scher. "It used to be."

Over the din of the pumps there was the sound of purling mountain streams. The wallpaper had slid from the walls, and so had much of the plaster, exposing bricks that were black with wetness. "The city told us to evacuate. But I couldn't do that—not when we're so near the end."

Did he mean the end of life? Or the end of the flood? Perhaps both. Mr. Scher was in his late seventies; his wife, a woman with vague, shocked eyes, was a few years younger, but looked older. "Elaine's taken this very hard. She gets no sleep. She's in a bad state. But I'm fine—just fine." His voice was southernly soft, and he smiled, out of polite habit, when he spoke. Trudging from pump to pump with his gasoline can, while the Mississippi leaned against his house and forced itself inside, Mr. Scher seemed at home with the flood: he might have been pottering in his garden on any sleepy summer afternoon.

His left arm ended in a bare stump below the elbow; his fortyish son was blind.

"We've been so lucky with our friends—I can't tell you. If it hadn't been for our friends, we'd have lost this house long ago. They've been so good to us—"

The Schers were defending a line about thirty yards long. Their sand-bag wall, over which the river was now so nearly spilling that the removal of one bag could easily have caused the whole wall to give out, stretched around the side and back of the house and across the yard, where it was shored up by the side of a trailer house. Sandbagging is a skilled craft, like dry-stone-walling, and the nine-foot wall had been built by several sandbaggers in several styles. The good bits were dry; the bad bits sagged and dribbled.

In the trench at the foot of the wall, the water was the color of beef bouillon; its surface was wrinkled and shivering in the contest between the leaks and the pumps. Measured against the coarse weave of a fallen sandbag, it was up a thread, down a thread, up two threads . . . winning—losing—winning—losing—losing.

In City Hall I found Mr. Kasky. The deal was done. He had the contract in his hand.

"I've found you a great media opportunity," I said, and told him about the Schers. "You could get on network television..." I stressed how the story of one deserving family, saved in the nick of time by a pump salesman with a heart, would carry more weight than the loss or salvation of a whole suburb; I came as close as I dared to suggesting that Mr. Kasky's face might make the cover of *Time*.

"I'm with you . . . I'm with you . . . it is a good idea," said Mr. Kasky. "But

what a shame you didn't come up with it this morning. If you'd come to me then, I could have helped them out, no problem. Now, though . . . " He shook his head and chewed on his moustache. "I haven't got a pump. I sold it to the city."

"You could get one by tomorrow."

"That would be tricky."

"Please."

Mr. Kasky consulted his watch and made a great show of being astounded by what he saw there. "Sorry!" he said. "I got to go!" And he was gone, the rat.

Jean Rissover was smoking on the loggia. When I told her about the Schers, she went off to talk with the city administrator, but came back with the news that there were no spare pumps of the right size for the job.

"Isn't there any way in which the Schers could make the city change their minds on that?"

"Oh, they *could*. But they'd need to get media coverage. If Mr. Scher could go on a radio show and tell his story there . . . "

Next morning, the river was still only shin-deep in the Scher basement. The previous evening, fourteen hundred new sandbags from the high-school yard had been added to the wall around the house. Half a dozen neighbors had turned out to form a chain, and we'd spent three hours slinging the bags up to an expert sandbagger on the top of the wall; some of the worst leaks were now stanched, though new ones had started overnight, and another pump—a hefty one, with a 4-horsepower motor—was on the blink.

"It's looking good," Mr. Scher said. "And the flood seems to be going down."

It was, too. A little up the street from the house, the river had found a new shoreline; there was a clear tidal margin of wet gravel, seven or eight inches wide. A wooden stake in the water now showed a distinct dark band. As I watched, a whiskery splinter on the stake popped clear.

Suddenly there were a dozen people in the street, watching raptly as the water exposed first one crumb of gravel, then another, and another. We were witnessing a miracle.

"They were forecasting a rise—"

"What do they know?" said a woman with an exhausted face and a wild laugh. "They've been wrong about everything."

In ten minutes, the level of the water dropped by a full inch.

A Coast Guard man, with a quacking VHF set holstered to his hip, then

arrived by bicycle. Half an hour ago, the levee at Kaskaskia Island, twelve miles downstream, had burst. Ste. Genevieve's few inches of remission were someone else's misfortune: thousands of acres had gone under, the Mississippi even now fanning out through the corn in a great wave.

"They're saying it's real bad down there," he said.

"Excuse me!" said the woman with the laugh. "My house is half underwater, and you're telling me to feel sorry for a *field*?"

Every time a levee went, it relieved the pressure of the river, for a few hours at least, on the towns nearby. This was tempting knowledge. In Quincy, Illinois, the breaching of the levee was officially put down to sabotage, and there was much unofficial talk of other levees that had burst with some help and encouragement from the neighbors. Townspeople were prone to blame the farmers for unfairly constricting the river—as Missourians were inclined to blame the people of Illinois with their great federal levee.

It didn't take much to cause a breach. It was night work, but easy to do, given a half hour or so of privacy. You'd need to shift a dozen sandbags to create a good strong waterspout, and the river would do the rest. In no time at all, the hole in the levee would be big enough to float a barge through it—then the whole soggy wall of softened earth would collapse and the river would swallow the long, flat miles of floodplain, as it was always meant to do.

The river dropped four inches, then began to rise again. It crept back across the gravel until it was an inch or two farther into town than it had been before it took Kaskaskia Island. The excitement and the ensuing lurch of disappointment of the morning had tired people, made them cranky and strange. I spoke to a woman whose basement had the usual assortment of pipes and hoses leading out from it to the river.

"How are things holding up in your house?"

"We've got everything in there but the alligators," she said. "Everything but the alligators!" she repeated. "Everything but the alligators!"

A boy of eight or nine came out of the house next door. "Did you hear the noise, mister?"

"What noise?"

"A weird noise. I was out here earlier. I heard it. It was weird."

"What kind of weird?"

"Kind of like a frog noise. But much louder. And weirder."

We listened together. There was just the drone of the pumps in the heat and dust. The boy drifted away, his head full of monsters.

Out on the levee I met a telephone engineer, working for Southwest Bell, whose job it was to visit a long string of river towns, inspecting their phone equipment for flood damage.

"It's interesting," he said. "Every town reacts differently. Some towns, it's just like what people say it is on TV—everybody pulling together, neighbor helping neighbor, all that. You can see that in Dutchtown—it's real cohesive. But there's the flipside: towns where people sit on the hill, watching television and saying, 'Why do I have to lift a finger to help those dumbasses down by the river?' A lot of towns are like that. I don't know what it is—maybe it's in their history, but it seems that whatever was in that town before, the flood finds it and brings it out. It's bringing out a heap of meanness, a heap of resentment, a heap of pettiness . . . Have you been down to St. Mary?"

"No."

"You ought to. There's no National Guard there, and no media. It's just a town that was flooded, and nobody paid any attention. When folks from St. Mary see Ste. Genevieve on the evening news, they'll tell you: they're bitter—"

He was interrupted by a mud-splattered farm pickup, which jounced up the levee in a dust cloud and parked by his elbow. From the driver, there were salutations for the telephone engineer and an irritable growl for me.

"Reporter?" Repawdah?

"Sort of." Sawdah.

The farmer and the telephone engineer grunted companionably at each other for a while, then fell to staring at the water. Silence. The river here flowed over shunting yards and through a factory. It was a placid floodscape—the whorls of current slowly turning, the telephone poles and warning signs standing on their reflections. It was easy to imagine people coming here with paintboxes and easels, trying to catch the picturesque serenity of the scene at our feet. You could sell this in the gift shops.

"Repawdahs." The farmer gazed stolidly ahead. A heron flapped past, its wings creaking like a pair of old church doors. Water chuckled under the eaves of a bungalow. The pumps grumbled and spat. "They're making it out to be a whole lot worse than what it is." He put the truck into reverse and backed off the levee before I had a chance to agree.

On the Waterfront

On the Beach, where the sea wets the land, boundary disputes and ambiguities naturally pile up with bladderwrack and plastic bottles. The seaman looks anxiously to his depth sounder as he closes with the shore, for land is always dangerous to ships, while the landsman fears the water—the tide fanning out at speed over the level sands, the undertow, the deep. The law of the land gets into trouble when it reaches the ocean, it often being hard to say where the land is, or if the land is. For instance, here on the Pacific Northwest coast, whose mixed diurnal and semidiurnal tides work in a lolloping daily rhythm of high-high-water, low-low-water, low-high-water, and high-low-water, the state of Washington holds title to the inshore seabed "up to and including the line of ordinary high tide," which would be a tidy definition except that no such thing as an ordinary high tide has ever been witnessed in these parts.

Legally, socially, morally, the beach is a marginal zone to which marginal people tend to gravitate, and where respectable folk tend to behave in marginal and eccentric ways. The best beach architecture reflects the limbolike character of the place. In *David Copperfield*, Mr. Peggotty's residence on the sand at Yarmouth has long since ceased to be a ship but has not yet entirely become a house. Author and illustrator are at odds over what sort of an object it is: Dickens describes it as a stranded barge, right side up; Phiz pictures it as an upturned boat. The discrepancy is a happy one, for everything about Peggotty's "ship-looking thing" is importantly discrepant—his apparent wife is not his wife, his stable family, seated snugly around the fire, turns out to be an assortment of stray widows and orphans. The warmth and solidity of their domestic interior, crowded with knickknacks, freshly painted and "beautifully clean," are pitched against the "great dull waste" of the sands outside. That a wrecked ship should serve as a welcoming lighted

haven from the cold and storm of early-nineteenth-century England is a wonderful, paradoxical transformation of a kind that could happen only on the outermost fringe of society—on the beach.

So the Prince Regent, later George IV, built his astonishing royal pavilion beside the sea at Brighton. Many years later an aged courtier, Lord William Pitt Lennox, fondly remembered George as "that mighty magician, who, Aladdin-like, raised a magnificent town from a small insignificant fishing village." (Thackeray, born in 1811, the first year of the regency, recalled him as "Swaddled in feather beds all his life, lazy, obese, perpetually eating and drinking," and referred to the pavilion as "the Prince's hideous house at Brighton.") The pavilion was, in a word, outlandish. Its onion domes reminded early guidebook writers of the Kremlin, its stables were "Indian," its furnishings a riot of chinoiserie. Recreations there were famously dissipated in the Byronic style of cards, women, wine, and laughter (sermons and soda water the day after). The prince's chief architects—first Humphry Repton, then John Nash—were paid to let their fancies fly. Working down on the coast, they were unbridled by the conventions that helped to tame their designs in London and the genteel shires. On Brighton beach there were no existing buildings with which the new pavilion had to blend, no local arbiters of taste to protest the excesses of the plan. The result was a pure seaside extravaganza, a forerunner of Coney Island, a monument to the beach as a territory of extraordinary license.

On a subtler scale of marginal behavior, there is Henry James, on holiday at Étretat in 1876. James disliked the sea but loved the seaside, a significant distinction. At Newport, Palm Beach, Cannes, and Hastings, he wrote appreciatively of places where the land was "exquisitely modified by marine influences" and where the "habit of pleasure" was developed under the "pressure of luxury and idleness." At Étretat, the novelist wore a white flannel fishermen's cap ("these articles may be extolled for their coolness, convenience and picturesqueness") and canvas shoes. Reclining on the pebbly beach, he watched "Mademoiselle X., the actress of the Palais Royal Theatre," take to the water from a diving board.

She wears a bathing-dress in which, as regards the trousers, even what I have called the minimum has been appreciably scanted; but she trips down, surveying her liberated limbs. "C'est convenable, j'espère, hein?" says Mademoiselle, and trots up the springboard which projects over the waves with one end uppermost, like a great see-saw. She

balances a moment, and then gives a great aerial dive, executing on the way the most graceful of somersaults. This performance the star of the Palais Royal repeats during the ensuing hour, at intervals of five minutes, and leaves you, as you lie tossing little stones into the water, to consider the curious and delicate question why a lady may go as far as to put herself into a single scant clinging garment and take a straight leap, head downward, before three hundred spectators, without violation of propriety—and why impropriety should begin only when she turns over in the air in such a way that for five seconds her head is upwards. The logic of the matter is mysterious; white and black are divided by a hair. But the fact remains that virtue is on one side of the hair and vice on the other. There are some days here so still and radiant, however, that it seems as if vice itself, steeped in such an air and such a sea, might be diluted into innocence.

To find James going on so waggishly about the brevity of a young woman's trousers is itself a significant example of seaside license, if not quite in the royal pavilion class. In the somersaulting actress, he hits on the embodiment of the ambiguous, topsy-turvy character of the seacoast, where inland values and meaning are apt to be inverted and diluted by marine influences.

In literature, painting, and movies, the beach has long figured as a dangerous edge where social rules grow lax and where the land is vulnerable to foreign ideas, as to foreign invasion. It is the scene of extravagant pleasure, tragedy, dramatic confrontation, self-knowledge, crime. From King Lear to Brighton Rock, Key Largo to Atlantic City, sands, cliffs, piers, and waterfronts represent the extreme margin of society. What is surprising is that historians and sociologists have generally preferred to stay well inland of this fascinating area, and until now, with the exception of a handful of anecdotal histories like Anthony Hern's useful small book The Seaside Holiday (1967), the coast has been pretty well clear.

First published in French in 1988, Alain Corbin's *The Lure of the Sea* is a compact and brilliant taxonomy of the shifting meanings of the sea and shore between the mid-seventeenth and the mid-nineteenth centuries. Corbin, who is a professor of history at the Sorbonne, is evidently fond of margins: his last book to be translated into English was *Women for Hire*, which was both a scholarly history and a libertarian defense of prostitution. In *The Lure of the Sea* he roams, with an air of devastating familiarity, through writing in Latin, English, French, and German, through poems,

travel memoirs, journals, and philosophy, generalizing stylishly as he goes along. That the academic English into which the book has been translated by Jocelyn Phelps still retains a powerful Gallic accent only adds to the impression that one is witnessing a great lecture-hall performance by one of those Parisian scholars whose chief business it is to dazzle with provoking insouciance.

He moves at speed, though never too fast to relish a paradox or tease a deep signification from a passing phrase. He conducts the reader from a theocentric interpretation of the shore as the line drawn by God's finger after the Flood, through the sea as experienced by neoclassical travelers on the Grand Tour, to the beloved sea of the Romantic poets and the growth of the popular seaside resort that came in their wake. Corbin is especially good at compressing a whole cast of mind into a few sentences. Describing the beach as the manifestation of the power of a benevolent god, for instance, he writes:

The biblical text magnifies the paradoxical strength of the sands. It focuses attention on the shoreline, and fills it with meaning. Nowhere else do the power and goodness of the Creator appear so clearly as on the beach that still bears the imprint of his finger. This most astonishing miracle is constantly being fulfilled. For the Christian, the threatening wave is merely a reminder of misfortune and the Fall. The line where it breaks arouses *astonishment*, and fosters admiration and thanksgiving. For the Christian, the curve of the wave in the presence of divine omnipotence, as it becomes calm and ebbs away, evokes a gesture of respect.

Corbin's beachgoers all treat the shore as a source of important knowledge: they take themselves to the water's edge in order to learn—about God, then about ancient history and modern fortifications, then about the "primordial" characters who make their livings from the sea. In the Romantic period, they went to the beach to gain self-knowledge. Even the ritual of therapeutic sea bathing (which began to be touted as a cure-all in the 1670s) was for most people a terrifying educational experience. An attendant was employed to force the bather's head below the waves:

Brutal immersion head first in water at a temperature of 12 to 14 degrees brings about an intense shock. This practice was part of the technique for toughening the patient, as Michel Foucault once described it. It is reminiscent of tempering steel. The process acts on

the diaphragm, considered the seat of sensibility . . . this was a means of toughening young girls who suffered from dangerously pale complexions; it got them accustomed to being exposed to the elements, and prepared them for the emotions and pains of puberty, as well as the sufferings of childbirth.

The history of the coast (at least since the early eighteenth century) is inseparable from the history of tourism. Corbin tracks the Grand Tourists, accompanied by their tutors, on their pilgrimage to the shores of the Mediterranean, where they tramped around the designated classical ruins, sketched the military architecture of the major harbors, and sought out the vantage points (these were listed in guidebooks) that would put them, as it were, in front of the easel supporting a painting by Claude Lorrain or Salvator Rosa. They went to see what had been seen many times before, and whose meaning had been already firmly established by better minds than their own—and they went in groups, for the lone traveler is inevitably at a disadvantage when what he seeks is essentially public knowledge. Corbin locates the beginning of industrialized mass tourism in the neoclassical "picturesque code," and identifies the Romantic insistence on solitary adventure and solitary sensation as, in part, a turning away in disgust from the upper-class coach-party trips of the previous age.

The visit to the lonely shore became an exercise in self-discovery and self-expression. "The ocean's vastness became a metaphor for the individual's fate, and made of the beach a fine line marked by the rhythms of the water, which were in turn driven by the lunar cycle; treading this line became an invitation to reassess one's life." The problem with this kind of private communion with the deep lay in communicating the intensity of one's experience to one's fellows. Byron ("And I have loved thee, Ocean!") used his pen; less talented folk used their bodies. "Unprecedented ways of standing or posturing on the beach or of sitting or lying on the sand were the signs of this deepening of the quest." So the prized solitude of the Romantic traveler was not so solitary after all.

From late in the seventeenth century to early in the nineteenth, the attractions of the beach steadily accumulated, and Corbin makes an amusing inventory of things that drew tourists to the sea some twenty years before the generation of Byron, Shelley, and Heine came on the scene and swept all before them:

A look at the popular journals devoted to the world of the sea and published during the last forty years of the [eighteenth] century shows the

fascination exerted by the shore and the powerful evocativeness of this theatre of the void criss-cross with shadows: it was a kaleidoscope that juggled composite mosaics and created fleeting series of characters, stony men who had not changed since the times of the bards and the Druids, virgin priestesses of Belenus, strong-blooded barbarians whose ferocity satisfied readers' sadistic sides, heroic rescuers, anxious women gathering the sea's manna on the strand and the rocks and awaiting the fishermen's return, and the moving spectacle of young girls questioning the sea-gulls about the destiny of their beloved. All these polysemous figures nourished the contemplation and reverie that filled tourists' souls and which had already been refreshed by the legends collected from the shore-hauler's mouth or from the old fisherman. In short, the quality of the place, at the meeting-point of sea, sky, and land, facilitated the mingling of images and an additional feeling of travelling through time and space. It was a springboard for the imagination, producing a body of literature and painting whose richness between 1810 and 1840 exceeded that of rustic imagery.

When Corbin takes leave of his subject, in 1840, railway lines run from London and Paris to the beach resorts. The shiplike architecture of the new coastal town is in place, with its passenger-deck promenades and its line of boardinghouses and hotels fused into a single white superstructure above the sea. The modern seaside—the product of a complex braid of ideas going back some two hundred years—is under way.

It is with high hopes that one opens John Stilgoe's study of the American coastal edge, Alongshore. Stilgoe, a professor of landscape history at Harvard, has a good track record. He has published three substantial books on the impact that Americans have made on their environment, and his last one, Borderland: Origins of the American Suburb, 1820–1939, dealt with the ambiguous margin between the city and the country in a way that might have been a rehearsal for dealing with the even more ambiguous margin between the land and the sea. In Alongshore he sensibly focuses on his own home stretch of shoreline—and he is extraordinarily lucky to live where he does. The twenty miles of coast between Gurnet Point and Strawberry Point on Massachusetts Bay is a fascinating configuration of water, sand, architecture, and salt marsh. Between the towns of Cohasset to the north and Duxbury to the south lies a maze of shoals and bars, gluey mud, sandspits, dog's-leg channels where the tide runs fast and dangerously,

brackish creeks, beaches, dunes, and lagoonlike pools of sheltered water. Local industries range from tourism and fishing to national security and the drug trade. It would be hard to find on a world atlas a better place to write about as a test-case sample of seaside life.

In his introduction, Stilgoe announces *Alongshore* as a "personal book" which means, unfortunately, that he has put aside the lucid expository prose of his earlier work and set up shop as an unbuttoned stylist. His writing here seesaws between the sonorous and the whimsical. He describes himself as "the barefoot historian," though when he was a fully dressed historian his prose was far plainer than it is in Alongshore. He likes to rummage at leisure through his dictionaries, searching for antique and dialect words like "marge," "glim," "dipsey," "guzzle," which he then proceeds to work to death. "Gunkhole" (a small, muddy anchorage) is already a threadbare old favorite of the boating magazines; Stilgoe makes a great fuss over his discovery of it, equips it with a deeply suspect etymology, and uses it, on average, once every eighty-five words for the next ten pages. When he writes of "explorers and mariners gunkholing their way [from Europe] to America," he robs the poor word of what little meaning it has left: the explorers and mariners might as well be said to have found their way to America on pogo sticks.

The prevailing tone of *Alongshore* is well caught in a sentence that deals ostensibly with the sale of thrillers in beach resorts:

How tourists can be pleased to learn that among the locals lurk drug smugglers, thieves, and murderers remains a deep unreached by dipsey lead, something the barefoot historian ponders frequently between Memorial Day and Labor Day.

The pompous syntax, showy alliteration, the drollery, pipe-sucking and disabling self-consciousness are the stylistic signature of the book: Stilgoe loves language, but handles it with such clumsiness that it's not to be trusted in his keeping.

Some of the merits of his previous books survive here. He has developed a useful scattershot approach for targeting slippery and elusive subjects. Short, copiously illustrated chapters on topics that bear more or less indirectly on the main theme seem arbitrarily assembled until you realize that the center is being defined by its periphery. If Stilgoe were to draw a man, he'd start with the hands and the feet. So in *Alongshore* there are chapters

on swimsuits, piracy, coastal defenses, boat design, the rise of the outboard motor, quicksands, the color chartreuse, and so on. Here Stilgoe is inland, there he's out at sea; as he moves around his subject, crossing and recrossing it, the line of the coast gradually emerges, though the resulting picture is a lot more blurred here than were his portraits of the suburbs in *Borderland* and of the railroad communities in *Metropolitan Corridor*.

He raises many good questions, but answers them in a weirdly offbeam way. Alongshore begins with a fierce assault on the word seascape. "Seascape cannot properly designate the subject of this book, for all that its cousin landscape proves useful in designating land shaped by people for their own needs and in classifying certain sorts of pictures or views. The whole concept of seascape reeks of lubberly bias." The dictionaries are consulted (Webster's, Century, the 1891 Adeline's Art Dictionary), and Stilgoe concludes that seascape was a mid-nineteenth-century British neologism, a pretentious word for a pretentious object—a picture of the sea drawn by a non-seagoer from a stable perch ashore. Thackeray is brought in as a witness: in "A Shabby Genteel Story" a Cockney dauber named Andrea Fitch is found on the cliff at Margate, blathering about "yonder tempestuous hocean in one of its hangry moods" as he sketches "a land or a sea-scape" (the hyphen is a Stilgoe addition to Thackeray's original text). "In a few sentences, Thackeray ridicules the ostentation of seascape."

That is nonsense. The word was not a neologism in the mid-nineteenth century. The Oxford English Dictionary (which doesn't seem to have a place on Stilgoe's shelf) cites the Hull Advertiser, 1799: "One of the most eminent marine painters has painted sea-skips." In "A Shabby Genteel Story," Thackeray ridicules the person of the painter but has nothing whatever to say about either the word "seascape" or the genre it denotes.

Yet the appearance of the word in English, somewhere toward the end of the eighteenth century, was an important event in the evolving history of the coast, and Stilgoe is right to draw attention to it. "Marine painting" meant pictures of ships and harbors. In the work of the Van de Veldes and Dominic Serres, for instance, the water itself is a secondary element in the composition and often looks as stiff as if it were molded in plaster of paris. As Alain Corbin demonstrates, the sea was becoming increasingly interesting during the course of the century as a subject in its own right. A new word was needed to distinguish between marine paintings and paintings whose main focus was on the turbulent water, the translucence of a cresting wave—paintings in which ships, if they were present at all, were there to be overwhelmed by the greater majesty of the sea, like Turner's *The Shipwreck* (1805).

The OED's second meaning is from A Guide to Watering Places (1806), which commends a hotel with "a fine sea-scape from a terrace in the garden." As the Grand Tourists had used to view harbors from a scenic overlook through a Claude glass, and so turn them into living paintings, now, nearly a hundred years later, the sea itself had become a legitimate object of mental picture-making. Seascapes—both as canvases and as views from the terrace—were all the rage, and the pursuit of seascape, even before the word was coined, had begun to drive fishermen, boatbuilders, and other traditional shore dwellers from their old quarters, as the leisure industries seized hold of the best beaches. In Sanditon (1817), Jane Austen registered the dramatic change in value of waterfront property, from worthless desert to prime real estate. Bournemouth, which began life in 1810, was, like Sanditon, a town built around a seascape.

Why does Stilgoe so detest the word? Any serious reckoning with "seascape" would lead one to the fact that the coast has been importantly shaped by the tourist industry for the last two hundred and fifty years. Alongshore might usefully have considered the question of how far the development of the American seaside kept in step with its British and European counterparts; but Stilgoe's earliest substantial reference is to Thoreau's beachcombing in Cape Cod (1865), which is altogether too late for this purpose. According to the Encyclopedia Americana, Newport, Rhode Island, became a beach resort in the years immediately following the War of Independence, when it lost its strategic value as a naval station—which would make it younger than Scarborough and a few years older than Brighton. Stilgoe, though, seems in this book to be a historian with little interest in history, and his disregard for the past enables him to invent it at his convenience.

Like so many other writers about the coast, he affects a tone of routine threnody and his book takes the form of a lament for yesteryear—for lost crafts and industries, lost places, lost people. It's always the conceit of such writers that the golden age of the beach existed within living memory and that its fall from grace has happened as a result of very recent industrial, social, or bureaucratic upheavals. Since 1800, the beach has been a place for children, and everybody likes to think that his or her own childhood belonged to a larger age of innocence. So Edmund Gosse in 1907 conjured the glory of the Devonshire rock pools of his boyhood, only to reveal that no one would ever see them again as he had seen them.

If the Garden of Eden had been situated in Devonshire, Adam and Eve, stepping lightly down to bathe in the rainbow-coloured spray, would have seen the identical sights that we now saw—the great prawns gliding like transparent launches, anthea waving in the twilight its thick white waxen tentacles, and the fronds of the dulse faintly streaming on the water, like huge red banners in some reverted atmosphere.

All this is long over, and done with. The ring of living beauty drawn about our shores was a very thin and fragile one. It had existed all those centuries solely in consequence of the indifference, the blissful ignorance of man. These rock-basins, fringed by corallines, filled with still water almost as pellucid as the upper air itself, thronged with beautiful sensitive forms of life—they exist no longer, they are all profaned, and emptied, and vulgarized. An army of "collectors" has passed over them, and ravaged every corner of them. The fairy paradise has been violated, the exquisite product of centuries of natural selection has been crushed under the rough paw of well-meaning, idle-minded curiosity.

The collectors (who, as it happens, earn a good, plain, well-researched passage in *Alongshore*) came and went. In 1950, when I was seven, I vacationed with my parents on the same stretch of the south Devon coast and saw rock pools just as startlingly clear, as populous, as magical, as any described by Gosse in the golden age ca. 1856—same prawns, same anthea, same dulse, same corallines, same pellucidity. (They're all gone now, of course.)

Stilgoe, born in 1949, seems too young for his heavy-lidded Tiresian style, but he would have one believe that the 1960s marked the beginning of the end of the old, idyllic coast. Embedded in the chapter titled "Harbors" is an age-of-innocence description, only marginally flyspecked with professional landscape-history jargon, of a harbor as Stilgoe himself might remember seeing it at age seven:

Right next to the water... stood a densely packed concatenation of spaces and structures and vessels, a concatenation enlivened from late spring through early autumn by furious activity, for even in midsummer wooden boats rumbled up marine railways for repair and repainting, especially for the bottom repainting that helped fast boats win races. The ring of land jammed with cradled boats all winter marked the visual high-tide zone, a zone in from the actual high-tide limit but in which vessels occupied space comfortably, almost 'naturally.' Crowded,

active, and instantaneously announcing itself as the boating edge of the land, the harbor collar attracted everyone from boys building or repairing a rowboat to fishermen examining a hauled-out trawler to tourists savoring a salty scene. And then, in the 1960s, the collar frayed . . .

People of all ages and classes—fishermen, yachtsmen, boys, and tourists—are interlocking elements in this scene of idealized social harmony. But the picture begs a lot of questions. Why are the marine railways occupied by racing yachts, while the trawler appears only to have been beached? Why are there so many yachts in sight and only one fishing boat? What are the fishermen saying about the yachtsmen, and vice versa? What is everyone saying about the tourists? What Stilgoe portrays, quite unwittingly, is a battleground of competing class and economic interests, where the recreational boating industry has driven commercial fishing into a corner of a harbor to which the fishermen no doubt feel historically entitled. The "collar," as Stilgoe fondly calls it, might reasonably be perceived by some of the people in his picture as a noose.

The "Harbors" chapter is a fair example both of Stilgoe's general method and of the note of false elegy that pervades the book. It begins with a nostalgic salute to the builders of wooden boats and to the continuous maintenance work needed to keep them afloat. All the boats mentioned are, significantly, pleasure craft—sailboats, skiffs, and small motor cruisers. The chapter goes on to note, sadly, the triumph of fiberglass over wood in the evil 1960s. (In a memorable insult delivered by an older technology to its newfangled successor, the great wooden boat designer L. Francis Herreshoff once likened fiberglass to "frozen snot.") The "plastic" boats required less maintenance, so there was less work for the traditional boatyards; and as the new craft became lighter and lighter in weight, the old marine railways were torn up to be replaced by Travelifts. Many boatyards went out of business or were swept off the foreshore by yacht marinas. Now-according to Stilgoe-the marinas themselves are under threat, for "boatyards and marinas are worth more as vacant lots suitable for condominium development than as operating businesses."

The harbor of Stilgoe's glory days was a noisy, active place, with people caulking, painting, replanking, tinkering with marine diesels, and killing off the shellfish population with the toxins from their antifouling bottom paint. The harbor whose coming he unveils is silent and passive—a place where people go only to gawk at a seascape empty of all significant activity.

Harbors exist merely as parking lots in which boats temporarily dock, midway in odd passages from garages and inland boat dealers to garages again. And tourists stand on wharves, charmed by the neatness, by the quiet, oblivious to the economic and social change so manifest in the fiberglass boats and the condominia.

There's more rhetoric than truth in Stilgoe's vision of the death of the harbor. There has been no sudden Fall, as he describes; rather, change has come in a long, uneven drift whose general direction has been apparent since the early nineteenth century, but whose habit of speeding up, slowing down, and sometimes reversing itself has tended to confound its forecasters. Whenever coastal shipping and inshore commercial fishing have gone into decline, the slack in the seaside economy has usually been taken up by the tourist, retirement, and recreation industries. The Napoleonic Wars and the consequent naval blockades of cross-Channel shipping routes was a partial cause of the great burst of resort-building on both French and English coasts.

Diagnosing death depends on what you are prepared to count as life. The elegiac gong was being sounded on Stilgoe's home coast for many years before he himself arrived there. The Federal Writers Project guide to Massachusetts (1937) noted that tourists (known then, more politely, as "visitors") were Cohasset's "main source of revenue," and Samuel Eliot Morison, in the *Maritime History of Massachusetts* (1921), declared that *his* Massachusetts Bay was dead and gone: "Yachting centers have now replaced the fishing villages; Italian gardens and palaces blot out even the memory of the rugged seashore farms."

As for Stilgoe's surprising requiem for the passing of the yacht marina, environmental groups everywhere will cheer the news. But it would be premature to light the cliff-top bonfires yet. It's true that many pint-sized marinas inside old fishing harbors are losing out to "dockominiums"—apartment blocks, each with a small maze of mooring floats at its feet. However, there is big money in the marina business. The going rate for a marina slip is about \$10.00 per month per foot of boat length, or \$3,600 a year to tie up a small family cruiser to a pontoon. A large marina will have close to two thousand individual slips with an annual turnover of perhaps \$8 million. The new marinas are too big for the harbors that used to contain them: shielded by their own riprap seawalls, they sprout, like bleached fish bones, from every available patch of urban shoreline, as familiar a staple of coastal architecture now as piers and lighthouses. While Stilgoe watched, the harbor moved elsewhere.

Julia's City

I CAME TO LIVE IN Seattle in 1990, when I was forty-seven. It was late—very late—in the day for a new start. Literally so. At the departure gate at Heathrow Airport, it was announced that the flight would be delayed for an hour while engineers fixed a minor problem with the instruments. One hour grew, announcement by announcement, into ten, and it was dark when the plane eventually took off and we flew into the longest night I've ever known. There was a faint blue glimmer around the edge of the Arctic Circle, but otherwise the world was black. Working in the dim cone of light shed by the lens in the overhead console, my watch set to Pacific time, eight hours short of what felt like reality, I scribbled in a notebook through the in-flight movies and meals. I wrote excitedly about the life I hadn't yet begun to lead: about the companion whom (as it seems now) I barely knew; about the house we had not yet found to rent; about the book I hadn't yet written.

By the time the captain's voice came over the loudspeaker system to say that we were passing the lights of Edmonton, this unlived life was in perfect order on the page. There was the room, furnished with books, overlooking the water; the boat tied to the dock, within view of the window; the chapter steadily unfolding on the typewriter; my companion, pecking away at her computer within earshot. The scene was framed by fir trees, rimmed with sea. It included a softly lit restaurant, Italian, with the level in the bottle of Valpolicella sinking fast; the voices of friends, as yet unmet; the unbought car in which we scaled a logging track over the high Cascades; long, sane days of reading and writing and talking; rain on the roof; a potbellied woodstove; love in the afternoon.

Looking back at the scribbler from a three-and-a-half-year distance, I see (of course) that he's a flying fool: a middle-aged man, inflated with

unlikely hopes, trying to defy the force of life's ordinary gravity. Sailing over the wilds of Alberta at 38,000 feet, in time out of time, there's only one direction for him to move in, and it's *down*. At best, he deserves to figure as the fall-guy hero of a comic novel.

Yet the West wasn't settled by realists. I think of James Gilchrist Swan, walking out of a deadly marriage in Boston in 1850 to take ship for California and the Washington Territory. In the same year, Dr. David Maynard walked out on his wife and family in Ohio, set off on the Oregon Trail for Puget Sound, and became a founding father of Seattle, the city's first real-estate magnate. Swan was thirty-three, Maynard forty-two, at a time when those ages were a good deal older than they are now. The graveyards of the Pacific Northwest are packed with people like Swan and Maynard—last-chancers who left their failed businesses and failed marriages back east, hoping, against all experience to the contrary, that things might yet work out differently for them.

Jolting clumsily from cloud to cloud, its engines working in disquieting bursts and hiccups, the plane lost an awful lot of height in no time at all, and suddenly we were there, swaying low over Seattle. Lake Union was a black hole encircled by light; a late ferry, like a jack-o'-lantern, hung suspended in the dark space between Elliott Bay and Bainbridge Island. We scraped over the tops of the banking and insurance towers of downtown, and as the aircraft steadied itself on its glidepath I felt a rush of dizzy panic at what I'd done.

We found a house on Queen Anne Hill and furnished it from yard sales, joining the Saturday-morning drift of cars with out-of-state plates and people with out-of-state accents. The idea that my own move was a strikingly bold and original one was blown clean away at the yard sales, where everyone in sight was hastily patching together the ingredients of a new life. We were all chasing the same old things, hoping that their comfortable and well-used air would rub off on us and make us feel less keenly our own awkward novelty in the landscape. I bought a couch on which, I speculated, the sixteen-year-old Mary McCarthy might have been found necking with the painter Kenneth Callahan in 1928, when the precocious McCarthy was making her debut in the White Russian bohemia on the south slope of Queen Anne. Saturday by Saturday, the house filled with congenial bits and pieces, each one somewhat scratched, or stained, or tarnished, or in need of glue or reupholstering: within six weeks it looked as if we might have been living in Seattle all our lives.

I was a newcomer in a city of newcomers, where the corner grocer came from Seoul, the landlord from Horta in the Azores, the woman at the supermarket checkout from Los Angeles, the neighbor from Kansas City, the mailman from South Dakota. Every so often I would meet someone close to my own age who was born in Seattle, but it nearly always turned out that his or her parents had moved here during the Boeing boom of the early 1940s. It is comfortingly hard to feel a misfit in a society where no one you know exactly fits; but to live, rootlessly, among so many other uprooted people does tend to make you feel like a guest at some large, well-appointed but impersonal hotel. Seattle manners also seemed suited to a hotel: civil, in the chilly fashion of strangers keeping other strangers at arm's length.

There was another city, though, seen in rare glimpses and at a distance. Down by the Ship Canal, along Ewing Street, in the atmospheric tangle of cranes, ships, sheds, and floating docks, I eavesdropped on an older Seattle. The tug captains from Foss Maritime, boatbuilders, marine engineers, and sea entrepreneurs had a language of their own. They talked in gruff, laconic wisecracks and were masters of the sly obliquity that takes the indirect route to the heart of the matter. Unable to contribute, I was happy to offer myself up as a sacrificial stooge in return for being able to listen. The talk was knowing, intimate, affectionate, and malicious by turns—closely akin to the London gossip that I'd left behind me. These people remembered one another's parents and grandparents; they could speak allusively, confident of being understood; their city was an intricate closed circuit, built on a deep reservoir of shared memories and shared labor in the shipping and timber industries. To an outsider, it looked like a far happier city than the Seattle I saw most of-the Seattle of the lone Greenlake joggers, the transplants, the anxious liberals in REI outdoor gear and Volkswagen Cabriolets.

The society of the Ship Canal made me feel homesick and threw my own situation here into sharp relief. Lacking a usable past, we newcomers were like amputees. Without a shared past, we were short of humor, short of intimacy, short of allusions and cross-references—short of that essential common stock of experience that makes a society tick. It was no wonder that living in Seattle sometimes seemed like perpetual breakfast-time at some airport Sheraton.

At the Seattle public library I was struck by the busy prominence of the Genealogy section. I'd always thought that digging up one's ancestors was an eccentric hobby, and that people who went in for it—Mormons rescuing their dead relations for Judgment Day, English snobs claiming descendence

from the belted Earls of Loamshire—were to be given a wide berth. But in Seattle, suddenly hungry for history, I saw the point of trying to patch through a connection between oneself and the articulate and meaningful past. This was a place where everyone felt in need of a family tree.

Having no ancestors of my own in the Pacific Northwest, I bought some at a Queen Anne yard sale. They came in a job lot in a Red Delicious Washington Apple box and cost me \$15.00. The early birds had been picking at the contents of the box, but there were still more than a hundred sepia photographs left, some going back to before the Civil War. A little book of portrait miniatures, taken by a Philadelphia photographer, showed an extended family, including four men in Union army uniforms and a platoon of grim-visaged aunts in mobcaps and crêpe. Some photographs came from Maine; some from Albert Lea and Austin in Minnesota; but the bulk of the collection had been taken by J. Foseide, Artistic Photographer, of Buckley, Wash., and Pautske, Artist, of Auburn.

The name McNish was written in pencil on the back of a picture of a waterside lumber mill, its employees posing stiffly in line in the foreground. Sorting through the heap on the floor of my study, I found the ghost, at least, of a story. There was a Buckley man, moustached and pomaded, in wing collar and white tie. Though his nose was on the large side and his eyes seemed a little shallow, he looked handsome and self-assured, like a successful door-to-door salesman. From Austin, Minnesota, came a plump girl of high-school age, sweet and pudgy, first found garlanded with flowers in a tableau depicting the Three Graces. Soon the man and the girl were in the same picture. Here they were with a baby. And another. And another. The first of the amateur snapshots showed the couple on a rowboat outing, with a son of ten, or thereabouts. The woman grew, photograph by photograph, from plump to stout. She put her hair up in a not-too-tidy bun, and in the course of a decade or less she lost her meek smile and took on an expression of tired resignation. Meanwhile the man's moustache went gray; he began to wear steel-framed specs and an Oddfellows pin; at sixty or so, he sat behind a great desk piled with ledgers, his hair still exuberantly full, though nearly white now. Someone had scribbled "Uncle Alonso and Aunt Ottie" on the back of one of the husband-and-wife pictures, but there were no more clues.

I drove to Buckley, an engaging town, its 1890s Main Street still largely intact, and plodded up and down the rows of tombstones in the cemetery, hunting for names and dates. I called up Murray Morgan, the great Washington State historian. In the newspaper archive of the University of Washington I scrolled through the *Buckley Banner* on microfilm. Bit by bit, I

came to know the family in the cardboard box—and to anyone without ancestors in western Washington, I commend Alonso and Ottie Bryant as the perfect proxy forebears.

Alonso had grown up in Machias, Maine, where he was born in 1855. His grandfather had fought in the War of Independence and was proud of having once caused a British sloop to founder on a sandspit by putting out the light in the Machiasport lighthouse and erecting a decoy light a few hundred yards south of the harbor. Alonso himself was a boy during the Civil War, and would later remember carrying letters to the post office for the wives and girlfriends of Union soldiers.

In the first half of the nineteenth century, Machias had been an important port in the timber trade, but as the loggers moved westwards, the towns on the Maine coast drifted into recession. When he left school, Alonso Bryant worked as a casual laborer in the construction industry, but the jobs were few and far between. He went west—finding well-paid and dangerous work building bridges for the Northern Pacific Railway as it crossed the Rockies and followed the Columbia River to Portland, Oregon. I've seen those huge black timber trestles on which the trains creep over the gorges, and can imagine Alonso aloft, guiding a swinging beam into its slot in the crosshatching; a horrible job, but the money must have been good.

By the time the railroad reached Portland, he'd saved enough to set himself up in business as a builder and contractor—though not for long, because he evidently saw that the people who were making the most out of the construction industry were the suppliers and merchants, not the builders themselves. What he wanted was a rapidly growing town and a hardware store. He found Buckley.

He arrived in 1892. He was thirty-seven, a big, tough man with a dandy's taste in tiepins and starched collars, the points of his moustache oiled and twisted, his glossy hair trimmed close around the sides of his head. He swaggers through his pictures, looking as if he knows that he can still turn the heads of girls.

Buckley, on the White River south of Auburn, had been incorporated in 1890—a brand-new mill town standing in the middle of a desolate acreage of logged stumps. It had a brick main street, a newspaper, an opera house; it had great expectations. Picket fences enclosed dozens of swanky wooden villas in every phase of construction. Buckley was prime hardware-store territory.

Four years after Bryant's arrival, in the early summer of 1896, William L. McNish brought his wife and daughter to Buckley from Austin. (They weren't the first McNishes in town; a laborer, W. S. McNish, was reported by the *Banner* to have lost his tool chest in a fire at the sash and door fac-

tory in 1892.) Ottie McNish—the garlanded Euphrosyne—was seventeen, and not the most likely match for the forty-one-year-old owner of Bryant's Hardware.

Between 1896 and their eventual marriage in 1903, I've followed Ottie and Alonso through the social columns of the *Banner*, where he makes a big splash and she a few shy appearances. By now, Alonso was a justice of the peace, active in the Republican Party, a bachelor bigwig in great demand. Ottie's main claim to public attention was her singing voice. She joined the Presbyterian choir and graduated to singing solos, as when she took a leading part in the oratorio "Under the Palms" at the Presbyterian church.

I see Ottie in the hardware store, dithering in the fastenings section, and Alonso, self-important, avuncular, thumbs in his buttonholes, setting her to rights. He smells of patchouli oil and cigars. (I know about the cigars because I keep my business cards in a scuffed black-leather wallet that once belonged to him, and it is lettered, in gold leaf, Compliments of Julius Ellinger & Co. Havana Cigar M'frs Tampa Fla and New York.)

For a muddy frontier town—and perhaps because it was a muddy frontier town—Buckley had an intense social calendar. Newcomers were immediately enrolled by the clubs, church groups, and Masonic lodges. In winter there were musical evenings in private houses. Both Ottie and Alonso attended one at the home of Mr. and Mrs. J. F. Jones, where Miss Elisabeth Jones "rendered several choice selections in her rich contralto." There were organized trips to Tacoma, for Christmas shopping and to see the Ringling Bros. Circus. The town turned out for a demonstration of mental telepathy at the Opera House by Keller the Hypnotist. At the Women's Club, the mayor's wife, Mrs. McNeely, read a paper on Sappho and Mrs. Browning. The Buckley Dramatic Club mounted regular entertainments, including one of which I have a photograph; Alonso appears in it, resplendent in eighteenth-century wig and stockings.

In September 1903, the Bryant–McNish wedding merited seven paras in the *Banner*.

Wedding Bells.

At the residence of Mr. and Mrs. Wm. L. McNish, in Buckley, on Saturday, Sept. 19, at 7 o'clock P.M. occurred the wedding of their daughter, Miss Ottie R. McNish, to our well-known townsman, Mr. Alonso M. Bryant.

The wedding was a quiet one, only the near relatives of the bride and the wife of the officiating minister, Rev O. E. Cornwall, witnessing the ceremony. After a delicious wedding supper the bride and groom departed on the evening train for a brief bridal tour to Victoria, B.C., and other points down the Sound.

A goodly number of friends gathered about them at the station, with congratulations and showers of rice. Their friends who are many wish them a very happy journey together through life.

They will soon be at home to their friends at their new residence on East Main Street, Buckley.

The bride is a young woman of reserved habits and is held in high esteem by all who know her. She has been a resident of Buckley for a number of years and her friends are not a few.

The groom is one of our hardware merchants and has been here for a period of eight or nine years. In that time he has built up a good business and is highly respected by all who know him. THE BANNER joins the host of friends in wishing them many years of unalloyed pleasure.

Ottie was twenty-five, Alonso forty-eight, though in the pictures of the couple one might mistake her for the older of the two, she is so ample and matronly, Alonso so spruce. (I suspect him of dyeing his hair—or, possibly, of persuading J. Foseide, Artistic Photographer, to work some darkroom magic on it.)

Ottie had babies—three sons and a daughter. Alonso went into local politics. He was on the school board and the town council. He was town treasurer and later mayor of Buckley. In 1913 he was elected to serve as a state congressman at Olympia. In the young and fluid society of western Washington, this rolling stone from the East Coast had become a fixed pillar of the community. In the portrait that I've propped beside the typewriter he is looking up from his papers in the state house at Olympia: his eyes swim behind his glasses; his broad mouth is set in a downturned arc; he exudes that air of sombre rectitude that might gain him election to high office. He looks too refined for the large, practical hands he keeps closed, as if they embarrassed him.

Ottie's health broke in her fifties and she died in 1935, aged fifty-eight, but Alonso continued to run the hardware store in Buckley, which spawned an offshoot in Kirkland that was managed by their son, Mariner. When the United States entered the Second World War after Pearl Harbor, Alonso—

who could remember his grandfather talking about the War of Independence, and who had himself lived through the Civil War—was still in business. He was eighty-seven in 1942, when he died at his daughter's home in Seattle on July 19. I was then five weeks old—old enough, by a whisker, to count this pioneer of the Pacific Northwest as living in my own lifetime.

The newcomer here should at least be able to feel that he or she is in the historical swim of things, for the history of the Pacific Northwest since 1792 has been a history of newcoming and newcomers, a braid of interwoven Alonso-and-Ottie stories. The stories are all around us—in the fabric of the houses we live in, in the names of places and streets; they go begging at yard sales and can be fished out of Dumpsters.

My own house (built in 1906 in the wake of the Alaskan gold rush, a creaky timber warren of rooms with sloping floors and doorways that have twisted out of true—a relic of another wave of newcomers to the region) stands just below Mount Pleasant cemetery on Queen Anne Hill. I like to walk among the tombstones there, where so many of the dead are buried thousands of miles from where they were born. Carl Ewald, born near Marienwerder, Prussia, June 12, 1817, died in Seattle, June 27, 1909. Mary M. Ziebarth, geb. Kneable... Caroline Jacobs, born in Norway, died at Seattle, Washington... Isabella Blair Ormston, native of East Lothian, Haddington-Shire, Scotland . . . William Dickson, native of Belfast, Ireland . . . Anna Lloyd Tinkham, born May 28, 1849, Wales, England [sic], died Feb 9, 1908, Seattle, Wash. One inscription pleases me particularly: Sylvester S. Bower, born Newfield, N.Y., April 19, 1854, came to Wash. 1889, died July 12, 1936. That the date of his arrival in the Pacific Northwest should be commemorated as one of the three salient facts of Mr. Bower's life seems exactly right. That's how it feels to me, and how I want it on my own tombstone, please: . . . came to Wash. 1990 . . .

You can't look out of the window here without seeing that you are in an uprooted and homesick land. Seattle's domestic architecture pines for a world elsewhere. The old German Club on 9th Avenue, with its tall and narrow second-floor windows, harks back to some tree-planted *strasse* in nineteenth-century Hamburg or Cologne; the well-to-do English who settled around St. Mark's Cathedral on Capitol Hill had their own mullioned and half-timbered enclave of replica manor houses, their details copied from Chamberlain's *Tudor Homes of England*, the great architectural sourcebook of American mock Tudor. Close by the English quarter, a

graystone Russian dacha glooms over a lordly view of Interstate 5 and Lake Union. Down in the International District, the glum brick buildings with balconied shrines set high over the street are homesick for Shanghai, while the "classical" terra-cotta friezes of downtown, with their gargoyles and cartouches and anthemions, are homesick for history itself—anybody's history, and the older and grander the better. Stand near the corner of 3rd Avenue and Madison, and look up at the wild and dizzy conflation of Ancient Greece, Ancient Rome, English Gothic, Art Deco Egyptian, French Empire, Italian Renaissance, all handsomely molded in Green River mud. Out in the countryside, one finds a Bavarian mountain town, a Norwegian fishing village, and, in the Skagit valley to the west of Mount Vernon, an entire landscape that even a Dutchman (with a slight case of astigmatism) might plausibly mistake for the flat farms and poplar-fringed villages of Friesland.

What is true of the architecture and the landscape is even truer of people's domestic interiors here. When I first visited Seattle, to research a chapter of a book, I got used to the oddity of parking my car outside a ranch-style bungalow in a street of more or less identical ranch-style bungalows, then, once through the door, taking off my shoes and entering the cross-legged-on-the-floor life of an immigrant Korean family, with its rugs and carved chests. Outside lay Greenwood, or Ballard, or Phinney Ridge: inside, we were halfway back, at least, to Seoul or Inchon. When I came to live here, I found that half the houses I visited in Seattle were like this-nostalgic reconstructions of another time, another place. A ground-floor apartment turned out to be a Greenwich Village loft, the plaster on the walls hacked off to expose bare brick, the ceiling strung with decorative, nonfunctional plumbing. I'm writing this with a mild hangover, incurred at a party last night in the Madrona district: the American owners of the house were Anglophile enthusiasts of Early Music, and stepping through their front door one entered a sort of legendary Merrie England of shawms and sackbuts and psalteries, of morris men and maypoles. The pictures on their walls were watercolors of the great Elizabethan piles, like Moreton and Hardwick halls; the books on their shelves had the sort of bindings that you rarely see outside the set on which Alistair Cooke used to introduce Masterpiece Theatre; the books themselves were described to me by an awed friend who had checked out the library in the downstairs bathroom as "works of medieval feminism." I like to think that the next-door neighbors were passionate Arabists whose living room was a faithful reconstruction of a merchant's diwan in a house deep in the Aleppo souk; or

maybe tribal-Africa buffs, with a houseful of spears, blankets, and goatskin drums.

For Seattle tends to slop about in time and space. In New York, vou're rarely in doubt that this is New York and the time is the present, but there's less here-and-now in Seattle than in any city I've ever known. Its woody plots and inward-looking houses, screened from their neighbors by thick tangles of greenery, allow people to live in private bubble worlds of their own construction. My neighbor's Seattle isn't mine-or yours. There are days when the city seems to me to be dangerously like an oldfashioned lunatic asylum: here's the lady who believes herself to be Anastasia Romanov; and there's Napoleon; and this gentleman is Alexander the Great; and here's a teapot... Seattle does not insist—as both bigger cities and smaller towns do-on its own overbearing reality. It is unusually indulgent to those of its citizens who prefer to live in dreams and memories. If you want to bury yourself in a cottage in the trees, pretending that you're living inside a nineteenth-century French novel, or that you're back home in another decade and another country, Seattle will do astonishingly little to disturb your illusion.

My Seattle is a city of émigrés and migrants, and inevitably I see deracination as part of the basic fabric of the place. But I've planted a much deeper root here. My companion of the first para of this piece became my wife, and we have a child, now a year old. My American daughter—a Washington Native, as they say on the bumper stickers.

Even now, I see our two cities diverging.

For Julia, the word "tree" already means the shaggy cypress and the drooping fir, whose inky green will never convey to her the alien and depressive associations that they have for me. To my English eye, the Douglas fir has a sort of grim splendor, but it seems to me a congenitally unhappy vegetable. To Julia's Pacific Northwestern eye, it's the most homely tree she knows; it's where the squirrels live and where the little pine siskins fuss and flutter.

So, too, the word "water" is coming to mean the deep and dusty stuff of Puget Sound, on which she has already been afloat. To me this water, which drops to more than a hundred fathoms just a few yards out from the shore, is uncannily, shiveringly deep, and queer things live in its ice-cold profundity, like *Architeuthis*, the giant squid, and the brainy, jet-propelled *Octopus dofleini*. I grew up in a country where the wild things were rabbits

and foxes; she is coming into possession of a world where killer whales live in the watery suburbs of her native city, where real bears raid trash cans on the outskirts of Everett and mountain lions are sometimes spotted in Gig Harbor. God knows what she'll make of the wild, exciting world of Beatrix Potter's Lake District animals, Peter Rabbit and Jeremy Fisher.

Growing up in the mock-antique, mock-heroic architecture of Seattle, Julia won't be amused by its comedy or touched by its pathos, as I am: it'll just be old to her—as real Tudor and Jacobean architecture is old to me—and dull, as merely old things always are. When she gets to see Florence and tires of the long, hot hike around the Uffizi and the Bargello, she may be fleetingly reminded of Seattle; as when she visits her English grand-parents in Leicestershire, she may notice some battered, down-at-heel versions of buildings that are in a fine state of upkeep back home.

As children of migrants to the West must do, she'll grow up with a sense of distances unlike anything that either her New Yorker mother or I knew as children. Her maternal grandfather lives on the Upper West Side of Manhattan, her English grandparents in Market Harborough, and Julia has been born into a house where the phrases "back east" and "in England" are constant, almost daily reference points—where two shadowy worlds-elsewhere hover in the middle distance behind the world she lives in.

This is such a standard feature of West Coast life that I bet Julia will share it with half the children at her school. I've heard people born in this region talk of it as "out here," as if to be a westerner was to be in some sense, however faint and ancestral, in exile from the warm center of the world. I hope my daughter doesn't grow up to speak of her birthplace as "out here," and doubt that she will: if the present tilt of the world economy continues, if there's even a grain of truth in all the boosterish talk about the Pacific Century, then Seattle will be, and perhaps already is, a good deal closer to the center of things than either New York or London.

This is her city in a way that it can never quite be mine; and as new-comers must take their cues from the natives, I now have to learn about Seattle from Julia. I'm making a beginning. I'm relearning the meaning of the word "tree," and a whole enormous syllabus looms ahead. But I am—in my daughter's American English—a quick study. I'll get to figure it out.

Edge Walking on the Western Rim, Sasquatch Books, 1994

Why Travel?

A CURSE OF TRAVELING is that one is so often made to supply reasons for doing it. STATE PURPOSE OF VISIT, demands the visa form. "Pleasure" sounds downright suspicious—I imagine the "blind Sheikh," Omar Abdel-Rahman, framing the word, letter by letter, on his application to enter the United States. Better to come up with a phrase that conveys some wispy and innocuous thread of intention, like Robert Byron's pretext for wandering in Persia on the trip that became *The Road to Oxiana*, "to look for coloured architecture," or Alexander Frater's happy excuse for going to India, because he liked rain.

If you admit the real reason, you're liable to attract the attention of men in white coats, or the police. For travel is a kind of delinquency, more often rooted in the compulsion to escape the boredom and responsibilities of home than it is in any very serious desire to scale the Great Pyramid of Cheops or walk the length of the Great Wall of China. It's kinder to say, "I'm going to Surabaya," than just to say, "I'm going"—but as you wrestle your bags through the front door and into the street, it's the leaving-behind, the going for the going's sake, that quickens the blood and makes the street itself look suddenly different, full of promise even on this bleak morning. Yesterday it was a dead end, today it's the beginning of the road to who-knows-where. Oh, Surabaya, maybe; and maybe not.

The street looks different, and so does the person standing on it. Yesterday's creature of duty and habit is today's free spirit, a traveler, open to adventure as the dictionary defines it, *That which happens without design; chance, hap, luck.* Travel in its purest form requires no certain destination, no fixed itinerary, no advance reservations, and no return ticket, for you are trying to launch yourself onto the haphazard drift of things and to encounter whatever chances the journey may throw up. It's when you miss the one

flight of the week, when the expected friend fails to show, when the prebooked hotel reveals itself as a collection of steel joists stuck into a ravaged hillside, when a stranger asks you to share the cost of a hired car to a town whose name you've never heard, that you begin to travel in earnest.

Nowadays you need to work quite hard to open your life to the workings of hap and luck. Nothing short of a terrorist hijacking is likely to deflect the modern traveler from his inexorable path as he jets from one major city to another, from Trust House Forte to Holiday Inn, with CNN talking him to sleep from one end of our shrunken-orange world to the other. You have to find some other way of going.

I like to travel as much as I possibly can in a boat small enough to manage on my own, and gratifyingly rarely do I land up where I'd meant to go. The wind gets up nastily—or dies altogether—in otherwise perfect weather; a gale warning is broadcast over the radio; I misread the tide tables and on the harbor approach find the entrance to be a scarifying cauldron of boiling milk; idly gazing at the chart, I notice a deep cleft in the woods, well protected by a sheltering headland; a jellyfish blocks the water intake, and the engine overheats; the summer haze suddenly thickens into fog so dense that a swimming seagull is lost to view in it at thirty feet . . . and so on, ad inf. It's not at all like flying British Airways 087. It makes getting from, say, Ipswich to Newcastle (over a period of a week, in fair weather) at least as interesting and eventful as riding the turnpike in the age of the highwaymen, and every so often it reminds one of the roots of travel, buried deep in travail and trepalium, the triple-staked torture of the Inquisition.

Bad weather and mishaps have led me to all sorts of curious places, from Port St. Mary on the Isle of Man (where I landed up living for a year) to a strange island village in British Columbia, where all the men spoke in the Falls Road accent and responded to me as if I were the Special Branch in oilskins. In my experience, nowhere in the world is more compellingly beautiful than the cluster of houses around the harbor into which you've floundered out of a gale at sea: glorious Grimsby! kindly Pwllheli! merciful Dover! A five-foot swell with a cross-sea breaking over it can make a between-the-wars council house seem a fine piece of architecture, and an open pub a greater wonder than Chartres Cathedral.

The rougher the travel, the more you value the places where you stop and the people you meet there. Most of the glory that has attached itself to legendary destinations like Samarkand, Timbuktu, and Mandalay derives, I suspect, from the dangers and miseries of getting to any of them. By the time the Renaissance traveler at last had the citadel of Samarkand in view, he was in such a state of exhaustion, wonder, and relief that he would have been no less ecstatic to find himself within sight of Potter's Bar. It's hard to replicate that sensation now, unless your plane has just made an emergency landing and you've helter-skeltered down the inflatable yellow chute, or you've sailed to Grimsby in a small boat.

I keep on writing you. I mean tu—the second person insistently singular. For this kind of pure, serendipitous travel is a solitary vice. Going with a companion is cozy, but you might as well be going on a bus excursion. The marital parliament has to sit in order to debate and settle the issue of lunch. You leave unexplored all the turnings that you would have taken on impulse if you were alone. The stranger doesn't approach you in the dark bar (you're up on the terrace, drinking cappuccino), you don't get off at the wrong station, you don't go netting larks with the retired lieutenant of police. Adapting Clausewitz, traveling in pairs and families is the continuation of staying at home by other means.

Most damagingly of all, in the luck and hap department, you are simply not lonely enough when you travel with companions. "I was hemorrhaging with loneliness . . . " wrote Edward Hoagland in African Calliope. That captures a mood. For spells of acute loneliness are an essential part of travel. Loneliness makes things happen. It's when you haven't spoken to a soul for days, when your whole being feels possessed by the rage for company, that even the withdrawn social coward feels an invigorating rush of desperate courage. Then you start risking things you wouldn't dare at home. Steeling yourself, you make that call; you go over to the stranger's table; you gratefully accept the dubious invitation. This is how adventures begin. This is why people find themselves waking up in strange beds and don't go home again.

Every journey is a quest of sorts, though few travelers have more than a dim inkling of what it is they're questing for. Most of us leave the house with, at best, a tangible absence in the heart, a void of indeterminate proportions, that we vaguely hope to fill with—what? Some person as yet unmet? Some life beyond the life we're leading? How can I know what I'm looking for until I see what I've found? But that sense of incompleteness gets us on the move. As the boat slips its moorings, or the familiar city tilts suddenly away, free of the climbing plane, and you remember with a pang the unlocked kitchen window and the unpaid telephone bill, you think, It doesn't matter, everything will be different when I come back; I will be different when I come back.

So watch the visitor standing in front of an illuminated real-estate agent's window in a foreign town, searching surreptitiously for that other life that has somehow escaped her until now. Her face is a study as she

scans the laconic poetry of hectares, kitchens, beds, and baths. She's raising goats from a tumbledown farmhouse in Provence. She's writing a screen-play in a rented apartment overlooking a Pacific beach in Venice, California. She's opening a small fish restaurant, with living quarters above, on the not-as-yet-entirely-spoiled Greek island of Litotes. Traveling, the self goes soft and pliable. You can recast your life in shapes you wouldn't dream of when you're stuck at home.

The good traveler is an inveterate snoop, always ready to poke his nose into other people's business and ask impertinent questions. How much did you have to pay for your ox? How long does it take to learn to play the nose flute? So how did you come to lose your other leg? The surreal dottiness of phrase books is a true reflection of the fact that when people go abroad they really do say the weirdest things. But you have to ask some odd questions when you're trying out someone else's life for size. At home, I'm a grump; it's as much as I can do to pass the time of day with the mailman and the checkout clerk. On the road, I am a champion pesterer, milking people for the workaday details of what they do and how they do it, and always the underlying question is *Am I cut out for this, could this life be mine?* So, in imagination, I've been an agricultural-machinery salesman in the Middle East, a barge operator on the Rhine waterway system, a drug smuggler in the Florida Keys, a tuna fisherman in the Cape Verde Islands. I've grown olives in Tuscany and established a salmon farm in the Hebrides.

Worming your way into the skin of a true denizen, you begin to see the landscape itself as a real place and not just as the pretty backdrop to your own holiday. But it is a risky exercise. One day, you'll find a life that seems to be a perfect fit—and you'll be there for good. The world is littered with travelers who asked one question too many, got a satisfactory answer, and never went home again. It happened to me. For the last four years I've been living in a place that I went to visit for a month. But I got talking to a stranger.

Sunday Times, January 1994

The Waves

I LOVE TO WATCH WAVES. Away from a suitable ocean, I'll happily stand by a puddle in the street on a windy day, gazing at air transferring its energy to water. The obsession goes back a long way: the earliest known Egyptian hieroglyph depicts a wave, and so does the first Neolithic decoration on the rim of a cooking pot. Of all natural symbols, the breaking wave is the most laden with suggestive meanings. For several thousand years, the waves have been talking power and sex and death to us: it's hardly surprising that we watch and listen to them so raptly.

Nowhere do waves break with more reliable splendor than on the melancholy coast of Oregon, where the great Pacific wave trains come to a spectacular end on beaches of pulverized green sand. Everything about the place is sombre—the crumbling basalt cliffs, the dripping conifers, the slanting gray cathedral light. This is not the shallow, pretty, recreational sea of Newport, Cannes, or Brighton. Too moody and frigid for boating or swimming (except by those hardy fanatics who go in for cruel and unusual self-punishment), it radiates menace even on days of balmy sunshine. Its utterly unfriendly character is caught in the names along Route 101, the coastal highway: Cape Foulweather, Jumpoff Joe, Humbug Point, Seven Devils, Devils Elbow, Devil's Punchbowl, Devil's Kitchen.

The highway is dotted with "waysides" where mute couples in Winnebagos sit for hours on end, staring at the ribbed swells as they roll sedately out of the fog and then explode in a seethe of powdery white. The couples look like devotees crowding in to see a famous epiphany. They have the stillness, the inward expression, of people in the presence of a religious mystery, as if something obscure in themselves were being answered by the crash and boil of the surf.

On the day of the autumn equinox, hoping for high winds (there's no

meteorological basis for the "equinoctial gales" of maritime mythology, but the end of September does seem to bring an awful lot of stormy weather), I dragged my wife, Jean, and two-year-old daughter, Julia, down to Bandon, Oregon, for a wave-watching vacation. We camped out in a scabbed beach cottage, close enough to the high-water mark for its timbers to shudder when a big comber hit the sand. We arrived in darkness. I slid open the glass door at the back of the cottage and let in the hollow growling of the surf, breaking beyond a line of low dunes. Julia, usually fearless, shrank from the sound.

"It's a good noise. It's the sea."

"Sea?" Her voice was full of skeptical derision. The only sea Julia knew was the tame stuff of Puget Sound, where the waves barely tickle the miniature beaches on which they break. These Pacific waves had the raucous volume of a low-flying F-111. "Close door! Close door!" Julia said, her face crumpling in panic.

I stepped out onto the deck, sliding the door shut. Inside the cottage, Jean drowned out the scary ocean with the safe burble of the radio while I listened to the regular thump of the sea against the sand, punctuated at thirty-second intervals by the flat oboe note of the harbor foghorn a mile to the north.

The cliffs around us were a patchwork of lighted picture windows, each identical to the others—same standard lamp, same outward-facing director's chairs, same telescope on a tripod aimed into the blue. As inland rooms look to the fireplace, these high-ceilinged living rooms seemed to be trying to warm themselves in front of the ocean. Where I could see activity in them, it was the cautious movements of the bad back, the replacement hip, the game knee. In the winter of life, the sea lulls and comforts. It has the look and sound of eternity without putting one through the trouble-some formality of having to die for it.

The next morning, the foghorn was still mooing and the sky lay on the sea in wreaths and coils of smoke. We strolled through a low rain cloud to the beach, where eight distinct lines of breakers were pounding on one another's heels. We led Julia to the edge of the "swash"—a broad glisten of water, thin as a sheet of Saran Wrap, that coated the sand for twenty yards or so ahead of the final, feeble breaker. The tide had begun to flood, and every few seconds the swash improved on its last effort by a matter of inches. Julia hid behind her mother's knees and screeched, "Water coming!"

The idea that the sea might just keep on coming has always been a source of anxiety. Eighteenth-century theologians liked to see the tideline as mate-

rial evidence of God's mercy: His divine finger had traced it in the sand when He commanded the waves to stop their advance, and by His Providence man was saved from being swallowed by the chaos of the ocean. The Salish Indians around Puget Sound believed the tideline was a kindness bestowed on them by the Changer, who, with the help of Raven, Supernatural Halibut, and other personages, had made the sea lay bare its clams for human consumption.

It'll be a year or two before I can discuss theology with Julia. All she saw was the sea *coming*, a roaring monster on the loose, and, starting to squall, she tugged us back. "No talking! No sea! Go away! Go home!"

Bandon was already on short winter hours. The summer people had mostly gone, and CLOSED signs hung in the windows of half the restaurants, gift shops, and boutiques. Our footsteps echoed in the huddled grid of timber buildings that had once been a busy port. Until a few years ago, Bandon went to sea in a big way, shipping millions of board feet of lumber from the mills along the Coquille River and serving as home base to a fleet of fishing boats. But the Oregon forests were denuded now, the salmon and halibut fisheries very nearly exhausted, and Bandon like so many towns along this coast had to be content with merely looking at the sea from which it had once earned its living.

There was money to be made out of its sea view. Far from falling into decrepitude, the town was on a spree of new construction. Houses were going up all along the cliffs—strange architectural confections, part Spanish galleon, part Victorian bed-and-breakfast, part Florida condo, part log cabin. From every available nook and ledge they sprouted belvederes, crow's nests, widow's walks, and gazebos, so their owners could keep the Pacific under round-the-clock surveillance. With his eye clapped to his telescope and Old Glory flying from the foretop above his attic, the Bandon householder could spend his declining years brooding over the deep like Captain Ahab.

The gift shops were full of bright nautical junk with which to furnish the new houses: barometers to be tapped with a knowing forefinger; ship's wheels for the wall; port and starboard steaming lights to go at each end of the mantelpiece. While the remains of its fishing fleet rotted on their moorings in the harbor basin, Bandon now went to sea in make-believe. So did Julia. At the children's playground, she ignored the swings and slide and headed straight for a blue-and-white tugboat at anchor in a sea of woodchips. She waved us goodbye, clambered into the wheelhouse, and took off

on long, solemn voyages of several minutes apiece, her face as intent as that of a novice skier on the coconut-matting slalom run. Whatever storms she braved among the woodchips seemed to embolden her in her encounters with the real thing. On the second day, she stood her ground, scowling frog-eyed at the waves. It was late afternoon, and the tide was on the ebb. She stared the sea down.

The Bandon waves were exceptionally mature and powerful. They had probably begun about two months before they reached Oregon, as wind wrinkles in the surface tension of the sea off the coast of Japan. A tiny differential in pressure between the windward and leeward sides of the wrinkle is enough to create an embryo wave, which then builds steadily in the westerly airstream over the Pacific. Properly speaking, a wave is not a configuration of the water but a pulse of energy that travels through the water, just as it travels through a cornfield in a breeze, passing from one set of stalks to the next. The stalks rise and fall but don't move with the wave—nor does the water. The orchestrated wave that makes the circuit of a football stadium works in just the same way.

In deep ocean water, a wave train, once started, jogs effortlessly along: it will keep on going long after the wind stops. I imagine my young Japanese waves following the general drift of the weather toward the Gulf of Alaska, where they're absorbed into one of the nearly continuous storm systems there, plumped up by a gale or two, and sent down to Oregon by a hard nor'wester. By the time they reach Bandon, they have a fetch of more than four thousand miles, which is huge—nearly twice the fetch of the North Atlantic waves whose thunderous arrival on the Cornish coast I used to watch when I was a child.

Long before they come ashore, waves begin to feel the drag of the sea bottom. This friction causes them to steepen and makes the intervals between them grow shorter. At Bandon, on a day of greasy calm, these shallow-water waves, making their final run for the coast, showed as bars of violet shadow a hundred yards apart.

To keep its shape, a wave needs water at least one and a third times as deep as it is high. The moment a ten-foot swell finds itself in less than thirteen feet of water, it's in trouble. There's insufficient water ahead to fill out the bulging sine curve of the wave front, and what should be convex is suddenly yawningly concave. The wave top thins into a translucent crest, rears upward, and the whole wave folds in on itself—water crashing into air, compressing it, exploding. The energy that began with the air is

returned to the air, in surf as dense with trapped bubbles as egg whites in a kitchen mixer. The line of breakers on the beach is a fantastic dissipation of long-accumulated power. It is the fall of kings.

So at Bandon it was with the reverence due to doomed great ones that we watched the waves collapse: saw the diffused sunlight shine apple green through their refining crests; saw the moustache of foam spread suddenly wide across their lips, and then the break—the drum-roll climax, the boiling surf, the bronchial wheeze and gargle of spent water on flat sand. By the third day, braver now and newly educated in basic oceanography, Julia was saying, "Waves—big waves! Going crash!" In her new rubber boots she stomped in the waves' gleaming aftermath and chased the sanderlings, who sprinted on stiff legs across the swash, pecking among the broken sand dollars and thumbnail mole crabs.

A breaking wave has the force of a ball hammer. In a 1953 study of the impact of waves on harbor pilings in Monterey, it was shown that a three-foot breaker—a baby—hit the pilings with a force of 226 pounds to the square foot. A Pacific storm wave will shake a whole coast like an earthquake.

Our beach was littered with signs of the wanton strength of the waves: bleached gray trunks of Douglas firs—escapees from the timber mills—flung about above the high-tide line like so many matchsticks; rotting tangles of bull kelp, torn from the seafloor; even the sand, ground as fine as face powder. For anything to live in the constant bludgeoning of the surf, it had to be armor-plated, or have fantastic powers of adhesion to the rock, or be able to burrow deep into the sand for shelter.

There were tide pools in the jagged spurs of basalt that ran out from the cliffs, and here I introduced Julia to the ultimate submarine tough guys. "Creature . . . running," she said of a low-slung crab in sandy camouflage as it scuttled across the floor of the pool. I showed her how to feed a ballpoint pen to a malachite-green anemone. Its tentacles hesitantly closed around the cap, and Julia felt its queer, vibrant, otherworldly handclasp. "Creature . . . sucking!"

The tide-pool animals were magnificently alien, far beyond the reach of bunny-rabbit and dickybird whimsy, and Julia investigated them with unsmiling gravity, like a diplomat engaged in difficult negotiations with a possible enemy. She peered. She gently prodded. She rocked on her haunches, full of thought. The only report she was able to render back to her mother was the one word. "Creatures."

At twenty-three months, Julia was a good deal better attuned than I

was to the destructive violence of the surf zone. The beach itself, with its smashed seashells, randomly hurled rocks, and clumps of seaweed yanked out by the roots, looked as if a child of Julia's age had recently passed by. On the dunes, she ran about tearing out fistfuls of marram grass and flinging them onto the sand. When Jean and I built sandcastles for her, with carefully crafted moats and battlements, she took aim with her boot and joyfully blasted them to bits. In the cottage, it took her five minutes or less to reduce our orderly, maid-serviced rental world to a storm-tossed rubble.

By the fifth day of the vacation, she was perfectly at home with the waves. She graduated from the lacquerlike swash to the boiling-milk edge of the surf, where the sea filled her boots and she yelled at the breakers, cheering them on with her fists like a demented football fan. There is a passage somewhere in Freud that argues that most of us have no memory of being younger than three because until that age we are possessed by such gales of lust, rage, and dizzy elation that it would be intolerable to recall them. Julia seemed to have found in the waves something grandly commensurate with her own oceanic inner turbulence.

"Wa-ay-ves," she said back in the cottage, listening to the rumble of the surf at night. She drew the word out luxuriously and made it rise and fall like the waves themselves.

In Dickens's *Dombey and Son*, little Paul Dombey, lying terminally ill in a Brighton boardinghouse, listens to the rolling waves outside his window and asks his older sister, "The sea, Floy, what is it that it keeps on saying?" To him, of course, the talk of the waves is of his own coming death. To Matthew Arnold, in his "Dover Beach," the "melancholy, long, withdrawing roar" of the ebb tide over the pebbles spoke of the receding tide of Christian faith as it exposed the hard, cold, secular, materialist new world of Victorian England. People hear in the waves what they bring to the waves, and if, like Julia, you bring to them an inexhaustible animal vitality and a delight in bangs and crashes for bangs' and crashes' sake, they'll talk to you of life as surely as they talked of death to Paul Dombey. The zigzag pattern around the rim of the Neolithic pot, the crest of each wave poised for its downfall, is a universal symbol because it unites the extremities of human experience in a single continuous line. That's why we went to Bandon.

Walden-on-Sea

IN APRIL 1895, when he sailed from Boston in a tubby homemade sloop on a solo voyage around the world, Joshua Slocum was fifty-one and on the run from his Furies. He was then barely on speaking terms with his second wife ("[My father] and Hettie did not pull on the same rope," said Slocum's youngest son, Garfield). He was at the bitter—and litigious—end of his seagoing career. His one published book, *Voyage of the Liberdade* (1890), had attracted little notice and almost no sales. If he had hoped to follow Dana and Melville into the ranks of seamen-turned-authors, he began from a position of huge disadvantage. His father had removed him from school when he was ten. His spelling and punctuation were stuck in the third grade. Later on, his letters to publishers would speak, unpromisingly, of "litterary production," of his mind being "deffinately fixed" on his "voyoage."*

Like Conrad (who was thirteen years his junior), Slocum was pigheaded in his attachment to sail at a time when the shipping industry was converting to screw-driven steamers. As a result, he captained a succession of elderly craft carrying second-rate cargoes and manned by third-rate crews. Two ships under his command ran aground on shoals and became total losses. In 1883, he was convicted in New York on a charge of cruel and false imprisonment of a crew member, whom Slocum kept in irons in a lazarette on a voyage from South Africa to the United States. In 1884, his beloved first wife, Virginia, died suddenly aboard the *Aquidneck* at Buenos Aires. She

^{*}For the details of Slocum's life, I've relied largely on Walter Teller's Joshua Slocum (1971), the revised edition of his The Search for Captain Slocum, published in 1956. Researching his book in the early 1950s, Teller was able to interview Hettie Slocum and to meet or correspond with many people who knew Slocum more or less well. Victor Slocum's Capt. Joshua Slocum (1950), a glossy, retouched portrait of his father, is less interesting, though useful for its private memories of life aboard Slocum's ships.

was thirty-four. In 1887, in Antonina, Brazil, Slocum shot dead one crew member and injured another; he was detained, tried for murder, and acquitted on the grounds of justifiable homicide. Four months later, he grounded the *Aquidneck* on a sandbar and for the next six years he engaged in a quixotic lawsuit against the Brazilian government, claiming \$50,000 in damages for his lost ship. He returned from this misadventure, with his sons and his new wife, in an eccentric sailing craft named the *Liberdade*, built largely from the wreckage of the *Aquidneck*. The experience wasn't a happy one for the second Mrs. Slocum. When Slocum invited her to join him on further cruises, she is reputed to have answered stonily, "I've had a v'yage, Joshua."

He was a profoundly disappointed and frustrated man when he came to build the *Spray* in a field at Fairhaven, Massachusetts. Slocum's carpentry was rough but rugged. The boat, more barge than yacht, with its low sheer, blunt bow, sawn-off stern, and shallow draft, was a private ark, designed to float free of the irksome land. With no crew to make trouble, no wife to bicker with, and no perishable cargo (except for an unusually well-stocked library), Slocum took off into the blue. He meant to make the voyage pay for itself by writing travel articles for the *Boston Globe* at twenty dollars a pop, and by giving lectures at his ports of call.

The voyage was a triumph of practical navigation and boat handling. It salvaged Slocum's reputation as a master mariner when he would otherwise have been remembered, if at all, for his misfortunes, bad calls of judgment, and costive tangles with the authorities. By the time he was halfway around the globe, he was tasting fame of the bright but evanescent kind that comes to astronauts and Olympic skaters. In 1896, the *Sydney Morning Herald* feted him as "a worthy descendant of an illustrious line of sea kings," and the *Daily Shipping News* printed a poem in his honor:

Hear the song of skipper Slocum Best Afloat. This is not a Yankee Fairy Anecdote . . .

Crowds showed up for his lectures. When he reached South Africa, he was introduced to President Kruger and taken on an ambassadorial tour of the country. Spry, bald, beginning to wizen, dressed in a crumpled suit of dark serge a size too big for him, Slocum was an unlikely, late-flowering hero. He had rescued his dignity and good name out of the teeth of a loveless marriage and a derailed career.

When he sat down to write Sailing Alone Around the World in 1899, first in his sister-in-law's house in East Boston, then in the aft cabin in the Spray, moored at the Erie Basin in Brooklyn, he aimed at something more ambitious than a mere record of the voyage. The record existed in the logbook and in the official entry stamps in the ship's papers. Sailing Alone was a conscious literary production. Slocum allowed his memory and imagination free play over the events of the previous four years, and recast the facts of the voyage in the stylized and patterned form of a myth.

He was a passionate reader. His eldest son, Victor, remembered his father's stateroom aboard his biggest ship, the *Northern Light*, as looking like "the study of a literary worker or a college professor," with its shelves of Tennyson, Dickens, Coleridge, Cervantes, Lamb, Addison, Irving, Macaulay, Gibbon, Hume, Bancroft, and Prescott. Twain and Stevenson were favorite contemporaries, and though Slocum never quotes Thoreau directly, *Sailing Alone* is so full of echoes of *Walden* that it reads like *Walden-on-Sea*.

Thoreau's cabin in the woods and Slocum's boat are both built in the spring—the season of new life, and of new lives for their constructors.

Hardly were the ribs of the sloop up before apple-trees were in bloom. Then the daisies and the cherries came soon after. Close by the place where the old *Spray* had now dissolved rested the ashes of John Cook, a revered Pilgrim father. So the new *Spray* rose from hallowed ground. From the deck of the new craft I could put out my hand and pick cherries that grew over the little grave.

In a typically graceful maneuver, Slocum throws out a long line, lassoes the *Mayflower*, and brings it without fuss alongside the *Spray*. Twenty pages later, he secures the *Pinta*, the *Niña*, and the *Santa Maria* by a similar stratagem. Slyly, and without immodesty, Slocum sets his own voyage beside the two most important voyages in American history. In *Walden*, Thoreau issued a grand injunction: "Be a Columbus to whole new continents and worlds within you, . . . explore the private sea, the Atlantic and Pacific Ocean of one's being alone." In *Sailing Alone*, Slocum at once inverts that metaphor and makes it literal: he turns real oceans into the private sea of his own being.

As Thoreau tendered the accounts for his construction project ("In all, \$28.12 ½"), so does Slocum (\$553.62); and as Thoreau signaled his communion with nature by charming the perch in Walden Pond with his flute, so Slocum is no sooner afloat than he is performing a broad comic riff on that famous *Walden* moment.

You should have seen the porpoises leap when I pitched my voice for the waves and the sea and all that was in it. Old turtles, with large eyes, poked their heads up out of the sea as I sang "Johnny Boker," and "We'll Pay Darby Doyl for his Boots," and the like. But the porpoises were, on the whole, vastly more appreciative than the turtles; they jumped a deal higher.

Thoreau removed himself from Concord society in order to discover "what are the gross necessaries of life"—a question that helps to give Sailing Alone its carefully plotted shapeliness. At regular intervals on the voyage, Slocum jettisons bits of navigational equipment until, at the end, he is at one with the turtles and the porpoises. Unable to afford the \$15.00 repair bill, he leaves his marine chronometer at home and instead ships a \$1.50 tin clock (reduced to \$1.00 because it has a busted face) that needs to be boiled to keep it going.

The tin clock is a joke with a long fuse. One's meant to guffaw at Slocum's foolhardiness. To calculate longitude by the usual method, an accurate chronometer is essential. But eighty pages later Slocum confesses that he can solve the infamous equation needed to estimate longitude by measuring by sextant angle the rapid transit of the moon across the sky—the immensely difficult "lunar distance" method, for which a chronometer is unnecessary. The business of the tin clock, like the reference to John Cook's grave, is a sly plant.

Making the lunar calculation, Slocum finds that his navigational tables are in error—and so another of the ingenious works of man turns out to be superfluous to the navigator's needs. "If I doubted my reckoning after a long time at sea I verified it by reading the clock aloft made by the Great Architect, and it was right." Next, Slocum hauls in the patent log (for measuring distance traveled through the water) after its blades have been chewed by a shark. His tin clock loses its minute hand. Finally, back in the Atlantic, a goat eats his chart of the shoal-ridden approaches to the West Indies. Sans chronometer, sans tables, sans log, sans chart, Slocum sails on free of the whole technological apparatus of modern navigation, an avatar of Emersonian self-reliance.

Abandoning the contrivances that stand between himself and nature,

Slocum finds his route across the ocean by instinct and intuition. He has become a creature of the sea. On the first page of the book, it is "the wonderful sea," and on the last, the point is tartly underscored: "The *Spray*... did not... sail to powwow about the dangers of the seas. The sea has been much maligned."

Before Slocum, the literature of nineteenth-century small-boat adventuring was one long powwow about the dangers of the seas. British yachtsmen like John MacGregor (*The Voyage Alone in the Yawl "Rob Roy"*), R. T. McMullen (*Down Channel*), and E. E. Middleton (*The Cruise of "The Kate"*) worked up their vacation cruises on the English Channel, the North Sea, and the Irish Sea into heroic tales of their own valor in the face of a cruel, treacherous, and spiteful ocean. In these books, the sea was a battleground on which manly courage was tested, and the publication of a sea memoir was proof that the author had fought and triumphed over the terrible water.

Slocum's kindly, hospitable ocean was a heretical novelty. In *Sailing Alone*, the land is the dangerous element. Inshore, pirates lie in wait for unwary small craft; on shore, Slocum is dogged by bores, thieves, and bureaucrats. He nearly loses his life on a lagoon in the Keeling and Cocos Islands, "where I trusted all to some one else."

Whenever the land sinks out of sight astern, Slocum resumes his strange, gruff, fugitive idyll. He reads. He cooks supper. He watches the fish and the birds. He sleeps soundly. "There was no end of companionship; the very coral reefs kept me company." The heart of Sailing Alone lies in these passages, where nothing much happens except for Slocum's comfortable enjoyment of his own solitude and his growing kinship with the sea creatures. It's an axiom of the book that the *Spray* could sail itself for improbably long periods with the helm lashed: Slocum claims to have sailed 2,700 miles in twenty-three days, with less than three hours spent at the wheel. Whatever one thinks of that feat (and many people have doubted it), the miraculous self-steering properties of the boat are essential to the book. They set Slocum free to loaf and meditate, and they shift the burden of command and control from the captain to the Spray herself. This is her voyage, on which Slocum is a privileged passenger. In gales and shoals, he potters about his floating freehold, shortening sail, keeping watch; the Spray's attendant rather than her master. Most of the time, he affects a Zen-like passivity: "I was en rapport now with my surroundings, and was carried on a vast stream where I felt the buoyancy of His hand who made all the worlds."

According to Victor Slocum, his father used to recite "the albatross part"

of the *Ancient Mariner* by heart, and something very much like the albatross part happens in *Sailing Alone*. As Slocum comes to experience his own creatureliness, he recoils from the idea of eating meat:

In the loneliness of the dreary country about Cape Horn I found myself in no mood to make one life less in the world, except in self-defense, and as I sailed this trait of the hermit character grew till the mention of killing food-animals was revolting to me.

Slocum had his own albatross. He had killed the sailor in Brazil (in self-defense). He must also have felt that he was at least partly to blame for Virginia's death aboard the *Aquidneck* (she died before Slocum could reach a doctor). Watching over his little family of Boston spiders in the *Spray*, and blessing the sea creatures unaware, Slocum reaches an atonement that he makes explicit, in a typically covert and riddling fashion, at the end of the book.

I had profited in many ways by the voyage. I had even gained flesh, and actually weighed a pound more than when I sailed from Boston. As for aging, why, the dial of my life was turned back till my friends all said, "Slocum is young again."

And so I was, at least ten years younger than the day I felled the first tree for the construction of the *Spray*.

That day was in the winter of 1892. Ten years before, Slocum was captaining his best and biggest ship, Virginia was alive and well, his tangles with the law lay in the future, and Hettie was merely a cousin with whom he was on nodding terms. The voyage of the *Spray* symbolically expunged the worst decade of Slocum's life.

Although he needed an editor to season his prose with commas and semicolons, Slocum had a pitch-perfect ear for tone and cadence—and he created for himself a written voice of understated eloquence and tinder-dry irony. In outline, *Sailing Alone* can easily be misrepresented as solemn, with its celebration of the Transcendentalist watchwords of nature, solitude, self-reliance. In reality, it is surprisingly funny. Slocum was expert at sounding the plangent chord and simultaneously deconstructing it with a sardonic cough. If his book resembles *Walden*, it's even more like Mark Twain's *Walden*. Slocum's whole strategy as a stylist depends on his maintaining a calculated distance between himself and his readers. He is, in the original sense of the term, aloof: luffed-up into the wind, standing off from the shore. He is a great withholder of secrets, and his confidences come in brief flashes. Sometimes he resorts to a private code, meant to be cracked, perhaps, only by his sons, as when he revisits Buenos Aires and cheerily remembers its most entertaining citizen, a coffin maker. Always he plays his hand close to his chest. In the Transvaal, he causes President Kruger, a devout flat-earther, to erupt in a flurry of indignation because Slocum is announced as a man who is sailing around the world. "You don't mean *round* the world," said the president; "it is impossible! You mean *in* the world. Impossible!" Slocum sums up this encounter by saying, "Only unthinking people call President Kruger dull."

Sailing Alone came out in 1900. It was a timely appearance. The big best seller of that year was Charles Wagner's *The Simple Life*, translated from the French, an inspirational book about sloughing off the false sophistication of the city and getting back to elementals. Slocum offered a palpable version of the simple life that was calculated to inspire fond daydreams among back-to-nature urban types. He also painted the sea as an unspoiled wilderness at a time when the interior wilderness of the United States was turning, almost overnight, into a massive quilt of barbed-wire enclosures. The West was lost as a territory for solitary adventure: in 1902, Owen Wister would have a huge success with *The Virginian*, a tear-spattered requiem for wide-open spaces. But Slocum's sea was still pristine. Wister's friend Theodore Roosevelt made the connection in a fan letter to Slocum: "I entirely sympathize with your feeling of delight in the sheer loneliness and vastness of the ocean. It was just my feeling in the wilderness of the west."

Slocum's book sold steadily, though it never made the lists. He tried once again to settle down with Hettie, on a tiny farm he called "Fag End" in West Tisbury on Martha's Vineyard. He proposed a submarine adventure, and wrote to inquire about the possibility of his becoming an aviator. Rejected as a living exhibit by the Paris Universal Exhibition of 1900, Slocum took the *Spray* to Buffalo and the Pan-American Exposition, where he tried to emulate Buffalo Bill by restaging his great adventure on a park lake. He sold souvenirs of the voyage to visitors, including small squares of a blown-out mainsail, like fragments of the True Cross. He rambled up and down the East Coast, giving talks to yacht clubs.

The land was—as ever—a source of trouble. In May 1906, Slocum sailed up the Delaware River to give a talk at the Riverton, New Jersey, Yacht Club.

While the *Spray* was lying on the club moorings, a twelve-year-old girl visited the boat. Some hours later the police, acting on a complaint by the girl's father, arrested Slocum on a charge of suspected rape. The examining doctor stated that there was no evidence of rape, and the girl herself produced an incoherent account of what, if anything, had happened. The charge was reduced to one of indecent assault. Slocum, according to the local paper, "said he had no recollection of the misdemeanor with which he is charged, and if it occurred it must have been during one of the mental lapses to which he was subject." He was kept on remand for seven weeks in the Mount Holly jail, was urged by counsel to plead no contest, and was eventually released on condition that he never return to Riverton "by rail or water."

Walter Teller, Slocum's best biographer, suggested that "old man that he was now becoming, Slocum may have been, as he sometimes was, negligently unbuttoned." Whatever the truth of the matter, it makes the point that Slocum had good reason to feel safest when he was alone at sea. Three court appearances, on serious charges, in one lifetime is above par for the course, and Slocum clearly had no gift for extricating himself from tricky situations. He was shy, and he was given to bluster, a dangerous combination. Sailing Alone is punctuated with accounts of intended pleasantries that went askew; again and again, one glimpses Slocum as he must have appeared to others—an odd fish and a puzzlingly awkward customer.

The governor of Rodriquez, who had most kindly given me, besides a regular mail, private letters of introduction to friends, told me I should meet, first of all, Mr. Jenkins of the postal service, a good man. "How do you do, Mr. Jenkins?" cried I, as his boat swung alongside. "You don't know me," he said. "Why not?" I replied. "From where is the sloop?" "From around the world," I again replied, very solemnly. "And alone?" "Yes; why not?" "And you know me?" "Three thousand years ago," cried I, "when you and I had a warmer job than we have now" (even this was hot). "You were then Jenkinson, but if you have changed your name I don't blame you for that." Mr. Jenkins, forbearing soul, entered into the spirit of the jest...

One would dearly like to hear Jenkins's side of this meeting. Like many people (writers especially) who habitually live inside their own skulls in a private language, Slocum had difficulty translating thought into speech. Talking to himself—writing his book—he was a sane and happy man; talking to strangers, he was often maladroit. His friendly overtures come across as clumsy and overwrought, his jokes tend to misfire.

Fresh out of jail in Riverton, he sailed to Sagamore, the summer White House on Oyster Bay, where he delivered a long-overdue cargo of a single orchid to President Roosevelt. Though his arrest and imprisonment had been widely reported, he was warmly received by the president's family, and took the Roosevelt boys sailing on Long Island Sound.

In the fall of 1909, he cast off from Vineyard Haven, supposedly bound for the Bahamas and South America. The *Spray* was in bad shape, her rigging loose and frayed, her timbers frail. (L. Francis Herreshoff, the yacht designer and writer, saw the boat that year and deplored her condition.) Slocum himself, at sixty-five, was said by people who met him to be a sad and conspicuously lonely man, "eccentric" and "a little cracked." Even in November, the North Atlantic was a more welcoming prospect than the domestic hearth at West Tisbury. That evening, a southeasterly gale blew up, making the Vineyard Haven fishing fleet run for home. Slocum was never heard from again. He was declared officially dead in 1924.

He has been sighted since. Joseph Heller's solo navigator through the reefs and shoals of corporate America in *Something Happened* is named Slocum; and so was the hero of Richard Ford's *The Sportswriter* (now Frank Bascombe), until Ford realized that Heller had beaten him to the post. In Ford's novel, Slocum/Bascombe is in a state of nonstop compulsive travel. Though the function of the *Spray* has been distributed among a variety of cars, cabs, and planes, *The Sportswriter* is unusually rich, at least for a novel set squarely among suburbs, in gale-force marine weather—rich, too, in nautical metaphor, as Bascombe navigates the inland, industrial seas charted by Rand McNally.

It's a shame that Bascombe didn't survive as Slocum beyond the proof stage of the book, because *The Sportswriter* returns a clear reflection of those aspects of Joshua Slocum that now belong to myth—his burdenedness, his flinty solitude, his carnival high spirits when under way, his danger of drowning in sorrow when he's stuck in port. (Harbors rot boats and men, goes the saying, and it's equally true of Ford's hero and Slocum himself.) In the near-century since *Sailing Alone Around the World* was published, Slocum has become the archetype of the American wanderer: creating himself on the page, he drew a classic hero as resilient, as full of rough-diamond signification, as Huckleberry Finn.

Last Call of the Wild

I FIRST NOTICED that something odd was happening to fishing—the passion of my boyhood and an occasional pleasure in my adult life—on a visit to New York in 1988. The Ralph Lauren store on Madison Avenue had become a museum of old fishing tackle, and I pored affectionately over the displays of green-heart and split-cane rods, wicker creels, fly boxes, brassbound wooden reels, and deerstalker caps stuck about with flies. Though I hadn't fished in a dozen years, I could still name the flies—Greenwell's Glory, Coch-y-bonddhu, Silver Doctor, Tup's Indispensable.

For me, the stuff was pungent with memories of the geezerly world of English brooks and chalk streams: it summoned a crew of aged gentry folk smelling of damp tweed and pipe tobacco. Liver spots. Bifocal specs. Whisky and soda ("Chin-chin!") in the snug bar of the Dog and Duck. That these characters had somehow become the cynosure of New York fashion in the eighties, or at least that their discarded paraphernalia was being cast as a lure to hook the affluent young on shirts and pants and blazers, was so bizarre that I began to suspect Ralph Lauren of having a ribald and anarchic wit. What would he go for next? Stamp collecting? Amateur chemistry? Toy trains?

Then came Robert Redford's movie version of Norman Maclean's *A River Runs Through It*—a feature-length Ralph Lauren window display. In a rinsed sepia light, men in period leisurewear did pretty things with varnished antique fly rods. The wristy craft of casting put them in touch with the historic past, and it made them at home in nature—at home in their own natures. The grace of the line unrolling from the rod tip, the fly kissing the surface of the water as a trout rose to meet it, was pure fashion plate. Then, with the rod bent into a hoop, one could feel in the musculature of one's own forearm the burrowing shudder of the fish at the other end. In an

as yet unspoiled Eden, we were joined to wild nature by a thread of oiled silk.

That image now has a poignancy that would have seemed incomprehensible a few years ago. Within the last decade, we've come to live with the idea that nature is in its fifth act. The corpses are piling up onstage—the dying species, razored forests, wrecked habitats. Wilderness, once thought of as inexhaustible, has been reduced to posted wilderness trails, with park rangers issuing permits to overnight campers. Like any other commodity, nature, by growing scarce, has shot up in value, and access to the wild has become a luxury and an emblem of social status.

But what do you do when you get there? Hugging trees palls after the first splinter or two. Hiking is too tame and objectless for people bred to displays of competitive prowess. Rock climbing is dangerous. Hunting lands one in moral difficulties in mixed company. A River Runs Through It offered a solution in the form of an equipage of covetable goods and garments, the attainable landscape of the Northwest, a show-off skill, and the promise of a direct line to the wild.

So the Sage graphite six-weight, encased in a monogrammed leather cylinder, slides into the BMW, its butt nudging the car phone. Even in the underground garage on the Upper East Side, the rod is capable of some remarkable distance casting, tangibly connecting its owner to a purling, snow-fed river nine states away. The line soars, loops over Wisconsin, unfolds past the Dakotas and falls weightlessly across the current of the Clark Fork. There's an answering tug, like a small electric shock, and you're in touch.

When I moved from London to Seattle in 1990, my self-esteem was dented by the discovery that I was part of a mass movement of city people piling into the Northwest because they wanted to rub up against whatever was left of nature. We brought bird books, tree books, and Japanese microbinoculars that you can flip out of your coat pocket to zoom in on a passing bald eagle when the car's stalled in a jam on the morning commute.

Seattle is a city fixated on the countryside. Bright scraps of sea and lake show at the ends of streets, and an upward glance finds snowcapped mountains moored between the high-rises. Downtown is crowded with stores that cater to the nature industry—Patagonia, REI, Eddie Bauer. A river runs through Eddie Bauer; a makeshift mountain stream that tinkles over slate falls slap through the middle of the split-level store. The fishing department is sited on its east bank. There are no trout in the Bauer River, so far

as I could see, and the rocky bottom is littered with small change instead of pebbles, but it makes the point that in Seattle, swift water is always at the heart of things. The city is bisected by the Lake Washington Ship Canal, at whose entrance by the sea locks there's an underground bunker with aquarium windows, where one can watch Pacific salmon climb the ladder on their journey from the ocean to the inland rivers. In their seasons, coho and king salmon pack into the ladder as tightly as sardines in a can. Jostling one another, fin to fin, they struggle up against the current—huge, brilliant, battle-scarred creatures in a blind rage to spawn and die.

I had never seen a city with so many shops devoted to fly-fishing, each with its fly-tying classes, casting clinics, and a chalkboard for the news of the day—as that the Royal Coachman Bucktail is fishing well on the Stillaguamish. Several million dollars are spent every year in Seattle on fly rods, reels, lines, leaders, and flies—and this is only the beginning of a river of money that fills motel rooms and restaurant tables, funds the state Department of Fish and Wildlife through license fees, keeps Barbour jackets on the racks of the outdoor-clothing stores, and pays the wages of professional guides. The hankering to be purposefully alone in nature has major commercial ramifications.

Seattle and Portland, Oregon, are the twin capitals of a particularly dramatic and intense form of fly-fishing: the ritual persecution of the steelhead trout. The steelhead is a queer fish, as big as a salmon, weighing anywhere up to thirty-five pounds. It's usually described as a sea-run rainbow trout, which is like describing a Roman Catholic as a Southern Baptist with a taste for incense. It spends most of its life at sea, in the ocean south of the Aleutians, and unlike the Pacific salmon it returns to sea after spawning in freshwater, which saves it from the helpless fatalism of its salmon cousins. Whereas salmon go up the rivers in gangs and on a strict timetable, steelhead move in ones and twos, and though there are distinct summer runs and winter runs, they enter the rivers during every month of the year.

Wild steelhead (serious fly fishers despise hatchery-bred "plastic fish") are now rare enough to make them prized. Since they do not ordinarily feed in freshwater but live off the accumulated fat of two or three years' gluttony at sea, they are satisfyingly hard to tempt with an artificial fly, and steelheading has the quixotic glamour of a unicorn hunt. The first fly fisher I met was a man I found wading ashore from a whitewater riffle on the Snoqualmie River, a half-hour's drive from downtown Seattle. I hadn't yet bought any fishing gear and wanted hints and tips. I asked the man if he'd made contact with a fish.

"Yes," he said, and took on a visible glow as he described making a long cast across the current and how, after a moment's pause, the cast kept on going and going while the reel yammered like a stuck doorbell. "He was only on for a few seconds—but it's the few seconds that you remember on all the fishless days . . . It stays with you."

"And that was just down here, this morning?"

I got a dim bunny look.

"That," he said, "was three months ago. Ninth of October," making it sound like a date for marching bands and fireworks displays.

East of Seattle, off Highway 405, lies the cutting edge of sub-suburbia, where new housing developments sprout from patches of freshly cut-down woodland. Here, in the foothills of the Cascades, the rivers flatten out after their headlong tumblings from the mountains. Here the newcoming nature-bibbers settle, cheek by jowl with the woods and the water. Wherever you look, the fir trees part to admit another brand-new community of identical houses. Timber with brick trimmings, they're half Olde English gentleman's residence, half overgrown log cabin. They are painted in pastel shades of buff, pink, ochre—the colors of western Washington rain clouds. COME LIVE WITH US! implore the banners strung out over the unfinished streets, and the names of these settlements promise the house buyer that here is the perfect \$140,000 rural idyll—Cottage Crest, Aspenwood, Cedar Park, Lake of the Woods (More Home and More Privacy).

This is horse-farm and software country. Small computer outfits—satellite moons of Microsoft—dot the landscape, while the humans in sight seem all of a piece: lightly built, thirtyish, bespectacled, and brainy-looking, they drive VW Golfs with infant seats in the back. The men would as soon admit to owning a gun as they would to sexually harassing their personal assistants. But they go steelheading.

In a cloud-colored house with coach lamps, in a development called Chestnut Glen, lives the publisher, editor, and cover star of a new folio-size slick, *Wild Steelhead and Atlantic Salmon*. I'd read Tom Pero before I met him and enjoyed the lacquered angling prose of his editorial credo:

We believe in the heart-stopping swirl of a sixteen-pounder under your dry fly; in the twenty-four-hour Norwegian summer light; in the brilliant red of an October maple reflected in the Margaree; in a scratched Wheatley fly box filled with tiny feather-wing doubles; in a dropping river the color of jade; in blue campfire smoke; in the first-day music of wilderness steelhead water slapping rhythmically against the bottom of your loaded raft; in hundred-year-old salmon-fishing books; in leather rod cases; in the smell of spruce after a hard rain . . .

Driving into Chestnut Glen, I saw how a similar nostalgia powered both Pero's writing style and the street of pale repro boxes on which he lived: both were homesick for the genteel European past, for nature, for old craftsmanly artifacts. It was a rainy February morning when I visited Pero, and his house was full of the smell of wet spruce (at least wet Douglas fir), leather rod cases, and hundred-year-old fishing books.

Eyeglassed, moustached, and weather-tanned, Pero was a few years older than his standard-issue neighbors, but like them he was a newcomer. His life was defined by his fishing. He grew up in Massachusetts, but the East Coast was barren of the Atlantic salmon that used to swim up its rivers; they had disappeared in the eighteenth century, victims of absentee English mill owners whose dams had blocked their streams. "Steelhead are why I moved to the West Coast," he said. In 1977, he began editing *Trout* magazine, moving it, in 1984, to Bend, Oregon. At the beginning of 1993, he moved up the coast to Seattle to start *Wild Steelhead*.

With its full-page watercolors and line drawings, its edible landscape photography, and ten-dollar cover price, "The Best Fishing Magazine Ever Published" is another sign of the social ascent of fly-fishing.

"Steelheading used to be a working-class sport," Pero said. Its masculine nomenclature had been given to it by loggers, Boeing engineers, construction workers. Whereas favored lies on Scottish salmon rivers had soft-spoken, drawing-room names like Home Pool, the Willows, the Birches, comparable reaches of steelhead water were called Car-Body Hole, Shit-House Run, Powerline Hole. Steelhead flies were "short, fat, bulky—real chunks of meat," with names like the Boss, Green Butt Skunk, Brad's Brat, Moose Turd, Killer, Juicy Bug. "When the runs collapsed," said Pero, "the old working-class fishermen quit."

For the new generations of anglers, the rarity of the wild steelhead was its point. To connect with one was to experience an epiphany. That a season might go by without a touch only intensified the purity of the quest. The new generation used flies tied on barbless hooks, and on the rare days when they beached a fish, they carefully wet their hands, raised the fish to have its picture taken, and let it swim free. You do not club an epiphany to death.

The class distinction between the old and new fishermen was mirrored by the distinction between the increasingly small and select runs of wild steelhead and the common mob of fish born in Department of Fish and Wildlife hatcheries. When Pero spoke of hatchery fish, he talked in a language of class metaphor. The hatchery types, conceived in buckets of pink caviar squirted with milt, were of "questionable origins," "foreign stock." They were raised in "concrete jails," and when they came back from their years at sea, they did not, like wild fish, enter the rivers like gentlemen, one by one, but came "in slugs, like motorcycle gangs." They "destroyed the character of the wild steelhead."

The politics of nature in the Northwest are fought along hard ideological lines, and when Pero blazed away about genuine and counterfeit fish, he was taking a political stand on a subject that goes far beyond the question of steelhead genetics. The diminishing runs of "wild native" fish, like the diminishing stands of old-growth forest, represent the remains of a great inheritance, now inflated and devalued by an influx of forged currency manufactured by the timber industry or the Department of Fish and Wildlife. "Nature" here is deceiving, as the newcomer to the region quickly learns. In your innocence, you see a tract of green forest reaching up a mountainside: wrong. It is (you are informed) a tree farm, a plantation of firs, all exactly the same age and size, with none of the complex characteristics, the canopies and understoreys, that make a true forest into a suitable habitat for, say, the spotted owl, that dishevelled, cross-eyed bird whose housing requirements have been at the center of so much acrimonious debate. You see a steelhead wearily finning-and-tailing upstream from the ocean to the creek where it was born: wrong. It's a hatchery mutant, a mass-produced, proletarian creature with the perverted instincts of a born-and-bred gang member.

Soon you find yourself tilting every landscape that you see this way and that against the light, like an art dealer searching a painting for signs of inauthenticity. "It's not right" is art-dealer parlance for *fake*, and a dam on a river, a planted tree, a farmed fish, a clay slide, a dusting of silt on the gravel bottom of a stream, the distant skirl of a buzz saw, are giveaway signs that the landscape is *not right*. These are severe tests. If they were applied to England, the whole country would be revealed as a gigantic fake, the product of some nine hundred years of intensive agriculture and technology, with no real nature left in it at all.

I see the point in the special case of the Pacific Northwest, where odd patches of irreplaceable habitat still survive and might yet be saved. But there's a nasty streak of consumerist connoisseurship in how these tests are conducted. It is the newcomers themselves who are the fiercest judges of the landscape, the couple fresh from Brooklyn or New Haven who raise

their voices loudest against the loggers, fish biologists, developers, and all the other despoilers of the wilderness, and they do so in the aggrieved tones of people who fear they're not getting their money's worth.

Like the spotted owl, the wild steelhead has become a touchstone species. If you can find one, you are looking at real, *natural* nature. It comes with a convenient built-in guarantee of authenticity, in the form of an intact adipose fin. (Hatchery fish have theirs chopped off before the prison gates are opened, and so carry the stigma of their industrial origins for the rest of their lives, like branded slaves.)

This obsession with locating the genuine in nature is part and parcel of the larger quest to find the genuine in our own natures. After all, we came out here to slough off our superficial urban selves (those counterfeit industrial products) and be, well, more *real* than we were back in our eastern cities. Going fishing has entered the therapy culture.

I bought a nine-weight rod and practiced casting from our third-floor deck onto the roof of the neighbors' house. I was rusty and inept, but after half an hour of tossing aerial spaghetti, my wrist began to recover its memory and I was laying a more or less straight line just upstream of the chimney pot. I made a date to spend a day on the Skagit River with Dec Hogan, a guide known as a steelhead magician.

We'd arranged to meet at the crack of a late-February dawn, at a gas station outside the town of Concrete, Washington, where I checked into a motel and went barhopping along Main Street. Concrete was barely a hundred miles to the northeast of Seattle, but the two-hour drive seemed longer: it took one back to the middle of the 1970s, to an enviably guiltless and robust attitude toward nature.

Concrete people were still smokers. In the bars, drifts of pungent violet fog threw the pool players into soft focus. The Saturday-night crowd of broad-beamed folk put one in mind of corn dogs, Jo-Jos, and tubs of chocolate-chip-cookie-dough ice cream. The bars were monuments to local sport and industry. Their walls were hung with rusty two-man saws, with mirrors advertising the Winchester Repeating Arms Company along-side Michelob and Budweiser, with antlers, stags' heads, and the pinned-out skins of wildcats. No bar in Concrete was properly a bar without a stuffed lynx or bobcat, its back arched, its right-hand foreclaws raised against the viewer, its jaws wide open for the kill.

The taxidermist (the half-dozen examples of the genre that I saw all looked as if they were by the same hand) had gone to a lot of trouble to

represent these creatures as the embodiment of primal ferocity. An inartistically stuffed lynx might easily look like the bartender's pet mouser; the ones in Concrete had been equipped with two-inch fangs, and their throats were painted in Day-Glo scarlet. They stood for the wilderness as man's mortal enemy, for the hunter as hero. In Concrete, people knew how to relate to nature: they chopped it down, shot it, trapped it, killed it, ate it.

I liked Concrete a lot. It was a welcome escape from the goody-goody atmosphere of Seattle. I dined on chicken-fried steak, lit up a Swisher Sweet, called for a Christian Brothers brandy, and felt pleasantly red in tooth and claw for the first time in ages.

Next morning, there was a dusting of frost on the ground outside the motel and a lumpy skin of ice on the car windshield. Dec Hogan was waiting at the gas station, his boat in tow behind a mud-slathered truck. He'd said over the phone that he was thirty, but his face was so eroded that he looked a good ten years older. Like Pero, he wore a moustache, for warmth, I guessed: freezing rain is thought to be ideal weather for winter-run steel-head, and Hogan's face, crevassed and windburned, might have belonged to some Arctic explorer. The sight of it made me want to go home.

We drove a dozen miles up Highway 20, the road clinging to the weaving contour of the riverbank. Hogan, nodding at the water, said, "My office." The Skagit was swollen with snowmelt from the recent warm spell, and its windless surface was riddled with the crazy Arabic of deep turbulence—water in friction with water, moving in great swirls and boils. Patches of fleecy white showed where the river's course was broken by boulders the size of Ford Escorts. Two hundred yards or so from bank to bank, pouring westward at eight or nine knots, the Skagit went growling, bearishly, through the woods; a big, wild brute of a river and perfect steel-head water.

Hogan launched the Mackenzie drift boat from a clearing by a trestle bridge. The sun, a hazy wafer, had narrowly topped the scissored edge of the mountain snowfields when—in neoprene chest waders, half frogs, half men—we began to raft downstream. The river was startlingly pellucid—gin with a dash of lime. Turbulence kept on throwing the bottom out of focus, like smoke in a Concrete bar, but every few seconds an oval window of water would open on an aquarium scene of boulders ten feet down.

"Steelhead motel," Hogan said, looking in.

But every room was vacant, so far as I could see. A bright flash in the rocks was someone's lost fishing lure; a promising, torpedo-shaped dark shadow was a sunken log.

In water, life is always murky, as in the plankton-rich Puget Sound,

which has the appearance of thick beef soup. Sterility is pristine; and the Skagit, empty of weeds, of minnow shoals, of almost everything except the odd caddis larva, was brilliant and lifeless. Only steelhead, on an extended Ramadan after years of oceanic self-indulgence, could live happily in this prismlike torrent of melted snow.

Hogan beached the drift boat on a patch of dew. "Do you see the seam in the water there?" A sandbar deflected the current, thrusting it from the north to the south bank of the river; the "seam" was a sharp pencil line where the fast-moving water of the mainstream rubbed against the idle water on its northern side. A string of finger-size whirlpools marked its length. The idea was to fish along, and just inside, this seam. "You're looking for walking-speed water."

Steelhead do their traveling at night and rest up by day. They hang out on the fringe of the mainstream, tucking themselves in behind boulders, saving their energy for the journey they will make when covering darkness falls. The problem is first to find their hidey-holes, then to get the fly down deep enough to interest them.

Below the sandbar, hip-deep in the freezing river, I began to cast, pitching the line across the current and trying to let the fly drift downstream. Time and again, the current seized the line, bellying it out so that the fly skittered uselessly across the top of the water. Hogan, at my elbow, made suggestions while my toes lost consciousness. I improved, slowly, under his instruction, and it wasn't long before I was fishing in earnest, probing the river with the fly as it went shimmying through the deep. "Remember," he said, "you're trying to find the needle in the haystack."

Somewhere down there lay *something*. With each cast, I tried to contact it. *Pick up the phone*, *steelhead!*

"Nobody at home," Hogan said.

Back in the drift boat, we floated on downstream, the swirls of current crackling like a brushfire under the hull. On both banks, leafless alders climbed from an ashen tangle of blackberry and salal. I studied the fly I had been using—a nameless creation of Hogan's and a work of violent surrealism. Part polar bear, part jungle cock, part Christmas tinsel, part tangerine chenille, it was an object one might meet in Native American mythology or a seriously bad dream.

"It's meant to be lifelike," Hogan said.

"Like what? Like a shrimp or a squid or . . . ?"

"No. Like life."

I dangled it in the water, where it quivered and collected pinpricks of light.

"You see how the hackles are working—"

"Is it just supposed to annoy the hell out of the fish?"

"I think it's territorial. He sees this other creature on his patch, and bang! I don't think he gives it too much thought."

We fished the next pool in tandem, with Hogan following me down-stream. I tried to imagine the lifelike thing as it pirouetted in a ball of turbulence and swam on a zigzag track across the current—and the fish, half asleep in the lee of a boulder, suddenly alert to the presence of an impudent, Pierrot-costumed intruder. Hunched over the rod, forefinger crooked around a loop of line, I was all expectancy and ardor; with each fresh cast, the unseen steelhead grew more palpable, until it was so nearly *there* that I was in a state of premonitory shock at the sudden, violent wrench of the fish's assault on the fly.

Underfoot, the basalt pebbles were treacherously slick, and my toes were numb. Halfway down the pool, I clambered ashore onto the warming sand. I'd saved the stub of last night's Swisher Sweet to celebrate my first fish; now I lit it in honor of a phantom. Launching a curlicue of smoke into the mountain air, I lay on the sand and watched Hogan.

He was making enormous casts with a double-handed Spey rod. It was a depressing sight, to see seventy-five or eighty feet of line spill from his rod tip and uncoil lazily over the water, where it made a weightless landing, as true as a line of longitude. Up to his solar plexus in the river, padding confidently along its slippery bottom, jaws working slowly on a quid of chewing tobacco, casting like an angel, he was giving a humiliating demonstration of how to make oneself comfortably at home in nature.

The nasal churring of a woodpecker in a tree was overlaid, on the instant, by a cowboy yodel from Hogan. It wasn't a woodpecker; it was the ratchet on the reel, and a fish running fast and deep across the current.

"Not a lightning bolt," Hogan called, as the sound dropped in pitch to a leisurely *tirra-whirra*. The big Spey rod was bent in a half circle, its sunlit tip shivering. Hampered by waders, I stumbled along the water's edge; it was like trying to sprint through glue.

By the time I reached him, Hogan was a circus ringmaster. His long whip flicked and, far away, under the trees on the far bank, the fish climbed into the air and hung there, a glowing quarter moon whose sudden brilliance made the rest of the world look flat and monochrome. Hogan's leaping fish, released from the laws of perspective, a blaze of silver, spraying the air with light, looked like the manifestation of some unearthly presence. It was too big for the river, too full of life for the sterile clarity of the water from which it sprang.

Within two or three minutes, the fish was twisting wretchedly in the shallows, directly under Hogan's rod tip. It had shrunk a lot since its moment of glory in the air: it turned out to be a hen fish, wild (it exhibited an unmutilated adipose fin as it rolled), of about six pounds—a tiddler, as steelhead go. It splashed and wallowed, shook the barbless hook from its mouth, and was gone. It left a fading wink in the water, like a sinking hubcap.

"This was a good day—now it's a great day," Hogan said. It was his first full hit in more than a week.

All afternoon, we drifted and fished, drifted and fished. An eagle riding a thermal sauntered over us; we floated past the white stumps of young trees, tidily logged by beavers. We skidded over a succession of small rapids, then inched down a long, deep, translucent pool. I hung over the bow of the drift boat, searching the checkerboard of colored rocks and gravelly holes for fish. Not a fin stirred in that beautiful, deserted underwater world.

When the sun collapsed into the Douglas firs on a hilltop not far off, the whole valley was immediately refrigerated. The chill was bitter as I began to fish the last pool. The opposite bank was a sheer cliff of greenery, fast turning black, and the braids of current in the mainstream had lost their sparkle and taken on the viscous look of poured tar. A truck, its headlamps on full beam, raked the trees fifty feet above the water. I'd quite forgotten about the roads: earlier, the sound of the river, half wind, half rockfall, had drowned the noise of traffic—but now I saw that the whole day had been spent not in a wilderness but on a roadside.

Neither this thought nor the icy cold could drag me back to the boat and the last half-mile to the public ramp. I could feel the steelhead readying themselves to stir from their daytime hideouts and begin the long night's cruise upstream. I was casting better now. My luck was in.

It was just a question of getting an extra yard farther out...a foot or eighteen inches deeper... The fly was so nearly within reach of the fish that it seemed that one last muscular push would make the connection. I cast and cast, until I could no longer see where my leader was falling on the water. Back in the boat, as Hogan ferried us into the current, I held out two frozen white forefingers within half an inch of each other. "It was this close," I said.

Seagoing

IN MARITIME LAW, a ship is a detached fragment of the society under whose flag it sails; a wandering chunk of Britain, or Liberia, or Panama. However far it travels overseas, it's an ark containing the laws and customs of its home port. Here is the happy paradox of seagoing: nowhere on earth can you be as exposed to and alone with wild nature as at sea, yet aboard a boat you never leave the culture of the land.

Cruise-ship passengers know this. A mile offshore, the ship skirts the coast of an alarming and exotic country, famed for its unpronounceable language, its foul drinking water, its bloody political coups and casual thievery. High on C Deck, a steward bears gin-and-tonics on a silver tray; the tourists, snug in their temperature-controlled, four-star world of comforts and deference, see the dangerous coast slide past like a movie. They're home and abroad in the same breath.

On an autumn Atlantic crossing in 1988, in a British cargo ship, we ran into a declining hurricane in midocean. For twenty-four hours the ship was hove-to, going nowhere, while the sea boiled around us like milk and the wave-trains thundered. In the officers' mess, the floor rolled through seventy-five degrees of arc and tropical fish spilled onto the carpet from their tank beside the bar.

"Bit of a windy day we've got today," the captain said, from behind his preluncheon glass of dry sherry, and the two junior deck officers, stumbling crazily up the sudden hill toward the framed portrait of the Queen and Prince Philip, tried as best they could to nod vigorously and smile, as junior officers must when spoken to by their captain. The radio officer landed, from a considerable height, in my lap. "Oh, pardon! Whoops! Do please excuse me!" he said.

Had the Atlantic Conveyor been registered in excitable Panama, the

scene might have been different, but we were flying the Red Ensign; and the more the ocean tossed us about like bugs in a bucket, the harder we all worked to maintain the old-fashioned prim civilities of our little floating England. Every student of the British class system, its minuscule distinctions of rank and precedence, its strangulated politenesses, its style of poker-faced reticence, should get a berth aboard a Liverpool-registered merchant ship in a severe storm.

The last case of cannibalism to be tried in Britain came to hinge on this conflict between the culture of the ship and the untamed nature of the sea. In 1884, the yacht *Mignonette*, on passage from Tollesbury in Essex to Sydney, Australia, met heavy weather in the South Atlantic. Caught by an enormous breaking wave, the yacht foundered and her professional crew (who were delivering the boat to its new Australian owner) took to the thirteen-foot dinghy, where they drifted for three weeks on the empty ocean under a hot and cloudless sky. On the twenty-fourth day of their ordeal, the four emaciated mariners cast lots. The cabin boy, Richard Parker, seventeen years old, drew the short straw, and the captain slit his throat with a penknife. The survivors dined gratefully on the boy's remains.

A German ship eventually picked them up and took them back to Falmouth, England. Their trial in London was a sensation of the day. The first line of the defense was that there was no case to answer: the *Mignonette*, a registered British ship, had sunk, and the killing of the cabin boy had taken place in an unflagged open boat on the high seas. The law of the land, argued the defense, had no jurisdiction over the men's conduct in a dinghy in international waters. On the ocean, a thousand miles from the nearest coast, the law of the wild prevailed.

Unfortunately for the men (and for those of us who would like to get up to mischief in dinghies beyond the twelve-mile limit), this reading of the law ran counter to a section of the British Merchant Shipping Act of 1854, which held that a British seaman was subject to English law whether he was on or off his ship—and that the dinghy, flag or no flag, was, legally speaking, an integral part of its parent yacht. The captain and mate of the *Mignonette* were found guilty of murder, sentenced to death, then granted a royal pardon. The sympathy of the court (and British public opinion) was with them, but a guilty verdict was required to prove that the long arm of the law can extend far out to sea.

The ocean itself *is* a wilderness, beyond the reach of the morality and customs of the land. But a boat is like an embassy in a foreign country. So long as you are aboard one, you remain a social creature, a citizen, answerable to the conventions of society. You might as well sally forth alone across

Seagoing 187

the trackless ocean in a clapboard cottage with a white picket fence and a mailbox.

I am now readying my own boat for a sea trip (I can't quite call it a voyage) from Seattle to Juneau, Alaska, and I'm living day to day on the slippery interface between the nature and culture of the thing. My boat, a thirty-five-foot ketch, is Swedish-built and American-registered; like its owner, it is a native of one country, resident in another, and not quite a citizen of either. I never fly a flag, except under official duress, preferring to think of the boat as an independent republic; liberal-democratic in temper, easygoing in its manners, bookish in its daily conversation. My slovenly utopia.

On a wall of the saloon, between the fire extinguisher and the VHF radiotelephone, is mounted a 1773 cartoon of George III—Farmer George, the obese, rubber-lipped, mad King of England . . . our gentlest, most generous monarch, who lost the American colonies and was in the habit of putting grave constitutional questions to the wise shrubs in his garden. Every British ship has its royal portrait, and George III seems the right king for me. His erratic captaincy of the ship of state is an apt emblem for my own often fumbling command of my vessel.

The real heart of my boat is its library. There are few sea books in it—the inevitable coastal pilots, tidal atlases, and one or two grim volumes with titles like The 12-Volt Bible. But when I'm galebound on the dank and gloomy northwest coast, I'm in no mood to read Conrad or Melville. At anchor in a lightless British Columbian inlet, where black cedars crowd the ruins of a bankrupt salmon cannery and the rain falls like ink, I shall pine for brilliance and laughter, for rooms full of voices. So on the long shelf in the saloon, overhung by the gimballed oil lamp, are Lolita and Madame Bovary, the novels of Evelyn Waugh (all of them), Dickens's Great Expectations, Trollope's The Way We Live Now, Thackeray's Vanity Fair, Byron's Don Juan. There are books by friends and acquaintances, like Paul Theroux, Richard Ford, Cees Nooteboom, Ian McEwan, Martin Amis. I rejoice in the thought that my eye might lift from a page of Waugh (let it be Julia Stitch, in bed, at the beginning of Scoop) to the sight of a black bear snuffling in the driftwood at the water's edge: nature outside the boat, society within, and just an inch of planking between one world and the other. The essence of being afloat is feeling the eggshell containment of an orderly domestic life suspended over the deep. The continuous slight motion of the boat, swinging to its anchor on the changing tide, is a reminder of the fragility of our tenure here—aloft with a novel, coffee cup close at hand, while

the sea yawns underfoot and the bear prowls through its dripping wilderness on shore.

I love the subtlety and richness of all the variations on the theme of society and solitude that can be experienced when traveling by sea. It is like living inside a metaphor for the strange voyage of a human soul on its journey through life.

Out on the open sea, with a breaking swell and the wind a notch too high for comfort, you are the loneliest fool in the world. You are trying to follow the vain hypothesis of a compass course. It's marked on the chart, 347° Magnetic; a neat pencil line bisecting the white space of the ocean. The absurd particularity of that number now seems to sneer at you from the chart as the boat blunders and wallows through the water, its hull resounding like a bass drum to the impact of each new ribbed and lumpish wave. The bow charges downhill on a bearing of 015°. Ten seconds later, it's doing 330° up a potholed slope. Abandoning the helm to the autopilot, which at least will steer no worse, if little better, than you do, you go below.

Slub...thunk. Dickens, Thackeray, Trollope, and the rest are lurching drunkenly in line along the bookshelves. Two oranges and an apple are chasing each other up and down the floor. Your morning coffee has turned into a jagged brown stain on the oatmeal settee. The glass decanter has smashed in the sink. The door of the closet is flying open and shut, as if a malevolent jack-in-a-box were larking about among your laundered shirts. A dollop of green sea obscures the view from your living-room window. Your precious, contrived, miniature civilization appears to be falling to pieces around your ears, and you cannot remember what madness impelled you to be out here in the first place.

Then you hear voices. For a moment, you fear that you're losing your wits, then realize that the voices are coming from the VHF set: a captain calling for a harbor pilot, or a fisherman chatting to his wife in the suburbs. It is, after all, just a dull morning at sea, with the invisible community of the sea going about its daily business. You turn up the volume on the radio, climb the four steps to the doghouse, and regain control of the wheel. Three or four miles off, a gray, slab-sided bulk carrier shows for a few seconds before being blotted out by a cresting wave, and you find yourself watching the ship with a mixture of pleasure at finding a companion and rising anxiety at encountering a dangerous intruder.

Loosening the sails to steer clear of the big stranger on your patch, you quickly recover your taste for solitude—and the waves themselves seem to

Seagoing 189

lose their snarling and vindictive expressions. In the society of the sea, it is the duty of every member to keep his distance from all the others. To be alone is to be safe. It's no coincidence that those two most English of attitudes, being "standoffish" and "keeping aloof," are nautical terms that have long since passed into the general currency of the language. Standing off is what a ship does to avoid the dangers of the coast; aloof is a-luff, or luffing up your sails, head to wind, to stay clear of another vessel. The jargon of the sea is full of nouns and verbs to describe the multitude of ways in which a ship can keep itself to itself. The ocean is, in general, a sociable and considerate place, where people (professional mariners, at least) treat one another with remarkable courtesy. But this civility is based on distance and formal good manners. Always signal your intentions clearly. Always know when to give way and when to hold your course. If people on land behaved like ships at sea, they'd look like characters in an Italian opera or members of the Japanese imperial court.

I've never crossed an ocean under my own steam—never, really, more than nibbled at the ocean's edge. The longest open-sea crossing that I've made so far was from Fishguard in Wales to Falmouth in Cornwall; two hundred miles, thirty-five hours; a day, a night, and most of the next day, with a dream-harrowed sleep (full of collisions, groundings, swampings, and founderings) at the end of the trip. Simple cowardice is one reason for my failure to tackle an ocean; my passion for arrivals is another, just as powerful as my timidity. When the light begins to fail and the sea turns black, I yearn to make landfall—to pick out the winking entrance buoys leading into a strange port. The intricate, heart-stopping business of coastal pilotage is for me the great reward for spending a day jouncing about in the waves offshore.

Dusk is a good time (though just before dawn is best), when lights stand out but the shape of the land is still clearly visible. You bring one shadowy headland into line with another, then find the lazy flash of the fairway buoy, timing it against your watch to check its ID. Cautiously standing off, you wait until the pinpricks of light ahead resolve themselves into a narrow, winding lane, into which you thread the boat, moving under engine, at half speed.

The most satisfying harbors are those that are fringed with a maze of shifting sandbars, like the entrance to the Somme estuary in northern France or the approach to Wexford in Ireland, where buoyed channels take one on bafflingly serpentine routes into town. Each channel represents a

pooling of knowledge by the local pilots and fishermen, and is a path whose broad outline has been trodden for hundreds of years. But sandbars alter their positions after every gale, and the buoys are never exactly in the right places. As so often at sea, you are at once in good, experienced company and entirely on your own.

Inching warily from buoy to buoy, you watch the shivering needle on the depth-sounder. It is your blind man's stick with which you tap tap along, feeling for deep water as you go. Twelve feet. Ten feet. Eight feet—and you've lost the channel. Nine feet. Ten feet—and you breathe again. Now you're inside the line of breakers, in a broad, lakelike sea, with the lights of the town silvering the water in the distance. In a moment of inattention, the bow of the boat suddenly climbs as the keel scrapes sand, but it settles back, the buoy slides past, and the floating town drifts slowly toward you, taking you in.

Anyone who has struggled into a harbor out of a bad sea will understand why the words "heaven" and "haven" are closely cognate. A dismal slate-roofed town (visit the Methodist chapel and the fish-and-chips shop) is paradise itself when you find shelter there after a day of being cold and frightened aboard a lurching boat. You'd willingly kneel to kiss the stones of the dock, you are so full of gratitude for the fact of Dulltown's existence. Its people are so friendly! So attractive! Its Methodist chapel is, as Methodist chapels go, a very cathedral! Its fish and chips are, without doubt, the best fish and chips in the world!

Few travelers have ever felt like this about Dulltown. You are privileged. Your means of arrival have revealed to you a place hidden from the mass of humanity—Dulltown Haven... Dulltown as Heaven. For a writer, such an epiphany is pure gift—and it will save you from the addled cynicism that is the usual curse of traveling.

Yet we were, a few moments ago, on the Somme estuary and the mouth of the River Slaney, and neither St-Valéry nor Wexford is in the least like Dulltown. They are beautiful and complicated places even if you reach them dully, by car. The miracle of coming into them by sea is that, once your boat is attached to the dock by a trapeze of ropes, it instantly becomes part of the architecture and skyline of the town. You belong to the daily working fabric of the community as no ordinary visitor can possibly aspire to do. Your neighbors (at least in places unspoiled by yachting marinas) are fishermen, longshoremen, local boat owners; and the more difficult the harbor approach, the more nearly will you be accepted as a resident. In remote communities, your patience and skill as a navigator (you wouldn't be there if you were a complete buffoon) is an automatic ticket of entry to society.

For a day, or two, or three, or as long as the weather outside remains discouraging, you settle into dockside life. You go visiting in the afternoons, clambering over decks that are slick with fish scales. You work on your boat. You learn a dozen names. In the evenings, you go with your new neighbors to the bar across the street, where (if you are a writer) you try to listen harder than you drink. You hear things that no one would dream of telling you, had you come here by car.

Then, at five o'clock one morning, in the final hour of the flood tide, you untie the damp ropes in the dark and steal away from the place without saying goodbye. You leave behind a small gap, like a missing tooth, in the shape of the town as you will come to remember it.

At the fairway buoy, the sea is oily calm, with curlicues of mist rising from the water. The fading remains of a big swell make the surface of the sea bulge and contract, like a fat man breathing. Visibility is down to a mile, maybe less. A moderate westerly is forecast.

Ahead lies the open sea, and a day like a blank slate. But some things are certain. There will be—as now—moments of wonder and elation such as rarely visit you on land. There will be the building magnetic power of the unknown port across the water. There'll be at least one serious cause for alarm, and at least one unpleasant surprise.

You kill the engine and let the boat drift on the tide, waiting for enough wind to hoist the sails. The town you left is now hidden in haze. Alone in a circle of diffuse light, you float in silence. In time, the sea and the day will begin to impose their own narrative order on your life; but for now, you are a character as yet unformed, awaiting the sequence of events that will define you.

Bon voyage.

Outside, September 1996

Homesteading

IN AMERICA, time has a habit of moving faster than it does elsewhere: during the life of a single man or woman, the present slides into the historic past and history itself frays into mere romantic legend. The American way of building—tearing down the old and replacing it with the new—alters the landscape beyond recognition, robbing it of all the signs and clues that can make the recent past articulate and vivid. It is no wonder that American grandparents are chronic memoirists, for their own childhoods are likely to seem to their grandchildren as remote as the era of the Boston Tea Party or the Alamo.

So it was for Percy Wollaston when, in 1972, he sat down at his elderly manual Smith-Corona and began to type *Homesteading*, a memoir intended for his grandchildren. Myrtle, his wife, had died in May, and Percy, finding himself suddenly alone, returned to the land of his and Myrtle's childhood, re-creating on the page the bare, dry country of eastern Montana in the teens of the century, its wide-open miles of sagebrush, shale, and buffalo grass. Writing in the age of Watergate and the aftermath of the Vietnam War, he transported himself back into that long-lost America of the Progressive Era, when faith in the idea of America, in American science, and technology, and education, had been at its dizzy zenith.

The contrast between the time in which he was writing and the time of which he wrote could hardly have been sharper. As he pecked out his descriptions of the arid, treeless landscape of his boyhood, he could look out the window to a dripping pine forest and listen to the chuckle of a pellucid trout stream just a few yards from his door. As dryness had shaped his early years, so Percy had spent his adult life in the constant, comforting presence of water. He'd worked for Montana Power, first on the hydroelectric dam across the Clark Fork at Thompson Falls, Montana, then on

the dam across the Missouri River at Great Falls. When he retired, he and Myrtle settled in a handsome log house in a clearing in the woods near Eureka, Montana, on the wet, western slopes of the Rocky Mountains. Elk trespassed on his garden from the surrounding Kootenai National Forest. Grave Creek—ice-cold, boulder-strewn, dimpled with rising fish—ran past his lawn.

In Where the Bluebird Sings to the Lemonade Springs, Wallace Stegner wrote of how control of water is the key to the history of the West—a lesson instinctively absorbed by Percy Wollaston. He once told his youngest son, Michel, that his most abiding childhood memory was of seeing his mother on her knees day after day, weeping and praying for rain. When Percy fled the dry prairie after graduating from high school, he made a beeline for the water. Water meant security, income, insurance against heartbreak.

Before he wrote his book, he almost never spoke of the homestead on which he had grown up. He was a taciturn man, not given to flights of reminiscence, and Michel Wollaston came to understand that the family homestead near Ismay was a touchy subject with his father. Questioned about his childhood, Percy was habitually gruff. Then, in 1974, the father handed the son a sheaf of manuscript, saying it was nothing much, probably not worth the trouble of reading. After fifty years of bottling up the past, Percy had at last allowed it to come flooding back to him in memory—the story of that doomed community on the Montana prairie in which his parents had invested their lives, of an American dream that turned, literally, to dust.

The Wollastons were among the many thousands of people who were lured west by the passing of the Enlarged Homestead Act of 1909 and the extravagant promotional literature of the railroads. The government promised three hundred and twenty acres of "semi-arid" land to anyone willing to cultivate it and erect a dwelling on it; the railroads (needing population to support their own westward march to the Pacific) set out to depict the land as boundlessly fertile, waiting only on the efforts of hardworking men and women to transform it into a green quilt of farms and busy market towns.

This was the heyday of unregulated advertising, when copywriters were free to talk up their products in the language of magic and miracles. The land was talked up, relentlessly. The Chicago, Milwaukee, St. Paul & Pacific Railroad (this mouthful was usually condensed to "The Milwaukee Road"), which brought the Wollastons and their goods out to Montana, employed a band of prose poets and fanciful artists to represent the prairie as a new Arcadia. The jacket illustration to the company's most famous

pamphlet showed a strangely clerklike plowman, steering a single-bladed plow, drawn by two horses, across a map of the Montana section of the Milwaukee Road line. As the soil peeled away from the blade, it turned into a stream of gold coins, each one stamped with the figure of Liberty.

The pale shirtsleeved plowman (evidently still unused to the outdoor life) was meant to signal that no farming experience was needed to cash in on this astonishing free offer. The text of the pamphlet recommended that the novice study the "Campbell Method" of "dry farming" in order to ensure his or her success. The results that the novice might reasonably expect were attested to in photographs of spring wheat standing as thick as the bristles on a brush, of heaps of succulent fruits and vegetables, of acres of plowed, dark, level soil. Most of the photography, it seems, had been done on irrigated land close to the Yellowstone River—land that had long been taken up and which bore precious little resemblance to the dry prairie, just a few miles away, that was actually available for homesteading.

The railroad brochures hymned the climate of eastern Montana: it was temperate, invigorating, medicinal—which would have come as news to anyone familiar with its regular summer droughts, its 40-below winters, its hail, its lightning storms, its plagues of grasshoppers. They made light of its scant rainfall, and bamboozled the reader with long-outdated pseudoscience. Rain follows the plow, claimed the copywriters; it follows settlement, it follows the railroads. Much was made of the Agassiz theory, forty years old and conclusively disproved, that locomotives, passing at speed through a landscape, create some kind of electromagnetic brouhaha, in which rain clouds materialize out of nowhere to water the crops sown close to the line. The homesteading region had been part of what was shown on old maps as the Great American Desert, but twentieth-century science had solved the rainfall problem, and the would-be settler should have no fears on that score. On the green cloth front of Campbell's Soil Culture Manual was embossed, in gold, a camel with a banner trailed across its legs that read: "The Camel For The Sahara Desert, The Campbell Method For The American Desert." Campbell's method was a peculiar blend of Calvinist theology and kitchen-table science, in which capillary attraction was presented as a mystical nostrum to be exploited by the "dry farmer." The method was largely hokum—and it was responsible for the destruction of much of the valuable topsoil in eastern Montana and the western Dakotas. But Campbell's Manual became the agricultural bible of the inexperienced homesteaders. In the first issue of Ismay's newspaper, The Ismay, in May 1908, there appeared a poem which nicely captures the spirit of the dry-farming craze, of which H. W. Campbell was the self-proclaimed evangelist:

"The Dry Land Homesteader"

I've started to dry-farm A piece of bench land sod, And if I meet no harm I'll win or bust—by jinks. Plow and harrow and disc-Disc and harrow and plow: Of course there is some risk Until a chap knows how. Campbell says they will grow If seeds are put in right— Depends on how you sow With ground in proper plight. And so I work all day: At night I read his book— I get no time to play And hardly time to cook.

The pamphlets—addressed as much to the store clerk, the schoolteacher, the barber, the discharged soldier, as to the farmer—were printed in bulk and distributed through the overcrowded cities of the eastern United States. They even reached Europe—Bessarabia, Germany, Sweden, Norway, Ireland, England. They promised a new life in a green land to anyone who could muster the fare to Montana. Families spent their life savings on the transatlantic passage, in steerage, to New York, and thence by rail on the long journey to the Far West. When they disembarked from the train, at Ismay, Mildred, or Terry, most were confounded by what they saw. The gently rolling farmland of the pamphlets turned out to be mile after mile of open range—bone dry, dotted with the mushroom-shaped rock formations of the badlands, without a sheltering tree in sight.

The Wollastons were not confounded. Unlike so many of their neighbors, they were used to the harsh climate and topography of the dry West, and they had every skill necessary for homesteading. If anyone could make this great experiment succeed, Ned Wollaston was qualified to do so.

Born in England, Ned was aged four when his father, a Liverpool shipping agent named Percy, took his family out to Fairfield, Minnesota, in 1876. Percy Wollaston was an unusually well-heeled immigrant. The descendant of a long

line of intellectually minded Anglican clergymen, Percy had done well in the shipping business. At fifty-one, full of energy and hankering for a change of scene, he set out to make a splash in America. In the brand-new agricultural town of Fairfield, he helped found the Episcopalian church, became a banker, a farmer, a miller (his Norfolk-style windmill, with its thirty-foot sails, became a famous landmark in the district), and the owner of the general store. To house his family, he built a sixteen-room mansion with landscaped grounds. Measured by the ordinary standards of the rural Midwest, the house was a palace: but Percy, whose energy wasn't confined to his commercial activities, had fathered thirteen children, of whom Ned was the youngest.

Ned grew up around the farm where his father was raising wheat and barley on four hundred and sixty acres of moist Minnesota soil. When he left home, he worked as a general hand on a cattle ranch near Dickinson, North Dakota, and became an expert horseman and carpenter. In 1900, aged twenty-eight, he returned briefly to Fairfield, where he married Dora Marietta, a young widow with a son named Raymond. Ned, Dora, and Ray then went west again—to Madison, South Dakota, where they ran a country store and farmed a small acreage two miles south of town. Here the younger Percy Wollaston was born in 1904.

In South Dakota, the Wollastons barely made ends meet. The passage through Congress of the Enlarged Homestead Act must have seemed a godsend to them. It promised a great increase of land, for free, less than four hundred miles west of where they were living. Yet this very closeness of eastern Montana to western North Dakota was, perhaps, a fatal delusion.

The true West—the dry West—is usually said to begin at around 100°W, which is the line of longitude that corresponds with an average annual rainfall of fifteen inches. East of the line, there's more than fifteen inches; west, there's less. Madison, North Dakota, is 97°W—securely inboard of the dry/moist line. Ismay, Montana, is a few miles short of 105°W, and rainfall there drops to an annual average of eleven or twelve inches; a modest difference, but a crucial one.

Experienced as Ned was, he too fell for the new scientific miracle of "dry farming." Conserve moisture. Loosen the topsoil. Pack the subsoil. Create a "reservoir" beneath the surface of your land... The Campbell Method and its many local variations were agricultural gospel in 1909, when Ned Wollaston prepared to move his family to the vaunted free land of Montana.

The young Percy was six going on seven when Ned auctioned off his unwanted goods in Madison and the family shipped out on the Milwau-

kee Road for their new life. It is a perfect age for the accumulation of photographically brilliant memories. At seventy, Percy Wollaston was able to recall on paper the family's first days on the homestead with a child's promiscuously attentive eye. Nothing, it seems, was lost on him. All his life, he had been a practical man—a fine carpenter, a devoted gardener, a crack shot with a rifle. He had always attended patiently to details. Alone in his log house by the river, he now attended to the details of his childhood on the homestead with the same scrupulous care that he brought to his woodworking.

He was not a practiced writer. His wife, Myrtle, had grown up on a Norwegian-American homestead on Cabin Creek, a few miles east of Ismay, her childhood matching Percy's point for point, and she had been the literary member of the family. She and her sisters, known far and wide as "the Amundson girls," had opened a school on the prairie, and as a mother she had introduced her children to an impressively broad range of poetry and fiction. When Percy sat down to write a book, he may, perhaps, have been taking on the task that Myrtle had been promising to do before she died. Certainly his writing came as a great surprise to his children.

The wonder of it is that it is pitch-perfect. Unforced, unsentimental, often drily funny, it has the ring of experience insisting on making itself manifest in writing. It tells the story of what now must seem a tragic episode in American history, but it tells it with artful reticence, withholding the tragedy, yet letting it impinge, by suggestion, on the narrative.

It is a three-dimensional portrait of the community of homesteaders which assembled on the prairie after the arrival of the Milwaukee Road. In the spirit of the settlers themselves, the book focuses on the high hopes and considerable achievements of the homesteaders as they established their farms on the unforgiving land. Though Percy Wollaston alludes importantly to *Giants of the Earth*, the tone of *Homesteading* is a world away from that of Rollvag's grim epic. The casual reader, flipping through these pages, might mistake it for mere sunny-side-up cheerfulness.

But Wollaston was an instinctive ironist. If the main thrust of his story is about the brave resourcefulness of that makeshift society on the Montana prairie, its margins are darkly shadowed: disappointment, loneliness, sudden death, foolish incompetence are continually in evidence, and the book comes to be haunted by a horribly memorable suicide—all the more effectively rendered thanks to Wollaston's habitual laconic detachment. The reader grows to understand, by inference, that this is a story of a colossal failure.

From 1917 onwards, the homesteaders began to flee the land to which

they had come with bold and optimistic dreams. They were exhausted and bankrupted by a combination of brutal cold, drought, falling wheat prices, and a burden of debt, taken on when bank loans were cheap and easy (see Percy Wollaston on the smiling bank manager, Hayden Bright). Credit was as much to blame, in the end, as the Montana weather.

The Wollastons survived longer than most of their immediate neighbors. They bought a car (a Model T), but they did not go in for the expensive farm machinery—the tractors and threshers—that led so many to penury. Ned continued to plow with horses. Dora's trade in butter, eggs, and honey kept the household alive when cattle died and the wheat crop failed.

Percy left in 1924, taking the train west to the Pacific and, it was vaguely said, "to college." He probably intended to try for a place at the University of Washington in Seattle, the western terminus of the Milwaukee Road. But when his train pulled in at Thompson Falls, a forest fire was raging along the mountainside and all able-bodied men aboard the train were asked to volunteer to fight it. When the fire was under control, Percy stayed put. For the next year, he worked for the Forest Service as a "smoke-chaser," living a Huckleberry Finn existence in the woods above Thompson Falls. Then, with his impending marriage to Myrtle much in mind, he took a job with Montana Power on the hydroelectric dam: to a young man who had grown up amid so much failure, so many blighted hopes, the value of company housing, health care, and a pension scheme was already apparent. Homesteading was the epitome of the life of Emersonian self-reliance and proud financial independence. Percy's experience of that life evidently led him to settle gratefully for a niche in corporate—and watery—America.

His parents followed him to Thompson Falls in 1926. Ned and Dora were drained, but not penniless. Most of the homesteads in the neighborhood were simply abandoned, to be reclaimed by the county for their unpaid taxes. Ned retained his title to the Wollaston place, and even found a tenant to pay him a peppercorn rent on it. Arriving in Thompson Falls, he was able to muster \$550 to buy about two-thirds of an acre of land overlooking the river, where he built a house that was a small replica of the homestead on the prairie. The Wollastons had escaped lightly. Their small Utopian democracy, centered around the Whitney Creek schoolhouse, had collapsed on top of them, but they were among the least seriously injured victims of the catastrophe.

In 1994, Michel Wollaston and I drove to Montana to look for whatever might remain of the homestead. The land had reverted, long ago, to open range. The prairie was dotted with wrecked houses—most of them vacated relatively recently, in the 1950s and '60s—and rusted farm machinery. Of the homestead society described by Percy Wollaston, little was left except for a few weathered fenceposts trailing whiskers of barbed wire. The schoolhouse described in the book was just barely in business; it had two students and was due to close forever in the summer of '94. The meadow-larks and killdeer plovers appeared to now have most of eastern Montana to themselves: I had never seen a lonelier landscape, where the dead so outnumbered the living, and where the wreckage of failed enterprises was the most conspicuous human feature of the place.

We found the "swale" of the book—a zigzag seasonal creek running west to east, with a long, low bluff on its southern bank. A lone cottonwood tree marked the site of Ned's spring. It took us a while to figure where the house must have been. We carried Percy's sketch of the homestead and its outbuildings, holding it up at various points along the swale until at last the picture and the land made a perfect fit.

Then, quite suddenly, we couldn't walk a step without stumbling on a further relic of the family past. Here, buried in the dirt, were the flaky remains of a milk churn; there, a piece of a wooden wagon wheel. We found a child's broken sled (Percy's?), identifiable bits of a Model T, the front of a cooking stove, half a toy pistol. We parted the grass to uncover the foundations of the house that Ned had built; the flagstone path from the kitchen to the hen house was still intact.

As a twelve- and thirteen-year-old, I had spent summers helping to dig up the remains of Roman villas in Winchester. Archaeologizing on the prairie, brushing dirt off rusty artifacts, made the Wollastons' twentieth-century past seem almost as remote and forlorn as the buried civilization of those ancient conquerors, with their centrally heated terra-cotta floors, their fine Samian ware (the glaze on the shards of pottery still vivid in 1954), their silver *denarii* (so easily mistakable for the English sixpenny piece). The homesteaders, like the Romans, had believed that they'd be here forever—building stout houses for their succeeding generations. Eighty years on, their prairie empire had already met the fate of Roman Britain.

On the north side of the swale, between the house and the spring, we found a spot where the buffalo grass grew thinly over an irregular patch of black dirt. There'd been a bonfire here. Digging with my fingernails, I unearthed a small silver medallion. The head of a Greek goddess was stamped on it. A broken hinge—or something—was attached to its edge.

I handed it to Mike, who put on his reading glasses and studied it in his open palm.

"I think I know what this is. It's the clasp from an old-timey photograph album." He handed it back to me. "They must have burned the family photos when they left."

If they had burned the family photos, it was easy to imagine why. Leaving the homestead, Ned and Dora could not bear to take with them the record of their own guileless optimism—the smiling faces, the half-built barns, the new plow or horse . . . the new life in all its pristine possibility.

That would explain Percy Wollaston's lifelong taciturnity when it came to speaking of the homestead. But as the years passed, the absence of that record must have made itself felt as a sad loss that needed to be repaired. In place of the burned album, we have a book; and it is infinitely more vivid than the faded Brownie snapshots could possibly have been.

Foreword, Homesteading, 1997

Keeping a Notebook

When I travel I keep a notebook—actually a Grumbacher sketchbook, ring-bound, 8½ by 11 inches, with a hundred sheets of heavyweight drawing paper. Blotched and swollen, its pages parting company with their binding wire, the notebook is my main solace when I dine alone at some cheerless eatery where the only remedy for the microwaved chicken is in the ketchup bottle. Writing in it gives me occupation and identity when I might otherwise recognize myself as an aging, unkempt drifter without visible means of support. So it's scribble, scribble, scribble all through dinner. Into the notebook go long descriptions of landscape and character; some fuzzy intellection; scraps of conversation; diagrammatic drawings; paras from the local paper; weather notes; shopping lists; inventories of interiors (the sad cafe gets grimly itemized); skeletal anecdotes; names of birds, trees, and plants, culled from the wonderfully useful Peterson guides; phone numbers of people whom I'll never call; the daily target practice of a dozen or so experimental similes.

"Looks like you're a *rider*," says the career waitress with fried hair, whom I gratefully overtip for not saying, "Looks like you're a bum."

From my last piece of serious traveling, a solo round-trip by boat from Seattle to Juneau, Alaska, I came back with three notebooks stuffed with such writing—the raw material (supposedly) for the book I am now trying to begin. At home, at this desk, seated at this typewriter, I find myself wading through the notebooks with familiar irritation. If the man who wrote them had been hired by me as my researcher, I'd sack him for gross neglect of duty.

My dim-bulb alter ego. The notebooks expose him as shortsighted and long-winded by turns. Bogged down in the quotidian details of his adventure, he can't see the forest for the trees. He's traveling, but can't remember

why. He's short of wit and rarely passes up an opportunity to whine. He asks all the wrong questions (when he remembers to ask any at all). He's at his worst when trying hardest to "write": I have to skip page after page of phony lyricism in search of one memorable fact. The chipped flint of the waves? Give me a break. The mauve ring on the page, left by a glass of British Columbian plonk (than which no plonk in the world is plonkier), is more articulate than my man's laborious notebook writing. It reminds me that—as he sat at that bar in Prince Rupert, the nib of his Paper Mate racing across the page—a scene was going on beside his shoulder... two angry women: one pregnant, the other in fishnet tights... They'll find a place in the book; his blessed sea piece won't. Why didn't he write about them? Why didn't he listen to the row more closely? Because, in our ill-matched duo, he's the traveler and I'm the writer, and the two are chalk and cheese. He can be a character in my story—a useful stooge—but he can never be its author, for all his tiresome literary pretensions.

Traveling (and one might as well say living) turns us into creatures of hap and contingency. We are forever navigating in fog, where the sensations of the moment are intense, and both our point of departure and our intended destination are lost to view in our concentration on the overwhelming here and now. Things are constantly happening, but we're in no position to judge their meaning and significance. The rumble of a ship's engine in the murk may turn out to be the sightless bulk carrier that will run us down and send us to a watery grave. Or it may not. As the case may be. The fogbound navigator, all ears for sounds of distant danger, fails to keep his eyes on the depth-sounder and runs himself aground on the silent reef. So it is with the poor mutt who keeps my notebooks for me, because the narrative of the journey is kept hidden from him until the journey's over. Blundering through the world in zero visibility, he leaves a record only of his own misapprehensions—the scary ship that faded into nothing, the impending storm that never blew, the promising channel that led nowhere. Only by the merest accident (for contingency cuts both ways) does he happen to light, occasionally, on something that will still seem to him important when the voyage is done.

Writing—real writing, in the iron discipline of a book—is the mirror opposite of traveling. A book is a strictly subordinated world. Its logic, of symbol and metaphor, is at once tantalizingly suggestive and ruthlessly exclusive. From the moment that a narrative begins to develop its own momentum, it insists on what it needs and what it has no time for. It's at his peril that the writer loses sight of where the book began and where it's destined to find an ending. (Endings almost invariably change as the book

develops, but the sense of an ending is crucial, even if it turns out to be nothing like *the* ending.) Writing is—in the terms of Philosophy 101—all *cause*, *cause*, *cause*, where traveling is a long cascade of one damn contingency after another. Good writing demands the long view, under a sky of unbroken blue; good traveling requires one to submit to the fogginess of things, the short-term, minute-by-minute experiencing of the world. It's no wonder that my alter ego and I are on such chronic bad terms.

So—tossing the notebooks into the dunce's corner of my workroom and feeding a clean sheet of paper into the IBM Quietwriter—I'm at last about to find out what really happened to my mobile, purblind self on his travels; what it all meant, and how his voyage fits into the larger story that the book must eventually unfold. Now—touch wood—comes the interesting bit, where the act of writing itself unlocks the memory bank and discovers things that are neither in the notebooks nor to be found in the writer's conscious memory.

You try a phrase out: it rings false. That's not it—it wasn't *like* that . . . You have to mail a stack of rejection slips to yourself before you hit on the phrase that rings true, or nearly true. Successive errors narrow the field to an increasingly fine band, then—*Snap!* When you do find a match between the provisional words in your head and that shadowy, half-buried recollection of events, there's no mistaking it; it's as plain as a pair of jacks on the table. Sentence by slow sentence, you begin to discover the world as it truly was—which is nearly always at variance, and sometimes wildly so, with how it was seen at the time by the dumb cluck with the Paper Mate.

He has his uses. He can be relied on (generally) for names, dates, the odd line of dialogue, the exact wording of a public notice—the basic facts and figures in the story. But on anything of larger importance, he's a tainted witness, too caught up in the proceedings to give a reliable account of them. For the truth of the matter, go not to him but to the language—testing words against the cloudy stuff of past experience, until you get the decisive fit that signals yes, that's how it was; that's what really happened.

Novelists will understand this process well enough—it's more or less how things come to happen in a work of realist fiction. But journalists—wedded to the notepad, the tape recorder, the "verified quote," the querulous gnome in the fact-checking department—may curl their lips in scorn at my habit of trusting the contents of my head more than I trust the documentary evidence of the notebooks. To them I'd offer this remark, made by the Barbizon school painter Jean-François Millet: "One man may paint a picture from a careful drawing made on the spot, and another may paint the same scene from memory, from a brief but strong impression; and the last

may succeed better in giving the character, the physiognomy of the place, though all the details may be inexact."

Just so. For the next twelve months or so, I mean to leave the notebooks in the corner of the room, to the spiders and the rising damp, and go fishing, instead, in memory's haunted lake. *Tight lines*.

Washington Post, 1997

Julia and Hawaii

WHEN WE STEPPED OFF the plane into the sauna weather of a Honolulu evening in late December, my old friend Paul Theroux was waiting for us at the gate carrying a brown paper bag, packed by his wife and full of gifts for my companion—a lei, a hula skirt, a straw sun hat, and a rainbow bikini. Everything except for the bikini, which I nixed, was donned then and there, while our fellow passengers surged past us. Hatted, garlanded, hula skirt swirling, my companion strode off toward Baggage Claim. She looked like the Tourist from Hell.

Julia is four, and it was for her sake, mostly, that we were here. I like the sea but not the seaside, and Hawaii has always struck me as too blatantly clichéd a destination. But four-year-olds have rigidly conventional tastes in travel (most brochures read as if they were addressed to four-year-olds), and for Julia there was still unsullied magic in the idea of sun, sand, sea, the "tropical paradise" with . . .

"Look! Palm trees!" she yelled, joyfully incredulous at seeing the illustrations to *Curious George* and *The Enormous Crocodile* spring suddenly into 3-D all around her. "Why do they have those *rings* on them?" Each tree had a tin sleeve on its trunk, fifteen feet above ground level.

"To stop the mice and rats from climbing up and eating the coconuts," Paul said. Julia stored this piece of information; her first serious nugget of Hawaiian research.

On the drive into town, she gazed perplexedly at the familiar signs, streetlamps, traffic signals. "I keep thinking I'm in Seattle, but I know I'm in Hawaii." To Paul she explained: "Hawaii is always hot because it's nearer to the sun."

At the seafood restaurant where we were meeting Sheila Theroux, Julia took the maître d'into her confidence: "I know I look like a Hawaiian girl,

but I'm not really a Hawaiian girl. *Actually*, I'm from Seattle." The maître d' did his best to appear astonished by this revelation.

The kids' menu yielded pizza. "They have pizza in Hawaii!" Sometimes life just goes on getting better. But after one slice, and before the grown-ups were properly started on their hors d'oeuvres, Julia fell into a coma in Sheila's arms.

Sheila Theroux is Hawaiian-born, of Chinese ancestry, and we settled into a discussion of the complex fate of growing up on Oahu before statehood, when the islands were tugged every which way, between the cultures of Asia, Polynesia, and America. As a child in Honolulu in the '50s, Sheila had felt a "special relationship" between her native islands and the U.S. mainland—a telling phrase, most commonly used to describe the kinship between Britain and the United States, two sovereign powers. San Francisco, the nearest American city, was then half a world away across the ocean (it is as far from Honolulu as, say, Halifax, Nova Scotia, is from Caracas, Venezuela). Statehood came in '59, but it was the arrival of the passenger jets in the 1960s that decisively Americanized the islands. The jets built Waikiki ("It was nothing—it was just a beach"). The jets brought soldiers from Vietnam for R&R, hippies, Minneapolitans on the run from their dreadful winters, and within the decade they robbed Hawaii of its proper oceanic isolation and made it seem to most Americans as little more than an offshore extension of San Diego. Now Oahu's only freeway bills itself as Interstate 1—which, in a sense, it really is.

At dinner's end, I slung my unconscious daughter over my shoulder and carted her off to a room in the Sheraton Waikiki, where a very few hours later I was woken by her announcement that it was "a beautiful morning." It wasn't beautiful. It wasn't morning. In the crepuscular light, well short of dawn, Julia was out on the balcony, already dressed in hula skirt and lei, watching pale explosions of surf on the black beach.

In fifty-four years of active fantasy life, I had never imagined that I might find myself on Waikiki Beach at 7 a.m. in a thin and chilly drizzle, helping to dig burrows for nonexistent rabbits. Unsurprisingly, we had the place to ourselves.

"It's raining," I said reproachfully. "Just like Seattle."

"It isn't!" Julia was leaping to Hawaii's defense. "It's hot rain. Hawaii is always hot because it's closer to the sun."

"I wish I'd never told you that." We were bickering like an old married couple. I wanted breakfast; she didn't. Getting overambitious in the burrowing department, I spoiled the warren. "Now you've made me sad!" In

response: "Where's your other sandal?" It was 9 a.m. before I persuaded her to hit the Rice Krispies.

Back at the airport, we found our flight to Lanai was delayed. Julia, unflappable and uncomplaining, crawled with her favorite bear into the space below the twin rows of back-to-back seats and took a nap. When the Dash 8 eventually began its sprint down the runway, she was enthralled by the takeoff, the sudden release from earth, the diminishing—and now sunlit—city. "We're higher even than the palm trees!"

But the weather worsened as we flew south over an increasingly sullenlooking sea. We came down low over a rocky shoreline rimed with white, no more tropical in appearance than the Isle of Man. The landing gear plopped down from its cowling under the wings and we were almost on the ground when, with an abrupt snarl, the plane climbed steeply and Lanai faded out as we lurched, bumping, through the clouds. The pilot's voice came over the intercom: he was going to make a second attempt to land at Lanai, but if the visibility defeated him again, we'd have to go on to Maui.

"I'm not scared anymore," Julia said, as we twisted and bounced through lumpy fog. "I like it now." I didn't. I held her hand, more for my own comfort than hers. Red dirt materialized out of nowhere just beneath us, followed by the shuddering thump of the wheels on tarmac and the voice of the pilot, rather too plainly registering his own adrenaline level, saying, "Welcome to Lanai." His passengers applauded him, Julia clapping the longest.

From the hotel bus, Lanai was unexpectedly forbidding. Patches of tawny rock showed through the mesquite scrub to which the abandoned pineapple fields were fast returning. Red mud sluiced along the roadsides. We skirted Lanai City, a meagre grid of dripping tin-roofed bungalows with tangled yards. "Are we *still* in Hawaii?" Julia asked, peering through the window at a world so far from the one I had painted for her that I felt like a snake-oil salesman. But as the bus started to corkscrew down the steep road to Manele Bay, the rain stopped, and there was a smear, at least, of sunshine on the gale-torn sea ahead.

All Julia's doubts fled when we stopped at the hotel, where a uniformed bell captain hung yet another lei around her neck—to which I added the lei he tried to pin on me. Bowed down by flowers, and hugely, shyly grinning, Julia entered her paradise on earth.

Paradise—in the shape of the Manele Bay Hotel—is where the taste of Ralph Lauren collides with that of the T'ang dynasty: it has something of the English country house, something of the heyday of the Raj, something of the Venetian Lido, and enough ostentatious chinoiserie to fill a container

ship end to end. From the grand public rooms at the center of this marvellous confection, one is led out to a maze of beige-colored open cloisters, through gardens packed with jasmine, palms, bougainvillea, orchids, jacaranda, where a winding stream, full of ornamental carp, is fed by a succession of prettily constructed waterfalls. *In Xanadu*...

The hotel's preferred term for its own architectural style is "Mediterranean"-but that's too modest. It is, rather, triumphantly American: American in its lavish capital investment, American in its lofty disregard for natural obstacles. For the southern, leeward shore of Lanai is dry to the point of being arid; when left to itself, it was a rust-colored cinder heap, nearly bereft of vegetation. When David H. Murdock, the Californian owner of Castle & Cooke and the Dole fruit company, the Kubla Khan of Lanai, took the island out of pineapples and into up-market tourism, he built a new landscape with imported dirt, moistened by water that was piped down from the wet, forested uplands beyond Lanai City. The Manele Bay Hotel's scented domestic jungle and broad, spongy lawns are kept alive by an underground network of nighttime sprinklers. The place is—in the eighteenth-century sense of the word—a folly; a monument to the wily artifice of the hydraulic engineer and landscape gardener. In the can-do arrogance of its conception, it's in the spirit of Las Vegas or the Grand Coulee Dam.

Our room, at the far end of the maze, was backed by a waterfall, fronted by a lawn, a ha-ha, then the sea. Julia was enchanted—by the green at our doorstep ("We've got our own field!"), by the marbled splendor of the bathroom and its fittings, by the expensive collection of Chinese breakables. She expertly raided the minibar, changed into her bikini, and went visiting with the neighbors along the row of oceanfront patios.

She was instantly at home here. Four-year-olds, of course, are born to room service; they know no other kind. What I hadn't realized was how very closely the world of the resort hotel resembles that of the preschool. The young women who run the concierge desk are the controlling grown-ups; they set the curriculum and sort out squabbles. The fifty-five-year-old guest, in his beach romperwear, with bulging face and shrilling voice, is the two-hundred-pound toddler having a snit.

As at preschool, the hotel day is organized around mealtimes, with, between meals, what Julia's Seattle school calls "sensory activities," centered on the pool, the spa, and the beach. For the adult guest (if that's not a contradiction in terms), the trick is to adjust to being four years old again. You

have to learn the school rules: no swimwear in the public rooms . . . elegant resort attire is acceptable in the restaurant . . . You have to slot yourself into the regimented spaces of the school day. I settled for the activities known to Julia as Quiet Time and Stories—lounging on our patio reading Trollope's The Bertrams and trying to put names to the neighborhood birds.

The birds, as it turned out, exactly mirrored the human sociology of the islands. Very few were native to Hawaii. Most had been introduced within the last hundred and fifty years—foreigners who had thrived in the balmy climate with its easy pickings, just like the Chinese, the Scots, the Filipinos, the American mainlanders, the Samoans. So the starlings, who roosted noisily each evening in the palms above our waterfall, were descendants of birds brought to New York in 1890 by a misguided Noah, an Englishman named James Edmund Harting, whose mission it was to supply the New World with all the birds mentioned in Shakespeare's plays. The house sparrows had come over from New Zealand in 1871; the black-hooded mynahs from India in 1865; the cardinals from the United States in 1929. The many Japanese guests at the hotel could wake to the familiar dawn chorus of Japanese bush-warblers, resident aliens in Hawaii since 1929. And so it went. Lanai was an island of immigrants, more Filipino than Hawaiian native; a cultural salad of exotic birds and people, deposited in mid-Pacific by the plane- and shipload. The imported bric-a-brac in our room, the German family from Munich staying two doors down, Julia's and my own presence here—we were all authentically part of the salad. In Hawaii, nearly everything and everyone comes from somewhere else; so being a tourist in the islands isn't a matter of embarrassment, as it so often is elsewhere. Here, the vast majority of "the locals" are, like the sparrows, just visitors who stayed put.

Meanwhile Julia, in the care of the Children's Activity Center ("Let's pretend I'm going to school in Hawaii"), was conducting a strenuous social life on her own behalf: she played bingo, she went on epic scavenger hunts, she watched movies, she attended poolside pizza parties, and she fell in love with her swimming instructor.

I was walking to lunch, *The Bertrams* in hand, when I was hailed from the pool. "*Daddy!*" Julia, in rainbow bikini, was wetly reclining in the arms of a mahogany-tanned twentysomething beach god. "This," she said, glowing with pride in her conquest, "is Kenjy." "Hi, Kenjy," I said, reaching down with the fake bonhomie that, I guess, all fathers learn to exercise in this situation. Kenjy, with Julia riding on his back, lapped the pool.

"I shall not forget this day in my entire life," said Julia.

Next morning, she awoke at six forty-five, sitting bolt upright in her bed and announcing, "I *love* Kenjy."

"I know," I said. "Go back to sleep."

Over room-service breakfast, she tried another tack. "I hate work," she said. "I like it where we have fun all day, like in Hawaii."

"What work are you talking about, Julia?"

"Oh, you know," she said, in an airily dismissive tone that was new to her. "Like all your typing."

I saw in a flash how the writer's life was being compared, most unfavorably, with the carefree existence of her swimming instructor. "My typing," I said, "is what brought us to Hawaii."

"You're kidding," said Julia, spitting out Rice Krispies as she laughed at the sheer ridiculousness of my remark.

The Therouxes were due to join us on the island on Friday. Paul and I had planned a vinous weekend of gossip, and he was billed to introduce my Saturday-night reading at Lanai's other hotel, the Lodge at Koele (which, via the Lanai Visiting Artist Program, was how typing had brought Julia and me to Hawaii). But I woke on Friday morning to the brushfire crackle of rain on the patio: our ocean view had gone, and from the radio I learned that Lanai airport was closed to all traffic.

An intense kona storm was dawdling through the islands. Gleaming rods of rain were drilling holes in the lawn, and the dry creek bed just to the west of us (the favored haunt of the Japanese bush-warbler) had become a foaming torrent of red water. It was tearing up small trees by the roots and flinging them into the ocean. The waterfalls were running red, and so was the ornamental stream, which had burst its banks and was drowning the orchids in the gardens. The hybrid carp were nowhere to be seen. "Poor fish—I expect they're dead," said Julia. Our usual elevator was out of order: it had sprung a leak, and red water was dripping through the shaft. At the top of the stairs, six Filipino maids were trying to stanch the flood by pushing at it with long brooms. I rolled up my trouser legs, hoisted Julia onto my shoulders, and waded the last twenty yards to the main body of the hotel.

Towels from the pool had been requisitioned to do duty as sandbags in the great hall, and worried engineers, in overalls and tool belts, were exchanging notes over two-way radios. Julia befriended a wet kitten that was taking refuge from the downpour. A brief lull in the rain revealed that the sea itself was stained red with runoff: a half-mile-wide band of water the color of dark tomato soup now encircled the island.

We were marooned in our stately pleasure dome. Bands of would-be

travelers were begging the concierge staff to make planes fly. The lobby was piled high with their luggage. "I have to be in New York tonight!" "I have to be in Tokyo tomorrow!" The only way off the island was by boat to Maui. "But it's rough, and I get seasick!" wailed a toddler in her sixties.

Things were quieter below. Couples were bent over million-piece jigsaw puzzles. Single men were making tents of two-day-old copies of the *Wall Street Journal*. There were novels—John Grisham or Danielle Steel, depending on the reader's gender. Several men were deep in a book titled *Golf Is Not a Game of Patience*. People would stare out into the gray yonder, then consult their watches importantly, as if they expected their bomb to go off at any moment.

With Julia dispatched to the children's center, I finished *The Bertrams* and went off to browse through the hotel library, where I encountered my daughter, who was on a scavenger hunt. "Have you seen Kenjy?" she said.

Getting through to Honolulu on the phone was like trying to raise Bora Bora or Uttar Pradesh: Paul's voice was a whispery vibration in the wires. "Tomorrow!" it croaked, from another world.

So I got Julia as my dinner date. For my entertainment she juggled the silverware. She conducted a physics experiment involving the horizontal flow of liquids (apple juice, in this case, and the experiment failed). She slid under the table ("Let's pretend you don't know where I am—"). She waved at strangers and kept up a running commentary on their varying degrees of baldness, redness of face, girth, age, prosthesis, and fashion-victimhood. All this had an eerily familiar ring to me—though, as I remembered it, such behavior usually emerged only toward the end of the second bottle of wine.

The staff—pineapple pickers, retrained for the hotel trade—extended to both of us a smiling tolerance that went far beyond the call of duty. They indulged Julia; they talked to me of their children and grandchildren. Unaffected, with none of the solemn snootiness that tends to go with jobs at a \$400-a-night hotel, these cheerful and elastic islanders seemed the best possible advertisement for Murdock's economic revolution.

On Saturday morning it was still raining, with the cloud-ceiling pegged to the ground. The weather system had stalled over Lanai and showed no sign of budging. No flights in or out. No Therouxes. Our long-planned weekend was a bust. Julia splashed through the cloisters, clutching a fallen coconut she'd found in the grass. She took in the thrashing palms, the rusty flood, the glum adults staring at the weather from their dripping patios. "I love Hawaii." She had an appointment with Kenjy at the children's center.

I pride myself on meeting the ordinary happenstances of traveling with equa-

nimity, but Julia was making me feel a rank amateur. "So do I," I said. We passed the concierge desks, with their throng of grown-ups throwing tantrums. Julia marched through them, full of happy purpose, while I bumbled in her wake. She was in command of the vacation now; she had the Manele Bay world at her fingertips. "Come *on!* This way!" And I obeyed—glad to learn from my daughter, at this late stage, how to travel gracefully.

New York Times, September 1997

The Turbulent Deep

IN 1990 I MOVED from England, where I kept a boat on the Black-water estuary, to Seattle, from where I sail a thirty-five-foot ketch. The move took me from shallow to deep water: from sandbars and swatchways, where the depth-sounder dickers around the ten-foot mark, even in the middle of a buoyed channel, to the abyssal inland sea that stretches from Puget Sound to Glacier Bay in southeast Alaska. Here, the depth-sounder searches in vain for an answering rebound from the dark seafloor, where the giant bedroom-eyed *Octopus dofleini* reclines on its soft bed of silt.

"Sounded with 100-fathom line. Found no bottom," wrote Peter Puget—a fellow-Londoner—as he tried to get the measure of these waters in 1792, when, as George Vancouver's lieutenant, he was on the *Discovery* expedition, mounted by the British navy to survey the Pacific Northwest. It's a refrain that runs through Puget's journal: "Sounded with 80 fathoms. No ground"; "Tryed for Soundings but could not reach Bottom." I know how Puget felt—almost within touching distance of land, but vertiginously suspended above a fathomless deep. The lie of the land was homely, to him as to me: the low wooded hills of Puget Sound would remind any Englishman of Devon—the approaches to Dartmouth, or Salcombe. Nothing in Puget's seagoing experience can have prepared him for the eerie behavior of the lead, on its thick hemp line, as it sank, and sank, and went on sinking, the line bellying-out and thrumming in the current as if a big fish had swallowed the fourteen-pound lead.

I'm a thin-water man, and after seven years I still find something sinister and alienating about such profound and unexpected depths. They remind me that I'm a novice here, an awkward stranger sailing over these drowned rift valleys, with the troubled water forming itself into whirl-pools, rips, and overfalls. Crossing the Strait of Georgia is like a homecom-

ing: its short, sharp chop and estuarine shallows make it a close cousin to the North Sea—squint, and the brown water off Sand Heads could easily be the sandbank maze between Harwich and the Kentish Knock, where the Thames and its fellow east-coast rivers spread themselves out in a wicked, dun-colored, brackish sea. But the Strait of Georgia is an exception. It's in the deep sounds and passes that the sea here shows itself in its true colors—as it boils, at fifteen knots, through Seymour Narrows; breaks short, waves hoisting themselves on each other's backs, in the long reach of Johnstone Strait; explodes white against the insolent obstacle of Egg Island; or eddies, with viscous smoothness, like poured molasses, through the deeps of Puget Sound and Stephens Passage.

It is as intricate and devious a sea as any in the world, and it defeats the best efforts of hydrographers to draw its portrait according to the usual rules. The tidal atlases, Canadian and American, come nowhere near to catching its real likeness with their little arrows flying in parallel, like so many volleys from the bowmen of Agincourt. This sea simply doesn't move like that. It goes in swirls and gyres. For every current there's a counter current. It is chronically turbulent. Its most typical facial expression is the whirlpool; water rubbing against water to make turmoil.

Far better than the hydrographers, the GPS does capture something of the sea's riddling and disturbed character. You're on passage, say, from Sooke on Vancouver Island to Dungeness on the Washington shore, riding a supposedly favorable flood tide down Juan de Fuca. The wind is steady. You're making an easy five and a half knots through the water. Race Rocks lighthouse is a couple of miles off on your port beam. The Garmin reports that you're making nine knots over the ground (Wheee!)...9.5...9.6... 10.1! For five minutes you're in double figures; then, with the boat nicely heeled and the water sizzling under the counter, you look to the GPS and see the number 0.8 bewilderingly displayed. Suddenly the sea is heaped and growling, the standing breakers dribbling foam down their fronts. You can watch the current move fast and smoothly through the waves, like the glissade of a river over boulders. Snatching at the wheel, white-knuckled, you hear the sound of crockery smashing down in the saloon. The boat is trying to turn itself into a corkscrew. Its front end rears up and slams into the trough as if it had been dropped on concrete from a crane. The GPS says, 1.2 knots, 0.9, 0.0. There's sea in the cockpit, swilling round your ankles. You are a secular rationalist, a committed skeptic. But on this sunny morning, in a modest westerly breeze, you check out the unusual movements of your own lips and find that they are saying prayers.

One needs the vocabulary of chaos theory—strange attractors, Mandelbrot sets, fractals, quarks—to begin to describe the sheer aberrant swirliness of this corner of the North Pacific. Its extraordinary depth gives it such volume that whenever it feels encumbered by the land, a little too squashed for comfort, it behaves as if it were as volatile and shallow as a whitewater mountain stream. The tide is always trying to shift more water than the land will allow. The bottom is uneven, with raised sills that create unseen submarine cascades. These deep waters don't run still.

Their turbulence is kind to life in general. I've brought home a bucket of Puget Sound water and gazed at samples of it through a yard-sale microscope. It was a wriggly soup of plankton: copepods, rotifers, flagellates, their whips pulsing feebly on the glass. Through the 97X lens, a teaspoonful of this water yields a Spielberg-like world of scaly-tailed, bug-eyed, diaphanous monsters—true creatures of chaos. For it's in the churning-up of cold, lightless, saline water from the deep with the warm, sunlit, aerated water from the surface that living things get on the hop. The more turbulent the sea, the richer it's likely to be in tiny forms of life and, consequently, in big ones too. This dusty and opaque sea, always reluctant to mirror even the bluest sky, looks dull and preowned, like dishwater; but its dustiness is the dustiness of life itself.

Zooplankton feed on phytoplankton, fish feed on zooplankton...It takes only a handful of links in the food chain to arrive at the black-and-white Dall's porpoise, torpedoing under the bow of the boat, or the faint plume in the air, like a twist of smoke from a dying campfire, where an orca is blowing. It's almost impossible to put out to sea here without meeting large mammals, all of whom ultimately owe their existence to the roiling water of the rip and the eddy. Marine life thrives on flux and commotion.

But what is good for plankton has always inspired deep-rooted fear in humankind, and in more unexpected ways than one might casually assume. The maritime art and oral literature of the Northwest coastal Indians is full of images and interpretations of turbulent water. The day-to-day experience of navigating tide races and whirlpools in easily swamped dugout cedar canoes supplied the Indians with an inexhaustible metaphor for the conduct of life at large.

They saw the whirlpool as a malign trickster. There's a Tsimshian story

about Nagunakas, a vicious and resentful creature who took the form of a whirlpool near Prince Rupert, British Columbia. He would reach up from the sea bottom, snatch a canoeful of fishermen, and toy with them in his underwater lair. Or there's Getemnax, a violent whirlpool who manifests the head and shoulders of a young woman, but who has an elephantine penis. Getemnax's hobby is to seduce young men and drown them. In Salish mythology, there's the cunning whirlpool at Deception Pass, where the tide bowls through the narrow gap between Whidbey Island and the Washington mainland. This creature appeared as a lithe and attractive suitor to a young woman, Kokwalalwoot, who was gathering clams on the beach. Sucked into the water by her whirlpool lover, she began to lose her human attributes and turn into a grotesque sea-being: kelp sprouted from her nostrils and eye sockets, barnacles grew on her skin. When she tried to go back to her village, she was reviled as an outcast. Yet Indian navigators, negotiating the tricky water of Deception Pass, looked to her for help in getting through safely. In one version of the story, the scrolls and curlicues of current in the pass are seen as tresses of Kokwalalwoot's hair, waving to and fro in the stream.

There are dozens of such whirlpool stories—all of them versions of the same essential story, in which turbulent water is seen to correspond with some kind of dangerous turbulence in the social order. Sexual ambiguity, treachery, incest, murder . . . these tumultuous social events, which threaten to overturn the fragile canoe of the family or the village, are embodied and given names as famously destructive whirlpools. One can read the stories as parables of poor judgment in the navigation of life, and as dreadful warnings of the likely consequence of tangling with turbulence.

Much more than their inland cousins, the Indians of the Northwest coast developed a rigidly stratified society, with strict rules governing every aspect of behavior and a fantastic panoply of fine distinctions of class and status. Their daily seagoing gave them an intense firsthand experience of chaos—of just how easily things can spin out of control. The smooth sea suddenly steepens; the current reverses on itself and overpowers the paddler; the whirlpool sucks you in. It's only to be expected that a people who spent their days literally skirting the lip of the maelstrom would run their society as a very tight ship indeed.

Turbulence speaks to us in private ways, too.

The more he explored the serpentine waters of the Inside Passage, with their baffling tides and immense depths, the lower sank George Vancouver's spirits. In April 1792, when *Discovery* entered Juan de Fuca Strait, Vancouver was high on the prospect of the "expansive mediterranean ocean" that lay ahead. For a while, everything pleased and excited him. Anchored in Discovery Bay, at the southeast end of the strait, he exulted in the prettiness of the landscape that encircled the ship:

... the surface of the sea was perfectly smooth, and the country before us exhibited every thing that bounteous nature could be expected to draw into one point of view. As we had no reason to imagine that this country had ever been indebted for any of its decorations to the hand of man, I could not possibly believe that any uncultivated country had ever been discovered exhibiting so rich a picture.

He was put in mind of "certain delightful and beloved situations in Old England." Vancouver's commonplace taste in the picturesque was amply satisfied in the long sound that he named after Peter Puget: every bird, every bush, every clearing in the forest, every steep fall of timber made him think, approvingly, of some "ingenious designer of pleasure grounds"—presumably Capability Brown, the great landscape architect, creator of walks and vistas for the English aristocracy, who had died nine years before.

By June, Vancouver was entombed in depression. Much of his time was spent locked inside his cabin, taking potions prescribed for him by Archibald Menzies, the ship's naturalist and stand-in surgeon. He took it out on his crew, sentencing men to grim public floggings. "Punished Willm. Wooderson Seaman with 24 lashes for Insolence." On June 25th, heading northwest along the British Columbia mainland coast, he left behind the broad Strait of Georgia and entered "a very unpleasant navigation." "Soundings could not be gained though close to the shore." "By the influence of the tides we were driven about as it were blindfolded in this labyrinth." He looked out at the surrounding country with frank loathing: "Very inhospitable"— "stupendous rocky mountains"—"dreary and unpleasant"—"dreary rocks and precipices that compose these desolate shores"—"our residence here was truly forlorn"—"nor was the sea more favourable to our wants... not a fish at the bottom could be tempted to take the hook."

He had found his heart of darkness. He called the place Desolation Sound.

There was a deep and troubled abyss in Vancouver's own character. Short, fat, with protuberant thyroidal eyes, his body racked by a violent hacking cough, Captain Van (as he was called behind his back) was given to fits of malevolent rage. Menzies described him as "passionate and illib-

eral in his abuse"; another lieutenant, Thomas Manby, wrote of him that he was "Haughty Proud Mean and Insolent . . . his Language to his Officers is too bad." Like many people who feel that they are standing on the edge of a terrible internal precipice, Captain Van clung desperately to rank, order, convention. The structure of his often-clumsy sentences (yet another officer aboard *Discovery*, Robert Barrie, called Vancouver's *Voyage* "one of the most tedious books I ever read") betrays a homesick yearning for early-eighteenth-century notions of correctness and subordination. The undereducated Vancouver ached to write like Dr. Johnson, but could never master the Latinate syntax he so admired. In the dark labyrinth of islands, swept around and around by the unruly tide, unable to reach bottom with the lead, Vancouver, I think, found himself confronting something intolerably commensurate with his own inner chaos.

George Vancouver was a great measurer, a brilliant surveyor, a genius with the sextant, the compass, and the clock. One could sail now with his charts, using his *Voyage* as a pilot book, and pass safely from Seattle to the Alaskan panhandle. But in the mad scribble of islands and inlets at the northwest end of Georgia Strait, he came up against the classic chaos-theorist's problem: how do you measure a coastline? Around every rock? Every pebble? Every grain of sand? The more you measure, the longer it gets—until the whole concept of measurable distance becomes arbitrary and absurd. The sea was too deep to chart. Worse still, the tide, whose predictable rhythms plot the seaman's normal day, appeared to have gone haywire.

In the region around Desolation Sound, the tide is so irregular that the compilers of modern tidal atlases leave the area blank, except for asterisks warning the mariner to expect capricious currents here. On Tuesday, the ebb tide will run south to the Pacific by way of Georgia Strait; on Wednesday, it may elect to run north, finding the open sea via the Sechelt Rapids and Charlotte Strait. Vancouver commented:

in the course of some days there would not be the least perceptible stream; and in others a very rapid one, that generally continued in the same direction twenty four hours, and sometimes longer. The time of high water was equally vague and undefinable.

All Vancouver's knowledge of the sea, his faith in tables, predictions, measurements, was affronted by the weird conditions he met in Desolation Sound. It was an encounter with chaos for which he was profoundly unequipped. His experience there colored the rest of the voyage for the

worse. His published book tries to put a good face on his intense depression, but as one reads between the lines, one keeps on catching glimpses of the black dog on Vancouver's shoulder. It's in a private letter to a friend, written from Friendly Cove in Nootka Sound, shortly before *Discovery* set sail for England, that one hears Vancouver's voice at its most miserably candid: "I am once more entrap'd in this infernal Ocean."

It would dumbfound Vancouver to learn that Desolation Sound is now a favorite tourist destination for the boating families of the Northwest—though it wouldn't greatly surprise Puget. Seven years younger than his captain, Puget came from a Huguenot banking family based in central London; and his journal reveals him as hip to the new Romantic ideas of the sublime and the wild that were stirring in the intellectual circles of his time. Where Vancouver was repelled by "dreary precipices," Puget was capable of seeing them with cultivated Romantic awe.

The Victorian rage for wilderness, for untrammeled nature, from Wordsworth's Lake District to John Muir's Alaska, went hand in hand with taking a connoisseur's aesthetic pleasure in the turbulent motion of fluids. The thunderously breaking wave, the Niagara Falls, the boiling cataract of the Grand Canyon of the Yellowstone became standard set-pieces in the Romantic artist's repertoire. The painters of the West, like Bierstadt, Church, and Moran, reveled in the swirl and tumble of things—in tumultuous clouds, volcanic eruptions, and rock that appears to be still molten, with its dizzy upwellings and twisted crags. Even as Captain Van found his spiritual nadir in the random tidal currents of Desolation Sound, chaos was becoming picturesque.

In our present phase of post-Romantic, postmodern cool, we've so fallen out of touch with the visceral dread of chaos that we'll never meet Getemnax face-to-face, or feel Vancouver's desolation on our own pulses. I'm told that the buzzword now at Amazon.com is "fractal"—used in editorial meetings to denote a draft page design, as in "This is the basic fractal we'll be working with..." It's not quite what Mandelbrot had in mind when he coined the word to describe his new geometry of chaos; but the Amazon usage is a measure of how airily we take on the state of nature that used to inspire horror in our ancestors.

Yet sometimes, in a small boat, fearing for your skin, you can get an inkling, at least, of how they felt. If I were a far less timid sailor than I am, I

might go out in a kayak and let myself get caught in the great tidal gyre, six to eight miles in diameter, on the Canadian-U.S. border at the south end of Haro Strait. On a spring tide, in a moderate-to-strong wind, you'd soon lose your cool in that maze of whirlpools and overfalls. It is catastrophic water, serious and turbulent enough to frighten one back into prehistory.

Even my safe-as-houses ketch, with its fifty-horse diesel and electronic navigation aids—a sedentary, bookish, middle-aged sort of boat—can unexpectedly turn into a vehicle for time travel, jolting me into the mind-set of a heartfelt animist.

I'm just back from a twelve-day sailing trip to Nootka Sound, on the west coast of Vancouver Island. I wanted to walk on the beach where Captain Cook landed in 1778, and which served as Vancouver's HQ on his surveying expedition of 1791–95. Nootka is about two hundred and fifty miles northwest of Seattle—five comfortable day-sails away. A friend was with me, as she put it, for the sake of the suntan.

On the morning of our third day out, we left the Makah Indian settlement of Neah Bay at 5:25. In the east, the sky was promisingly streaked with rose and lemon. I had feared fog but the visibility was magnificent, with the razor-slash peaks of the Cascade Range showing clearly against the predawn luminescence. Gruff-voiced, short of sleep, we motored round the black shadow of hogbacked Waadah Island into the western entrance of Juan de Fuca Strait, bound for Cape Beale, twenty-seven miles away on the Vancouver Island shore.

The ebb was running, and much faster than its official schedule had announced. The tide tables gave two knots max at Juan de Fuca West; but as the boat shed the land, it began to hurtle over the ground. The GPS was giving ten-knots-plus; six from the engine, four from the tide. It's not good for water to move at that speed. The current was colliding with the usual low westerly swell from the ocean, shortening the intervals between the crests to no more than four or five seconds and turning normally smooth hillocks into steep, greasy walls of water, nine feet high and climbing. The offshore breeze, from the southeast, came in mild, flatulent gusts; just enough to keep the headsail filled and steady the boat as it rolled in the swell.

I didn't like it. Everything was held in too delicate a balance. If the wind increased by just a notch, or if this puzzling current got any faster, our lolloping ride over the sea could turn into something seriously nasty. I looked over my shoulder to see how my friend was doing. She had been worried about being seasick, and conditions now were perfect for a bout of technicolor yawning.

Two suns had risen in the sky.

One sun had just cleared the dark ridge of the mountains. The other hung twelve to fifteen degrees above it, on the same meridian.

One was not a paler image of the other. They were two: equally round, gold, substantial, as sharply defined as a pair of coins.

For a space of time hardly longer than the blink of a camera shutter, I was possessed by a mad piece of intelligence, as I grasped the physics of what was happening. Of course the tide was running like this! Double the magnetic pull of the sun on the liquid skin of the earth, and the oceans might boil in their basins like the Colorado River.

"A sun dog!" my friend said. "I've never seen one. So that's a sun dog!"

But I had seen a derangement in the heavens, and no amount of talk about ice crystals and refraction could quite dispel for me that momentary, foolish apprehension of universal chaos. I felt spooked and queasy.

In ten minutes or so, the higher of the two suns abruptly faded from the sky. The current slacked, the swell subsided. The next four hours were perfectly uneventful. I got up Bowditch—American Practical Navigator—from downstairs, and looked up "sun dog":

A *parhelion* (plural *parhelia*) is a form of halo consisting of an image of the sun at the same altitude and some distance from it, usually 22°, but occasionally 46°... A parhelion is popularly called a *mock sun* or *sun dog*.

So it wasn't a sun dog, at least as defined by Bowditch.

Sailing now on a friendly wind that was enough to raise waves that peaked but didn't break, more cradled than rolled by the surviving swell, I was still haunted by my nanosecond of stupid shock, and by the derailed logic that followed in its wake. I watched the water anxiously, for signs and omens, and raided my friend's pack of cigarettes at too frequent intervals.

Later, at anchor in a still lagoon in the Broken Group, in Barkley Sound, I leafed through two fat, glossy books of Kwakiutl and Haida art—more informative than Bowditch on the peculiar celestial events of the morning. In their firelit winter ceremonies, the Indians acted out tumult in nature, wearing masks designed half to scare and half to entertain. Here were the lords of chaos, hinged and articulated, in grotesque cedar carvings, like the gargoyles of medieval cathedral stonemasons. Earthquake appears as a human face with enormous staring eyes and fat wooden lips that clack up and down to speak; suspended from hooks on his skull, his eyebrows sud-

denly descend to form a visor, transforming him into a creature of blind, snapping menace. Thunder is the head of an aquiline bird with a massive curved beak, which opens wide to reveal the face of the moon inside; its companion, Lightning, is a serpentlike fish. The Master of the Tides is the head of a giant, painted blue, with eyes that roll and wink on their controlling strings.

The masks, with all their ingenious moving parts, represent a nature that can transform itself from the benignly familiar to the cataclysmic at the tug of a string. They're masterpieces of the art of shock and surprise. They recognize the chaos that might, at any second, engulf your world: the quake, the lightning strike, the sudden turmoil of the sea.

We sailed on to Nootka, where we snugly weathered a storm of fifty-knot winds from the southeast. Four inches of rain fell during that day, an average deluge in those parts. When Captain Cook sailed into the sound, his ship, *Resolution*, was met in the roadstead by three canoes under the command of Maquinna, the local chief. The Indians wore their ceremonial masks to receive the visitors. Cook was puzzled about the masks' meaning:

Whether they use these extravagant masquerade ornaments on any particular religious occasion or diversion, or whether they be put on to intimidate their enemies when they go to battle, by their monstrous appearance, or as decoys when they go to hunt animals, is uncertain.

I'd like to think that the Indians were simply supplying Cook with important navigational information, using their masks to tell him in advance about the deep, treacherous, sudden, inherently chaotic nature of their native sea.

Cruising World, 1998

White Warfare

IN EARLY SEPTEMBER 1916, there was no more common sight in England than that of post boys pedaling off to cottages and farms to deliver the telegrams that would break hearts. The Battle of the Somme was in full swing. Three months had passed since the Battle of Jutland, with its long columns of names of men lost at sea. The previous two years had been punctuated by the bloodbaths of Vimy Ridge, Verdun, Ypres, and the Marne, and people had grown numbly used to the idea that young men were the necessary fuel for the thirsty machinery of modern war.

It was a strange time to read the news breaking from Punta Arenas in Chile, where it was reported that all twenty-eight men of Sir Ernest Shackleton's Imperial Trans-Antarctic Expedition were safe and well, after a two-year ordeal that no one could reasonably have been expected to survive. "Not a life lost" was the catchphrase; ironic words to the grieving families of England. Shackleton's own survival had been known of since late May, when he and two companions, Frank Worsley and Tom Crean, had stumbled—a trio of frostbitten Robinson Crusoes—into the whaling station of Stromness on the island of South Georgia. At that time, a British journalist from *John Bull* magazine had found (or, as likely, invented) a rustic "kelper" in the Falklands to give voice to the presumed popular sentiment on the expedition and its leader: "E ought ter ave been at war long ago instead of messing about on icebergs."

In his provocative, bravura essay *I May Be Some Time: Ice and the English Imagination*, Francis Spufford writes that "the Edwardian world lasted longest" in Antarctica, where

a tiny bubble of pre-war feeling and expectation persisted... in the form of Shackleton's marooned *Endurance* expedition. Probably Shackleton's men were the last Europeans on the planet still inhabiting the lost paradigm in 1916.

This is an interesting thought, but it fails to take into account Shackleton's un-Edwardian, ungentlemanly (and distinctly Anglo-Irish) instinct for publicity and image manipulation.

From the summer of 1913, when he began to raise funds for his projected crossing of the Antarctic continent, from the Weddell Sea to the Ross Sea, Shackleton saw the expedition in anticipation of the lucrative news splash that would attend its triumphant return home. "Imperial" was a key component of the expedition's title. Although Roald Amundsen had raised the Norwegian flag over the South Pole in 1911—having beaten out the competing English expedition of Captain Robert Falcon Scott—a successful coast-to-coast journey would establish a pathway of Empire, linking Britain's guano-encrusted possessions in the South Atlantic to its Pacific colonies of New Zealand and Australia. At least, the expedition's path could be made to look like that on newspaper maps of the great endeavor. The route was calculated to gratify jingoists like the Marquis of Lothian who (in the 1890s) had delivered himself of the opinion that "I should not like to see foreign names upon that hemisphere where all civilized points are inhabited by our countrymen, and belong to this country."

Like Empire, Science was another glossy pretext useful for drumming up sponsorship. Shackleton—who had left school to join the merchant navy at the age of sixteen—had no interest in science, and thought of scientists as boring deadweights who couldn't sing and were likely only to spoil a good adventure. But he shipped a full complement: a geologist, a physicist, a meteorologist, and a biologist. These boffin-types were meant to give the expedition a desirable aura of academic gravity.

Sir Ernest was careful to mask from his backers his own guiding enthusiasms, which were essentially juvenile. He was fixated on the possibility of finding gold and/or buried treasure. Frank Worsley, the captain of *Endurance* (and something of a perpetual schoolboy in his own right), wrote of Shackleton that he "was as romantic as a schoolboy on the subject of treasure, and always believed that he was going to find untold wealth on his expeditions. Why, I don't know. There were never any signs of it."

A sometime journalist (he was briefly employed as a subeditor at Royal

Magazine, a popular monthly), Shackleton had a more realistic grasp of the potential gold mine in his "story," which was fully themed and plotted long before he left England. He registered the ITA (Imperial Trans Antarctic) Film Syndicate Ltd. in order to milk the movie and photographic rights, and hired Frank Hurley, a profane, strapping, and mechanically gifted Australian, as official cameraman and photographer. In January 1914, the London Mail carried this gossip item:

The mercenary side of a Polar "stunt" is absorbing. Any day you may see Sir Ernest—always alone—taxiing from one newspaper office to another. He is trying to arrange the best terms and it is going to be a battle royal both for the news and pictorial rights.

The *Daily Chronicle* beat out its rivals for an exclusive. Book rights went to Heinemann, publishers of Shackleton's 1909 best seller, *The Heart of the Antarctic*. The ghost on that book (Shackleton was a thoroughly modern author), a New Zealand–born journalist named Edward Saunders, was standing by in readiness for the new adventure. In these pre-radio and -TV days, London lecture halls could command West End theatre ticket prices, and when the time came Shackleton would be found performing twice a day, with his magic lantern, at the Philharmonic Hall, Great Portland Street.

Hard up as always, Shackleton planned to make a fortune from his polar journey. The immediate costs of the expedition—about £60,000—were met by a government grant of £10,000, in addition to hefty individual investments from a jute magnate, a bicycle manufacturer, and a tobacco heiress. The heiress was Janet Stancomb-Wills, and the Wills Company's Wild Woodbines were soon destined to become an iconic feature of trench warfare in Flanders. When men sang, "While you've a lucifer to light your fag...," the fag would almost invariably be a Woodbine, and a kindly clergyman who handed out cigarettes to the troops earned lasting fame as "Woodbine Willy."

Shackleton pitched his expensive project during the last anxious months of peace. The outbreak of the war with Germany forced him to hastily revise his presentation, and justify an arduous but thrilling treasure hunt as a patriotic contribution to the war effort.

Endurance sailed from London for Plymouth on August 1, 1914. Britain declared war on Germany at 11 p.m. on August 4, when the ship was taking on final provisions and equipment at her berth near the Hoe. Shackleton

immediately cabled the Admiralty, volunteering *Endurance* and her crew for service in the hostilities. It was a necessary gesture, but he must have been keeping his fingers crossed as he waited for the reply—which came promptly, declining his offer, and ordering *Endurance* to proceed south as planned.

Between August 8, when *Endurance* sailed for Buenos Aires, and September 19, when Shackleton followed her aboard a fast passenger liner from Liverpool, he was busy in England settling affairs with his creditors, his wife, and the newly appointed minister for war, Lord Kitchener. Somewhere en route between Liverpool and Buenos Aires, he seems to have hit on the sound bite that would effectively tie the polar expedition to the European war. On October 26, just before *Endurance* left Buenos Aires, Sir Ernest cabled London:

We are leaving now to carry on our white warfare, and our farewell message to our country is that we will do our best to make good. Our thoughts and prayers will be with our brothers fighting at the front.

We hope in our small way to add victories in science and discovery to that certain victory which our nation will achieve in the cause of honour and liberty.

This struck some English readers as a bit rich. The first Battle of Ypres had begun five days before, with heavy British losses, and "white warfare" was a bold (and, one might have thought, tactless) way to describe a lavishly funded adventure among the penguins.

But Sir Ernest was wedded to the phrase. When he and Saunders wrote *South* (1919), the dedication read:

To
My Comrades
Who Fell in the White Warfare
of the South and on the
Red Fields of France
and Flanders

The first page of the preface addressed an audience of prospective readers who would

now turn gladly from the red horror of war and the strain of the last five years to read, perhaps with more understanding minds, the tale of the White Warfare of the South. The hammer-blow repetition betrays Shackleton's anxiety, in 1919 as in 1914, that he might be seen to have ducked out of the real war and gone off on a lark. Far from inhabiting Spufford's lost paradigm, he was painfully conscious of the fact that his expedition—so long as it was on public view—must be conducted on heroic *pro patria mori* lines. Since Shackleton was an exuberant man who liked bad jokes, tall stories, singalongs, this must at first have seemed to put a damper on things; but he was also an instinctive actor, well capable of playing the part of field marshal in the Great White War.

Endurance finally fell out of contact with the rest of the world on December 5, when she left Grytviken, on South Georgia. Shackleton could not possibly have guessed at the war's terrible duration, but its extent, and the scale of its casualties, were already clear. Eighteen months later, when he crashed back into the world, seemingly from the dead, Shackleton's first question would be: "Tell me, when was the war over?"

Shackleton grew to dislike Frank Hurley, the photographer, thinking him too clever by half. At their first meeting, Hurley took against Shackleton ("From what I can see," he wrote, "Sir E. cares very little for the scientific work but is eyeing the expdn. more in the light of a commercial venture"). Yet it is Hurley's pictures that have propelled the expedition into the realm of heroic myth. Previous books—including those by Shackleton himself, Worsley, and Alfred Lansing—have had to rely on a handful of prints, usually poorly reproduced, yet still arresting enough to charge even pedestrian writing with a power beyond its natural means. The one great merit of Caroline Alexander's *The Endurance* is that it has a hundred and forty photographs, nearly all of them by Hurley, turning the book into an enthralling magic-lantern show. Not since Sir Ernest lectured in the darkened auditorium of the Philharmonic Hall has anyone been able to come so close to the idea of white warfare, as conceived by Shackleton, and represented, with brilliant fidelity, by Frank Hurley.

Hurley began (and ended) his photographic career in the Australian picture-postcard industry. His eye was not offended by the obvious. Unlike Herbert Ponting, whose somewhat fussy and "painterly" photographs documented Captain Scott's 1910 expedition to Antarctica, Hurley went instinctively for the picture that told a story, made a four-square statement, or expressed a bald metaphor. If one tries to think of him belonging to a pictorial tradition, paintings are not part of it; advertising and magazine illustration (especially those drawings for boys' adventure stories, with

gigantic grizzlies looming over diminutive gold prospectors) were more in Hurley's line of antecedents.

He was on his second visit to Antarctica (his first had been with Douglas Mawson in 1911), and his response to the extremes of light and shadow on the ice was to play with them, with a kind of bouncy technical self-confidence. Until *Endurance* was crushed and consumed in the pack ice, in October 1915, Hurley worked mostly with a Graflex, one of the handiest and most sophisticated cameras of its day, and much in use by correspondents at the front in World War I. After the ship went down, he was left with only a Vest Pocket Kodak—one step up from the tourist's Box Brownie. The change in cameras didn't cramp his style. Some of his best pictures were taken with the VPK.

Hurley's mythopoeic approach to the expedition is apparent from the moment he joined *Endurance* in Buenos Aires. One early photograph in Alexander's book depicts a broad, grubby spread of patterned linoleum on the mess deck floor. Three men, seemingly oblivious to the camera, are on their knees with buckets and scrubbing brushes, working their way slowly toward the photographer. The point of the picture is that the men are the geologist, one of the ship's surgeons, and the third officer; in a single shot, Hurley has captured the singularity of Shackleton's style of command.

Shackleton was born in Ireland and began his career as an apprentice in the merchant navy; he had not been happy serving under Captain Scott in Scott's first expedition to the Antarctic beginning in 1901. (He collapsed while suffering from scurvy, among other illnesses, and was the only member of the expedition who was invalided home.) All this put him at a critical remove from the English class system. On his expedition, officers and gentlemen were expected to go down on their knees and do the dirty work, while comforts and privileges were consistently extended to the other ranks. On the night following the loss of Endurance, Able Seaman Bakewell wrote about how lots were drawn for sleeping bags: "There was some crooked work in the drawing as Sir Ernest, Mr. Wild, . . . Captain Worsley and some of the other officers all drew wool bags. The fine warm fur bags all went to the men under them." The least popular officer on the expedition, Captain Thomas Orde-Lees, seconded to Shackleton from the Royal Marines, complained to his diary: "I simply hate scrubbing. I am able to put aside pride of caste in most things but I must say that I think scrubbing floors is not fair work for people who have been brought up in refinement."

Shackleton would have none of this. The grave, withdrawn, English style, of officering, with its mystical cult of class superiority, was anathema to him. The innate gallantry, nobility, and honor of "the English gentleman"

had been a preoccupation of Scott's as he lay dying in his tent with Bowers and Wilson after finding that Amundsen had beaten him to the pole. Writing to Bowers's mother, he was able to comfort her with the assurance that her son was dying as a gentleman, as Oates had died before him. Defining himself against Scott, Shackleton threw gentlemanliness to the winds. He capered on the ice, doing an Irish jig with Frank Worsley; he led the singing, told the worst jokes. Where Scott's expeditions had been strict military hierarchies, Shackleton's was a snowflake cluster, with its leader at the center, embodying in himself something of all the twenty-seven men under his command.

In Frank Hurley's Antarctica, class distinctions are dissolved in a remarkable way—by speeding up the shutter or stopping down the aperture on the lens. *Endurance* entered the pack ice at the height of the Antarctic summer, early in January 1915, coming into a bright, white world that gave the photographer two basic options. On the Scott expedition, Herbert Ponting nearly always chose to time his exposures to do justice to the men in the picture, creating masses of overexposed, undifferentiated white all around them.* Hurley generally chose to do the opposite, exposing the film for the ice, and letting the men remain as angular, transparent blobs on the negative. The result is a sequence of ravishing icescapes, full of chaotic shape, shadow, granularity, on which are superimposed the two-dimensional black silhouettes of small, grasshopperlike men. They look alien, and sometimes absurd. In one photograph, a twiggy little homunculus pops up in the middle of a great desert of extruded ice boulders and pinnacles, appearing to point the way to nowhere. He may or may not be a gentleman.

One sees Hurley rejoicing in this diminishment of the individual against the enormity of the ice. When we consider the conditions under which the pictures were taken, there is an amazingly buoyant hilarity about them. Look at what we got ourselves into! they seem to exclaim—and what they reveal is, indeed, a pretty pickle. The expedition never once set foot on the continental landmass that it had set out to cross—and when you look at these comic stick figures, you are not in the least surprised.

Yet add all twenty-eight together, and something unexpectedly grand emerges, in the shape of the expedition's central symbol, the ship *Endurance*. In reality, *Endurance* was not a naturally inspiring vessel: a

^{*}See Robert Falcon Scott, Scott's Last Expedition: The Journals (Carroll and Graf, 1996).

three-hundred-ton sail-assisted steamship, barquentine-rigged, her masts disproportionately short for her length. But this was not how Hurley pictured her. He called her "a bride of the sea," and by dint of ingenious fudging and low camera angles, he transformed her into a great square-rigged sailing ship, a revenant ghost from England's nautical past. Drake, Raleigh, or Nelson might have been found aboard Hurley's *Endurance*, whose give-away steam funnel has been lost behind the high sheer of her bows, and whose fore-and-aft sails on the main- and mizzenmasts are conveniently obscured behind the square yards on her foremast.

Hurley's most stunning photographs of *Endurance* are the ones taken on August 27, 1915, in the darkness of the Antarctic winter, with the ship stuck fast in the ice, its rigging spangled with hoarfrost. They are jubilant triumphs of flash powder. Hurley had to set off twenty strategically placed flashes to light up the ship against the dark sky, and he nearly blinded himself in the process. In this unearthly fireworks show, *Endurance* is turned into a pure icon of the doomed endeavor of her voyage. It was a brilliant whim of Hurley's to reverse the usual terms of the Antarctic, and picture the human enterprise as a spectral white folly against the engulfing black.

On October 27, when the ice finally squeezed *Endurance* to death, Hurley insisted on staying dangerously close to the ship to catch every last moment of its dismemberment and sinking. It's the end of a civilization, as the masts topple, the rigging falls in snake's-nest tangles around the spars, and the decks subside beneath the level of the pack. He wrote: "Awful calamity that has overtaken the ship that has been our home for over 12 months . . . We are homeless & adrift on the sea ice." Yet from this scene he managed to compose a pertly ironic picture-postcard image: six sled dogs, in harness, sitting on the snow, apparently engrossed in the spectacle of the collapsing palace of their mad masters. The dogs were subsequently shot.

Hurley rescued his negatives from the sinking ship, but had to winnow just a hundred and twenty plates from his collection of more than five hundred. The rest were dumped as excess baggage. *Endurance*'s three lifeboats were dragged away from the wreck, and for the next five months the expedition camped out on drifting floes, gaining northerly latitude, in increments of a few minutes a day, as the prevailing southerly gales nudged the ice pack toward the open ocean. There followed a grim seven-day voyage across berg-strewn water to the comfortless way station of Elephant Island, unvisited by man since a bunch of misfortunate American sealers had landed there in 1830. "Such a wild and inhospitable coast I have never

beheld," wrote Hurley. "Yet there is a profound grandeur about these savage cliffs with the drifting snow & veiling clouds . . . "

One photograph gives an inkling, at least, of the brutal character of those months. The lifeboat *James Caird* (the name is that of the sponsoring Dundee jute magnate) is being hauled across the ice by a team of thirteen men, while seven or eight more steady the boat on its sledge and Shackleton, in a becoming fedora, stands by, his back to the camera. The harnessed men have become sled dogs; their animal exertions vivid in the blurring of their legs and arms, and in the straining diagonal angle of each man's body to the ground. But the one-ton lifeboat remains in obdurate, immobile sharp focus. Here Hurley has overexposed the snow and sky, so that the puny humans are laboring against a horizonless white abstraction, like an empty page. It is his most haunting and direct picture of white warfare.*

Given the splendors of Hurley's photographs, it may seem niggardly to carp at the shortcomings of Caroline Alexander's text, which is a work-manlike retelling of a story told many times before. The best-known version is Alfred Lansing's *Endurance* (1959); much the best-documented is to be found in Roland Huntford's splendid 1985 biography, *Shackleton*. In a somewhat condescending note of acknowledgment at the end of her book, Alexander belittles Lansing's as "a rip-roaring narration," which does it a calculated injustice. Alexander has taken pains to distance herself from Lansing: she ends each of her chapters on a different beat, tries not to replicate quotations, and has added a mass of new details, many of them from Huntford. Yet in its essential shape and tone, *The Endurance* seems more than faintly derivative of *Endurance*.

What she has not done—and it is a huge missed opportunity—is to bring Frank Hurley fully into the foreground of the story. We're given snippets from his journal, and a rudimentary sketch of his character, but one aches for much more—for examples of his work before and after his time with Shackleton, for an altogether richer account of the photographer's role, for a real reckoning with Hurley himself. She had his journal at hand; and in her acknowledgments Alexander refers to four books about him, published in

^{*}Frank Hurley's scrappy movie of the expedition—far less composed and articulate than his still photographs—is available on video. The film begins with the sled dogs and their puppies as the stars of the show, and ends with elephant seals and penguins cavorting on South Georgia. The central portion of the sandwich contains some wrenching footage of the day-to-day rigors and drudgery of icebound life. *Endurance*'s last hours are recorded in a grimly fascinating sequence of splintering masts and falling rigging. The film works best with the mute button on: its piano accompaniment is nearly unendurable.

Australia between 1966 and 1984. So the material was there for an original book about the expedition, with the photographer as its center.

Instead, she chose to rescue a very minor character aboard *Endurance* and restore to him a prominence he hardly earns. In *Mrs. Chippy's Last Expedition: The Remarkable Journal of Shackleton's Polar-Bound Cat*, she has written a first-person novelette about the carpenter McNish's (male) cat—a tedious and whimsical exercise ("*April 21st.* Left a mouse's head on Crean's bed").

We would be altogether more in her debt if only she had extended to Hurley the interest she has squandered on the cat.

With the rest of the expedition, Hurley stayed behind on Elephant Island while Shackleton, Worsley, Crean, McCarthy, McNish, and Vincent attempted to sail *James Caird* to South Georgia to get help. It was one of the most improbable voyages in maritime history—eight hundred miles across the Southern Ocean in hurricane-force winds, in a twenty-two-foot boat, rigged as a stumpy ketch. They left on April 24, with the polar autumn hardening into winter. No sane person would have held out much of a realistic hope for their survival, but tenacious unrealism was the hallmark of the expedition and the key to its eventual escape from Antarctica.

Written nearly twenty-five years after the event (and nine years after his much slighter memoir of the expedition as a whole), Frank Worsley's Shackleton's Boat Journey is, of all the books that came out of the adventure, the most intimate and revealing. There's much significance in its title, for an outsider might think that this was really Worsley's boat journey. Shackleton was not much of a navigator and had little experience of small boats. Worsley, while a hopeless leader (when he was in command of Endurance on its voyage from Plymouth to Buenos Aires, discipline on the ship fell disastrously apart), was possessed of an eerie navigational genius. From a rare glimpse of the sun in the thick sky, he could conjure an astonishingly accurate position. Worsley's early career in the New Zealand mailboat service had made him wonderfully crafty at handling a boat in surf and in high, confused seas. Had Worsley not been on board James Caird it would undoubtedly have sunk—as did a five-hundred-ton steamer, lost with all hands, due to stress of weather, just a few miles away from where the tiny ketch rode the cross-grained forty-foot seas.

In South, Shackleton had unfairly stolen Worsley's thunder, taking credit himself for every decision. "I had all sails set . . . I altered course . . . " Worsley's role is sometimes comically minimalized. "Worsley got a snap for longitude." (Under the conditions described, fixing longitude was a brilliant

feat, worthy of a page, at least, of Shackleton's open-mouthed admiration.) With Shackleton long dead, *My Boat Journey* would have tipped the scales in the direction of natural justice, but Worsley gave credit for the voyage to Shackleton nonetheless.

This tells much about Worsley's reverence for his leader, and more about the peculiar nature of Shackleton's leadership. For Sir Ernest was expert in nothing. He relied on other people's skills, from carpentry and photography to skiing and navigation. He was the heart and brains of the enterprise; and he regarded his men as limblike extensions of his will. Aboard *James Caird*, he was known, as always, as "the Boss," with Worsley taking the title of "Skipper." Even at sea, where he was a relative innocent, he was able to conceive that Worsley's expert judgment of the situation was really his own—and Shackleton's greatest gift lay in his ability to somehow persuade Worsley, and the others, that this was indeed so.

It was to Shackleton that men looked for their own spirit, claiming his effervescent optimism for themselves. Worsley wrote:

Shackleton had a genius—it was neither more nor less than that—for keeping those about him in high spirits. We loved him. To me, he was as a brother.

"Father" would seem a truer word, in context; for all of Shackleton's disregard for his own dignity, he didn't go in for fraternal equality. Even in his all-singing, all-dancing mode, the Boss was the Boss.

If his optimism kept the expedition alive and *James Caird* afloat, it seems to have been rooted in the condition that would eventually lead to Shackleton's early death. He was, as we say, in deep denial. His response to his own seriously diseased heart was to avoid doctors—and the possibility of a medical examination—at all costs. He explained his symptoms away by ascribing them to an ailment of his own invention, which he named "suppressed influenza." Denying the obvious had become a habit of mind; and after the loss of *Endurance*, Shackleton insisted on taking the same sunny view of the expedition's future that he took of the future of his degenerating body.

This sometimes maddened those of the men, like Orde-Lees and the first officer, Lionel Greenstreet, who persisted in taking an unseasonably realistic view of their plight. "His sublime optimism all the way thro being to my mind absolute foolishness," Greenstreet wrote in his journal. "Everything

right away thro was going to turn out all right and no notice was taken of things possibly turning out otherwise and here we are." Greenstreet was the kind of man who sees his doctor for a regular checkup. Shackleton's tactic with dissenters was to first isolate them, then squash them. When McNish, the carpenter, tried to take a firm (and intelligently grounded) stand against Shackleton's decision to march across the pack ice, Sir Ernest threatened to shoot him for insubordination. Denial triumphed.

In *Shackleton's Boat Journey*, one sees and hears five men infected by one man's deranged certainty of survival. One might call them codependents, as, half frozen to death, often swamped by great waves, they sing their way across the South Atlantic.

... Crean made noises at the helm that, we surmised, represented "The Wearin' o' the Green." Another series of sounds, however, completely baffled us. I sang—Macarty [sic] thought it was a recitation—that classic:

She licked him, she kicked him, She wouldn't let him be; She welted him, and belted him, Until he couldn't see. But Macarty wasn't hearty; Now she's got a different party. She might have licked Macarty, But she can't lick me.

The last part triumphantly to Macarty, but I doubt if he believed it. Then I sang "We're Bound for the Rio Grande." No one complained. It's astonishing how long-suffering people become on a trip like this.

In the telling, Worsley's voice, with its cock-sparrow chirpiness, has a ventriloquial quality, as if Skipper were the big-mouthed puppet sitting on the Boss's knee. When Worsley writes about the infinitely tricky details of his sun sights, or describes the face of a great wave, his voice is his own, but when he captures the mood aboard *James Caird*, it is Sir Ernest that we hear, mysteriously infusing himself into each member of the crew.

After nearly seventeen days at sea (including a wide southerly detour, forced by the hurricane), *James Caird* landed on the wrong side of South Georgia, divided from the inhabited northern coast by a frozen, unexplored mountain range whose glaciers and crevasses might in themselves have inspired a full-scale expedition. For the boat party, the mountains were merely a last, annoying obstacle. Shackleton, Crean, and Worsley crossed them, armed with one frayed rope and McNish's adze, in a nonstop thirty-four-and-a-half-hour climb.

This is Shackleton's year. England didn't know what to do with him in 1916: for the duration of the war he was fobbed off with a succession of more or less futile assignments designed to keep him out of the War Office's hair. Scott, whose death in the Antarctic had turned him into a national symbol of patriotic self-sacrifice, was a more convenient hero for the times than Shackleton, who appeared to have cherished the lives of himself and his men to a quite unnecessary and embarrassing degree. *Pro patria mori* was the watchword of the moment; *vivere* was a suspect verb, smacking of conscientious objection.

Shackleton's intense feeling for his men (Worsley described how he aged, shockingly, with anxiety, as the attempts to rescue the Elephant Island party dragged on from May through August) was clearly rooted in his habit of treating them as extensions of himself. Did fear for his own precarious health translate directly into fear for the lives of the Elephant Islanders?

Whatever psychological mechanisms were at play inside this complicated man, Shackleton has emerged as the most admirable and glamorous of twentieth-century explorers—though he was less an explorer, in any serious sense, than a perpetually deluded fortune hunter. Scott is at present in partial eclipse, with Roland Huntford, his leading detractor, excoriating his "witless valour." When I was a child, English schoolboys liked to soulfully fantasize about dying nobly with Scott; the present generation has sensibly decided that it would be a far better thing to live, against all the odds, with Shackleton.

But one ought to be wary of looking to Shackleton as a model of leadership. His way involved the near-total identification of the mass with the leader, and the leader with the mass. He was contemptuous of "realistic" constraints and had an astonishing knack for making other people lose their ordinary sense of likeliness and proportion. A fine man for an adventure, but a type to be avoided for anything much bigger.

New York Review of Books, June 1999

The Unsettling of Seattle

IN A FEW WEEKS' TIME, I shall have lived in Seattle for ten years—long enough to qualify as a near native of a city where everyone comes from somewhere else. I haven't yet found my feet here, and maybe never will, for the social ground of Seattle is as inherently unstable as its endlessly shifting marine light and weather. Ten years is an uncomfortably long time to be a visitor, but it is a curiously ingrained Seattle habit of mind to think of oneself as a stranger in town—and perhaps that very sense of estrangement is itself a sign that one has well and truly settled in.

In *The American Scene* (1906), Henry James paid the city a handsome compliment. Disparaging the natural advantages of New York ("the terrible town"), he listed in order six cities of the world that were "the real flowers of geography": Seattle comes in at number 4, behind Naples, Cape Town, and Sydney, but ahead of San Francisco and Rio de Janeiro. On the day in late April 1905 when James came here (by rail from Portland, Oregon) to deliver a lecture, Mount Rainier must have been "out," as we say, and the razor-edged snowcaps of the Olympics must have scratched the faultless Prussian blue of the sky. Despite unkind rumors to the contrary, such days do sometimes happen here.

Yet the natural features that make Seattle a real flower of geography—its enveloping mountain ranges, its deep hook-shaped bay, its Tuscan-style hills, its internal lakes, and offshore suburban islands—also serve to break it apart, to put its citizens at cold arm's length from one another. At the last official count there were a hundred and sixty-one bridges in the city. Any place needing that many bridges to connect its separate quarters is surely suffering from a chronic sense of isolation and dislocation. We have lifting bridges, swinging bridges, floating bridges; bridges to span the I–5 freeway, which rudely bisects the city north to south; bridges to straddle

the mile-and-a-half-wide gulf of Lake Washington; bridges to overarch yet more bridges. We have a bridge that goes nowhere, abruptly stopping in midspan above the marshy wetland at the south of Union Bay. This long-unfinished bridge, reaching out bravely but failing to connect with anything at all, has taken on the air of a venerable civic sculpture. One might title it, simply, *Seattle*.

The grandest bridge is still the seventy-five-year-old one that carries Highway 99, Aurora Avenue, over the Ship Canal from high on Queen Anne Hill to high on Phinney Ridge. This is the bridge the jumpers use. Its lamp standards are pasted with *Don't Do It!* notices, put up by the Samaritans, but the jumpers go on jumping (nine people killed themselves from here in 1995). They die instantly: when you hit the canal from a fall of a hundred and eighty feet, the water is as unyielding as concrete. It may be that some jumpers cherish the irony of employing a bridge to make the ultimate act of disconnection. It would be an interesting thought to carry with you on the plunge.

Until quite recently, Seattle's most vexing disconnection was the city's isolation from the rest of the world. I know many people of roughly my own age and temperament who grew up here, then escaped at the first possible opportunity. Life in Seattle was dim, dull, wet, constrained. My coevals felt that they were in a state of Siberian provincial exile from the big bright city of adolescent daydreams. They fled Seattle for the intellectual glamour of the East Coast, or for the sybaritic promise of Haight–Ashbury or Venice Beach. What is strange is how many of them came back in their forties, drawn by the same physical geography that charmed Henry James. Remembered from a high-rise condo in New York or a traffic-choked exit ramp in L.A., the mountains and water of Seattle have the power to hex the Seattle-born and drag them reluctantly home.

Last year, an Italian journalist here on a five-day visit came up with a happy insight. A friend in Milan had strongly advised her to cut Seattle from her American itinerary because, despite all the hype in the Italian press, it was "boring and provincial," and not worth the considerable effort involved in getting there. Livia came anyway. On the road to the airport when her five days were up, she remarked, "I don't think Seattle is 'provincial' at all. I think it is a frontier town."

She was right, I think. Frontier towns were communities of strangers, each of whom was there to make a killing and move on. They attracted the footloose and the loners, the mobile hunter-gatherers rather than the stolid farmers and settlers. Seattle has a long history (long for the West, at least) of being just such a town. People first came here to make a killing out of

timber, then out of Alaskan gold, then out of the bonanza salmon fisheries, then out of the aircraft industry in the 1940s, then out of software and stock options in the '80s. Now it's dot-commerce that is pulling in young hopefuls by the planeload, all trying to get a piece of the action in a dizzy Internet start-up. Most of them here today will be gone tomorrow. As soon as the company downsizes, or the options vest, they'll take wing again and head out, on their Seattle money for one of the warm and fashionable Santas—Barbara, Monica, Cruz, or Fe.

With half its population on the hop like this, Seattle's social life is predictably threadbare. People meet more regularly for coffee than for dinner; and except when funds are being raised, the Seattle dinner party is a rare and often burdensome occasion, with invitations sent out weeks in advance to guests who have little more in common than their zip codes. In such random and heterogeneous company, the standbys of the metropolitan table—national politics, new books and plays, salacious gossip—are of little use here. Conversation, or serial monologue, tends to veer between the relentlessly personal and the relentlessly careerist. In this early-rising city, the yawning is likely to begin promptly at 9:15 p.m. That's my experience, anyway—though I still fantasize that sometime in my eleventh year in Seattle I may be admitted to some elusive social circle where the animated talk flows with the wine into the small hours.

On its bad days, or mine, Seattle can seem like the world's capital of transience and deracination; a city run on the lines of a giant, well-appointed, impersonal Intercontinental hotel. On good days, though, the view is rather different. Not only are the Seattle-born returning home, but the richest of the new rich are showing an encouraging tendency to stay on into their (ridiculously youthful) retirement years. The compulsive fly-by-nights are the kids who make a quick million and then vamoose, but people who can count their millions in the tens and hundreds are inclined to dig in here for life. The appeal of the city as a flower of geography is a large factor, for them as for me. In what other major U.S. conurbation can one keep a boat at the bottom of the street and be within comfortable sailing distance of anchorages shared only with bald eagles and black bears?

Also, Seattle is small enough to be a pond in which a single multimillionaire can still make a big splash. With their new businesses and foundations, the retired cybercrats (most of them from Microsoft) are now pumping a lot of their money back into the city to which they came as poor strangers just ten or fifteen years ago. They build sports arenas and museums, put computers into local schools, rehabilitate old theatres, donate baby blankets to Seattle newborns, and fund a spreading galaxy of social and educational nonprofits. Downtown Seattle is littered, or decorated, with the hobbyhorse projects of the new rich, from Ida Cole's Paramount Theatre to Paul Allen's silver, gold, scarlet, and blue temple of rock and roll, which is now beginning to emerge from its chrysalis of tarps and scaffolding beside the Space Needle. Only completion of this gigantist project, designed by Frank Gehry, will reveal whether it more resembles a pile of electric guitars (its ostensible inspiration), a vast human torso gruesomely dismembered, or four collapsing barrage balloons. At present it's a splendid puzzle and affords high entertainment to motorists stuck in the gridlock at Fifth, Broad, and Thomas.

Meanwhile the impoverished filmmakers, festival organizers, arts groups, and other professional mendicants run around Seattle with their begging bowls, in search of dollops of software-or-Internet money. This has become a city where it's easy to think of \$100,000 as a sum that you might very likely find with the fluff at the bottom of a rich man's pocket, and which he'd be only too glad to get rid of.

Last week, two friends and I spent a day cruising around the shores of Lake Washington in a small motorboat—a trip I hadn't made in five years. More had changed since my last visit than I could possibly have anticipated. Then, the modest summer cabins of the old Seattle families were still dotted along the eastern shore between the rising French chateaux, Elizabethan English manor houses, and Roman palazzi. You now can count the surviving cabins on the fingers of one hand. Shoehorned into their small lots, all house and no garden, are the lavishly balconied, squillion-bedroomed, multi-roofed waterfront homes of the cybercrats. Where rickety staircases used to zigzag down the wooded cliff between Kirkland and Medina, twin funicular elevators (one for goods, one for people) now connect each house with the road on the summit of the bluff.

The houses come in every style, from retro-Euro (designed, it would seem, from vacation postcards or the picturesque labels on Grand Cru wine bottles) to exoskeleton postmodern. Though most of them do share a common taste for the muted, rainy colors of the Pacific Northwest—shades of gray, brown, buff, and stone, with trimmings of inky conifer-green. From their front decks extend long private floats, in expectation of a busy waterborne social life. Broward and Chris-Craft motor cruisers hang aloft in hydraulic boat hoists; Beaver seaplanes sit on the water, tethered to the docks by their floats.

This is how 1990s money looks—and by the standards of earlier generations of new wealth these houses are not half as immodest as one might expect. They have a certain shrugging cool. Some even appear bashful about their own windfall affluence. I thought of Henry James on Newport in 1906, where "monuments of pecuniary power rise thick and close," great villas and palaces along Ocean Avenue that he called "white elephants":

They look queer and conscious and lumpish—some of them, as with an air of the brandished proboscis, really grotesque—while their averted owners, roused from a witless dream, wonder what in the world is to become of them. The answer to which, I think, can only be that there is nothing to be done; nothing but to let them stand there always, vast and blank, for reminder to those concerned of the prohibited degrees of witlessness, and of the peculiarly awkward vengeances of affronted proportion and discretion.

The white elephants of Newport were, of course, put up before building codes and height restrictions curbed the Pharaonic ambitions of the very rich. No one can build a Great Pyramid on Lake Washington now. Yet even within the terms imposed by the city, the new waterfront houses seem possessed of a degree of conscience unknown to the old commercial barons. The biggest houses evade the charge of vainglory by artfully distributing their space on an unpretentious human scale, in cottage-sized portions.

The biggest surprise of our little voyage was the public face of the Bill Gates compound. When I last passed by, it was a gargantuan muddy eyesore, comical in its resemblance to a sprawling, half-built truckers' motel. It has since grown into an unexpectedly cohesive hill village, camouflage-colored in sky-gray and timber-brown. Its stone is local, its wood, "green-certified," comes from demolished warehouses and river-recovered lumber. Its modular components have a distinct ancestral connection to the summer cabins that Gates, as a local boy, must have visited in his childhood. Much of the place is discreetly hidden underground. The terraces leading down to the water have been thickly planted, and soon the whole intricate assembly of conservative building forms will shrink, foliage-enshrouded, from view. This was a structure that I had never expected to admire; I am confounded by its tact, its respect for the small-scale, its subtle, unassuming conformity with the colors and character of lake and bluff.

A couple of years ago, singing for my supper at a literary fund-raiser, I found myself dining in a newly built house on the lake with a dozen or so retired Microsoft millionaires. I listened to the drift of the talk, feeling like

a codfish stranded in the Arizona desert, and picked out a single recurrent theme. It was about the distances traveled by the materials that had gone into the making of the guests' houses. Though the Pacific Northwest is hardly short of native rock, someone had found the perfect quarry in Maine and trucked their stone out to Seattle, coast to coast. Someone else swore that only English glass, imported from the Pilkington factory, would do for their windows. Another person slyly boasted about their discovery of a brilliant landscape architect in—as I remember—Romania, whom they had flown out to supervise the construction of their garden. Admired by everybody was the very senior Microsoft executive, not present at the dinner, who was getting his stone excavated in India and sending it to Italy to be cut by the best masons before shipping it to a site just across the lake from where we were sitting.

This was magnificently inconspicuous conspicuous consumption—tales of vast expense that would be visible only to a handful of similarly rich consumers. Neither the mailman nor I would ever notice, but the seventeen Seattleites who really counted would gaze on this Indian stone cut by Italian stonecutters and be able to compute the beauty of it against its stunning price. Until I sat in on this curious conversation I hadn't realized that money could be spent with such secretive irony, for the benefit of two audiences, one in the know and the other out of it. The great pleasure of irony lies in the sense of privilege that comes with the awareness that one belongs to the first audience; and just for a moment, hearing of those dusty-faced Italian masons, I felt the glow of being privy to a brilliant, and otherwise incomprehensible, Seattle joke.

Out on the lake, I was back in the second audience, looking but not seeing, because I don't have nearly enough money to really see what's going on here. Lawn grass transplanted in moist sods from the banks of the Danube? Roof slates from Wales? Chimney pots, of a unique design, from old Uppsala? The point is that *someone* will know.

Its new money has profoundly unsettled Seattle, and, I suspect, made it a more interesting place to live than it has ever been before. It has become an ambiguous, mercurial city, gratifyingly hard to decode.

From the subtle to its reverse. While I was writing this piece, a couple I know put their resources together to make the down-payment on an elderly fixer-upper in a viewless and not especially sought-after quarter of north Seattle. They had agreed to the asking price of \$380,000. On the afternoon when they were due to sign the contract, they were gazumped by two

people in their early twenties who put in a bid for \$550,000. To secure the house, \$450,000 would have been more than enough; the extra \$100,000 was pure gesture, designed to rob the property (and the street in which it stands) of specific value, and to announce the arrival of the cybercrats, with their gas-bubble economy, in the neighborhood.

The two buyers were lowly employees, barely visible to the sort of people who build houses on Lake Washington, but even their relatively threadbare style of money-theatre is being conducted far beyond the means of the teachers, journalists, university professors, shipyard workers, and Boeing engineers whose fluctuating fortunes once governed the city's economy. If all of Seattle's hundred and sixty-one bridges were laid end to end, they wouldn't span the ever-increasing gap between the traditional middle class and the emergent e-millionaires.

All this has led to a new credulousness. Giddy affluence now looks like a twenty-five-year-old, wearing a grubby T-shirt and nose ring, stepping out of a new BMW or Lexus. The car isn't mandatory, since the punkish youth may well have been working too many hours to spare the time for a trip to the dealership. This person has become a central figure in the city's mythology, familiar to everyone. He just paid \$1.2 million in cash for a bachelor pad a couple of streets away from where you live. She just bought an island, or a ranch in Montana, or a Gulfstream jet, or a resort in Hawaii, or a telecommunications company.

It's now widely assumed that every suitably attired twenty-five-year-old is rich beyond the dreams of avarice until proved otherwise. If he/she lets drop the magic initials IPO, Seattle now wonders how many commas will be needed to punctuate the string of zeroes. Such ready belief in other people's money has opened a promising new field of phantom house purchases, phantom takeovers, phantom philanthropy. Deals are being confidently struck all over the city, and it will take months, and maybe years, for the gulls to discover that the true assets of their tame Internet entrepreneur amounted to little more than the value of his or her nose ring. A city whose old establishment has been marginalized, and most of whose citizens are strangers both to the city and to one another, is wonderfully fertile territory for the poseur and the confidence man.

I wonder what Balzac, Dickens, Trollope would have made of this extraordinary moment in the life of Seattle. Certainly Augustus Melmotte, Trollope's man from nowhere in *The Way We Live Now*, dazzling all of London from within his vast iridescent bubble of bogus wealth, would have been perfectly at home here, though he would have to lop thirty years from his age to pass as a credible Seattleite. I know exactly which spot on the lake

that Melmotte would choose to site his house, and from where he would juggle his chimerical millions.

Seattle now feels like a novel just beginning, and it's off to a good start. The money is here—most of it virtual, some of it bound (but when?) to prove illusory. The titanic ambitions of the characters are already on display, in the orgy of building and speculation. The all-day, all-night tango involving venture capitalists (known here simply as "vee-cees"), software engineers, and babyfaced nerds with killer website ideas goes on at full tilt. Yet, though rumors of imminent collapse are Seattle's meat and drink—Microsoft will be carved into little pieces by the government; Amazon will tumble into the colossal pit of its annual losses—there is so far no obvious sign of an impending climax or denouement. But things move fast in the digital city, and it's likely that we shall not have to wait very long.

We have already been treated to the sight of one spectacular implosion. Late in March 2000, the still-unpaid-for Kingdome (built in 1976, and a major classic of New Brutalism, in my view) came down after being strategically wired with 4,500 pounds of dynamite. When the detonating switch was turned, on a still and sunny Sunday morning, the great landmark building took just under seventeen seconds to crumple elegantly from the inside out, sink to its knees, and grovel in the dirt, enveloping the city in a storm of concrete dust.

Watching the event on TV, I thought that here was an image, an emblem, to be stored away for future use. When the next implosion happens and the shock wave reverberates through downtown Seattle, we can be sure of one thing. There'll be just as much blinding dust next time, but it won't be concrete that comes falling from the sky.

Architectural Digest, November 2000

The Last Harpoon

On May 17, 2000, just before 7:00 a.m., a crew of Makah Indians from Neah Bay, an impoverished reservation village on the extreme northwestern tip of Washington State, harpooned by hand, then shot dead, a gray whale. The sea was calm, with a gentle westerly swell. Drizzle was falling from the low sky, where helicopters carrying reporters and cameramen hovered noisily over the whalers' thirty-five-foot cedar canoe. Close by, a motorized support vessel held the gunman with his .50-calibre rifle. Two boats lay a little way off—one crammed with more newsmen, the other carrying biologists from the National Marine Fisheries Service who were there to see fair play at the kill. Beyond them, a Coast Guard patrol ship stood ready to enforce the five-hundred-yard-wide DMZ between the whalers and the motley fleet of protesters from animal-rights and environmental groups. None of the activists had arrived on the scene quite yet, due to the earliness of the hour and the fact that their fleet had been seriously depleted when the Coast Guard impounded many of their boats on previous days.

This was the less-than-grand climax to what Robert Sullivan, in A Whale Hunt, calls, in a nicely balanced phrase, "the first modern traditional whale hunt." Since October 1997, when the International Whaling Commission, meeting in Monaco, gave the Makah tribe permission to kill four gray whales a year (a decision sanctioned by the U.S. government, with the Commerce Department chipping in with \$310,000 by way of support), the hunt had been the subject of an impassioned shouting match. The quarrel between would-be whalers and determined protesters was complicated, to say the least, given that one of the most sacred traditional myths of the environmentalist movement concerns the role of Native Americans as exemplary "stewards" of nature. The prospect of Indians killing a whale with a specially modified gun—described by Sullivan as looking like a

bazooka—was an inconceivable affront to many white people's received notions of "Native American spirituality" and of the Indian as someone who lives in an exalted state of harmony with the earth and its creatures.

The Makah Indians insisted that whale hunting had been at the center of their tribal life for several thousand years, and that by resurrecting the tradition they were recovering their ethnic pride and identity, as well as exercising a right that had been ceded to them in their 1855 treaty with the United States government. The protesters claimed that this was a sham—that the Indians' true motive was financial, with whale carcasses fetching more than \$100,000 apiece on the Japanese sushi market. They saw the ritual hunt of the Makahs as the thin end of a large wedge that would lead to the reintroduction of commercial whaling in American waters.

Some unexpected positions were taken in the row—none more so than the Save the Whales stand made by Jack Metcalf, a right-wing Republican congressman from Washington State, and an antienvironmentalist supporter of "property rights" (which of course made him a natural foe of Indian treaty rights). His antipathy to "special rights for Indians" was quickly translated into a newfound enthusiasm for animal welfare, which he trumpeted around the state and in Washington, D.C., on every available occasion.

Metcalf's conversion to the Green cause is a measure of the looking-glass world created by the impending whale hunt. The Indians' usual friends suddenly became their enemies, while many new and rather peculiar pro-whaling friends crowded into Neah Bay from Greenland, Iceland, Japan, Russia, the Faeroe Islands, and Tonga to offer their moral support. Along with the beleaguered whalers of the world came the journalists—first in small exploratory platoons, then in battalions.

As the crow flies, Neah Bay is only about a hundred and twenty miles northwest of Seattle, but it is more remote than that distance suggests. Past Port Angeles, the road quickly deteriorates. Going by sea, a boat faces the ninety-mile-long (and often very rough) slog up the length of Juan de Fuca Strait. Before the whale hunt put Neah Bay on the map, the federally funded marina there was three-quarters empty even in high summer, and the handsome tribal museum attracted only a thin trickle of tourists from the coastal resorts on the west side of the Olympic Peninsula. The village's chief tourist trade lay with sports fishermen, who towed their boats out to Neah Bay by truck or car, launched them from the ramp, and some-

times stayed overnight in one of three rundown motels. Unemployment in the town itself—a bedraggled assembly of cabins and trailers set around a pretty half-moon beach, and backed by thick forest—ran at more than 50 percent. In 1995, per capita income was just \$5,200. To the casual visitor, Neah Bay seemed starved for attention, in every sense of that loaded and modish term.

The whale hunt brought it more attention than any small community could comfortably deal with. Its motels bulged with journalists and their expensive equipment; Washburn's, the reservation supermarket, did a roaring trade with the expense-account visitors. Such a flood of money had never been seen in Neah Bay, even in the days when salmon packed the strait wall-to-wall. This wasn't the kind of glancing brush with media fame, cash, and klieg lights that, say, the discovery of Theodore Kaczynski, the "Unabomber," brought to Lincoln, Montana (a far bigger, richer, and less isolated place) in 1996. The hunt took a year to prepare—and be protested against-before the first of many unsuccessful attempts to actually harpoon a whale was made in the fall of 1998, when the animals passed Neah Bay on their annual southward trek from the Bering Sea to the Sea of Cortez. It was resumed in the spring of 1999, when the whales swam north; and since the killing of the whale last May several more (unfruitful) expeditions have been made—though a temporary stop has been put to them by an injunction issued in June of this year by a panel of Ninth Circuit judges in San Francisco.

During this long period, the Neah Bay Indians appeared to learn a good deal more about the journalists than the journalists ever learned about them. They grew expert at calling snap press conferences and tweaking the story whenever it looked to be growing cold. They became familiar public figures, on the *Today* show as on the front page of the *New York Times*. So did their opponents, like the ubiquitous Captain Paul Watson and his whale-saving ships *Sea Shepherd* and *Sirenian*.

From the news editor's point of view, the whale hunt had all the attractions of a protracted and highly photogenic war. Fought against a backdrop of romantic local color, it involved poor people, ancient history, exotic folk customs, vehement and articulate spokespersons, boats, nature, controversial ethical matters, and, for one brief moment, a patch of sea turning red with blood. Its only visual defect was the Pacific Northwest rain.

Robert Sullivan went to Neah Bay early, on a self-sought assignment from the New York Times Magazine, and stayed on through the dog days when

other reporters went home. He attached himself to the whaling crew, pitched his leaky pup tent on the beach, became a regular at the Makah Maiden cafe. During the long wet spells when nothing much was happening, he read *Moby-Dick* for the first time, then reread it until he nearly had the book by heart. Keeping the ghostly company of Ahab, Starbuck, and Queequeg, Sullivan trailed after Micah, Donnie, John, and Wayne. The roaming solitary writer can't afford to be too particular in his choice of friends, and Sullivan hung out amiably with anyone who was prepared to speak with him—Indians, protesters, visiting whalers, journalists—more as a lonely soul in search of conversation than as a reporter with an angle and a deadline. Out of his eighteen-month off-and-on sojourn in Neah Bay, he has written a book that is at once enthralling, fair-minded, and very funny.

By means of Melvillean digressions and footnotes, Sullivan has cleverly intertwined his own narrative with that of *Moby-Dick*, to which *A Whale Hunt* is offered as a modest and ironic footnote. But the book it most resembles, to my eye, is Evelyn Waugh's *Scoop*. The persona that Sullivan constructs for himself is uncannily like that of William Boot, the reclusive young nature writer ("Feather-footed through the plashy fen passes the questing vole...") who, because of a mix-up over his name, is dispatched to cover the war in Ishmaelia by the all-powerful Lord Copper of the *Daily Beast*.

The loopy innocence of William Boot works both as catalyst and foil for the linguistic chaos of journalese and sloganeering that is Waugh's real target in the novel. So Robert Sullivan, last seen in the plashy fens of *The Meadowlands*, his book on the urban wetlands of New Jersey, offers himself as an innocent—someone who knows nothing about Indians, whales, environmentalists, journalists, or Herman Melville. He goes to Neah Bay as an idiot, in the original Greek sense of "a private person," and his true business is as much with the corrupt and adulterated language that he finds spoken there as it is with the hunt itself.

Occasionally his mask slips, as when he describes the hunt as the "half-baked ark with which the Makah believed their culture might be saved," or makes this most un-Bootlike observation:

The hunt became—in the chaotically formal and semiliturgical manner of the kind of postmodern news coverage that tends to surround such controversial public happenings—an event.

At moments like these, one is rather too sharply reminded that Sullivan is less of an idiot than he appears and, like every other journalist on the

scene, can speak in a professional dialect of his own. But such moments are rare. Mostly he keeps his pose intact, doesn't generalize, lets things happen to him as they will, and listens keenly, with cultivated promiscuity, to all the voices within earshot. Like Boot, he gets comically preoccupied with details that have nothing to do with the official story. Crossing his fingers for luck, he wonders, in a very Williamish moment, if people from other cultures do the same—so he consults a busy German film director in the middle of a shoot. (Germans don't, apparently; they make a fist with the thumb tucked inside.) From an Englishman he learns that the seven brightest stars in Ursa Major, known as the Big Dipper in the United States, are called the Plough in England ("I was amazed by that").

There's a good deal of faux in his naïveté, but on the whole the strategy works well. In the rhetorical cacophony set off by the hunt, Sullivan's voice, like that of an intelligent questioning child, rings clearly through the din of bad, grown-up language. The journalists and their editors, trying to side with both the Indians and the whales, tie themselves up in grievous knots. The Seattle Times hits the authentic note of feeble and conflicted judiciousness with this little nugget of journalistic cant:

Uncertainty about techniques, motivations and repercussions has made *The Times*' editorial board reluctant to support a gray whale hunt off the Washington coast. Both the Makah tribe and the United States government, however, have made a compelling case that the hunt embodies restrained stewardship after a species' triumphant comeback.

Lord Copper ("The *Beast* stands for strong mutually antagonistic governments everywhere") could hardly have put it better.

The English language is in trouble in A Whale Hunt. Its cause is not well served by the fence-sitting contortions of the journalists, any more than it is by the head of the German consulate in Seattle, who proclaims that "in my heart I think I am an Indian," or by the self-important fax issued by the producers of the movie Lethal Weapon announcing that they cannot bring themselves to support the hunt. Pious cliché is the order of the day. In the protesters' camp, the predominant language is one of ripe, sentimental anthropomorphism, nicely encapsulated in a passage quoted by Sullivan from Captain Paul Watson's memoir, Sea Shepherd: My Fight for Whales and Seals, where he describes the last moments of a whale killed by Russians from a Soviet processing ship:

His eye fell on Fred and me... two tiny men in a little rubber raft, and he looked at us. It was a gaze, a gentle, knowing, forgiving gaze. Slowly, slowly, as if he did not want to disturb the water unduly, as if taking care that his great tail did not scrape us from our little perch, he settled into the quiet lapping waves.

Then there is the argot of the Indian whalers. In the nineteenth century, the Northwest coast Indians used to communicate with whites in a makeshift Creole known as Chinook Jargon. In the last twenty years a kind of New Chinook has emerged, in which firsthand grandmothers' stories and secondhand ethnography are jumbled up with New Age mysticism and the quasi-technical lingo of twelve-step recovery and *The 7 Habits of Highly Effective People* by the management expert Steven Covey. This mixed language is widely spoken in Neah Bay. One of its adepts is Micah McCarty, a woodcarver, and a member of the whaling crew in its first season, whom Sullivan calls a "Save the Whales whaler." McCarty gathers sea urchins from the beach at low tide as part of his "subsistence pathway." He begins each day by saying a water prayer, "thanking the Creator for the gift of water." He tells Sullivan:

I've been doing a lot of spiritual preparation of my own. That's been an ongoing deal. That's the mind, body, soul-edification process. And I've started gathering things that are relevant to the position my grandfather had.

McCarty, the designated harpooner on the first crew, says, "I want to be honorable enough to be chosen by the whale." Sullivan comments: "Activists who were against the Makah whale hunt oftentimes seemed to relate to Micah's version of the whale hunt, especially when he talked about being in harmony with nature—he used their vocabulary." So, too, this kind of hazy, obfuscatory language enabled the whalers to "relate" to the protesters, as when Keith Johnson, the president of the Neah Bay Whaling Commission, told a press conference:

I keep quoting that Steven Covey book . . . I don't know, maybe he'll call me up one day, but it says, "Seek to understand before you seek to be understood." So we *understand* the whale. We *understand* the whale rights people. We *understand* that they really love the whale.

But such dubious "understanding" worked better in press conferences, from where it entered the ever-growing (and ever more fuddled) journalistic account of the hunt, than it did in the day-to-day life of Neah Bay and its besieged patch of sea.

Two of the hunt's most ardent opponents were Steph Dutton and his wife, Heidi Tiura, who had founded a whale-saving organization named In the Path of Giants. The couple came to Neah Bay in kayaks, with a brilliant solution to the quarrel they had hatched back home in Monterey and turned into what they believed was an irresistibly persuasive slide presentation. Instead of killing whales, the Makah Indians would, with training provided by In the Path of Giants, become whale-watching entrepreneurs, taking tourists out in boats to view the migrating grays. Dutton and Tiura presented themselves to the tribe not as "protesters" but as "observers." Sullivan perfectly catches the linguistic car crash that ensued when Dutton first stepped out of his kayak onto Makah soil:

Steph: (With his head held high as he walks to the Makah canoe, with an air that said, Big plans.) Hi, my name is Steph Dutton and I just want to introduce myself . . . you guys look good out there.

A big guy on the whaling crew: Fuck off.

Despite this unpromising beginning, the presentation was made to the tribal council, whose members responded warmly to it:

I had heard that the council members had enjoyed Steph and Heidi's slide presentation, especially the shots of the gray whales breaching: some of the council members were thinking they could use the presentation as a kind of training film for the whaling crew, which had to learn how to approach whales.

That moment has a parallel in another Waugh novel, *Black Mischief*, in which General Connolly at last succeeds in obtaining a truckload of boots for his barefoot troops. The troops, mistaking the boots for an overdue issue of rations, obligingly eat them.

Given that the hunt consisted of long periods of inactivity punctuated by tangled verbal exchanges, internal squabbles, an unseemly fistfight, and such unalluring preparations as practicing harpooning on harbor seals (they missed) and jumping, in wetsuits, into the ice-cold waters of the bay in winter, it's remarkable how Sullivan has managed to spin so fluent and

suspenseful a narrative from such unpromising raw materials. The book coheres around its unlikely hero, Wayne Johnson, the captain of the whaling canoe, a character who grows before our eyes into a complex, riven, and unexpectedly sympathetic figure.

Wayne is Sullivan's ironic counter-Ahab. Shambling through the early pages in his Raiders jacket, a cigarette never far from his lips, divorced, out of work, living with his mother on the reservation, and worrying about his son, who is getting into trouble down in Oregon, luckless with his beat-up automobiles, attending anger-management classes imposed on him by a court in Port Angeles, Wayne looks likely to disappear from the story altogether at the end of each next paragraph. He has few admirers in Neah Bay, and none of the obvious qualities of a natural leader. He does not even intend to be aboard the canoe when it comes to the kill.

What endears him to Sullivan, and to the reader, is that in this gaseous rhetorical war, Wayne Johnson is as rhetoric-free as any man could reasonably be. "I'm not too good with the spiritual stuff" is his signature line. Treaty rights, subsistence pathways, being in harmony with nature, Native American identity, are all the same to him. He returns from the International Whaling Commission meeting in Monaco with one vivid memory—of the caffeine kick induced by strong French coffee.

He has, instead, the rueful, realistic wit of the born loser. "You're fired," he likes to say whenever Sullivan shows up late, and it's a joke about how Wayne isn't in a position to fire anyone. He refers to the hunt as "this whale thing." To the protesters, his captaincy of the canoe is one of the hunt's most objectionable features, precisely because Wayne has no elevated language to bring to the table. Captain Paul Watson contemptuously says, "What you have here is a bunch of boys from the hood. Wayne Johnson. He's just a thug... This whole thing with Wayne Johnson taking over, it means that the thugs have won."

But Johnson is far from being "just a thug," and one of the great pleasures of the book is watching him acquire conviction, a strengthening if tremulous assurance, and a kind of gruff tenderheartedness for the well-being of his crew, until he emerges as the most competent and responsible person aboard the boat. By the final chapters of the book, Wayne Johnson is, at last, in a position to fire people, and he comes close to firing Theron Parker, the new harpooner and self-appointed star of the canoe. In circumstances that would tax anyone's forbearance, Johnson finds hidden reserves of self-control and keeps Parker on the crew. There's more triumph in that moment than there is in the killing of the whale.

The language of paperwork is a perpetual bafflement to him. "What's a per diem?" he inquires, in exasperation, as he fills out a form required by the tribal council. Later, he's found puzzling over an ethnological document, propped on a soda can, which describes how portions of the whale used to be divided among the hunters in the old days, as well as more papers from the National Marine Fisheries Service:

"Look at this," he said. "Look at all the stuff we gotta do with the biologists when we get the whale. We gotta assist in measurement of ovaries and earplugs, measure the"—he sorted through a stack of papers—"measure the whatever, but I mean, look at all this! And I've gotta get my butchering team up. I never knew how much work there was to be done but then I was always out in the boat." He continued, "There's all kinds of things we have to do. There's spiritual training and there's butchering. The saddle of the whale, it has to be cut out and it hangs for three days in the house of the captain with the eyeballs."

Required to speak in public, Johnson usually dries up with stage fright. So it is strange to discover him, after the whale has been killed, staying up late into the night working on a speech, described by Sullivan as "not so much a speech as a simple list of people he wanted to thank." It required long hours of revision and rehearsal. "He read it over and over. He vowed to read it carefully, not to be nervous, to stay calm."

When the great celebratory feast of whale meat and Jell-O is served in the high-school auditorium, many speeches are made. The captain of the whaleboat waits his turn, but when the time comes he is not invited to stand:

The people in charge of the festivities never got around to letting Wayne speak. This made Wayne so angry. This made Wayne so angry, in fact, that he left his table and walked disgustedly over to his house. He sat there on the couch all night. He didn't want to talk to anybody.

Yet the organizers clearly had a point: at this climactic episode of glorious unrealism and high-flown talk, they had no need of the services of a realist like Wayne Johnson at their feast.

On May 18, the morning after the killing of the whale, Sullivan called

at Johnson's house and found Wayne drinking coffee and looking flat-out exhausted:

... He'd give a press conference later. Then he took a shower and got dressed and drank a cup of coffee from his whale-art-covered mug and went downtown. "Come on," he said, opening the door. "Let's go see who hates me."

There remains the problem of the whale. As the whale hunters, in all their fumbling inexperience, were very different from whale hunters in the past, Indian or white, so the whale they killed appears to have been strangely mild and docile, a late-twentieth-century sort of whale. Sullivan wasn't out on the water when Theron Parker successfully lodged his harpoon in the whale's flesh; his graphic close-up description of the kill seems to be based on a mixture of firsthand accounts by the whaling crew and action replays of the lavish video footage.

When the harpoon struck, the whale submerged, quite slowly, turned on its side, surfaced, flapped the water once with its tail, received a second harpoon thrown by Parker, towed the canoe along for a while—again quite slowly—and was then shot dead. It wasn't in the least like any nineteenth-century account of a harpooned whale—the thrashing tail, the stoved-in boats, the enraged animal turning its great bulk and muscle on its pursuers.

Many of the protesters explained the whale's behavior by saying that it—or rather *she*—had been tamed by years of exposure to whale watchers; that she thought of men in boats as her natural friends; that she was appealing to the whalers to rescue her from the inexplicable agony in which she had suddenly been engulfed. That is a plausible explanation. It might certainly be true of some whales, but may not be true of this one.

Another reason for its behavior presents itself. During 1999, a lot of gray whales washed up dead on the beaches of Washington's Pacific coast and Puget Sound. Exactly why they died—and are still dying—isn't known. The most likely cause, or at least the one most voiced in the Seattle press, is that gray whales have recently become so numerous that they are exhausting their supplies of food (they eat small crustaceans known as amphipods). In the last year or so, each spring and fall migration has been attended by an unprecedented number of apparently natural casualties.

Watching the hunt on television, my own first thought was that the Makah whalers had managed to home in on a whale that wasn't long for this world anyway, and that only a sick whale was likely to fall victim to such amateurish hunters. If that's true, it gives a flicker of life to the *Seattle Times* editorialist's wan phrase about the hunt embodying "restrained stewardship after a species' triumphant comeback." Still, as so often when the word "stewardship" is applied to Native Americans and nature, in effect this means only that the Indians lacked the numbers and the technology to do much serious harm.

No very great harm was done last May. It now looks as if the whale killed then may be the last whale ever to be harpooned in U.S. waters. In 1998, the Makah Tribal Center's Cary Ray told Sullivan that the whale hunt was "gonna be like a blood transfusion for this community," and for a brief moment it was. It happens that this year the halibut and salmon fisheries have been in better shape than for several years, and the marina and the motels are full as I write this. But the flood of press attention has left no lasting economic impact, according to a Makah council member whom I spoke to on the phone. "Things are pretty much back to where they were." One is reminded of the great blood transfusion described by William Empson in "Missing Dates":

They bled an old dog dry yet the exchange rills Of young dog blood gave but a month's desires

To which he added the characteristic footnote: "It is true about the old dog, at least I saw it reported somewhere."

New York Review of Books, November 2000

Battleground of the Eye

LANDSCAPE—if you give that rather slippery term its full weight—is one of the great divisive issues in the Pacific Northwest. The landscape paintings of the region, from the eighteenth century to the present day, are pictorial dispatches from a long war that is more heated now than at any time in the past two hundred years.

Landscape is land *shaped*—land subordinated to a vision or a use. A picture frame or a Claude glass* converts land into landscape; so, too, does a logging road or a barbed-wire fence. The railroad magnate and the painter of majestic wilderness scenes have in common their designs on the land: James J. Hill and Albert Bierstadt are brothers under the skin.

Consider this curious tale of two pictures of the Pacific Northwest. In 1999 Slade Gorton, the Republican senator from Washington State, tacked an ingenious rider onto a bill intended to provide American aid for Kosovo. His rider concerned a proposed cyanide-leach goldmine in Okanogan County (he was for it). Eighteen months later, in the race between Gorton and his Democratic challenger, Maria Cantwell, this came back to haunt him. It probably lost him the election, which Cantwell won by a hair, after a string of recounts.

In the Gorton-Cantwell race, landscape turned into the central topic of debate, as the candidates fought over such questions as the Okanogan

^{*}In the eighteenth century, when the landscapes of Claude Lorrain were hugely admired in England, no tour of a great country estate was complete without a Claude glass: a gilt frame with an ornate handle, containing sometimes a tinted mirror, sometimes a pane of clear glass. From selected viewpoints along the route, the finest vistas of the estate were inspected with the Claude glass—living landscapes, in which (as in the paintings that figure in J. K. Rowling's Harry Potter books) the sheep and deer could be seen to move.

County mine, logging in national forests, and the breaching of dams on the Snake River. From the barrage of television ads that were broadcast by both sides, two pictures emerged, each executed in a style familiar to any Northwest gallery-goer. Gorton's was a tame Augustan landscape, with irrigated farms and gardens and orderly plantations, in which nature was tailored to human needs and specifications. Cantwell's was a landscape in the manner of Bierstadt or Thomas Cole—a Romantic wilderness, with free-swimming salmon and untouched stands of tangled old-growth forest where spotted owl called to spotted owl, a realm of aboriginal solitude and grandeur.

Rural voters east of the Cascade Mountains showed an overwhelming preference for the Gorton picture, with its promise of money and jobs. West of the mountains, along the urban corridor that stretches north and south from Seattle, the Cantwell landscape found favor with hikers, birdwatchers, fly fishers, and the mass of college-educated white-collar voters, who bear out the interesting paradox that Seattle is the first big city to which people have swarmed in order to get closer to nature.

One might hear echoes of that debate almost anywhere in the United States, but in the Pacific Northwest it is conducted with a peculiar and obsessive intensity, because here the wilderness itself seems to possess a tenacious memory. In this damp, dauntingly fertile climate the creeping salal and salmonberry, and the green spears of infant Douglas firs, are bent on restoring everyone's back yard to the temperate rainforest that it was not so long ago. The towns and cities of the Northwest tend to have a makeshift, provisional air, as if the forest might yet swallow them alive. Because the region was settled by whites more recently than elsewhere, its Indian past—ten thousand years of it—lies very close to the surface, and Native American conceptions of landscape and land use remain live political issues here.

Last year's Senate race was fought on terms that go back to the eighteenth century, as the painted landscapes of the Pacific Northwest remind one, with their endless variations on the themes of wilderness, white settlement, tribal rights, and the competing claims of industry and nature. These paintings haven't dated. The questions they raise are all around us, even now.

John Webber was the first white artist to unpack his paint box in the Pacific Northwest. In the spring of 1778 Captain James Cook's *Resolution* put in to Nootka Sound, on the west coast of Vancouver Island, after a long

northward haul up the Pacific Ocean from New Zealand, with stops in Tonga, Tahiti, and Hawaii. En route through Oceania, Webber, the official expedition artist, had painted a series of watercolors that are dominated by exotic tropical greenery in which every palm frond has a life of its own.

Cook's ship left the palms, wili wilis, breadfruit, and hibiscus of Hawaii on February 2; on March 29 it sailed into the great funnel-shaped approach to Nootka Sound, on the same latitude as the mouth of the English Channel. To British eyes the Pacific Northwestern light falls at a familiar and homely angle. The vegetation is Scottish, the weather Irish. After Hawaii, Nootka Sound must have felt to the voyagers like a wet and windy corner of their own country, and they named it New Albion in honor of its teasing similarity to home.

Webber, who trained as a painter first in Switzerland and then in Paris, clearly seems to have experienced a bout of déjà vu. In sharp contrast to his Tahitian and Hawaiian watercolors, his Nootka sketches render the local scenery (and "scenery" it is) in brisk pictorial shorthand, the water, rocks, pines, and mountains composed into a strikingly efficient and conventional landscape. We might be on the shore of Lac Léman or Lake Windermere here.

Like Cook, in his posthumously published *Voyage to the Pacific Ocean* (1784), Webber seems to have barely noticed the land itself, so preoccupied was he with the Indians in the foreground—their swan-necked cedar canoes, their curious timber dwellings, the frames on which they dried their salmon. In Paris he had specialized in "picturesque peasant scenes," a useful preparation for his studies of Indian life. Though the figures are small on the page, they are exquisitely detailed and individuated. With a magnifying glass one can pick out their conical hats, woven from cedar bark, and capes made from sea-otter hides. Given his education, Webber almost certainly had encountered the ideas of Rousseau, and his Pacific Northwest is the habitat of "natural man," drawn with the fastidious zeal of a keen amateur anthropologist.

In 1791 and 1792, more than a decade after *Resolution*'s flying visit to the Northwest (from Nootka, Cook sailed offshore to the Gulf of Alaska, sighting land to starboard but not stopping there), Spanish and British expeditions cruised through the region, proving the insularity of Vancouver Island and charting Puget Sound. The Spaniards shipped professional artists (Tomás de Suría, José Cardero, Atanásio Echeverría), whereas the English, under Captain George Vancouver, made do with the artistic efforts of a bunch of talented young midshipmen, including John Sykes, Harry Humphrys, and Thomas Heddington. From the mass of sketches

that came home to London and Madrid one can see something of the Pacific Northwest but much more of the tastes and interests prevailing among cultivated young Europeans in the last decade of the eighteenth century.

One catches the artists' excitement at the strange customs, costumes, and architecture of primitive man, and their elation at finding themselves in a real-life Salvator Rosa landscape, with all its shaggy cliffs, tangled woods, blasted trees, and lurid skies. Rosa, the Sicilian Baroque painter, was a great and much imitated favorite in Georgian England, where the novelist Tobias Smollett called his work "dreadfully picturesque." So the young men had a fine time, in their journals and sketchbooks, with granite precipices, waterfalls, and snow-capped peaks, as the land steepened around them along the Inside Passage.

Dread was in fashion in the 1790s, when the word "awful" still had a precise meaning and images of the vertiginous crag, the dark forest, and the storm at sea were calculated to induce a delicious sensation of vicarious terror. It happened that the Pacific Northwest was discovered by whites just as the idea of the Romantic sublime was gaining sway. The lonely and forbidding geography of the place perfectly fit the reigning conception of how a Romantic landscape ought to look. It conveniently combined, within a single view, the essential features of the Swiss Alps, the German forest, and the English Lake District.

There was a single dissenting voice on the voyage—that of George Vancouver, known by his men (though never to his face) as Captain Van. At thirty-four, Vancouver was far behind his time. He was a provincial (from King's Lynn, in Norfolk, where his father was employed by the Customs Service); his education had been mostly acquired at sea (he'd been one of Captain Cook's midshipmen); and the sublime left him cold. His posthumously published *Voyage* (1798) gives a candid, heartfelt portrait of the Pacific Northwest as seen through the eyes of a young fogey who was out of touch with the intellectual currents of his age.

Captain Van took a great shine to Puget Sound and its surroundings. Among the low hills and forest clearings he was able to imagine himself in a reborn England of close-shaven lawns, artful vistas, rolling fields, and country houses. Remembering the stretch of coast over which the retirement homes of Sequim are now sprawled, he wrote,

The surface of the sea was perfectly smooth, and the country before us exhibited every thing that bounteous nature could be expected to draw into one point of view. As we had no reason to imagine that this country had ever been indebted for any of its decorations to the hand of man, I could not possibly believe that any uncultivated country had ever been discovered exhibiting so rich a picture.

But his pleasure in this newfound land soon curdled into repugnance as the expedition sailed north and west into the narrow, mountain-walled channels of the Inside Passage. While his juniors, along with the expedition naturalist, Archibald Menzies, thrilled to the dramatic sublimity of their surroundings, Vancouver recoiled from what he saw. The snow-capped peaks were "sterile," the cliffs of dripping rock and vertical forest were "barren," "dull," "gloomy," "dreary," "comfortless." Of the much-admired waterfalls he complained that their incessant noise made it impossible for him to hear birdsong.

Vancouver's voice seems to come from the wrong end of the eighteenth century, when mountains were conventionally seen as rude geologic excrescences—chaotic, useless, and offensive to the mind and eye ("vast, undigested heaps of stone," as the theologian Thomas Burnet described the Alps in 1681). Yet most of the effusive paeans to the region's scenic grandeur conspicuously lack the real depth of feeling in Vancouver's response to a grim and spiritually corrosive landscape whose epicenter he named Desolation Sound. Captain Van ought to be adopted as the patron saint of all Northwesterners who have felt walled in by their mountain ranges, or suffered a jolt of depression when faced by the black monotony of the fir forest under a low, wintry, frogspawn-colored sky.

The back-of-beyond aspect of the Pacific Northwest heightened its romantic allure. Even after the Oregon Territory came within reach of the enterprising tourist, Washington and British Columbia remained comparatively remote. The famously grueling sea passage from Portland to Seattle was a serious deterrent, and it wasn't until the Northern Pacific Railway at last arrived at its Tacoma terminus, in 1883, that Puget Sound became easily accessible to the casual traveler. In the meantime, a growing mystique attached itself to the area: people who had never been there spoke of it as the last resort of unspoiled wilderness, romantic solitude, and wild indigenous inhabitants.

It was the Indians who drew the Irish-Canadian painter Paul Kane to British Columbia, Washington, and Oregon on a long and adventurous trip in 1846–47. But Kane's noble red men, alone with their primeval forest and steam-belching volcanic cones, are disappointingly generic and look as if they stepped straight out of James Fenimore Cooper's *Leatherstocking Tales*. What Kane's pictures celebrate is, rather, the intrepidity of the artist—the solitary white man out in the Far West, ahead of the crowd, communing with primitive people in their natural state. His sketches and studio canvases document the progress of the artist as romantic hiker-hero. Kane's journey is the real subject; his Pacific Northwest is an adequately wild backdrop for a sequence of pictures in which one's attention instinctively fastens less on the land than on the personality of the painter.

In 1855, when the artist George Catlin was pushing sixty, he stopped in the Northwest, breaking a voyage that took him from Cape Horn to the Bering Sea. At the mouth of Clayoquot Sound, on the west coast of Vancouver Island, then as wild a site as any in the region, he painted a prophetic elegy on the fate of wilderness in an industrial, land-hungry age. A Whale Ashore—Klahoquat is as ambitious a painting as Catlin ever attempted: half moody seascape half grim morality tale. Set against a troubled sunset over the Pacific, the stranded whale is not the only creature in the picture that is seeing its last day. The Indians swarming around the carcass, in canoes and on foot, are observed from such a distance that one can tell little about them except that they are members of the same species. They might just as well be a colony of prairie dogs. The swirling pattern made by the crowd on the beach has the organic coherence of a shoal of minnows or a flock of gulls. In the middle distance a trim schooner rides at anchor. A boat has just put off from it. On the far horizon, to the right of the schooner, is a flattened contrail from a steamship going south. Numerous as the Indians may appear, it's the smoke in the distance that signals the inevitable outcome of this story. Historically speaking, we are just seconds away from the arrival of the logging crew, the pulp mill, the cannery, and all the rest of the machinery that will change forever the lives of the unsuspecting people on the beach.

Since 1830 Catlin had been chasing Indians westward across the plains, trying to capture them on canvas before they were swamped by the tide of white conquest and settlement. By 1855, great tracts of the land that he had known as wilderness had been claimed for civilization by fenced rectangular grids. That Catlin could see the Indians as doomed even here, in the last outpost of the truly wild, reveals the depth of the visionary pessimism he had acquired on his travels. And he was right, of course. Ten years before he stood above the beach at Clayoquot, the Hudson's Bay Company had made Victoria its western headquarters; three years before, the Seattle city fathers had staked claim to their settlement on Elliott Bay. Catlin's nearing steamship was as unstoppable as the setting sun.

The Indians in A Whale Ashore are squarely seen as part of the Pacific Northwest's nature, not its culture. It's no accident that one of the best collections of Native American art from the Northwest coast is housed not in the National Gallery but in the American Museum of Natural History, where the Salish, Haida, and Kwakiutl tribes take their place alongside stuffed elk and bison. In the basic grammar of nineteenth-century landscape painting, no stretch of Northwest water is complete without its canoeful of Indians—a native aquatic species whose presence gives the stamp of regional authenticity to a canvas. As the same water filled in real life with square-rigged lumber ships and steam tugs, its painted counterpart became an exclusionary zone in which white vessels were banned and only cedar canoes allowed.

In 1863, on his second swing through the West in search of material for his enormous pictures of the American sublime, Albert Bierstadt planned to visit Puget Sound. However, his companion, the journalist Fitz Hugh Ludlow, fell ill in Oregon, and the two men sailed instead from Portland to San Francisco, en route to New York. The unvisited territory evidently loomed large in Bierstadt's imagination, and in 1870 he produced a curious painting titled *Puget Sound*, *on the Pacific Coast*, in which he depicted a landscape of artistic myth and rumor, a Pacific Northwest de l'esprit.

By Bierstadt's usual seven-by-twelve-foot standards, this canvas is quite modest, but every last inch is packed to the bursting point with the stock ingredients of the sublime, all lusciously painted in the artist's best theatrical style. Here are rocks, precipices, withered trees, the darkness of a howling storm, a shaft of golden sunshine of the kind that might herald the Second Coming, a thunderous cascade descending a mountain face, a turbulent and angry sea, and Indians hauling their canoes to safety out of the exploding surf. The picture turns Puget Sound into a brand name for the dreadfully picturesque.

More effectively than the Oregon paintings that Bierstadt drew from the life, *Puget Sound*, *on the Pacific Coast* formulates the terms on which the Pacific Northwest made its appeal to the aesthetic tourist. The region was soon dotted with established vantage points offering painterly views of the major landmarks: Mount Hood seen from the northwest bank of Lost Lake, Mount Adams seen from the Oregon side of the Columbia River, Mount Rainier seen from across Commencement Bay, on Puget Sound. It was a quickly established convention that Northwest water—river, lake, or branch of the sea—was sufficiently still to hold a faithful reflection of a mountain

for hours at a time. This despite Bierstadt's suggestion that Puget Sound waves break on the shore like those of the Mediterranean in a full gale.

Sanford Gifford, a Luminist painter and a close friend of Bierstadt's, was another early visitor. In 1874 he pitched his easel on what I take to be the beach on the southeastern tip of Vashon Island and painted Mount Rainier mirrored in the lakelike water of Commencement Bay. The snow-capped summit, rose-tinted in the light of a late-summer afternoon, rises above a layer of hazy cloud like an apparition, or (in Gifford's own terms) a manifestation of the divine. The water is made radiant by the diffused brilliance of the mountain's reflection. On the scored-glass surface of the bay float two Salish canoes. On the far shore the most prominent trees are as green and, more surprisingly, deciduous as any in Gifford's English and Hudson River landscapes. It's a picture of an undisturbed American Arcadia, in which Indians—with their pathless woods, their peaceful water, and their inspiring alp—are seen to be living apparently beyond the reach of time.

It's Gifford's determined erasures that catch the eye. Gone (from the patch of land immediately above the canoe in the foreground) is the young town of Tacoma, with its new lumber mill, new docks, and fleet of moored cargo ships. Gifford's lovely Arcadia, so seemingly present, belongs to an imagined past, and the painting is suffused with nostalgia for a period that never really was, when bushy elms grew out over the water and Indians were the nymphs and shepherds of European pastoral tradition.

Fifteen years after Gifford painted Mount Rainier, Bierstadt at last reached Puget Sound, having completed a painting tour of southeastern Alaska. Camped out on what appears to be the same spot that Gifford had used for his view of the mountain, Bierstadt set to work. By 1889 Tacoma had grown to a smoke-and-steam-wreathed city of thirty thousand people. Bierstadt obliterated it from his vision. To accentuate the enchanted solitude of the scene, he painted just one Indian canoe in place of Gifford's two.

It should not be thought that Bierstadt took no interest in the great industrial developments of his time. He was acutely sensitive to them. His major patrons were financial, timber, mineral, and railroad magnates for whom Bierstadt's pictures (like those of Thomas Moran) were grandiose souvenirs of the West as it had been before their own work crews landscaped it to the industrialists' design. When Bierstadt finished his Rainier painting, in his New York studio, he sent a hopeful letter to James J. Hill. Mount Tacoma (the alternative name for Rainier) was, he wrote, "one of the grandest of mountains," and it was happily situated "on the line of your road." The railroad baron didn't bite.

In a spirited counteroffensive to the idea of Manifest Destiny, the Romantic painters made it their great mission to depopulate the Northwest of all

but its aboriginal inhabitants. It was left largely to amateurs—and, interestingly, to painters of Indian scenes such as Catlin and John Mix Stanley—to tell the other side of the story. No one had a keener sense of the fantastic pace of white settlement and industry than the artists who spent their lives searching for authentic Indians in the ever-decreasing wild.

Though John Mix Stanley specialized in Indian portraits, he was an accomplished, if conventional, landscape painter. His *Oregon City on the Willamette River* (c. 1850) is a conspicuously fair-minded treatment of the theme. The sublime survives in the immediate foreground, where a bluff overlooks the Willamette Valley, but it has mostly been exiled to the back of the canvas, where sandstone cliffs and thick forest frame a splendid river-wide waterfall. Sandwiched between wilderness in the distance and wilderness nearby lies an infant city of neat rectangular plots and newly painted houses, dominated by an English-style church and a three-storey sawmill. Covered wagons are rolling down Main Street. The low light is falling from the east; it's early morning, and this is just the beginning of what is going to happen to Oregon in the near future.

Cut to the figures on the bluff—still in shadow, for the morning hasn't reached them: two Indians, a man and a woman, with what looks like a bedroll between them. The man is leaning on a staff, so he's a pilgrim, or a vagrant. Both figures look directly at the viewer. They might be homeless people on a modern street, begging passers-by for change. With hindsight, we know where the couple are headed. In 1857 Stanley painted an allegory titled *Last of Their Race*, in which ten Indians, wearing the costumes of different tribes, are perched on a pile of rocks at the edge of the Pacific Ocean, their last toehold on the West that was once their domain.

Yet Stanley rendered the fatal city so affectionately that the painting seems to shimmer with ambiguity, like a hologram changing shape as it is tilted under a light. Now you're with the Indians, now you're with the whites. At first glance the picture looks like an advertisement for the civic pleasures that await travelers at the end of the Oregon Trail; it promises space to build and to breathe amid tranquil natural surroundings—a school for one's children, a waterfall to delight one's eye. At second glance that cheerful promise seems callow and heartless—but not so callow, or so heartless, that it cancels out one's first impression. As in the hologram, both images are equally there, but never quite at the same time.

In the 1880s an amateur, Emily Inez Denny, a member of one of Seattle's founding families, took the robust, monocular view of settlement in a painting of Smith's Cove, on Elliott Bay. The artist is standing in the middle of a stump field, where land is being cleared for future development. (The space just behind her will turn, eventually, into a chain-link-fenced compound for imported Japanese cars.) Beyond the field lie the already substantial accomplishments of Denny's ingenious, hardworking family and friends: a handsome homestead with barns, outbuildings, and an orchard; ships under steam and sail in the harbor; a locomotive hauling a line of cars on the railroad, which is carried on trestles over the shallows at the north end of the bay; two horse-and-buggy outfits heading down a lane into town. The sky is dominated by a roiling billow of steam issuing from the impossibly tall smokestack of a mill somewhere over on Vashon Island, or beyond. Emily Denny's picture, with its proud detailing of modes of transportation, makes that most poignant of provincial boasts: we may seem to live miles from anywhere, but we are really very well connected. In that respect her painting is bang up-to-date a hundred and twenty years later.

Denny's work belongs to a tradition of vernacular landscape which includes picture-postcard photographs of the Pacific Northwest. Photographers and painters used many of the same views and vantage points, but these coincident locations serve only to expose the huge rift between their visions of the land. Turn-of-the-century postcards abhor solitude. They represent nature as a resource, for industry and for recreation. One wonders what Bierstadt, for instance, would have made of the diagonal line of twenty-five people "nature coasting" down a snowy slope of Mount Rainier and waving to the camera as they slide by. Every river has its fisherman, every lakeshore has its picnic table. A postcard from Oregon shows Mount Hood mirrored in Lost Lake, a favorite view of painters—but here a man in a bush hat sits in the foreground cradling a gun, as if he were about to unzip the reflection with a bullet. Mountain scenes afford a pretty backdrop for early Oldsmobiles and Fords, shown parked on dirt tracks in the heart of the sublime.

As the postcards promote the luxury hotels, the parks, the zoos, and the electric lighting of the new cities, so they take a boosterish line on the sources of the cities' wealth. Loggers are represented as gnarled western heroes, grinning widely from halfway up the trunk of some monarch of the forest they are about to dethrone. Massive balks of cut timber, a hundred feet long and seven feet square, are captioned "Washington Tooth Picks." A class of twenty-five grade-school children is pictured sitting atop the flat stump of a single logged cedar. Bridges, ships, farms, mills, and railroads

figure on the postcards as triumphs of civilization over the wilderness—a wilderness that by 1905 or thereabouts could already be thought of as a lavish extension of a civic park, to be valued in terms of its facilities for tourism and sport.

A postcard from a later date—circa 1950—qualifies as one of the few iconic Northwest landscapes. It shows the vast glaciated extrusion of Mount Rainier, grandly outclassed by a B-17 Flying Fortress that appears to be cruising directly over the summit. Here is the awe-inspiring, Seattle-manufactured, technological sublime, putting nature in its place. The dormant volcano and the Boeing bomber are up to the same deadly waiting game. This was the card to send, with love, to Moscow.

The most powerful and dramatic landscapist of the Northwest was the timber industry, which has turned the forested mountainsides into a new kind of wilderness, of skid roads, stumps, and slash. I saw my first clear-cut eleven years ago, when I was out here on a visit. It was unexpectedly stirring to see the sheer totalitarian scale of damage that the chainsaw can inflict, and the sight ranks in memory somewhere alongside my first view of the Manhattan skyline or of the Pyramid of Cheops, as one of the great eccentric wonders of mankind. I understand perfectly why Paul Bunyan was a leading mythological god in the American pantheon, before his activities came to be regarded as commensurate with spilling oil and dumping untreated sewage.

No sooner had the Pacific Northwest been established as the last outpost of the sublime than it was recast as a battlefield in the war between man and nature. The loose group of Seattle-based painters whom *Life* magazine would in 1953 label "The Northwest School"—Morris Graves, Mark Tobey, Guy Anderson, and Kenneth Callahan—lived within view of the clearcuts. If their best-known work leans toward the calm restraint and stylization of Japanese and Zen Buddhist art, that might be—in part, at least—a response to the violence and upheaval that figure so prominently in their early paintings. Against Graves's later, light-infused and delicate studies of birds, animals, and potted plants should be set his *Logged Mountains*, painted from 1935 to 1943.

The upstanding dead and withered trunks left by the loggers are identical twins to the lightning-blasted trees found in the spooky landscapes of Salvator Rosa, such as Landscape with Mercury and the Dishonest Woodman and Landscape with Tobias and the Angel (both in the National Gallery). But they are the least of it. The land itself has turned into slurry; it's

pouring in a viscous, yellowish-green waterfall right through the bottom of the painting. The grand cascade, central to Romantic pictures of the Northwest in the nineteenth century, has here been perverted into a Niagara of waste. The draining land leaves behind bare chunks of rock, like rotten molars, under a stormy and sinister sky. The dominant colors—russet, ochre, greens that verge on black—are the true colors of Washington as seen by an unillusioned resident rather than by tourists like Gifford and Bierstadt.

Graves was only describing what actually happens when a mountain is indiscriminately logged and its drainage system wrecked: it turns into a mudslide. His landscape—as dreadful as anything conceived by the Romantics—is based on close observation. Similarly, *House in a Landscape* (believed to date from the 1930s), his exquisitely precise depiction of a collapsing homestead, its timbers warped and splayed as the house melts back into the earth, is at once a bold statement about the decay of human hopes in an unkind land and a cool exercise in pure draftsmanship. In both paintings one feels Graves's fierce intimacy with his region and its areas of darkness. This is a northwesterner's bleak version of the Northwest—and it is little wonder that Graves later escaped into the light and airy simplicity of his post-1960s work. It's not for nothing that rainy Seattle leads the country in the per capita sale of sunglasses.

The response of Graves's friend and colleague Kenneth Callahan to the clearcuts was a sequence of big, almost Bierstadt-sized canvases that tip their caps ironically to the Romantic sublime: same mountains, same rivers, same forest—except that the forest has been stripped from the picture, and the landscape rendered in a monochromatic muddy brown and littered with the machinery of the timber industry, so that it recalls a strange, alpine version of the battlefields of the Marne and the Somme. One might expect to see the tin hats of dead soldiers hung on the crosslike projections of Callahan's surviving stumps.

In the 1940s, before he entered his squiggly, Zen-inspired, drip-painted white-writing phase, Mark Tobey was paying close attention to the art of the Northwest coast Indians, as in his *Drums, Indians and the Word of God* (1944). Since John Webber first sketched at Nootka, Indians had often been in the foreground of Northwest landscapes, as the obligatory genii loci of the region, but their art had made only incidental appearances, in the form of carved and painted canoes, house posts, totem poles, and embroidered hats. The rediscovery of primitive art was part of the core curriculum of twentieth-century modernism, with Braque and Picasso rivaling each other in their extensive collections of Amerindian and Pacific

Island trophies. Borrowing from the stylized and abstract vision of the world as represented in tribal art became a modernist mannerism, and on the Northwest coast the white artist had immediate access to an extraordinary body of native work. The art of the Kwakiutl, Haida, Tsimshian, and Tlingit Indians was as vital, strange, and complex as any in the world. On bentwood boxes, muslin wall hangings, housefronts, masks, and domestic equipment the Indians left their own, often highly enigmatic, landscapes of the Pacific Northwest—a great treasury of techniques and images to which twentieth-century white artists began freely to help themselves.

Tobey-like Morris Graves, who took on Oregon-accepted a commission to paint Washington for a United States series that was funded from 1946 to 1949 by the Container Corporation of America. Graves's Oregon is a delicate, feathery, Japanese-looking study of Northwestern evergreens. Tobey's Washington is an intensely busy Indian-inspired pictographic puzzle, like the totemic heraldry on a Kwakiutl painted chest. It's a labyrinth of interlocking rectangles, each one packed with images and symbols, on a ground as luminously gray as a Seattle sky. Inside the rectangles are dozens of ovoids or "eye shapes"—the basic building blocks of Northwest coast Native American design. As with a Kwakiutl chest, the painting demands to be "read" by the viewer, and, as with the chest, some of its meanings readily disclose themselves whereas others appear to be deeply secretive and private. One sees immediately the salmon, the Pike Place Market scene, the seascape with a sailboat, the tribal masks, but the larger code is not so easily cracked. On one level the painting resolves into a game of Can You Spot the killer whale? canoes? logs? mountains? the Indian bird-rattle? Skagit Valley tulips? the artist in his studio? the oyster? clams? On another it's a palimpsest-writing-on-writing, some legible and strongly foregrounded, some faint and obscure, with the whole composition giving the impression of infinitely recessive depth. More than any other painting in the Container Corporation series, Washington succeeds in condensing an entire American state—its nature, industry, and recreations—into a square of paperboard; and it does so by summoning the aid of the state's aboriginal inhabitants, whose art informs the whole conception of the piece.

It was Tobey who nagged at Emily Carr, a British Columbian painter, to get the Indian-folklore material out of her pictures. After training in Paris, where she fell for the work of Derain and the Fauvists, and after a long spell in an English mental hospital, where she filled an aviary with British songbirds, hoping to import them to Vancouver Island, Carr traveled through coastal British Columbia, painting Indian canoes, house posts, and totem poles in the forest. In 1930, when he was forty and she was fifty-nine, Tobey

appointed himself Carr's mentor and critic, advising her to drop the Indian subjects and follow his lead into greater abstraction. The famously spiky Carr was not a natural follower. "Clever but his work has no soul," she remarked of Tobey in her journal (published posthumously as *Hundreds and Thousands* [1966]).

Though Tobey's opinion of her work rankled, it evidently made its mark, because the canoes and totem poles began to disappear from Carr's canvases, allowing the turbulent shapes of the forest itself to emerge as her great subject. Before, she had concentrated on re-creating, in two dimensions, the swooping curves and expressive distortions of carved figures like Raven and Thunderbird. After about 1930, the foliage of the fir forest and its undergrowth of bracken, blackberry, and salal became for her a kind of painted sculpture in its own right. Every leaf and twig looks chiseled, in Indian house-post style, and Carr's forest is thick with fortuitous visual echoes of the mythological creatures who dominated her earlier paintings—especially Dzonogwa, the female Kwakiutl child-stealer; Raven; and Eagle. This is animistic nature—a realm of gross and copious fecundity, where powerful half-seen beings live in the shadows.

In her journal Carr took a dim view of people who "stay outside [the forest] and talk about its beauty."

Nobody goes there. Why? Few have anything to go for. The lone-liness repels them, the density, the unsafe hidden footing, the dank smells, the great quiet, the mystery, the general mix-up (tangle, growth, what may be hidden there), the insect life. They are repelled by the awful solemnity of the age-old trees, with the wisdom of all their years of growth looking down upon you, making you feel perfectly infinitesimal—their overpowering weight, their groanings and creekings [sic], mutterings and sighings—the rot and decay of the old ones—the toadstools and slugs...

If this passage seems to be at least as much about the dank and smelly mystery of sex as about trees, so do Carr's paintings—though the explicit sexuality of her forest is far from being its only signification. In August 1937 she wrote of an unfinished picture of the woods, "It all depends on the sweep and swirl and I have not got it yet." In her best paintings the forest is literally a whirlpool of meanings, in a state of constant dissolution and recombination. Sex is to be found there, but so are worship, peaceful refuge, fear, revulsion, beauty, power, and pathos. It's a complex and

accommodating place, which answers equally to, say, George Vancouver's desolation and the Romantic sense of wonder. It seems as close as any white artist or writer has ever come to the Indian version of the Northwest forest as it appears in the native stories collected by Franz Boas and other early anthropologists.

The Pacific Northwest is now entangled in a rancorous quarrel about landscape: "Wise Use" has become a sly euphemism for chainsaw liberation; farmers rally to protest the reintroduction of wolves into the mountains; salmon-first conservationists plan on dynamiting the hydroelectric dams about which Woody Guthrie used to sing.

Here's a contemporary Pacific Northwest landscape: on the Olympic Peninsula the carcass of a northern spotted owl was found nailed to a fence-post. The bird had been expertly shot with a high-powered small-calibre rifle. Beside it was pinned a typewritten note, or caption: "If you think your parks and wildernesses don't have enough of these suckers, plant this one." The anonymous artist left behind two beer cans, a Band-Aid, and a spent match.

This stretch of land has been so fought over, painted and repainted, laden with partisan and contradictory meanings, that it tends to invite the response of a tired postmodern shrug. A recent *New Yorker* cartoon by David Sipress shows a vacationing couple standing beside their RV atop a dizzy precipice, from which they're looking down at the usual natural amenities of the Pacific Northwest—fir trees, mountains, waterfalls, winding trails. The man, in baggy tartan shorts and wraparound sunglasses, is saying to the woman, "So this is the famous environment everyone's so hyped up about?"

It's "the famous environment" that the Portland artist Michael Brophy depicts with sardonic cool in *People's View*. At the turn of the twenty-first century Brophy has achieved the ambition of every nineteenth-century Romantic painter: he has voided the land of its people. Not even a solitary Indian disturbs his denuded Northwest, with its lonely geology, water, and dark-green vegetation—though field lines and bridges survive, and the hills have been largely shorn of their timber. Nature (or what little is now left of it) has become a prettily lit stage set, from which the audience has been divorced by a proscenium arch. In the immediate foreground of the picture the spectators are assembled, their backs to the painter—a dense crowd of urban types in Birkenstocks and earth-toned leisurewear from Eddie Bauer.

We're in there too, dutifully gazing at this empty spectacle, this picture of a picture, which is what the Pacific Northwest has become. We're in exactly the same position as the people who look at the sea in Robert Frost's poem:

They cannot look out far.
They cannot look in deep.
But when was that ever a bar
To any watch they keep?

Atlantic Monthly, March 2001

The Strange Last Voyage of Donald Crowhurst

MORE THAN THIRTY YEARS after Donald Crowhurst stepped to his death in the Atlantic, somewhere between the Caribbean and the coast of North Africa, he is enjoying a busy new life as a mythological figure. Between 1990 and 2001 the Crowhurst story inspired a novel by Robert Stone (Outerbridge Reach); a one-man opera (Ravenshead by Stephen Mackey and Rinde Eckert); an art installation (Disappearance at Sea) by Tacita Dean that was shortlisted for the Turner Prize; a multimedia performance piece (Jet Lag) by Jessica Chalmers; a stage play (Pelican) by Chris Van Strander; along with a radio documentary, a projected movie, and a play for BBC Television. Of all the competitors, living and dead, who sailed in the 1968 Golden Globe race for the first nonstop solo circumnavigation, it is, ironically, Crowhurst, the cheat, who has won the most secure place in the pantheon of heroes; his sufferings have fired the world's imagination and made him perhaps the most famous amateur sailor who ever put to sea in a small boat.

Everything we know about Crowhurst comes from one book, and it is the narrative brilliance of *The Strange Last Voyage of Donald Crowhurst* that has given his story its extraordinary posthumous energy. Though Ron Hall and Nicholas Tomalin were working on assignment for the London *Sunday Times* (the chief sponsor of the Golden Globe race), their book magnificently transcends its journalistic origins. The two were perfectly matched. Hall was and is a redoubtable investigative journalist; Tomalin, who was killed by a sniper's bullet on the Golan Heights in 1973, when he was reporting the Yom Kippur War, was a lavishly talented writer. (His shocking and funny essay, "The General Goes Zapping Charlie Kong," survives in anthologies as one of the handful of great dispatches from the Vietnam War.) Hall was the sleuth, Tomalin the stylist, and between them

they created a book which has at once the memorable shape and pattern of a work of fiction and the abundant hard detail of a work of unimpeachable fact. I've been reading *The Strange Last Voyage* at least once a year for more than twenty years, and with each further reading, the Crowhurst story deepens and darkens, gaining in power as the world it records slides farther into the past. I often find myself quibbling with Hall and Tomalin's judgments, as the book generously encourages one to do, for it renders Crowhurst in three solid dimensions—as ambiguous, and sometimes baffling, on the page as he clearly was in life.

"You couldn't tell what was going on inside of him," complained a Teignmouth local in the Lifeboat Inn after Crowhurst's death. From infancy (his mother had intended him to be a girl), Donald Crowhurst had reason to mask his feelings. His family was precariously positioned in the English class system: Donald was twelve when the Crowhursts moved in 1947 from British India to a genteel village outside Reading in Berkshire, where they attempted to sustain upper-middle-class pretensions on a manual laborer's wage. "Putting on appearances" is the chilly English phrase for that painful and very English predicament, and Donald, an only child, learned early to put on appearances. He was cleyer, brave, intense, and burdened with self-consciousness. University might have liberated him intellectually, but his father died suddenly when Donald was sixteen, and he had to make do with a course in electrical engineering at a technical college, funded by the Royal Air Force, in which he was eventually commissioned as a trainee pilot officer.

Watching the young Crowhurst as he emerges in the book, one sees a fragile, histrionic personality engaged in an often frantic search for a role and a voice. He does nothing by halves, throwing himself completely into the role of the moment, whether it be the keen student, the boisterous gang leader, the jaunty young officer, the rejected lover, the devoted husband and father, the tireless promoter, the Bridgwater town councilor, the brilliant entrepreneur. A friend said of him that he was "the most vivid and real person I have ever met," and there's an element of hyperreality about Crowhurst when he's on form; an air of larger-than-life theatrical performance.

Tomalin and Hall are inclined to detect a streak of innate insincerity in this—a gap between the "real" Crowhurst and the roles he played. On the evidence they present, I disagree. So long as other people gave Crowhurst his cue, he wholeheartedly became the character they expected him to be. If they looked to him for leadership, he'd be their leader; if they looked to

him for an original idea, he would instantly come up with it. But he needed social conventions as a train needs rails. He was most himself when he was living up to the expectations of his friends and family.

In the summer of 1968, several weeks before he left to sail around the world, Crowhurst drafted a letter to his wife, to be opened in the event of his death at sea. The letter sheds a great deal of light on his essential character. It is a touching document—heartfelt, eloquent, dignified, and admirably sane. It is also powerfully reminiscent of another famous letter—one familiar to every English schoolboy of Crowhurst's generation—written by Robert Falcon Scott to his wife when Captain Scott lay dying in Antarctica. The conscious dignity of tone, the stiff upper lip in the face of death, the instructions on how to bring up the children, all have their ghostly counterparts in the Scott letter. If Crowhurst had to die, he meant to do so, like Scott, with valor. The details in the letter are Crowhurst's own, but its rhetorical élan is pastiche-Scott. He wasn't being insincere. He was a man who instinctively looked to models and heroes for guidance as to how best to be himself; and shaping his letter in the mold of Scott's, he was being pure Donald Crowhurst.

In 1967, he was urgently in need of a model and a hero. His business—manufacturing a cheap handheld radio direction finder (RDF) that he named the Navicator—was failing, and he felt stifled by small-town life in Bridgwater. For the last eight years, his chief escape had been sailing, in *Pot of Gold*, his blue twenty-foot sloop, on day-trips along the Bristol Channel coast. So on Sunday, May 28, when Francis Chichester made his triumphal entry into Plymouth aboard *Gipsy Moth IV* after sailing around the world, Crowhurst (who was out on Bridgwater Bay that day, just ninety miles from the admiring crowds, gunfire, and dipped ensigns that met *Gipsy Moth*'s arrival) saw in him a providential new hero—and a new life for himself.

After it was all over, people would say that Crowhurst was laughably inexperienced; a weekend sailor who should never have been allowed to take part in the Golden Globe race. Yet many successful circumnavigators have started their voyages with no more firsthand acquaintance with ocean sailing than Crowhurst. The Bristol Channel, with its fierce tides and wide-open exposure to unforecast southwesterly gales, is a tough training ground for anyone in a twenty-foot boat; and Crowhurst impressed those who sailed with him as a competent if sometimes slapdash seaman—as he impressed several prominent figures in the sailing world, including the yacht designer Angus Primrose. With a good head for math, he quickly became

a first-rate navigator. (It is a real tribute to his skill that he was able to work out celestial sights backwards, from wholly fictional positions—something far beyond the ability of most honest navigators.) He was a persuasive salesman of himself and his project, an important qualification in the dawning age of commercial sponsorship.

To the design and fitting out of his trimaran, Crowhurst brought a sackful of radical new ideas, including an automatic inflatable self-righting system and a novel method for fastening the chainplates so his rigging could take the strains imposed on it by the Southern Ocean. The heart of *Teignmouth Electron* was to be its computer, taking messages from electronic sensors distributed through the boat from the masthead to the bilges. Writing in 1970, Tomalin and Hall couldn't suppress a knowing chuckle at Crowhurst's vision of a computerized sailing vessel. The idea struck them as plainly dotty. Thirty years later, in the light of such developments as Jim Clark's cyberyacht *Hyperion* (the dubious heroine of Michael Lewis's book *The New New Thing*), it's tempting to see Crowhurst as a lonely prophet of the impending digital future—just as his Piver-designed, Victress-class trimaran was a lumbering early forerunner of the thirty-knot-plus carbon-fiber multihulls to come.

But time was against him in more senses than one. By the rules of the race, Crowhurst had to sail by the end of October 1968. He did not find sponsorship until late in May, when at last a boatbuilding firm in Norfolk was given the go-ahead to start construction. *Teignmouth Electron* was thrown together in a blinding hurry. It wasn't rigged and ready to sail until October second. Its famous computer remained a tangle of disconnections. The delivery trip from Norfolk to Devon turned into a two-week nightmare. When *Teignmouth Electron* finally crossed the bar of its home port, Crowhurst had just sixteen days in which to prepare himself and his boat for a voyage around the world. There was hardly any point of resemblance between Crowhurst's original conception of a high-tech sailing machine and the lackluster reality of the hastily assembled trimaran with its trailing wires and its piggish refusal to go to windward.

He could not now withdraw from the race. It was characteristic of Crowhurst that he was ruled by financial and social obligations. He sailed west from Teignmouth like someone who marries the wrong person because the wedding invitations have been sent and the church has been booked: he could not face the storm that would ensue if he pulled out before it was too late. It's hard now to reconstruct the total isolation of the solo ocean sailor in the late 1960s. As I write, four separate around-the-world races are in progress, one of them the single-handed Vendée Globe. E-mails, faxes, videos, satellite phone calls, and audio broadcasts stream between the sailors and the land. Even in the wilds of the Southern Ocean, the yachts have never truly left society behind. I know what the competitors had for breakfast this morning; I can monitor their sleep patterns and eavesdrop on their thoughts. By means of an Argos beacon on each boat, every tack and jibe is seen at race headquarters, and its exact position on the globe, to within a hundred feet or less, is constantly monitored. These single-handers can hardly break wind without it becoming news on the shore.

When Donald Crowhurst left Teignmouth, he sailed into a void of a kind that no longer exists except in the far reaches of outer space. Like most of his fellow competitors in the Golden Globe he carried an MF radio (Bernard Moitessier, who hated all things electrical, declined to take one on the grounds that it would violate his precious solitude); but radio communication, patched through shore stations, was always intermittent, brief, riddled with interference, and necessarily formal in its tone and content. Radio certainly didn't restore the sailor to the ambit of society; rather, it served only to remind him of his awful loneliness on the deep.

No man who fathers four children by his early thirties can be an isolate by nature. Crowhurst always wanted to be master of his own business and loathed being someone else's employee, but he was never a self-sufficient loner like Moitessier or Robin Knox-Johnston. Nothing in his experience had prepared him for the unbounded solitude that soon opened before him. He was a good enough seaman, an inventive Mr. Fixit, an increasingly assured navigator—but he was not created to be so utterly alone as he now found himself to be, on the face of the wintry North Atlantic.

It's no surprise (nor does it shed serious discredit on Crowhurst) to learn that *Teignmouth Electron* performed miserably. Fifteen days out he was off the coast of Portugal, not much more than six hundred miles southwest of Teignmouth, giving him an average speed-made-good of just 1.6 knots, or a likely arrival home sometime in February 1971, as against his airy projected date of February 1969. It says a lot for Crowhurst that he kept his cool through this agonizingly dispiriting experience in the Channel approaches and off the Bay of Biscay, and on November 15 was able to take realistic stock of the voyage so far in terms that reflect a remarkably agile and complex grasp of the situation. He ached for the cup to be taken from him, for release from a race that had clearly become impossible for him to win or, probably, to finish. He was also—as ever—bound by obligations; to his

wife, to his Teignmouth supporters, to his own reputation as a pioneering yachtsman, and to his sponsor, the trailer-home dealer Stanley Best. So far as his wife and family were concerned, he owed it to them to quit there and then. So far as Best and the larger, public world were concerned, he owed it to them to plow on, at least as far as Cape Town, if not Australia. Poor Crowhurst. He had no one to discuss his decision with except himself, and as you watch him side first with one point of view, then with the other, you might be reminded of F. Scott Fitzgerald's definition of intelligence as the ability to hold two opposed ideas in the mind at once. Fitzgerald would have admired Crowhurst's intelligence on November 15, as he juggled with opposed ideas like ping-pong balls. He so nearly made the right decision. It was a fatal, if minor, flaw in his character that made him take the wrong one.

Sometimes he called Stanley Best "Stanley"; more often, "Mr. Best." The deferential Mr. was a measure of Crowhurst's need for authority figures in his life. Letting down Mr. Best loomed larger, finally, in his thoughts than letting down Clare and their children. "Mr. Best" represented social convention, the world's good opinion, and Crowhurst's likeliest hope of escaping financial bankruptcy. "Philosophising is irrelevant, however," wrote Crowhurst in his log; "and must stop. I have things to do!" He'd made his decision. He went on sailing—slowly—south.

With renewed determination, he tried to fling himself bodily into the role of the intrepid single-hander, which required understated bravery and a dry, English, Chichesteresque humor. Again, I differ with Tomalin and Hall in their interpretation, for I see no conscious insincerity in Crowhurst's log entries or in the film and tapes he was making for the BBC. Putting a brave face on his predicament placed Crowhurst under enormous strain; but when he wrote cheerful verse in the style of Kipling, or attempted to joke with future TV viewers about his life aboard *Teignmouth Electron*, he was simply trying, as sincerely as he knew how, to become the person he needed to be in order to sail around the world. Not for the first time, he was desperately seeking the voice—the model, the conventions—that would safely see him through. Out at sea, with no responsive audience to lift his spirits and moderate his performance, he grew louder, shriller, more insistent, and less plausible, like an actor addressing a cavernously empty theatre. But he wasn't acting. This was his only life.

Deception snuck up on him from behind. It began as mild inexactitude, a fudging of his reported positions and an unwise claim to have covered 243 miles in a day when in fact he had sailed a very creditable 170 miles. Every

amateur sailor who has described seven-foot waves as ten-foot waves has been similarly guilty. Crowhurst, badly in need of a boost, received admiring headlines in the English papers—and it is hard to grudge him that fleeting moment of acclaim. Having lied once—to the joy of his press agent, Rodney Hallworth—made it easier to lie again, and Crowhurst began to feed back to England what England expected of him.

It was late in December, when he was south of the equator, that he began telling lies from which there could be no turning back. He was then as far out of society and its rules and customs as it is imaginable for any human being to be—in a corrosive solitude quite unimaginable for someone of Crowhurst's outgoing social temperament. When Robin Knox-Johnston, the Golden Globe's eventual winner, returned to England, he called his book about the voyage A World of My Own. More than Knox-Johnston, more even than Moitessier, Crowhurst found himself in a world truly his own: an endlessly shifting, watery, blue universe that grew more solipsistic by the day. By putting into an obscure Argentinian fishing harbor to repair his damaged starboard hull on March 6, 1969, he officially disqualified himself from the Golden Globe race. But by then Crowhurst was making up his own rules as he went along. Alone at sea, he was floating free of all the usual constraints of earth. For someone who had lived by conventions and social appearances, this was a dangerous and frightening kind of liberty.

Sir Francis Chichester had failed him as a model, but Crowhurst found a new hero to supplant him. His ship's library was scantily supplied with books, but in Teignmouth he'd shipped a copy of Albert Einstein's Relativity: The Special and the General Theory: A Clear Explanation That Anyone Can Understand. In the wisdom of hindsight, one wishes he had instead taken a collected edition of Anthony Trollope's Barsetshire novels. For Einstein, though a keen dinghy sailor in his time, proved to be a terrible role model, and relativity theory was the last thing that Crowhurst needed to understand at this stage in his life. His relation to the rest of the world was tenuous enough as it was; Einstein's theory enabled him to sever the final remaining cords that connected him to society, and to sanity.

Ambling around the Atlantic, waiting for the rest of the race fleet to catch up with him as it sailed eastwards to round Cape Horn, Crowhurst apprenticed himself to Einstein, drinking in his language and preparing to go one better, just as, a year before, he'd prepared to go one better than Chichester. His quick mathematical brain responded to the book with a kind of dangerous ecstasy. On June 24, 1969, after being alone at sea for 237 days, he opened a fresh logbook, titled it "Philosophy," and began to write.

Like most things that Crowhurst did (like the Navicator, for instance),

his "Philosophy" has a jejune, homemade ring to it. One feels painfully his lack of a university education as he strains for the proper tone of the philosopher addressing Everyman ("A Clear Explanation that Anyone Can Understand"). Yet one does not—in the early pages—see it as the work of a madman. There is intelligence in it, and at least a bare coherence. Some passages are more or less fully worked out; some are in the form of shorthand notes (I think Tomalin and Hall are too quick to detect insanity in Crowhurst's shorthand). It probably wouldn't muster a D in a first-year philosophy course, but nor would it earn the student a bed in a mental ward.

Crowhurst seems to have planned to return to England shortly after the arrival of Nigel Tetley in his trimaran *Victress*. Thus he would avoid having his logs scrutinized too carefully by the race judges (and especially by Chichester himself, who had long been skeptical of Crowhurst's claims). When *Victress* sank off the Azores on May 21, Crowhurst was in effect condemned to be hailed as the winner of the Golden Globe—and to have his logbooks closely inspected by his critics. This news, however, took some time to reach him. It was not until June 25—the day after he began work on his "Philosophy"—that he received a cable from his press agent which gloatingly described the hero's welcome awaiting him in Teignmouth, a spectacular reception that would comfortably outshine Chichester's triumphal entry into Plymouth two years earlier.

During the course of the next six days, Crowhurst, writing at breakneck speed, plummeted into lunacy. Inspiration was upon him. He was going (or so he seems to have believed) beyond the limits of earthbound reason, into an enchanted realm of vatic revelation. It is heart-wrenching to read the last entries in the book. They are beyond paraphrase or explication. Their language is a chaos of private, incommunicable symbols, in which Einstein, religious mysticism, and celestial navigation have become impossibly tangled. Yet they don't quite fit the notion that Crowhurst killed himself "in despair." Rather, they convey the dizzy exaltation of mania. No problems exist. The great puzzle of existence has been solved. The author has become a master of the universe. They give rise to the suspicion that when Crowhurst stepped off *Teignmouth Electron* to dissolve himself into the beauty of the cosmos, he might well have believed that he could walk on water.

This is at least the sixth edition of *The Strange Last Voyage of Donald Crowhurst*, and there will undoubtedly be more. For the Crowhurst story seems to speak most vividly to people too young to have known of his voyage at the time it was made. The artist Tacita Dean, for instance, was three

years old in 1968. The profound solitude into which *Teignmouth Electron* sailed has disappeared forever in our hooked-up world, and we can only vicariously experience the oceanic isolation endured—or enjoyed—by Crowhurst and his contemporaries.

That fact was powerfully underlined when Robert Stone tried to update the Crowhurst story from the 1960s to the 1980s in *Outerbridge Reach*. To get around the problem that the yachts in his fictional race would all be equipped with Argos beacons, with their every move closely surveyed from the shore, Stone had to contrive a Rube Goldberg piece of plot machinery. In his novel, signals from the boats can be received only by one radio station, located in Spain, that is conveniently blown up by a gang of Basque terrorists.

The meaning of Crowhurst's voyage has greatly altered since the book's first publication. In 1970, Crowhurst was seen as a hoaxer who came to a pathetic end. There was sympathy for his story, but it was laced with a condescension that sometimes surfaces in Tomalin's and Hall's account. Now he is more likely to be viewed (as Tacita Dean sees him) as a tragic hero, a tortured soul in involuntary exile from the stable world, who holds up a mirror to us all. *Teignmouth Electron* has become like a ship in an allegory—a vessel to transport the reader beyond the known world into a strange and lonely realm where the reader, too, will lose his bearings and face the ultimate disintegration of the self in the cruel laboratory of the sea. For the passage of time has revealed that *The Strange Last Voyage of Donald Crowhurst* is not merely a work of graphic reportage; like the story of Icarus, it has the arc of a classic myth. In his "Philosophy," Crowhurst fancied himself an immortal. In one way, at least, he has turned out to be right.

Introduction to *The Strange Last Voyage of Donald Crowhurst*, Sailor's Classics Edition, 2001

Gipsy Moth Circles the World

On the Morning of July 7, 1967, an extraordinary scene took place on the south bank of the Thames at Greenwich, where an elderly man, wearing thick spectacles and looking like a frail bag of bones inside his clothes, kneeled bareheaded before the Queen and was dubbed a knight of the realm with, it is said, the same sword that the first Queen Elizabeth had used to knight Sir Francis Drake on his return, in 1580, from his around-the-world voyage in the Golden Hind.

For Britain in the mid-1960s, the occasion was richly laden with meaning. Sir Francis Chichester's solo circumnavigation of the world, greeted with all the pomp and circumstance that Buckingham Palace could command, was seen as a precious symbol of national regeneration. This was a period in which the pound was falling, inflation rising, the last of the colonies were shaking off their bonds, and there was mounting industrial unrest. The one area in which Britain could be seen to shine was viewed by the Establishment with something close to horror. Bishops, Conservative politicians, and homegrown moralists of every hue deplored the rise of Carnaby Street, the Beatles, the Rolling Stones, and all the rest of the triumphant youth culture of short skirts and psychedelia.

So the second Sir Francis became a conservative symbol to hold up against the decadence of Swinging Liverpool and Swinging London. Old enough to be Mick Jagger's grandfather, he came from one of the ancient "county" families of England and spoke in the crisp accent of a true-blue gentleman. Despite lifelong myopia, and a diagnosis of terminal lung cancer, Chichester had achieved something to astound the world with; a solitary, heroic feat of manly fortitude and daring. To a Britain robbed (as many then believed) of its overseas possessions, Sir Francis restored the glorious illusion of British mastery of the seven seas. As the great anthem

of English jingoism has it, "Rule, Britannia! Britannia, rule the waves! / Britons never, never, never shall be slaves!" That morning in Greenwich, with live TV coverage of the ceremony (Gipsy Moth IV looking impossibly tiny in the background), people found something to celebrate in themselves as they watched their screens in pubs and clubs across the country. Their new, stooped, shortsighted knight reminded them of the salt in their veins, their brave historic past, their English mettle. Sir Francis stood as a living refutation to the seedy claims of sex, drugs, and rock-and-roll.

More than thirty years on, the meaning of Chichester's circumnavigation has undergone a radical change. Yet it means hardly less in the twenty-first century than it did in 1967, for Chichester (as we see only now) decisively altered the terms on which lone sailors would put to sea. He has turned out not to be a sentimental throwback to the past (as I saw him that morning), but a harbinger of the future.

He was by no means the first person to sail alone around the globe. Nearly all his predecessors, though, like Joshua Slocum, Harry Pidgeon, Alain Gerbault, and many others, treated their voyages as extended cruises, and were as interested in the earthy parts of the world as in its watery ones. They took their time. The palm for leisurely circumnavigation must surely go to the redoubtable British yachtsman Edward Allcard, who took thirteen years to complete the circle, at an average speed of a little over one quarter of a knot. Chichester defined his "wonderful venture," as he calls it in *Gipsy Moth Circles the World*, as a race against time, a merciless test of personal endurance and boat speed. His wife, Sheila, spoke of his voyage as "a pilgrimage," and one needs the language of religious austerity and ritual suffering to properly describe Chichester's peculiar achievement.

From the start, he was determined to pit *Gipsy Moth IV* against the Victorian clipper ships which traversed the world on the same course that he would take. It was a punitive and quixotic challenge. Since the speed of a sailing ship is a function of its wetted length,* and *Gipsy Moth*, at 53 feet overall, was only a fraction as long as, say, *Cutty Sark*, at 212 feet, there

^{*&}quot;Wetted length," not waterline length, is the key factor, though the usual equation for hull speed is to take the square root of the length of the boat along the waterline and multiply it by 1.3, 1.35, 1.4, or even 1.5, depending on which authority you consult. When the hull of almost any sailing boat is heeled 25° or 30°, its effective waterline length is substantially increased, which explains why most boats—even my own sedate cruising ketch—can make gratifying improvements on their theoretical hull speed, given a wind strong enough to heel them over. Chichester on several occasions saw Gipsy Moth IV come within kissing distance of 10 knots, which suggests that the boat's wetted length may have been nearly 10 feet longer than its specified length-along-the-waterline of 39.5 feet.

could on the face of it be no competition. If both vessels were sailing at their optimum speeds, *Gipsy Moth* would be doing something over eight knots, while *Cutty Sark* would romp past at around seventeen knots. It's true that the Bermuda-rigged racing yacht could sail far closer to the wind than the square-rigged clipper; but in the southeast trades or in the savage westerlies of the Southern Ocean, this would be a trifling advantage.

Small as Gipsy Moth was when set beside a clipper, she was a gigantic handful for a single man as old and slightly built as Chichester. To get her going at her best, he would often have to set a total of about 1,500 square feet of terylene sails, distributed around the rig like so many pieces of washing. When a squall hit, the labor of taking down so much sail was both exhausting and dangerous. By contrast, one thinks of the small, tubby, sea-kindly ketch Suhaili, in which Robin Knox-Johnston sailed nonstop around the world in 1968–69. Knox-Johnston, less than half of Chichester's sixty-four years, carried barely half of Chichester's daunting sail area. He spent more days at sea (313, as against Chichester's total of 226), but as Knox-Johnston's book A World of My Own makes plain, his days were vastly more comfortable. He could find serenity in his solitude on the ocean; to the hard-driven, hard-driving Chichester, serenity was alien to his nature.

It was Chichester who set the records and the times to beat, and in the years since his pioneering voyage, single-handed circumnavigations have been done in Chichester's style, not Knox-Johnston's. With successive leaps and bounds of marine and electronic technology, boats have grown longer, sails bigger, times (much) shorter. Global single-handed races are organized on an industrial scale, as trials of stamina and feats of athletic survival. Nothing could be further from that idyllic world of the unhurried lone sailor, conjured so infectiously by Joshua Slocum in Sailing Alone Around the World:

I learned to sit by the wheel, content to make ten miles beating against the tide, and when a month at that was all lost, I could find some old tune to hum while I worked the route all over again, beating as before . . . The days passed happily with me wherever my ship sailed.

Tell that to Francis Chichester.

His biographer, Anita Leslie, records a childhood of classic English misery. Francis's father, the ninth son of a philoprogenitive baronet, was a cold and

steely Anglican clergyman who took no pains to conceal the fact that he found his own second son by far the least lovable of his four unlovable children. The Georgian rectory, in the village of Shirwell, Devon, was an emotional icehouse. Francis Chichester became a goggle-eved self-communing solitary, happiest outdoors, where he kept the company of birds and fish. Boarding school (he was sent away from home at age six) was no escape: thrashed and bullied, he learned to bully in his turn. At thirteen he went to Marlborough College, a famously tough establishment. During the First World War, when Chichester was a pupil there, the school's general atmosphere was that of a particularly brutal prisoner-of-war camp, in which the boys were flogged, usually by one another, and starved into severe malnourishment. Chichester showed no academic talent, and his poor eyesight ensured his humiliating failure on the playing fields. This grim upbringing and education might be calculated to produce, with equal chances of success, either a sedated wreck in a psychiatric ward or a phenomenally hardy and competitive loner.

He left school at seventeen to work on a Leicestershire farm, where he fell for the farmer's daughter and took a violent beating from her father. Chichester then embarked on a ship bound from Plymouth to New Zealand, where he found a job as a hand on a sheep station. In short order, he became a gold prospector, a door-to-door subscription salesman, a real-estate agent, and the cofounder of a successful timber company. By 1929, when he was twenty-seven, he had made a small fortune, at least on paper, and when he returned to England that summer he bought a single-engined Gipsy 1 Moth that he planned to fly to Australia and, eventually, around the world.

For a man so afflicted by myopia to set out to become expert at celestial navigation is proof of ferocious willpower. Within a few months Chichester managed to transform himself into a magician with a sextant—a half-blind man who was at home with vast interstellar distances and who could work out the notoriously difficult "lunars" (as Slocum did) without recourse to Greenwich Mean Time. The pioneering English aviator Amy Johnson is reputed to have called Chichester "the greatest navigator in the world."

His flying exploits brought him the public attention that he craved. One acquaintance would later say of him that he was "clever at backing into the limelight." In the age of Lindbergh and Saint-Exupéry, the lone pilot was a popular hero, and Chichester was bent on securing himself a place in the pantheon and the record books. But his career as a flier came to an abrupt end in 1931, when he crashed into a span of unmapped overhead telephone wires in Katsuura, Japan. He was lucky to escape with his life.

He was turning fifty-two, happily married (on his second try), and a

London publisher of maps and guides when he bought his first boat, in September 1953. This was *Gipsy Moth II*, named in memory of his plane, an eight-ton cutter that Chichester converted for offshore racing. With the same impatient disregard for the usual learning curve that he showed when becoming a flier, he turned himself into a sailor more or less overnight. In April 1958, he was diagnosed as suffering from lung cancer (though David Lewis, a London doctor, and a fellow-competitor in the first solo transatlantic race, evidently disagreed; in his book about the race, *The Ship Would Not Travel Due West*, Lewis calls Chichester's ailment a "lung abscess"). In any case, there was no surgery. Chichester took what amounts to a nature cure in the south of France, and came away healed.

In the summer of 1960, Chichester was sailing a new boat in the first single-handed race across the Atlantic. At 39 ½ feet overall, *Gipsy Moth III* was by far the longest and fastest boat (three were 25 feet, one was 21 feet), and Chichester arrived in New York eight days ahead of his nearest rival. Dissatisfied with his forty-day passage, Chichester sailed the course again in 1962 and shaved nearly seven days from his 1960 record. But in the second transatlantic race of 1964, he was comfortably beaten to the finish by Eric Tabarly, sailing the longer and faster *Penduick II*.

Length equaled speed, and so the fourth *Gipsy Moth* came into being, even longer, even faster. Sailing the Atlantic alone was quickly losing its glamour and originality. Five men had sailed in the '60 race; fifteen left Plymouth in '64. Only a world circumnavigation could now provide the blaze of glory commensurate with Chichester's own compulsive need to shine.

Books about leisurely circumnavigations were themselves written at leisure, allowing the rose-tinted glow of comfortable retrospect to play on the experience they record. We shall never really know the truth of Slocum's seagoing; his book is an artistic recasting of his voyage, and if Slocum was ever in a state of panic or despair, he has taken pains to cover his tracks. The extraordinary—and sometimes unsettling—candor of Gipsy Moth Circles the World is in part a product of the speed at which it was written, sometime in the crowded period between May 28, when Gipsy Moth crossed the line at Plymouth, and early September 1967, when the book went to press. Chichester came back to England with eight logbooks, filled with a total of two hundred thousand words. Writing Gipsy Moth Circles the World, he adhered closely to the language and narrative contained in the logs. There was little conscious retrospect. In his book he relives the voyage blow by

blow, sail change by sail change, and in the process he allows the reader astonishingly intimate access to how it felt to be Francis Chichester. We are nakedly exposed to his explosive bursts of temper, his intimations of spiritual emptiness, his tenderest affections, his terrors—to the full force of Chichester's unpredictable and unstable internal weather.

We have the logbooks to thank for that. Enforced solitude is often the making of a writer, and so it was with Chichester. He used his logs as confidants, trusting them with his most painful thoughts because there was no one else present to hear them. Much of what he told his logs must have been edited out when he wrote his book, yet enough has remained for the reader to feel that he is almost inside the skin of this complex, wounded, irascible, and unexpectedly touching personality.

He was more thoroughly *alone* than any other single-hander on record. It is a convention of sailing narratives that a bond be established between the sailor and his boat, to the point where "We" (meaning man and boat together) are the twin heroes of the story. No such bond existed between Chichester and *Gipsy Moth IV*. Within a few days of leaving port, he had the bitter conviction that he had the wrong boat for the voyage. It (not *she*) was too tender, given to violent hobbyhorsing, and inclined to veer wildly offcourse when heeled. It had the wrong winches, the wrong rig, the wrong windvane-pilot, the wrong keel design, the wrong interior. Again and again, Chichester berates the boat's designer, John Illingworth, for having talked him into accepting this temperamental racing machine, when what he needed was another boat altogether. "Vicious" is his repeated word for the boat, and his voyage is as much a lonely struggle against *Gipsy Moth IV* as it is against the combined forces of wind and sea.

Chasing the chimera of the clipper passages—the magic hundred days between England and Australia—Chichester tortured himself with calculations of distances run and days to go. He used the clippers as a goad to punish both himself and the boat, and one keenly feels his anguish as he sees *Gipsy Moth* slipping behind in its race against those phantoms from the Victorian past. It's hard to resist guessing at the phantoms from Chichester's own past whom he was trying to outrun as he tore down the latitudes, from the stony-faced, unforgiving rector of Shirwell to the captains of games at Marlborough who kept him off the team because he couldn't see the ball. Whoever and whatever these phantoms might have been, they were clearly there. Something far more deeply personal than clipper-ship statistics was driving Chichester on this purgatorial voyage.

Islanded among the frustrations, tribulations, and "shemozzles" is one of the most oddly memorable scenes in sailing literature. Somewhere above

the Sierra Leone Rise, six hundred miles off the African coast, and fast closing with the equator, Chichester celebrates his sixty-fifth birthday (a British milestone, because it is the date on which men can begin to draw from the state their weekly old-age pension). The new pensioner, dressed in his old green velvet smoking jacket, toasts himself with champagne-and-brandy cocktails and cherishes the pair of silk pajamas that Sheila has given him for his birthday. His mood is uncharacteristically radiant. The miles are streaming by at a steady seven knots; a tape is playing in the cabin. "This must be one of the greatest nights of my Life," Chichester tells his log. Then, thinking of his wife and son, and imagining their deaths, he asks, "Is it a mistake to get too fond of people?" The question reveals more of the man than any other line in the book.

His birthday celebrations are rudely terminated by a squall, which lays *Gipsy Moth* over on its side and has Chichester, naked and hungover, fighting down 950 square feet of sail to save his boat from foundering. This is always how it seems to be for Chichester: happiness is a fleeting moment, an illusion, in a world of unrelenting harshness and toil.

The heart of Chichester's purgatory lay in the Roaring Forties of the Southern Ocean, where his spirits reached their nadir but his writing flowered. As no other sailing author has done, he gives to the Southern Ocean a moral dimension that richly overshadows its great waves and incessant gales.

He was exhausted, "feeble as a half-dead mouse," by the time he rounded the Cape of Good Hope, and he confessed to his "intense depression" and "sense of spiritual loneliness":

I felt weak, thin, and somehow wasted, and I had a sense of immense space empty of any spiritual—what? I didn't know. I knew only that it made for intense loneliness, and a feeling of hopelessness...

And again:

I find hard to describe, even to put into words at all... the spiritual loneliness of this empty quarter of the world. I had been used to the North Atlantic, fierce and sometimes awesome, yes, but the North Atlantic seems to have a spiritual atmosphere as if teeming with the spirits of the men who sailed and died there. Down here in the Southern Ocean it was a great void. I seemed planetary distances away from the rest of mankind.

After his pit stop in Sydney, followed by his capsize in the Tasman Sea, Chichester confided to his log:

I could not be more depressed. Everything seems wrong about this voyage. I hate it and am frightened.

If one takes Sheila Chichester's hint and thinks of Chichester's voyage as a version of *Pilgrim's Progress*, here was the Doubting Castle of Giant Despair.

Yet for all his loneliness, contact with other people appears to have been no balm for Chichester. When human beings—with the exception of his wife and his son—enter his narrative, they nearly always do so as nuisances and intruders. He is plagued on the radio by inquisitive ships' captains and journalists, and he shoos them off for trespassing on his solitude. To a "girl reporter" from the London *Sunday Times*, who wanted to know what his first meal had been after his successful rounding of Cape Horn, Chichester tartly cabled: "Strongly urge you stop questioning and interviewing me which poisons the romantic attraction of this voyage."

As in his boyhood, he found solace not in people but in the creatures of the sea. It is another convention of sailing narratives (especially single-handed ones) that, as the boat takes leave of the land and all it stands for, the sailor befriends a bird, or a fish, as a signal that he has forsaken civilization and entered the community of nature. In Chichester's case, birds and fish were his best companions, and, unlike most sailors, he bestowed on them the keen attention of a lifelong amateur naturalist. In *Atlantic Adventure* (1962), he had "Pidge," a stray French racing pigeon, which flew on board *Gipsy Moth III* and is a major character in the book. In *Gipsy Moth Circles the World* he dotes on storm petrels, or Mother Carey's chickens. Twice in the voyage these birds blundered aboard the yacht, and were enthusiastically mothered by Chichester.

Something soft and warm, not cold like ropes and gear are, fluttered in my face, startling me. It was a Mother Carey's Chick, dazzled by the light. I picked it up and put it in a safe place in the cockpit, and after I had finished my job I put it on the after deck, from which it could hop into the air or sea as it might like best when I put the lights out. A Mother Carey's Chick is the most wild creature I know, yet it is both soft and delicate, and with most charming manners. It will not attack, and stays cosy and warm in one's hand. It is so small that one's hand easily closes round it.

But just as the squall spoiled his birthday party, the little bird is dead by the next morning. Back in the North Atlantic, Chichester fished two Portuguese men-of-war out of the floating sargasso weed and kept them in a bucket as pets.

Their mauve-and-blue-tinted air bladders nosed their way around the bucket, and I was surprised to see how they shot out their long dangling tendrils in a flash.

Chichester's tenderness for warm, soft birds and stinging jellyfish is in striking contrast to his instinctive hostility to the ships' captains and girl reporters; and in his descriptions of both creatures one senses the ghostly lineaments of self-portraiture at work, as if Chichester himself were half storm petrel, half Portuguese man-of-war.

In the end, he had rivaled the times of the clipper ships (and beaten many of the slower ones). It was a magnificent—if desperate—voyage. Laden with celebrity and honors, Sir Francis might reasonably have taken to pottering around the coast with his wife and son. But he was unappeasable in his need to prove more to the world, and to himself. As his last book, The Romantic Challenge (1971), recounts, Chichester was to be found in 1970, aged sixty-nine, aboard an even longer boat, the 57-foot Gipsy Moth V, with an even bigger sail area, thrashing back and forth across the Atlantic in pursuit of a new chimera—the two-hundred-mile day, two thousand miles in ten days flat. It came as no surprise that he could not—quite—match these arbitrary and quixotic numbers, and perhaps it was just as well for him that he didn't. Heroic failure (by his own exalted lights, though by no one else's) perfectly suited his stoic temperament. Such failure, or so I suspect, confirmed his instinctive view of the world as a hard and pitiless place, where there are no true successes and the measure of a man lies in the mettle he displays in his inevitable defeat.

> Introduction to Gipsy Moth Circles the World, Sailor's Classic Edition, 2001

Too Close to Nature?

SEATTLE SUNSETS are raw and bloody things: good ones look like a busy day at the slaughterhouse, as the sun, or its refracted image, grazes the white peaks of the Olympic mountains beyond the dark industrial forests on the far side of Puget Sound. Stuck for a dramatic front-page picture, the local papers, the *Times* and *Post-Intelligencer*, regularly run photos of the previous night's heavenly gore: in the foreground, a container ship plowing northward up the Sound; in the middle distance, low hills of second- and third-growth Douglas firs; the scissored line of background mountains; the sky a wild light show of reds, oranges, and rifts of unearthly green. There must be a cause for these sunsets: the scattering effect of salt particles from the Pacific Ocean in the air and the reflective properties of the Olympic snowfields seem the most likely candidates. Whatever their physics, the spectacular sunsets are an important part of Seattle's claim to be "a flower of geography"—as Henry James called the city in 1907, placing it in the company of Cape Town, Rio de Janeiro, Naples, Sydney, and San Francisco.

With mountain ranges front and back (the Olympics to the west, the Cascades to the east), puddled with lakes, and squatting on a reach of sea more than a hundred fathoms deep, Seattle is up to its ears in nature—rather too much nature for its own good. When the view is not socked in by mist and rain, you can see the great snowy heaps of Mount Rainier to the south and Mount Baker to the north, apparently suspended in midair, and even within the city nature is engaged in a perpetual guerrilla operation against culture: in this moist and temperate climate, every unattended patch of ground turns quickly into a little wilderness of bramble, vine, salal. I've watched bald eagles on Fifth Avenue and picked blackberries on my street.

The boosters like to say that this is a city where you can go skiing in the morning and sailing in the afternoon, which is the line that accounts for

the stubbornly un-urban style affected by so many Seattleites—Gore-Tex and Velcro, Birkenstock, North Face, Patagonia, Helly Hansen. If you spot someone wearing a skimpy black cocktail number, you can bet she's a tourist. The residents clump around in gear more suited to the piste, the marina, and the rockface than to a city. The homeless are clad in the cast-offs of these outdoor types, so that a gathering of winos in a Seattle back alley looks disconcertingly like an ad hoc convention of dinghy racers or mountaineers.

The truth is that Seattle's intense proximity to nature makes it an unsatisfactory city. Real cities supplant nature—witness the man-made cliffs and canyons of Manhattan, or the labyrinthine, warrenlike character of central London. In a real city, the landmarks are unnatural: the Monument, the dome of St. Paul's, Marble Arch, Nelson's Column. Nature, where it is allowed to show its face, must be strictly gardened (St. James's Park) or tamed with memorable architecture. When I think of the Thames in London, what springs first to mind is not the river itself but the string of bridges that traverse it, from the pretty pink-and-white confectionery of Albert to the Victorian storybook medievalism of Tower. Real cities are works of epic communal artifice, and they tend to flourish best on flat, or flattish, land that denies the citizen the chance to compare a cathedral with a living forest or a skyscraper with a fifteen-thousand-foot mountain—comparisons that are always likely to work to the city's disadvantage, making its most audacious flights of fancy look conceited and puny. Had Wren been forced to build his Monument on the foothills of Mount Rainier, it would have had all the nobility and grandeur of a telephone pole.

Since 1852, Seattle has been trying to assert itself against its overpowering geography. After a fire razed the downtown in 1889, the city was rebuilt in the florid style of Wild West classical, part Emperor Vespasian, part Klondike whorehouse, part Harrods. In 1914, the forty-two-storey Smith Tower was completed; for an eyeblink it was the tallest building in the world outside New York, and until 1963 it stood as the tallest building west of the Mississippi. Seattle, chronically height-challenged, puts much store in claims of that sort. The Space Needle—a Dan Dare—era UFO sitting atop wasp-waisted six-hundred-foot pylon—went up in 1961 as the chief icon of Century 21, the Seattle World's Fair. Age has given the Space Needle the wan charm of period kitsch, and there are mornings of thin luminous fog when it loses its habitual air of hangdog provincial aspiration and succeeds in looking spooky; even, almost, monumental.

Lately, Seattle has taken to commissioning internationally famous architects to design buildings that are sufficiently imposing, or eccentric, to

wrest the eye from nature and bring it back to the city. Robert Venturi's art museum was already past its postmodernist sell-by date when it was completed in 1991. Frank Gehry has created some wonderful buildings, like the Guggenheim Museum in Bilbao, but his Seattle effort, the Experience Music Project, is not one of them. EMP squats at the foot of the Space Needle, a garish assemblage of curvilinear modules supposedly based on the idea of crumpled guitars. People who work at the neighboring TV station call EMP "the hemorrhoids"—and once you hear that wickedly appropriate name it's hard to remember the building by any other.

The most recent architectural novelty is Rem Koolhaas's almost-finished public library, a genuinely extraordinary creation that has the knack of turning dubious visitors into astonished converts. Seen from the street, Koolhaas's traffic-stopping, cantilevered, gravity-defiant, many-angled stack of toppling glass boxes is a work of extravagant artifice, as ingenious as a trick picture by M. C. Escher. Inside, it brims with natural light and treats book borrowers and the homeless (always an important sector of a public library's clientele) to million-dollar views of Mount Rainier and Puget Sound. Where Gehry's EMP and Venturi's art museum are effectively windowless, as if the best way of dealing with the competition was to blot it from sight, Koolhaas's library is all window: spectacular in itself, it appropriates the spectacular view as an amenity, as if the wild nature surrounding the city were its private park. It's a refreshingly urban take on Seattle's peculiar predicament. Looking at the new library, you see immediately that Koolhaas isn't overly impressed by forests, mountains, sea, and sunsets: like pictures on a wall, they have decorative value, prettily enhancing the true wonders of trapezoid steel frames, and copper mesh, and gas-filled glass, and people congregating around the spiral core of shelved books.

Seattle needs this building. Locals flatter themselves shamelessly when they say (and they always do) that it is "a beautiful city." It's not. It's nondescript, spread in a higgledy-piggledy, low-rise, low-density sprawl, across miles of hills and lakes that were beautiful once, framed by mountains and sea that are beautiful still. It's an unfortunate fact about flowers of geography that they don't bother to work as hard on their appearance as places less favored by nature, like the muddy ford where London got its start, or the salt swamp from which Venice triumphantly arose. So far as architecture and town planning are concerned, Seattle has bothered even less than most.

Not that there's a want of money here: rich Seattle has bought itself all the essential ingredients of metropolitan life—restaurants, theatres, universities, major-league sports teams, a first-rate symphony orchestra, opera

and ballet companies, a famous rock-music scene, and much else. It's an intricate patchwork of diverse neighborhoods; any city that requires a hundred and sixty-one bridges to connect its different bits together can hardly be accused of lacking complexity. What's wrong with Seattle is that it has no real consciousness of its own urbanity.

Having earned for itself a strange distinction as the first big city to which people have flocked in order to be closer to nature, it likes to boast that it owns more boats, pairs of skis, and mountain bikes per capita than any other city on earth. If you happen to be reading this on a packed commuter train, you'll probably consider that a powerful recommendation of Seattle's charms, but you'd be wrong. Our nature-fixatedness has turned Seattle into a place where nobody dresses up for anything short of a wedding or a funeral, where dinner parties, arranged weeks beforehand, end on the stroke of ten, where the vital hum and buzz of city living are generally regarded as the regrettable price to be paid for the pleasure of being able to escape into the countryside. As a result, Seattle's social fabric is depressingly threadbare, existing as it does in pockets of underground resistance to the city's prevailing tone.

That's why Rem Koolhaas's library is such a tonic piece of architecture. Here is a thoroughly urbane building, street-smart and witty, that knows how to live on easy terms with the nature around it without ceding an iota of its big-city swagger. It would be nice to think Seattle might take its new library to heart and follow its splendid example. It's time Seattle grew up. For the last couple of decades it has clung to the conceit that it's really an overstuffed Cowes or Klosters which just happens to have an international port, an aircraft factory, a giant software corporation, and a few other useful engines for making money. Now is the moment for it to wake, like Rip Van Winkle, to the realization that sometime while it was out snowboarding and sailing it turned into a metropolis, and should learn to live like one.

Seattle Times, April 2004

A Tragic Grandeur

ROBERT LOWELL'S star has waned very considerably since his death in 1977, when his obituarists treated him, along with Yeats, Eliot, Auden, and Wallace Stevens, as one of the handful of unquestionably great twentieth-century poets. The publication two years ago of Frank Bidart and David Gewanter's massive edition of the *Collected Poems* did much to restore his work to public and critical view, but even now Lowell's poems are, I would guess, less widely read, taught, and anthologized than those of his two friends and contemporaries Elizabeth Bishop and John Berryman—a judgment, if that's what it is, that would have astonished serious readers of poetry between the 1950s and the 1970s.

The death of a writer considered great when he or she was alive is quite frequently the occasion for a drastic revaluation: Tennyson shares began their long—temporary—slump shortly after 1892; Trollope's critical reputation went into near-total eclipse after the posthumous publication of his *Autobiography* in 1883. In Lowell's case, poetry itself appears to have shrunk from the high ground he commandeered: his grand conception of the poet as public figure and public conscience, half classical Roman and half seventeenth-century English, has gained little traction in the present era of notably small and private poems. In a climate of shy minimalism, Lowell's finest work has tended to strike some younger readers as immodest, messianic, out of date.

Ian Hamilton's critical biography of Lowell, published in 1982, has not helped. Hamilton, an astute, sometimes lethal English critic, and a spare and private poet who always preferred the laconic to the lavish, uninten-

in the same sentence:

tionally supplied many of the grounds for Lowell's revaluation. His book remains indispensable—not least because he tracked down and elicited candid interviews from almost everyone who knew Lowell, from his first fiancée, Anne Dick, to a conscientious objector who'd been a fellow-prisoner at the jail in Danbury, Connecticut, where Lowell served his felony sentence for refusing the draft. But where most of the people closest to Lowell saw him as a sane man cruelly afflicted by intermittent bouts of mania, Hamilton was inclined to see his life as one of overwhelming madness punctuated by spells of sanity. Lowell's manic "antics," and the emotional damage he inflicted when he was sick on those he loved, so dominated the book that John Carey, reviewing it for the London Sunday Times, reported that his first thought on closing its pages was, "What a skunk!"—a verdict that greatly shocked Hamilton but has lingered insidiously in the air for the last twenty years or so. Caroline Blackwood, to whom Lowell was married at the time of his death, said that nobody reading the book would understand why people loved him.

Writing about the poems, Hamilton judiciously hedged his bets. There are many fine close readings, unusual in a biography, like his intent analysis of the emergence of the brilliant "Waking in the Blue" from a confused love poem written in mania to Anne Adden, a young "psychiatric fieldworker" from Bennington College, whom Lowell met during one of his periodic incarcerations in McLean's Hospital near Boston. But Hamilton's Englishness hindered him, I think, from responding fully to the most powerful, and powerfully "American," of Lowell's poems. Reading him on "For the Union Dead" or "Waking Early Sunday Morning," one sees him repeatedly trying to offer two queasy judgments, one positive and one negative, often

If, in itself, ["For the Union Dead"] seems overdeliberate and without the energy and rhythmic grace of the best of the Life Studies poems...it is nonetheless his first step towards extending the possibilities of his self-centeredness: towards treating his own torments as metaphors of public, even global, ills.

Such damning with faint praise was characteristic of Hamilton's treatment of all but a few of Lowell's poems, and it set the tone for the tacit revisionism that has shortened the long shadow cast by Lowell a quarter-century ago over the poetry of the age.

The Letters of Robert Lowell is sufficiently plump to stand shoulder to shoulder with the Collected Poems. Saskia Hamilton, no relation to Ian, has selected 711 letters from an undisclosed total. She writes that the "many wonderful letters" she has had to exclude from the book might someday be published in a multivolume edition, but it would have been helpful for the reader had she indicated just how many of Lowell's letters now survive. Are we looking at one in three? in five? in ten? Without that knowledge, and with no clue to her principles of selection, one can only say that this enthralling compilation feels broadly representative, even though it omits several important letters that are quoted or alluded to in the Hamilton biography. At any rate, I've spent a long time trying to sniff out some covert thematic bias and have found none worth reporting: so far as I can judge, the selection seems excellent, if a little wanting in the niceties of scholarly presentation.

Here, at last, is Lowell in vivid and complex chiaroscuro, living his "wayward but always rebounding life," as he described it in a letter to his cousin, Harriet Winslow—more often well than ill, supremely dedicated to his vocation, blazingly intelligent, funny, a warm and generous friend. The "manic" letters arrive in irregular clusters, registering a total of fourteen major crack-ups for which he had to be hospitalized in the twenty-eight years between 1949 and his death. Each cluster violently disrupts the prevailing current of sanity, in which Lowell gossips, tells stories, fights depression, argues, commiserates, talks shop, makes love, rehearses images for poems, all with such candor and impromptu eloquence that he makes a clear place for himself as one of the finest letter writers in modern literature.

Although there are earlier extant letters, Saskia Hamilton has chosen to begin with two letters that Lowell wrote to Ezra Pound in the spring of 1936, when he was slogging through his unsatisfactory freshman year at Harvard. Like an aspiring fifteenth-century painter seeking a place in Leonardo's workshop, Lowell proposed that Pound should take him on as his apprentice: "I want to come to Italy and work under you and forge my way into reality." The freshman explained that after going through a series of schoolboy crazes, including collecting marbles and turtles, birdwatching, and an obsession with Napoleon, he had come to poetry as a result of reading Homer "thru the dish-water of Bryant's 19th century translation." Homer's world "contained a God higher than anything I had ever known, and yet his world blinked at no realities." "All my life I had thought of poets as the most contemptible moth so you can see how violently I was molded and bent." At Harvard, Lowell lamented, "I have yearned after iron and have been choked with cobwebs." Having flattered Pound for re-creating (in The Cantos) "what I have imagined to be the blood of Homer," Lowell

promised him, "You shan't be sorry. I will bring the steel and fire, I am not theatric, and my life is sober not sensational."

Heaven knows what Pound made of this. The letter's swaggering pastiche of the Poundian manner, its mixture of boldness, humility, and awkwardness, its blurted confidences (about collecting more marbles and agates than any other boy at school, about having "never mixed well or really lived in the usual realities"), its more than faint smack of patrician entitlement, its precocious oddity, must have raised an eyebrow at the breakfast table. Pound had had his fill of Lowells since the days when Amy Lowell hijacked the Imagist movement and turned it into "Amygism." But he evidently made some kind of prevaricatory reply, for Lowell was soon back, complaining that "your tone is hard to catch," then launching into a critique of The Cantos that was designed to show Pound how the apprentice could improve on and outdo the master. For all its "quantity, music, directness, and realism," Pound's work was full of too many "spondées and compound nouns," and essentially "static," while Lowell meant to "bring back momentum and movement in poetry on a grand scale, to master your tremendous machinery and to carry your standard further into the century."

At nineteen, Lowell knew exactly what he had to do and who he had to be—the standard-bearer of literary modernism in the second half of the twentieth century. One sees why his friends at the time—Blair Clark and Frank Parker, his first disciples—lived in awe of him, and also why Ford Madox Ford would remark a few months later that Lowell was the most intelligent person he'd met in Boston. There's something both impressive and a little scary in the teenage Lowell's inflexible resolve and certainty of ambition. Everything was in place except the poetry. While the letters to Pound are unmistakably "Lowellian," the few poems that survive from his school and college days give no real hint of the style that would first become apparent in *Land of Unlikeness*, published in 1944 when Lowell was twenty-seven, with the furious "momentum and movement" of such poems as "The Drunken Fisherman."

After his grim experience of family life in the tense and unhappy household of 91 Revere Street, it was inevitable that Lowell would try to build for himself an alternative, loving family of friends, if only to ensure that he would never again have to endure the "fogbound solitudes" of his boyhood. Pitching a tent on the lawn of Allen Tate's house in Clarksville, Tennessee, in the summer of 1937, Lowell asserted his membership in the literary tribe, where he found his truest parents and siblings, ancestors and cousins—

a great multigenerational, affectionate, quarrelsome family of the kind that he must have dreamed of belonging to as a child.

By his midthirties, he was friends with, among others, Eliot, Pound, Williams, Frost, Santayana, Tate, Ransom, Warren, Jarrell, Bishop, Berryman, Mary McCarthy, J. F. Powers, Peter Taylor, Theodore Roethke, Delmore Schwartz, and Flannery O'Connor. He was married to Elizabeth Hardwick, and had earlier been married to Jean Stafford. Letters, most often signed "Love, Cal" to men as to women, were his means of sustaining this web of intimate relationships with an ever-growing circle (though it now looks more like a literary tradition) of writer friends. He was a tireless correspondent: the mail kept friendship alive, and nearly all Lowell's friendships were ended only by death. A sonnet in *Notebook* quotes a grateful letter from Elizabeth Bishop: "Your last letter helped, / like being mailed a lantern or a spiked stick." Reading Lowell here, one sees what she meant.

Bishop, introduced to him by Randall Jarrell in 1947, was like the sister he'd never had. Their work was almost uncannily complementary, and it's hard to imagine how Lowell would have made the transition from the rhetorical verve and fervor of Lord Weary's Castle and The Mills of the Kavanaughs to the restrained delicacy and precision of Life Studies without Bishop's encouragement and example. Except in the throes of mania, when all such distinctions ceased to exist, there was safety and comfort for him in the fact that Bishop was lesbian and therefore out of bounds. Her far-flung addresses, in Florida and Brazil, made her the ideal recipient of news and gossip from inside the literary and political swim.

For him, at least, there was a childlike coziness in their relationship. He could chatter comfortably to her about music (about which he was enthusiastic but inexpert), gripe about trifles, rattle on at leisure about his writing and hers, conjure a book, a scene, another friend, in marvelously economical freehand sketches, in which his speaking voice leaps from the page. On La Fontaine, for instance:

You should like him, in French, at least—so solid, shrewd, tender, unromantic, worldly wise, full of people—hard and soft where he should be—a perfect craftsman. He might be much larger than the other extreme Rimbaud. Enough talk about verse!

Or the unusual domestic arrangements of William and Hetta Empson's London house:

They live in a hideous 18 room house on the edge of Hampstead Heath. Each room is as dirty and messy as Auden's New York apartment. Strange household: Hedda [sic] Empson, six feet tall still quite beautiful, five or six young men, all sort of failures at least financially, Hedda's lover, a horrible young man, dark, cloddish, thirty-ish, soon drunk, incoherent and offensive, William Frank Parker red-faced, drinking gallons, but somehow quite uncorrupted, always soaring off from the conversation with a chortle. And what else? A very sweet son of 18, another, Hedda's, not William's, Harriet's age. Chinese dinners, Mongol dinners. The household had a weird, sordid nobility that made other Englishmen seem like a veneer.

It's a novel in a conversational nutshell, the details gathering steadily to its unexpectedly elegant climax. Or witness Jacqueline Kennedy's birthday party on Cape Cod in 1966:

... a slightly tawdry untimely Marie Antoinette feeling of a festival when the age for being whole-hearted about such things has passed, the flash of the jet-set, a little lurid and in bad taste in a world of poverty and blood, a certain real ease-meeting with McNamara, Jackie putting her hand over my mouth and telling me to be polite and I saying something awkward about liking him, but not his policy, then Jackie saying "how impossibly banal, you should say you adore his policy, but find him dull."

It was, predictably, when writing to Bishop, in 1956, that Lowell hit on the vernacular of text-messaging many years before its time: "U R 2 good 2 B 4 got 10. What a grand line!" His playfulness, an essential streak in his character, was conspicuously missing from his biography: it is here in abundance.

The longest single letter to Bishop (it runs to nearly 3,500 words), was written from his summer house in Castine, Maine, in August 1957, when he was coming down from a manic spell at which Bishop and her companion, Lota de Macedo Soares, had been present when they visited Lowell and Hardwick a few weeks earlier. It begins in rue ("Your letter, besides bringing its cheerful tempering of the spirit, has brought me terrific relief. I feared that I was forever in exile, along with those other clinging, clutching, fevered souls...") but moves swiftly into an extended divertissement,

a ship-of-fools story about a cruise through the Maine islands aboard a forty-foot ketch under the hazardous captaincy of Richard Eberhart, with the poet Philip Booth; Eberhart's wife, Betty; "the second ex-Mrs. Rexroth"; Hardwick and an old school friend of hers; and various others. It's entertaining enough, but the humor seems more self-consciously baroque than usual:

There was a difficulty, Dick is color-blind and at this supreme moment [they were trying to thread their way down a narrow channel in Casco Strait] with the eyes of the ex-Mrs. Rexroth on him he reverted to his old heresy that colors have no functional difference and spars are painted now red, now black, merely to vary their monotony...

So it goes, through a multitude of comic mishaps, human and marine, until finally Lowell confesses that it's another, larger, and more personal folly that is on his mind:

After so much buffoonery . . . I want to make a little speech . . . I want you to know that you need never again fear my overstepping myself and stirring up confusion with you. My frenzied behavior during your visit has a history and there is one fact that I want to disengage from all its harsh frenzy. There's one bit of the past that I would like to get off my chest and then I think all will be easy with us.

What follows is an exquisite passage of intimate plain-speaking in a voice that is sane, low, and loving, as Lowell explains that in the summer of 1948, after Bishop had said "rather humorously" that she was the loneliest person who ever lived, he had haltingly tried to propose to her. "For so callous (I fear) a man, I was fearfully shy and scared of spoiling things and distrustful of being steady enough to *do you* [the two words were deleted] be the least good." Free will, he writes, "is sewn into everything we do . . . Yet the possible alternatives that life allows us are very few."

Asking you is *the* might have been for me, the one towering change, the other life that might have been had. It was that way for these nine years or so that intervened. It was deeply buried, and this spring and summer (really before your arrival) it boiled to the surface. Now it won't happen again, though of course I always feel a great blitheness and easiness with you. It won't happen, I'm really *in* love and sold on my Elizabeth and it's a great solace to me that you are with Lota, and I am sure that it is the will of the heavens that all is as it is.

Perhaps in the very repetition of "it won't happen" there was a lurking acknowledgment that it might, and in March the next year, toward the end of another incarceration in McLean's, he had to write, "Let's not let my *late* [erased] slip into the monstrous cloud our love."

His first bout of full-blown mania happened in the spring of 1949 when, after several wild weeks, first at Yaddo, then Chicago, then Bloomington, Indiana, he was committed to a padded cell at Baldpate Hospital in Georgetown, Massachusetts, from where he wrote to Bishop, "I'm in grand shape . . . The world is full of wonders." To Santayana: "I've been having rather tremendous experiences." To William Carlos Williams: "I think the doctors are learning about as much as I am." To Berryman: "I'm flourishing in an odd way." To Taylor: "I'm in mysteriously wonderful and rugged shape." To the Tates: "I'm in wonderful shape in all ways." And to Jarrell: "When I get out I'm going to do everything in my power to get the Sacco case reopened, so that those responsible are imprisoned and *electricuted* [sic]."

Four months later, he described his mania to Gertrude Buckman: "I was a prophet and everything was a symbol." In these states of exalted revelation, Lowell, whose mental temper was normally finely balanced, ironic, paradoxical, would brim with dangerous and wholly uncharacteristic certitude. To Bishop, he explained that in mania he had "a headless heart," and it was in this condition of decapitation that he became a man of decisive action, reopening the Sacco–Vanzetti case (his cousin, A. Lawrence Lowell, the Harvard president, had been in effect responsible for their execution, though he was long past "electricuting," having died in 1943), leading a campaign to expose Elizabeth Ames, the chatelaine of Yaddo, as a communist agent, or running for office as a Massachusetts state senator. He enlisted Pound (in January 1958) as his political consultant:

Do you think a man who has been off his rocker as often as I have been could run for elective office and win? I have in mind the State senatorship from my district—the South End, Back Bay Boston, and your son's Roxbury etc. The incumbent is an inconspicuous Republican. His rival is a standard losing party democrat. I'd run as a democrat, and if I could edge out in the very difficult primaries, then I'd cream the Republican . . . What's your advice.

During such episodes, the world became miraculously simplified, and Lowell had plans and solutions for everything. When he took up with

Giovanna Madonia, a young Italian woman whom he barely knew, in the manic weeks that followed his mother's death in 1954, he mailed his friends breezy notices of the end of his marriage to Hardwick ("we are quite chatty and cozy about it, and there is no bitterness") while to Hardwick herself, he wrote:

When you come back from the Virgins, I'll pick a steady. For you. I think we have the same one in mind. Guess who mine is?

Throughout the 1950s and 1960s, his attacks fell into something of a routine, a "groove of repetition" as he told Bishop. For the reader of the *Letters*, they supply much of the compulsive narrative tension that makes this long book seem short, as one learns to anticipate the signs—the too-boisterous high spirits, the compulsive reaching out to friends, the joke-too-far, the use of telegrams as the only means of communication sufficiently urgent to answer to Lowell's mounting impatience, the hospital address, the new girl in his life, the announcement of his and Hardwick's separation . . . and then the chastened descent into sanity. In a 1961 letter to Bishop, he summarized one such crack-up in the weary tone of the repeat offender:

I was in hospital for five weeks or so, less high and in an allegorical world than usual and not so broken down afterwards. Once more there was a girl, a rather foolish girl but full of a kind of life and earth force, and once more a great grayness and debris left behind me at home. Now we are back together, wobbly but reknit almost...

Hearing that Theodore Roethke, similarly afflicted, had separated from his wife during one of "our dizzy explosions," Lowell counseled him:

I hope this won't be final. She seems such a beautiful person and wise wife. To my grief, I too tried to break away from Elizabeth. It was all part of my mania and nonsense. For two months, I was striding and posturing, writing letters, making wild plans. Then it all passed—again I was home. You mustn't feel that you have done anything irreparable. All that was lost is returned. We even bring back certain treasure from our visits to the bottom.

That letter is in itself an example of the kind of treasure that Lowell found on his visits to the bottom. Along with the tangled pages of rough drafts that he would return with from the hospital, more the raw materials of poems than poems in their own right, there was an empathic understanding of other people's suffering, a brave and modest humor, an imagination enlarged by his repeated confrontations with his demons. Each spell in hospital was a leveling experience in which he became just another drugged mental patient in the enforced democracy of others—a taste of life in a society as remote from his usual circle as an island in New Guinea. From the grimly named Institute of Living in Hartford, Connecticut, he wrote to Hardwick in 1965:

The patients are senility cases, not cuckoo like Judge Rohrabach (now dead alas) but dim slow and talkative. During most of the day I transfer to a unit called Butler II, where the patients are adolescents, some wear long hair and almost none have finished high school. I won't go into the boredom of "leather appreciation" and ceramics appreciation, of watching basketball games for an hour without smoking, or of trying to converse with the oldster reading Francis Bacon sentence by sentence and complaining but never specifying about the difficulties of the Elizabethan vocabulary, then turning to the boy, three months a freshman at some unknown university, [who] carry[s] around the *Modern Library* giant collected Keats and Shelley, but who has never heard of the "Ode to a Nightingale."

The ever-increasing range of dramatic voices in his work—in plays like Benito Cereno, as in the poems from Life Studies through Notebook—surely owes something to these humbling incarcerations. More than any poet I can think of—excluding Shakespeare, Ben Jonson, and, to a much lesser extent, Browning—Lowell came close to giving speaking life to a whole society, from its hapless underclass to its political aristocracy. One of the pleasures of reading Lowell, and one rather neglected by his critics, is the sense of entering a vast, bustling, marvelously articulate world, where presidents and prisoners, intellectuals, soldiers, artists, policemen, characters out of legend, men and women, the living and the dead, consort on equal terms as in some enormous anarchic hospital.

Lowell lived to write, and wrote to be alive. When he wrote to I. A. Richards in the spring of 1973, after a long winter of correcting the final proofs of *History, For Lizzie and Harriet*, and *The Dolphin*, "I feel almost the hollowness of having finished a life's work," the words carry the sombre weight of a death notice. He had just turned fifty-six, his and Caroline Blackwood's son, Sheridan, was eighteen months old, but Lowell was already a valetudinarian, beginning to say his goodbyes to the world. He

always told people that his father had died "at sixty," though his father's dates (1887–1950) contradict that, and Lowell seems to have fixed on 1977 as the year most likely fated to appear on his own tombstone.

In 1970 he had flown alone to England, to take up a visiting professor-ship at All Souls in Oxford and to scout out an offered job at the University of Essex in Colchester. At a party thrown for him by Faber & Faber, his London publisher, he met Blackwood, whom he had known glancingly in New York, began an affair with her, and settled in England, half in Blackwood's London house in Earl's Court and half in her country house, Milgate, near Maidstone in Kent.

The letters from this last period are a wrench to read. He and Blackwood were often extravagantly happy in their first four years together, but it was a happiness always rimmed with danger: as he wrote to his old friend Robie Macauley in 1974, "Much of the last years has been so happy, it is not real." Lowell well knew that such unreality was fraught and precarious. The letter he wrote to John Berryman during a brief visit to New York in 1970 could as well have been addressed to himself:

You write close to death—I mean in your imagination. Don't take it from your heart into life. Don't say we won't meet again. I am writing at home with Lizzie and Harriet, but I give my London address. A new life. One to be envied, but today it fills me with uncertainties that mount up terror.

The phrase "at home"—on West 67th Street, where he'd lived with Hardwick—is poignant: England was not home, and the pains of expatriation show through even the most blithe of his letters to America. "Lonely" is a word that crops up again and again. In the late spring of 1971, he wrote to Peter Taylor, begging the Taylors to visit him in Kent. "We would love to have you... Or we could find you a house... I miss America..." He signed off: "My love and loneliness to you both."

A vein of oracular, sad gravity runs through the later letters, in which Lowell's most casual asides, about the weather ("It's so much colder here," to Allen Tate) or his ailing typewriter ribbon ("My type is dimming," to Frank Bidart) invite the possibility of a darker secondary meaning. Illness (Blackwood's as much as his own) and domestic troubles—with taxes, the help, the houses—weigh heavily. In the fall of 1974, he wrote to Jean Stafford, his first wife:

Do you realize all of us are the older, not yet senile, generation, the long-on-view whose shadow falls on all who are younger? What can we do about it? I write about being 57.

"Long-on-view" is a fair description of the poems he was writing then, which were collected in *Day by Day* (1977): loose-limbed free-verse poems, full of intimations of approaching death, that revisit his childhood, his parents, his friends, his manic attacks, his courtship of Blackwood, and his writing, as if exile in England were an afterlife from which he could look down on his own mortality.

In both poems and letters, Lowell harped on the theme that his writing had come within sight of the end of the road. In 1974, to Bishop:

I think a lot about getting things right, when I haven't enough to make it matter—and often there is a scrawl that cannot be arranged. We seem to be near our finish, so near that the final, the perfect etc. is forbidden us, not even in the game.

In 1976, to Peter Taylor:

Have you ever tried to stop writing? It's harder than alcohol, which I also foreswear as the very early sun crashes at about four through the faults in the blinds. The trouble is I've become a sort of orange-squeezer expected to produce new and better juices. My method is formidable enough to turn out new poems, but not new subjects.

A haunting poem in *Day by Day*, "Shifting Colors," explores this theme quite beautifully, beginning as a crisp, lyrical re-creation of a day spent fishing in a stocked trout pond in Kent:

I fish until the clouds turn blue, weary of self-torture, ready to paint lilacs or confuse a thousand leaves, as landscapists must.

The landscapist's eye moves to a nearby horse, to a fleet of ducks, a hissing goose, a cuckoo, all conjured with graceful precision. Then Lowell turns on the poem he is writing, seeing in it only "universal consolatory / description without significance, / transcribed verbatim by my eye":

This is not the directness that catches everything on the run and then expires—
I would write only in response to the gods, like Mallarmé who had the good fortune to find a style that made writing impossible.

It is a poem that aches for its own nonexistence, without apology or flourish.

The intensely painful unraveling of his marriage to Caroline Blackwood (they separated in early 1977) lends a terrible poignancy to the final letters. Those to Blackwood herself exist only in fragments transcribed by Ian Hamilton when he was researching his biography: the originals have since disappeared. Let one fragment speak for the many: from his old berth in Castine, Maine, where he was staying with Hardwick, in July 1977, Lowell wrote,

I feel broken by all conversation, and a voice inside me says all might be well if I could be with you. And another voice says all would be ruin, and that I would be drowned in the confusion I made worse. If I were to get sick in Ireland? But here it all can be handled. But it's the effect my troubles have on you. It's like a nightmare we all have in which each motion of foot or hand troubles the torment it tries to calm...

Yet even as one eavesdrops on Lowell's private despair, one can't help admiring the careful eloquence in which it's phrased. He'd always managed to give anguish a voice of memorable grandeur—

Pity the planet, all joy gone from this sweet volcanic cone . . .

—and there was a kind of tragic grandeur, tempered with irony, in the way he wrote and rewrote his last days, in both letters and poems. Terminal heart attacks are generally supposed to curtail a life in medias res: Lowell's didn't. His death in a taxi, en route from Kennedy Airport to West 67th Street, was the necessary last line of a work otherwise set up in final type. He had written the end of his own story: every word was in place, except the hour and date.

New York Review of Books, June 2005

Surveillance Society

NO WONDER the state feels it can spy on our every move, when we so casually snoop on our friends via the Internet.

In the last few years, most of us—even instinctive technophobes like me—have become practiced in the dark art of surveillance. When I'm going to meet a stranger at dinner, I'll routinely feed her name to Google and LexisNexis to find out who she is and what she's been up to lately. If you know the person's street address, you can spy on her house with Google Earth, and inspect the state of her roof and how she keeps her garden. A slight tilt of camera angle, and you'd be able to see into her sock drawer and monitor the bottles in her liquor cabinet.

The seemingly bottomless capacity of the computer to store billions of unrelated bits of information, and the extraordinary facility of search engines to trawl through the stuff, have made this kind of warrantless intrusion into other people's lives irresistible—to private individuals and to governments alike. We're all dataminers now. Just ten or fifteen years ago, it would have taken days in libraries and record offices, along with the full-time services of a private detective, to get the kind of hard intelligence on my prospective dinner date that I can now retrieve in a few idle minutes; and if I can do that, I tremble to think of what governments, equipped with massive financial and technological resources, are capable of doing.

Last week, USA Today reported that the National Security Agency (the U.S. intelligence organization so secretive that it's popularly known as the No Such Agency) is assembling "the world's biggest database" of records of phone calls made within the United States since 2001. The NSA, it's said, is not listening to those calls, but is using them for "social network analysis," looking for cluster patterns that might betray a terrorist cell. Exactly how, on this basis, one distinguishes a terrorist cell from a

bridge club hasn't yet been properly explained, although "Connecting the Dots—Tracking Two Identified Terrorists," by Valdis Krebs (www.orgnet. com/prevent.html), lays out the basic methodology of network analysis in a brief and readable way.

The news that the NSA is trying to log "every call ever made" in the United States comes five months after the New York Times reported that the agency was bugging Americans' overseas calls. Like its predecessor, this new story has provoked a firestorm of indignant comment from politicians and journalists on the liberal left and the libertarian right, but has been greeted with indifference by the American public at large. A Washington Post—ABC News poll, conducted last Thursday, found that 63 percent of those interviewed said they thought the NSA program was an "acceptable" way to combat terrorism, including 44 percent who "strongly endorsed" it. Democrats looking for a popular casus belli in their fight against the Bush administration had better forget about surveillance as an issue: a clear majority of Americans, it appears, feel entirely comfortable about it.

This is hardly surprising. Since September 11, CCTV cameras, magnetometers, Bio Watch air sniffers, razor wire, concrete fortifications, and all the rest of the machinery of state security and surveillance have become so much a part of the furniture of life in the United States that we barely notice them. It has become automatic to remove one's shoes and hat and deposit keys, change, and cell phone in the tray provided as one passes the No Joking sign at the airport checkpoint, or to flourish an ID when entering the lobby of a public building. We expect to be intimately investigated, to be ordered to prove our good intentions. Year by year the government grows more importunately parental, the citizenry more obediently childish. Of course they log our phone calls—who are we to contradict the grown-ups who wage their high-tech secret war on our behalf? They know best.

The ambitious NSA scheme finds its mirror image in another mighty surveillance effort, the Association of Chief Police Officers' plan called Denying Criminals the Use of the Roads, which was published in Britain in March 2005. Again, a massive national database is involved, this time a log of every journey taken by every vehicle in the UK, with number-plate-reading (ANPR) cameras, already ubiquitous on Britain's roads to my estranged eye, multiplying to the point where you won't be able to nip out to Sainsbury's without landing in the database, where your innocent trip will stay recorded for a minimum of two years (the Chief Police Officers want to make that five). Among the several aims of the project, besides the detection and reduction of crime, are two old friends: "Promote Public Reassurance" and "Deter Terrorism."

It might be that I've been deaf to the roar of protest that has met this authoritarian and intrusive measure. Sixteen years of living in America, where ANPR cameras are legal in some states, outlawed in others, and nowhere used in anything like the numbers that they are in Britain, could have made me unduly surprised and angered by the covert flash of the speed camera in the hedge as it snaps my rental car. I simply haven't grown accustomed to the things in the slow, steady, incremental way that enables one to accept strange innovations that would strike a foreigner as intolerable. I am now that foreigner, and I'm innocently baffled by the apparent absence of furious debate and thundering editorials on the subject of spycams at four-hundred-yard intervals all over England.

Yet I have only to remember my own first day with Google Earth to see the immense attraction the cameras hold for the chief constables of the land or the lure of the comprehensive national database, with which I could have hours of not-so-innocent amusement fishing for the recent movements of all my friends and enemies.

Lacking a written constitution, Britain has no adamantine standard against which to test individual cases of privacy violation, but deals with them on an ad hoc, hit-and-miss basis, which has earned it the scorn of many privacy advocates. In 2002, Simon Davies, the director of Privacy International, said: "The UK demonstrates a pathology of antagonism toward privacy."

It is—or at least was—different in the United States, where the privacy of the citizen is supposedly guaranteed by the Fourth Amendment, which reads in full: "The right of the people to be secure in their persons, houses, papers, and effects, against unreasonable searches and seizures, shall not be violated, and no warrants shall issue, but upon probable cause, supported by oath or affirmation, and particularly describing the place to be searched, and the persons or things to be seized."

A couple of months ago, the Weekly Standard, a neoconservative magazine in close touch with the Bush administration, published an arresting article titled "The Misunderstood Fourth Amendment," by Stanley C. Brubaker, a professor of political science at Colgate University. Brubaker argued that since the 1960s (when the liberal-thinking Earl Warren was Chief Justice of the Supreme Court) America has been unfortunately saddled with a reading of the amendment based on its second clause, with its emphasis on those pesky warrants and probable causes.

An "originalist" reading, true to the intentions of the founders, would, said Brubaker, be "first-clause dominant"—in other words, all the provisions of the second clause apply only as a check to "unreasonable" searches

and seizures. "Reasonable" searches, therefore—and Brubaker instanced the security procedures at airports—require neither warrant nor probable cause, and any search or seizure occasioned by the needs of national security and the war on terrorism is, de facto, "reasonable."

This has been the implicit logic of the Bush administration since September 2001. Every kind of promiscuous surveillance is justified so long as it can be said to further the hunt for terrorists. And most Americans seem to agree. In the Washington Post—ABC News poll on the NSA's latest exploit, 65 percent of those interviewed said it was more important for the federal government "to investigate possible terrorist threats, even if that intrudes on personal privacy."

The key word there is "possible," which could so easily supply a license for speculative trawling through the databases. There's obvious reason for alarm at these developments, in Britain as in the United States. But people cannot fairly expect their governments to observe higher standards of delicacy and restraint than they demand of themselves. We're all in this together. Almost overnight we've mutated into a surveillance society, largely thanks to the Internet and its search engines. Trawling through cyberspace in search of the lowdown on a stranger, one should perhaps spare a sympathetic thought for the government agency as it trawls through cyberspace in search of us.

Some weeks ago, I read in the *New York Times* that the western head-quarters of the No Such Agency is located somewhere to the northeast of Yakima, Washington. I couldn't resist launching Google Earth and visiting Yakima. Moving the cursor, clicking the mouse, I moved steadily northeastward into land marked "Military Reservation." There in the desolate acres of sagebrush I came across what looked like an ailing mushroom farm of scattered dome and dish antennae, and zoomed in, descending from 1,000 feet to 50. I found no secrets, but the action supplied a neat image for these peculiar times: the surveilled surveilling the surveiller who's surveilling him.

Guardian, May 2006

September 11: The Price We've Paid

Woken by the jarring peal of the phone at 5:58 a.m., Pacific time, I heard a friend's voice say, "Turn on your TV! Turn on your TV!" Then she hung up. Groggy with sleep, I clicked the remote, and the screen bloomed into a scene of aghast confusion. I was still dopily figuring out the what and where when, at 6:03, the second plane, arrowing at a tilt through a sky of flawless blue, penetrated the strangely pliant flesh of the South Tower like a whaler's barbed harpoon. At the very moment of impact, one could see the plane's nose cone simultaneously protruding slightly from the far side of the skyscraper. Was it a bystander or the cameraman who shouted "Ho-ly shit!"?—words, inadequate as they were, that now seem so inseparably glued to that astounding instant that I've never been able to speak them since.

For the next few hours, with the BBC on the computer screen, CNN on the TV, and the phone ringing off the hook, I felt the world shrinking around me. By midafternoon, New York, London, Honolulu, Paris, and Seattle had contracted into one neighborhood, and when, next morning, *Le Monde* ran its famous banner headline, we are all americans now, the sentiment seemed so obvious as to be hardly worth stating. Now, of course, that headline is remembered only because it is a bitterly sarcastic marker of the enormous distance we've all traveled in the five years since that day.

"Since September 11..." we say, as if the attacks were what changed everything. The month is right but the day wrong, because the real metamorphosis has arisen not so much from what Mohamed Atta and his coconspirators did to us on September 11 as what we've subsequently done to ourselves—and continue to do, today, tomorrow, and in the foreseeable future (incredibly foreshortened though that has become). On September 12,

still in shock at the extraordinary injury inflicted on the United States, we woke to essentially the same world we'd been living in before the phones began to ring. The death toll—then estimated at ten-thousand-plus—was horrifying, on the scale of a major earthquake or tsunami, but the globe continued to revolve on its accustomed axis, as it does after even the most devastating seismic killers.

On the evening of the eleventh, the president of the United States—last seen in a second-grade class at a Florida elementary school, staring numbly at *The Pet Goat* in Reading Mastery II: Storybook I—read haltingly to camera from a script: "These acts of mass murder were intended to frighten our nation into chaos and retreat, but they have failed. Our country is strong. A great people has been moved to defend a great nation." On the fourteenth, he found a voice and a persona when, dressed in a clerical-gray anorak, he visited the firefighters and rescue workers at the ruins of the World Trade Center. As the *Dallas Morning News* reported the next day: "When he climbed onto the wreckage of a fire truck to speak through the bullhorn, the workers began complaining: 'George, we can't hear you!'"

"'I can hear you,' Bush responded. 'I can hear you. The rest of the world hears you. And the people who knocked these buildings down will hear all of us soon!' The crowd whooped and then the chant began: 'U-S-A, U-S-A.' Bush grabbed a small American flag and waved it high."

On the sixteenth, when Bush spoke of "this crusade, this war on terrorism," the alarming and foolishly inflated language chilled much of the listening world even as, perhaps, it stirred his electoral base of fundamentalist Christians to heroic thoughts of sword and cross, liberating the holy places from Muslim occupation. Presumably unintentionally (unless a Swiftian ironist was at work in some back room in the White House), the phrase echoed Osama bin Laden, who since 1998 had been calling Americans "Crusaders" in repeated fatwas and speeches.

But September 18 is the real date to circle. That day, Congress rushed through its Authorization for Use of Military Force (AUMF), entitling the president, as the nation's commander in chief, to "use all necessary and appropriate force" against "those nations, organizations, or persons" that "he determines" were responsible for the September 11 atrocities, "... in order to prevent any future acts of international terrorism against the United States by such nations, organizations, or persons." It's the "such" that's the key, the inclusion of nations, organizations, or persons "of that sort," which nicely covers, for instance, the invasion of Iraq, the arrest and detention of most of the prisoners now languishing in Guantánamo Bay,

possible future military action against Iran, or Syria, or both, and heaven knows what else, since "such" is a term of potentially limitless capacity to make hitherto unguessed-at likenesses and connections.

The sloppily worded AUMF endowed the administration with unique and wide-ranging powers. It has become the license for the executive branch to wave at Congress and the judiciary whenever its actions are questioned or censured. On September 18, 2001, the delicate balance between the three branches of government, as laid out in the American Constitution, was thrown severely out of whack; since that day, one branch, the presidency, has enjoyed an unprecedented primacy over the others, and we've been living with the consequences of the AUMF ever since.

On the same day that Bush talked of the coming "crusade," Vice President Dick Cheney told the host of Meet the Press how the new war was going to function. "We... have to work sort of the dark side... We're going to spend time in the shadows in the intelligence world. A lot of what needs to be done here will have to be done quietly, without any discussions . . . It is a mean, nasty, dangerous, dirty business out there, and we have to operate in that arena." So it was to be cloak-and-dagger stuff, top secret, with the administration "working the dark side," out of view of the people. Secrecy has its own romantic allure, and in the shaken and frightened mood of America that September, there was reassurance in the idea of the White House going undercover, stealthily prowling on our behalf in Cheney's arena of shadows. Barely a voice was raised to suggest that a secret presidency might not be entirely compatible with the basic principles of American democracy. On the "You're either with us or against us" principle, enunciated by Bush in November 2001, the few liberals who spoke out against the new-style covert administration were condemned out of hand as siding with terrorists.

The threat of terrorism yet to come gave the White House an unimpeded freedom to act on its own discretion that most U.S. presidents have probably dreamed of, but is more often exercised by dictators, benevolent and otherwise. Such extravagant presidential liberty can only be maintained in a democracy so long as the threat is not just real, but immediately palpable to the electorate. The enormous quantity of ugly hardware that has shown up on the streets of American cities in the last five years serves a dual purpose: it supposedly protects us from acts of terrorism and daily reminds us of the danger we are in.

Sometime in early 2002, a nondescript rectangular gray box, with a tall vented pipe and a radio antenna, appeared on a telephone pole in my neighborhood in Seattle, and I drove past it several times before I figured

out what it was—a device for sniffing pathogens in the air, like anthrax or ricin, and reporting back to headquarters, wherever they might be. The conspicuous presence of the box alarmed me a lot more than any of my previous thoughts of chemical and biological attack, and I was glad to see it gone a few days later—no doubt moved to another neighborhood to put a small shiver down their spines (apparently these boxes cost \$25,000 apiece and are consequently in rather short supply). So it is with all the blast shields and concrete barriers, security checkpoints, metal detectors, X-ray machines, and the new generation of "smart" video surveillance cameras described, in rather too wide-eyed prose, by a reporter for the New York Times a couple of years ago: "Sophisticated new computer programs will immediately alert the police whenever anyone viewed by any of the cameras placed at buildings and other structures considered terrorist targets wanders aimlessly in circles, lingers outside a public building, pulls a car onto the shoulder of a highway, or leaves a package and walks away from it. Images of those people will be highlighted in color at the city's central monitoring station, allowing dispatchers to send police officers to the scene immediately."

So, too, the TopOff (short for "top officials") exercises, which are mounted by the Department of Homeland Security in order to prepare "first responders" to deal with a terrorist attack. These multimillion-dollar pieces of experimental street theatre travel from city to city and involve actors dripping stage blood and stumbling around among overturned vehicles, corpses wearing "Role Player" sashes, blazing tires, broken glass, severed water mains, and the rest of the horror-show scenery.

Such measures are here, we're told, to keep us safe—and also to scare our socks off. For the unique power of this administration depends on Americans staying frightened of another September 11—or worse. Every actual terrorist event—the Bali bombing, the Madrid train bombings, the London Tube and bus bombings, the Mumbai train bombings, the August 10 revelation of the alleged London-and-High-Wycombe plot to down transatlantic airliners—strengthens the presidency's hand against the other two government branches. The first American consequence of the news from London last month was the announcement by Alberto Gonzales, the U.S. attorney general, that the administration would stand firm on military tribunals—otherwise, kangaroo courts—at Guantánamo, in the face of the latest Supreme Court ruling in its disfavor.

The reality of terrorism and the manufactured illusion of terrorism now bleed seamlessly together. The sporadic attacks launched by real terrorists have so far been insufficient to keep the attention-deficit-prone electorate in lockstep with the presidency, so phantoms have to be continually summoned from the deep in order to juice up the fear level and justify administration policies. When facts fail, fiction is always at hand to fill the breach, and White House speechwriters appear to believe that no story is as good as an old story retold, however slender its basis. Just last week President Bush, speaking to a captive audience of veterans at an American Legion convention in Salt Lake City, said once again that Iraq "is the central front in our fight against terrorism . . . If we give up the fight in the streets of Baghdad, we will face the terrorists in the streets of our own cities."

"The terrorists" used to mean the dubious entity of al-Qa'eda. Now it's an umbrella term spread wide enough to shelter an astonishing variety of administration-designated bad guys: Hamas, Hizbollah, Kashmiri separatists, the Taliban, Ba'athist insurgents, Sunni jihadists, the Mahdi Army, the governments of Iran, Syria, North Korea. It's like Falstaff conjuring ever greater numbers of enemies heroically fought off: two, four, seven, eleven men in buckram . . . So Bush multiplies terrorists and counts them by the million. Now they surround us on every flank and quarter, and if we don't fight them abroad (the traditional resort of domestically weak presidencies), we'll find ourselves combating them, hand to hand, on Walnut and Jackson in our own hometown.

Nowhere is the ambition of this administration so eloquently displayed as in the peculiar institution of Guantánamo Bay, which is the very model (to loosely quote W. S. Gilbert) of a modern military dictatorship. Bush, who in the 2000 presidential debates denounced the idea of "nation building," has, at Guantánamo, constructed a tiny offshore statelet, answerable to no laws except those dictated by the White House and its military and intelligence agencies. Here is detention without charge, trial, or access to lawyers. Here—by all accounts—the line between legitimate interrogation and torture has repeatedly been crossed. Here is one small world that, in every ascertainable particular, is the polar opposite of the United States as conceived by the nation's founders: no checks or balances, no Bill of Rights, nothing except the unbridled exercise of executive-branch power.

The administration has treated Guantánamo as an exceedingly precious possession, tigerishly protecting it from the intrusions of the judiciary. Time and again the Supreme Court has ruled, or tried to rule, that the camp's detainees have rights under American law. Time and again the attorney general and his crew of administration lawyers have managed to find an escape route in the small print of the ruling. On each occasion, Bush loyalists in Congress and elsewhere have angrily denounced both the judgment and the judges who formed the "liberal" majority in the court.

In March this year, the recently retired Supreme Court justice Sandra Day O'Connor (herself a Republican and a Reagan appointee to the court) warned that such attacks could be seen as the first signs of a slide into dictatorship. As Nina Totenberg, the legal correspondent of National Public Radio, reported: "Pointing to the experiences of developing countries and former Communist countries where interference with an independent judiciary has allowed dictatorship to flourish, O'Connor said we must be ever vigilant against those who would strong-arm the judiciary into adopting their preferred policies. It takes a lot of degeneration before a country falls into dictatorship, she said, but we should avoid these ends by avoiding these beginnings."

Coming from a middle-of-the-road Supreme Court justice, this was a remarkable measure of the extremity of these times, articulating as it did the fear of many Americans that the United States under the Bush administration is inching toward the kind of regime on view at Guantánamo Bay.

Warrantless wiretapping, detention without trial, the most secretive presidency on record, rupture between the branches of government... Terrorism has supplied the pretext for all of this, but none of it has flowed inevitably from the events of September 11. "Mass murder" was the president's first call on that appalling day, and had the jihadists continued to be treated as mass murderers, the United States would have retained the warm sympathy and enthusiastic cooperation of the rest of the civilized world. But the administration, supported by a loyal Republican majority in Congress, and armed with the carte blanche of the AUMF, chose another far more dangerous, lonely, and audacious route.

Five years on, we're mired in the bloody wreckage of Iraq (and the rising chaos of Afghanistan). The United States is increasingly isolated from its traditional allies. At home, Americans are more bitterly divided than at any time since the Civil War. A small but growing minority of Muslims are telling British pollsters that they admire the jihadists. Osama bin Laden is still free, making regular broadcasts to his followers. As the "global war on terror" has proceeded, government—in Britain as in America—has erected all around us the necessary machinery of the security-and-surveillance state.

This is an anniversary so cheerless that any straw is worth clutching at. Here's a straw: in the most recent polls, the number of Americans who believe that Saddam Hussein was personally involved in the September 11 plot, which stood at 80 percent in 2002, and 64 percent early in 2005, has now slipped to the high twenties—roughly the same numbers, give or take a percentage point, as those of the conspiracy theorists who believe that the Bush administration planned the atrocities, or at least allowed them to hap-

pen, in order to further its imperial ambitions in the Middle East. Bush's presidential rhetoric has never been so widely disbelieved. The fiction that in Iraq we're fighting terrorists abroad to stop them attacking us at home is increasingly being recognized for what it is. The administration's renewed efforts to conflate every militant Islamic organization across the globe into a single homogeneous force, the terrifying equal of Nazism, Fascism, and Soviet communism, is at last beginning to ring hollow in the ears of a distinct majority of Americans. The president's approval ratings (between 36 percent and 38 percent last week) suggest that he is now very nearly down to his unshakably faithful core base.

Were the Democrats to gain control of the House of Representatives and/ or the Senate in the November midterm elections (not very likely but certainly possible), that would at least restore the separation of powers, allowing a Democratic legislative branch to check and balance the Republican executive. Unless and until that happens, the Bush administration is likely to go on using the images and memories of September 11 to reinforce and justify the enormous boost of power it received on September 18. What further discord this turbocharged presidency may engineer here and in the larger world between now and January 2009 is the stuff of international bad dreams.

Independent, September 2006

Guantánamo Bay

MOST MOVIEGOERS whom I've watched leaving the cinema after seeing *The Road to Guantánamo* have been wordless and whey-faced, numbed, as I was, by the film's distressingly vivid re-creation of brutal interrogations in the American detention camp on Cuba's south coast (sequences that were filmed on location in—of all places—Iran). It takes a while to realize that one has witnessed something more than a shocking indictment of the peculiar institution of Guantánamo Bay. Michael Winterbottom and Mat Whitecross's drama-documentary, a deliberately confusing medley of fact (interviews, news footage) and fictional devices (lavishly filmed re-enactments), also has the great merit of exposing the special fog of "asymmetric" as opposed to conventional warfare. Grueling as it is to watch, and it's the most protracted ninety-minute movie I've ever seen, it is packed with sly insights into Bush's "long war," hitherto known as the global war on terror.

Winterbottom's last movie was *Tristram Shandy: A Cock and Bull Story*, and his Shandean relish for confusion, dead ends, contradictions, and non sequiturs is everywhere in evidence in this convoluted tale of how three young Englishmen from Tipton—part of the postindustrial urban sprawl of the West Midlands between Birmingham and Wolverhampton where many immigrant Pakistani families originally settled in the 1960s—went to Pakistan for a wedding (it was meant to be "a great holiday," one of them says) and ended up in Guantánamo, via Kunduz, Afghanistan, in the chaotic aftermath of the battle there in November 2001. The Tipton Three, Asif Iqbal, Ruhel Ahmed, and Shafiq Rasul, should have been four, but one of their original number, Monir Ali, was lost in Kunduz and is now presumed dead.

"Our idea," Winterbottom has said, "was to let [the three] tell their story themselves." So the directors have appointed themselves as poker-faced secretaries to the Tipton Three, whose reliability as narrators remains in question throughout the film. Winterbottom and Whitecross have tried to be as faithful as possible to the Tipton Three's version of things, while leaving ample room for the audience to doubt the logic and plausibility of what transpires on-screen. The men appear as themselves in on-camera interviews, but are played by actors who bear little or no resemblance to their real-life counterparts—and thereby continually remind us of their own fictionality. The style of trompe l'œil, on-the-fly realism in which the three's catastrophic intercontinental adventure is filmed—like the Battle of Namur scenes in Winterbottom's *Tristram Shandy*—owes a good deal to such graduates of 1960s and 1970s BBC television drama as Ken Loach and Tony Garnett, expert forgers of the blurred action and grainy texture of newsreel.

After returning from a trip to Pakistan, Asif Igbal's mother tells him she has found a bride for him there and that he "should go out to Pakistan and get married." "So I got a ticket and I went," Iqbal says flatly in his adenoidal Black Country accent. Bargain travel has much to answer for in The Road to Guantánamo, which at one level might be seen as a long monitory riff on Pascal's remark to the effect that all human evil comes from a single cause, man's inability to stay quietly at home in his room—a remark that applies as much to the uniformed Americans as it does to the British civilians. Having arrived at his family's village in Pakistan, Igbal decides to marry the girl selected by his parents and invites his friend Ruhel Ahmed to witness the wedding. Ahmed departs for Pakistan with Shafiq Rasul and Monir Ali, who are both eager to visit the country. Arrived in Karachi, the trio add long tunics and prayer caps to their Tipton wardrobe of nylon tracksuits and hoodies. Speaking Punjabi and Urdu, they merge seamlessly into the Karachi crowd and doss down for free at the Binori mosque. The filmmakers don't tell us that the mosque just happens to be where Mullah Omar learned his militant brand of Islamist theology, or that it was described in 2002 by Wilson John, a senior fellow at the Observer Research Foundation in New Delhi, whose specialty is terrorism in Pakistan, as "the alma mater of all jihadis." That the Tipton visitors found lodgings there was, perhaps, pure travelers' coincidence—or not, as the case may be.

Although Iqbal says the three visitors were supposed to go to his village, he instead meets them in Karachi. Idly sightseeing, the lads pass by another

mosque where a preacher is speaking of the "chaos and terror" unleashed by the American invasion of Afghanistan and calling on his congregation to offer their "help." Because the bus fare to Kabul, nearly one thousand miles from Karachi by road, is just 250 rupees (\$4.15 at today's rate of exchange), the four tourists, ignorant of everything about Afghanistan except the legendary size of its flatbreads, decide to make the trip. "We jumped in a bus and off we went."

Torrential diarrhea, the scourge of tourism, attacks Shafiq Rasul en route to the Afghan border, and he is somehow forgotten by his friends and left behind by the bus, emptying his bowels in the toilet of yet another mosque, but he is later reunited with his mates after walking across the border. As ever, the story line is odd, bald, unexplained, but the scenes themselves are rendered so persuasively that one easily forgets the hiatuses between them.

When the group arrives in Kandahar amid bombing, the flatbreads satisfactorily live up to their reputation ("Look at them naans—fucking big!"), though the promised "chaos" of Afghanistan turns out to be strangely elusive. The four adventurers spend one day in Kandahar before leaving for Kabul. British newsreel footage shows the city under relentless aerial bombardment, but the Tipton boys see it differently: swirling red dust, nimble pedestrians dodging traffic, a group of old men placidly smoking and drinking coffee at a sidewalk cafe. Speaking no Pashto, they become aimless, awkward spectators of the world in which they are adrift. For two and a half weeks, they "chill out," nurse Asif Iqbal, who has fallen desperately sick, grow ever more bored, and decide to go back to Pakistan.

Along the way, they have somehow acquired a minder, or mentor, in Kabul named Sher Khan, who ushers them into a crowded minivan, assuring them that it's Pakistan-bound. But it's the wrong bus. The hapless, geographically challenged travelers are transported north to Kunduz instead of south toward Karachi—straight into the war zone where Northern Alliance troops under General Rashid Dostum, assisted by American bombers, are wresting the city from the Taliban and taking many thousands of prisoners.

When Northern Alliance troops enter Kunduz, prompting an evacuation, Monir Ali is lost in the dash to the city's outskirts, apparently left behind in Kunduz as the rest of the Tiptonites scramble aboard a moving truck laden with armed men on the run. Outside the city they encounter true chaos, brought to life by the directors with manic and persuasive exuberance. Illuminated by exploding bombs on the horizon, panicked humans surge back and forth on foot and in trucks, their movements simultaneously as suggestive and as unintelligible as *Tristram Shandy*'s marbled

page. Shouts from the swarm are translated into contradictory subtitles: "We are surrendering!" "We have safe passage!"

By the light of day, a kind of order emerges. The arid terrain of rock and shale is littered with the bodies of men killed when the trucks in which they'd been traveling were bombed. After helping to bury the dead and leaping aboard a passing truck, the three are captured by the Northern Alliance and forced to march through the landscape with a trudging column of what look like exhausted refugees. On every salient outcrop stands a man wearing a makeshift camouflage top and holding a machine gun. One has to work quite hard to make sense of what one's seeing here and to figure out that the gunmen are with the Northern Alliance and the refugees are their captives. Most of the prisoners wear baggy Afghan tribal dress, but here and there one spots an Arab kaffiyeh, a Pakistani tunic, and, materializing from the edge of the screen, Ruhel Ahmed's trademark claret-colored Gap hoodie.

As William S. Lind and others wrote in their important 1989 article "The Changing Face of War: Into the Fourth Generation," in asymmetric warfare "the distinction between 'civilian' and 'military' may disappear."* In the picture on the screen, that distinction has entirely disappeared: the Northern Alliance brigands are clad in a sort of homemade gesture at military uniform but the hundreds of shabby men passing before the camera have perfectly illegible identities. Searching the faces and the clothes, all you can say with certainty is that everyone appears to be a Muslim. Some are, you presume, Taliban fighters, some may be al-Qa'eda. But there's ample room in this bedraggled crowd for unlucky shepherds, cooks, bus drivers, butchers, and bakers; room, too, for a trio of clueless English tourists. You are now looking at the world almost exactly as it must appear to the American interrogators to whom the enormous, indiscriminate mixed bag of humanity will shortly be delivered.

It has to be remembered that leaflets promising bounty of up to \$5,000 for a Taliban fighter and \$10,000 for a member of al-Qa'eda were then being airdropped all over Afghanistan, falling, as Donald Rumsfeld boasted at the time, "like snowflakes in December in Chicago." One such leaflet read, in part:

You can receive millions of dollars for helping the Anti-Taliban Force catch Al-Qaida and Taliban murderers. This is enough money to take

^{*} Marine Corps Gazette, October 1989, pp. 22-26.

care of your family, your village, your tribe for the rest of your life. Pay for livestock and doctors and school books and housing for all your people.*

Inevitably, Afghans turned in their next-door neighbors, old rivals, teachers who'd given them a failing grade. Non-Pashto-speaking foreigners like the Tipton Three were of course prime bounty material.

Between Kunduz and the jail at Sheberghan, a hundred and eighty miles to the west, the Northern Alliance packed their prisoners so tightly into shipping containers that many died of suffocation. Still more were killed when their containers were raked by machine-gun fire in the disputed Dasht-i-Leili massacre (depending on the source, the dead numbered from two hundred and fifty to three thousand), named for the site of the mass grave near Sheberghan where the victims were buried. The Tiptonites survive this horror only to face violent interrogation by U.S. intelligence agents at the prison. They are now among the "worst of the worst," in Bush's words: alleged al-Qa'eda terrorists bent on the destruction of Western civilization. They are also, as native English speakers, natural targets of opportunity for American interrogators demanding to know the whereabouts of Osama bin Laden.

In the hellhole of Sheberghan, the prisoners are shaved, stripped naked, forced into orange jumpsuits, gloves, earmuffs, black goggles, and hoods—the outlandish uniform in which they will be flown to Guantánamo. Whatever they may have been before, tourists, shepherds, or fighters, they now look like an army of enemy aliens. The transformation wrought on them by their American captors is a work of cunning genius: arriving at Sheberghan, they were forlorn, exhausted, starving men; departing on the flight to Cuba, they are made to seem evil orange monsters, identical, inhuman, and, as their shackles bear witness, very, very dangerous.

Up to the moment when Ruhel Ahmed is forced into a Guantánamo uniform, his Gap hoodie leads such an insistent life of its own that one comes to read it as a sly emblem of the Tipton Three's story. Travelers' tales, riddled with faulty recollections, inventions, and self-serving omissions, are notoriously untrustworthy, and this one is true to the genre. The artfulness of *The Road to Guantánamo* lies in its implicit acknowledgment that neither the directors, nor the audience, nor the American inquisitors are in a position to get to the bottom of what "really" happened. The trio's account may be true in all essential details, with a lot of bits left out, or it

^{*}See psywarrior.com/afghanleaf40.html.

might be—to borrow the subtitle of Winterbottom's last movie—a cock and bull story. We'll never know.

Yet the Tipton Three's version of events has one enormous strength: in the end, it holds together better than the rival narrative that is told by their captors at Guantánamo. For the Americans possess a photograph and video of a rally in Afghanistan, held in 2000, where Mohamed Atta met with Osama bin Laden, and they claim to have identified Asif Iqbal, Ruhel Ahmed, and Shafiq Rasul among the indistinct faces in the crowd. So a kind of battle of the narratives ensues as we watch the three being repeatedly kicked, beaten, and tormented by ear-splitting music and strobe lights in the interrogators' attempt to make them admit the truth of the American story. In a sequence of nearly unendurable scenes, the Tipton Three try to hold their ground (though a confession of a meeting with Atta and bin Laden was extracted from Rasul), until at last their captors reluctantly concede that there's a mighty hole in their own tale, too. For throughout 2000, Rasul was employed at a branch of Curry's, the British chain of electrical stores, while Ahmed and Iqbal were both on parole for various offenses including fraud, receiving stolen goods, and violent disorder. Unlike almost everything else in the entire film, those facts were verifiable. "The police were our alibi," Ahmed says in an interview, with understandable ironic relish.

Held for a further three months at Guantánamo, the trio were eventually sent back to Britain in the early spring of 2004, where they were released without charge. They had been in American detention for more than two years.

In Britain (he is not permitted to leave the UK), Moazzam Begg has become the widely admired voice of those unjustly detained at Guantánamo, as much for his remarkably personable and articulate interviews on television and radio as for his book *Enemy Combatant*, which is an odd collaborative effort written with Victoria Brittain, a London journalist who is also the co-compiler, with Gillian Slovo, of the documentary play *Guantánamo: Honor Bound to Defend Freedom*. In the prologue to *Enemy Combatant*, Begg writes that "one of the more ambitious aims of this book is to find some common ground between people on opposing sides of this new war, to introduce the voice of reason, which is so frequently drowned by the roar of hatred and intolerance." That laudable ambition so overshadows the book that it doesn't quite work either as a

credible personal memoir or as the generous and forgiving essay in bridge building it struggles hard to be.

Much of the problem is, for want of a better word, literary. For the first hundred or so pages, the "I" of the book is not so much an emerging character as a passive, and distinctly journalistic, witness to his own experience. Begg, or Begg and Brittain, tell of his singular childhood in the Sparkhill area of suburban Birmingham (ten miles east of Tipton), where his father, an Indian-Pakistani banker and real-estate agent, sent him to a Jewish elementary school at which he discovered an early fascination with religious studies; of his first bruising encounters with "Paki-bashing" skinheads associated with the neo-Nazi National Front; of his own gang, the Lynx, mostly Pakistani boys who tackled the racist skinheads at their own game; of his growing sympathy for underdogs everywhere, expressed by an admiration for Fidel Castro, Nelson Mandela, and Ho Chi Minh; of the music he liked (UB40, Gloria Estefan, Simply Red) and his favorite movie (Braveheart); of his touristic visits to Pakistan and Afghanistan, his participation in convoys carrying humanitarian aid to Muslims in Bosnia, and his aborted journey to Chechnya; of his increasing attendance at the local mosque and how he came to open an Islamic bookstore. A great quantity of information is delivered, but the first-person singular obstinately remains a cipher. One has the sense of reading not a memoir but a résumé. Like most résumés, it feels airbrushed. It is a strategic (one might almost say a "campaign") biography of—as Begg calls himself elsewhere—"a crazy idealist," but it is a very insufficient self-portrait of Moazzam Begg, who, as the book's leading character, has no personal quiddity at all.

Like many inept first-person narrators (and aspiring politicians), he attributes to himself a degree of earnest naivetè that doesn't square well with his story. A few bland generalities about injustice, conscience, and self-defense are all we are allowed to hear about the detailed politics and theology of radical Islamism, which is a pity, since Begg's bookshop (which isn't named in the text) has, since September 2001, been a convenient, and rather famous, source for journalists looking for the literature of jihad against the West. It was visited by the London *Sunday Telegraph* in 2001, and by *Newsweek* in 2004. Mark Hosenball's breathless account in *Newsweek* was headlined "Barnes & Noble It's Not":

Anyone who believes the war on terror has shut down terrorist propaganda centers in U.S.-friendly countries should visit the Maktabah al Ansar bookshop in Birmingham, England. Amid shelves of Qur'anic

tomes and religious artifacts are bookshelves and CD racks piled with extreme Islamist propaganda: recordings of the last testaments of 9/11 hijackers, messages from Osama bin Laden and jihad pamphlets by Sheik Abdullah Azzam, the late Palestinian activist who was a bin Laden mentor and early apostle of suicide bombing.

A best seller at the bookshop last summer was a jihad recruitment manual published by the shop itself and written by Esa al-Hindi, described in a biography as a British Hindu who converted to Islam and served in Afghanistan as an instructor in a training camp for Islamic holy warriors. Sales of the book soared after British and U.S. authorities announced that the author was one of a group of suspects arrested last summer for plotting attacks in Britain.*

It should be said immediately that selling old bin Laden recruitment videos (many of which were made when the mujahideen were fighting the Soviet occupying forces in Afghanistan) or the new edition of *Milestones* (1964), by the extremely influential radical Muslim thinker Sayyid Qutb, which is currently being promoted on Maktabah al-Ansar's home page, is evidence of absolutely nothing except Begg's probably sophisticated grasp of jihadist ideas, about which he plays diplomatically dumb in his book, even as he shows himself to be intellectually adept when it comes to discussing almost anything else.

Maktabah al-Ansar was raided by MI5 in 1999 and again in 2000, but the bookstore was doing well enough for Begg to leave the business to manage itself in the summer of 2001 and transfer his growing family to Kabul under Taliban rule. His wife, Zaynab, had been racially harassed on the street in Birmingham, and Begg was anxious to move to a country where his children would receive "a good grounding in their roots, their culture, and their religion." He was also swayed by the attractive cost of living in Afghanistan: "Many people told us that we could live in the best areas of Kabul for less than £100 a month." He planned to help run a school, for girls as well as boys, install hand-pump wells in the parched countryside, and work as a literary translator. "I'd bought some old classical Islamic texts, which I intended to translate into English from the Arabic. I thought they could make some interesting little booklets for our bookshop back in Birmingham."

^{*}Newsweek, December 27, 2004/January 3, 2005.

He was thus innocently employed when news broke in Kabul of the September 11 attacks on New York and Washington. "There were no televisions for me to see the horrifying images of the victims of the attacks, and I simply failed to grasp the enormity of the event." In mid-October, when the first U.S. missiles hit the city, Begg and two friends moved their families out of Kabul to Logar, some sixty miles south, "where we were all going to stay until the situation calmed down. For the children this was a fun camping trip, and they loved the freedom of the countryside, although it was just desert."

From then on, Begg's travels, like those of the Tipton Three, get confusing, and plotting them on an atlas only adds to the reader's puzzlement. He drives back and forth several times a week between Logar (a large province, described by him as a "desert town") and Kabul, visits Pakistani friends somewhere north of Kabul, gets "totally lost," reaches Surobi, encounters bandits and a fleeing unit of Taliban fighters, finds the road to Logar and his family closed, then becomes one of several men who are led by a guide on a two-day trek over the mountains into remote tribal areas of western Pakistan, where he is in despair at ever finding his lost wife and children. Separated for three weeks, the Beggs are joyfully united in Islamabad, where, at midnight on January 31, 2002, he is arrested by Pakistani security forces accompanied by two cursorily disguised Americans.

Up to this point the narrative is a contender for the Gap hoodie award, on multiple grounds. The gaps in his story—and they're more frustrating than downright suspicious—cease at the moment when Begg enters captivity. Held by the Americans for six days short of three years, first at Kandahar, then Bagram, then Guantánamo Bay, he describes his incarceration with restraint, precision, and sometimes withering humor. As a prisoner, he at last gains a credible identity as a character, and he is able to supply the first authentic portrait of a detainee's life at Guantánamo and of the unique cosmopolitan society that flourishes there despite shackles, nonstop, often violent, interrogations, and a prevailing mood of numb despair. Begg's account of Camp Delta, its daily routine, its jokes, fights (as when two Afghan men come to blows over their differing views of the Taliban), and late-night discussions of politics and theology, makes his book essential reading. But its problems do not end there.

Enemy Combatant has been praised in Britain for Begg's outstanding liberality of mind and evenhandedness toward his captors, some of whom are described as unfeeling brutes, others as decent human beings who become

his "friends." Unfortunately, these relationships are rendered in long passages of direct speech, and Begg and/or his coauthor are notably talentless at writing dialogue. So one has to plow through exchanges like this one, with a Republican-voting soldier from Alabama named Jennifer:

Once, she confided, "When we were briefed about this place we weren't relishing the idea of spending a long time here. Gitmo was home to the 'worst of the worst,' they said. Then a handful of us were chosen for this mission in Echo, maximum-security isolation block, where the most dangerous terrorists in the whole island were kept. I was expecting a Hannibal Lecter/Agent Starling type situation, with you guys trying to terrify us using perverse mind games ..."

"So how does it feel, discussing *Les Misérables* with one of the most dangerous men on earth?"

"I can see now how we all bought the hype. I don't know if they've even accused you of anything, but I know y'all can't be guilty. The government would have displayed their strongest evidence in a sensational show trial by now . . . I expected you to hate all Americans after all you've been through, especially us soldiers. But you're wonderfully complex, Moazzam. All the things I'd expect you to be, you're not."

Perhaps Begg really did strike up a warm relationship with soldier Jennifer, but all one can say of the words on the page is that they are resoundingly phony. Only in bad fiction do people speak like this, and true though Begg's story may well be in its essential facts, it is very poorly served by line after line of rankly implausible writing.

However, this isn't a matter of the trustworthiness of individual victims and witnesses. There can be no doubt about the reality of the predicament described by Moazzam Begg and the Tipton Three: the indiscriminate dragnet thrown out by the United States in its frenzied hunt for members and associates of al-Qa'eda brought in a catch that included many bystanders who happened to be in the wrong place at the wrong time, and whose single common denominator was that they were Muslims. Many hundreds were arrested in New York and other American cities in the days immediately following September 11, 2001, such as Ehab Elmaghraby, an Egyptian national who had the misfortune to be running an Arab restaurant near Times Square, and was hustled off to the Metropolitan Detention Center in Brooklyn, where he was denied access to a lawyer, held for two years, subjected to violent physical and verbal abuse (he alleges torture), and eventually deported. He sued the U.S. government and in April this year received

a check for \$300,000, though as a condition of the settlement the government denied any fault or liability. Thousands more were caught in the net in Afghanistan and Pakistan, then, later, in Iraq. Those who ended up at Guantánamo found themselves in a "legal black hole" (as it's been characterized by the British law lord Johan Steyn), the preeminent symbol, in the world's eyes, of the Bush administration's airy indifference not just to international law, but to the basic principles of common humanity.

"When we look back at the crumbling shell of Camp Delta, we will be forced to confront its lasting damage—to the Constitution, to the country, and to the rule of law," writes Joseph Margulies in his superbly argued *Guantánamo and the Abuse of Presidential Power*. As a lawyer representing two of the Tipton Three (Shafiq Rasul and Asif Iqbal) among other Guantánamo detainees, Margulies is an interested party here, and his book is powerfully fueled by personal indignation at the injustice suffered by his clients. What makes it so remarkable is the cool eloquence and clarity with which Margulies conducts the lay reader on a revelatory and unexpectedly invigorating tour of the mephitic legal swamp of Guantánamo Bay.

The exceptional status of the camp as a world in limbo, ruled by the executive but out of reach of American law, is rooted in the threadbare fiction of Cuba's "ultimate sovereignty," written into the 1903 lease of Guantánamo to the United States. (Cuba has long tried to exercise that sovereignty without success, and the annual rent check for \$4,085 is never cashed.) When Margulies and his colleagues filed the case of *Rasul and others v. George W. Bush*, they were, he writes, seeking to clarify "a deceptively simple question: what is the role of the judiciary in the war on terror?"—to which the administration's effective answer was "none at all," because the camp was on foreign soil. In a gratuitous assertion of presidential power, the administration even refused to allow Rasul and his co-plaintiffs to learn of the existence of their own case:

The Administration's lawyers did not merely ask the court to dismiss the case: they took the position that our clients should not be allowed to know the litigation had started. We were not allowed to speak or meet with our clients. We could not even send them a copy of the lawsuit. (We could mail them anything we wanted, but the military would not deliver it to them.) *Rasul* is apparently the first case in more than 150 years in which the subjects of the litigation did not know that a case was under way on their behalf.

Rasul was filed in February 2002, some six weeks after the Tipton Three were taken prisoner by the Americans in Sheberghan, and took more than two years to reach the Supreme Court, by which time Rasul, Iqbal, and Ahmed had recently been returned to Britain. In a 6–3 majority decision (Scalia, Thomas, and Rehnquist dissented), the Court agreed that Guantánamo inmates did indeed have the right to a writ of habeas corpus to challenge their detention, and added:

Petitioners' allegations—that although they have engaged neither in combat nor in acts of terrorism against the United States, they have been held in Executive detention for more than two years in territory subject to the long-term, exclusive jurisdiction and control of the United States, without access to counsel and without being charged with any wrongdoing—unquestionably describe custody in violation of the Constitution or laws or treaties of the United States.

Lawyers for the president claimed that the ruling was "oblique."

In a move that has become increasingly familiar since, the administration first appeared to bow gracefully to the decision of the Court, then came up with a fix that violated the spirit, if not quite the letter, of the decision and enabled Guantánamo to continue as the fiefdom of the executive branch, barricaded against the petty and intrusive concerns of the judiciary. Its response to *Rasul* was to create the now infamous CSRTs, Combatant Status Review Tribunals—three-man kangaroo courts in which detainees were forbidden to be accompanied by a lawyer, and where they could be convicted as "enemy combatants" on the basis of confessions obtained under duress or torture, or by evidence so secret that it could not be disclosed at the hearing. Most importantly, the definition of "enemy combatant" was sufficiently elastic to stretch to include almost anybody. In December 2004, in the federal court in Washington, D.C., Judge Joyce Hens Green put several hypothetical cases to Brian Boyle, representing the U.S. attorney general:

What about, she asked, "a little old lady in Switzerland who writes checks to what she thinks is a charity that helps orphans but really is a front to finance al-Qaeda activities. Would she be considered an enemy combatant?" She could be, Boyle answered, noting that the military would not be "disabled" from detaining her even if she did not intend that the money go to terrorism... Or "a resident of Dub-

lin... who teaches English to the son of a person who the CIA knows to be a member of al-Qaeda?" Yes, Boyle said, because unbeknownst to the teacher, the al-Qaeda agent might be learning English as part of his plot to launch an attack.

One might see Guantánamo as the Bush administration's most audacious attempt at nation building: a tiny offshore state, run, like any totalitarian regime, by an all-powerful president, the military, and the intelligence services. Nowhere has unfettered presidential power been so stubbornly and pugnaciously defended as in the continuing conflict between the executive and the judiciary over Guantánamo Bay. The camp and the administration are so wedded together that the state of either one is perhaps the best guide we have to the health of the other.

The temporary cages of Camp X-Ray went up in early January 2002, when Bush's authority as a "war president" was at its zenith, and long before the rift in public opinion over the proposed invasion of Iraq began to tear the country apart. The flabbily worded Authorization for Use of Military Force (AUMF), rushed through Congress on September 18, 2001, gave the president his carte blanche:

The President is authorized to use all necessary and appropriate force against those nations, organizations, or persons he determines planned, authorized, committed, or aided the terrorist attacks that occurred on September 11, 2001, or harbored such organizations or persons, in order to prevent any future acts of international terrorism against the United States by such nations, organizations or persons.

"Determines" should be ringed with a red pencil, and so should "future acts," with its implicit license for preemptive warfare, but the trickiest word is that "such" in the final clause. "Such... persons" seems to mean "persons of that sort"—an infinitely expandable category. In effect, the AUMF entitled the Bush administration to use all necessary force not just against terrorists but against persons determined by the president to be of the terrorist sort—such as Ehab Elmaghraby, the Tipton Three, and Moazzam Begg, along with charitable elderly Swiss ladies and Irish ESL teachers. The concrete, chain-link, and razor-wire architecture of Guantánamo rose as a forbidding monument to the extraordinary power invested by the nation in its commander in chief and his circle of close advisers. Like warrant-

less wiretapping, the camp is one of the multitude of examples of how the executive has claimed exceptional liberty from the law on the grounds of its commission to fight the war on terror as it—and it alone—determines.

Liberals, appalled by Guantánamo and all it represents, have cheered too early and too often when the Supreme Court has appeared to bring the camp within the sway of national and international law, only to see the administration wriggle out from under each new decision. In *Hamdi v. Rumsfeld*, Justice Sandra Day O'Connor memorably wrote that "a state of war is not a blank check for the President," but the stinging ruling had little more effect on the running of the place than, say, a *New York Times* column by Paul Krugman might have done. Yasser Hamdi himself was eventually released, but the intolerable conditions of his incarceration at Guantánamo remain for others to endure. Writing in the spring of 2006, before the Supreme Court ruled on *Hamdan v. Rumsfeld* on June 29, blocking military tribunals and affirming that detainees were protected by Common Article 3 of the Geneva Conventions, Joseph Margulies came to the depressing conclusion that despite a succession of critical Supreme Court decisions, "Camp Delta continues in 2006 much as it began in 2002."

On the face of it, the decision on Salim Hamdan in *Hamdan v. Rumsfeld* was more far-reaching and consequential than those on Rasul and Hamdi. Once again, editorialists and human-rights advocates applauded the ruling. The *New York Times* reported:

The decision was such a sweeping and categorical defeat for the Bush administration that it left human rights lawyers who have pressed this and other cases on behalf of Guantánamo detainees almost speechless with surprise and delight, using words like "fantastic," "amazing," "remarkable." Michael Ratner, president of the Center for Constitutional Rights, a public interest law firm in New York that represents hundreds of detainees, said, "It doesn't get any better."

Once again, the administration vowed to accept the decision and "looked forward" to working with Congress to resolve the issue. Once again, after a couple of days of liberal euphoria, a rash of hitherto invisible fine print broke out in both the decision itself and the administration's response to it. Once again, it looked as if the Supreme Court had delivered to the commander in chief not a mighty blow, as was first thought, but a slight passing inconvenience.

Yet familiar as this sequence of events was, one aspect seemed new. In the past, the administration had mainly to deal with the scruples of squeamish

judges, like the now retired Justice O'Connor and the eighty-six-year-old Justice John Paul Stevens. But by the summer of 2006, the legislative branch, seeing its own powers neutered, or at least diminished, by the "unitary executive theory" and Bush's eight-hundred-plus "signing statements," was starting to cavil at the administration's seizure of the right to operate above and beyond the law. As the prime symbol of that right, Guantánamo appeared more vulnerable than it ever had. In 2002 it was a monument to extraordinary circumstances and extraordinary presidential power. Until just a few weeks ago, it was looking more and more—even to an apparently growing number of Republicans in Congress—like a grim cautionary monument to the arrogance of the presidency that went too far.

Then, on August 10, came news of the alleged terrorist plot in Britain, which was said to involve the downing of up to a dozen U.S.-bound airliners with liquid explosives. With impressive speed, the Bush administration moved to exploit the climate of suddenly renewed fear of an atrocity comparable to the attacks of September 2001. High on the administration's agenda was the issue of the Guantánamo military tribunals. As the *Times* reported on August 12:

Insisting on anonymity, a senior administration official in Washington said news of the plot against airliners would add momentum to efforts to create military tribunals for Guantánamo detainees that would strictly limit defendants' rights.

September 6 brought two new developments: Bush announced that four-teen top terror suspects—including Khalid Sheikh Mohammed—who were previously held at secret foreign prisons by the CIA had been transferred to Guantánamo Bay and will be tried (Congress permitting) by military tribunals; and the Pentagon issued a new army manual prohibiting ten specific forms of torture and "degrading treatment," which was seen in some quarters as implicitly granting detainees full rights under Article 3 of the Geneva Conventions. Once again, hopeful liberals were inclined to see concessions by the administration to the rule of law. Ingenious electoral maneuvers? A "significant retreat" (as the London *Times* billed it)? Another temporizing rhetorical sleight of hand? We'll see.

New York Review of Books, October 2006

A Postregional City

WHEN I ARRIVED in Seattle in 1990, one had only to look from the streets to the water to see the city's essential history: slow-moving tugs towing rafts of logs like floating islands; Japanese-flagged freighters laden with raw timber destined for the Tokyo construction industry; husband-and-wife gillnetting boats laying nets across the tide for Puget Sound salmon. Squint, and you could almost see Seattle as it was in the 1850s: a sheltered deep-water harbor on the edge of a limitless forest of massive Douglas firs and cypresses, with an abundant fishery on its front doorstep. Given such lavish natural resources, it would be hard for a city founded here to fail. Add a railroad connection to the interior (James J. Hill's Great Northern transcontinental line reached Seattle in 1893, in ample time for the Klondike gold rush of 1897) and the place was bound to enjoy the kind of extravagant and unruly success that is both the blessing and curse of the American boomtown.

Yet even in 1990 there was a rootedness to Seattle that evaded most boomtowns. The cautious, Lutheran, Scandinavian character of so many of its settlers perhaps helped; likewise the Lutheran, Scandinavian quality of its weather. Manic elation is difficult to sustain under the low gray skies of the Pacific Northwest, and Seattle was never likely to emulate the dizzy excesses of Los Angeles or Las Vegas. Hemmed in by parallel mountain ranges to the west and east, its livelihood grounded in tall trees and deep water, the city stood at an odd, proud, provincial angle to the rest of the United States, insulated by its geography from the crazes and fashions that took hold elsewhere.

Entirely predictably, the city's first "big" business was Henry Yesler's steam sawmill, built in 1853 on Elliott Bay at the foot of what is now Yesler Way. Docks, mills, salmon canneries, and shipbuilding yards quickly

assembled themselves along the waterfront, forming a basic infrastructure that shaped Seattle's development for more than a hundred years. When William Boeing, president of a family-owned timber company based in Aberdeen, Washington, entered the aircraft-manufacturing business in 1916, he moved into a bankrupt yacht yard on the Duwamish River, where he employed shipwrights to construct his first planes. Built on the "stick-and-stringer" principle, with light wooden frames sheathed in fabric instead of timber planking, early Boeings, such as the Model C training seaplane, were like featherweight avian boats (lovely examples of these shipshape planes hang from the ceilings of the Museum of Flight at Boeing Field airport). So the pedigree of the 787 Dreamliner is thoroughbred Seattle, reaching back to the fir forest, the mill, and the delicate skills of the boatbuilder with his spokeshave and chisel.

When I arrived here, I cherished this kind of logical continuity. No city I knew seemed on such comfortable and unself-conscious terms with its own beginnings. I warmed to Seattle's downtown, its modest cluster of skyscrapers rising from streets still dominated by turn-of-the-century brick-and-stucco examples of Far West neoclassical swank. Rebuilt after a fire leveled most of the business district in 1889, Seattle had Roman dreams of the grandeur yet to come, and its hotels, clubs, department stores, and theatres were designed like palaces in the reign of the Emperor Hadrian. In a region of logging and mining camps, of here-today-and-gone-tomorrow, the city itself meant to stay for the ages.

From early on, Seattle had a canny grasp of how to act as a provincial capital. Its potential hinterland was vast if underpopulated, stretching to Alaska in the north and beyond the Rocky Mountains to the east, a nearly boundless territory of isolated, makeshift towns whose inhabitants might reasonably consider it their center for shopping, entertainment, medical facilities, and higher education (the very large and highly ranked University of Washington began life as Territorial University in Seattle in 1861, just ten years after the arrival of the first settlers). The behavior of the city during the gold rush was typical: when prospectors swarmed through en route to the Klondike diggings, Seattleites mostly stayed home, preferring to make reliable fortunes from the miners rather than chance their luck in the gold fields. Stores sold clothing, shovels, pans, sluice boxes, and hydraulic equipment to the stampede of hopefuls, and for those few who returned with money in their pockets, the city laid on whorehouses, dives, casinos, restaurants, and burlesque shows. Seattle effectively turned Alaska into its own client-state, making the last open frontier dependent on it for shipping, supplies, and services, handsomely enriching itself in the process.

Few cities have enjoyed such a long-distance reach into their hinterlands. In the mid-1990s, I conducted an experiment. Driving eastward, I stopped at subsequent towns to find out where allegiance to Seattle's big-league sports teams—the Mariners in baseball, the Seahawks in football—shifted to the Minnesota Twins and Vikings. At the five-hundred-mile mark, Missoula, Montana, was solidly for Seattle. I crossed the Continental Divide near Butte and drove on to Billings, where, with eight hundred and thirty miles on the clock, I saw a travel agency advertising weekend packages to Seattle, with hotel, Mariners tickets, and a show at the 5th Avenue Theatre thrown in. A day or two later, more than a thousand miles from Seattle, I was at a barbecue lunch on a North Dakota ranch. After a long morning's calf branding, Minneapolis now six hundred miles away, I asked my neighbor which baseball team was most closely followed in these parts. "Mariners," he gruffly said, as if dismissing a silly question. Seattle's reach is that long. The Montana novelist Deirdre McNamer had a piece in the New York Times Magazine not long ago, describing how she and a Missoula friend would drive to Seattle to get their hair done. Five hundred miles for a haircut.

It's been a long while since I last saw a gillnetter at work off Seattle's waterfront, a laden timber freighter heading north, or even a log tow. Puget Sound chinook salmon are now listed under the Endangered Species Act. Market changes and Clinton-era restrictions on logging in federal lands have drastically reduced the visibility of the timber industry. Most of the lumber mills, whose acrid steam used to give the coastal Northwest its characteristic smell, have closed down during my time here.

Seventeen years ago, Seattle was still, if only just, a regional city, connected with its hinterland by a complex skein of cultural and economic threads and tendons. Grunge rock—the music for which Seattle was becoming famous when I first arrived—provides a nice example. Kurt Cobain and Krist Novoselic, the founding members of Nirvana, both came, in Cobain's words, "from the bowels of a redneck logger town called Aberdeen, WA," but it took Seattle, the local metropolis, with its clubs, record producers, and studios (and its ready supply of heroin) to broadcast to the world the band's drum-heavy strain of backcountry Weltschmerz and fury.

Like the wood-products industry, the rock scene depended on a close symbiotic relationship between outlying counties and a provincial hub. Since then, Seattle has become postregional, paying far closer attention to the hourly fluctuations of the NASDAQ and Nikkei indices than it does to what's happening in its immediate vicinity. Increasingly divorced from the hinterland, it now seems to float more in virtual space than in the regional

space that until surprisingly recently used to define and sustain it. For both the hinterlanders and many old-guard Seattleites, this uprooting has been a painful and incomprehensible process, alienating them from the city they'd long regarded as theirs by right of birth.

Microsoft came here with its twenty-eight employees from Albuquerque, New Mexico, in 1979, for a tangle of reasons. Bill Gates and Paul Allen were returning to their hometown; the high-tech side of Boeing had warmed the bed for the nascent software industry; the University of Washington was turning out a steady supply of graduates in computer science; the growing satellite cities of Bellevue and Redmond on the east side of Lake Washington offered cheaper office space than could be found in the Bay Area, which was considered as a possible alternative; Gates's Seattle network of influential family and friends could be counted on as a deep pool of advisers and investors; and the out-of-the-way character of the city provided the right atmosphere in which to develop a then-experimental—and always congenitally secretive—company.

Microsoft's impact on Seattle was already making itself felt on the streets when I arrived. Its young workforce, androgynously dressed in cargo pants and T-shirts, topped by Velcro-fastened outdoor gear from Eddie Bauer and REI, looked like a culture in the making. Their air of perpetual studentdom was reinforced by Microsoft calling its headquarters "the campus," and they worked eccentric, studentlike "all-nighters," which explained their seemingly permanent attachment to paper cups of espresso coffee. Caffeine was their acceptable vice, as cigarettes and martinis had been to earlier generations, and a symbol of their sleepless labors at the keyboard. Had Howard Schultz (who bought out Starbucks from his former employers in 1987) not existed, Seattle would've had to invent him.

Not since the great influx of blue-collar workers who came from the south and east to work for Boeing during the Second World War had Seattle seen such a tide of incomers. The college-educated migrants of the 1990s, most from the urban East Coast and California, generated a riot of new construction: for them, pastel-colored condo blocks, mountain-bike shops, branches of Starbucks on every other corner, kayak schools, and assembly-required furniture showrooms sprang suddenly into being. Outside of Abu Dhabi in the 1970s, I'd never seen so many tall cranes maneuvering ponderously against the sky.

The rise and rise of Microsoft has had an intense magnetic force, drawing into its field dozens of small software outfits angling to be acquired by the "big M." Departing executives, retiring from Microsoft when their stock options "vested," set up their own Seattle-based enterprises, such as

Rob Glaser's RealNetworks. Other businesses, such as Expedia.com, were spun off from their parent company but stayed in the city. Seattle, swarming with qualified job seekers (the inept waiter at one's restaurant table almost invariably a recent arrival, with a degree in computing), became the perfect site for Internet-related start-ups, from Amazon in 1994 to Zillow just last year (this is a site where, dear to Seattle's moneymaking heart, you can surveill your own and your neighbors' houses and check their current market prices). By the mid-1990s, it was far easier to find obliging venture capitalists (or "VCs," like the Viet Cong) than it was to find a carpenter or plumber. For a period, the city seemed flooded with money in search of the next smart idea to be hatched by a couple of kids in a garage.

Such a bonanza might have overwhelmed a smaller city, but Seattle was sufficiently big and diversified to seem on the surface rather underwhelmed by its latest stroke of fortune: having taken the gold rush in its stride, it wasn't about to have its head unduly turned by Bill Gates or Jeff Bezos. It helped that much of the frenetic action was taking place across the water on the East Side, in Bellevue, Kirkland, and Redmond, which indigenous Seattleites tend to consider as remote as a chunk of Southern California that has unaccountably washed up on their shore. Boeing, the grizzled giant, supplied a surprising counterbalance; even after its head office moved to Chicago in 2001, it remains Seattle's biggest employer of local labor, outstripping Microsoft by a ratio of almost two to one (60,000 to 35,000). With queues of container ships anchored in Elliott Bay, waiting to be unloaded at the docks on Harbor Island, and the Alaskan fishing fleet headquartered at Fishermen's Terminal on the Ship Canal, it was possible, if you chose your vantage point with care, to pretend that the city was going about its business as usual, more seaport and manufacturing center than Silicon Valley North.

It took the ministerial conference of the World Trade Organization in late November 1999 to fully expose the deepening rift between the old city and the new. This was at the delirious top of the boom, with the NASDAQ set to break 4,000 by Christmas and venture capital growing on trees. At the "Battle of Seattle," the headlines and pictures were overly concerned with black-masked "Oregon anarchists" smashing the windows of chain stores and looting them; but what I saw was an enormous, mostly local, all-age crowd of men and women—welders, machinists, dockers, store clerks, fishermen, timber-industry workers, students—marching together under the aegis of the union federation AFL-CIO, in a peaceful and sometimes witty demonstration. "Globalization" was the catchword of the moment, but the real target was much closer to home.

These were the people whom the boom had left behind. The demonstrators were protesting Seattle's leaping rents and house prices; the unfathomable workings of the "new economy" in which companies were valued not on their ability to make money, but on their capacity to spend it at a hell-for-leather burn rate; the marginalization of once-prized manual skills; the takeover of the city by alien, baby-faced stock-option millionaires.

Earlier in the year, a fleet of primrose-yellow vans had appeared in the streets wearing the livery of the newest extravagantly bankrolled start-up, MyLackey.com. The lackeys, capped and braided like bellboys, ran errands and did chores. The company name, however facetiously meant, was incendiary, suggesting as it did a gleeful return to an upstairs-downstairs master-and-servant society—which was exactly what the WTO demonstrators hated, for they knew all too well on which side of the baize door they were expected to belong.

On the morning of November 29, when I was driving my then seven-year-old daughter to school over a high freeway overpass, she was excited to see a banner strung from the boom of a mammoth crane, held in place by men dangling gymnastically from ropes a hundred feet above the ground. One waved to her as we passed by at eye level. The boom was aligned due north and south, and the banner showed two enormous arrows. The southward arrow pointed downtown, and said wto; the northward one said DEMOCRACY. Where had democracy fled? To the—relatively—blue-collar city of Everett, Washington? To Canada? To the Arctic wastes? It was impossible to tell.

Since I moved here, greater Seattle—which includes the morainelike sprawl of tract housing and subdivisions along the urban corridor on Interstate 5 as well as the East Side cities and suburbs—has grown in population by 37 percent, from 2.4 million to 3.3 million. In a farflung state considerably bigger than England, Seattle, broadly defined, holds slightly more than half the total population and its votes. The governor and both its senators are liberal Democrats whose elections were bitterly fought by the state's timber, mining, ranching, farming, and construction lobbies. Resentment of Seattle's financial and political power has intensified as its numbers have risen: one needn't travel far out of the city to find it viewed as the Great Wen, William Cobbett's name for London in 1821—smug, tyrannical, leaching the life out of its suffering hinterland.

But if anything, Seattle loves its surrounds too dearly, calling it "the environment." On weekends, we disperse into the environment to pursue such urbanite pleasures as skiing (but not snowmobiling), fly-fishing, hiking, mountaineering, birdwatching, kayaking, and sailing. (The city's

latest promotional slogan is the grating coinage "Seattle—Metronatural.") So the hinterland presents itself to the conurbation as a giant recreational park, whose every last vestige of wildness—stands of old-growth forest, salmon-spawning habitat, bear and cougar territory—must be vigilantly preserved or restored, whatever its longtime residents might have to say. Seattle, which likes to flaunt the title of "America's most educated city," knows best.

As soon as one leaves its suburbs, incomes fall precipitately, as if off a cliff. An air of quiet—too quiet—distress pervades once-prosperous timber towns such as Forks, on the Olympic Peninsula, whose best hope now is to divert tourists before they hike into the rainforest that Forks used to cut down with chainsaws. An underpatronized cafe here isn't a bad place from which to contemplate the host of cultural luxuries to which Seattle has recently treated itself—the new opera house, the just-reopened and greatly expanded art museum, the dazzling public library designed by Rem Koolhaas, the new downtown sculpture park, the state-of-the-art symphony hall, new baseball and football stadiums, the botched fantasia of Frank Gehry's Experience Music Project—or to reflect on its latest political controversy, which was about whether to replace the aging and earthquake-vulnerable Alaskan Way viaduct with a \$3.4 billion tunnel.

As people on the make tend to snub and discard those who've helped them on the way up, so do cities. Yet Seattle, having disentangled itself from its roots over the past twenty years, seems unconcerned—and no wonder. Its stake in the expanding commerce of the virtual world is big and growing bigger. As the nearest port in the continental United States to Tokyo, Shanghai, and Hong Kong, it looks to the rise of China with more equanimity than any other American city (and for the same reason, it views the nuclear ambitions of Pyongyang with more apprehension). Cyberspace and Asia beckon.

But this is a very different city from the one I settled in in 1990. Most days, I take myself off to Fishermen's Terminal, a mile from where I live, to buy a cigar at one of the last remaining proper cigar stores in Seattle and to wander its seventy-six acres of clanking masts and spars. So much water, scattering the reflections of dock pilings rooted in deep mud, is consoling, and so are the smells and sounds of paint and sawdust, the churring of power tools, the old skills of patiently mending nets and diesel engines. I like boats and the people who tend them—reminders of what work used to be, of what Seattle used to be.

But I'm not fooled. Five years ago, the terminal—the United States' last dedicated fishing port—began opening berths to yachts and cruise ves-

sels. The fleet of trollers, gillnetters, and purse seiners is an increasingly marginal part of the Seattle economy; like my cigar, it's fast turning into a quaint anomaly and a draw for tourists in search of a splash of local color to take pictures of, a taste of old-fashioned "real" life in this virtualized city. Given the present strength of salmon runs in southeast Alaska, the fishermen will continue to make a decent living, at least for the next year or two, helped by the growing discrimination of consumers and restaurateurs who reject cheap farmed fish in favor of expensive wild ones. So the oilskinned fisherman survives courtesy of the Amazonians and the Microsofties, much like the Sussex thatcher who's kept in business by London owners of weekend cottages.

The cigar butt is flipped off the dock, making circles in the water like a rising fish. For me, it's back to Seattle's present, to the screen blossoming to Windows XP, the black Thermos mug emblazoned with the green Starbucks logo, and the peculiar silence of a twenty-first-century boom city minting money, intermittently broken by the distant whistling noise of incoming 767s on their glidepath over Lake Union. As Seattle conquers the world with its brand names, it seems to me—as it never could have seemed in 1990—that I might be anywhere.

Financial Times, June 2007

Indian Country

IN HIS ACCEPTANCE SPEECH at the Republican National Convention in 2004, George W. Bush said, to rapturous laughter and applause, "Some folks look at me and see a certain swagger, which in Texas is called walking." Nobody would have scripted that line for him four years before, but in the aftermath of the September 11 attacks, one of his most potent electoral attributes lay in his investiture as a Western gunslinger hero. It was an improbable transformation: Bush's build is too slight for the role, his scratchy tenor voice too high, and his rococo verbal flubs anything but laconic. His face lets him down, falling too easily as it does into the expression of a snigger, or of pettish irritation, rather than one of manly resolve. There still clings to him, at age sixty-one, a perplexing element of juvenility. As one of his advisers, quoted in Robert Draper's *Dead Certain: The Presidency of George W. Bush*, asks, "What kind of male obsesses over his bike-riding time, other than Lance Armstrong or a twelve-year-old boy?"

But expedient myths have to be made of whatever raw materials are to hand, and in the intellectual and emotional turmoil that followed the events of 9/11, when American journalism entered a dark period of frantic mythopoeia, both the president and his then defense secretary were decked out by the press in heroic buckskin. The new idiom of U.S. foreign policy—"smoke 'em out," "bring 'em on," "stuff happens," "Wanted: Dead or Alive"—was less the spontaneous creation of the White House than a ready collusion with the public clamor for cowboy vengeance. On September 24, Bush said of the terrorists, "They thought they could diminish our soul. They just strengthened our country . . . we'll be a stronger nation as a result of this." In search of a national vernacular of strength and virility, Bush and his ghostwriters, along with a thousand editorialists and commentators, reached for the language of the 1950s Western.

That reflexive retreat into America's haunting mythology is explored by Susan Faludi, with characteristic lucidity and drive, in The Terror Dream. She argues that the September 11 atrocities, far from being "unprecedented," as people like to say, awoke this country's oldest, darkest, and most enduring folk memory: the fear of sudden attack by Indians-the burning village, the glint of the tomahawk, the triumphant whooping of infidel savages bent on the destruction of white Christian civilization. For more than two hundred and fifty years, from the Pequots and Narragansetts in seventeenth-century New England to the Comanches, Sioux, Cheyennes, and Apaches on the western plains in the last quarter of the nineteenth century, Native Americans were assigned the role of murderous fiends by the settlers. Even after the 1890s, when the last beaten Indians were interned on government reservations, their role as the original terrorists survived them. The Ku Klux Klan cast blacks in their image, as Joseph McCarthy cast Reds in the Cold War, but it wasn't until 2001 that Americans came face to face with men who so perfectly embodied the demons of antique nightmare—swarthy heathens who had been living undetected in our midst, bringing death by fire out of a clear blue sky.

The mythic connection was instantaneous. Faludi reports that on September 11 she was in Los Angeles, where she took a call from a reporter (who has to be admired for his lightning grasp of the new zeitgeist) asking for her opinion on what the attacks meant for the "social fabric." His own view became clear moments later: "This sure pushes feminism off the map!" Sometime before noon that day, the Manly Man returned to America with, alongside him, the Womanly Woman, whose childlike dependence and frailty were required in order for her to be rescued and protected by the burly male hero. By 8:30 p.m. EDT, when the president addressed the nation on television ("These acts shattered steel, but they cannot dent the steel of American resolve"), we were already beginning to find ourselves inside a familiar movie plot.

A formidably adroit polemicist, Faludi has the great merit of rarely sounding polemical. Like an archaeologist patiently sifting through a midden, she picks fastidiously through the slurry of bad journalism that followed 9/11, letting the patterns she discerns in it speak more or less for themselves. Her own tone is cool, often amused, always lethally observant, as she holds up for inspection each new artifact in the form of a quotation from Ann Coulter, James Wolcott, Jonathan Alter, Diane Sawyer, Camille Paglia, Thomas Friedman, David Brooks, Charles Krauthammer, and dozens more. In the process, she reconstructs the national temper of that time with a kind of shocking fidelity to its lunacies. In September this year,

Friedman belatedly admitted that "9/11 has made us stupid. I honor, and weep for, all those murdered on that day. But our reaction to 9/11—mine included—has knocked America completely out of balance." On one level, The Terror Dream is our Dunciad, a satire on an era of stupidity and its hack writers that began in the fall of 2001 and lasted at least until election day in November 2006, if it's not still with us now.

As in Backlash and Stiffed, Faludi uses the cultural manipulation of gender as a close-up lens, directing it on events to great, if necessarily selective, effect. Within the first few hours, the taciturn bravery of the New York firefighters—immediately and pointedly renamed firemen—supplied the mold into which politicians would try to shape themselves in the days and years to come. Although the firefighters themselves would attribute their appalling losses (three hundred and forty-three died at Ground Zero, or, as they called it, "the pile") to a failed command structure and radios that didn't work inside the towers, the media insisted that they'd voluntarily sacrificed their lives in an act of rugged male heroism; and although two out of three people working in the World Trade Center were men, the dominant photographic image of the firefighter was of a man rescuing a woman. Firemen—to their widespread embarrassment—were cast as the new sex symbols: the Orange County Register commissioned a female reporter to date one ("All day I'd wondered whether the Real Man could kiss. All I can say is wow, can he ever").

By a seamless sleight of hand, the firefighter with axe and helmet became the cowboy with gun and Stetson, the alpha-male defender of his imperiled women and children. In a column for the *Wall Street Journal*, published on October 12, 2001, Peggy Noonan wrote:

I think [John Wayne] returned on September 11. I think he ran up the stairs, threw the kid over his back like a sack of potatoes, came back down, and shoveled rubble. I think he's in Afghanistan now, saying, with his slow swagger and simmering silence, "Yer in a whole lotta trouble now, Osama-boy."

I think he's back in style. And none too soon.

Welcome back, Duke.

Among the people who had "killed" Wayne, Noonan blamed "feminists... peaceniks, leftists, intellectuals," along with Woody Allen, who "made nervousness and fearfulness the admired style."

This rebirth of pungent, few-words masculinity—or the "Menaissance" as the *Boston Globe* dubbed it just last year—required women who were

properly grateful to be slung over the shoulders of their stalwart rescuers. Those who dared to question or critique the emergent cowboy code, like Susan Sontag, Katha Pollitt, Barbara Kingsolver, and Arundhati Roy, were vilified as witches—"hysterical," "moronic," "repulsive," "deranged," "despicable," and "foaming-at-the-mouth." Ed Koch prophesied that "Susan Sontag will occupy the Ninth Circle of Hell." By contrast, Faludi points out that Bill Maher, when he said "We have been the cowards..." on *Politically Incorrect*, was defended by such unlikely figures as Rush Limbaugh, Bill O'Reilly, and Sean Hannity. When Jonathan Alter wrote a *Newsweek* column titled "Blame America at Your Peril," about "ignorant and dangerous appeasement" and "mindless moral equivalency," he named only three such ignorant and dangerous "lefties," all of whom were women: Sontag, Kingsolver, and Alice Walker.

The war on terror was men's business in which there was little or no room for opinionated women, and Faludi documents the sudden, precipitous decline after 9/11 of female bylines on the op-ed pages and female contributors to radio and TV talk shows, noting that even the liberal *Nation*, edited by Katrina vanden Heuvel, kept in step with the national trend. In the media dissection and mythicization of the last minutes of Flight 93, the software salesman Todd Beamer ("OK. Let's roll") was the anointed hero, while the flight attendant Sandra Bradshaw, who phoned her husband to say she was boiling water in the galley to scald the hijackers, was effectively edited out of a story in which her quick-thinking initiative might have diluted the tough-guy glamour of Beamer and his athletic male colleagues as they sprinted down the aisle. *Time* authoritatively reported that, as a high-school basketball player, "Todd Beamer was the kind of guy you wanted on the free-throw line in a tied game."

Rather than Sandra Bradshaw, it was Lisa Beamer, the grieving widow, devout Christian, and stay-at-home mother, who was held up as the role model for American women at a time of war—the prototype of the "security moms" who were later predicted to swing the 2004 presidential election for George W. Bush. The good woman was promoted as someone who knew little about politics but expected her leaders to keep her and her family "safe," preferred childrearing to a career, and dressed fetchingly for the Real Man in her life. Faludi has a good deal of fun with the spring 2002 fashion pages, in which the new post-9/11 look proclaimed a return to exaggerated femininity.

The new styles for women are "distinctly nonaggressive," a Vogue editor announced. "They're not about dominance, power...but

instead gentle and private"—like the "diaphanous chiffon dress" that reflected "the internal landscape of a peaceful existence." *Allure's* fashion director asserted that, "as a result of the atrocities of Sept. 11," clothes should be white—it's "a very angelic, soothing, ethereal type of color" that makes us feel "like we're on some kind of road to recovery." The general media helped promote these new fashion priorities, too. "The toughness of last season has surrendered to a sweet, romantic, girlish sensibility," *Newsday* advised readers. "The clothes themselves are a lovely salve for our wounds."

The fashionable man kitted himself out in "protector gear": "Armani peddled camo duds," and "Bloomingdale's opened 'The Fire Zone' in its flagship Upper East Side store, where men could dude themselves up in firefighter's jackets and 'FDNY' sweatshirts." Journalists, themselves writing in the new season's style of butch fireman prose, clad the Bush administration in becoming gunfighter outfits:

A Vanity Fair cover-story photo essay featured Bush as a flinty cowboy in chief, sporting a Texas-sized presidential belt buckle—and assigned all the president's men superhero monikers: Dick Cheney was "The Rock," John Ashcroft "The Heat" ("Tough times demand a tough man"), and Tom Ridge "The Protector" ("At six feet three, with a prominent Buzz Lightyear Jaw, he certainly has the right appearance for a director of homeland security"). Rumsfeld had "gone to the mat with al-Qaeda, displaying the same matter-of-fact, oddly reassuring ruthlessness." And national security officials Richard Armitage, Paul Wolfowitz, and Stephen Hadley were "almost as battle scarred." At least at the gym, where Armitage "can bench-press 440 pounds."

In November 2001, Karl Rove enlisted the help of Hollywood to project the image of Bush as heroic defender of the nation. The result was a three-minute montage of "110 scenes of valorous vengeance" from classic movies, assembled by the director Chuck Workman and titled *The Spirit of America*. Massively distributed to cinemas and schools around the country, this hectic distillation of mostly brutal virtue was "bookended," as Faludi says, by the opening and closing shots of John Wayne in *The Searchers*, made by John Ford in 1956.

That film was a strange and telling choice. Ford had earlier cast Wayne as a white-hat hero, but in *The Searchers* he plays Ethan Edwards, an outlaw (at the beginning of the film he appears to be fresh from a bank rob-

bery), an Indian-hating racist, and pathological killer. His six-year search for his niece, Debbie, abducted by Comanches after they killed her parents, her brother, and her sister, is not a mission to reclaim her for white society; he plans to shoot her because "Livin' with Comanches ain't livin'," by which he means that the girl will have been so unspeakably violated by the Indians that only death can redeem her. Moreover, Ford strongly insinuates that Debbie may not be Edwards's niece but his daughter, conceived with his sister-in-law shortly before he rode off to fight for the Confederacy in the Civil War. When, at the end of the movie, Wayne puts away his gun and cradles Debbie-now the young widow, by a few minutes, of a Comanche chieftain—in his arms, his action is one of unprecedented mercy by a cynic with a tungsten heart. Rove and Workman, encouraging twenty-first-century schoolchildren to see Ethan Edwards as an inspiring model for their Texan president, were plumbing the lower depths of public feeling at a time when being in touch with one's inner Indian killer had become the hallmark of the true-blooded American male.

The brazenly staged "rescue" of Private Jessica Lynch from her hospital bed in Nasiriyah in 2003 is the well-constructed central hinge of *The Ter-ror Dream*, and Faludi folds the American present into the American past around that day when the war in Iraq was turned into an episode from a Hollywood Western. Lynch herself has always refused to recognize as her own the story of a helpless maiden rescued from the fate worse than death by a posse of daring male heroes, insisting that she was receiving exemplary care from her Iraqi doctors and nurses when U.S. commandos, equipped with night-vision video recorders to immortalize their mission, burst into the hospital, draped Lynch with an American flag, and raced her on a gurney to the safety of a Black Hawk helicopter.

But no one listened to Lynch—least of all her ghostwriter, Rick Bragg, the former color-writer-in-chief at the *New York Times*. In Bragg's *I Am a Soldier, Too*, Lynch was required to be raped by her savage captors (something she has continued to deny), relentlessly girlified ("She looked like a child who had sneaked into her daddy's closet and tried on his uniform to play soldier"), and transformed from a servicewoman who had voluntarily reenlisted for a second four-year term into a civilian princess deserving to be rescued from the dark tower by knights in shining armor. In all this, Faludi sees a flickering reprise of the tale of Cynthia Ann Parker, abducted by Comanches in 1836 and eventually rescued by the Texas Rangers in 1860, in the course of a massacre whose victims were nearly all Indian women and

children. (It was the Parker story that inspired Ford's *The Searchers*, via the 1954 novel of the same name by Alan Le May.)

Cynthia Ann Parker, long sought by James Parker, her ne'er-dowell uncle, a horse thief, fraud, and bounty hunter (he published a selfpromoting book titled Narrative of the Perilous Adventures, Miraculous Escapes, and Sufferings of Rev. James W. Parker), had resisted a string of attempts to ransom or capture her from the Comanches. She took an Indian name, Nautdah, and married the warrior who'd led the 1836 raid on her family compound, and to whom she bore three children. On her unwilling return to white society, the Texas newspapers went to town on the supposed tortures and rape she had endured during "her long night of suffering and woe." Then as now, the sexual violation of the woman was needed in order to validate the myth of her heroic male saviors. In fact, Parker repeatedly tried to escape back to her Indian family, and had to be locked in a room by her white relatives. Topsannah, the infant daughter with whom she was seized by the Rangers, caught pneumonia and died. Parker mutilated herself, refused to speak or eat, and died in 1870 of starvation and flu.

The national obsession with the fate of people kidnapped in Indian terror attacks found voice in the "captivity narrative," which Faludi claims as the "only genre indigenous to American literature." Between 1682, the date of Mary Rowlandson's A Narrative of the Captivity and Restoration of Mrs. Mary Rowlandson, and 1890, more than two thousand of these works were published, and "in the early nineteenth century, every best-selling novel featured a captivity drama." "The trial of Indian bondage was the first story America told itself."

Rowlandson, taken prisoner along with her three children in an Indian raid on Lancaster, Massachusetts, in 1675, spent twelve weeks with the Narragansetts before she was ransomed by her countrymen for £20. "I had often before this said that if the Indians should come, I should choose rather to be killed by them than taken alive," she wrote, but—like Lynch and Parker—she was not forced to endure the rape she dreaded. "Not one of them ever offered me the least abuse of unchastity to me, in word or action." Her sharpest words were reserved for her own people: "I cannot but remember the slowness and dullness of the English army, in its setting out." It was the failure of the white man to protect and rescue her, rather than the atrocities of the savage infidel, that appear to have loomed largest in Rowlandson's memory of her experience—and white men behaving badly is both a recurrent theme in the captivity narratives and forms the essential nub of Faludi's argument.

Time and again, the stories report the lax defenses of the townships against Indian attack. Husbands gallop away on horseback, leaving their women and children to fend for themselves. Rescue attempts are belated and feeble. Women are forced to make excuses for the cowardly behavior of their menfolk, as in this exchange from a late example of the genre, not mentioned by Faludi, Fanny Kelly's *Narrative of My Captivity Among the Sioux Indians* (1871):

Mrs. Larimer, with her boy, came to us, trembling with fear, saying, "The men have all escaped, and left us to the mercy of the savages."

In reply, I said, "I do hope they have. What benefit would it be to us, to have them here, to suffer this fear and danger with us? They would be killed, and then all hope of rescue for us would be at an end."

Some women prisoners took matters into their own hands, in the most unwomanly way, like the celebrated and reviled Hannah Duston of Haverhill, Massachusetts, who, aided by a young English boy, hacked ten Abenaki Indians—two men, two women, and six children—to death with stolen tomahawks in 1697, made her escape by canoe, then returned to scalp her victims (since the going rate of bounty money was \$50 a scalp, she turned a handsome profit on her fifteen-day captivity). Thoreau, in *A Week on the Concord and Merrimack Rivers*, admired Mrs. Duston's audacity, but Hawthorne called her "the bloody old hag." Such unseemly enterprise on the part of a woman threatened to undermine the entire structure of the American family.

Anticipating Jerry Falwell, Increase Mather explained Indian attacks on white settlements as "awfull testimonyes of divine displeasure," and saw King Philip's War as a "providential dispensation of God" that was meant to bring about "A Reformation of those Evils which have provoked the Lord to bring the Sword upon us." To this end, regular days of "Publick Humiliation" were added to the calendar, when New Englanders repented of the "strange degeneracy" into which they'd sunk, and which presaged for them the same fate that God had inflicted on the wicked cities of Sodom and Gomorrah. Here, Faludi slightly overplays her cards. Wanting Mather to lay the blame for the colony's woes at the feet of its young men, their idleness, drunkenness, and effeminate taste for "monstrous and horrid *Perriwigs*," she fails to complete the quotation, which goes on, "and women with their *Borders and False Locks* and such like whorish fashions, whereby the anger of the Lord is kindled with this sinfull land." But of course degeneracy in women reflected a breakdown of male authority and morality, and

Faludi is surely right to say that Mather saw the Indian raids as divine retribution for a more general crisis of American manhood.

So the myth of the male guardian and avenger, which took its most powerful form in stories of the West, beginning with the elevation of the bemused and hapless figure of Daniel Boone to the status of national hero, arose, according to Faludi, because in real life American men had from the beginning failed to live up to the roles in which they were cast. In the multitude of asymmetric wars against the Indians, the army was off somewhere else, leaving the women and children as easy meat for what Mather called the "Heathen Enemy." Or the fortifications were neglected. Or the husband fled to save his own skin. This extensive history of male humiliation gave birth to the compensatory fiction of protective male bravery and power. Riffing on a passage from Richard Slotkin, Faludi asks:

What if the unbounded appetite for conquest derives not only from our long relish for the kill but from our even longer sense of disgrace on the receiving end of assault—assaults to our women in our own settlements and in our own homes? What if the deepest psychological legacy of our original war on terror wasn't the pleasure we now take in dominance but the original shame that domination seeks desperately to conceal?

Claude Lévi-Strauss wrote that "the purpose of myth is to provide a logical model capable of overcoming a contradiction." In *The Terror Dream*, the main contradiction exposed by Faludi is between the more or less impossible duties assigned to men in American society from its earliest days and the predictable failure of men to adequately perform them. Yet that contradiction, important as it is, and eloquent as Faludi is in its unraveling, sits in the shadow of a larger and more glaring one: the fact that white American settlers, whether in New England or the nineteenth-century West, were in the unusual predicament of being simultaneously "at home" and "in enemy territory," two categories that are normally kept rigidly separate, though perhaps Israeli settlers on the West Bank are in a rather similar situation.

The early colonists didn't see themselves as occupiers, garrisoned in a foreign country, making themselves as comfortable as they could while far from their real home. Though many did in fact return to England, they came to stay, in what Mather called "our Judah"—the name at once of a people and of its appointed land. That God had populated their new world with agents of the Devil and punished them for their sins with sporadic attacks on their homes, was a sign of His providence. As Mather said, "God

does not send such things for nothing," and Indian raids were to be interpreted as uniquely intimate communications from the Creator to His chosen people. It was a peculiarly American fate to sit comfortably at one's own hearthside and be in a state of barely suspended terror. Benjamin Franklin described the Indians' "manner of making war" as "skulking, surprising, and killing particular persons and families"; their ability to skulk patiently for long periods and then surprise, classic terrorist tactics, meant that no spell of seeming domestic serenity could be entirely free of anxious thoughts of ravening infidels in the woods or the backyard.

That curious plight, or state of mind, is caught quite beautifully in the opening scenes of *The Searchers*, as John Ford lingers over the selling points of the Edwards family homestead. Far from being the standard wood-frame cabin of the mobile and temporary West, the Edwards place is a house built for the ages, with sturdy walls of adobe brick (so symbolically important is the brickwork that it forms the backdrop on which the movie's credit titles are superimposed) and massive timber beams to support the shingled roof. Inside, lamplight plays on the matching china on the dining table, the rugs on the immaculately carpentered floor, the accumulation of treasures and knickknacks on the shelves. A fire glows in the hearth. It's like a Delft School interior, a tribute to the warmth and solidity of family life.

But the illusion stops dead at the unglazed windows, which look out on a wilderness of sagebrush and red shale, low buttes, eroded cliffs, rock pinnacles (the movie, set in Texas, was filmed in Monument Valley, Utah)—the terrain of menace, where Indians skulk and bide their time. A few withered-looking junipers dot the desert, making one wonder where on earth those roofbeams came from. On a hillock near the house, two gravestones form the beginnings of the family graveyard, the tombs of the Edwards grandparents "Killed by Comanches" in 1852, sixteen years before the action of *The Searchers* begins, and it won't be long before the two graves are joined by four more. Between these contradictory realms of the domestic and the savage stands the gun hung on the lintel over the front door.

Wayne as Ethan Edwards, the solitary nomadic outlaw, belongs to the hostile exterior world; inside the house, he's an awkward and disruptive figure. It's his younger brother, Aaron, played by Walter Coy as if he were in urgent need of a course of antidepressants, who has to be both indoors and outdoors at the same time. Grimly sure that Comanche warriors are gathering in the middle distance, a few hundred yards from the house, he takes the gun down, loads it, and mutters, "I think I'll see if I can't knock off a couple of sage hens before supper"—a necessary fiction, and one he carries

off with no aplomb at all. Poor Aaron: cuckolded by his own brother, he's expected to juggle the roles of husband and father, cattle rancher and one-man militia. As Susan Faludi would say, Aaron Edwards has been stiffed.

Only after September 11, as newspapers began to document the American lives and travels of Mohamed Atta and his accomplices, did we wake to the notion that, like the Edwards family, we'd been living in enemy territory all along. The credit-card trails left by the terrorists showed that they had been skulking everywhere amongst us, in New Jersey, Florida, Nevada, California, and points between. Across the country, from Dearborn, Michigan, to Seattle, plots and conspiracies involving Arab Americans were uncovered and trumpeted by the administration before they disintegrated in the courts as fantasies. The attorney general, John Ashcroft, floated his plan to enlist meter readers and postal-service workers as neighborhood spies, to keep a lookout for heathen types who might be up to no good. Local TV news bulletins were full of sightings of suspicious "men of middle-eastern appearance." The resemblance between twenty-first-century America on red alert and the movie version of an Indian war was further strengthened by the administration's resort to the rough justice of the frontier, as it interned prisoners in the legal no-man's-land of Guantánamo Bay, licensed torture, endorsed the CIA program of "extraordinary rendition," and bent the law with warrantless wiretaps.

There was in all this a simmering manic elation, and a widespread sense that, after the frivolities of the Clinton era, the terrorist attacks had restored America to its original roots and destiny. Once again Americans could see themselves as a nation uniquely imperiled by devilish savages. In the nineteenth century, scenes like that of the burning, ransacked homestead in *The Searchers* were an intermittent reality mainly because of the policy of brutal extermination pursued by such white heroes as General "Squaw-Killer" Harney and General Custer. Looking at the parallel situations of Canada and the United States, it's tempting to see acts of Indian terrorism south of the border as much as expressions of a perverse need of white Americans to feel terrorized as of any great desire by the Indians to wage war on the settlers.

Why America has repeatedly nourished itself on stories of murderous demons in its backyard is the great unaddressed question in *The Terror Dream*. Faludi brilliantly dissects what happens when the nation reverts to a quasi-frontier society in which "mythical male strength... can only measure itself against a mythical female weakness," but she writes about a

consequence without quite nailing its cause. Wholly convincing on Indians as the proto-terrorists of America's paranoid imagination, she fails to explain the strange, centuries-old obsession—even love affair—with the sensation of thrilling endangerment that the Indian presence kindled in white minds. When the country lapsed into cowboy histrionics in 2001, it seemed to be feeding a long-standing addiction, not so much to divisive and outdated gender roles, as Faludi rather anticlimactically suggests at the end of her book, but to the powerful psychotropic substance of terror itself. The rescue of helpless female victims by John Wayne—style avengers was an essential part of the paraphernalia of the trip, but hardly either its reason or its object.

November 2007

The Curse of the Sublime

HERE IN THE WEST, there's an ongoing war (with real shots sometimes fired from real guns) between the metropolitan cities and their outlying rural towns. From the perspective of the small town it's tempting to see every environmental initiative—to halt or restrict logging, mining, and ranching on federal lands, to demolish dams on rivers like the Columbia, the Snake, and the Colorado, to reintroduce the buffalo, the wolf, and the grizzly bear—as the work of wealthy big-city hobbyists who show up in the countryside on weekends in hybrid SUVs laden with backpacks, fly rods, and climbing gear. With their ready money, soft hands, and unlined faces, the carbon-footprint-conscious invaders look like an alien tribe, zealots bent on the destruction of traditional rural livelihoods. From the perspective of the city, the country dwellers are too easily seen as lacking in education and enlightenment, hapless dupes of the timber and mining corporations, proletarian obstacles to the great mission of conserving what little is left of American wilderness.

Important arguments about land use in the West are aggravated by class resentment and class condescension. This isn't just the result of the real disparity between rural and metropolitan incomes in the region: something nastier and deeper is going on, and it's embedded in the DNA of the language in which we talk and think about wild nature.

Not all that long ago, the kind of landscape now so prized in the Intermountain West struck civilized observers as merely ugly and useless—heaps of geological rubbish. In the 1720s, Daniel Defoe made a tour of Great Britain and was repelled by the very modest mountains (none much higher than 3,000 feet) that he encountered in Scotland and Wales: "barren," "impassible," "frightful," "barbarous," "terrible," "horrid," and "desart" were his words for them. It was only in the second half of the eighteenth century that

the rage for the Romantic Sublime took hold, and it became fashionable to see mountains, cascades, precipices, and impenetrable forests as objects of transcendent wonder and beauty. By 1806, when the Lewis and Clark expedition came within sight of the Rockies—which would soon prove to be an almighty headache for the explorers as they tried to cross them—Lewis was able to greet the mountains as "picturesk," "sublime," "noble"; "august spectacle," "beautiful," "majestically grand scenery."

That vocabulary, still relatively fresh when Lewis was writing his journal, has had an astonishingly long and resilient life in America, mainly because of the huge influence of John Muir, the sainted godfather of the conservation movement, founder of the Sierra Club, and prime mover in the establishment of the National Parks system. At a time when the cult of the sublime was all but dead, Muir brought it back to life, stamping it with his own brand of evangelical fervor. "Christianity and mountaininity are streams from the same fountain," he wrote to a friend, and his work combines acute and precise botanical and geological observation with a kind of shivering religious ecstasy in the presence of nature's "divine truth." Muir was part scientist, part missionary, part hard-nosed salesman: selling the wonders of the West to railroad tourists from the East, he wrapped them in an irresistible package of expert natural history, lofty spirituality, and old-fashioned poetry.

Rhapsody was his natural medium. Traveling through the mountains with Muir, one is exhorted in almost every paragraph to thrill to their sublimity, grandeur, nobility, and majesty—words that dot his prose like currants in a bun. His message couldn't be more plain: in the craggy aristocracy of the peaks and woods, we commune with majesty and nobility, and thereby rouse something noble and majestic in ourselves. In the National Parks—"Nature's sublime wonderlands, the admiration and joy of the world"—spiritual uplift goes hand in hand with social uplift, and to hike through Yosemite is to enjoy a uniquely patrician experience in democratic America.

The distinct undercurrent of class and racial elitism that runs through Muir's writing has always, I suspect, been part of his appeal. In *My First Summer in the Sierra*, he complained of how the Mono Indians polluted the purity of Yosemite with their "dirty and irregular life" in "this clean wilderness," and went on to remark, "The worst thing about them is their uncleanliness. Nothing truly wild is unclean"—a sentiment worth dwelling on for its complicated tangle of implications. In *A Thousand-Mile Walk to the Gulf*, he sang the praises of Athens, Georgia, "a remarkably beautiful and aristocratic town," admiring the "many classic and magnificent man-

sions of wealthy planters, who formerly owned large *negro-stocked* plantations [my italics]. Unmistakeable marks of culture and refinement . . . were everywhere apparent. This is the most beautiful town I have seen on the journey, so far, and the only one in the South that I would like to revisit." What impressed him most was the deferential behavior of the blacks he encountered in Athens:

The negroes here have been well trained and are extremely polite. When they come in sight of a white man on the road, off go their hats, even at a distance of forty or fifty yards, and they walk bare-headed until he is out of sight.

There's a connection here between Muir's infatuation with a hierarchical, aristocratic society, where the lower orders know their places and doff their caps to their betters and the lords and ladies exhibit their culture and refinement (all rather odd, coming from someone who was raised as a Scottish Presbyterian), and his rapturous exultation in the nobility and grandeur of the mountains. In the thin, clean air of Muir's beloved wildernesses lay a healing alternative to the plebeian jostle of the American city, where people led lives "mildewed and dwarfed in disease and crime." Visit the high places of the West, he promised, and vacation like a king.

Today, Muir's language flourishes and sometimes runs riot in guide-books, in the writing of outdoors columnists, and, not surprisingly, in the newsletters put out by local chapters of the Sierra Club, where hikers and mountaineers report on their adventures. "The view from the aerie perch was sublime." "I stopped frequently to absorb the majesty." "Whitney's regal profile towered over us." The word "noble" gets attached to trees ("noble giants"), silence, summits, bighorn sheep, bald eagles, and, mysteriously, both snipe and Chinese bicycles.

The words matter because they define the north rim, as it were, of that great rift of sensibility which divides the nature tourists and conservationists from the majority of people who live and work in landscapes cherished by visitors for their grandeur. Anyone who's driven through the mountainous West on twisting, unpaved forest roads and minor state routes knows the shock of arrival at the next town. For hours, you drive through the furniture of Muir's sublime, the landscape of conventional majesty: dense pathless forest; lone pines clinging to needlelike crags; plunging cataracts; jagged, snow-capped peaks; sheer, thousand-foot drops from the edge of the unfenced gravel road. Then the gradient of the river-hugging road eases, the current slows, and the first speed-limit sign comes into view. From the

T-junction where the gravel meets the highway, you get your first sight of the town, and the circuits of the brain go into overload as the eye tries to square what's gone before with what's to come.

It's a generic western town—wide main street; single stoplight; a pair of competing motels; a pair of competing gas stations; a decaying mercantile block of brick and stucco, dating from the 1920s; the off-pink cinder-block bulk of a Kmart; a strip mall with the adult-video store next to the Mexican restaurant; a Safeway; a drive-through bank; a tavern; a school; a church or three; all of this set in a grid of bungalows that fills the narrow valley like a moraine.

If there's an election on, yard signs in the side streets will supply you with the name of everyone running for sheriff, mayor, or city councilman, for local democracy functions here with an enthusiasm and an informed knowledge of the issues and personalities that put national politics to shame. The bungalows—apparently identical when seen at a distance—in close-up turn out to be entertainingly full of individual eccentricity and character. The town is well worth a wander, for it is, in its way, an American classic, an example of expressive vernacular architecture as distinct—and certainly as recognizable—as that of a Tuscan hill village.

But if you approach it with your head full of Muir-speak, it's an eyesore, a blot on the landscape, a square mile of schlock. Its massive, boldly painted chainsaw sculptures, far from being marks of culture and refinement, appear as brutal assaults on the sacred nature of old-growth forest. Its neon signs are an affront, its broad streets out of all proportion to the low homes that line them. The one-storey (and largely one-class and one-industry) settlement, which got its start in life as a mining or logging camp, or an arbitrary railroad stop, is a world away from Athens, Georgia. In the elevated, quasi-aristocratic language of the decadent sublime, there's no place for the ad hoc, democratic architecture of the working rural West. The casual visitor, fresh from his noble mountains, sees its glaring lack of nobility, wealth, beauty, antiquity, and height, and disdainfully regrets its existence—or would, if only he weren't running short of gas. Ghost towns, of course, adorn the view, by reminding the romantic tourist of the mortal folly of all human enterprise when set against the enduring grandeur of nature, but living ones tend to ruin it.

Consider Leavenworth, Washington, which in its heyday had a railroad depot and roundhouse and a big sawmill, but lost both in the course of the 1920s. In 1965, after three decades of slow moldering and population loss, it did what westerners are famed for doing and set out on a program of fantastic self-reinvention. Taking its cue from its setting on the eastern

slopes of the Cascade Range, a two-hour drive from Seattle, it became a Bavarian alpine resort, the Berchtesgaden of Chelan County. The town has a draconian building code governing roof pitches, extent of overhangs, scrolled lookout beams, shutters, balconies, flower boxes, the proportion of timber to stucco, and so forth, and requires would-be developers to pore over such books as *Bayern in Bildern*, *Häuser in den Alpen*, and *Wohnen in Alpenland*. There are cuckoo-clock shops, German gothic street signs, restaurants serving wiener schnitzel and sauerkraut, at least one hotel where guests are woken for breakfast by a folk-costumed *mädchen* tootling on an alpenhorn, and the calendar is punctuated by *fests* of accordions, wine, and beer, and, for the holidays, the *Christkindlmarkt*.

Kitsch, certainly, but not quite Disney: Leavenworth is too earnest a replica for that, saved from mere whimsy by its ferocious attention to realistic detail and materials. Seattleites flock to it (as do, apparently, homesick German exiles) because the place reeks alluringly of castles, kings, prince-electors, its architecture in tune with the lust for antiquity and nobility that goes with spending a weekend in the mountains. By artfully obliterating from view as much as it can of its own history, nationality, language, and culture (no exceptions are permitted; even McDonald's and Exxon have undergone Bavarian makeovers), Leavenworth has made itself acceptably picturesque. In the eye of the tourist, focusing her camera on the conventionally grand alpine scene beyond the town, there's no incongruity between the streets in the foreground and all the majestic stuff in the middle and far distance. The usual problem in these parts has been ingeniously solved, though a little forgiving myopia helps.

One has to admire the town's enterprise, and I've enjoyed my visits there, but one Leavenworth is quite enough. It's time to retire the language of the sublime, with its implicit class snobbery, its muddling-together of aesthetic pleasure with social hierarchy, and to look freshly at the relationship between the un-gussied-up townships of the American West and their natural surroundings.

You can't move around the rural West without bumping into the stereotype of the environmentalist as someone who is messianic, impervious to argument, insufferably superior in his manners, with a lofty disregard for the lives, jobs, and communities of ordinary people. "Are you an environmentalist or do you work for a living?" was a favorite bumper sticker in the 1990s timber wars here in the Pacific Northwest. As stereotypes go, it's crude but not entirely baseless. Much antique rhetorical baggage is carried by the environmental movement, most of it directly traceable to Muir. There are powerful reasons to protect as best we can the federally

owned forests and mountains from the chainsaw, the drill, and unregulated grazing—not for their majesty and grandeur, or the recreational opportunities they afford to visitors from the city, but for their ecological necessity for everyone. It isn't a matter of mere aesthetics: the West, once seen as limitless in its myriad resources, as the oceans were, is perilously delicate and vulnerable—not least to the lines of tourists trailing up its mountainsides. But the environmental case is lost, like the baby with the bathwater, so long as the countryside can perceive it to be made in terms of the ennobling spiritual benefits of roadless hiking, and the snobbish taste for natural beauty of the urban leisure class.

The region's history has always been one of rancorous battles between mutually incompatible visions of its use and future, from whites vs. Indians and cattlemen vs. sodbusters to our present multifrontal conflict between exploitation and conservation. We should at least remove from that debate, which is fought with righteous fury on every side, the outworn, undemocratic assumptions that covertly underpin our long, unthinking, sentimental attachment to the sublime.

Playboy, January 2008

Good News in Bad Times

Belief is the open-sesame word in Barack Obama's vocabulary: on Thursday night he told his cheering audience that January 3 would stand as the moment when "America remembered what it means to hope," and ended with the hoarse, exultant shout: "We are ready to believe again!"

At the University of Chicago Law School, famous for its faculty of conservative jurists, Obama, senior lecturer in constitutional law, is still listed as being on leave of absence. Six miles from the university on Chicago's far South Side, in the nondescript, low-rent, mostly low-rise neighborhood of Brainerd, is Trinity United Church of Christ, which Obama attends and where his pastor, the Rev. Dr. Jeremiah Wright, apostle of black liberation theology, delivers magnificently cranky sermons on how the "African diaspora" struggles under the yoke of the "white supremacists" who run the "American empire."

Obama's membership in both institutions, the radical black church and the conservative law school, is a measure of the chasm that this latest candidate of hopes and dreams is trying to span. It's also a measure of his political agility that the senior lecturer in law has managed to recast the language of black liberation theology into an acceptable—even, conceivably, a winning—creed for middle-of-the-road white voters.

Obama is cagey, in a lawyerly fashion, about the supernatural claims of religion. Recounting a conversation about death that he had with one of his two young daughters, he wrote, "I wondered whether I should have told her the truth, that I wasn't sure what happens when we die, any more than I was sure of where the soul resides or what existed before the big bang." So I think we can take it that he doesn't believe—or doesn't exactly believe—in the afterlife or the creation.

His conversion to Wright's brand of Christianity was "a choice and not an epiphany," born of his admiration for "communities of faith" and the shape and purpose they give to the lives of their congregants. "Americans want a narrative arc to their lives. They are looking to relieve a chronic loneliness"; "They are not just destined to travel down that long highway towards nothingness." As for himself, and his enlistment at Trinity United: "Without a vessel for my beliefs, without a commitment to a particular community of faith, at some level I would always remain apart, and alone." It's typical of Obama that such a cautiously footnoted profession of faith rings sympathetically to both atheists and true believers.

To become a virtual congregant at Trinity United is to enter a world of metaphor, in which the manifold trials of the children of Israel at the hands of emperors and kings are transformed by Wright into the self-same sufferings of African Americans today. As Obama put it, describing his own moment of conversion in Wright's church when, as a community organizer in Chicago, he was still a near stranger to black culture: "At the foot of that cross . . . I imagined the stories of ordinary black people merging with the stories of David and Goliath, Moses and Pharaoh, the Christians in the lions' den, Ezekiel's field of dry bones. Those stories of survival, and freedom, and hope—became our story, my story."

In a Christmas sermon on the theme of "Good News in Bad Times," Wright fuses Nebuchadnezzar, Caesar Augustus, and George Bush into a single being, and the U.S. occupation of Iraq, the Babylonian occupation of Jerusalem, and the Roman occupation of Galilee into one event.

Under a universal tyranny of "corporate greed and rampant racism," AIDS flourishes, along with gang bangs, murders, injustices of every kind. Slavery is here and now, and fifth columnists, traitors to their own kind, are all around us—such as the black Republican Alan Keyes and the Supreme Court Justice Clarence Thomas. Bad times. "But right now ain't always," and "great joy is coming in the morning." Wright abruptly shifts gear, from a giddy tour of two and a half thousand years of oppression and tribulation to the good news, bringing his congregation to near-rapture as he launches on a rapid, high-decibel riff on the salvation to come:

The good news that's coming is for all people! Not white people—all people. Not black people—all people. Not rich people—all people. Not poor people—all people. I know you'll hate this . . . not straight people—all people! Not gay people—all people. Not American people—all people . . . Jesus came for Iraqis and Afghanis. Jesus was

sent for Iranians and Ukrainians. All people! Jesus is God's gift to the brothers in jail and the sisters in jeopardy. The Lord left his royal courts on high to come for all those that you love, yes, but he also came for those folk you can't stand.

It's a piece of merely rhetorical wizardry, this conjuring of hope from the grounds of despair, but Wright carries it off with exhilarating command, and one sees immediately how much Obama has learned from him.

The title of Obama's latest book, *The Audacity of Hope*, explicitly salutes a sermon by Wright called "The Audacity to Hope," and his speeches are sprinkled with Wrightisms, but his debt to the preacher goes deeper. While Wright works his magic on enormous congregations with the basic message of liberation theology—that we're everywhere in chains but assured of deliverance by the living Christ—Obama, when on form, entrances largely white audiences with the same essential story, told in secular terms and stripped of its references to specifically black experience. When Wright says "white racists," Obama says "corporate lobbyists"; when Wright speaks of "blacks," Obama says "hardworking Americans," or "Americans without health care"; when Wright talks in folksy Ebonics, of "hos" and "mojo," Obama talks in refined Ivy League. But the design of the piece follows the same pattern as a Wright sermon, in its nicely timed transition from present injustice and oppression to the great joy coming in the morning.

In the speech that brought Obama into the national limelight, his keynote address to the Democratic convention in 2004, he tailors the rhetoric of Trinity United to fit the needs of America at large. First, the bad times: the Constitution abused, the nation despised around the world, joblessness, homelessness, crippling medical bills, a failing education system, veterans returning home with missing limbs, young people sunk in "violence and despair." Then, the good news: "There's not a liberal America and a conservative America—there's the United States of America. There's not a black America and a white America and a Latino America and an Asian America—there's the United States of America . . . " The voice of Jeremiah Wright haunts both the sentiment and the metrical phrasing as Obama comes to a climax with his unveiling of "the politics of hope":

I'm not talking about blind optimism here...I'm talking about something more substantial... The hope of slaves sitting around a fire singing freedom songs. The hope of immigrants setting out for distant shores... The hope of a skinny kid with a funny name who

believes that America has a place for him, too. Hope in the face of difficulty, hope in the face of uncertainty, the audacity of hope! In the end, that is God's greatest gift to us, the bedrock of this nation, a belief in things not seen, a belief that there are better days ahead.

God gets the obligatory mention, but the true divinity here is America itself, a mystical entity that holds out the same promise of miraculous liberation as Jesus does in Wright's sermon.

That address, received with rapt applause at the convention, remains the template for Obama's grand set pieces on the stump, where his adaptation of Good News in Bad Times continues to play to packed houses. When he has the stage to himself, and turns his audience into a congregation, he can be an inspiring preacher, but he shrinks when lined up alongside his fellow candidates in debates, where he's often looked more like an embattled Ph.D. student defending his thesis in an oral exam. He is far better taking questions in town meetings, where he listens gravely, thinks out loud, and comes up with answers that are at once complex and lucid, always seemingly unrehearsed, and lit with occasional shafts of irony.

Obama's transparent intellect, his grasp of legislative detail, the fine points of his health-care plan versus Clinton's, and his views on early childhood education are not what draw the big crowds to his events (and if crowds were votes, he would win the nomination in a landslide). Rather, it is the promise of the "narrative arc" that Obama credited churches with bringing to the lives of black Americans. People want the sermon, not Obama's well-turned thoughts on foreign or economic policy. What the crowds crave from this scrupulous agnostic is his capacity to deliver the ecstatic consolation of old-time religion—a vision of America that transcends differences of race, class, and party, and restores harmony to a land riven under the oppressive rule of a government alien to its founding principles.

Watching the tail-ends of these events, one often sees boredom and disappointment on the faces of people who came for the evangelist but got the competent politician. It is a problem for his campaign that there are several Obamas now running: the charismatic preacher, loved by all; the adroit and well-briefed policy wonk; the lean, dark-suited, somewhat aloof figure so engrossed in his reflections that he seems to be talking as much to himself as to his audience, Hamlet brooding on the state of Denmark. There's also the man who can look far younger than his age (he's forty-six), like a boy with sticking-out ears, the Obama whom Maureen Dowd, the *New York Times* columnist, labeled "the child prodigy." For this last Obama, one

suffers—especially in debates—as one suffers for one's precious offspring on the night of the school play, crossing one's fingers that she won't screw up. Sometimes Obama bombs.

You never know which of these personae will be on show at an event, which is probably why Michelle Obama, barnstorming the country for her husband, has rather over-egged the pudding in her attempt to ground him in domestic reality. From Michelle we've learned that he snores, has "stinky" morning breath, is incapable of returning the butter to the fridge, and is "just a man"—an assurance hardly required of any other candidate, but necessary in his case because the line between demigods and demagogues in U.S. politics is dangerously fine, and Obama, on a religiose roll, can seem, like snake oil, too good to be true.

What seems entirely genuine in his candidacy came out unexpectedly in the last televised debate, when the moderator asked Obama why, if he represented "change," so many of his advisers were drawn from Bill Clinton's two administrations. Hillary Clinton immediately interjected, "Oh, I want to hear that!" and gave vent to her painfully stagey laugh, which was echoing in the rafters when Obama replied, "Well, Hillary, I'm looking forward to you advising me as well." The audience laughter that met this return of service nearly drowned Obama's next remark: "I want to gather up talent from everywhere."

The point where Obama's lofty secular theology and his skills as a practical politician merge is in the likely face of an Obama administration. If Hillary Clinton wins the nomination and the presidency, it's depressingly probable that her cabinet will look a lot like Margaret Thatcher's team of sworn loyalists, purged of "wets." Were Obama to become president, one might fairly look forward to the third branch of government becoming more ecumenical than it's been in living memory, an administration of all the talents, drawn from the ranks of political opponents as well as party allies. Wright says that Jesus comes for the folk you love, yes, and the folk you can't stand. Obama, in 2004, put the thought another way:

The pundits like to slice and dice our country into red states and blue states: red states for Republicans, blue states for Democrats. But I've got news for them, too. We worship an awesome God in the blue states, and we don't like federal agents poking around our libraries in the red states. We coach little league in the blue states and, yes, we've got some gay friends in the red states.

In Obama's sacralized "United States of America," folk sit down with folk they thought they couldn't stand—Republicans with Democrats, Americans with Iranians and Syrians. He's managed to articulate this so persuasively that poll after poll shows his support mounting among registered Republicans, despite the fact that all his declared policies are far to the left of those of the present Republican Party. In a speech in Iowa on December 27, he announced that he was out to "heal a nation and repair the world." On Thursday even Fox News showed an unprecedented soft spot for *this* Democratic candidate. It says a lot about the damaged state of America now that even Republicans hunger to take Obama seriously.

Guardian, January 2008

I'm for Obama

I want a hero: an uncommon want When every year and month sends forth a new one, Till, after cloying the gazettes with cant, The age discovers he is not the true one.

Byron, Don Juan

FOR THE LAST FEW WEEKS, I've left the blue-sheathed national edition of the *New York Times* out in the yard, where it's tossed over the gate at 3 a.m., and gone straight to the paper's website, because news printed nine or ten hours ago is too old to keep up with the fast-moving course of the Democratic nomination battle. As an Obama supporter, I tremble for him as one trembles for the changing fortunes of the hero of an intensely gripping picaresque novel. What does the latest poll say? Has his campaign, usually sure-footed, stumbled into some damaging foolishness? Has another skeleton been uncovered in his closet? Has his vanity got the better of him again, as when he delivered his smirking line, "You're likeable enough, Hillary"? Are the cloyed gazettes finally tiring of him?

As recently as February 29, those of us who were finding the suspense already unendurable were looking to March 4 to provide a swift denouement. Then stuff happened—news of Professor Goolsbee's clandestine visit to the Canadian consulate, the "red phone" TV ad, the start of the Antoin Rezko trial—and the Texas and Ohio primary results made clear that this book has at least a hundred pages yet to go.

This may not seem a very grown-up method of following an election, but it's been forced on us by the apparent shortage of serious policy differences between the two remaining candidates. The question of whether or not the future president should meet with Mahmoud Ahmadinejad, or

if people who fail to pony up for subsidized health insurance should have their wages docked, don't inspire much impassioned conversation at the watercooler. So we're down to arguing over the character and style of Clinton and Obama, rather than—tut-tut!—"talking about the issues." But in this case, character and style are issues because they supply the best available clues as to how each candidate might set about forming an administration and handle the business of government.

In Seattle, one of the most solid liberal-Democrat constituencies in the country, people have been so united in their loathing of the Bush administration and all its works that until now they had pretty much forgotten how to disagree. They have relearned fast. Friendships are strained, dinner parties wrecked, marital beds vacated for the spare room over the Obama v. Clinton question. Our lefty congressman, Jim McDermott, currently in his tenth term (last time around, he beat his Republican opponent by 79 percent to 16 percent), has wisely chosen not to endorse either candidate; and when he showed up at the local caucus on February 9, it was to escort his wife there, not to participate himself.

Some women I know take the rise of Obama as a personal affront. They've seen him too often before—the cocky younger man, promoted over the head of the better-qualified female. They circulate ("I hope you'll share this with every decent woman you know") op-ed pieces by Gloria Steinem ("Why is the sex barrier not taken as seriously as the racial one?") and Erica Jong ("If I have to watch another great American woman thrown in the dustbin of history to please the patriarchy, I'll move to Canada"), along with a grand tirade by Robin Morgan, a reprise of her 1970 essay "Goodbye to All That":

How dare *anyone* unilaterally decide when to turn the page on history, papering over real inequities and suffering constituencies in the promise of a feel-good campaign? How dare anyone claim to unify while dividing, or think that to rouse U.S. youth from torpor it's useful to triage *the single largest demographic in this country's history:* the boomer generation—the majority of which is *female*?

Morgan's piece ends with the resounding but opaque antithesis: "Me, I'm voting for Hillary not because she's a woman—but because I am." Her furious italicizations fairly represent the tone of the quarrels at which I've been present: quarrels in which the word "bullshit!" is freely deployed on both sides, by people whose use of the expletive is as surprising as if they'd suddenly broken into fluent Portuguese.

Two days before the Washington state caucuses, I picked up my fifteen-year-old from her high school, where she's a freshman. She was full of what had happened at morning assembly. A senior ("and he's kind of popular") had stood up to announce that Hillary Clinton would be speaking that evening on the Seattle waterfront, and "the whole school" had erupted in catcalls, boos, and hisses.

"The whole school? Didn't the girls stand up for her?"

"It was everybody. I think the girls were loudest. Nobody's ever hissed or booed at Community Meeting before. It was totally weird. Then another senior got up to say that Obama's going to be at Key Arena tomorrow morning, and everyone was clapping and cheering. It was like the building was coming down."

Next day, her French class had to be canceled because half the school was playing truant at the Obama rally.

Age, gender, race, and class have featured so prominently in the quarrel that they've sometimes seemed to define it as merely demographic warfare and led the pundits to forecast the primary results by doing the simple arithmetic of counting up whites, blacks, browns, union members, college graduates, under-thirties, and over-sixty-fives. But again and again the pundits have got it wrong, suggesting that the real divisions between the Obamaites and the Clintonites are to be found elsewhere.

In a recent issue of *New Republic*, Leon Wieseltier, an Obama skeptic, complained that his positions on foreign policy and national security had "a certain homeopathic quality," more calculated to appeal to his "legions of the blissful" than to meet the needs of an "era of conflict, not an era of conciliation." "I understand," he wrote, "that no one, except perhaps Lincoln, ever ran for the presidency on a tragic sense of life; but if it is possible to be too old in spirit, it is possible also to be too young."

I think Wieseltier raises the right point, but gets it backwards. For a tragic sense of life is exactly what has marked Obama's candidacy from the beginning. His powerful memoir, *Dreams from My Father*, written in his early thirties, is shot through with that sense: its gravely intelligent, death-haunted tone, beautifully controlled throughout the book, is that of an old voice, not a young one—and the voice of the book is of a piece with the plangent, melancholy baritone to be heard on the campaign trail.

Those who hear only empty optimism in Obama aren't listening. His routine stump speech is built on the premise that America has become estranged from its own essential character; a country unhinged from its constitution, feared and disliked across the globe, engaged in a dumb and unjust war, its tax system skewed to help the rich get richer and the poor

grow poorer, its economy in "shambles," its politics "broken." "Lonely" is a favorite word, as he conjures a people grown lonely in themselves and lonely as a nation in the larger society of the world. (Obama himself is clearly on intimate terms with loneliness: *Dreams from My Father* is the story of a born outsider negotiating a succession of social and cultural frontiers; it takes the form of a lifelong quest for family and community, and ends, like a Victorian novel, with a wedding.)

The light in Obama's rhetoric—the chants of "Yes, we can" or his woo-woo line, lifted from Maria Shriver's endorsement speech, "We are the ones we have been waiting for"—is in direct proportion to the darkness, and he paints a blacker picture of America than any Democratic presidential candidate in living memory has dared to do. He courts his listeners, as legions not of the blissful but of the alienated, adrift in a country no longer recognizable as their own, and challenges them to emulate slaves in their struggle for emancipation, impoverished European immigrants seeking a new life on a far continent, and soldiers of the "greatest generation" who volunteered to fight Fascism and Nazism. The extravagance of these similes is jarring—especially when they're spoken by a writer as subtle and careful as Obama is on the printed page—but they serve to make the double point that America is in a desperate predicament and that only a great wave of communitarian action can salvage it.

By contrast, Clinton wields the domestic metaphor of the broom: "It did take a Clinton to clean up after the first Bush, and I think it might take a second one to clean up after the second Bush." It's a deliberately pedestrian image, and it has defined her campaign. Stuff needs to be fixed around the house, but the damage is superficial, not structural. She has a phenomenal memory for detail and, given half a chance, reels off long inventories of the chores that will have to be undertaken—the dripping faucet, the broken sash, the blocked toilet, the missing tiles on the roof, that awful carpet on the stairs. Clinton tends to bore journalists with these recitations, though her audiences seem to like them: after the visionary but catastrophic plans of the neoconservatives, the prospect of a return to commonsense practical housekeeping has undeniable charm. Swiping at Obama, she says: "I'm a doer, not a talker" (a phrase with an interesting provenance—it goes back to the First Murderer in Richard III, by way of Bob Dole in his failed bid for the presidency in 1996). But it's a line that unwittingly draws attention to the intellectual as well as the rhetorical limits of her candidacy.

"We can get back on the path we were on," she promises, meaning the path from which we strayed in November 2000, as if the 1990s were a time of purpose, clarity, and unswerving Democratic progress, as well as

a period of (largely coincidental) economic prosperity. Memory's a strange thing, and Hillary Clinton's own most notable contributions to those years—the absurd mess of "Travelgate" (widely held to be a factor in Vincent Foster's suicide), her imperious management of her health-care plan, whose ignominious defeat contributed to the Republican landslide in the midterm elections of 1994, her invocation of a "vast right-wing conspiracy" at the time of the Lewinsky allegations—say a lot about her intense personal involvement in projects, good and bad, but hardly speak well for her judgment or diplomatic talents. On the campaign trail now, she presents herself as "a fighter," battle hardened and combat ready, prepared to take on the Republicans "from Day One," thereby reminding everyone that from January 1995 until January 2001 a state of war existed between the Clinton administration and the Republican-controlled Congress, and that of the many memorable battles in which Hillary Clinton herself was directly engaged, it's hard to name one she didn't lose.

Politicians who receive mass adulation are a suspect breed, and it's natural to feel pangs of disquiet at an Obama rally in full cry: the roaring thousands, the fainting women, the candidate pacing slowly back and forth, microphone in hand, speaking lines that have become as familiar as advertising jingles but are seized on by the audience with ecstatic shouts of "I love you, Obama!" to which the candidate replies, with offhand cool, "I love you back." Lately, I've been listening to ancient audio recordings of Huey Long exciting crowds as big as these with his pitch of "Every Man a King," also to Father Coughlin, the anti-Semitic "radio priest" from Michigan, just to remind myself of the authentic sound of American demagoguery. But to see a true analogy for an Obama rally, one need only attend almost any large black church on a Sunday morning and hear the preacher's sermon kept aloft by the continuous vocal participation of the congregants.

"A-men!" they shout; "That's right!"; "Yes, sir!"; "Oh, my sweet Lord!"; "Unh-hunh!"; "Yeah!"; "It's all right!"; "Hallelujah!" The antiphonal responses allow the preacher to pause for breath and thought, and from my one experience in the pulpit of such a church, during a mayoral election in Memphis in 1979, when the Rev. Judge Otis Higgs invited me to speak on his behalf, I know firsthand how readily magniloquent phrases leap to the tongue when you're urged on by several hundred people hallelujahing your every other sentence. Five minutes or so in that pulpit kept me high for days.

Yet Obama, brought up by his white mother as a secular humanist, was a stranger to black religion until he went to Chicago in 1984, to take up a job as a trainee community organizer. His boss prepped him at his interview in New York: "If poor and working-class people want to build real

power, they have to have some sort of institutional base. With the unions in the shape they're in, the churches are the only game in town." In Chicago, a black pastor extolled the church as "an example of segregation's hidden blessings":

... the way it forced the lawyer and the doctor to live and worship right next to the maid and the laborer. Like a great pumping heart, the church had circulated goods, information, values, and ideas back and forth and back again, between rich and poor, learned and unlearned, sinner and saved.

Always by necessity a chameleon, Obama picked up in Chicago the style and rhythms of the black charismatic preacher, just as he'd picked up vernacular Indonesian when he was a child in Jakarta. He can now instantly turn a basketball stadium, a high-school gym, or a university auditorium into the pumping heart of a black church, with uninitiated whites taking their cue from him ("Yes, we can," he murmurs into the mike, to signal that a hallelujah would not be out of order) and from the blacks in the audience who've been doing this on Sundays all their lives. For the suburban white kids, it's a novel transportation into an exuberant community of souls. No wonder the French class was a washout.

But his rallies, galling as they must be to the Clinton campaign, convey a misleading impression of his political skills. Better to eavesdrop on him, via unedited video on the Internet, at dinner with four constituents in a District of Columbia restaurant or answering questions from the editorial board of a local newspaper. What strikes one first is his gravity and intentness as a listener and observer: a negative capability so unusual in a politician that, when one watches these clips, it's hard to remember that he's running for office and not chairing a seminar in a department of public policy. When his turn comes to speak, he is at first hesitant, a man of many ums and ers, but as he articulates his answer you realize that he has wholly assimilated the question, inspected it from a distance and seen around its corners, as well as having taken on board both the character and the motive of his questioner. The campaign trail is the last place where one expects to see an original intellect at work in real time, pausing to think, rephrase, acknowledge an implicit contradiction, in such even tones and with such warmth and sombre humor.

He's an old hand at this. Early in *Dreams from My Father*, the boy, aged seven or eight, is playing a boisterous game with his Indonesian stepfather in the backyard of their Jakarta house, when Obama suddenly takes leave

of his own skin and jumps inside the mind of his mother, watching from behind the window. For the next five pages, we see their situation through her eyes, with all her building dissatisfaction and anxiety at her bold new life as an expatriate. It's the first of many such narrative leaps, as Obama experiments with the novelistic privilege of inhabiting other people's points of view and endowing them with an eloquence that they almost certainly could not have summoned for themselves. Giving voice to other people, which he does with grace in his writing, with a sensitive ear for their speech and thought patterns, was also his job as a community organizer in Chicago, and it's hard to think of anyone for whom the ideas of literary and political power seem so naturally entwined.

In *Dreams from My Father*, there's an often-repeated moment when Obama learns something important about the world, the adults around him, or his school and college contemporaries, but has to hug it to himself. Describing his dawning recognition of the subordinate roles handed out to blacks on television and in print, he explains why he couldn't communicate the discovery to his mother: "I kept these observations to myself, deciding that either my mother didn't see them or she was trying to protect me and that I shouldn't expose her efforts as having failed." It's the story of many writers—the solitary child who learns to keep such knowledge secret, and finds in that concealment hidden power.

Even when Obama's at his most public, firing up an audience at a rally, one notices a detachment, a distinct aloofness, as if part of him remains a skeptical and laconic watcher in the wings, keeping his own counsel, as he appears to have been doing since infancy. In more intimate and less artificial circumstances, his capacity for empathy and his innate reserve work in consort. He's hungry for the details of other people's lives. He conducts each meeting with his trademark ambassadorial good manners, sussing out his companions and playing his own hand cautiously close to his chest (as a state senator in Illinois, he was a leading member of a cross-party poker school). In the heat of a fierce election, he could be mistaken for a writer doing research for a book.

Hillary Clinton, armed with a relentlessly detailed, bullet-pointed position paper for every human eventuality, is a classic technocrat and rationalist; Obama is that exotic political animal, a left-of-center empiricist. The great strength of his writing is his determination to incorporate into the narrative what he calls "unwelcome details," and you can see the same principle at work in the small print of his policy proposals. Abroad, he accepts the world as it is and, on that basis, is ready to parlay with Ahmadinejad, Assad, and Castro, while Clinton requires the world to conform to her

preconditions before she'll talk directly to such dangerous types. At home, Obama refuses to compel every American to sign up for his health care plan (as Clinton would), on the grounds that penalizing those who lack the wherewithal to do so will only compound their problems. Where Clinton promises to abolish the Bush education program known as No Child Left Behind, Obama wants "to make some adjustments" to it (like moving the standardized tests from late in the school year to the beginning, so that they are neutral measures of attainment and don't dictate the syllabus like an impending guillotine).

Clinton's world is one of absolutes, with no exceptions to the rules; Obama's is far messier and less amenable to the blunt machinery of government. During the last televised debate in Cleveland, Ohio, he won a big round of applause when he said, "A fundamental difference between us is how change comes about," meaning that for her it comes about by legislation from the top down, for him by inspiring and organizing a shift in popular consciousness from the bottom up.

Traditionally, such empiricism has been associated with the political right, and such rationalism with the left. In the UK, Michael Oakeshott liked to blame Rationalists (always spelled with a capital R) and their "politics of the book" for every benighted socialist scheme from the Beveridge Report and the 1944 Education Act to the revival of Gaelic as the official language of Ireland. And his description of the Rationalist as someone who "reduces the tangle and variety of experience to a set of principles which he will then attack or defend only upon rational grounds" rather nicely fits Clinton, with her dogmatic certainties and simplifications. Although their specific promises are so similar as to be often indistinguishable, Clinton always stresses the transformative power of government, while Obama's speeches are littered with reminders that government has strict limits, as when, every time No Child Left Behind comes up, he segues into a riff on the importance of parenting. That's why so many Republicans and independents have turned out to vote for him in the Democratic primaries: for a liberal, he speaks in a language that conservatives, to their surprise, instinctively recognize as their own: a language that comes partly straight from the living room and the street and partly from the twin traditions of empiricism and realism. Clinton has lately tried to take Obama down by snapping out the line, "Get real!"; it generally falls flat because to most people's ears he sounds more real than she does by an easy mile. He's transparently at home in the "irksome diversity" of American life, while she appears to be on a day pass from a D.C. think tank.

Henry James famously said that to be an American is a complex fate. Few

living Americans have as fully embodied that complexity in their own lives as Obama has, and none has written about it with such intelligent regard for its difficulties and rewards. His differences with Clinton aren't ones of merely rhetorical positioning and presentation; they're rooted in the temper of his mind. My hope is that, on the road to Pennsylvania and his next big showdown with Clinton on April 22, he'll articulate that temper more plainly than he's done so far. He does it with small audiences. He does it brilliantly in his memoir. But many voters still know him by hearsay as a feel-good evangelist of hope and change—a false impression that Clinton does everything she can to foster and which may yet end his candidacy. Obama has been relying on speechwriters of late: this is one he has to write himself.

London Review of Books, March 2008

Going, Going, Gone

ONCE, WELL WITHIN my adult lifetime, the chief lure of the big city was the prospect of living in a community of strangers who were different from you in every respect—age, income, language, class, manners, skin color, and occupation. The city was the ultimate human charivari, a polyglot honeycomb of social possibility, where unlike collided with unlike on the streets. As Dr. Johnson said to Boswell, "A great city is, to be sure, the school for studying life." But that idea is dying on us fast.

In Seattle, a massive civic reconstruction project is under way on a hundred and eighty acres of land immediately north of downtown. Paul Allen, the Microsoft cofounder, and his real-estate company, Vulcan, which owns around sixty of those acres, are the prime movers in the attempt to create a new inner-city neighborhood. The area, known as South Lake Union, is now an enormous building site: beneath the swinging booms of tower cranes, dozens of office buildings and condo blocks are climbing skyward while fleets of excavators dig pits in the ground for more still to come. Brand-new candy-colored streetcars, each with only three or four passengers aboard, ply the 1.3-mile line connecting the site to the downtown hub.

Until recently, this was a relatively low-rent quarter of the city, a place to visit for its junk shops, its odd, specialist services (the man who fixed the creased hood of my convertible, the man who restored and rephotographed a torn sepia snapshot and blew it up to full-plate size), its workmen's bars and cafes, its down-at-heel arts organizations. Where else would the Seattle Gilbert & Sullivan Society make its home, or the amiable, gloomy emporium selling secondhand office furniture? South Lake Union was a place where new immigrants could get a start in business, alongside old Seattleites practicing useful if obscure crafts with meagre profit margins.

But it's going, going, gone. I walk its streets now for the last chance to set

eyes on that half-demolished Victorian brick warehouse, those century-old frame houses, their blue and green paint flaking from their shingles, the ornate art-deco car showroom, built in the age of the Packard and the Hupmobile. Soon, if all goes as planned, twenty thousand people will be working here and ten thousand will be living in the half-built apartments and condos, paying \$400,000 for a studio. Existing biotech companies and institutions are the anchor, and Amazon recently signed up to move into eleven office buildings, bringing its Seattle workforce of six thousand people from its present headquarters in an old naval hospital. Already, new street-level businesses are opening every week to cater to this influx of population: gyms, coffee houses, boutiques, restaurants, sporting goods stores, a Whole Foods organic supermarket, all aimed at the affluent, well-educated twentysomethings in whom the quarter will shortly be awash.

There's a lot to applaud here. Not only will South Lake Union dramatically broaden and deepen the city's tax base (something dear to the hearts of mayors and their councils), it'll also have admirable density, at the equivalent of thirty-eight thousand people to a square mile, and be eminently walkable, safe, and green in its construction methods and materials. Its one snag is that it promises to have all the exhilarating diversity of the Stepford wives.

For South Lake Union goes far beyond mere gentrification. As the Vulcan website says, it is "rethinking the urban" to claim a big chunk of the city for a narrow demographic defined by age, education, income, and marital status (singles and couples welcome, children a problem). The provision of a hundred units of "affordable housing" and an upscale retirement community won't do much to dent the impression made by hordes of well-heeled twenty-seven-year-olds clad in Seattle's working uniform of cargo pants, T-shirts, Converse hightops, and iPhones, all with college degrees, all eco-conscious Democrats.

Meanwhile, diversity has gone suburban. The best dim sum in the Seattle metro area are no longer to be found in Chinatown (known here as the International District) but in Kent, nearly twenty miles south, an unlovely congeries of new tract housing and office and industrial parks, which until the 1970s was a broad valley of market gardens that liked to bill itself as the lettuce capital of the world. To go to the Imperial Garden restaurant in the Great Wall Mall on a Sunday lunchtime is to enter the kind of many-hued, motley society that used to thrive in the inner city. Here are the ethnically blended families—Anglo-Chinese, Korean-Chinese, African-American-Chinese, Hispanic-Chinese. Here are Chinese grannies, so elaborately wrinkled that they could date back to the Qing dynasty,

rocking squalling American babies on their laps. The melting pot survives, but ambitious planning and high rents are driving it from its traditional home in the city to the remote suburbs.

I imagine a woman in her twenties sitting in a studio apartment in South Lake Union, reading *Our Mutual Friend* on the screen of her Kindle and marveling at the extraordinary vitality of Dickens's city compared with the strangely anemic character of her own. She has every amenity to hand, is within easy walking distance of restaurants, theatres, cinemas, the opera house, the symphony hall, the ballet, the downtown clubs with their rock bands, all the advertised pleasures of urban life except one—the essential element of human variety and surprise. The plum-colored, energy-saving electric streetcar whispers past beneath her window, which commands a view of the dense constellation of city lights around the shimmering black bombazine of the lake. To the mayor, to Paul Allen, to the architects and designers who have rethought the urban, here's a picture-perfect life.

But what a price we're paying for it. Suburbia—once the synonym for dullness and conformity—is growing ever more socially and economically diverse, while the central city grows more and more "suburban," as we used to condescendingly say. It seems to me a bad bargain for everyone, from the woman in her twelfth-floor apartment to the immigrant stranded out in Kent. And it's happening everywhere, this steady dilution and dispersement of life in the city, which threatens to undermine our best reasons for choosing to live in the city in the first place.

Monocle, August 2008

An Englishman in America

As BARACK OBAMA never tires of saying, America is a country where "ordinary people can do extraordinary things." In January 2006, Neil Entwistle, a seemingly ordinary twenty-seven-year-old Englishman with an honors degree from the University of York, who'd been living in the United States for barely four months, shot dead his American wife, Rachel, and their baby daughter, Lillian, with a long-barreled Colt .22 revolver borrowed from his father-in-law's gun collection. By the time the bodies were discovered in their house in Hopkinton, Massachusetts, huddled together beneath a rumpled duvet in the brand-new four-poster bed bought by the couple just ten days before, Entwistle was home in England, living with his parents in Worksop, as if what had happened in America was a violent dream from which he'd woken to reality in his old back bedroom at 27 Coleridge Road.

For several days, it seemed that he was going to get away with it. The police then had no weapon and no motive. People who knew the Entwistles remembered them as a happy couple, with Neil as the beau ideal of the doting father. Their family website, rachelandneil.org, still eerily preserved at web.archive.org, is a Hallmark-card-style commercial for wedded bliss, decorated with sepia-toned bridal sprays and full of pictures of the Mediterranean cruise, the weekend trip to Martha's Vineyard, and baby Lillian at every stage of her nine months of life. Its home page is addressed to "Dearest family and friends" and is signed: "Love, the happy family."

Neil was described as "not a suspect," then later as a "person of interest." The case against him wasn't helped by a careless mistake on the part of the police. On the night of Saturday, January 21, some hours after Entwistle's plane had landed at Heathrow, Rachel's mother called the Hopkinton police department to say that her daughter hadn't turned up for a lunch

date that day and wasn't answering the phone. Officers made a "well-being check" of the house at 6 Cubs Path, upstairs and down, but found nothing amiss. The next morning, two of Rachel's friends borrowed a key from a neighbor and made their own search, but it wasn't until 5:30 p.m. on Sunday that the police, going through the place for a second time, smelled a "foul odour" and traced it to what lay beneath the duvet. After the news of the murders broke, American cable stations paraded a chorus of defense attorneys and legal experts who deplored the botched forensics of the crime scene, explained the demanding subtleties of extradition from the United Kingdom, and forecast that Neil Entwistle could well live out the rest of his days in Worksop.

Had he not driven back to his in-laws' house in Carver, Massachusetts, and replaced the revolver, he might be in Worksop now. But tests on the Colt, done on February 8, identified it as the murder weapon and connected it with Entwistle. On February 9, three weeks after the killings, he was charged in the United States on two counts of first-degree murder and arrested by police from Scotland Yard at Royal Oak tube station in London. He waived his right of appeal against extradition and was flown back to Boston in the custody of the U.S. police.

After a long-delayed trial, he was sentenced on June 26 this year to two concurrent life terms without parole; passing sentence, the judge told him that his crimes "defy comprehension."

Early in the investigation, the local district attorney, Martha Coakley, suggested on national television that Entwistle had probably planned a murder-suicide, but that his courage had failed when it came to pulling the trigger on himself. This possibility was never discussed at the trial; the prosecution avoided it because it might have led the jury to feel some shred of sympathy for Entwistle, while the defense settled, feebly, on an implausible tale of how Rachel had killed herself and her baby while her husband was out shopping. But it remains the nearest thing to a comprehensible explanation of Entwistle's extraordinary behavior that morning.

Born in 1978, Neil Entwistle is just about young enough to count as an Internet native rather than immigrant. He spent his gap year working as a PUE, a pre-university employee, at IBM in Warwick, and his master's degree from York was in electronic engineering and business management—a logical education for a would-be digital entrepreneur making his living in virtual space, which is where Entwistle spent most of his time.

The global theatre of the Internet, on whose enormous stage anonymous actors experiment with personae, using whimsical screen names and avatars that can be changed from moment to moment, is a haven for

the insecure. Shy teenage girls turn into bold sirens on their Myspace and Facebook pages, and it's a safe bet that many of the most vituperative and expletive-laced comments on newspaper blogs are written by people who wouldn't say boo to a goose if you ran across them in a pub.

Entwistle, described by two of his university friends at his trial as "quiet," "reserved," but "not unsociable" in person, lived large on his computer, registering a string of .co.uk enterprises to the address of a rented student house in Heslington Road, York. He was, by all accounts, technically competent, even gifted, but what's striking about all these sites is their imitative banality. He appears to have trawled for inspiration through the lower reaches of his spam cache, and the language of the sites is not that of a graduate but of a none-too-bright twelve-year-old.

Millionmaker.co.uk ("Copied by Many but Never Beaten") sold a scheme for making "£6000 a month within six months" and "£1m in under two years" by hosting porn sites ("You Have Nothing to Loose"). SR Publications (the SR stood for "specialist research") was a shabby digital emporium that sold e-books and DVDs with titles including How to Get Free Microsoft Software, Pay Per Click Commando, Instant Internet Empires, 1001 Newbie Friendly Tips for E-Business, Secret Online Casino Winning Systems, 600 Famous Cheesecake, Fudge and Truffle Recipes, Grandma's Recipes and Wives Tales and "our flagship product," The Big Penis Manual ("No Pills! No Pumps! No Surgery!"). Another site, registered to the same address on Heslington Road by "Mark Smith," apparently an alias for Entwistle, was deephotsex.co.uk, which promised "Over 150,000 images of innocent teens," "Real World Hidden Sex Cams" and "Live sex shows where you tell girls what to do."

The nastiness of these efforts shouldn't blind one to their sedulous conformity. In the libertarian world of the Internet, pornography is a meat-and-potatoes business, and it seems more than likely that Entwistle, always a creature of convention, was simply trying to follow the most obvious and well-trodden path to online riches. The trademark of his sites is not so much their sordidness as their imaginative poverty. The most interesting example of this is a site he set up later, embeddednt.co.uk, on which he offered his services as a consultant to companies branching out into digital commerce. Here's his sales pitch: "Embedded New Technologies (ENT) offers Intellectual Property Cores for Xilinx, Altera and Actel FPGAs. DSP systems and systems-on-chip, SoC, embedded systems can be provided using our floating-point, fp, fast Fourier transform, fft, fir filter and digital down-converter cores."

Understanding nothing of this except its bad grammar, I tried Googling

each term in the hope of figuring out what on earth it might all mean. Every time, I was pointed to a bona fide company in Malvern named Enterpoint Ltd., which has its office in a science park, right next door to QinetiQ, the high-tech defense contractor where Entwistle was employed after he left York University, from 2002 to 2005. The layout of embeddednt.co.uk looks like a rip-off of the Enterpoint site, from its pictures of circuit boards to its technical descriptions. Whether posing online as a porn king, a loving husband and father, or an electronics design expert, Entwistle (who no doubt hung out with Enterpoint people in the Malvern tech crowd) was a copycat, slavishly modeling himself on his elders and betters in the field.

This accords closely with what's known of his boyhood. The son of a former miner, now the Labour councilor for East Worksop on Bassetlaw District Council, and a "dinner lady" at a Worksop school, Entwistle was intelligent, well mannered, and conformable. The family were said to keep themselves very much to themselves. As such dull but clever children do, Neil shone at school: his teachers at Valley Comprehensive remembered him as "an amenable, nice, approachable young lad...an ideal pupil," while several of his classmates called him "shy."

Throughout his televised trial, the Entwistles—his father, Clifford, his mother, Yvonne, and his brother, Russell—sat immediately behind Neil and his defense counsel, bringing a microcosm of respectable, working-class England to the court in Woburn, Massachusetts, where they exuded an air of tortured dignity and fortitude in the face of impossible odds. When gruesome video evidence from the crime scene was played to the jury (it was shielded from the press and TV cameras), Clifford Entwistle escorted his wife from the room. She was reported to have "broken down," but I saw no more than her slightly quivering shoulders and a hand raised to her mouth. Mr. Entwistle, ramrod-straight in a Sunday suit, looked more like a figure from the 1950s than from the twenty-first century, one of those withdrawn and stoical breadwinners who haunt period TV drama. He conjured the lace-curtain world of appearances kept up, stiff collars, the vegetable plot in the narrow backyard, the union card, the party membership, and the second-hand Hillman Minx, hand-washed and polished every weekend without fail. In the America of 2008, he looked like a perfect anachronism.

Neil, in his turn, looked like his father's son. His dark suits were better cut, and he had his mother's big hair, center-parted in a distinctly outmoded do that was a credit to the artistry of the jailhouse barber. But he too maintained a demeanor of close-buttoned gentility throughout his trial, looking more like a poker-faced juror than a man accused of double murder. The American press found the entire family spooky and "psychotic" in

their apparent absence of emotion, but what I saw was four old-fashioned people from northern England trying to put their best face on the unspeakable, in a show of grimly punctilious deference and good manners.

Strict adherence to convention appears to have ruled Neil Entwistle's life from the beginning, and in Worksop and York his amenability seemed to guarantee success in a conventional world. It was a coup for him to gain admission to York University, which is highly selective and as upper-middle-class in tone as any English university outside Oxford or Cambridge. Ever the conformist, he joined the boat club—without, so far as I can discover, previous rowing experience. But he's powerfully built and became a fine oarsman, stroking university fours and eights. For a child from Valley Comprehensive, it was an achievement to be, in effect, the captain of a racing shell packed with young men from schools like Radley, Shrewsbury, Westminster, and St. Paul's.

It was at the boat club that he met Rachel Souza, the American girl who was at York in her junior year abroad from a college in Worcester, Massachusetts. As Neil reported in the potted biography he wrote for friends reunited.co.uk in 2003:

Did lots of A-levels.

Worked at IBM

Got an M.Eng(Hons) in Electronic Engineering with Business Management from York.

Rowed throughout my degree—proud to be that white rose. Showed those public school \$% &'s how to do it properly.

Making bombs and other stuff for a living—would tell you more but I'd have to kill you. [A reference to his work for QinetiQ.]

Getting married to the most amazing woman in the world this summer: Rachel. We met through rowing. She was my cox, I her stroke! She's from the good ol' U.S., Boston to be more specific, Plymouth (the original landing site) if you're really curious.

Living south of the Birmingham border is my only complaint in life.

It was a shock to hear his voice in court. Entwistle never took the witness stand, but two long taped conversations between him and an American police officer, recorded just after his return to Coleridge Road, were played to the jury. His accent was pure Worksop—"coom" for "come," "becoss" for "because." He dropped his aitches and left a lingering hard g-sound at the end of participles like "going." I found it hard to square the man with this mild, vague, homely tone—a voice that might never have gone

near a university or traveled to the United States, but was rooted to its working-class birthplace. Expressing bewilderment at the murders of his wife and child, he said: "Things like this just shouldn't—just don't 'appen. We picked 'Opkinton becoss it doesn't 'ave any crime. It's not like we were stook in the middle of a roof a-rea."

At eighteen or nineteen, most university students modulate their voices to fit in with their new surroundings (Tony Blair learned to talk in Estuary when he was deep into his forties). Yet Entwistle, an instinctive mimic in every other aspect of life, an Internet chameleon, an earnest social climber, hadn't managed to retrieve a single missing aitch or shorten one long northern vowel. There was no trace of the years of clubhouse time spent in the company of "those public school \$% &'s." In anyone else, one might assume stubborn defiance in this attachment to the sound of home, but Entwistle was a born pleaser and adapter, and his failure to change his accent weighed heavily with him. His mother-in-law, Priscilla Matterazzo, told the police in an affidavit that Rachel had said to her that Neil had wanted to move to the United States on the grounds that he "would never amount to anything in England because of his accent: he was obviously a coalminer's son from a working-class background." That may sound archaic, but Neil, for all his new-technology expertise, seems to be a throwback to the class-bound England of his father's generation, and perhaps the University of York and its boat club only helped to remind him of his lowly standing on the hereditary class ladder.

Rachel Souza—and it's one of the great virtues of Americans that they tend to be deaf to the nuances of the class system—saw him, as her mother said, as "an English gentleman," her "knight in armor." Petite, just five feet tall, though a bit too plump to be an ideal cox, she fell for the guy between whose outstretched legs she had to plant her feet as she steered the boat with a loop of string. Having been a cox myself, of a house four when I was twelve, I know the peculiar intimacy between cox and stroke: the rub of leg on leg, the intense eye contact, the piping, double-entendre cries of "One...away! Two...away!"

Rachel, unlike the \$%&'s, heard England in Entwistle's voice, not Worksop and Valley Comprehensive. He was stroke, and therefore the natural superior of Shrewsbury, Radley, and all the fellows sitting on sliding seats behind him in the boat. No wonder he saw her as "the most amazing woman in the world": she was probably the first girl he'd ever met who didn't immediately place him by his accent.

At the end of her year abroad, she went back to Massachusetts to finish her degree; graduating in 2001, she returned to York to be with Neil for the final year of his master's, and to get a Cert. Ed. to qualify her to teach in British schools. When Neil found a job with QinetiQ at Malvern, she found one as a teacher of English and drama at a Catholic high school for girls in Redditch, and they set up house in a rented three-bedroom one-bathroom semidetached in Droitwich Spa, roughly midway between their places of work. No. 119 Swan Drive is in a new development, the Hanbury Park subdivision, on the outskirts of Droitwich, and is strikingly similar to the senior Entwistles' house in Worksop. As Coleridge Road is one of more than a dozen streets named after writers and poets, including Browning, Kipling, Thackeray, Tennyson, Macaulay, and Masefield, so Swan Drive runs past Heron Place and Mallard Place. The house was so elaborately wired that, when the Entwistles and their baby daughter left it in the summer of 2005, the landlord had to call in BT to assist in the removal of Neil's spiderweb of cables.

From his bird-themed address in Droitwich, Entwistle moonlighted as an eBay merchant of XXX sex cartoons, Adult Games, Vend-o-Matic Software With The Ebook Creation Toolkit, *The Big Penis Manual*, and all the rest of his unsavory inventory of get-rich-quick potions and notions. After their marriage, in August 2003, Rachel was registered as the codirector of SR Publications, though it's impossible to tell how deeply, if at all, she was involved in Neil's schemes.

In Droitwich they should have been able to live comfortably within their means. The current value of a Swan Drive semi is around £156,000, and their monthly rent—to judge by a recent price on that road—would have been roughly £500, easily affordable on their dual income. Neighbors remember them as an attractive young couple, with Neil proudly wheeling his infant daughter along the bank of the river Salwarpe, a hundred yards from the house. His "only complaint" about "living south of the Birmingham border" was clearly more about class than geography: too many public schoolboys with blah voices in Droitwich and Malvern. Even in the Hanbury Park development, home to many of Droitwich's jobbing plumbers and electricians, he proclaimed whenever he opened his mouth—or imagined that he did—the social disconnect between his York degree and his professional work for QinetiQ, and his Worksop childhood. But in cyberspace, his natural element, he was anonymous, accentless, free to live inside his steadily multiplying range of personae. It's curious that this man, so conspicuously lacking an authentic self, evidently regarded his single most authentic feature as a curse and a stigma.

After Lillian Rose was born in April 2005, Rachel grew homesick and Neil, whose weakness for shopworn slogans is abundantly on display on his websites, embraced the idea of moving to the "good ol' U.S.," land of opportunity, the melting pot, the classless society. In July, he resigned from his Malvern job for "domestic reasons," as a QinetiQ company spokesman said in January 2006. Rachel and Lillian flew on ahead to Boston; Neil followed them a few weeks later, leaving a growing pile of bills and letters from collection agencies. From September to the first week of January, the Entwistle family lodged in the house belonging to Rachel's mother and stepfather in Carver, Massachusetts, a small town of relatively modest means, fifty miles south of Boston.

English people fresh to the United States are often shaken to find themselves in hyperreality. The landscape, so familiar in two dimensions from television, movies, and print, suddenly, unsettlingly, takes on a third. From my own first visit, which happened to be to Massachusetts, in 1972, I remember the hallucinatory character of the experience: my first three-dimensional armed cop, my first American rental car, a boatlike Chevrolet (and this was the season of Don McLean singing "American Pie"), my first pay phone, my first cocktail in the bar of a three-dimensional Howard Johnson's, my first freeway exit, my first white-shingled house with picket fence. Living the movie, I was in that peculiar no-man's-land, half fact, half fiction, where I remained for weeks, and where I can occasionally still find myself after eighteen years of permanent residence here. No other country in the world has quite this disorienting effect on the British visitor or immigrant, this capacity to induce a semipermanent jet-lagged high in which the newcomer feels himself to be standing at a slight but constant tangent from reality.

Neil Entwistle had visited the United States before his wedding took place in the Second Parish Church of Plymouth, Massachusetts. But his new life in America had from the beginning the flavor of the hyperreal. His behavior in Carver was that of a man floating adrift of his moorings in the real and living in a virtual world of his own. His in-laws found him puzzling. He was, as newspapers would later describe him, "an unemployed computer programmer," but he appeared to have mysteriously invisible means. Rachel talked vaguely of money held in "offshore accounts." Although he'd brought his own laptop, Neil spent much time upstairs, working on the family's desktop computer, apparently managing his affairs at Embedded New Technologies, understandably the only site he showed to the Matterazzos. He combed the Internet for IT jobs and had phone interviews with recruiters, but his qualifications, though impressive, never quite matched a specific position. Nevertheless, he was always ready with credit cards, and the in-laws gained the impression that he might be employed by the British secret service.

The phrase "perfect gentleman" crops up again and again, used by the Matterazzos and by Rachel's girlfriends, who admitted to finding Neil a bore. Unfailingly polite and complaisant, he came across in much the same way as the amenable boy at Valley Comprehensive. Certainly the Matterazzo menfolk liked him enough to drive him off to the Old Colony Sportsmen's Association in Pembroke and teach him how to shoot the Colt .22 revolver that Joe Matterazzo kept in a locked gun safe. Wearing headphone-style earmuffs, he practiced on the club's indoor range, and, according to Rachel's uncle, "handled the firearm well."

It's an iconic American scene, male bonding over the pop-pop-pop of spent cartridges, and to Entwistle, who'd never used a gun before, it must have been a solemn initiation rite into the New World. The symbolism of the Colt revolver—that old staple of Saturday morning cinema in England—holds a peculiar magic for Englishmen, as I found a dozen years ago, when filming a segment of the South Bank Show in eastern Montana. I was with a Seattle friend whose family had farmed a homestead in the area, and he had brought his brother, a retired air force general, along for the ride. The general had brought his Colt. After a long morning of filming, the British TV crew took the afternoon off, and the general taught them all to shoot in the yard of a long-abandoned farm. It was the highlight of their trip. We were deep in the sagebrush of the Far West, and this was gunplay with real live rounds of ammunition: John Ford, John Wayne, Henry Hathaway, and the Colt, legendary instrument of masculine power and decisiveness. The general's impromptu movie was a good deal more exciting than the twenty-minute one that we were actually filming. At dinner that evening, everyone, including the director's female PA, couldn't stop talking about his or her newfound prowess with the revolver.

For an Englishman as impressionable, and as imaginatively dim, as Entwistle, feeling the surprising heft of the Colt in his palm and the ease of dispatching a bullet on its trajectory with a gentle squeeze of the finger—like clicking on a mouse—was likely to have been a moment of pure Americana as toxic in its effect as any controlled substance, and it's no wonder that he noted where Joe Matterazzo kept the key to the gun safe.

During this time, a poorly documented dribble of income from his eBay transactions appears to have been Neil's only continuing means of support, and his funds from the years spent at QinetiQ were fast evaporating. On another "Mark Smith" site, moneyhound.biz, registered to the York address, he announced: "We run this site without profit. We are making such serious money, using just the methods listed on these pages, that we don't need any more." Moneyhound, which linked to millionmaker and

srpublications, promoted spam, or "paid email," as Entwistle called it, as the quickest online route to riches. "For just 15 minutes work a day, you can expect returns starting from \$1500 a month." There's no evidence to suggest that he ever made more than pocket money out of pornography, spam, or any other of his wheezes: the best example I can find of his business acumen is that once, at least, he managed to sell on eBay a copy of OpenOffice, the open-source, free software program, for ninety-nine cents.

From Carver, he regularly updated rachelandneil.org and the rosy, sentimental fiction of his domestic life, with new pictures of Lillian. "Lillian's first Halloween" showed the seven-month-old in a skunk costume and was soon followed by a series of photos titled "Lillian getting ready for Christmas," including one of her crawling on Neil's stomach, with the caption: "I love my Daddy." So long as he was sitting at the Matterazzo computer, he was a tycoon of sleaze, a technological wizard (he once boasted that he was one of only three people in the world who knew how to perform a certain digital operation), as well as a devoted family man; and it seems probable that, lost in the afflatus of composing and revising his many sites, each of his personae was as sincerely inhabited as the others. With no daily commute to make to Droitwich, he was employed full-time in virtual space, and when he made the trip downstairs, it took him to America—a country which, for Entwistle, might as well have been named Cockaigne for its absence of realistic constraints.

Wanting a car, he took over an existing lease on a white BMW X3, a show-off sports utility, suitable transport for the successful CEO of Embedded New Technologies, SR Publications, and all the rest. Here, one constraint did emerge, when Joe and Priscilla Matterazzo declined to countersign the lease, precipitating a row with Rachel. But Neil got his car anyway, at \$400 a month, a rate that seems surprisingly cheap. The BMW took the Entwistles on tourist weekends to the coast and house-hunting expeditions in the Massachusetts interior.

They lit on Hopkinton, an hour's drive northwest from Carver, an up-and-coming IT town. EMC Corporation, Massachusetts's biggest technology company, has its headquarters there, and a number of satellite software outfits have gathered around EMC. In a crook formed by the intersection of I–90, the Massachusetts Turnpike, and I–495, the semicircular road that skirts Boston at a distance of about thirty miles, the Entwistles found a house for rent in yet another new development. Cubs Path, like Coleridge Road and Swan Drive, has the ring of a whimsical made-up name, coined, perhaps, by the developer's wife or daughter, and meant, in this case, to conjure life in the wild (it's off Roosevelt Lane, which leads

to Rough Rider Ridge and Bullmoose Run). In fact, Cubs Path is part of a subdivision of four- and five-bedroom houses, or mini-mansions, vinyl clad, top-heavily gabled, and vaguely "colonial" in style, all set back from the road in open wooded yards, and all within earshot of the oceanic roar of the two freeways. No. 6 Cubs Path, the Entwistle residence, appears to be the only house on the street without its own swimming pool.

With its four bedrooms and three bathrooms, it was vastly grander than the Swan Drive semi—a house in which nothing less than a BMW X3 would look comfortable in its garage. Rent was \$2,700 a month, and Neil managed to produce \$8,100 (in the form of two cashier's checks, signed by Rachel) for three months in advance, even though by then the Entwistles' credit cards were rapidly maxing out. To furnish their new place, Neil and Rachel did not, as they surely should have done, haunt weekend yard and estate sales with a borrowed pickup truck, but drove to Worcester to patronize the new bedding and furniture stores there. The canopy bed in which the bodies of Rachel and Lillian would be found was an item of pretentious bad taste before it became part of a crime scene.

While the Entwistles shopped away their dwindling resources, something odd was happening on the Internet. Until December 30, 2005, Neil's feedback on eBay had been consistently positive: "Super quick delivery—Good Ebayer"; "Great communication. A pleasure to do business with"; "Prompt delivery. Good product. Recommended seller. A++" and several hundred similar messages. Then, from January 6, 2006, his customers turned furious: "Complete Scam, Ebay users beware!"; "Rachel Entwistle is a thieving Liar do not buy here!!"; "Sharp practice? No product, no contact, no respect!!"; "Do not do business with this individual as he does not exist!!!!!!!!!! (THIEF)." Within days, eBay suspended SR Publications from further trading.

Sometime after Christmas, it appears that Entwistle simply logged out of his life in e-commerce, leaving a crowd of would-be purchasers of *The Big Penis Manual* or 600 Famous Cheesecake, Fudge and Truffle Recipes in the lurch. It's hard to believe that, as several reporters suggested, this was a deliberate scam; more likely that he suddenly lost interest in his online schemes and, this being virtual reality, chose to switch them off. When the abusive mob showing up at your door is just a scroll-down page of silent messages from strangers, displayed on a screen you need not visit, it's very easy to cancel other people from your consciousness with a click. My best guess is that, for whatever reason, sheets 11, spud383, prodogsports, maggiemoola, soupcam70, sweety4027, wilmslowwarrior, and the rest of his angry complainants had abruptly become unreal to Entwistle and so he

wiped them out by the simple expedient of opening a new window. Soupcam70, who advised eBayers not to "do business with this individual as he does not exist," had a point: existence on the Internet means something very different from existence in Worksop or Droitwich.

Back in what virtual-worlders call the "actual environment," Neil remained the English gentleman in America. The family made the move to Hopkinton on Thursday, January 12. On Sunday they were visited by Pamela Jackson, Hopkinton's self-appointed "welcome lady," who made it her business to greet newcomers to the neighborhood. On the witness stand, Ms. Jackson gushed, the word "adorable" peppering her testimony. Lillian was "adorable," "a conversation stopper." The Entwistles were an "adorable, cute couple." Neil "absolutely beamed" every time he looked at his daughter. "It was adorable. It seemed he'd been away in England for some time and missed the baby terribly." "It was just a lovely family."

Neil was sure to tell her that he owned a BMW (it was presumably hidden inside the garage), said that he was self-employed in the "insurance industry," and inquired about schools and country clubs. The lie about working in insurance seems oddly gratuitous, but by now he seems to have become so ensconced in the hyperreal that touches of merely decorative fiction were coming naturally to him. Insurance sounds more solid than IT, and perhaps Neil needed to give her—and possibly himself—the impression that he was more grounded in everyday reality than was the case.

Working on his laptop in the Hopkinton house, he indulged himself in a world of banal fantasy, Googling escort agencies and swinger sites. He took a trial membership in Adult Friend Finder (motto: "Join today and make love tonight"), where he posted the ungracious message:

I am an Englishman just moved over to the U.S. I am looking for 1-on-1 discrete relationships with American ladies and always aim to make all experiences ones to remember. I'm looking to meet American women of all ages. I need to confirm what friends have told me that you are much better in bed than the women over the ocean, as from there. We both want the same thing so there is little point dragging it out here.

Accompanying the message was a photo of himself, naked and with penis erect. (This was disallowed as evidence in court because the defense argued that it was impossible to prove that the body in the picture was Entwistle's.) He also Googled "quick suicide method" and "how to kill with a knife."

These forays were damaging to him at his trial, but the hard-drive record

of most people's Googling and net surfing would suggest that a severely disturbed mind had been at work. The average search on Google takes between a tenth and a fifth of a second, and the operation is so easy that it's impossible for an outsider to tell the difference between the determined pursuit of an obsession and the gratification of a momentary whim. Even in the light of what happened later, it's quite conceivable that, at this stage, Entwistle was only toying, lightly and vicariously, as adolescents do, with lurid thoughts of murder, suicide, and extracurricular sex.

What's hardest to understand is the two-hour round trip on the I-495 freeway to retrieve the Colt from the Matterazzo house in Carver, which Neil made on Friday, January 20. Until now, his adventures in the virtual had generally failed to translate into the actual (as, for instance, no meeting with a real woman transpired from his adultfriendfinder.com activities, though he did exchange e-mails with one). But on the freeway, at the wheel of the BMW, he became the killer in a noir movie with a characteristically defective plot.

As Eliot said of Hamlet, there was a glaring lack of an objective correlative for Entwistle's actions that day. He and Rachel were in debt, but only to the tune of about \$30,000, including her modest college-tuition loan of \$18,000. Their sex life lacked lustre. In America, he missed his parents (among his January dealings on the Internet was an apparent plan to fly them out to Hopkinton in April). He was having difficulty finding a job. None of this should add up to more than an excuse for a glum morning of self-pity. As a motive for killing his wife, child, and/or himself, it's pathetically inadequate, and his two hours on the road gave him ample time to see the absurdity of what he planned to do. Every exit on the freeway offered him the chance to change his destination and drive to Logan airport and a flight back to England and reality. There's been speculation that Rachel might suddenly have happened upon his password-protected "secret life" online, and that his various facades had collapsed around his ears, but even if that were true the obvious escape from his failed American experiment beckoned at regular intervals as he drove south along 495.

I have the weather data from the nearest airport to Entwistle's route that day. At 10 a.m., the sky was cloudless and the temperature, at 48°F, was warm for January in Massachusetts—perfect weather for an outing. In Carver, the Matterazzos were out at work for the day. Neil let himself into the empty house and found the key to the gun safe.

On his websites, he'd shown himself to be a prisoner of his illogical grammar, crappy writing, flights of vainglorious unrealism, and beggarly imagination; nothing he'd done on the Internet was as crappily written as

this lame American scenario, in which the solution to a very ordinary predicament was a Colt revolver and a box of ammo. His latest scheme bore a strong generic resemblance to all his others in its combination of technical competence and human cluelessness.

He was in the grip of another of his tall stories. I doubt that there was anything strange about his driving as he got back on the freeway and returned to Hopkinton. The sequence of necessary actions was mapped out for him, and he carried out each one with mechanical proficiency.

At Cubs Path, Rachel and Lillian were still dozing in the master bedroom. Given how their spooned bodies were discovered, it's probable that they never heard Neil's entry, Colt in hand. The killings were done "execution style," with the muzzle of the revolver touching, or nearly touching, its target. Rachel was shot in the top of her forehead, Lillian Rose in her abdomen, with the bullet passing clean through the baby's body and lodging in the flesh of Rachel's left breast. It took just two clicks. Then, if the prosecution's timeline was right (it was never challenged by the defense), Neil went downstairs to the living room, where he logged on to his laptop at 12:29 p.m.

The district attorney's theory required him at some stage—in the bedroom, immediately after the killings, or, minutes later, in the living room—to turn the muzzle on himself. Perhaps he did, and found his cowardly forefinger incapable of making the third click. Or perhaps his resolution simply died on him as he began traveling through the familiar, calming territory of cyberspace. Whatever happened in the hour following the murders, it's difficult to imagine that his next movements were part of his original scheme.

He drove back to Carver and replaced the revolver in the gun safe, leaving, as Joe Matterazzo's son would later notice, the safety catch in the off position, then struck north for Boston and Logan, where, at around 8 p.m., a new window opened on him. Airport surveillance cameras showed him looking composed, ambling patiently from cash machine to cash machine, scraping together a total of \$800. The clerk at the British Airways customer-service desk, where he booked himself on a one-way flight to Heathrow departing the next morning, reported that they'd had a pleasant conversation, and that she'd spotted nothing out of the ordinary in his unhurried and amiable good manners.

BA flight 0238 leaves Boston at 8:20 a.m. and arrives at Heathrow at 7:40 p.m. That Saturday evening, Neil rented a car at the airport, then drove eight hundred unexplained miles, stopping en route at an unidentified hotel, and showed up at his parents' house in Coleridge Road on Monday morning.

Eight hundred miles in thirty-six hours, including a night at a hotel and various meals? No evidence was produced in court to suggest that he met anyone on this hectic journey, more an American road trip than a British one. Perhaps he was just trying to get his story straight as he ate up the miles. If so, it was time and gas squandered. Late in the afternoon on Monday, he took the first of the two long calls from Trooper Manning of the Massachusetts state police and told a weird, vague, cockamamie tale of coming back from the mall on Friday morning to find his family slain in bed.

He couldn't explain why he hadn't thought to call 911 and report the murders: "Looking back on it, I don't know why I did things the way I did," was all he could say. His first impulse on discovering that Rachel and Lillian were dead was, he claimed, to kill himself. "I got the knife, and—and I couldn't do it. I knew it would hurt." He'd flown to England without telling anyone about what had happened because "I got to the point where I just needed to be with someone." But there's a note of candor in one exchange:

Becoss I'm here. It's understandable that to Entwistle, on Coleridge Road, surrounded by furniture known since childhood, what had happened in America appeared to him as a bizarre and jumbled fiction. It was as if the events in Hopkinton had transpired in the interactive, gothic landscape of games like World of Warcraft and The Dark Age of Camelot, where the players' avatars engage in bouts of online slaughter. On the phone with Trooper Manning, his bafflement—"I just . . . I just don't understand how this could come about"—sounds genuine, and, back in Worksop, almost certainly was.

But another kind of unreality engulfed Coleridge Road as jostling platoons of cameramen and reporters, many of them American, besieged the Entwistles' house, where the curtains were drawn and whole days passed without the door being opened. One rare visitor, importuned for a quote, snapped at an American reporter: "We're a very private people in England. You should all go away." After two weeks of this, Neil took a train to London, to hang out with two fellow Old Blades, as former members of the York boat club call themselves: Benjamin Pryor, a hedge-fund manager, and Dashiel Munding, a music producer.

He stayed in Munding's flat in Notting Hill. The friends ate out, watched

[&]quot;I haven't even cried yet."

[&]quot;You haven't even cried?"

[&]quot;No, not properly. I think it's because I'm here. It almost doesn't seem real. It's just a void."

a video of the Jim Carrey film Fun with Dick and Jane, in which a couple facing bankruptcy turn to crime, while Neil exaggerated his money problems, saying he'd bought, not leased, the BMW and had taken out a 100 percent mortgage on the house in Hopkinton. "He wasn't himself," Pryor said on the witness stand. "He was very upset. He was playing with his wedding band. He wasn't the happy-go-lucky guy he'd been in the past."

On February 9, a Thursday, and the third morning of his London visit, his father called from Worksop to say that Scotland Yard had issued a warrant for his arrest. Wanting to hand himself over from Coleridge Road, Neil got his stuff together and prepared to take the train to Worksop. Munding walked him to the Ladbroke Grove tube. "I said my goodbyes to Neil, shook his hand, slapped him on the back, tried to wish him well." At Royal Oak, two stations past Ladbroke Grove, the police stopped the train and took Entwistle into custody.

A man faced with imminent arrest might be expected to rid himself of incriminating evidence beforehand, and a Borough of Kensington rubbish bin would have been the best place for two of the three documents found in Entwistle's traveling bag. The first was a one-page eulogy to Rachel, perhaps meant as the text for the final home page at rachelandneil.org. It began: "Rachel only knew how to care for others. Selfless to the end. As a husband I could never dream for more. She was my soul mate and my very best friend." Its most striking sentence was: "We believed that true love was not about gazing deeply into each others eyes, but staring out together in the same direction, the desire to reach those common goals being the strength that would drive us forward." This turns out to be a mangled version of an Internet-famous quote from Saint-Exupéry. Always imitating, copying, cribbing, Neil could never resist the lure of the ready-made, whether inaccurately plagiarizing Saint-Exupéry or committing a slipshod version of an American movie murder.

The second document was the beginning of a scripted phone call that he apparently intended to make to editors of the London tabloids:

Good afternoon, my name is

I am a close friend and confidant of Neil Entwistle. I am approaching you because I feel that Neil is in a frame of mind to tell his side of the story. What is of interest to us is what price you would be willing to pay for exclusive rights to the full story? There is no loyalty to any particular paper because all have printed slanderous comments, so we are leaning it goes to the highest bidder.

This was another of his millionmaker wheezes. The third document, a page torn from Wednesday's *Daily Sport*, advertised the services of prostitutes and escort agencies—adultfriendfinder in hard-copy form.

The contents of his bag were like his online life, as he flipped from persona to persona, switching identities and avatars on his Internet journeys. By the time of his arrest, all that seems to have been left of Neil Entwistle was the accent of the Nottinghamshire mines, nearly all now abandoned: a polite, bemused, and childish voice sounding like an echo from a past England.

Entwistle is now spending twenty-three hours a day in solitary confinement in the maximum-security wing of the state correctional center at Shirley, Massachusetts, where he's said to pass the time "losing himself in books." An automatic appeal of his conviction is pending. The lead prosecutor in his case, Michael Fabbri, was recently interviewed by the *MetroWest Daily News*. Asked what possible motive Entwistle could have had for doing what he did, Fabbri, who must have studied the murders in more detail than anyone on earth, said, with commendable philosophy: "Sometimes you just don't know why... No 'why' would really explain this. There is no why."

London Review of Books, August 2008

Second Nature

IN 1959, WHEN I WAS SEVENTEEN, the lake was as wild a place as I knew. My friend Jeremy Hooker and I would arrive there at around 4 a.m. in early summer, ditch our bikes in the tangle of rhododendrons, and pick out the narrow path by flashlight as we tiptoed, in existentialist duffel coats, through the brush. Still some distance from the water, we moved like burglars, since we attributed to the carp extraordinary sagacity and guile, along with an extreme aversion to human trespassers on its habitat. Crouched on our knees, speaking in whispers, we assembled our split-cane rods. In the windless dark, the lake's dim ebony sheen was at once sinister and promising. Somewhere out there, deep down, lay Leviathan, or at least his shy but powerful cyprinid cousin.

Our style of fishing was minimalist—no weights, no float, nothing but a hook concealed in a half-crown-sized ball of bread paste, attached to a hundred and fifty yards or so of nylon monofilament. Though the fish in the lake ran to twenty pounds and more, our lines were of six-pound breaking-strain. The carp, we believed, had eyes so keen that it would balk at nylon any thicker than gossamer 2X, soaked in strong tea to camouflage it on the muddy bottom. Before first light, and the first woo-woo-wooing of a wood pigeon in the trees, like a child blowing over the neck of a bottle, we'd cast our baited hooks far out, settle our rods between two forked twigs, and squeeze a bead of paste onto the line between the open reel and the first rod ring. A quivering movement of the bead would signal that a carp was showing interest in the bait. The rest was watching, waiting, taking gulps of hot coffee from a shared flask, smoking Anchor cigarettes, and talking in a conspiratorial murmur about books and girls.

The lake slowly paled, with helical twists of mist rising from the water. Then, as the sun showed through the woods, a big carp jumped, crashing back like a paving stone dropped from the sky and leaving behind a pinsharp, reminiscent after-image of olive and gold. We strained for signs of moving fish—the sudden flap of a disturbed lily pad, or a string of tiny bubbles filtering to the surface—and, tense with expectation, willed the telltale beads to tremble into life.

We nearly always had the lake entirely to ourselves. It was out of bounds to the boys in the prep school, a converted Queen Anne manor, on whose grounds it stood, and we regarded it—and the permission we had from the headmaster to fish there—as our exclusive privilege. The lake was no more than two acres at most, but with its resident water rats, moorhens, and wagtails, its visiting herons and kingfishers, and its enormous, mysterious fish, it felt like a sufficient world, magically remote from Lymington, Hants, a few miles to the west.

As often as not, the carp disdained our bait, and we'd leave at midmorning, five Anchors apiece for the worse, but on good days, usually after hours of waiting, the bead of paste would twitch, then stop, then twitch again. This could go on for half an hour or more. The carp—with its big, lippy, toothless mouth—is a leisurely feeder: it rootles along the bottom, vacuuming up silt; swills it about in search of delicacies, then ejects the muddy mouthful like a wine taster using a spittoon. The bead would rise an inch or two toward the first ring before sinking slowly back. Then, either nothing at all would happen or the line might at last begin to slide steadily through the rings, uncoiling from the open face of the fixed-spool reel. Here was the moment to strike—to lift the rod, engage the pickup on the reel, and find oneself attached to what felt like a speeding locomotive as the carp ran for the deep, the rod bent in a U, the taut line razoring through the water. Of the fish we hooked, most were quickly lost when they jumped, doubled back, or buried themselves among the lilies, but sometimes we'd have a thrilling twenty-minute battle, never seeing the carp until the last moments, when it flopped, exhausted, over the rim of the extended landing net. Out of its element, it looked prehistoric, like a paunchy coelacanth—its armor of interlocking golden scales glistering in the sunshine, its great mouth framing an O of astonishment and indignity at its capture. Still jittery from our encounter with this creature from a netherworld, we'd unhook it, weigh it, and return it to the water.

Jerry later wrote a fine poem about these expeditions, "Tench Fishers' Dawn" (there were tench in the lake, too, though they evidently interested him more than they did me), whose last line reads, "Then, casting out, we're suddenly in touch." In touch with what, though? *Nature* was how it felt at the time, an engagement with the wild. But in England, nature and

culture are so intimately entwined that their categorical separation is a false distinction. At the lake at Walhampton, the two were fused. The rhododendron jungle where we hid our bikes was made up of species introduced to England from the Alps, North America, and the Himalayas between the seventeenth and nineteenth centuries. Carp were first imported from Eastern Europe in the early thirteenth century. Until the monastery's dissolution in 1539, Walhampton was one of the many outposts of the powerful Augustinian priory of Christchurch, Twineham. The lake was certainly artificial—probably a later enlargement of a monastic fishpond—and our fat carp were the direct descendants of the exotics farmed by the monks, or so I like to think now. The surrounding woods were sculpted by "improvers" in the late eighteenth or early nineteenth century. We were fishing in the deep waters of several hundred years of patient engineering, cultivation, fish husbandry, and landscape gardening—not first but second nature.

As the word itself says, landscape is land-shaped, and all England is landscape—a country whose deforestation began with Stone Age agriculturalists, and whose last old-growth trees were consumed by the energy industry of the time, the sixteenth-century charcoal burners; where the Norfolk Broads—now in danger of becoming an inlet of the North Sea—are the flooded open-cast mines of medieval peat diggers; where the chief nesting places of its birds are hedges, many of which go back to hawthorn plantings by the Saxons; where domesticated sheep have shaved every hill clean; where coverts, coppices, and spinneys exist (or did until the ban) as subsidized amenities for the foxhunting brigade; where barely a patch of earth can be found that hasn't been adapted to a specific human use.

The English have a genius for incorporating industrial and technological change into their versions of both nature and the picturesque. It's hard now to imagine the wholesale wreckage of the countryside by huge gangs of Irish navigators, otherwise known as "navvies," as they dug and tunneled across England during the canal-mania period of the Industrial Revolution. But spool on another century and a bit, and the canals—still busy with commercial barge traffic—had become symbols of all that was green, pleasant, and tranquil in our land.

When my father was abroad in North Africa, Italy, and Palestine during the Second World War, my mother kept him supplied with a series of slender books, printed on thin, grainy war-issue paper and illustrated with evocative wood engravings, about British churches and cathedrals, pubs, cottages, ancient market towns, gardens, and scenic byways, designed to

remind the patriotic serviceman of the world he was fighting for. One book in the series, brought home to Norfolk by my father in 1945, and a particular favorite of mine, was devoted to the canals of England and their locks and bridges, now solidly established as key items in the paraphernalia of conventional English pastoral.

Many city children of my generation got their first experience of nature courtesy of the Luftwaffe, when bombed-out houses were transformed into little wildernesses of thistle, teasel, willowherb, and loosestrife. Redstarts and other birds nested in crannies in the ruins, among staircases leading to nowhere, with peeling wallpaper and upper-storey fireplaces, still with ashes in the grate, now open to the sky. The bomb sites, where I yearned in vain to be allowed to play, appeared to me to be immemorial landscape features, full of character and mystery, and one of the major attractions of family visits to London, Liverpool, and Birkenhead in the late 1940s and early 1950s.

Or one might look at Turner's astonishing Rain, Steam and Speed—The Great Western Railway (exhibited 1844), whose rendering of elemental swirl and tumult makes it close kin to his Snow Storm-Steam-Boat off a Harbour's Mouth... (1842). But where the earlier painting shows the paddle wheeler all but overwhelmed by a hurricane-strength wind and terrifyingly steep cross-seas, the train in Rain, Steam and Speed is not the victim of the wild weather but its apparent prime mover. To the peaceful, lately sunlit arcadia of Maidenhead, with its plow, scarified hare, and the unruffled Thames below, where two figures are seated in a punt (gudgeon fishing, I suspect), has come this roaring Boanerges, son of thunder, raising a perfect storm. On the final page of his J. M. W. Turner: "A Wonderful Range of Mind," John Gage asks, "Has the railway desecrated the beautiful stretch of the Thames it crosses here at Maidenhead?" But it's surely clear from the painting that Turner loves the locomotive, with the blazing inferno of its firebox eerily exposed. He paints the newfangled intruder on the landscape as a force of nature in its own right. Gage remarks on the "light-heartedness" of the picture's imagery; its wittiest touch is that the gudgeon fishers, if that's what they are, don't even bother to look up in wonder at the transcendent marvel of their age. But then they're English, born to a casual phlegmatic acceptance of astounding alterations to the landscape, and perhaps the train and Brunel's great flat-arched viaduct have already been absorbed into their sense of the natural order of things. If you're bred to living in second nature, it's relatively easy to find room in it for a Firefly-class steam engine alongside the gudgeon and the plow.

When I moved to the Pacific Northwest in 1990, I felt at a loss. Accustomed to living in England's secondary nature, I had difficulty reading a landscape in which so much primary nature showed through the patchy overlay of around a hundred and forty years of white settlement and enterprise. Hunting for a workable analogy, I tried to see myself as a visitor to Roman Britain at the end of the second century, taking in the new cities, the network of paved highways, and the agricultural estates and military installations superimposed on a land lightly occupied by tribal people. But that conceit was flawed: the British tribes had permanently altered the land with mines, farms, forts, and ritual or funerary monuments long before the Romans came, while the Northwest Indians left few visible traces of their twelve-thousand-year habitation. West of the Cascade Range, where wood rots fast in the soggy climate, the Indian past faded continually behind the ongoing present, like the dissolving wake of a cedar canoe. Artifacts like painted chests, ritual masks, and wall hangings survived, but whole towns were reclaimed by the forest within a generation, leaving little more than overgrown shell middens to mark where they'd stood. Wherever the land was significantly shaped, or "scaped," the work appeared to have been done just recently—a spreading accumulation of raw concrete, pressed steel, brick, sheetrock, telephone poles, pavement, fencing, neon, glass, and vinyl scattered in piecemeal fashion across a nature whose essential bone structure of mountains, lakes, forest, and sea inlets was still so prominent that the most ambitious attempts to build on and subdue it looked tentative and provisional.

Living in Seattle, one would have to entomb oneself in the basement to avoid the view. On clear days, the snowy bulk of Mount Rainier, high as the Matterhorn, towers over the city, which squats on the edge of Puget Sound, more than a hundred fathoms deep. The lower slopes of the Cascades to the east and the Olympics to the west are thickly furred with forest, or the appearance of forest (for most of the visible timber is actually second- or third-growth "tree farms"). Black bears and cougars forage in the suburbs; threatened chinook salmon flounder through the shipping on the Duwamish Waterway, struggling upstream to spawn and die; from my window, less than two miles north of downtown, I watch bald eagles on their regular east—west flight path over the Lake Washington Ship Canal. A walker in this city can see killer whales breaching, California sea lions hauled out on docks, beavers, coyotes, opossums, foxes, raccoons.

Nearly four million people live in the coastal sprawl of metropolitan Seattle, and there can be very few cities of its size where it's so easy to feel like a trespasser on the habitat of other creatures, and to be uneasily aware that given half a chance they would quickly regain possession of their old freehold. Squint, and you can imagine wood-frame houses collapsing into greenery and large mammals denning in abandoned malls. It's hardly surprising that the urban Pacific Northwest is home to a strain of radical environmentalism whose aim is not just to conserve what's still left of nature in these parts but also to dismantle the machinery of industrial civilization and restore large tracts of country to the wild.

Whenever a bridge on a forest road washes out in a winter storm, a lobby springs up to demand that the entire road be condemned. Some dams are being breached to return rivers to the salmon, and many more are targeted for demolition. The movement, supported by a string of court victories, to prohibit or drastically restrict logging, mining, and livestock grazing on public lands has steadily gained momentum over the last decade, even though the Bush administration and—until January 2007—the Republican-controlled Congress have fought to unstitch the environmental legislation of the Clinton years. Gray wolves, fishers, wolverines, and grizzly bears—all species that survive here in minuscule numbers at present—are being reintroduced. (In the case of the widely feared grizzlies, Canadians are making the reintroductions in British Columbia and the undocumented bears are immigrating into Washington State.) At present, two bills moving through Congress will soon add two hundred square miles of mountain lakes, old-growth forest, and river valleys to existing "wilderness areas" within an hour's drive from Seattle. As the Wilderness Act of 1964 put it: "A wilderness, in contrast with those areas where man and his own works dominate the landscape, is hereby recognized as an area where the earth and its community of life are untrammeled by man, where man himself is a visitor who does not remain."

This is landscaping in reverse. Its main advocates are politicians, activists, and nonprofit foundations in large coastal cities such as Seattle and Portland, Oregon, who argue that the rise in "quality of life assets" created by such wilding of the countryside can amply compensate for the loss of jobs in traditional rural industries such as logging, mining, ranching, and farming. "Nature" and "Solitude"—those Emersonian essay titles—have a potentially higher cash value, say the conservationists, than horizontal trees or pockets of natural gas trapped in the coal seams underlying a beautiful mountain pass. When land is designated as wilderness, property prices immediately increase in its vicinity, and so does the flow of cash brought

into the area by campers, hikers, hunters, fly-fishers, snowshoers, and mountaineers.

For the economist in a city office, it's a simple transfer of figures from column to column, from Agriculture & Industry to Services & Retail Trade: if the loss in one is equaled or exceeded by the gain in the other, nobody should have cause for complaint, at least in the long run. But that's not how it's seen in the country, where the fast-advancing cause of wilderness has been met with very modified rapture.

To loggers and farmers, the visitor who does not remain is just another tourist, a member of a breed much disliked in the rural West for its presumed wealth, ignorance, and disdain for the concerns of people who work the land instead of using it as a weekend playground. Hundred-year-old lumber and market communities, faced with the prospect of a radical shift in their economies, can see the future all too clearly in the "gateway towns" that rim national parks like Yellowstone, Glacier, and Yosemite, desolate strips of competing motels, minimarts, gas stations, gift shops, and fast-food outlets. Whatever these places may once have been, their only business now is to make the beds, pump the gas, serve the meals, and wash the tourists' dirty linen—occupations in which there's money but little dignity.

And it's the assault on their dignity that so offends the country dwellers: the treatment of the logger, proud of his skilled and dangerous job, as a reckless vandal; the subordination of rural work to the recreational interests of urban sportsmen and nature lovers; the assumption of intellectual superiority by city-based environmentalists, with their mantra of "best available science," routinely abbreviated to BAS. The West is in the middle of a furious conflict between the city and the country—in part a class war, in part a generational one—that has significant political consequences.

In the 2004 general election, every city in the United States with more than half a million inhabitants returned a majority vote for John Kerry. The election was won for Bush and the Republicans in the outer suburbs and the rural hinterlands. Much was made of "red states" and "blue states," but the great rift was between the blue cities and the red countryside. Environmental politics, in the form of fervent local quarrels over land use, were at the heart of this division. Beneath the talk of Iraq, health care, terrorism, gun control, abortion, and all the rest lay a barely articulated but passionate dispute about the nature of nature in America.

Forty miles east of Seattle, the crest of the Cascade Range, punctuated along its length by snow-mantled volcanoes, runs north to south, dividing

Washington state into two regions. Crossing from one to the other over a mountain pass, you experience in minutes a violent change of climate and culture, as the inky green of Douglas firs, mosses, ferns, and salal suddenly gives way to shale, sagebrush, and juniper. Annual rainfall plummets from around eighty inches a year to ten or less; incomes and house prices drop; on the car radio, the news on National Public Radio fades into a drizzle of static, its place quickly occupied by a gospel or Spanish-language station. In the newly moistureless atmosphere, the light turns hard and clear, collapsing distances so radically that the entire Columbia Basin, an area larger than France, seems to make itself visible all at once: a web of branching canyons, intricate as a leaf skeleton, threaded between bare whaleback hills.

On old maps, it shows as part of the "Great American Desert"—an arid, treeless expanse, home to jackrabbits and rattlesnakes, fit for human use only for its mineral deposits and as an open range for sheep and cattle grazing on the sage and bunchgrass. But the Columbia River and its tributaries, laden with snowmelt from the Cascades and the Rockies, flowed through the canyons, and the pillowy basalt uplands—solidified streams of the molten lava that coursed from the mountains during their formation—were coated in fine wind-blown silt, or loess, soil in which almost anything would grow if it could be moistened with water from the rivers. What would turn into one of the most grandiose landscaping projects on earth began in a modest, ad hoc way, as nineteenth-century white settlers built diversion dams and sluices, and dug canals and ditches, tapping the nearest river for irrigation by using the same minimal technology with which Mesopotamians watered the Iraqi desert from the Euphrates, and the Hohokam Indians of Arizona periodically flooded their parched flatlands on the Gila and Salt rivers fifteen hundred years ago.

In the national mythology, it's the quintessential American experience to arrive in a wild and inhospitable place, bend raw nature to one's own advantage, and make it home. So the land encountered by the Columbia Basin settlers was an American classic: mile upon mile of twiggy sage, spread over bald, shadeless hills and broken by sheer cliffs of fissured rock.

Near where steep, fast-flowing streams met the Columbia, settlers built weirs to channel water into irrigation ditches that hugged the contour lines and eventually, after a serpentine journey around the countryside, discharged into the main river, several hundred feet below the level of each weir. These "highline" canals, most of them financed by railroad companies and consortia of city businessmen, opened broad swathes of land for cultivation. Sagebrush was plowed into fields, fifty-dollar windmills were

installed to pump water onto the soil, and the lower canyons were transformed into a quilt of farms and orchards.

From the beginning, the U.S. government watched over such private-enterprise schemes like a jealous parent. In the federal imagination, the watering of the dry West presented a fantastic opportunity at once ideological and practical. The region was still best known for its mining camps, its migrant cattle and workers, its wide-open towns whose success was measured by the number of their saloons, brothels, casinos, and murders. Irrigation, on a scale far beyond the means of the private sector, would turn this barely governable land into a settled agrarian democracy—a society of farmers with family values, beholden to the government for their good fortune. When the National Reclamation Act was passed in 1902, President Theodore Roosevelt called it "one of the greatest steps not only in the forward progress of the States, but in that of all mankind" and forecast that "communities flourishing in what is now the desert finally will take their places among the strongest pillars of our Commonwealth." Reclamation of the soil would bring about a greater reclamation—of morals, manners, and citizenship.

The act's sponsor, a Nevada congressman named Francis Newlands, envisioned that sixty million acres of arid wilderness would eventually come under the plow. The enormous cost of irrigation would be paid for by the sale of public lands to homesteaders on ten-year mortgages. To stop the corporations—especially the railroad companies—from making a government-subsidized land grab, each family would be limited to a maximum of a hundred and sixty acres and would have to prove permanent residence on their farm.

The plan had the charm of a perpetual-motion machine: it would produce a continuously revolving fund of money from a limitless supply of presently useless land and generate a steadily expanding tax base of prosperous small farms. It would tame the lawless West, ease overcrowding in the eastern cities, feed the hungry, and enrich the nation—all at no cost to the taxpayer. It was the quintessential politicians' dream.

The new U.S. Bureau of Reclamation sent out teams of geologists to scour the West for possible sites for dams and involved itself in a multitude of schemes, most of which ran awry as irrigation works fell behind schedule, costs overran, and farmers went broke trying to meet their monthly payments on the proceeds of scanty harvests. In 1923, the secretary of the interior admitted that "Reclamation of arid lands by irrigation from Government funds . . . is failing on a majority of projects." Although successive

presidents, including Hoover and Coolidge, talked up the federal dream of landscaping the West, it wasn't until the Great Depression and Franklin Roosevelt's New Deal administration, more than thirty years later, that the big dams, so long promised, at last began to take real shape.

In 1933, the first concrete was poured at the Boulder Dam across the Colorado River on the Arizona-Nevada border and work started on the Fort Peck Dam across the Missouri in Montana as well as the Bonneville and Grand Coulee dams on the Columbia. "We are in the process of making the American people 'dam-minded,' "Franklin Roosevelt said at the Grand Coulee site in 1934, where the sheer gigantism of the project made the dam a symbol of national regeneration in hard times. "The largest structure ever undertaken by man," Roosevelt called it, and a *New York Times* reporter, traveling with the presidential entourage, tried to convey to his readers the immensity of the Grand Coulee, first in familiar New York terms—"a structure that will be higher than a forty-story building, longer than four ocean liners the size of the *Queen Mary*, and almost two city blocks in thickness"—and then in terms of the extraterrestrial: "It stretches across the Columbia like the crenellated wall of a giant fortress built to withstand the artillery of some super-warriors from Mars."

It took eight years to build, the urgency of its completion mounting every year as conditions in the dust bowl worsened and more than a hundred thousand homeless farm workers and their families streamed into Washington State. Some found work as laborers on the dams, others as seasonal fruit pickers in the orchards around Wenatchee and Yakima; they set up home in smoky encampments along the Columbia Valley, living in tents, plywood shanties, and cardboard boxes. More bold promises were made: irrigation would create farms of forty acres, where half a million refugees from the agricultural catastrophes to the east could be resettled and see their self-respect restored.

In 1941, when the dam was finished and the first hydroelectric turbines were spinning, the Bonneville Power Administration, a federal agency, hired Woody Guthrie to sing its praises, giving him a month-long contract, a chauffeur-driven Hudson, and a \$266.66 paycheck. The short, sparrow-weight folk singer was known to the FBI as Woodrow Wilson Guthrie, a Communist Party sympathizer, whose guitar soundboard carried the message, in big letters, THIS MACHINE KILLS FASCISTS. For four weeks, Guthrie was driven up and down the Columbia between the Bonneville and Grand Coulee dams, during which time he was reported by his

driver to have never changed his clothes or taken a bath: "Poor guy had BO so bad you could hardly stand it."

If his songs are to be believed, Guthrie's usually sardonic take on the world melted in the face of the Columbia Basin project. "This is just as close to heaven as my traveling feet have been," he sang in "Roll, Columbia, Roll," and seems to have persuaded himself that something not far short of a socialist utopia was dawning in the Pacific Northwest. In a homely voice, pitched midway between a croak and a yodel, he extolled, in "Pastures of Plenty," the electrification of rural America—lighting farmhouses, powering factories and mills—and the greening of the desert.

Guthrie wrote: "I saw the Columbia River and the big Grand Coulee Dam from just about every cliff, mountain, tree and post from which it can be seen"—vantage points from which that other panorama, of penniless rural nomads in their Hoovervilles, unfolded all around him. Many of the songs, including "Talking Dust Bowl (Washington Talking Blues)," are phrased from the point of view of the "Okie" traveling man, wistfully imagining a settled future on a watered plot, his crops sprouting all around him.

But these songs were thick with cautiously subjunctive "would's" and "could's" because the irrigation scheme—Grand Coulee's original main purpose—had already been shelved. More than a year before Pearl Harbor, the U.S. government decided that in view of the "national defense emergency" created by the war in Europe, only the hydroelectric function of the dam could be justified for the time being and the green pastures of plenty would have to be put on hold until the end of the war.

Hidden in a cleft between hills of unreclaimed sagebrush, its presence signaled only by converging lines of skyscraper-high transmission towers, the Grand Coulee Dam still has the power to astonish. The front of the dam—where Guthrie admired "the misty crystal glitter of that wild and windward spray"—is dry now, a stained and weathered concrete cliff, over which the engineers release water from Lake Roosevelt above the dam only for the son et lumière shows put on for tourists on summer nights. Wedged snugly into the landscape, the Grand Coulee has become a period piece, like the Mussolini-era railway stations that are its close contemporaries.

Though many other dams have since been built across the river—between the Bonneville Dam, upstream of Portland, Oregon, and the Grand Coulee, there are now eleven dams in U.S. territory, plus a further three in Canada—the Grand Coulee is still the Columbia Basin's haunting genius loci, the prime shaper of its landscape, and the hulking embodiment of the

idea that man's mastery over nature had reached such a degree that he could work transformative miracles of the kind traditionally performed by gods: water into megawatts, desert into garden, wilderness into civilization.

It wasn't until 1950, under the presidency of Harry Truman, that the great federal irrigation scheme at last got under way. Nearly sixty years on, Truman, Guthrie, both Roosevelts, and a string of presidents in between would be astonished by the appearance of the rural wonderland they conjured into being in songs and speeches. On a recent drive across the Columbia Plateau, I had Guthrie singing on the CD player as I took in mile after bullet-straight mile of country whose desolate character remains obstinately unsoftened by no end of technological ingenuity and agricultural enterprise. The roads run north to south and east to west, one mile apart in each direction. Aside from the occasional line of irrigated poplars, planted as shelter belts, the only verticals in the landscape are telephone poles; otherwise it's like a gigantic sheet of graph paper.

For this one must thank Thomas Jefferson, who in the 1780s inaugurated the marvelous eighteenth-century rationalistic scheme of taming unruly American nature by imposing on it the "township and range" system. From an arbitrary point on the Ohio River, where it crosses the western boundary of Pennsylvania, surveyors were to map the rapidly expanding territory of the United States, dividing it into "townships," each measuring six miles by six, and further subdivided into thirty-six "sections" of one square mile apiece. Section 16, near the center of the notional township, three squares down from its northern limit and three from its western one, was to be set aside for the purposes of public education. In effect, Jefferson flung out a potentially infinite graticule across thousands of miles of as-yet-undiscovered country, planting phantom towns, each with its schoolhouse or college on every Section 16, wherever it might fall—on the craggy top of a mountain or the muddy bottom of a lake.

Although actual townships never conformed to Jefferson's grand plan but grew up for the usual reasons—because they were on a river, a cattle trail, a railroad, or, later, an interstate highway—the survey method, with its six-mile squares and square-mile sections, has improbably continued into the present. Wherever you are, in wide-open prairie or deep forest, you stand in a numbered section of a numbered township. Roads hew to these lines without paying any attention to contours, which makes driving in the West feel like being on watch aboard a ship on automatic pilot, locked to a compass course. I was going south, on a road named "QNW." Longitudinal roads were designated by letters, latitudinal ones by numbers: if one

could count and spell, it was impossible to get lost on this dusty tableland, now more geometry than nature.

Each field occupies a full section—a 640-acre square, watered by a center-pivot sprinkler that makes a perfect circle of green or chocolate-brown in the pale-olive desert. The computer-controlled sprinklers, driven by electric motors, trundle slowly around and around on wheeled under-carriages, taking a day or more to complete a single circuit. The fields' edges are strewn with the handiwork of the water engineers: pipes and spigots, squat pumphouses, lateral ditches and canals that, even after all these years, still look like rawly excavated trenches in the earth.

Miles of this flat, robotic agriculture separate farmhouse from farmhouse—a far cry from what was envisioned in 1952, when a lottery was opened to Second World War veterans, who had first dibs on eighty-acre parcels of irrigated land, each just one-eighth of a section, for an initial investment of \$4,600. The federal planners were incorrigible sentimentalists, still clinging, in the mid-twentieth century, to that peculiarly American mythologization of the small farmer as the fount of human goodness and the family farm as the essential building block in the atomic structure of democracy. "Farmers are the chosen people of God, if ever he had a chosen people, whose breasts he has made his peculiar deposit for substantial and genuine virtue," wrote Jefferson. The planners saw the Columbia Plateau as an organic society of such pocket-sized farms, peopled like some epic Robert Frost poem with salt-of-the-earth types mending walls and fences, planting seeds, aiming their long, two-pointed ladders toward heaven.

What actually emerged was an enormous tract of government-subsidized agribusiness, a monotonous and lonely landscape dedicated to the mass production of such valuable items as the frozen french fry. Within the federally regulated area of the plateau, the family farms quickly swelled to a dozen times their original size, while on its fringes the agricultural corporations moved in during the 1970s and 1980s to piggyback on the federal project, using cheap federal electricity to pump cheap federal water over acreages that measured in the tens of thousands. One barely credible statistic: in 2001, the *New York Times* reported that Columbia Basin farmers were paying \$1.50 per megawatt of electricity at a time when it was commanding a price of \$375 to \$400 on the open market.

Sharing the narrow roads with eighteen-wheeler refrigerated trucks, catching intermittent glimpses of the Columbia River, flanked by sheer

cliffs of dark basalt, and nearly a thousand feet below the plateau, I thought of how I'd been brought up with the quaint idea that cultivation gives a human shape and scale to the land. But this land seemed now less friendly than when the farmers first arrived. The rectilinear severity of its roads and its vast identical fields of beets and potatoes robbed it of distance and perspective. Its chief architectural feature wasn't the farmhouse but the "facility"—white metal sheds, spread over the best part of an acre, where vegetables were processed and packaged in loading bays full of eighteen-wheelers, lined up hull to hull. From these grim facilities came french fries—machine cut, parboiled, pre-fried, flash frozen—along with tinfoil sachets of instant mashed potatoes and the rubbery, vermicular tangles that pass for hash browns on the breakfast plates at chain restaurants.

I stopped for lunch at Mattawa, a familiar-looking grid of bungalows and trailer homes just big enough to support a supermarket and a high school. SERVICIOS EN ESPANOL said the signboard by the Mormon tabernacle, an unnecessary piece of information since everything in Mattawa was so obviously *en Español:* the Catholic church; the grocery-cum-video store; the hair salon; the laundromat; the family clinic; the rival *taquerias*, La Popular and El Jato, where a Mexican soap opera was turned up to full volume on the TV.

Mattawa was a displaced *barrio*, more than a thousand miles from home, with the melancholy air that displacement brings. Its per capita income, as I later found out, is around \$7,500 per year, which makes for a minimum-wage town typical of the Spanish-speaking settlements scattered over the plateau. Where the town peters out near the Shell gas station, the facilities begin: one is a potato-packing plant, another makes malt from barley, a third produces compressed hay cubes for cattle feed. They are all owned and managed by Anglos, with Mexican, Guatemalan, or Mexican-American workforces. During the picking season—from May to September—the Hispanic population doubles, as truckloads of migrant laborers pour into the Columbia Basin, filling spare rooms and run-down cheap motels, with many living in encampments hardly distinguishable from the Hoovervilles of the Great Depression.

From the Mattawa restaurant, sucking on a bottle of Pacifico beer, waiting for tamales to arrive, I found it hard to conceive that such gigantic investment—of rhetoric, sentiment, rural nostalgia, and incalculable billions of public money—could have resulted in a farmscape so characterless and bleak, where the majority of inhabitants appeared little better off than the dust-bowl refugees for whom this land had been designed as an agrarian sanctuary.

That Desert Aire, six miles south of Mattawa, lay right on the river's edge, was a powerful lure, but what interested me most was its street plan. According to the map, it was a maze of culs-de-sac and crescents, with hardly a straight line in sight, in defiance of the universal reverence for the austere grid. It boasted an airstrip with a limp windsock and a narrow, looping golf course that took the route of what might otherwise have been the town's main street. The buildings were mostly "manufactured homes," ready-made houses in an assortment of styles—ranch, Queen Anne, New England colonial—that had been trucked out to the site and craned into place. Started by a developer in 1970, Desert Aire looked as if it had failed so far to take root; its curvy streets empty of people, its front yards neat but bare, a social experiment in a waste of sagebrush that was still in its beta-testing stage.

I drove down to the river. A line of immature poplars shadowed a beach of thin shale. A rectangle the size of a modest building plot had been roughly excavated to create what the sign above it said was a marina, which held a single short pontoon but no boats. The beach fronted a mile-and-a-half-wide stretch of inert, tea-colored water, formerly the Columbia. A couple of miles to the south lay the pale concrete ramparts of the Priest Rapids Dam.

Before the dams, the Columbia was one of the great rivers of the world. Black-and-white photographs (handily collected in William D. Layman's *River of Memory: The Everlasting Columbia*) show it in full glory—tumbling falls, narrow chutes, white-water rapids, whirlpools, slow, reflective deeps, changing continuously in character from mile to mile. On one page, it's a level drift through a fringing forest of willows, cottonwoods, and alders, its surface lightly patterned by arabesques of current; on the next, it's a torrent of boiling milk.

As each dam went up, the river rose behind it, drowning its natural banks. Sandbars, islands, trees, and farms went under. Where it had once thundered, it fell suddenly silent. People euphemistically renamed the dead water between the dams "lakes," so at Desert Aire I was standing on the beach of Priest Rapids Lake. But it wasn't a lake; the best thing it could be called was an urban reservoir, a holding tank to supply water for irrigation and energy to drive the turbines inside the dams. From each dam, lines of pylons marched in every direction over the bare hills like gangs of thieves making off with their swag, robbing the Columbia of its life in order to sell corporate farmers electricity at a laughable price.

For conservationists, the salmon is the paramount symbol of life in the

river, and the courts are full of ongoing litigation brought on the salmon's behalf—especially the case for demolishing the dams on the Snake River, the Columbia's biggest tributary. But as a sometime carp fisherman, I have another fish in mind—a creature bigger, stranger, and more deserving of wonder than the salmon, which has the conformist mentality of a drudge on a commuter train as it travels en masse between fresh water and the ocean. My candidate is the Columbia white sturgeon.

Somewhere down at the bottom of Priest Rapids Lake, grubbing in near darkness through the sludge, there must be a surviving sturgeon or two that might have sprung from the imagination of a mythmaker, its size and power commensurate with those of the Columbia River itself before humans destroyed its upper reaches. This fish can grow to twenty feet long, live for more than a hundred years, and weigh up to 1,800 pounds. It has small, myopic eyes and the streamlined build of a pike or a U-boat, with a tapering snout from which trail four whiskery barbules and hoselike lips that it extends, concertina-style, to savor likely morsels. Its only true bones are in its head; its body is a mass of cartilage and muscle, armored with rows of interlocking diamond-shaped, razor-edged plates. It's an opportunistic eater, foraging on plants, live and dead salmon, shrimp, lampreys, shellfish; one caught on the Snake was found to have scoffed a bushel of onions, and pictures of trophy sturgeon, taken before strict size limits came into force, make their grinning captors look as if they might as well have been the fish's lunch.

Before the dams, sturgeon were anadromous, swimming freely between the river and the sea, spawning many times during their long lives, unlike Pacific salmon, which spawn once and die. Below the Bonneville Dam, that's still true; but above it, the fish are trapped, too big to negotiate the ladders used by the ever-decreasing runs of salmon, and their numbers are shrinking fast. Here there are monster sturgeon that were striplings in their thirties when the Bonneville and Grand Coulee dams were built. Trying to re-create whatever dim, ichthyotic memory they might have of fast-running water, they hang around the spillways of the dams at spawning time and lay eggs in the shallows there, some of which actually hatch into fry. But these landlocked sturgeon, trying as best they can to adapt to their changed circumstances, are slowly losing the fight against extinction.

At Desert Aire, I spent half an hour studying the water through polarized sunglasses like a fisherman methodically searching each quadrant for rising strings of telltale bubbles, dark submarine shadows, distant humps or swirls. But no fish—sturgeon or otherwise—stirred. The water appeared lifeless except for occasional patches where it was frosted by a

temporary and feeble breeze. It's said that sturgeon, like carp, sometimes spontaneously fling themselves skyward. Suppose, on a still night, a spry, eighteen-foot nonagenarian were to leap for the stars: the ensuing crash would scare Desert Aire's entire population out of their beds. That would be something to see.

Not far beyond the Priest Rapids Dam, I crossed the Columbia on a road trending southwest that led through the most undisturbed "brush-steppe" habitat in America, where no range cattle intrude on the sagebrush dotted with wild phlox, evening primroses, and Piper's daisies, the unchallenged territory of mountain elk, mule deer, bobcats, coyotes, and porcupines. Peregrines and prairie falcons ride on thermals overhead. For thirty miles, one sees the land as it was before ranchers—then irrigators and factory farmers—changed its face for the worse. Even the road—State Route 240—has natural bends that conform with the swell of the hills.

"Fat Man" did this. The plutonium that powered the bomb that was detonated over Nagasaki, immediately killing forty thousand, was manufactured at the Hanford Engineer Works. The Manhattan Project required a site remote from human habitation, with access to unlimited supplies of water and electricity. Everything necessary was here, where the Columbia made a crooked dog's-leg swing to frame a level stretch of country. The riverbank farmers were evicted and the place was code-named Site W.

From the road, there wasn't much to see beyond the prohibitive barbed-wire fencing: the cluster of white buildings, six or seven miles off, looked like an innocuous farm town, where they might have been grain silos, barns, a water tower, a church. More buildings tapered in the haze to the east, but nothing in view helped one to imagine the real scale of the plant, which by the summer of 1944 employed several thousand more people than Fat Man killed, and then went on to make its specialized contribution to the U.S. nuclear arsenal for another forty years.

Hanford is routinely described as the most polluted nuclear site in the nation. Some fifty-three million gallons of highly radioactive waste are stored in underground tanks, all of them obsolete, many of them leaking, and clean-up workers keep finding unexpected burial grounds for irradiated reactor fuel along the west bank of the river. The business of decontaminating this lethal dump began in 1989, shortly after it stopped producing weapons-grade plutonium. Every year, the estimated costs rise and the deadline for completion—when the waste will be vitrified into glass and safely removed—is projected further into the future. At present that date

is 2048, though in a year or two, no doubt, another decade will be added to it.

Yet the secrecy and danger of the site kept irrigation, farming, and hydroelectric schemes away from the river and made a nature reserve of the land, which in 2000 became, by presidential proclamation, the Hanford Reach National Monument. So the A-bomb restored more than six hundred square miles of what used to be orchards and farms to at least the appearance of the wild, and left the Columbia to flow relatively freely between Priest Rapids and the McNary Dam, fifty-one miles downstream. But it's a spooky kind of wild, where the razor-wire security fence and the black-trefoil-on-yellow-ground danger sign are part of the furniture, where the jackrabbits are lightly irradiated with trace amounts of radioactive iodine-129.

I drove on to Richland, at the junction of the Yakima River and the Columbia, once a small farm town, then a dormitory for workers on the Manhattan Project, and now—attached to its close neighbors, Pasco and Kennewick—part of a charmless urban agglomeration known as the Tri-Cities. This is a sixteen-mile sprawl of malls, parking lots, and high-rise offices, through which the two rivers flow as mere impediments to their more perfect union. At my first attempt to find the center of Richland, I overshot and found myself on the wrong side of the Columbia, in Pasco. On my second, I landed up in Kennewick. On my third, I clung to the west bank of the Columbia and lucked upon a hotel room that overlooked the river. My ambition was to see it move.

Though an evening wind had sprung up, the ruffled tan water looked no less reservoirlike than it had at Desert Aire. There's a drop of seventy-five feet along the Hanford Reach—not much over a length of fifty miles, but more than enough to impart life and motion, to make it by far the best salmon-spawning ground on this dammed section of the river. Disappointed, I took myself off on a tour of Richland, looking for somewhere to eat that was neither a Red Robin, McDonald's, Pizza Hut, Arby's, Jack in the Box nor a chain restaurant catering to conventioneers, and came across the local high school. What was one to make of a city whose sports teams call themselves the Richland Bombers and proudly wear a logo consisting of a capital R superimposed on a pluming mushroom cloud?

After a long search, I found a small bistro tucked inside an unpromising-looking office complex, where, over the best bowl of Ukrainian borscht I've ever tasted, I wondered if Richland had many visitors from Nagasaki.

Shortly after dawn the next morning, I went down to the river to take another look. The air was perfectly still, and thin spirals of mist were rising from the glassy surface, just as they used to do at Walhampton. Inshore, the water was dead, but close to midstream, a hundred and fifty yards out, the current showed in a scribble of lines and curlicues, bright silver in the early sun. Upstream, I heard the splash of a jumping fish and saw the concentric ripples it had left behind turn oblong as the river's thrust distorted them. A late-running fall chinook, probably, still trying to rid itself of sea lice. To get to Richland, it would have had to struggle up the ladders of four hydroelectric dams—a killer journey that only a small minority of fish survive. Safe now in Hanford Reach, it would spawn and promptly die. After salmon-spawning time on Pacific Northwest rivers, the stench is terrible, the gravelly shallows full of putrefying corpses, but the smell—strong enough to make one gag-is a measure of the river's health, and in recent years it's grown steadily fainter as more and more salmon runs, including that of the Columbia chinook, are listed under the Endangered Species Act.

Immediately south of the Tri-Cities, where the Snake River joins the Columbia, commercial river traffic starts. Grain barges, bound for the container terminal in Portland, Oregon, from as far inland as Lewiston in Idaho, pass through the locks that are built into the eight dams on the combined Snake-Columbia navigation. The busy road along the Columbia's east bank was lined with wharves and with facilities belonging to industrial agriculture giants such as J. R. Simplot, ConAgra, and Agrinorthwest. As I turned east into the valley of the Walla Walla River, its dozens of small tributary creeks were marked by winding lines of cottonwoods, and farmhouses were suddenly within hailing distance of each other. Fields came in all shapes and sizes. A horse at grass stood in the shade of an old tree. At the foot of the sagebrush hills and canyons lay exactly the countryside—the multicolored patchwork of family farms—that the apostles of irrigation had designed and legislated for the Columbia Plateau. But what federal laws and money could never achieve was this untidy, impromptu landscape that had been settled by white farmers since the 1850s.

The cause for this change of character, and the source of the multitude of creeks, were the cloud-stopping Blue Mountains to the south and east. Low by the standards of the mountainous West, the Blues rose to around 5,000 feet—sufficient to increase the rainfall from six or seven inches a year to ten, eleven, twelve, just over the dividing line that separates "semi-arid" from "arid" land. Irrigation is still necessary, but it is of a piece with the landscape, small-scale, improvised. I stopped by one ditch so narrow that I could almost have jumped across it, and watched clear water burbling over

the lip of a shallow homemade weir. Its grassy banks were still—at the end of October—speckled with wild flowers.

I had an appointment with Rick Small, a winemaker whose vineyard was in the hills to the north of the valley. When I could afford them, I'd much enjoyed his Woodward Canyon Cabernet Sauvignons, boutique wines that start at \$40-plus a bottle and are scored in the 90s by Robert Parker's Wine Advocate. I parked outside the nineteenth-century farmhouse where Woodward Canyon has its tasting room, then rode with Small up from the green valley into the bare hills to his vineyard.

"My wife hates this bit," he said, as the truck took a tight corner and hurtled up a narrow rutted track, roaring in first gear and raising a storm of brown dust behind it. The land was "rolling," but the word conveys a gentleness entirely absent here. These hills roll as a gale-torn sea does, in lurching peaks and troughs. As we kept on climbing, sage and thistle abruptly gave way to terraces of trellised vines on a slope as steep as the face of a wave. We stopped at the summit, beside three big water tanks, and Small liberated his young German shepherd from the cab.

Below, his forty acres fell away from the southeast to the southwest, tracking the daily path of the sun. The vines, brown now, were decorated with streamers of silver foil to scare the birds. Here and there, bunches of unpicked grapes remained, their skin wrinkled but their taste still fresh and sweet. Rick Small, lean, bald, and buff, dog capering around his heels, led me through the terraces. My local wine merchant in Seattle had told me that Small was an "enthusiast"—an understatement. "I was born to do this," he said. He'd grown up on this land, where his grandfather and his father had been wheat farmers. In 1981, when the Washington State wine industry, now second to California's, was still barely fledged, he planted his first vines.

I said that wine grapes must be the last remaining crop from which a good living in these parts could be made on such a tiny acreage.

"So long as you have vertical integration. If you grow your own grapes, make your own wine, and be your own sales rep, yes, forty acres can make economic sense—all that, plus the passion for it. And patience. It may take twelve, fifteen years to get an idea of whether a grape is planted in the right place."

On the excavated sides of the terraces, he showed me how unevenly the loess had settled on the basalt underneath. In places, the layer of silt was seven or eight feet deep; elsewhere, just a few inches. I rubbed a pinch of loess

between forefinger and thumb; it felt as fine and smoothly lubricant as talc. A crumbled fragment of basalt was riddled with small bubbles—pockets of ten- or fifteen-million-year-old air, trapped when the immense, successive tides of molten lava rolled over the Columbia Basin, covering it to a depth of up to 16,000 feet.

Small's Merlot grapes liked to be featherbedded in an ample layer of silt, and the tone in which he mentioned this had in it a faint but distinct hint of moral disapproval. What he wanted me to admire was the Spartan fortitude of his Cabernets.

"See? It's practically growing straight from the rock. It's amazing. The silt's so thin there that you'd think nothing would grow. But that's cab. Not much fruit, and they're rooted quite far apart, but look at that determination. It's do or die."

It was in this spirit that he kept his vines thirsty. We were standing on a latitude exactly midway between that of coastal Bordeaux and inland Burgundy, and I asked him if—given France's generous rainfall—he'd take it as a blessing or a curse.

"I can manage my moisture—that's a great part of being here."

The well at the bottom of the slope went nearly eight hundred feet down. The water was then pumped another three hundred feet up to the tanks on the summit, from where Small dribbled it down to his vines in a measured prescription. "Half a gallon an hour for five to eight hours every eight days."

Too much irrigation brought bigger crops, fatter grapes, more juice, less skin. "It's what a lot of people like, but not me. The wine has flavor, but no concentration. My ideal is small berries with a big ratio of skin to juice. My best Cabernet vines are fifteen years old—just half a ton of grapes to the acre in a good year, which is way low by industry standards, but it's what I like to see."

Despite his high scores from Parker, he deprecated the trend toward Parker-style "New World" wines—big and bold, all fruit and power. He wanted his own wines to have restraint, subtlety and—a word he repeated several times—"concentration."

"How local is *terroir* here?" I said, swimming somewhat out of my depth. "In a blind tasting, could you recognize the grapes from this vineyard from everyone else's?"

"I might have difficulty with Walla Walla Valley, but I could easily tell them from Yakima Valley, Columbia Gorge, or Horse Heaven Hills." Each was a separate Columbia Valley appellation, or AVA, a federally licensed American Viticultural Area.

"And can you describe the taste?"

"Herb, with nuances of tobacco, berry, and cassis."

I wasn't sure if this was a straight answer or if he was ribbing me about saying "terroir." What I did cherish was his "flavor without concentration"—a crisp, non-pseud description of a lot of wines I'd glugged down without much caring for.

No pesticides or herbicides touched his precious loess. Every terrace was hoed and weeded by hand. "It's all about sustainability." He was proud of the fact that he was now employing the sons of the Hispanic men who'd worked for him when he first started the vineyard. "Sustainability again."

I was admiring his plantings of native shrubs, like juniper, on the land around the terraces. Everything fitted—this was landscape farming that molded itself closely to the shape of its original nature. "It's perfect here," I said, looking down over the valley to the forested Blue Mountains in the distance.

"I love this place's violent history," Small said, meaning the lava surges and the catastrophic, Noachian flood that had swept through the Columbia Basin in the last ice age, some thirteen thousand years ago. The flood had been caused when a huge glacial lake in what is now Idaho and Montana had broken through the ice plug at its western end and poured into the basin as a racing wall of water nearly a thousand feet high, scouring the valley to bare rock. It had left behind low hills in the shape of giant ripple marks, dry coulees, cataract cliffs, and plunge basins, the Martian "Channeled Scablands" that had drawn NASA scientists here to investigate the terrain that the Viking and Phoenix landers would meet when they touched down. It had also left behind Rick Small's favorite found object on his property, a lump of granite the size of a small chest of drawers. "My erratic."

The boulder had once been trapped inside a floating berg. When the flood receded and the ice melted, the alien granite found a home on Small's vineyard. One side was a sheer plane, the rock sliced through as cleanly as if it were cheese. "See those scratches there, how straight they are? The ice did that. I had a geologist from the university come out here to look at it. He told me exactly where in Canada it came from. It's kind of inconvenient where it is, but I'd never move it. It's part of the history of the land."

At the north end of the vineyard, the rising, rollercoasting hills of sagebrush steppe went on for as far as one could see.

"So this was the last farm."

"Oh, no, all this was wheat. Dry-farmed, no irrigation. It paid some years, but just about everybody went bust." Pointing to the hills, he named the farmers.

I looked more closely, but couldn't see a single fencepost trailing strands

of rusting barbed wire. There were no collapsed barns or abandoned plows, nothing to suggest that here had once been homesteads, farm tracks, fields. No doubt a botanist would have corrected me, but all I saw was pure natural habitat, sage-grouse country, as it must have looked when the first white settlers showed up in the Walla Walla Valley.

If the market for perfectionist, expensively produced wines were to collapse, Rick Small's vineyard would fade back into the wild in the course of one generation, perhaps two. Hanford's plutonium factory will take a little longer only because of the toxic horrors buried in its grounds. From there, it needs no great exercise of the imagination to see the canals of the Columbia Plateau run dry and its mega-farms revert to sage.

Here's the big difference between British and western American ways of seeing nature. Each time I drive through England on a visit, fresh blots on the landscape present themselves to my conventional eye: business parks, new subdivisions, a motorway under construction, an expanded airport. But, as one does, I have a definite yet arbitrary line drawn in my mind between the undesirably modern and the immemorial. That line is recent—not much earlier than about 1900, or about the time the car arrived on the scene. A reflexive nostalgia for the antique is hardwired into my brain. Old stuff, however junky or ugly when it was first made, takes on value because of its age alone: the small thatched cottage with crooked windows, which began life as a miserable human sty, is a Grade II—listed building now.

So I take indiscriminate pleasure in the packhorse bridge over the canal, the drystone wall, the field still marked by the medieval ridge-and-furrow system, the blackthorn hedge, the wooden stile, the now-dry communal village pump, the straight-line Roman road, the Neolithic tumulus, the one-track lane overarched by trees, the distant Victorian (or any other period's) spire—all equally immemorial and to be cherished because they represent ways of living on and changing the land that are all either long gone or as good as gone.

But here, where the lust for the antique is no less keen than in Britain, the true antiquity is wilderness. Old mining towns, chasing tourist dollars, deck themselves out with false storefronts, wooden boardwalks, and faux shoot-'em-up saloons, but nobody's fooled. The real thing—the pricelessly *antique* antique—is deep forest, the river running wild, the open prairie. There is no second nature here to fall back on, only an either/or choice between nature as it was before we came and the dreck we've piled on it in the recent past.

In the dry and lightly populated West, for all the ranching, farming, logging, mining, damming, and city building that have gone on for the last century and a bit, for all the immense expenditure of public and private money lavished on its development, Americans have altered the land less immutably than the Romans, Saxons, and Normans altered the face of England. Most of what has been done here still looks like a recent project, a work in early progress, that could yet be stopped.

In 1987, Frank and Deborah Popper of Rutgers University made a shocking proposal in a short article for *Planning* magazine, in which they suggested that the Great Plains, lying west of the ninety-eighth meridian and stretching from the Canadian border down to Texas and Colorado, should be returned to the buffalo. "The small cities of the Plains will amount to urban islands in a shortgrass sea," they wrote, calling their scheme "Buffalo Commons." The article was greeted with outrage by the implicated farmers. The Poppers were threatened with assassination (it didn't help that they came from, of all places, urban New Jersey). The idea was so extreme and sweeping that many people took it as a joke in bad taste. Yet twenty years later the article is still discussed, and the Poppers remain unrepentant.

As rural depopulation continues on the Plains, especially in northern states such as the Dakotas and eastern Montana, they see their idea as being vindicated by history. In 2004, Frank Popper said that the article was originally meant as "a metaphor for the environmental and ecological restoration of a lot of the Great Plains," and that he and his wife had been astonished by the enormous audience it had attracted. "There is no question that some form of the Buffalo Commons will happen. We believe it is a done deal."

That such a proposal could be entertained at all is a measure of how lightly white civilization still sits on nature in the interior West, how precarious is its tenure here. It's as if the land itself whispers that everything could be otherwise, that it's not too late to change. And this is the vision that haunts the radical environmental movements.

Only in the West could one look at the Columbia Basin and so easily reshape it in one's mind's eye. Why not dynamite every dam on the Columbia and the Snake? Take down the power lines? Resettle the cities? Free the sturgeon and the salmon? Reopen the plateau to the elks and wolves? Farming would go on along the banks of the rivers, as it did before the federal government began dreaming its grandiose dreams, but for the most part this land would soon go back to its immemorial state as sagebrush steppe, a tract of near wilderness larger than any country in Western Europe.

Of course it would wreck the U.S. economy. It would send electricity prices rocketing, drive the local inhabitants to (probably armed) revolt, and mobilize the multinational agricultural and mining corporations to jam the courts with litigation for decades. The point is not that any of this is likely to happen, but that it's conceivable that it could. And people do conceive it, just as the Poppers did the Buffalo Commons.

The idea of home as a temporary habitation is built into the folk psyche of the West. Most of the farmers who settled in eastern Montana and the western Dakotas in the teens of the twentieth century eventually starved out and moved on. Loggers and miners were itinerants, accustomed to striking camp every few months or years. Driving through the West, it's common to see houses mounted on the flatbeds of beflagged tractor-trailers, each off on a journey to a new site in another state.

In 1981, Norman Tebbit, then Mrs. Thatcher's secretary of state for employment, caused an outcry when he told the jobless in the north of England to "get on your bike" and look for work elsewhere. The remark deeply offended the instinctive English sense that attachment to one's place of birth and its known landscape and society is a moral right. People may move away of their own volition, but they cannot be cruelly ordered to get on their bikes.

It's different here, where people are in the habit of getting on their bikes many times in the course of their lives. One's local patch of soil is rarely an ancestral tenancy, going back through the generations, but rather a perch from which one may at almost any moment flit. That the demolition of the four dams on the lower Snake—an issue that's now being fought through the courts—would drive many farmers from their land is of no great concern to the conservation groups that have brought suit, because upping sticks and moving on has always been the way of the West. Let them be compensated and go farm—if they must—somewhere else. *Get over it*.

So the hankering to wild the West persists, and I suppose that the project of restoring the Columbia Basin to nature would be hardly more gigantesque and unrealistic than the federal project of filling it with human population. For a start, one might post billboards around the perimeter of the Tri-Cities (population 168,000) to remind everyone living there that, in the fine words of the Wilderness Act, man is a visitor who does not remain—the unsettling truth that westerners know already in their bones.

Cyber City

IT'S CHASTENING to realize that since Soft City's first publication in 1974, the book's citizens, nearly all in their go-getting twenties and thirties, have moved on to the world of bus passes, if not the Great Beyond. It's sic transit gloria mundi time for the pioneer knockers-through who gentrified Islington, the vegan squatters of Notting Hill with their I-Chings and Ouija boards, the band of young writers in the Pillars of Hercules pub on Greek Street, the rival salons of Holland Park. The girls who affected granny glasses are grannies themselves now. I moved to Seattle nearly twenty years ago, and so my increasingly imaginary London still has Muriel Belcher presiding over the Colony Room, otherwise plain "Muriel's," and Gaston over the French Pub; you can lunch at Mario and Franco's Trattoria Terrazza ("The Trat"); two can dine at L'Escargot, with a carafe of house red, for around £7 (or five review copies sold to the literary knackers' yard, owned by another Gaston, off Chancery Lane); and you can still smoke on the tube.

Thirty-plus years ago I tried to write about metropolitan life as it had existed since the eighteenth century—as a theatre in which the newly arrived could try on masks and identities more daring and extravagant than any they had been allowed in their villages or small towns, as a place that guaranteed a blessed privacy, anonymity, and freedom to its inhabitants, and, most of all, as somewhere where every citizen created a route of his or her own through its potentially infinite labyrinth of streets, arranging the city around them to their own unique pattern. That was why it was soft, amenable to the play of each of its residents' imagination and personal usage. A town, even a large one, imposes on its people certain fixed patterns of movement and, with them, a set of rather narrow expectations of what

kind of character you're permitted there. If I live in Worksop, Worksop largely defines me; if I live in a great city like London or New York, I can make the city up as I go along, shaping it to my own habits and fancies.

Cities have become harder, less humanly plastic in the past thirty years. My London was far seedier than it is now—an immense honeycomb of relatively inexpensive flats and bedsits, mostly contained by the perimeter of the Circle Line. It was a place where immigrants and the impecunious young could still afford to live within walking distance of Hyde Park Corner, quarrying out nooks and crannies for themselves in Victorian houses originally designed for large families and their servants. The Earls Court square on which I lived when I was writing the book was as diverse and cosmopolitan as any place I've known: it was home to Arabs in dishdashas; gays in leather gear, waiting for the Coleherne pub to open; out-of-work actors; titled diplomats; jobbing plumbers; microskirted prostitutes in fishnet stockings; Australian students; Italian waiters; and the most famous American poet of his age. I see that a rather poky-looking one-bedroom flat on Redcliffe Square is now on the market for a cool half-million pounds, which would put it impossibly beyond the reach of nearly all the characters I knew when I was there. The £10-a-week rents in districts like North Kensington and Ladbroke Grove have mushroomed to around £400 (had rents followed the declining value of the pound, £10 then would be a fraction less than £50 now).

The inevitable consequence is that diversity is being driven from the central city to its remote peripheries—a trend that is reflected in metropolitan areas around the world. Here in Seattle, for instance, to find good Indian, Chinese, or Korean restaurants one now has to make a twenty-mile drive into the suburbs, which is where immigrants, along with artists, students, freelance writers, and other natural denizens of the soft city are increasingly moving because they can't afford the alpine rents of downtown. The densely populated inner-urban honeycomb—what Henry James, writing of London, once called "the most complete compendium in the world"—has become so expensively reconstructed, so tarted-up, that only people with a merchant banker's income will soon be able to live there, outside of the steadily diminishing supply of low-rent public housing.

In the soft city—whether it was Dr. Johnson's, Dickens's, or my London—the rich lived cheek-by-jowl with the poor, a source of daily interest and entertainment to both parties. In Victorian times, even posh new areas like Belgravia had mewses tucked behind their grandiose stucco mansions, where stable boys, with lurchers at their heels, and coach repair-

ers hung out amid the washing strung on lines and the ever-present stink of horse manure. Even in my time, there were still a few defiant survivors from that working-class world, as in the South Kensington mews to which I used to take my car for repair by an elderly mechanic who had his rented cottage-workshop there, as if he'd weathered the transition from coaches to horseless carriages. My bet is that his modest digs are now priced at £1.2 million plus, to go by current offerings in the vicinity.

One essential element of soft-citydom remains unchanged: just as you're free to create your own unique paths through the honeycomb, so you can create your own community. In suburbia, you're stuck with your neighbors, and with the same bores you ran into over dinner last month and the month before. In a metropolitan city, you may well not know the names of the people living next door, or on the floor above; your true neighbors are scattered through the inner postal districts, connected by a spiderweb of phone lines (and now by texting and e-mail). I used to see "my" London as a circuit board whose electronic layout was my secret.

Friends X, Y, and Z were unknown to one another and unlikely ever to meet, but each was a close neighbor in my personal, improvised London community. We'd connect at different pubs and restaurants, widely spaced across the physical fabric of the city, each one a "local" for a particular friendship.

As someone who grew up in a succession of small towns and cathedral cities, subject to the confining social constraints of such places, living in London was an exhilarating liberation for me. In a thirdhand green MG Midget, I learned its back streets as assiduously as any cabdriver preparing for the licensing exam, and found poetry in its place names, from the Angel to Pimlico and Parsons Green, from Shepherd's Bush to Limehouse. In Iris Murdoch's 1954 novel *Under the Net*, there's a running philosophical joke in which north London is "necessary" and south London is "contingent," which is exactly how it felt to me. South of the river, I was lost, navigating by the London A-Z on cautious excursions to Clapham, Catford, Brixton, and Battersea, each place intimately associated with a friend who, so far as I was concerned, might as well have chosen to live in Sevenoaks or Guildford. But all of London north of the Thames felt like home to me. I joined the London Library and mugged up on the city's fantastically complicated social history, and could once name every major speculative builder and architect in the nineteenth century and explain precisely how and when London's high life moved westward from Grosvenor Square to Belgrave Square and Bayswater (the "wrong" side of the park). Living rather well on a spotty but sufficient income made mostly by writing book reviews and

plays for radio and television, I gypsied from quarter to quarter, picking up acquaintances, trying to absorb the peculiar atmosphere of each district, filling notebooks with scenes encountered on my inner-city travels.

Soft City, published just over four years after I first arrived, was meant both as a celebration of my own sense of intoxicating freedom in the city and as an attempt to connect my London life with those of James Boswell, biographer of Johnson and a comically dissolute man about town, Dickens, Mayhew, and General William Booth, author of In Darkest London and the Way Out. I found my city every bit as enthralling as theirs, and hoped that my book, in its quaint twentieth-century binding, might be happened upon by some future researcher in the London Library: turning its faintly mildewed pages, he or she would light on a familiar name—Earls Court... Highgate... King's Road... Portobello... Ah, that's how it was then.

Nowadays, as a visitor to London, I still recognize the city I used to live in but in postal districts far from my old haunts. Streatham High Road, for instance, not long ago voted "Britain's Worst Street," seems eerily familiar, in its babel of languages and accents, its walk-up flats above the lines of shops, its gentrifiers in their Range Rovers, dolling up the substantial Victorian houses just west of it, the students in its Indian restaurants, its parade of experimental fashions, its pure cityness. I can imagine myself living there, as I cannot anymore in Earls Court or South Kensington, where I stare with disbelief into real-estate agents' windows and feel the urge to cry—not just for the prices displayed there but for the single-class, moneyed homogeneity that has overtaken quarters once so excitingly diverse. If I were to move to London now, I'd go south—well south—of the river; in driving time, at least halfway to Brighton.

But things have changed in ways as unimaginable by me as by Dickens or Mayhew. I came to London in search of an elective community of my own making, looking for like minds. I ached for escape from the genteel, academic conventions of the town I then lived in (Norwich). I wanted to be part of the kaleidoscopic human variety to be found only in a metropolitan city; and in 1969 that meant London. Like Dick Whittington on Highgate Hill, I was summoned there by bells. In Margaret Drabble's *Jerusalem the Golden* (1967), a novel I devoured when it first came out, the provincial Yorkshire heroine hears the famous hymn of the title as a paean to London: "I know not, oh, I know not, what social joys are there, / What radiancy of glory, what light beyond compare." London's imagined social joys lured me exactly as they did Clara Maugham—and turned out to be surprisingly real.

Now, in Seattle, I watch my nearly-sixteen-year-old daughter lost to

Facebook. Her time is spent in an elective community of exactly the kind I once sought in the big city: she's "social networking" with friends in Seattle, New York, San Francisco, Copenhagen, Tokyo, and a multitude of places I've never heard of. That freedom to experiment with personae, to play out fantasies of self, once the unique gift of the metropolis, is available on everyone's laptop, as they masquerade anonymously behind screen names and avatars.

Cyberspace is lamentably short of restaurants and drinking clubs, and its two-dimensional architecture doesn't strike me as much fun, though its fine retail district combines the virtues of Old Bond Street and Petticoat Lane. You can't eat dinner there but it meets, in virtual form, almost all the conditions of a true soft city, and does so on a global scale, as cosmopolitan as any provincial isolate could dream of. In Concrete, Washington, or in Goole in Humberside, you can enter it with a mouse click; so maybe, thanks to the Internet, we're all freed—somewhat—of the burning necessity to move to South Ken.

Financial Times, August 2008

An American in England

IN 1994, SARAH LYALL, who used to cover the literary beat for the New York Times, moved to London "for love," as she writes in her tartly provocative book about the British. She moved in with, and later married, Robert McCrum, then editorial director of Faber and Faber, and resumed her work for the Times as a reporter for its London bureau. Her first story in her new role was published in December 1994—a piece about the "high-concept Manhattan" DKNY store that had recently opened on Bond Street, "like a nose-ringed teenager crashing a stately garden party," which is much how she presents herself in her book The Anglo Files.

Lyall's relationship with McCrum and with her adopted country immediately gave her pieces for the *Times* a different slant and tone from what one usually expects of the foreign correspondent, whose posting is temporary, for whom home is elsewhere, and who can write about the natives with the curious and amused detachment of the traveler who will soon move on. Lyall's dispatches from London—on such topics as class, the royals, British eccentrics, the literary scene, the national toleration of drunkenness and terrible teeth, the perverse English affection for wet and blustery seaside holidays—have always had an interesting edge to them, a hint of exasperation beneath their jaunty surface. She writes about Britain not as a neutral foreign observer but as someone who'd dearly like to set the place to rights with a course of psychotherapy.

I know that feeling, having myself moved, for much the same reason, from London to Seattle. The investment of the expatriate in his or her host country is very different from that of the roving correspondent. Though always perceived as a foreigner by the natives, you have a permanent stake in their

politics and society. Your children—the natural consequence of moving for love—go to their schools, speak in their accent, and acquire their manners and customs. What seemed charming and novel to you as a visitor can quickly tire when you're a lifetime resident. However you may fancy your abilities as a chameleon, the inside of your head remains obstinately wedded to assumptions and prejudices acquired in its country of origin. Relatively small differences in vocabulary, pronunciation, etiquette, and especially humor serve to daily remind the Briton in America and the American in Britain of their alien status. The longer one stays, the more jarring are these reminders of one's uprootedness: just when you're feeling most at home, an encounter at the supermarket checkout or an exchange at the dinner table confronts you with the bleak fact that you're a stranger here.

That sense of inescapable estrangement from the society in which she lives permeates Lyall's book. "Britain," she writes, "is an impossible subject... Things here are so coded, so unstraightforward, so opaque, so easy to misinterpret." She doesn't disappoint. There's plenty of misinterpretation here, but also sufficient truth in many of her engaged and disenchanted observations to make a British reader stir uneasily in his chair.

To a disappointingly large extent, The Anglo Files recycles Lyall's Times pieces written over the last fourteen years, but it tries to incorporate them into a bold and bewildering new thesis, in which she argues that Britain has undergone an extraordinary metamorphosis since 1994. When she first arrived, London was "an almost provincial town," coffee was "still mainly instant," the prevailing British mind-set was one of "low expectations, a sense of making do, a sense of enduring rather than enjoying," and that "miserable, gray period of extended privation" which followed the Second World War was still in evidence fifty years on, its depressing austerities "hardwired in the system." It's as if the country Lyall found had altered little since Edmund Wilson reported on it in 1945, in Europe Without Baedeker, when, ordering "roast duck" from the menu of a "first-class" London restaurant, he was served what he took to be the stringy carcass of a crow. Wilson's descriptions of dreadful food and miserable, frigid hotel rooms in a city he likened to Moscow are closely echoed by Lyall, whose "unhappy experiences when I arrived, on account of my foreign standards," are recounted in aghast detail, with none of the measured perspective that Wilson, traveling in the uniform of an army major, brought to the then-truly-dismal English scene.

However, Lyall writes, "I came at a singular period of change, one of those great transitional eras in the life of a country." At around the time of Tony Blair's victory in the 1997 election, "it all began to change." "The City, London's financial district, turned into a teeming hub of round-the-clock Eurobankers and thrusting American hedge fund managers, who brought with them a novel work ethic." "Restaurants got seriously good." London became "a truly international city, awash in riches." "Suddenly, people who never expected much began to want everything."

These assertions strike me as bizarre. There was no "suddenly" in Britain's unsteady lurch into affluence from the 1950s through the 1990s, its recessions generally deeper and its spurts of growth less vigorous than those in the United States. Its transition from an industrial to a service economy was slow and painful, as coal mines turned into tourist attractions and factories into enterprise zones, business parks, and digital media centers. During this period, the class system showed promising signs of disintegration. Some kind of landmark was reached in 1983, when-after Mrs. Thatcher purged her cabinet of highborn, landowning "wets," once the traditional backbone of her party—the elderly Harold Macmillan made the slyly anti-Semitic remark that there were now "more Old Estonians than Old Etonians" on the Tory front bench. The rise of the financial sector, with its astronomical rewards for baby-faced merchant bankers, arbitrageurs, and day traders, was actually more pronounced in the 1980s, a decade before Lyall arrived, than under the Blair government. As for Lyall's claim that coffee was "mainly instant" in 1994, it simply isn't true—with the sole exception of guest bedrooms in bad hotels, where a kettle and sachets of Nescafé and whitener are still the dreary norm.

Far from living through "a great transitional era," Lyall happened to arrive during a period of modest growth, which had begun at the end of the recession of 1991-92 and lasted until the first quarter of 2002. Although Blair's youth and the liberal evangelism of his rhetoric raised great expectations when he was elected in 1997, there was no cultural or political revolution for Lyall to witness. Blair and Brown proved to be disconcertingly faithful stewards of the legacy they inherited from Thatcher and Major, and the biggest change in Britain since 1994, as here, has been the impact of the global digital economy, along with all the consequences, domestic and foreign, that have followed from Downing Street's blind collusion with the Bush administration in the invasion of Iraq and the war on terror. Since Lyall's main interest is in what she sees as the repressed and masochistic British character, none of this ought to matter much, but her false and misleading historical framework so colors her first-person observations that her version of Britain sometimes reads to me like an account of an imaginary country that has certain poignant similarities to my own.

The book begins with a sketch of a chilly picnic with an unnamed earl

and his family on their enormous country estate. Having fished the nobility from their private quarters in the stately home, Lyall and her husband are driven off in a pair of comically disreputable Jeeps to the chosen picnic site, "a decrepit, semi-burned-down barn," where they unpack the food ("Hot canned cream of tomato soup in a thermos, poured into Styrofoam cups. Make-your-own sandwiches of processed supermarket ham on white, Wonder-style bread") and "some very nice wine for the grownups." The earl talks of "his latest quixotic scheme, investing in obscure British films, few of which had yet made it to the cinema."

It's a scene from Wodehouse: the scruffy aristo, blathering on about his eccentric hobby, might be a first cousin to Lord Emsworth, lost to the world in the pages of *Whiffle on the Care of the Pig.* But this particular earl is plainly identifiable as Henry Herbert, seventeenth Earl of Pembroke, who until his death in 2003 combined farming his estate and turning Wilton House near Salisbury into a major pillar of the British tourist industry, with a long career as a film and TV director.

It wasn't a hugely distinguished career: probably his best-known movie was a soft-porn romp involving Koo Stark, and he was regularly employed by the BBC to direct episodes of various popular detective series, as well as a more ambitious three-part biopic of Oscar Wilde starring Michael Gambon. Having started as a "glorified tea boy" on the set of *The Heroes of Telemark* in the early 1960s, he was the reluctant heir to Wilton House when his father died young in 1969, but continued to direct and produce through the 1990s, when Lyall encountered him.

She is determined to paint Herbert as a mossy relic of the ancien régime, when in fact he exemplified as well as anyone the changes happening in postwar Britain. That he was more proud of his work as a jobbing director than he was of being lord of Wilton House says much about him and the country, but Lyall's deaf to this; what she wants is a real live earl in his earldom, and she ruthlessly edits his life according to her (very American) requirements, relegating his profession to a "quixotic" pastime.

Her treatment of Henry Herbert is characteristic of the book. In 2005, she wrote a piece for the *Times* about the ailing Little Chef chain of road-side eateries, in which she harped on the unappetizing food, the ubiquitous pools of baked beans, the dirty, uncollected plates on tables, and wondered why its uncomplaining English customers could tolerate such culinary nastiness. That piece is reprised here, but with the startling claim that "Little Chef was the missing link between a past of privation and a future of abundance."

Like the mediocre chain restaurants that crowd the exits on U.S. free-

ways, Little Chef isn't any kind of missing link, just a convenience stop for motorists who can't be bothered to detour in search of somewhere better. The chief difference between Little Chef and its American counterparts is that here, at least in the rural West, there probably isn't anywhere better for the next hundred and fifty miles, while in England, if you head for the church spire beyond the trees, you have a fair chance of finding a gastropub with a decent wine list and a chalkboard daily menu.

Lyall needs Little Chef to demonstrate "the nation's low expectations and high endurance threshold" at the time of her arrival, and so she has to wipe from the picture the long wave of change that has been rolling through Britain's kitchens and restaurants ever since rationing ended in 1953. Aside from a passing nod to Elizabeth David, it's as if the host of cookbook writers, television chefs, restaurateurs, and editors of restaurant guides—Jane Grigson, Raymond Postgate, Robert Carrier, Philip Harben, Egon Ronay, Christopher Driver, Marco Pierre White, Raymond Blanc, Anton Mosimann, Albert and Michel Roux, Pierre Koffman, and many others—had never existed, and that Jamie Oliver, the Naked Chef, and Gordon Ramsay, the foul-mouthed chef, had sprung fully formed in 1998 from a uniformly gray culinary wasteland of all-day breakfasts and HP Sauce. One can find bad food anywhere in the world, but—outside America's major cities and college towns—it has long been possible to eat better in Britain than in the United States.

In Lyall's Britain, the supposedly vile food (a subject to which she tediously adverts again and again) is the key to the national character. Her theory is that a people raised on pig swill have been bred to accept the worst in every department of life. Their sports lack all excitement: she devotes a chapter to the watching-grass-grow boredom of cricket. Their frigid beaches turn picnics and summer vacations into survival exercises in hostile terrain. Their light-starved weather has conditioned them to assume chronic depression as a normal state of mind: Lyall writes that she had to install some kind of therapeutic sunshine lamp in her London house to maintain the "can-do spirit" and "perky enthusiasm" that she attributes to her own, American character (generalizing about the two nations, she is at least an equal-opportunity employer of clichés). "Britons like living on the edge of disappointment. Having their hopes thwarted bolsters the legitimacy of their congenital pessimism." No wonder they seek escape from their miseries by turning to the bottle.

"Britons love to drink and love to boast about drinking." In a memorable passage, she follows a stag party of Englishmen in their early thirties on a cut-rate flight to Prague, their only objective to spend the weekend get-

ting wasted. The conflict between the prim, abstemious *Times* reporter and the gang of sottish louts begins aboard the plane, where the drinkers are breakfasting on lager immediately after the 6.15 a.m. takeoff and churlishly refuse to supply quotes for Lyall's opened notebook. But, in the dauntless spirit of Henrietta Stackpole in *The Portrait of a Lady*, of whom she sometimes reminds me, she pursues them to an Irish pub in the center of Prague:

They were all but one sheet to the wind, still coherent; another group... was a little further along, attempting to flick sugar cubes into their water glasses and playing a complex drinking game whose rules included No Using Your Left Hand, No Pointing, and No Saying The Word "Point." One wore a headpiece in the shape of a plastic turd. He had visibly expressed annoyance, or "gotten a turd on," and would have to wear the hat until someone else got annoyed at something else, whereupon he could then pass it on.

The pub's owner obligingly supplies Lyall with statistics. "A party of twenty-three, fresh off the plane, consumed 180 vodkas and sixty cans of Red Bull in a single Friday afternoon," and returned on Saturday and Sunday afternoons for identical repeat performances. And that was just at the Irish pub, one of many such Prague attractions for British tourists. Heaven knows how much they got through in the evenings.

The accents change, but little else does, at the Man Booker Prize dinner, where Lyall nicely describes the vinous progress of her neighbor at the table, a publisher, from gruff wordlessness, through a brief period of charming lucidity, to morose incoherence. She is shocked by the quantity of wine downed at Sunday lunch parties in the country, from which everyone has to drive back to London, and writes that many of her British friends would in America "be considered functioning alcoholics." That's probably true, but it is a pity that Lyall's fixation on the rotten teeth and heavy drinking of the writers she meets leads her to pay scant justice both to the sober clarity of much of the writing that gets done in London and to the impressive diversity of its literary scene. One might add in this context that Lyall's Britain seems mystifyingly, unrecognizably white: the many-hued country of Monica Ali, Hanif Kureishi, Zadie Smith, and other British writers barely surfaces in The Anglo Files, and when Lyall runs into Londoners of Asian origin, it's their dental problems that get her attention, as if their teeth were their strongest claim to Englishness.

"I hate to sound like a spoilsport," she writes in her Stackpole voice, announcing that a lecture on the health hazards of alcohol is about to begin.

By her distinctly puritanical American standards, boorishness fueled by drink pervades English society at every level, from the dinner tables of Kensington and Chelsea to the pubs of Newcastle. Yet while British drinkers have the reputation of being the loudest and most aggressive in Europe, feared by every city that has to host an English soccer team's supporters, their annual consumption per capita of liters of pure alcohol, as measured in a recent OECD study, is less than one might assume. Britons, at 11.5 liters, are outdrunk by, among others, the Irish (13.6), Luxembourgers (15.5), the French (13.0), the Hungarians (13.2), and the Spanish (11.7), while Americans, always near the bottom of such tables, clock in at 8.4 liters—a cause of some despondency among visiting Europeans of whatever nationality. Lyall relates that, after lunching at a friend's house in East Hampton, Long Island, her English husband remarked that it was a pity that their fellow guest was obviously an alcoholic. Asked how he'd reached this "bizarre" conclusion, he pointed to their "hostess's failure to offer wine with lunch." As Lyall says, "In Britain, we would have been plied with drinks as soon as we pulled into the driveway." And not just in Britain, either.

Beneath the excessive drinking, sexual hamfistedness, and infuriating self-deprecation and lack of candor that Lyall sees as characteristic of English men, she discerns the malign influence of the boarding-school system, something she's unusually well placed to observe. Not only are the London circles in which she moves—literary, journalistic, and political—still disproportionately peopled by the products, or survivors, of England's so-called public schools, but the menfolk of the family she married into were supreme specimens of the public-school ethos. Her father-in-law, the distinguished academic Michael McCrum, served a spell as headmaster of Eton and wrote a biography of Thomas Arnold, the head of Rugby School from 1828 to 1841, and the most influential schoolmaster of the nineteenth century. Her husband, Robert, went to Sherborne, where his father had been a pupil, and whose school song has the defiant refrain of "Vivat Rex Eduardus Sextus! Vivat!"

The English middle- and upper-class ritual of posting male children off to boarding school at the age of six (first to a "preparatory" school, then, at thirteen, to a "public" one) was rooted, in part, at least, in a practical colonial problem. In the early 1800s, strong regional accents were still prevalent, even among the aristocracy, and Africans and Indians, having spent a couple of years laboring to understand a young British assistant district commissioner speaking in broad Yorkshire, would be baffled by his successor's thick Cornish burr. The boarding schools were tasked with turning out alumni who all spoke in the same synthetic accent, known as "received"

standard pronunciation," "Oxbridge English," or what snobbish and barely educated members of the upper class annoyingly call "an educated voice."

For this merely administrative convenience, the British have paid a very dear price. Many, if not most, of the boarding schools were brutal institutions in which the first lesson to be learned was defensive self-concealment and the development of a protective, stiff-upper-lipped mask with which to confront the bullying world. I'm a reluctant expert on this: in the 1950s, aged eleven, I was sent, at great expense to my parents, to a minor public school slavishly modeled on Arnold's Rugby, complete with fagging system, military drills, cold showers, no privacy, and corporal punishment lavishly inflicted by the older boys, where a minimal smattering of classical education was doled out by former wartime army officers, who clung to their old titles of colonel and major. (One teacher, the kindly, somewhat overweight Captain Bailey, was allowed to retain his relatively junior rank in civilian life because he'd won the Military Cross for bravery in the face of the enemy. Oddly, he taught German.) My childhood finished abruptly on the hour that I entered the place, and I'm continually reminded, especially here in the United States, that my character, such as it is, was permanently damaged by the experience.

So I feel a sneaking sympathy for Sarah Lyall's husband, who countered her accusation of being "emotionally autistic" with the smiling, ungainsayable reply of "Darling, I know. I am artistic." Talking to actors, writers, and politicians, she does a fine job of capturing the outer shell of jokey false modesty behind which English men—and some women—take instinctive shelter, and the embarrassment with which they respond to her attempts to make them address their own feelings. (When she quizzes Boris Johnson, the recently elected Conservative mayor of London, about his air of bland frivolity, he replies, "Beneath the carefully constructed veneer of a blithering buffoon, there lurks a blithering buffoon.") Though there's nothing new in the subject of boiled English manners, Lyall's treatment of it is fresh because she gives full vent to her own feelings of impatience and bafflement at the behavior of her husband's countrymen, and the closer that *The Anglo Files* approaches the dynamics of the Lyall–McCrum marriage, the more interesting it becomes.

It may seem a stretch to lay the chronic English habit of evasion and self-effacement at the feet of the boarding schools: only a small minority of boys attended them in the immediate postwar period, and even fewer do so now (the beastly institution I went to in the 1950s is now a blameless co-ed day school). Yet I think Lyall's right. Former public-school boys have dominated British politics, business management, the BBC, the civil

and armed services, and the arts to the point where the mind-set instilled at Eton, Winchester, Harrow, Rugby, or Fettes (Tony Blair's old school) has become a national pattern, oft imitated by Englishmen from every social background. The once-prized accent is in sharp decline, especially among public-school boys, who affect street-credible "Estuary English" with its whiffling, south London vowels, but boarding-school manners and attitudes—stoic denial, facetious irony, the studied avoidance of emotional directness—are still deeply entrenched in the character of the country. Even now, Englishmen like to emulate the "crust of calm detachment from all human emotion" that P. G. Wodehouse attributed to an Old Etonian in his great 1929 comedy, *Summer Lightning*.

Gordon Brown's Labour government is currently plumbing depths in the opinion polls not seen for thirty years. As Britain faces recession again, it appears to be turning for reassurance to its traditional ruling class and the politics of noblesse oblige. The two most popular politicians of the day are Boris Johnson, self-confessed buffoon, and David Cameron, the Tory party leader. Both Cameron and Johnson went to Eton, then Oxford, where they were both members of the Bullingdon Club, which Evelyn Waugh called the Bollinger Club in *Decline and Fall*, and whose customs (tailcoats, heroic drinking, and the sweet music of the sound of breaking glass) seem to have changed little since the 1920s. In May 2007, a report in the *Independent* identified fourteen Old Etonians among Cameron's front-bench spokesmen, with a further three in his private office. The tabloids have labeled this twist in the British political scene as "the return of the toffs," but the toffs, as Lyall notices, rather too closely for comfort, have never really been away. They were just having a drink on the side.

New York Review of Books, September 2008

Cut, Kill, Dig, Drill

SARAH PALIN has put a new face and voice to the long-standing, powerful, but inchoate movement in U.S. political life that one might see as a mutant variety of Poujadism, inflected with a modern American accent. There are echoes of the Poujadist agenda of 1950s France in its contempt for metropolitan elites, fueling the resentment of the provinces toward the capital and the countryside toward the city, in its xenophobic strain of nationalism, sturdy paysan resistance to taxation, hostility to big business, and conviction that politicians are out to exploit the common man. In 1980, Ronald Reagan profitably tapped the movement with his promises of states' rights, low taxes, and a shrunken government in Washington; the "Reagan Democrats" who crossed party lines to vote for him are still the most targeted demographic in the country. In 1992, Ross "Clean Out the Barn" Perot and his United We Stand America followers looked for a while as if they were going to upend the two-party system, with Perot leading George H. W. Bush and Bill Clinton in the midsummer polls. In 1996, Pat Buchanan ("The peasants are coming with pitchforks") appealed to the same bloc of voters with a program that was militantly Christian, white, nativist, provincial, protectionist, and anti-Washington. In 2000, Karl Rove cleverly enrolled this quasi-Poujadist faction in his grand alliance of libertarians, born-agains, and corporate interests. It's worth remembering that in 2004 every American city with a population of more than half a million voted for Kerry, and that the election was won for Bush in the outer suburbs, exurbia, and the countryside—peasants-with-pitchforks territory. For an organization so wedded to its big-city corporate clients, the Republican Party has been hugely successful in mopping up the votes of low-income, lightly educated rural and exurban residents.

Most large American cities, especially in the West, are situated in coun-

ties that extend far beyond the city limits. Liberal urban governments with high property-tax rates and progressive environmental policies wield great power (some say tyranny) over their rural hinterlands, delivering ukases about land use and conservation: brush cutting is to be limited to 40 percent of the property; setbacks of one hundred feet are required from streams and wetlands; new churches are denied building permission because they are deemed "large footprint items" in "critical habitat areas." So the householder or farmer sees "the city" making unwarranted infringements of his God-given right to manage his land as he pleases, and imagines his precious tax dollars being squandered on such urban fripperies as streetcar lines and monorails. These local quarrels spread to infect whole states. In Washington State, almost every ill that befalls people in the timberlands and agricultural regions, far from any city, is confidently attributed to "liberals from Seattle," a nefarious conspiracy of wealthy, tree-hugging elitists with law degrees from East Coast universities, their chief aim to destroy the traditional livelihoods of honest citizens living on either side of the Puget Sound urban corridor. Poujade—and Jean-Marie Le Pen—would have had a field day here; as, I'm afraid, the McCain-Palin ticket will in November.

Until now, the political leaders who've used the movement to their electoral advantage have come to it as outsiders. Reagan the Hollywood actor, Perot the data-processing billionaire, Buchanan the District of Columbia journalist, and George W. Bush the energy-industry scion and owner of a merely recreational ranch in Crawford, Texas, have had very little in common with their rural and exurban constituents, and their gestures at farmyard, strip-mall, or cowboy-boot cred have tended to come across as phony and embarrassing. Photographed inside J. C. Penney or Costco or Safeway, they've looked hardly less exotic than poor Michael Dukakis did on board his ill-advised tank. But the moment that Sarah Palin stepped up to the mike at the Republican Convention in St. Paul and began talking in her homely, mezzo-soprano, far western twang, she showed herself to be incontestably the real thing. Americans, starved of völkisch authenticity in their national politicians, thrilled to her presence on the stage. Forty million people watched her speech on television. When she said, "Difference between a hockey mom and a pitbull? Lipstick!" even in the liberal redoubt of Seattle I thought I heard a roar of delighted recognition coming from my neighbors on the hill. Palin doesn't need to say what Poujade used to tell his listeners: "Look me in the eye, and you will see yourself," and "I'm just le petit Poujade, an ordinary Frenchman like you." All she needed was her trademark blink from behind her librarian glasses, and to turn on her pert, wrinkle-nosed smile, in order to convince a crucial sector of the American

electorate, male and female, that it sees in her a looking-glass reflection, suitably flattering in both form and content, of itself. Sarah, c'est moi.

Like Wally the Green Monster, Baxter the Bobcat, the Mariner Moose and other giant furry creatures who accompany major-league baseball teams from game to game, Palin is the adored mascot of the anti-tax crowd. Her actual performance as mayor and governor counts for little beside her capacity to keep the fans happy during the intervals between play, which she does in the style she developed as mayor of Wasilla and then perfected in her triumphant gubernatorial campaign in 2006. Transcripts and videos from her time in Alaska show her parlaying the barest minimum of rhetorical and intellectual resources into a formidable electoral weapon. The least one can say of her is that she quickly learned how to make the most of herself.

What is most striking about her is that she seems perfectly untroubled by either curiosity or the usual processes of thought. When answering questions, both Obama and Joe Biden have an unfortunate tendency to think on their feet and thereby tie themselves in knots. Palin never thinks. Instead, she relies on a limited stock of facts, bright generalities, and pokerwork maxims, all as familiar and well worn as old pennies. Given any question, she reaches into her bag for the ready-made sentence that sounds most nearly proximate to an answer and, rather than speaking it, recites it, in the upsy-downsy voice of a middle schooler pronouncing the letters of a word in a spelling bee. She then fixes her lips in a terminal smile. In the televised game shows that pass for political debates in the United States, it's a winning technique: told that she has fifteen seconds in which to answer, Palin invariably beats the clock, and her concision and fluency more than compensate for her unrelenting triteness.

She has great political gifts, combining the competitive instincts of a Filipino gamecock with the native gumption she first displayed in her 1996 race to become mayor, when she blindsided the incumbent by running not on local but on state and national issues, as the pro-gun and pro-life candidate. Mayors have no say on abortion or on gun laws, but Palin got the support of the local Evangelicals (it greatly helped that her—Lutheran—opponent's surname was Stein, and her backers put it about that he was a Jew) and of gun owners who keenly supported a bill, then pending in the state legislature, that would affirm the right of Alaskans to carry concealed weapons into public buildings. On more typical mayoral concerns, she promised to halve Wasilla's property tax and "cut out things that are not necessary," citing the bloated budgets for the museum, the library, and arts and recreation. She won the election with 616 votes to Stein's 413.

There followed what some Wasillaites saw as her reign of terror. She demanded resignation letters from all the city managers, ridding herself of the museum director, the librarian (whom she was later forced to rehire), the public works director, the city planner, and the police chief, who'd argued against the concealed weapons bill and had supported a measure to close the town's bars at 2:30 a.m. on weekdays and 3 a.m. on weekends (the owners of the Mug-Shot Saloon and the Wasilla Bar had given money to Palin's campaign). She forbade city employees to speak to the press, and during her first four months in office she provoked a string of appalled editorials in the local paper, the *Mat-Su Valley Frontiersman*:

Wasilla found out it has a new mayor with either little understanding or little regard for the city's own laws . . .

Palin seems to have assumed her election was indeed a coronation. Welcome to Kingdom Palin, the land of no accountability . . .

Mayor Palin fails to have a firm grasp of something very simple: the truth . . . Wasilla residents have been subjected to attempts to unlawfully appoint council members, statements that have been shown to be patently untrue, unrepentant backpedaling, and incessant whining that her only enemies are the press and a few disgruntled supporters of former mayor John Stein.

Surrounding herself with fellow congregants from the Pentecostalist Wasilla Assembly of God and old school chums from Wasilla High, the thirty-two-year-old mayor set about turning the town into the kind of enterprise society that Margaret Thatcher used to extol. She abolished its building codes and signed a series of ordinances that rezoned residential property for commercial and industrial use. When the city attorney ordered construction to stop on a house being built by one of her campaign contributors, she sacked him.

Having come to power saying that her agenda was to pare down Wasilla to "the basic necessities, the bare bones," she surprised its citizens when she redecorated the mayor's office at a reported cost of \$50,000, which was salvaged from the highways budget; its new red flock wall-paper matched her bold, rouge-et-noir taste in personal outfits. Another \$24,000 of city money went for a white Chevy Suburban, known around Wasilla, without affection, as the mayormobile. She hired a city administrator to deputize for her in the day-to-day running of Wasilla's affairs

and employed a lobbyist in the District of Columbia to wheedle lawmakers into meeting the town's ever-expanding list of claims for congressional "pork" (so named from the antebellum custom of rewarding slaves with barrels of salt pork). That expenditure, at least, paid off: during Palin's six-year tenure as mayor, the federal government doled out more than \$1,000 for every man, woman, and child in Wasilla. Her pet project was a \$14.7 million ice rink and sports complex, which opened in 2004. It is said to be lightly used, it has left the city servicing a massive debt, and a Jarndyce and Jarndyce lawsuit continues over Palin's bungled acquisition of the land on which it's built.

Present-day Wasilla is Palin's lasting monument. It sits in a broad alluvial valley, puddled with lakes, boxed in on three sides by sawtoothed Jurassic mountains, and fringed with woods of spruce and birch. Visitors usually aim their cameras at the town's natural surroundings, for Wasilla itself—quite unlike its rival and contemporary in the valley, Palmer, eleven miles to the east—is a centerless, sprawling ribbon of deregulated development along a four-lane highway, backed on both sides by subdivisions occupied by trailer homes, cabins, tract housing, and ranch-style bungalows, most built since 1990. It's a generic western settlement, and one sees Wasillas in every state this side of the hundredth meridian: the same competing gas stations, fast-food outlets, strip malls, and "big box" stores like Wal-Mart, Target, Fred Meyer, and Home Depot, each with a vast parking lot out front on which human figures scuttle with their shopping carts like colored ants, robbed of their proper scale. (It has to be said that Pierre Poujade, champion of the small shopkeeper, would have been outraged by this sight.)

Wasilla is what inevitably happens when there are no codes, no civic oversight, no planning, when the only governing principle in a community is a naive and superstitious trust in the benevolent authority of the free market. Palin's view of aesthetics was nicely highlighted in 1996, a few months before she ran for mayor, when a reporter for the *Anchorage Daily News* happened to light on her in an excited crowd of five hundred women queuing up in the Anchorage J. C. Penney to snag the autograph of Ivana Trump, who was in town to hawk her eponymous line of scent.

"We want to see Ivana," Palin said, who admittedly smells like a salmon for a large part of the summer, "because we are so desperate in Alaska for any semblance of glamour and culture."

The blot on the Alaskan landscape that is Wasilla is the natural consequence of a mind-set that mistakes Ivana Trump for culture.

Palin's political gumption was never better exercised than it was five years ago, in a rather intricate sequence of maneuvers that reveals a lot about her. In 2002, toward the end of her term as mayor, she mounted an underfunded run for the office of lieutenant governor and came a close second in the Republican primary. She then attached herself to the gubernatorial campaign of Alaska's junior U.S. senator, Frank Murkowski, speaking by his side at every possible opportunity. The reason? If Murkowski won the governorship, his Senate seat would be his to award, and Palin had set her heart on going to the District of Columbia. On the trail, she feted him, slathering on the butter and topping it with jam. Murkowski won, the vacancy in the U.S. Senate yawned, and Palin went to Juneau for an interview. After due consideration, the new governor—this being Alaska—decided that the person best qualified for the job was his own daughter, Lisa. He could hardly have delivered a more insulting blow. However, his largesse was not yet exhausted and he gave Palin the consolation prize of a seat on the Alaska Oil and Gas Conservation Commission, a part-time job that paid \$122,400 a year—good money, but not at all what she was after.

The aggrieved Palin reluctantly accepted. She now had Murkowski in her sights, and he might have been wise to consider the fates of the Wasilla police chief, city attorney, museum director, and others who had dared to cross her in the past. She chaired the Conservation Commission (in Alaska, the word "conservation" means something rather different from what it means elsewhere), on which she was joined by the chairman of the state Republican Party, Randy Ruedrich, a former oil-company manager, and Dan Seamount, a geologist. She kept a watchful eye on Ruedrich, and office gossip came back to her with the news that he was conducting Republican Party business on his state computer, on state time: an ethics violation with which she was intimately familiar, since she'd been caught doing the same thing back in Wasilla, where the mayoral letterhead, fax machine, and e-mail account had been used in her campaign for the lieutenant governor-ship a few months before.

Palin reported Ruedrich to Murkowski, but the governor, already mired in accusations of incompetence and worse, refused to take her calls. More Nancy Drew–style detective work suggested that Ruedrich was misusing his position as impartial regulator to shill for a coal-bed methane company. One would give a lot to have been a fly on the wall at commission meetings during the summer and early autumn of 2003, as the improbably well-named Mr. Seamount, a leftover from the previous Democratic administration, sat quietly by during the sulphurous confrontations between Ruedrich and Palin, who quickly made public both her complaints against

Ruedrich and the governor's failure to take notice of them. As she told the *Anchorage Daily News* on November 7, 2003, "It's distracting, it's confusing, it's frustrating. It's not fair to Alaskans to have these questions about a possible conflict hanging over the head of this agency." Late the next day, Ruedrich resigned from the commission. Palin herself, forbidden by the governor to discuss the Ruedrich affair with journalists, resigned—to great acclaim in the Alaskan press—in January 2004.

The timing of these moves was immaculate. Murkowski was fast becoming the most unpopular governor on record, and the leaders of the state Republican Party, the "good ol' boy network," as Palin calls them now, had already attracted great public odium for their cronyism and underhanded dealings with the oil and gas companies. The FBI was preparing to move in. At the last count, at least fourteen public officials, oil-company executives, and Alaskan politicians (including the state's senior U.S. senator, Ted Stevens, and its only U.S. congressman, Don Young) are now either on trial, indicted, under federal investigation, or in jail, and it's probable that there are more charges and more suspects still to come.

After she left the commission, Palin told people that her whistle-blowing had "destroyed her political career"—a calculated disingenuity if ever there was one. But she came closer to the truth when, in an understandably cocky op-ed piece, published in the *Daily News* in April 2004, she wrote: "Success in the sports arena is essentially the same in the political arena . . . All I ever really needed to know I learned on the basketball court." Following Murkowski's appointment of his daughter to the Senate, Palin had taken possession of the ball, dribbled it brilliantly through the ranks of her slower-witted opponents, leaped for the hoop, and scored a clean slam dunk.

Alaskan journalists fawned on her. At a low point in the state's political history, especially for Republicans, Palin had bravely stood up against the leaders of her own party and exposed corruption. She'd taken on the governor, the party chairman, and the oil companies, and unselfishly sacrificed her hopes of advancement in the process. At that time, it would have been unseasonable to suggest that simple jealousy and opportunism might have played as large a part in her actions as moral principle, and the *Daily News* bestowed on her the ultimate newspaper accolade when it used her first name only in a headline on the front page of its B section: "What Would Sarah Do? We'll See Come the Next Big Election." Eight years before, in her first appearance in the paper, she'd been a fishy-smelling nonentity in the crowd of fame-suckers at J. C. Penney; now she was a beloved statewide mascot.

It was as a mascot ("New Energy for Alaska!") that she ran in the 2006 gubernatorial election, humiliating Murkowski in the primary and comfortably beating Tony Knowles, a former governor and the Democratic candidate, in November. When she took the oath of office in—appropriately—the Carlson Center sports arena in Fairbanks, the crowd of six thousand broke into a deafening chant of "Sarah! Sarah!" and had to be silenced before the ceremony could go on.

Then she went back to Juneau and started sacking state officials, from the attorney general down, so she could replace them with malleable old friends from her church and Wasilla High.

Alaska is unique among the states in that every permanent resident without a felony conviction is entitled to a share in the proceeds from its oil and gas resources. Each autumn, eligible Alaskans receive payments based on the interest accrued by the state's Permanent Fund during the previous year. In 2007, Palin again "stood up to Big Oil" when she successfully forced a bill through the legislature which raised the tax on oil companies' net profits from 22.5 to 25 percent, ensuring a gush of money into the Permanent Fund and a hike in the size of checks sent out to the citizenry. The move was strongly resisted by the Republican establishment, always averse to taxing "windfall profits" and zealous in the defense of its cronies and contributors in the oil industry, but it was wildly popular among ordinary Alaskans, bred to expect handouts, whether from the federal or the state government. That year, Palin announced the biggest payment in six years, \$1,654, with a whoop of "Oh, baby!" Late this summer, with oil prices still at around \$125 a barrel, she was able to trump that number with an all-time record of \$2,069, plus a further onetime payment of \$1,200 to help Alaskans deal with the spiraling price of gasoline and heating fuel. For a hard-pressed family of four, that translated into \$13,076—a jackpot figure, equivalent to forty-five weeks of pay at the Alaskan minimum wage rate of \$7.15 an hour, enough to pay cash for a new Ford Focus or put down the deposit on a pretty nice house. (The federal poverty line for a four-person family is just over \$20,000.)

It's no wonder that Palin's approval rating stands at more than 80 percent in her home state: populist leaders are rarely able to reward their constituents with lavish contributions to their personal bank accounts, and there's nothing like money for making people feel generously bipartisan. (Imagine how the polls might change if every family in Britain received a check for a little over £7,000, personally signed, as it were, by Gordon Brown.) The Evita-like adulation that "Sarah" was gaining in Alaska began to spread as a rumor through the nation in February, when she was first tipped as

a possible running mate for McCain, with Rush Limbaugh, the far-right radio rabble-rouser, as her noisiest fan. Her reputation for levying taxes on big business in order to fill the pockets of the common man—Alaska's own Robin Hood—struck a profound chord in the hearts of the "dittoheads," as Limbaugh's faithful sheep describe themselves, and when McCain eventually nominated Palin, Limbaugh took to calling him John McBrilliant, having previously abused him as a traitor to the Republican cause.

Before Palin, McCain was lucky to draw a crowd of a few hundred; with Palin, he has been rallying Obama-sized turnouts of many thousands. Liberals have tried to comfort themselves by putting this down to her novelty value, a quality they hope will pass its expiration date well before the November election, and by dismissing her as another Dan "Potatoe" Quayle or Admiral "Who am I? What am I doing here?" Stockdale, two of the last century's most memorably inept vice-presidential choices. Many hope that the present financial crisis will so deepen and darken that McCain's cavalier attitude toward economics ("Not something I've understood as well as I should") and Palin's seeming total ignorance of the subject will scare American voters into electing Obama. They expect reason to prevail and disenchantment to set in as Palin's many contradictions and untruths are exposed in the press and on TV. They believe that her views on abortion are alienating all but fervently Evangelical and Catholic women. The line to spin over the dinner table is that "she only energizes the base."

But as politicians of both parties in Alaska have discovered, underestimating Palin nearly always turns out to be a fatal error. When on form, she has the ability to connect with that surly mass of occasional, floating voters who feel themselves to have been disenfranchised by more orthodox politicians, and who respond to her as a paragon of domestic good sense and decency in a world rendered ever more incomprehensible by the dark arts of the elites.

She belongs to no elite. After drifting through five colleges in six years, she eventually secured a degree in journalism at the University of Idaho, less Ivy than Sagebrush League. She could hardly have had a higher education less offensive to the Limbaughites. As Obama stands tarred in their eyes by his Columbia and Harvard connections, so Palin represents the healthy values of the church and the outdoors against those of the deeply suspect East Coast universities.

Importantly, she's unimpressed by "science," whether it's the science of evolution, anthropogenic climate change, or the Endangered Species Act. In a period of stagnant wages and rising unemployment, science has been

vilified as the enemy of working-class jobs in such industries as mining, timber, agriculture, and construction. It is also—especially in the phrase "best available science"—very widely seen as the cause of unpardonable infringements of individual property rights. When, for instance, Palin contentiously advocates drilling for oil in the Arctic National Wildlife Refuge, she both promises well-paid jobs and champions the precious American liberty to do what the hell you like in your own backyard. Likewise, her fight against listing the polar bear as an endangered species even as the sea ice melts under its feet—which has entailed blandly denying the findings of her own state scientists—sits well with a large, disgruntled rural sector of the population which has seen jobs lost, mills closed, and property devalued in order to protect such critters as the northern spotted owl and the Delhi Sands flower-loving fly. The director of the Alaska Wildlife Alliance says that her motto is "cut, kill, dig, and drill" and that she lives "in the Stone Age of wildlife management, and is very opposed to utilizing accepted science." For many voters, that's ample reason to see her as a folk hero.

She has nicely positioned herself for national consumption as the enemy of the effete and oversophisticated cities; a "gal," as she says, from the remote provinces, untainted by the stain of the urban. In her convention speech, she managed to paint Wasilla as if it were the idealized small town of sentimental memory, complete with the drugstore soda fountain, barbershop striped pole, sociable Main Street, and rosy-cheeked postmistress. "Long ago," she said, comparing her own rise with that of the thirty-third president,

a young farmer and a haberdasher from Missouri, he followed an unlikely path—he followed an unlikely path to the vice presidency. And a writer [Westbrook Pegler, the McCarthyite newspaper columnist] observed, "We grow good people in our small towns, with honesty and sincerity and dignity," and I know just the kind of people that writer had in mind when he praised Harry Truman. I grew up with those people. They're the ones who do some of the hardest work in America, who grow our food, and run our factories, and fight our wars. They love their country in good times and bad, and they're always proud of America.

By implication, then, big city people are unpatriotic (Palin's last phrase was a sneer at Michelle Obama, a lifelong Chicagoan); they are insincere slackers and draft dodgers—in a word, liberals. The passage reminded Republi-

cans of their party demographics, their strength in the exurbs, and prepared the ground for an assault on the metropolitan manners and mores of their Democratic opponents, in a depressingly effective piece of hokum.

In Alaska, she has deployed her end-times fundamentalist beliefs with considerable adroitness, nimbly walking the tightrope between pleasing the church crowd and reassuring her secular constituency of her essential moderation. She appears to have learned from her early experience in Wasilla, when, pressed by her backers in the Assembly of God, she suggested to the librarian that such "unsuitable" books as Daddy's Roommate and Pastor, I Am Gay be removed from the library, only to backtrack later with the claim that she was merely asking a "rhetorical" (she meant hypothetical) question. Since then, as governor, she's handled such issues with impressive wiliness. When the Alaska Supreme Court ruled that gay partners of state employees must receive the same benefits as heterosexual spouses, the legislature passed a bill to block the payments. Palin made clear her sympathy with the bill's intent, but refused to sign it on the grounds that to do so would be to "violate my oath of office." Similarly, she endeared herself to Evangelicals during her gubernatorial campaign by saying that "intelligent design" should be taught alongside evolution in the state's public schools. "Teach both," she said, but then declined to back a bill which would have made that mandatory. Playing politics by the rules of basketball, improvising her moves according to the requirements of the moment, she is too opportunistic (some say pragmatic) to be an ideologue. While she likes to trumpet her narrow theology, with its stress on Calvinist predestination and the imminence of the Rapture (the Iraq war is "a task that is from God"), she simultaneously manages to embody her state's peculiar brand of live-and-let-live libertarianism.

The unfolding details of "Troopergate" will probably not seriously damage her, because the nation seems to have decided that her ex-brother-in-law, Mike Wooten, is a low-life skunk ("He tasered the kid") who deserved everything he got. Her various family troubles, including Wooten and her pregnant teenage daughter, help to underscore her authenticity as the people's candidate; and so do such peccadillos as charging the state \$60 per diem for living in her own house in Wasilla. Some politicians have the invaluable knack of reminding their constituents of their own easily forgivable improbities, and Palin appears to be one of them. Proven hypocrisy is another matter, but though her time as mayor and governor has been studded with incidents of bullying, meanness, and an unseemly thirst for personal revenge, no one has called her a hypocrite, so far as I can tell.

The most likely cause of her undoing will—strangely—be the McCain

campaign. In St. Paul, unveiled as the goose who could lay for the Republicans the golden egg of the presidency, she brimmed with the inflated self-assurance of the small-world conqueror, and held a national audience in the palm of her hand as she recited the same confident platitudes that served her so well in Alaska. If it ain't broke, don't fix it, and McCain and his advisers should have left well enough alone and let "Sarah" be her vote-winning self. Instead, they seem to be no less alarmed by her than liberals are, and have taken to force-feeding her, stuffing her gullet with "talking points" on foreign and domestic policy. Under their frantic tuition, Palin has recently looked less likely to lay the golden egg than to produce inferior goose-liver pâté.

On September 17, she was temporarily released from the crammers and allowed to take questions at a town hall meeting in Grand Rapids, Michigan, where someone in the crowd said that there was in certain circles a "perception" that foreign policy was not her forte. Palin replied:

Well, I think because I am a Washington outsider that opponents are going to be looking for a whole lot of things that they can criticize, and they can kind of try to beat the candidate here who chose me as his partner to kind of tear down the ticket. But as for foreign policy, you know, I think that I am prepared, and I know that on January 20th, if we are so blessed as to be sworn into office as your president and vice president, certainly we'll be ready. I'll be ready. I have that confidence. I have that readiness, and if you want specifics with specific policy or countries, go ahead, and you can ask me. You can even play stump the candidate if you want to. But we are ready to serve.

At which point McCain leaned into the microphone to say: "She's commander of the Alaskan National Guard." A little later, she was asked a friendly question on her top subject, energy policy, specifically oil.

Of course, it's a fungible commodity and they don't flag, you know, the molecules, where it's going and where it's not. But in the sense of the Congress today, they know that there are very, very hungry domestic markets that need that oil first. So, I believe that what Congress is going to do also, is not to allow the export bans to such a degree that it's Americans who get stuck holding the bag without the energy source that is produced here, pumped here. It's got to flow into our domestic markets first.

This was a new and startling Sarah Palin, the dim student, flustered by more teaching than her poor head could bear. *Molecules! Fungible commodity!* She flung the words like beanbags at a blackboard. She never talked like this in Alaska and would never have done so in Michigan if her new tutors hadn't succeeded in temporarily addling her brains. More, much more, of the same gibberish was on display in her recent extended interview on CBS with Katie Couric. On the proximity of Russia to Alaska: "It's very important when you consider even national security issues with Russia as Putin rears his head and comes into the airspace of the United States of America, where—where do they go? It's Alaska."

She may yet regain her poise. Her populist appeal is still enormous, and it's far too early to start dancing on her grave, as some commentators have already tried to do. Palin's campaign-trail mistakes will not calm that deep groundswell of public feeling of which she is now the national figurehead. But for the last few days, as her education at the hands of her captors has proceeded, we in the cities, with our elitist liberal ideas and our stark terror of what further harm the United States might inflict on itself and the world under a third consecutive Republican administration, have been just a little less likely to wake up screaming at three in the morning.

London Review of Books, October 2008

Election Night 2008

ON TUESDAY, dodging the hubbub of election parties, I watched the results come in with two close friends and my teenage daughter. We might have been patients showing up at a hospital for a surgical procedure, nervously joking over the early returns from Vermont (predictably, Barack Obama) and Kentucky (predictably, John McCain). When, at 8:01 p.m. Pacific time, CNN called the race for Obama, we collapsed in one another's arms. Even my dry tear ducts did their job, and, for a few moments, the room swam out of focus. The champagne, whose presence in the fridge I had thought to be ominously bad karma, was opened. No toast. Just "Thank God, thank God, thank God," spoken by four devout atheists. There was little triumph in our emotion, only an overpowering wave of relief that, after eight years of manic derangement, America had at last come to its senses.

Inevitably, Wednesday's headlines were all about Obama's skin color and the historic milestone of the first black presidency. For the United States and the rest of the world, that is a fact of huge symbolic importance, but it is the least of Obama's true credentials. What America has succeeded in doing, against all the odds, and why we cried when it happened, is to elect the most intelligent, canny, and imaginative candidate to the presidential office in modern times—someone who'll bring to the White House an extraordinary clarity of thought and temperate judgment.

Every White House has had its intellectuals, but very few presidents have been intellectuals themselves—Thomas Jefferson, John Adams, Woodrow Wilson, the list more or less stops there. Much of the nightmare of the last eight years has arisen from the fact that one of the least intellectually curious or gifted presidents in history was in thrall to a group of passionate,

but second-rate, neoconservative intellectuals, all associated with the Project for the New American Century (PNAC), whose imperial agenda for the United States was lost on the man they guided and advised. Richard Perle, Paul Wolfowitz, Douglas Feith, the architects of the war on Iraq and the "war on terror," were treated by George Bush as experts on parts of the world of which he was ignorant. "Wolfie" knew all about the Middle East; that this knowledge proceeded from a hardline political philosophy instilled in him by Richard Pipes of Harvard and Albert Wohlstetter of the University of Chicago, both avid cold warriors and proponents of U.S. military, political, and cultural domination of the globe, was grasped, if at all, only very dimly by the forty-third president, who prided himself on reading no newspapers and being in bed by nine. While Bush was bicycling and cutting brush at his Crawford ranch in Texas, the intellectuals in his administration were staying up late in Washington, busy with the task of reshaping the United States into the Roman Empire of the twenty-first century.

Since September 11, 2001, the damage inflicted by intellectuals on America and its constitution and justice system, as well as on the outside world, has been so great that we ought to be wary of the election of an intellectual to the presidency, and though he tried his best to veil his proclivities while on the stump, Obama is an intellectual. At the University of Chicago he taught constitutional law, the most demanding and far-reaching area of study in U.S. law schools. He names Philip Roth and E. L. Doctorow among his favorite living writers. In his memoir *Dreams from My Father*, the late-night life he describes himself as leading inside his own skull is every bit as real and vivid as the exterior life he records on the streets and in the homes of Honolulu, Jakarta, New York, Chicago, and Kenya. Again and again in that book, one finds Obama in the small hours, reconstructing in his mind recent events, searching for patterns, making connections, a novelist teasing meaning and significance from the chaotic stream of daily contingencies.

Dreams from My Father reveals more about Obama than is usually known about political leaders until after they're dead. Perhaps more than it intends, it shows his mind at work, in real time, sentence by sentence, in what feels like a private audience with the reader. The self at the center of the book is, above all, an intent watcher and listener—one of those on whom, as Henry James said of the ideal writer, nothing is lost—and there runs through the story an almost worshipful regard for what Obama calls "the messy, contradictory details of our experience."

The unique contradictions and messinesses of his own childhood made him an empiricist by instinct, finding a path for himself by testing his footing each step of the way. His education at Columbia and Harvard made him an empiricist by training. As a law professor at Chicago, he pressed his students to adopt contrarian views while playing his own opinions close to his chest. In July this year, the *New York Times* reported:

Obama liked to provoke. He wanted his charges to try arguing that life was better under segregation, that black people were better athletes than white ones. "I remember thinking, 'You're offending my liberal instincts,' " a former student remembered.

In the Illinois state senate as well as in the U.S. Senate, this has been his habit as a legislator, to solicit counterarguments against his own position, to deploy his unusual talent as a close and sympathetic listener, to probe, to doubt, to adapt, to change.

Such chameleonic powers are liabilities on the American campaign trail, where constant iteration of simple maxims ("Drill, baby, drill!" or "Read my lips: no new taxes") is required and any variation of policy is derided as a "flip-flop," but Obama the chameleon has conformed to the rules of this game, too. It's only now that we can expect to see the full extent of his natural flexibility of mind.

During the last two years he has been quietly surrounding himself with other intellectuals. Two are law professors: Cass Sunstein of Chicago and Laurence Tribe of Harvard, who taught Obama there and called him "the most impressive student I'd ever worked with."

There's Austan Goolsbee, Obama's senior economic adviser, from the business school at Chicago, a highly eclectic behavioral economist who writes about the dismal science with both impressive clarity and skeptical humor. Funny economists are in lamentably short supply: Goolsbee has moonlighted as a stand-up comedian.

This growing coterie of wits and scholars looks a lot like the "brain trust" which Franklin Roosevelt assembled in 1932 to shape the New Deal. Happy in the company of prominent intellectuals, and with a mind equal to theirs, Obama promises to spectacularly raise the IQ and the standard of debate inside the White House (unlike John Kennedy, who liked intellectuals as ornaments of his administration but never seriously engaged their talents).

Heaven knows, he will need all the intelligence and range of viewpoints he can muster to cope with the toxic legacy he inherits from the forty-third

president: the mounting turmoil in Afghanistan, the dangerous, simmering cauldron in Iraq; an America cordially loathed by at least half the world; an impending global economic catastrophe, triggered by the lunatic improvidence of deregulated Wall Street. Not since Lincoln and Roosevelt has an incoming president been landed with an America in such desperate need of rehabilitation and repair, and it was no surprise that, in his Chicago victory speech on Tuesday, Obama conjured the ghosts of those two presidents.

Early in the campaign, he was painted as an empty optimist—a description that couldn't be more wrong. For every rousing "Yes, we can!" there was the caveat of "It won't be easy," and, uniquely among the raft of candidates in the primaries, Obama brought to the election a clear-sighted grasp of the tragic aspect of U.S. history. His most uplifting speeches were grounded in images of the shame of slavery, the national agony of the Civil War, and the intimate humiliations of poverty in America, and it was by reminding his audiences of the depths to which the country is prone to sink that he was able to summon them to hope.

On Tuesday, there was a strong echo of Roosevelt's first inaugural speech when Obama said, "I will always be honest with you about the challenges we face. I will listen to you, especially when we disagree."

After eight years of an administration whose hallmarks have been secrecy, dishonesty, and a refusal to listen to any voice outside its own inner circle, this promise of candor and conversation was probably the most important policy statement that he could make as president-elect.

If there is one prediction that one can make with near certainty, it is that by January 20, 2009, inauguration day, things will be measurably worse than they are now, at least in Afghanistan and on the economic front, on which ever more dismal results and forecasts continue to roll in. Yet the worse the crisis, the more latitude it will allow the new administration in showing its intellectual mettle quickly and decisively, and it's to be assumed that Obama already is talking with Goolsbee, Paul Volcker, Lawrence Summers, Jason Furman, Warren Buffett, and his other on-tap economic advisers, in an extended seminar on the financial meltdown and its possible solutions. The best thing about living in the United States since Tuesday has been the gilt-edged assurance that somewhere out there, very smart people are thinking and talking in a serious conversation from which narrow ideologues have been rigorously excluded.

We've elected as president someone who is empirical, cautious, conservative with a small "c," yet unusually sure of his own judgment, which he often arrives at slowly.

He's sure to disappoint those of his supporters who believe he can raise

the dead, turn water into wine, and walk on water. But he has rescued the White House from the besotted rationalists of PNAC with their Platonist designs on the world, and restored it to the realm of common reason. It's a measure of the madness of the last eight years that, for this seemingly modest contribution to the nation's welfare (and to the world beyond our borders), grown men and women wept in gratitude on Tuesday night.

Guardian, November 2008

The Golden Trumpet

PRESIDENT OBAMA'S brave and surprising inaugural address was the fifty-sixth of its kind since George Washington delivered the first one in New York on April 20, 1789. Over the last two centuries, these speeches have become as thickly encrusted with conventions as the limerick, the sonnet, or the *Times* crossword: they are a bizarre literary form, unique to the United States, with a tiny handful of acknowledged classics (Lincoln's two inaugurals, Franklin Roosevelt's first, and John F. Kennedy's solitaire) that stand proud in a generally depressing mass of mediocre and bombastic writing, most of which now reads like cold porridge.

Since Andrew Jackson's time, inaugurals have been designed for outdoor delivery to an often wet and shivering crowd in Washington's capricious weather. Even before Inauguration Day was set back on the calendar from March 4 to January 20 in 1937, the ceremony seems to have been a magnet for snow, rain, and frigid northeasterly gales. Obama was lucky: the sun shone, though the temperature on the National Mall was a forbidding 28°F.

At William Henry Harrison's March inauguration in 1841, he stepped to the podium without hat or overcoat, under a threatening sky, his trouser legs flapping in the bitter wind, and delivered the longest address on record. At nearly 8,500 words, it took Harrison a hundred minutes to read aloud to a fast-diminishing audience. When he died the following month, of pneumonia and pleurisy, it was widely believed that his rash feat of oratory must have been the cause. In fact, he first showed symptoms of a cold nearly two weeks after the event, but the idea that a presidential inaugural can be fatal has gained such a hold on the American imagination that the legend of Harrison's death-by-speechmaking lives on, despite the medical evidence against it.

Nineteenth-century presidents could count on crowds of up to ten

thousand people milling around the East Portico of the Capitol building; Franklin Roosevelt spoke to a hundred thousand in 1933, and more than a million showed up for Lyndon Johnson's inauguration in 1965. At least half a million came when Ronald Reagan changed the venue to the West Portico in 1981, enabling the president to speak to the nation looking symbolically westward, down the Mall, past the Washington and Lincoln monuments, and through the earth's curvature over three time zones to the Pacific coast. Crowd estimates are always unreliable, but Obama is said to have drawn 1.8 million people on Tuesday, which, if true, is an all-time record.

The growing crowds and open-air character of the occasion help to account for the ever-increasing grandiosity of language in inaugural addresses. The words of most inaugurals would sound insane if spoken quietly indoors; and they sometimes do when carried on the wind via loud-speakers and vast JumboTron TV screens. These quadrennial speeches are as close as America comes to the rhetoric heard more than seventy years ago in Red Square, the Piazza Venezia in Rome, and the Reichsparteitagsgelände in Nuremberg. Or, to put it in the more kindly words of Peggy Noonan, the columnist and former Reagan speechwriter, they are "a golden trumpet that a president gets to blow at most twice in his life."

Four years ago, when George W. Bush lifted that trumpet to his lips, he used it to declare a global war on tyranny. "America, in this young century, proclaims liberty throughout all the world, and to all the inhabitants thereof. Renewed in our strength—tested, but not weary—we are ready for the greatest achievements in the history of freedom." Try saying that across the kitchen table, paying particular attention to your pronunciation of "thereof," then wait for the arrival of the men in white coats.

Rhetorically speaking, much too much is expected from a speech delivered from behind shields of bulletproof glass and introduced by the band of the U.S. Marines playing "Hail to the Chief," the music punctuated by gunfire from saluting cannons. Because the president's language has to struggle to maintain the ceremonial pomp of the occasion, lofty similes and metaphors are the order of the day. Classical tropes, with names like Aegean islands, from Anaphora to Zeugma, are retrieved from storage to give the oration an air of immemorial antiquity.

Inaugurals conventionally start with a history lesson and finish with a prayer. In the first paragraphs, the newly sworn-in president thanks his predecessor for his service to the nation, applauds the miracle of a peaceful transition (as if all other countries went in for putsches and coups), and reminds America of its unique place as the cradle of modern democracy, summoning the ghosts of his illustrious predecessors, Washington, John

Adams, Jefferson, Madison, and Lincoln, to crowd around him in a Mount Rushmore–like tableau. In the last paragraph, it's customary to call on God to bless the nation and the great enterprise of the incoming administration, addressing him by such honorifics as "the benign Parent of the Human Race" (Washington), "that infinite Power" (Jefferson), "the kind Providence" (Pierce), "the giver of Good" (Theodore Roosevelt), "the Author of Liberty" (George W. Bush).

Sandwiched between these more or less canonical beginnings and endings is the less predictable meat of the piece. Most often it's a mission statement, couched in terms of uplifting generality and promising great good for all in the sunlit years ahead. Clinton's second inaugural in 1997 was a dismal classic in this regard. Although he did try to address the issue of race, the majority of the speech was boilerplate: "We need a new sense of responsibility for a new century... Our greatest responsibility is to embrace a new spirit of community for a new century... The challenge of our past remains the challenge of our future... With a new era of government, a new sense of responsibility, a new spirit of community, we will sustain America's journey." Words that were already dead on the page died a second death as Clinton gave them voice. Coming from someone with a reputation for effortless, improvised rhetoric, the speech was shockingly empty: the liberal historian William Leuchtenburg called it "the most banal address by an American president I have ever heard."

It generally takes an imminent catastrophe to persuade the new president to talk in detail about current events. Lincoln, facing the coming Civil War in 1861, mounted an impassioned and closely argued defense of the "perpetuity" of the Union and the Constitution against the Southern secessionists, in a speech that's still ablaze with life today. In 1933, Franklin Roosevelt crisply laid out the economic theory and practice of the New Deal in less than two thousand words, weaving farm prices, factories, mortgages, foreclosures, jobs, and public works into an instantly comprehensible plan of action, which took immediate effect by lifting the spirits of a profoundly depressed nation. But these are famous exceptions to the tradition of the inaugural as an exercise in ghostwritten magniloquence.

Until very recently, the pretense was kept up that these speeches were the original work of the president-elect, scribbling alone up in his den or—in JFK's case—the locked cabin of a private yacht, surrounded by blunted pencils and scumbled pages from a yellow legal pad. But this has always been a polite fiction.

When Lincoln showed the first draft of his 1861 inaugural to William Seward, his chief rival for the Republican nomination and his designated secretary of state (yes, history does sometimes repeat itself), Seward returned it with a sheaf of corrections to almost every sentence ("Strike out the whole paragraph," "For 'treasonable' write 'revolutionary'") and a drastically changed ending. Lincoln adopted almost all of Seward's suggestions, including the most important one, where he insisted that the speech end not on a challenge to the South (Lincoln had written "Shall it be peace, or a sword?") but on an appeal to what he called "the mystic chords" of shared historical memory. Seward's mystic chords went in, as did his hearts and hearths, his patriot graves and battlefields, his bonds of affection, his angels and ancient music, but as Lincoln rewrote Seward he sharpened every idea and phrase, giving the new ending a poignancy and intimacy of tone that hugely improved on Seward's original.

Lincoln made Seward's words his own, but most presidents, although they tinker with their speeches, leave the business of writing to their ghosts and sometimes, on Inauguration Day, appear baffled by the strange-tasting language they find in their own mouths. In January 1965, with *Mariner 4* en route to Mars, Lyndon Johnson haltingly read aloud this lyrical paean, probably written by Richard Goodwin, LBJ's leading spook:

Think of our world as it looks from the rocket that is heading toward Mars. It is like a child's globe, hanging in space, the continents stuck to its side like colored maps. We are all fellow passengers on a dot of earth.

His disbelief was audible. So was George H. W. Bush's in 1989, when he found himself telling the children of America that "Democracy belongs to us all, and freedom is like a beautiful kite that can go higher and higher with the breeze."

The two best inaugurals of modern times were written by ghosts. Raymond Moley, a former professor of politics at Columbia, drafted Roosevelt's 1933 address, and its best-known phrase, "the only thing we have to fear is fear itself," was slipped in at the last moment by another aide, Louis Howe. As for Kennedy's 1961 rhetorical triumph, his chief speechwriter, Ted Sorenson, was recently questioned by Deborah Solomon of the *New York Times*, who asked him point-blank if he was the true author of "Ask not what your country can do for you..." His succinct reply was, "Ask not."

The trouble with ghostwriting is that it raises the issue of whether the president is in a state of diminished responsibility for what he says. Does he actually grasp the implications of the words he speaks? A case in point is FDR's attack on bankers in his first inaugural:

Practices of the unscrupulous money changers stand indicted in the court of public opinion, rejected by the hearts and minds of men... They know only the rules of a generation of self-seekers. They have no vision, and when there is no vision the people perish... The money changers have fled from their high seats in the temple of our civilization. We may now restore that temple to the ancient truths.

The embedded quotation from the Book of Proverbs ("They have no vision") only helps to underline the anti-Semitism of the passage. But Roosevelt himself was not an anti-Semite; his closest friends, his cabinet, and his Supreme Court appointments included many Jews, such as Felix Frankfurter, Henry Morgenthau, Abe Fortas, and Louis Brandeis.

Yet calling bankers "the money changers," along with talk of driving them from the temple, was a favorite trope of Father Coughlin, the explicitly anti-Semitic demagogue and "America's radio priest." Coughlin, who supported Roosevelt in the 1932 election against Hoover, broke with him shortly afterwards, deriding the New Deal as the "Jew Deal." The lightly encoded message about an international conspiracy of Jewish bankers, written into Roosevelt's speech by Moley, ought to have been recognized by the president for what it was and immediately struck out. But it remained.

It's a puzzle. Perhaps the period explains it: a time when genteel anti-Semitism was so routine that it passed unnoticed. Perhaps—though this seems most unlikely—Roosevelt was in secret agreement with Coughlin's paranoid tirades. Or possibly he just warmed to the biblical roll and grandeur of the words when Moley showed him a script rife with vision, money changers, temple, ancient truths—powerful inaugural stuff. Whatever its explanation, this curious passage illustrates the danger of a president becoming the unwitting puppet of his ghosts, as I believe George W. Bush did in 2005 with his neoconservative, Project for the New American Century, Weekly Standard—style inaugural and its—mercifully empty—promise to bring about democracy around the globe by force of American arms.

No recent inaugural has been as keenly anticipated as Obama's. On the strength of *Dreams from My Father*, he's not only the best writer to occupy the White House since Lincoln (not a title for which there's stiff competition), he's also the most rousing American political orator of his generation. The big question was: would he write it himself? To which the disappointing answer was a qualified no.

It was probably because Obama first made his name as an eloquent writer that in December the Washington Post broke the convention of tact-

ful silence on the issue of ghostwriting and published a long and revealing article about Obama's relationship with Jon Favreau, his chief speechwriter. Favreau, now twenty-seven, has been ghosting for Obama since 2004. He was found by the *Post* reporter in a local Starbucks, working at a laptop on a document headed "ROUGH DRAFT OF INAUGURAL," having missed his original deadline of Thanksgiving.

Unlike Sorenson, Favreau (otherwise "Favs") wasn't coy about his job as presidential dramaturge, chatting freely about how he'd been listening to recordings of previous inaugurals and had paid a visit to Peggy Noonan to get the inside dope on how to write one. (Bad news, this: the modern inaugural address is a form that cries out to be broken, not copied.) The reporter, Eli Saslow, described Obama's and Favreau's usual procedure as they work up a speech:

Before most speeches, Obama meets with Favreau for an hour to explain what he wants to say. Favreau types notes on his laptop and takes a crack at the first draft. Obama edits and rewrites portions himself—he is the better writer, Favreau insists—and they usually work through final revisions together. If Favreau looks stressed, Obama sometimes reassures him: "Don't worry. I'm a writer, too, and I know that sometimes the muse hits you and sometimes it doesn't. We'll figure it out together."

Favreau is said to travel everywhere with a copy of *Dreams from My Father*, written before Obama entered politics, using it as the key to his master's authentic voice. He has internalized Obama's speech patterns along with his biography, and can now impersonate Obama on the page, speaking in the first person singular, with uncanny plausibility. Favreau says that when he leaves the White House he'd like to write "a screenplay or maybe a fiction book based loosely on what all this was like." But—whether or not he knows it—he is writing fiction now, losing himself inside a character remote from his own, as playwrights do. Favreau is white, single, twenty years younger than Obama, a buzz-cut Generation Y-er whose chief amusement, when not channeling Obama on his laptop, is all-night videogaming. (He caused a momentary scandal when the press found on his Facebook page a silly photo of him groping the right breast of a cardboard cutout of Hillary Clinton, while a friend jammed a bottle of beer against her face.)

The gulf in age and temperament between Obama and Favreau is probably a liberation for the speechwriter. To inhabit the skull of someone different from oneself is one of the great pleasures of writing fiction, and the

character of Obama (should that be "Obama"?) must be fun to work with: his natural gravity, his unflappable cool, his perpetually wrinkled brow, his sudden flashes of self-deprecating humor ("a mutt like me..."), his ability to switch styles, from law professor to black preacher and back again, his rich and flexible actor's baritone. No president since Kennedy has given his ghost so much to exploit, so many opportunities for elaborate verbal invention.

I suppose it's naive to be disconcerted by the fact that Obama employs ghosts (Favreau heads a team of them), but his best speeches have been so personal, so drenched in the past he described in *Dreams from My Father*, that one can't help feeling a little let down to learn that, for instance, his masterful and exhilarating speech on race, delivered last March in Philadelphia, was a joint Obama/Favreau production. From the *Washington Post*:

One Saturday night in March, Obama called Favreau and said he wanted to immediately deliver a speech about race. He dictated his unscripted thoughts to Favreau over the phone for 30 minutes—"It would have been a great speech right then," Favreau said—and then asked him to clean it up and write a draft. Favreau put it together, and Obama spent two nights retooling before delivering the address in Philadelphia the following Tuesday.

I think it's fair to assume that Favreau was here minimizing his own role in the composition of the speech. Still, however one reads the account, what is one to make of this much-quoted passage?

I can no more disown [the Rev. Jeremiah Wright] than I can disown the black community. I can no more disown him than I can my white grandmother—a woman who helped raise me, a woman who sacrificed again and again for me, a woman who loves me as much as she loves anything in this world, but a woman who once confessed her fear of black men who passed by her on the street, and who on more than one occasion has uttered racial or ethnic stereotypes that made me cringe. These people are a part of me. And they are a part of America, this country that I love...

As soon as one becomes aware of the presence of Favreau's fingers on the keyboard, the can of Red Bull, his preferred energy drink, beside him on the table, and the whiteness of his skin, the questions multiply: does this sound like Obama talking over the phone to Favreau? Obama recalling his

Hawaiian childhood in his own words? Or just Favreau recalling Obama's 1995 memoir (which he must now know by heart)? As Bill Clinton almost said, it all depends on what the meaning of I is.

The aim of Obama's inaugural, he told George Stephanopoulos on ABC's *This Week*, was "to try to capture as best I can the moment we are in." It would have been a more obviously arresting speech if he'd tried to capture the moment in the language of the present century instead of using the faux-antique dialect of past inaugurals. So many phrases had the dull patina of silver that has jingled in dead presidents' pockets. The few mint coins in his oration stood out by their brightness, like "our patchwork heritage," followed by the addition of "non-believers" to "We are a nation of Christians and Muslims, Jews and Hindus"—the first time that atheism has been included under the rubric of religious tolerance and freedom. And there was the pretty rhetorical flourish of "The nation cannot prosper long when it only favors the prosperous."

The surface tone of the address was set by somewhat moth-eaten metaphors ("rising tides of prosperity and the still waters of peace . . . amidst gathering clouds and raging storms") and a curious solecism in its sixth sentence: "At these moments, America has carried on not simply because of the skill or vision of those in high office, but because we, the people, have remained faithful to the ideals of our forbearers, and true to our founding documents." Forbearers? In neither American nor British English is a forbearer a forebear, or ancestor; it's a person who shows forbearance—endurance under provocation. But someone (Favreau? Obama?) must have thought that the extra syllable in "forbearer" gave the word the sort of solemn weightiness suitable to the liturgical grandeur of an inaugural address, and tipped it into the speech without regard for its actual meaning. Its presence in the speech as delivered and distributed to the press (the White House has since corrected its official text) reveals just how anxious the authors were to uphold the stilted linguistic conventions of the form—and for good reason.

Under the guise of noble platitude Obama was able to get away with murder, cloaking in familiar and emollient language an address that otherwise defied convention. There was a hint of this in his ritual bow to the outgoing president, in which he spent five words acknowledging Bush's service to his country and ten in thanking him for his departure from office. In no inaugural has a president so completely repudiated the policies of his predecessor as Obama did on Tuesday. Look back at the "forbearers" sentence, and see the sting in its tail: "true to our founding documents." Most of the crowd of more than a million that packed the Mall, a few of whom loudly booed Dick Cheney when he was wheeled onto the stage, believed the Bush

administration had done its best to shred the constitution. The distinction between "we, the people," who are loyal to the founding documents, and "those in high office," who stand accused of abusing them hung ambiguously in the air. If you wanted to hear it, it was there; if you didn't, it wasn't.

This veiled quality suffused the entire address, whose central motif was stated early on: "The time has come to put away childish things . . . to reaffirm our enduring spirit; to choose our better history." The distinct echo of Lincoln's "the better angels of our nature" helped to soften the implication that the last eight years belong to our worse history, under a president famous for his childish pursuits. (As one of Bush's own advisers once asked, "What kind of male obsesses over his bike-riding time, other than Lance Armstrong or a twelve-year-old boy?")

Yet there was no triumphalism in this; there was, rather, a note of somber regret. It was necessary for Obama to announce to both the United States and the rest of the world (and his inaugural was directed, unusually, at least as much to the foreign as to the domestic audience) that on Tuesday the Bush era had ended and that America, after a long, unhappy detour in the wilderness, was returning to its better history. Since inaugural addresses are by tradition high-toned, bipartisan affairs, this was an immensely difficult feat to bring off with grace. What needed to be said had to be phrased in language as well-worn and conventional as possible, to give the illusion of smooth continuity between Obama's speech and those of past presidents.

The driving theme of the address made its appearance at artfully calculated intervals, with Obama touching on it, departing from it, returning to it, burying it for a while before digging it up again, which made some critics call the speech diffuse. But it was not diffuse. It was quietly, courteously insistent on its purpose.

"On this day, we come to proclaim an end to . . . the worn-out dogmas that for far too long have strangled our politics" an end, then, to the strident imperialism of the neoconservatives and the "Bush doctrine" of preemptive invasion. "Starting today, we must pick ourselves up, dust ourselves off, and begin again the work of remaking America," so, under the forty-third president, we have been floored and supine. The most damning censure of the Bush administration arrived exactly midway through the speech, at the nine-and-a-half-minute mark:

As for our common defense, we reject as false the choice between our safety and our ideals. Our founding fathers, faced with perils that we can scarcely imagine, drafted a charter to assure the rule of law and the rights of man, a charter expanded by the blood of generations.

Those ideals still light the world, and we will not give them up for expedience's sake. And so to all the other peoples and governments who are watching today, from the grandest capitals to the small village where my father was born: know that America is a friend of each nation and every man, woman, and child who seeks a future of peace and dignity, and we are ready to lead once more.

That is as near as George W. Bush has come to being impeached. It covers the legal black hole of Guantánamo Bay and its kangaroo courts, the over-reaching powers of the Patriot Act, torture, warrantless wiretapping, and all the other infractions of the civil liberties of Americans and foreigners alike that occurred under the outgoing administration. "We are ready to lead once more" is startlingly candid in its admission that, under Bush, the United States did not lead the world but attempted to bomb and bully it into submission.

The reference to "the rights of man" was salient. The title of Thomas Paine's giant pamphlet prepared us for his incognito appearance at the end of the speech, when Obama talked of Christmas night in 1776, when George Washington led his ragtag army across the ice-choked Delaware River to confront the British and Hessians who were encamped at Trenton, New Jersey. Obama spoke of "the timeless words" that "the father of our nation" ordered to be read to the American people: "Let it be told to the future world, that in the depth of winter, when nothing but hope and virtue could survive, that the city and the country, alarmed at one common danger, came forth to meet [it]." The oddly bracketed "it" replaced the original end of the sentence, which was "came forth to meet and to repulse it."

Every commentator I heard—including, surprisingly, the historian Doris Kearns Goodwin—assumed that the quotation came from Washington himself, but it is from Paine's *The Crisis*. "With hope and virtue, let us brave once more the icy currents," Obama said, and the commentators assumed, mistakenly I think, that he was speaking only of the recession as it deepens, with increasing speed, into depression. But Paine's authorship of those words suggests otherwise. The "common danger," requiring "hope" and, more pointedly, "virtue" in order to "meet [and to repulse] it," is surely as much the spectre of a dictatorial administration, emboldened by Dick Cheney's theory of the "unitary executive," and its dangerous freedom to abuse the rights of man, as it is the present economic crisis. No wonder "and to repulse" was left out: Obama, a cautious politician and sensitive to the nuances of words, stopped short of calling the Bush administration repellent.

His image of leaving the blood-stained snow behind to cross the freezing river—famous from schoolroom reproductions of Emanuel Leutze's 1851 painting *George Washington Crossing the Delaware*—and his marriage of December 1776 to "this winter of our hardship" were his most daring attempts at inaugural loftiness. But there was more to them than a stirring call to arms to fight recession; he was placing between his incoming administration and that of the outgoing president a broad river packed with growling chunks of ice—a river just crossed, at great hazard to the survival of America's "founding documents."

I've read—or at least skimmed—every inaugural address since George Washington's, and none comes close to so categorically rejecting the political philosophy and legislative record of the previous occupant of the White House. Obama did it by stealth—so much stealth that most of the red meat of the speech has so far passed largely unnoticed. The most astonishing visual moment of the inauguration came after the speech, and Elizabeth Alexander's dud poem ("On the brink, on the brim, on the cusp ...," mistaking her thesaurus for her muse), and the Rev. Joseph Lowery's magnificent, scene-stealing benediction, when Obama and his wife, Michelle, walked George W. and Laura Bush to the U.S. Marine helicopter parked beside the Capitol's West Portico. The two couples joked, then hugged, before the Bushes climbed aboard, off to Midland, Texas. It was like seeing Mark Antony and Brutus locked in a warm embrace after "Friends, Romans, countrymen..."

No one will say of Obama's inaugural, as the *Atlanta Constitution* said the day after Roosevelt's 1933 speech, "The address takes its place among the greatest of historic state papers of the nation, ranking with Lincoln's address at Gettysburg." Even on Inauguration Day itself, when the press usually takes a rosy view of whatever is said by the new president, journalists grumbled that Obama's oration, though predictably well delivered, was short of specifics, fire, and memorability. They searched the text for phrases to stand beside "the only thing we have to fear..." or "Ask not what your country...," and came away empty-handed. Conservative journalists noted that Obama had taken some "digs" at Bush, but failed to register the truly damaging subtext.

Among the first-response reviews, the Dow Jones Index appeared to pan the speech with its steady decline through trading hours, losing 332 points on the day, with a dip, not a blip, in the minutes immediately following the address. Certainly Obama failed to inject the nation with a shot of instant, FDR-style consumer confidence. "The state of our economy calls for action, bold and swift," he said, but already his stimulus package is under

attack from Keynesians for being far too little and from fiscal conservatives for being far too much. His appeals for a renewed spirit of community and mutual responsibility, though phrased more vividly than Clinton's in 1997 ("It is the firefighter's courage to storm a stairway full of smoke, but also a parent's willingness to nurture a child, that finally decides our fate"), were cast in the same communitarian mold and had the unfortunate effect of reminding me, at any rate, of the dullest inaugural in living memory. It was this aspect of Obama's address that his aides hawked around the TV networks as its dominant theme: he would, they said, use the address to herald "a new era of responsibility." But that was a blind: Obama's real preoccupations lay elsewhere.

Next week, the speech will be pretty much forgotten, and people will scratch their heads to remember a single quote from it. Yet if (and it's a huge if) 2009 should eventually turn out to have been the date when the United States renounced the accumulated policies of the Bush years, regained an honorable place in the wider world, and returned to the course of its "better history," then we'll reread Obama's inaugural and discover how subtly audacious he was being. It's already original—and not so much in spite of, but because of, its unoriginal language. It might, just conceivably, be seen as revolutionary.

Guardian, January 2009

Metronaturals

IN THE IMAGINARY America of books and movies, where every state and region has acquired a rich cluster of meanings and associations over time, the Pacific Northwest is a fairly recent arrival. Nineteenth-century painters like Albert Bierstadt visited Oregon and Washington in search of fresh landscapes to add to their stock of images of the sublime, and the explicitly social vocabulary of late Romantic sublimity ("noble," "regal," "grand," "majestic," and all the rest) still gets attached to the region's extravagant volcanic geography, its mountain ranges, evergreen forests, and superabundance of water in every form. In the second half of the twentieth century, that geography came to serve as backdrop to the unmajestic, ignoble life in the valleys and foothills, where low-rise, makeshift, ad hoc settlements stand in plain view of the snowcaps and forest, mockingly diminished by their spectacular surrounding nature.

Bernard Malamud—who taught at Oregon State College, now Oregon State University, in Corvallis, from 1949 to 1961—conveyed this beautifully in *A New Life* (1961), a novel in which the college town of Eastchester in the state of Cascadia is a scale model of McCarthy-era, small-minded social, academic, and political conformity, set in a landscape whose mountains, tumbled clouds, and vast sky hold out the promise of exhilarating escape and freedom to S. Levin, "formerly a drunkard," of New York City. Since then, in the stories of Raymond Carver, the films of Gus Van Sant, and the novels of Ken Kesey and David Guterson, among others, the Pacific Northwest has become familiar as the place in America where lives of grimly straitened circumstances play out within sight of the now-ironic sublime. The old-growth Douglas firs, the mountains, and the cascades are there to tease from a distance: it's in the trailer homes and bungalows below,

in insufficient, straggling towns, their single highways lined with the parking lots of big-box stores, that most Northwest fiction happens.

These drab lowlands, mostly shot under a wan, overcast sky, are the setting for Wendy and Lucy, directed by the Florida-born, New York-based independent filmmaker Kelly Reichardt. Like her last movie, Old Joy (2006), Wendy and Lucy is adapted from a short story by the Portland, Oregon, writer Jon Raymond, whose intently observant and unillusioned take on his home territory has been adopted by Reichardt as her own. In their latest collaboration, Raymond and Reichardt have turned the Great Pacific Northwest, as its boosters call it, into an allegorical landscape of economic and emotional recession; a world starved of credit, jobs, futures, sunlight, words, and social bonds. The December 2008 release of Wendy and Lucy, after a successful season on the festival circuit, was eerily well timed: it would be hard to find a more powerful illustration of Obama's talk of the danger of financial crisis turning into catastrophe than this spare and haunting film.

Wendy, played by Michelle Williams, is driving with her dog, Lucy, from Muncie, Indiana, to a seasonal job on the "slimeline" of a salmon cannery in Ketchikan, Alaska (where around \$750 can be earned for an eighty-four-hour week on minimum wage plus overtime), when her '88 Honda Accord falls terminally ill in a small town in Oregon. Whatever misfortune led her to the desperate solution of the cannery job is left deliberately unclear, but Wendy is not a feckless drifter: the spiral-bound notebook in which she records every expenditure on gas and food, in round but literate handwriting, and the money belt in which she keeps her dwindling supply of cash are tokens of her cautious, thrifty character. Almost degendered, in knee-length cutoffs and plaid shirt, her hair cropped into a pudding-bowl cut around her ears, Wendy is an androgynous Everyperson, a representative American, fallen on hard times through no particular fault of her own. When she arrives in the nameless Oregon town, her savings have fallen to precisely \$525—just enough to get her and her dog to Ketchikan so long as nothing goes wrong.

The town, such as it is, is one of those Northwest places that look like the outskirts of somewhere bigger, farther down the road, but turn out to be all there is. It has a railroad and switching yards, but the whistling trains (Raymond's original story was titled "Train Choir") are bound from some remote elsewhere to another. Like the prominent phone cables and the continuous thin surf of traffic on an arterial street, the trains draw attention to the infrastructure of a busy capitalist society, full of messages, appoint-

ments, destinations, but the town itself seems to have been bypassed by the business of America. We learn it once had a timber mill but that it closed down long ago, leaving the subsistence and occupations of the townspeople a mystery. For the purpose of the film, the town's heart is the almost-empty parking lot of a Walgreens, and perhaps that's the solution; they live on Medicaid prescription drugs.

In fact, Reichardt filmed these scenes on location in a suburb of Portland, and her detachment of the sub from the urb, islanding it amid woods and water as a dismal stand-alone community, is a clever piece of artifice that is strikingly true to the character of the region, where so many towns look a lot like this, but none is quite as perfectly centerless and accidental as this one. To the Pacific Northwest landscape, Reichardt brings a connoisseur's eye for bare asphalt; utility poles; chain-link fencing; the texture of cinder-block walls, painted and repainted in varying shades of beige; the street of motley bungalows; the shaggy, ink-black cypress, disproportionately dominating an otherwise squat and untidy backyard. Since her first feature-length film—River of Grass (1995), a rather discombobulated black comedy-thriller set, in pitiless subtropical sunshine, on the ugliest streets to be found in Miami-Dade and Broward counties—she's demonstrated an enthusiastic visual relish for the worst that humans can do to blight their environment, and in Wendy and Lucy she lets her dyspeptic view of man's inhumanity to nature rip.

In this unlovely setting, Michelle Williams (*Brokeback Mountain* et al.) gives a performance of engrossing depth and subtlety. In eighty minutes of screen time, I doubt that she has many more than eighty short, flat lines to speak, excluding her calls of "Lucy? Lu?" when her dog goes missing. Her commanding eloquence lies elsewhere, in posture and gesture, the tilt of a shoulder, the set of her lips and, most of all, in her eyes, which by turns, convey wariness, tenderness, terror, pride, disgust, resignation, and despair. Reichardt's camera treats Williams as a wonder of nature in her own right, and one is mesmerized by her capacity to make so much of a wordless shrug or a rare, reluctantly forced smile.

When she first shows up in town, with Lucy in tow, she meets what appears to be a tribe of savages—a bunch of stoner punks, their mutilated faces lit by the flames of a campfire. A little later, having scavenged a few crumpled cans and empty bottles from the roadside, she joins a more sedate and orderly group of homeless men, queuing in line at an automated recycling center, where they redeem their collections of discarded trash at the rate of a nickel per container. These two outcast communities are as near as she comes to encountering a functioning society—one from which she

is kept aloof only by the remaining bills in her money belt and her stricken car. For the rest, everyone in the town appears to be hardly less stranded and isolated than she is herself, and almost all of them—cop, security guard, supermarket checkout clerk, woman at the desk of the dog pound, auto mechanic—looks as if they might soon find themselves in her predicament.

Two cans of Iams dog food, slipped by Wendy into her purse in the supermarket, precipitate her personal slide from crisis into catastrophe, leading her to a police cell, fingerprinting, a budget-wrecking fifty-dollar fine plus court costs, and the disappearance of Lucy from the bike rack to which she had been left tethered outside the store. Alone on the street, with a dead car and a missing dog, she's tumbled from the ranks of those who just manage to squeak by on minimal means of support into the netherworld of the punks and the homeless. But she's not beaten yet. Her search for Lucy, which occupies the last fifty minutes of the movie, is conducted with method and resourcefulness. Watching her making Lost Dog posters ("floppy ears, sharp eyes, yellowish-brown, friendly face . . . "), quartering the town while calling Lucy's name, and creating a scent trail of her garments tied to trees for the dog to follow, one sees her fundamental competence: here is someone who eminently deserves a job. But there are no jobs in this town, and in any case, as Wendy says to the Walgreens security guard, "You can't get a job without an address." To which he replies, "You can't get an address without an address. You can't get a job without a job. It's all fixed."

An economy on the brink of collapse is at once the subject of the movie and Reichardt's directorial aesthetic. Wendy and Lucy cost \$200,000 to make, and the notebook detailing Wendy's running expenses might be Reichardt's own. Everything is frugally pared down to the barest minimum. The film's musical score is an eight-note theme with variations, first hummed by Wendy in the opening scene, then picked up by a distant synthesizer. This skeletal tune, vaguely liturgical to my ear, becomes as memorable a soundtrack as any I can remember (it was composed by Will Oldham, the Kentucky musician and actor, who also appears here as the chief of the fireside punks).

The economical music sets the key for the whole movie. With the pointed exceptions of the Oldham character, who's on an alpine high, and the pompous brat in the supermarket, who insists on turning Wendy over to the police with lines like "The rules apply to everyone equally" and "If a person can't afford dog food, they shouldn't have a dog" (and whose conspicuously dangling crucifix is Reichardt's only lapse into excess), everyone spends language as thriftily as if each syllable were hard-earned money. No

one is unnecessarily impatient or deliberately unkind, but the town has so little to spare the stranger in its midst that every expression of interest or concern must be measured and counted, cent by grudging cent.

Reichardt coaxes from her (underpaid) cast a magnificent ensemble performance of austere naturalism. Michelle Williams's restrained and gestural style is exactly matched by the other actors, and especially by Walter Dalton as the security guard, who first orders Wendy to remove herself and her car from the parking lot, then, by halting stages, falls into a shyly avuncular relationship with her. Dalton, slow of speech and movement, his unruly silver eyebrows deserving an Equity card of their own, is the living embodiment of the town, its good days in the past, now whiling away its time in tedious drudgery on minimum wage. Toward the end, after Lucy has at last been located in a "foster home," Dalton thrusts some money into Williams's hand. When he's gone, she counts it—a five and two singles. It's a measure of the film's own scrupulous economy that we know what the sum means: about what he earns standing on weary feet for an hour, gazing at empty asphalt and watching nothing happen.

Reunited with her dog, though a chain-link fence divides them, Wendy eyes Lucy's new life at the home of a couple who took her in, the spacious yard, the food and water bowls. So the Northwest has made good on its old promise of miraculous self-betterment, for one of the pair, at least. Crying—for the first time in the movie—she leaves Lucy to this canine version of freedom and bounty, then hops a boxcar on a train heading north, in the direction of Bellingham, Washington, and the Ketchikan ferry. As the train speeds up, the blur of passing tree trunks recalls an earlier shot in which Wendy walked through the dog pound, the bars of each cage going by faster and faster. But Reichardt is too subtle to insist on the point: the firs could be shades of the prison house, or they might just be trees.

A nicely obscure in-joke is embedded in the movie. At the supermarket, Wendy is about to pocket an apple, but sees an aproned stocker replenishing the produce department a few feet away. People who go to art galleries in the region will find the face of the stocker familiar: it belongs to Michael Brophy, the Portland landscape painter, much of whose work has been devoted to ironic deconstruction of the Bierstadt-style Northwest Sublime; here reduced to placing vegetables on shelves at \$7.80 an hour.

It's to be hoped that admirers of Wendy and Lucy will be led from the film to Livability, Jon Raymond's collection of short stories, whose title is another ironic deconstruction, this time of the lists of "Most Livable Cities" published annually by travel magazines, in which Portland and Seattle

regularly figure near the top. Such lists assume a readership of well-heeled types who are looking for somewhere to move to in search of suitably noble landscape views, ski slopes, hiking and biking trails, rock faces to ascend with ropes and carabiners, rivers on which to fly-fish, water on which to sail and windsurf, along with such conventional urban amenities as espresso coffee, luxury shopping, and good schools. Reading *Livability* might persuade such city-sipping, nature-loving, upper-middle-class nomads to be glad to remain where they are.

It's true that Raymond does once allow the word "majestic" to creep into the book, as a description of the Oregon coastline north of Florence, but that might be because the narrator of the story is an elementary-school teacher. Much more typical of his staunchly post-Romantic sensibility is the moment in "Benny" when his narrator (recently married, gainfully employed, and settled in a newly bought house in the pleasant neighborhood of St. Johns in North Portland) mourns the death of a schoolfriend who took the alternative-lifestyle route and OD'd under a rhododendron bush in a local park. Looking for the happiest memory of their shared childhood, he comes up with a day in the forest when they were thirteen, throwing rocks at trees:

We started with small ones, winging little nut-sized stones and waiting for the distant knock if we were lucky and hit something. From there we progressed to bigger things. We went a little crazy that day. We lifted rocks and banged them against the trees, chipping into the yellow meat. We rolled small boulders down the incline of ferns until they cracked angrily against something at the base of the ravine. We pounded the woods until our arms ached and our breath was ragged. We taught the woods a lesson they would never forget.

There speaks a true native of the Pacific Northwest, where punishing nature and teaching it lessons it won't forget has always been a more powerful regional tradition than its Romantic counterpart of nature worship. The slash-littered clearcut, like a First World War battlefield, the massive concrete dam, the cyanide leach mine, the subdivisions marching across what used to be forest only yesterday, are features of the Northwest landscape as prominent as its mountains, lakes, and waterfalls.

Raymond's characters live in and around Portland, along the urban corridor whose main street is Interstate 5, within a couple hours' drive of the ocean to the west and the Mount Hood National Forest to the east—destinations visited, in "The Coast" and "Old Joy," for their supposed power to heal the decaying friendship and the wounded soul; but in both cases nature turns out to be poor medicine for the malaise it's meant to cure. Reality is firmly situated in the city and the subdivisions, in the kind of territory on which Reichardt's camera dwells in Wendy and Lucy.

What the characters share is a peculiar lightness of attachment, both to one another and to the geography in which they're placed. Some (the screenwriter in "New Shoes," the sculptress in "Words and Things," the teenage sales assistant in "Young Bodies") exist on the risky economic margin of society; others (the teacher in "The Coast," the Porsche-driving, Chinese-American insurance company manager in "The Suckling Pig") have reliable means, but find themselves newly marginalized by widowerhood or divorce. Their social lives are typically improvised, with friends who are little more than acquaintances, or were friends in the past but are near strangers now, and lovers who won't last long.

Those who have spouses and children come across as slightly puzzled spectators of their own families. Ranging far and wide across Portland and its suburbs, crossing and recrossing boundaries of age, gender, and class, Raymond paints a world that has all the superficial appearance of a diverse, even flourishing society, but is built on ties so temporary and fragile that it might at any moment fall apart. An obsessive theme in these stories is that the characters in them will end up at a greater distance from one another than they began.

Verna in "Train Choir" (renamed Wendy in Wendy and Lucy), the last story in the book, carries that principle further than anyone else in Livability. Other stories leave their central characters alone, usually at night, quietly facing the void of their own solitude, but in "Train Choir" Raymond transports Verna into a version of the world in which society has ceased to exist. From her boxcar, Verna/Wendy looks out at the accelerating landscape:

Already the foster home was receding in the distance. A juniper bush whipped past. She was traveling ever deeper into a sterile, bone-dry planet of rock and sky.

Verna lay down on her side and pulled her knees to her chest. Far ahead, the engine's whistle blew, full-throated and remorseful. And then it blew again. Verna watched the ball of sun wobble in the sky. She knew she was going to be chasing that sound for a long time now.

That sterile planet, whose last human remnant is the remorse that Verna chooses to hear in the train's mechanical air horn, is where all of Raymond's characters, in their increasing remoteness, might ultimately be bound. In the meantime, they live in metropolitan Portland, throwing dinner parties, conducting affairs, taking their children shopping, driving to the region's accredited beauty spots, acting out lives driven more by custom than conviction.

All this might suggest that Jon Raymond is an austere writer, which he's anything but. Where Kelly Reichardt practices a strict, Carveresque minimalism, leaving out far more than she puts in, Raymond is a prose maximalist. Although his characters have difficulty relating to one another, they engage the reader with unbuttoned, occasionally garrulous, intimacy. They entrust to the reader their memories, thoughts, feelings, landscape descriptions, even as they explain why these private riches can't be shared with the people closest to them. At the end of "Benny," the narrator considers talking about his dead friend to his Vietnamese wife, Minh:

I heard her walking around in the kitchen and I knew she'd be happy enough if I came up and told her what was on my mind. I stayed put though. I had plenty of stories about Benny I could share, but I didn't really see the point. Why bother? . . . It was too late for Minh to understand what Benny had meant to me. It was too late for her to understand that we might as well have been brothers.

The cumulative effect of this, extended over nine stories, is to immerse the reader in a varied society of compulsive and fluent interior monologuists, who experience their lives with articulate intensity but find it uphill work to communicate satisfactorily with their fellow loners.

The book's Pacific Northwest setting, insistently present in every story, is not an accidental location but an intrinsic part of its theme. In no other American region has solitude been so exalted as a virtue, or society—especially in its concentrated urban form—tolerated, if not quite as a necessary evil, then as the acceptable price to pay for living so conveniently and romantically close to nature. A year or so ago, Seattle's Convention and Visitors Bureau adopted the limp neologism "metronaturals" to tout the allure of the city on brochures and mugs; and Raymond's Northwestern characters are, one might say, metronaturals—uneasy creatures, neither quite of the woods nor of the city, isolated from each other and their native ground.

Their attachments, fragile at the best of times, won't survive the notice of foreclosure or the pink slip that—as Raymond makes clairvoyantly plain in "Benny"—could arrive at any moment. Between the proud homeowner in St. Johns (he bought just after the median house price in Portland rose by "fucking one hundred fifty percent," and barely managed to scrape together the down payment) and the hunched and solitary figure in the boxcar, speeding into the void, lies one small misstep or stroke of ill luck, no bigger than the price of two cans of dog food.

New York Review of Books, March 2009

American Pastoral

Published in 1935 in the middle of the Depression, William Empson's Some Versions of Pastoral cast a hard modern light on sixteenth- and seventeenth-century poems about shepherds and shepherdesses with classical names like Corydon and Phyllida. Pastoral, Empson wrote, was a "puzzling form" and a "queer business" in which highly educated and well-heeled poets from the city idealized the lives of the poorest people in the land. It implied "a beautiful relation between the rich and poor" by making "simple people express strong feelings... in learned and fashionable language." Like so many of Empson's observations about literature, this idea was blunt, commonsensical, and novel: from 1935 onwards, no one would read Spenser's The Shepheardes Calendar or follow Shakespeare's complicated double plots without being aware of the class tensions and ambiguities between the cultivated author and his lowborn subjects.

Although shepherds and shepherdesses have been in short supply in the United States, versions of pastoral have flourished here. The cult of the Noble Red Man or, as Mark Twain derisively labeled it, "The Fenimore Cooper Indian" (a type given to long speeches in mellifluous and extravagantly figurative English) is an obvious example. So is the heroization of simple cowboys, farmers, and miners in the western stories of writers like Bret Harte (another of Twain's literary bêtes noires), the movies of John Ford, and the art of Frederic Remington, Charles M. Russell, Maynard Dixon, and Thomas Hart Benton. Both *Uncle Tom's Cabin* and *The Grapes of Wrath* might be read as pastorals in Empson's sense. The chief loci of American pastoral have been the rural South and the Far West, while most of its practitioners have been easterners for whom the South and West were destinations for bouts of adventurous travel, equipped with sketchpads and

notebooks in which to record the quaint and picturesque manners and customs of their homespun fellow countrymen in the deep sticks.

Empson noted the connection between traditional pastoral and Soviet propaganda, with its elevation of the Worker to a "mythical cult-figure," and something similar was going on during the New Deal when the Resettlement Administration (which later morphed into the Farm Security Administration) dispatched such figures from Manhattan's Upper Bohemia as Walker Evans and Marion Post to photograph rural poverty in the southern states. Like a Tudor court poet contemplating a shepherd, the owner of the camera was rich beyond the dreams of the people in the viewfinder, and these images were used by the government both to justify its liberal economic policy and to raise private funds for the relief of the dispossessed flood victims, sharecroppers, and migrant farmworkers. Some, though not all, of the photographers were, like Evans, conscious artists; their federal patrons, like Roy Stryker, head of the information division of the FSA, were unabashed propagandists who judged each picture by its immediate affective power and took a severely practical approach to human tragedy.

Of all the many thousands of photographs that came out of this government-sponsored enterprise, none was more instantly affecting or has remained more famous than Dorothea Lange's Migrant Mother. Taken in February 1936 at a pea pickers' camp near Nipoma, seventy miles northwest of Santa Barbara, it was published in the San Francisco News the following month, when it raised \$200,000 in donations from shocked readers. In 1998, it became a thirty-two-cent stamp in the Celebrate the Century series, with the caption "America Survives the Depression." My sixteen-year-old daughter, noticing the title of one of the books under review here, exclaimed "Migrant Mother!" because a poster-sized print of the photo dominates a classroom at her high school. For a long while now I've tried to observe a self-imposed veto on the overworked words "icon" and "iconic," but in the exceptional case of Migrant Mother it's sorely tempting to lift it.

The picture defines the form of pastoral as Empson meant it, and the closer one studies it, the more one's made aware of just what a queer and puzzling business it is. A woman from the abyssal depths of the lower classes is plucked from obscurity by a female artist from the upper classes and endowed by her with extraordinary nobility and eloquence. It's not the woman's plight one sees at first so much as her arresting handsomeness: her prominent, rather patrician nose; her full lips, firmly set; the long and slender fingers of her right hand; the enigmatic depth of feeling in her eyes. Even after many viewings, it takes several moments for the rest of the picture to

sink in: the pervasive dirt, the clothing gone to shreds and holes, the seams and furrows of worry on the woman's face and forehead, the skin eruptions around her lips and chin, the swaddled, filthy baby on her lap. As one can see from the other five pictures in the six-shot series, Lange posed two older children, making them avert their faces from the camera and bury them in the shadows behind their mother, at once focusing our undistracted attention on her face and imprisoning her in her own maternity. It's a portrait in which squalor and dignity are in fierce contention, but both one's first and last impressions are of the woman's resilience, pride, and damaged beauty.

Against all odds, she's less a figure of pathos than of survival, as the inscription on the postage stamp accurately described her. In a 1960 interview, Lange said of the woman that she "seemed to know that my pictures might help her, and so she helped me. There was a sort of equality about it"—a nice instance of Empson's "beautiful relation between the rich and poor," but not at all how her subject remembered the occasion.

In 1958 the hitherto nameless woman surfaced as Florence Thompson, author of an angry letter, written in amateur legalese, to the magazine *U.S. Camera*, which had recently republished *Migrant Mother:*

... it was called to My attention ... request you recall all the un-Sold magazines ... should the picture appear in Any magazine again I and my Three Daughters shall be Forced to Protect our rights ... Remove the magazine from Circulation Without Due Permission ...

Years later, Thompson's grandson, Roger Sprague, who maintains a website called migrantgrandson.com, described what he believed to be her version of the encounter with Lange:

Then a shiny new car (it was only two years old) pulled into the entrance, stopped some twenty yards short of Florence and a well-dressed woman got out with a large camera. She started to take Florence's picture. With each picture the woman would step closer. Florence thought to herself, "Pay no mind, the woman thinks I'm quaint, and wants to take my picture." The woman took the last picture not four feet away then spoke to Florence: "Hello, I'm Dorothea Lange, I work for the FSA documenting the plight of the migrant worker. The photos will never be published, I promise."

Some of these details ring false, and Mr. Sprague has his own interest in promoting a counternarrative, but the essence of the passage, with its insis-

tence on the gulf of class and wealth between photographer and subject, sounds broadly right. "The woman thinks I'm quaint" might be the resentful observation of every goatherd, shepherd, and leech gatherer faced with a well-heeled poet or documentarian on his or her turf.

It also emerged that Florence Thompson was not just a representative "Okie," as Lange had thought, but a Cherokee Indian, born on an Oklahoma reservation. So in retrospect *Migrant Mother* can be read as intertwining two "mythical cult-figures": that of the refugee sharecropper from the Dust Bowl (though Thompson had originally come to California with her first husband, a mill worker, in 1924) and the Noble Red Man. There is a strikingly visible connection, however unnoticed by Lange, between her picture of Florence Thompson and Edward S. Curtis's elaborately staged sepia portraits of dignified Native American women in tribal regalia in his massive collection *The North American Indian* (1900–1930), perhaps the single most ambitious—and contentious—work of American pastoral ever created by a visual artist.

Both Linda Gordon's *Dorothea Lange* and Anne Whiston Spirn's *Daring to Look* hew to the line that Lange suddenly became a documentary photographer in 1932, when she stepped out of her portrait studio on 540 Sutter Street in San Francisco's fashionable Union Square shopping area and took her Rolleiflex out onto the streets of the Mission District, three miles away, where she began to photograph men on the ever-lengthening breadlines in the last year of Hoover's presidency. But this is to underplay the importance of the pictures she took from 1920 onwards when she accompanied her first husband, Maynard Dixon, on his months-long painting trips to Arizona and New Mexico.

Lange was twenty-four when they married in March 1920, Dixon twenty years older. She was still a relative newcomer to San Francisco, having arrived there from New York in 1918; marrying Dixon, she also embraced his nostalgic and curmudgeonly vision of the Old West. A born westerner, from Fresno, California, he stubbornly portrayed the region as it had been before it was "ruined" by railroads, highways, cities, Hollywood, and tourism. In his paintings, the horse was still the primary means of power and transportation in a land of sunbleached rock and sand, enormous skies, cholla and saguaro cacti, with adobe as its only architecture and Indians and cowboys its only rightful inhabitants. Although Lange had already established herself as an up-and-coming

portrait photographer in San Francisco, her pictures on these trips to the desert were so faithful to her husband's visualization of the West that one might easily mistake many of them for Maynard Dixon paintings in black-and-white.

So she caught a group of Indian horsemen, seen from behind, riding close together across a sweep of empty tableland; a line of Hopi women and a boy, clad in traditional blankets, climbing a rough-hewn staircase trail through the pale rock of the mesa; a man teaching his son how to shoot a bow and arrow; families outside their adobe huts; and sombre, unsmiling portraits of Indians whose faces show the same weary resignation to their fate as the faces that Lange would later photograph on the breadlines and in migrant labor camps. It was among the Hopi and the Navajo that she picked up the basic grammar of documentary, with its romantic alliance between the artist and the wretched of the earth.

One photograph stands out from her travels in the Southwest: a radically cropped print of the face of a Hopi man, in which much darkroom wizardry clearly went into achieving Lange's desired effect. At first sight it looks like a grotesque ritual mask, its features splashed with silver as if by moonlight. Its skin is deeply creased, its eyes inscrutable black sockets. In its sculptural immobility, it appears as likely to be the face of a corpse as of a living being.

Seeing the finished picture, no one would guess the raw material from which Lange made the image as she focused her enlarger in the dark. There's an uncropped photo of the same man, obviously shot within a minute or two of this one, to be seen in the Oakland Museum of California's vast online archive of Lange's work, in which he's wearing a striped shirt and a bead necklace strung with Christian crosses, his hair tied with a scarf knotted around his forehead. He looks humorous and easygoing, amused to be having his picture taken. This is not the negative that Lange used for her print, but it's so close as to be very nearly identical. For the masklike portrait she moved her camera a few inches to her right, so the razor-edged triangular shadow of the man's nose exactly meets the cleft of his upper lip, and lowered it to make him loom above the viewer. What is remarkable is how she transformed the merry fellow in high sunshine into the unsettling and deathly face of the print. Hopi Man is pastoral-as-elegy (think of Milton's Lycidas). It might be titled The Last of His Race, or, as Edward S. Curtis called one of his best-known photographs, The Vanishing Race. There is, alas, no record of what the subject thought of his metamorphosis into a gaunt symbol of extinction.

Linda Gordon's substantial, cradle-to-grave biography of Lange is usefully complemented by Anne Whiston Spirn's careful documentation of one year—1939—in Lange's working life. Both books have their flaws, but between them they add up to a satisfyingly binocular portrait of the photographer as she traveled the ambiguous and shifting frontier between art, journalism, social science, and propaganda. Lange's work is much harder to place than that of, say, Walker Evans, and so is her personality. If neither Gordon nor Spirn quite succeed in bringing her to life on the page, they do convey her complex and mercurial elusiveness. Roy Stryker of the FSA, who worked closely with Lange from 1935 through 1939, repeatedly sacking and then rehiring her, vastly admired her photographs but found her maddening to deal with, and readers of Gordon and Spirn are likely to find themselves similarly conflicted.

Gordon, a social historian at New York University whose faculty bio says that she specializes in "gender and family issues," is best at placing her subject within the context of the various milieus in which she moved. She is good on the artistic and photographic scene in New York in the 'teens of the last century, where the young Lange discovered Isadora Duncan, Alfred Stieglitz, and the luminaries of the Pleiades Club, and excellent on the rowdier bohemian coterie that she joined in San Francisco in the twenties, when she met Dixon (in his customary urban uniform of Stetson and spurred cowboy boots), Ansel Adams, Edward Weston, Frida Kahlo, and Diego Rivera. Gordon is reliably lucid on the aesthetic and political movements of the time, though Lange herself too often remains more cipher than character in an otherwise vivid picture of her place and period.

It's in the gender and family issues department, her academic specialty, that Gordon is simultaneously confident and not entirely persuasive. Much is made of Lange's childhood polio, which left her with a crippled right foot and permanent limp. Gordon calls her "a polio"—a grating phrase that, according to Google, is rare but not without precedent. Further damage was inflicted on Lange when her father moved out of the Hoboken house when she was twelve, and it is as a damaged woman, "irascible," "obsessively controlling," and full of "hubris," that Gordon portrays her as a wife and mother.

Lange acquired a stepdaughter, Consie, when she married Dixon, with whom she had two children of her own, Dan and John. In her second marriage, to the Berkeley economist Paul Taylor, she added three more stepchildren to her brood, in an age when women were expected to do all the work of parenting. Like so many people of their class and generation, the Dixons and the Taylors were in the habit of boarding out their kids whenever they threatened to interfere with their demanding work schedules. Not surprisingly, the children came to remember Lange as a domestic tyrant who neglected their needs and scarred them for life.

Autres temps, autres mœurs. Artists and writers were especially culpable in this regard, taking the line that their unique talents entitled them to days of concentrated silence and bibulous, grown-up social evenings, undistracted by the barbaric yawps of the nursery. (Chief among Cyril Connolly's Enemies of Promise was "the pram in the hall.") Lange's treatment of the children in her life was not egregiously different from that of others in her set in San Francisco and Taos, and Gordon's nagging concern over her deficiencies as a parent tends to unbalance her book. Defending Lange against charges laid by herself, Gordon too often sounds like a social worker putting in a tentative good word for a notoriously feckless client.

The subjects of biographies are usually at their most alive in the letters and gossip of their contemporaries, yet Lange, rather oddly, seems to have attracted less of this in her lifetime than one might expect. Stryker's letters about her have the constraint of an employer writing about an employee, and the few reminiscences of her collected here are mostly of the marble-tombstone variety, cautiously respectful of the dead. Although Gordon speculates freely about Lange's thoughts and feelings, and surrounds her with an impressive mass of contingent details, one waits in vain to catch the pitch of her voice in conversation, her wit (did she have any?), her personal demeanor and manners when at ease among friends. She emerges from the book more as a stack of interesting attributes than as a fully realized character in her own right.

Where Gordon's *Dorothea Lange* and Spirn's *Daring to Look* coincide to happiest effect is on Lange's marriage to Paul Schuster Taylor and her on-again-off-again work for Stryker at the FSA. Taylor, described by Gordon as "a stiff and slightly ponderous suit-and-tie professor" (she's often sharper on her secondary characters than she is on her primary one), met Lange in 1934, shortly after her separation from Maynard Dixon, when an exhibition of her pictures of the San Francisco poor was showing at a gallery in Oakland. Later that year, he hired her, at a typist's salary, as the official photographer for the California Division of Rural Rehabilitation,

of which he'd just been appointed field director. From January 1935, they were traveling together across California, visiting enormous, featureless agribusiness farms, worked by mostly Mexican migrant laborers. Taylor, who'd learned Spanish from scratch for the purpose, conducted interviews while she took photos. She took to calling him Pablo, he called her *mi chaparrito* ("my little shorty"). They were married in December.

Much as she'd learned to see the uncultivated West through Maynard Dixon's eyes, and to frame her pictures like his paintings, in Taylor's company she acquired the mental habits of a painstaking social anthropologist. Taylor taught economics at Berkeley, but his avidity for human data took him far outside the usual confines of his discipline and into the "field," where he transcribed the life stories of individual migrants. Lange copied him. A shy man, Taylor would introduce himself to groups of Mexicans by saying that he was lost and needed directions, a technique quickly adopted as her own by Lange. Soon after they'd met, she began to accompany her photographs with what she called "captions"—crisply detailed accounts, some running to essay length, of the circumstances that had led each subject to his or her present situation.

For Stryker at the FSA, the picture was the thing, and he spiked all, or nearly all, her writing; in *Daring to Look*, Spirn reunites Lange's 1939 photos with their original texts in a long overdue act of restoration. The captions are rich in themselves, full of the dollars and cents of anguished household accounting, stories of escape from starved-out dust-bowl farms in rattletrap Fords, and snatches of talk, for which Lange had a fine ear; as a North Carolina woman told her, "All the white folks think a heap of me. Mr. Blank wouldn't think about killing hogs unless I was there to help. You ought to see me killing hogs at Mr. Blank's!" She was a patient listener, and relentlessly inquisitive. Photographing tobacco farmers, for instance, she became expert on how the plant was cultivated, harvested, cured, and sold, and her captions describe with great precision what was meant by such terms as "topping," "worming," "sliding," "priming," "saving," "putting in," "yellowing," "killing out."

Gathering this sort of information from her subjects changed the way she photographed them. Before 1935 and her collaboration with Taylor, she was a fly-on-the-wall observer in her pictures of Native Americans and the unemployed. After 1935, her pictures reflect an increasingly intimate relationship between the woman behind the camera and the person in front of it. One sees a new candor and engagement in her subjects' faces, as if each shutter click has momentarily interrupted an absorbing conversation. In this respect, *Migrant Mother* is quite untypical of Lange's FSA work:

she spent only a few minutes with Florence Thompson, and her caption is unusually brief (according to Thompson's grandson, it was also riddled with errors of fact).

The deepening involvement in her subjects' lives seems all the more impressive when one follows the hectic itinerary of her own life in Daring to Look. Between January and October 1939 she traveled widely through California, North Carolina, Oregon, Washington, and Idaho, spending weeks at a time in her car, documenting the trudging "bindlestiffs" and homeless families on Highway 99, the labor camps and mile-wide fields of factory farms in the California valleys, tobacco farms in North Carolina, "stump farms" on logged-over forest in the Pacific Northwest, the newly irrigated orchards and farms of the Columbia Basin. Wherever she went, she attached individual faces and stories to the desolate social geography of American agriculture from coast to coast. Spirn's book is redolent of the hot and dusty unpaved roads on which Lange drove by day, and of the inadequately lit rooms in cheap motels where she wrote up her captions in the evenings. These were punishing travels by any standard, though to people like the bindlestiffs and migrant fruit pickers, Lange's life was one of almost unimaginable privilege.

Bad as her relations with Stryker were, she made her best pictures for the FSA. The current of indignant political feeling that flows through her work was in tune with the agency's propagandist mission, and—more than Evans, Shahn, Post, and other FSA photographers—Lange had an increasingly deep knowledge and understanding of what she was seeing, as a result both of her own searching interviews with her subjects and of her husband's work on the inequities of the agricultural economy.*Time and again, she struck a perfect balance between photographing a mass plight and honoring the dignity of each singular life—a balance she never quite recaptured. Her 1942–43 series on Japanese internment, for instance, has ample indignation, but lacks the active and visible rapport that she made with the farmworkers.

In 1954, Lange snagged a commission from *Life* magazine to do a photo-essay on Ireland, and around 2,500 negatives survive from this trip,

^{*}Taylor and Lange merged their talents in An American Exodus: A Record of Human Erosion, published in 1939. The couple assembled her photographs, his text, and their captions, working together, as they wrote, "in every aspect of the form as a whole to the least detail of arrangement or phrase."

which she made with her son Dan, then twenty-nine and an aspiring writer. Daniel Dixon was assigned the job of interviewing subjects and composing captions, leaving her free to concentrate entirely on photography. The results of this unwise division of labor are revealing.

In County Clare, Lange was an enchanted tourist. As perhaps we all do on our holidays, she sought out reverse images of what she knew from home. After the barbed wire and vast flat landscapes of Californian agribusiness, she reveled in the small, irregular, hillocky Irish fields, their rainwashed drystone walls and ancient hedges. Instead of improvised shack towns and government-built camps, she focused on stone bothies overhung with thatch and streets of single-storey terraced cottages with rickety horse-drawn traps parked at their doors. She stopped to take shots of ruined churches; placid, grazing cows; horses and hay wains; old men with scythes; shepherds tending their flocks in the fields, and driving them down narrow lanes. In Lange's Ireland almost everybody's smiling, and her photographs form an archive of 1950s toothless, gap-toothed, and prosthetic Irish grins. Yet there's little hint of two-way rapport in the faces of these people, who appear to be saying "Cheese" to deferentially oblige the lady visitor from America as she roamed the countryside picturing its happy peasantry.

At home in the United States, Lange knew as much about rural poverty and its indignities as anyone alive, but abroad in Ireland she seems to have been disconcertingly blind to what she saw, hardly seeming to notice that the clothes of her Irish subjects were as tattered and patched as those of the poorest Okies. If she questioned why the farms and fields were so small, or why there were so many horses and so few machines, it doesn't show in her photographs. She was here to discover Arcadia—a land of simple folk, content with their lot, going about their time-hallowed rustic occupations, equipped with the same rudimentary technology that had served them for centuries. In Ireland, Lange reverted to pastoral in its most naive and sentimental form.

It's tantalizing to wonder how Lange would have handled this assignment had the commission come from a social activist like Stryker instead of Henry Luce's *Life*. Her photos were in perfect harmony with the conservative politics of the magazine: they extol the tranquillity of a society under the law of Nature, and of God. As C. F. Alexander's infamous children's hymn put it, in that year of revolutions, 1848:

The rich man in his castle, The poor man at his gate, God made them high and lowly, And ordered their estate.

The magazine rejected Daniel Dixon's captions and supplied its own, including Serenely They Live in AGE-OLD PATTERNS, and THE QUIET LIFE RICH IN FAITH AND A BIT OF FUN. Still, perhaps Lange did provide some kind of stimulus to the local economy: her essay, savagely cut at the last moment, appeared in the March 21, 1955, issue of *Life*—just early enough in the year for jaded Americans of a certain class to book summer vacations in the idyllic and picturesque old world of her photographs.

In the last chapter of *Daring to Look*, Anne Whiston Spirn drives along the routes taken by Lange in 1939. By 2005 the roads were generally improved, but the housing and social conditions of agricultural workers on industrial farms were little changed, and Spirn found new rural slums on the sites of the old New Deal labor camps. A caption written by Lange in 1939 still holds broadly true:

The richer the district in agricultural production, the more it has drawn the distressed who build its shacktowns. From the Salt River valley of Arizona to the Yakima valley of Washington, the richest valleys are dotted with the biggest slums.

This is painfully evident in Washington State. Were Lange to return here with her camera seventy years on, it would not be a Rip Van Winkle experience so much as a numbing sense of déjà vu all over again. The cities and suburbs would be unrecognizable to her, but the poverty in the country-side created by the corporate agricultural system would yield material for photographs identical to those she took in 1939. In small, Spanish-speaking farm towns on the Columbia Plateau, the average per capita income is still in the middling four figures. In summer, migrant fruit pickers pile into the Columbia and Yakima valleys, living in camps little different, and hardly more affluent, than the one where Lange found Florence Thompson. And inventive new ways of being poor continue to emerge. In Forks, at the foot of the Olympic National Park, run-down trailer parks on the edges of the town are inhabited by "brushpickers," mostly Guatemalan, who make a tenuous living by scavenging in the woods for the moss, ferns, bear grass, and salal used by florists around the world to add greenery to bouquets.

Migrant Mother has become the symbol of a now-remote decade, to

which the passage of years has lent a period glow. Yet across the rural West the Great Depression is less a historical event than a permanent condition, which existed before the 1930s and is still there now, though it shifts from place to place and fluctuates in its severity. The warning in the rearview mirror applies here: the lives in Lange's photographs for the FSA are closer than they appear.

New York Review of Books, November 2009

At the Tea Party

PEOPLE WHO WATCHED the Tea Party convention in Nashville on television in early February saw and heard an angry crowd, unanimous in its acclaim for every speaker. Standing ovation followed standing ovation, the fiery crackle of applause was nearly continuous, and so were the whistles, whoops and yells, the *Yeahs!* and *Rights!* and cries of "USA! USA!" Inside the Tennessee Ballroom of the Opryland Hotel, it was rather different: what struck me was how many remained seated through the ovations, how many failed to clap, how many muttered quietly into the ears of their neighbors while others around them rose to their feet and hollered.

It wasn't until the last night of the event, when Sarah Palin came onstage, that the Tea Party movement, a loose congeries of unlike minds, found unity in its contempt for Barack Obama, its loathing of the growing deficit as "generational theft," its demands for "fiscal responsibility," lower taxes, smaller government, states' rights, and a vastly more aggressive national security policy. "Run, Sarah, run!" everyone chanted, though if Palin could have seen inside the heads of the 1,100 people at the banquet, she might have felt a pang of disquiet at the factional and heterogeneous character of the army whose love and loyalty she presently inspires.

I went to Nashville not as an accredited reporter but as a recently joined member of Tea Party Nation. (I had my own quarrels with big government, especially on the matter of mass surveillance, warrantless wiretapping, and the rest, and was counting on my libertarian streak to give me sufficient common ground with my fellow Tea Partyers.) When I presented my Washington State driver's license at the registration desk, the volunteer said, "Thank you for coming all this way to help save our country," then, looking at the license more closely, "Seattle—you got a lot of liberals there." I accepted his condolences.

As we milled around in the convention center lobby, we might easily have been mistaken for passengers on a cruise ship. We belonged to a similar demographic: most—though by no means all—had qualified for AARP membership a good while ago; exactly 99.5 percent of us were white; in general, smart leisurewear was our preferred style of dress. (The TV cameras made far too much of the handful of exhibitionists in powdered white pigtail wigs and tricorn hats, and of the peculiar, bug-eyed gentleman from Georgia, who was sometimes costumed as an eighteenth-century American revolutionary, sometimes as a kilted Highland chieftain, his copper tea kettle lashed to both outfits, and spoke to his many interviewers in a hokey and ponderous English accent.) Few of us would see much change from \$1,500 to \$2,000 we'd spent on travel to Nashville, the \$558.95 convention fee with service charge, a room at the hotel, and a couple of drinks at the hotel bars, where a glass of the cheapest wine or whiskey cost \$12. Seen as a group, we were, I thought, a shade too prosperous, too amiably chatty and mild mannered, to pass as the voice of the enraged grassroots.

I asked one woman whether she'd been part of "9/12," as Tea Partyers call the great taxpayer march on Washington D.C., last September. No, she'd missed it, she said, and "felt really guilty" about doing so, but she and her husband had been on vacation.

"Where did you go?"

"We spent a week in Amalfi, then we toured Tuscany, then we spent a week in Rome."

Another woman, hearing my accent, told me about her and her partner's second home in Torquay, England, which they visited three times a year from their base in Atlanta, and about their thirty-five-foot powerboat, in which they'd crossed the Channel to Le Havre and cruised down the French canals to Marseilles.

Most of us were political novices. When we were asked how many attendees had never been involved in politics before joining the Tea Party movement, roughly four out of every five people raised their hands. On the outside balcony where the smokers gathered, I was joined at a table by an intense, wiry, close-cropped redhead from southern Virginia who dated her conversion to hearing Sarah Palin for the first time. "She was *me!* She's so down to earth! If Sarah was sitting here with us now, she'd be just a normal person like you and me. You could say anything to her. She's not like a politician—she's *real*. And Sarah always keeps her word. If Sarah promises something, you *know* she'll do it. She's just amazing."

Before Sarah, the woman said, her interest in politics had been limited to

voting in general elections. Her one big involvement was with her church. Now she was traveling around the country on behalf of Team Sarah and Conservative Moms for America, a fundamentalist group whose "Conservative Moms Pledge" begins with a quote from the First Epistle of St. Peter: "Wives, likewise, be submissive to your own husbands, that even if some do not obey the word, they, without a word, may be won by the conduct of their wives, when they observe your chaste conduct accompanied by fear."

In the last year, she'd marched on 9/12, gone to CPAC (the Conservative Political Action Conference), and attended a string of acronymic events, which she recited to me. Soon she'd be off to New Orleans for the Southern Republican Leadership Conference. Lighting her second cigarette in ten minutes, she talked about missing her family on these political jaunts. After their own children were grown, she and her husband had adopted two infant daughters, now aged six and nine. The girls were the light of their sixtyish lives. One was autistic, the other severely developmentally disabled: her birth mother was an "alcoholic" and a "drug addict," and the baby had suffered a series of strokes in the delivery room, where her heart had twice stopped beating.

"The hospital said they doubted if she was salvageable. Salvageable! Imagine talking about a human life as 'salvageable'! You see why I love Sarah? We have so much in common." She rattled on about her girls' accomplishments—how nearly normal they were, how happy, how responsive to the warm climate of affection in which they now lived. "Here, I'll show you..." She found her cell phone in her bag and treated me to a slide show of family photos: her husband, a heavily built man in plaid shirt and jeans, playing with their daughters in a well-kept backyard. She hadn't bothered to mention that both girls were black.

Her crowded freshman year in politics made her a veteran by comparison with most people I met, whose experience was limited to membership in a local Tea Party group and attendance at rallies, in which everyone seemed to have found a mirror of his or her own temperament and character. A dour man from Hilton Head, South Carolina, said of the 9/12 march, "You didn't see one person—not one!—with an adult beverage, and when we left the Mall there wasn't a single cigarette butt on the ground." He eyed me, no doubt scenting these vices on my own clothes and breath. "And they call *us* a bunch of radicals."

Although much of the convention was designed to stoke our wrath at the iniquities of the Obama administration, its less reported aim was meant to teach us how to take our first baby steps in the new world of politics.

One session I attended, "How to Organize a Tea Party Group," nicely reflected both the innocence and the age of so many of the conventioneers. The speaker, Lori Christenson, was a retired corporate trainer from Evergreen, Colorado, a small, wealthy, lakeside town in the foothills of the Rockies, thirty miles west of Denver. Her PowerPoint presentation was a handy vade mecum of hints and tips for absolute beginners. How to open an account at Meetup.com. How to name your group. Why alliterative phrases, like "Tea Party Tuesdays" or "Tea Party Thursdays" worked better than other days of the week, because they are more easily remembered by older people. Why school gyms are to be avoided as meeting places (the elderly would have difficulty climbing the risers). Ms. Christenson advised against using churches because too many people associated the movement with the Christian right; she suggested booking a room at the local public library as a more neutral territory. If you set up a card table outside a grocery store to recruit new members, you must remember to call yourself a "community group," not a political one. Everybody was nodding and taking notes.

She took us through the ins and outs of 501(c)3s and 527s, and for-profits versus nonprofits. She told us how to make flyers and hide them inside "conservative" library books, like those of Glenn Beck, and put them on the windshields of cars with old McCain-Palin bumper stickers. With a note of plaintiveness that I heard often at the convention, she said, "We've got to work on the youth."

At question time, someone stood up to say, "We did Obama Bingo at the State of the Union address—did you guys do that?" Good idea, said Ms. Christenson. Someone else suggested entering floats in town parades, so members could sing patriotic songs from them. It was a restful hour, like being back in nursery school.

We said prayers, recited the Pledge of Allegiance (with the words "under God" pronounced as if they were underlined and in bold type), and clapped in time with the beat of country music. Lisa Mei Norton, a former air force senior master sergeant, sang "The shining light, on the right, the left just doesn't get, / Sa—rah Palin for change you won't regret..." It would have taken a finely calibrated stopwatch to measure how very rapidly such folksy piety and patriotism could swivel into crude nativism, conspiracy theory, and xenophobia—and to measure, too, the dawning discomfort at this switch of tone registered by a sizable part of the audience.

The first night's speaker, Tom Tancredo, ex-congressman from Colo-

rado and no-hope presidential candidate in 2008, gave a taste of what was to come as he warmed up the audience with a show of self-deprecating, clownish good humor. He told stories—some of them extremely tall, as when he described visiting a new high school in the richest Denver suburb, where the students all drove new BMWs and, on Monday mornings, were fresh from skiing weekends in Vail. He had, he said, picked up their textbook on American history, whose first sentence was—"and this is exactly what it said"—Columbus came to America and ruined Paradise. Shaking his head, he repeated the sentence, which I took to be a fantastic, garbled invention, loosely inspired by Howard Zinn's A People's History of the United States. But we were still in the realm of good, relatively clean, political fun.

The drollery vanished as he climbed aboard his old anti-immigration hobby horse. "The revolution has come. It was led by the cult of multiculturalism, aided by leftist liberals all over, who don't have the same ideas about America as we do." Since George H. W. Bush's administration, RINO Republicans (Republicans in Name Only) had been conspiring with Democrats to boil us like frogs in the "cauldron of the nanny state." "Then something really odd happened," Tancredo said, "mostly because, I think, we do not have a civics literacy test before people can vote in this country. People who could not spell the word 'vote,' or say it in English, put a committed socialist ideologue in the White House. His name is Barack *Hussein* Obama." Though a ripple of cheers and applause spread through the ballroom, I was taking my cue from a middle-aged couple sitting immediately in front of me. When they clapped, I clapped. When they rose to their feet, I did too. Now they exchanged a hard-to-read glance and their hands stayed in their laps.

My guess was that few in the room were offended by the association of the "literacy test" with the Jim Crow laws, though some might have been. But everyone I'd met so far was in a position to know immigrants, legal and otherwise; they employed them in their houses and businesses, to look after their children and work in their yards. The idea that Maria and Luis, or Tatyana and Dmitri, had somehow subverted the political system to bring about Obama's election struck them as insulting and absurd.

Something very similar happened the next night, when Joseph Farah, the author and impresario of the right-wing news site WorldNetDaily took the stage. Farah, self-consciously handsome with his swept-back gray hair and bootblack chevron moustache, spoke in that tone of patient,

inexorable, commonsensical logic which seems equally distributed between long-tenured professors and certified lunatics. He took us on a quasi-scholarly tour of the first chapter of Saint Matthew's Gospel, where Christ's genealogy is traced from the patriarch, Abraham, down through many generations to "Jacob, the father of Joseph, the husband of Mary, of whom Jesus was born, who is called Christ," then invited us to compare Jesus' unassailable ancestry with Obama's dubious family tree. "I have a dream," Farah said. "And my dream is that if Barack Obama even seeks reelection in 2012, he won't be able to go to any city, any town, any hamlet in America without seeing signs that ask, 'Where's the birth certificate?' "Again, I saw as many glum and unresponsive faces in the crowd as people standing up to cheer.

Having established Obama as a Kenyan imposter, Farah went on to explain how his administration is using 1960s Marxist theory to bring about the destruction of the "American free-enterprise system." The president and his red henchmen are employing the "Cloward-Piven strategy"*—"turning make-believe crises into real crises" to paralyze capitalism, as, for instance, when they manufactured crises and bailouts, like those of the banks, AIG, and the auto industry. Farah seemed untroubled by the implication that, since these crises and bailouts dated back to September 2008 and before, George W. Bush must have been in on the plot too. Proof of his argument, Farah said, had come when Rahm Emanuel inadvertently let drop the secret of this master plan by saying "You never want a serious crisis to go to waste." This was Cloward-Piven strategy, succinctly stated. "It is the only paradigm that makes any sense," Farah told us.

I was off to the smokers' ghetto after Farah's speech, so I missed the confrontation in the lobby between him and Andrew Breitbart of Breitbart .com, another prominent and forceful speaker at the convention. But Dave Weigel of the *Washington Independent*, who was live-blogging from Nash-

^{*}Named for Richard Cloward and Frances Fox Piven's article "The Weight of the Poor: A Strategy to End Poverty," *Nation*, May 2, 1966. According to Wikipedia, "The two argued that many Americans who were eligible for welfare were not receiving benefits, and that a welfare enrollment drive would create a political crisis that would force U.S. politicians, particularly the Democratic Party, to enact legislation 'establishing a guaranteed national income.' "Since Obama's election, the Cloward-Piven piece has been widely cited on the American right as "a malevolent strategy for destroying our economy and our system of government." (James Simpson, "Cloward-Piven Government," *American Thinker*, November 23, 2009.)

ville, was himself caught up in the row and captured it on audiotape. Breitbart attacked Farah for raising the "birther issue" because it was "divisive." Here's a snatch of Weigel's transcription, with Farah speaking first and Breitbart second:

"It is a winning issue!"

"It's not a winning issue."

"It is! It becomes even more of a winning issue when the press abrogates its responsibility—"

"You don't recognize it as a fundamentally controversial issue that forces a unified group of people to have to break into different parts? It is a schism of the highest order."

Out with the smokers on the freezing balcony, I was feeling sufficiently at home with my fellow-attendees to voice, as mildly as I could, my own impatience with the birther stuff and the Cloward-Piven strategy. I wasn't surprised to find people agreeing with me. "Stupid," a woman said. "My first thought was, 'This guy's a liberal plant.' I thought we came here to talk about taxes and government spending and national defense."

The rhetorical extravagance of Tancredo, Farah, and other speakers was in tune with the extravagance of our surroundings. The convention had begun in discord and controversy, with the last-minute withdrawals of two star performers, the Republican congresswomen Michele Bachmann and Marsha Blackburn, and sniping from rival Tea Party groups who accused Tea Party Nation and its proprietors of trying to hijack the movement for personal profit. Much of the criticism was directed at the cost of the event and the choice of the gigantic Opryland resort hotel as a venue.

The scenic route from my hotel room to the convention center led through nine acres of jasmine-scented tropical rainforest, contained by interlocking atriums that resembled London's 1851 Crystal Palace. Bridges and winding pathways ran past waterfalls and fountains through a dense jungle of banana trees, palms, hibiscus, bougainvillea, canna, ferns, vines and orchids. "Mississippi flatboats" took passengers on circuits of the shallow canal that looped around Delta Island, and on my walk, I'd pass Epcot-style re-creations of old French New Orleans; an antebellum planter's mansion; a bit of Italy; a quaint village street, possibly English; and a Dublin pub. Such a concentrated dose of surreality, taken before breakfast, helped prepare one for life in the alternative world that was on offer in the ballroom.

Obama's election was "our Pearl Harbor." We were now living in "the Third Reich," the first two being FDR's New Deal and LBJ's Great Society. Liberal environmentalists were leading us into "socialist totalitarianism"

disguised as polar bears." Luxuriant and overreaching metaphors bloomed like the tropical foliage just outside. I suspected that few of the cheering Tea Partyers took them too seriously. They were, rather, the floorshow, a contrived entertainment meant to add spice and dazzle to proceedings that would otherwise have been tedious in their emphasis on modest neighborhood politics. The same speaker who roused us with talk of Pearl Harbor and the Third Reich later told us to run for our local school board, and be careful to avoid "divisive social issues."

Only once did I find myself with a group of people from whose company I was glad to escape. At dinner on Friday, our eight-person table was talking—somewhat facetiously—about emigration. "We may have to leave this country sooner than we thought," a woman said, and laughed. Australia was mooted as a possible destination. "Well, you could have gone to Australia once," said a beefy man in his sixties, with coiffed silver hair and matching beard, the alpha male of the table. "But now they've got another liberal in charge—even in Australia."

The woman's husband shook his head, and said, "It may still come to shooting," the tone in which he made the remark delicately balanced between eagerness and regret.

Then conversation swerved onto the subject of Obama, "the idiot," "missing a few marbles up here," "that nitwit." (It's curious that the Tea Party view of the president exactly mirrors how the left talks about Palin: both are self-evidently stupid.) Obama was an unknown quantity when he was elected. He had no record, no experience; he was an empty suit about whom we knew nothing.

"Well," said the alpha male, producing his ace of trumps, "we knew he was black."

I heard—and joined in—some grumbling about the religiosity of the event. "It's Tea Party Nation," a woman said. "They're a very religious group. You notice how they won't serve alcohol at dinner?" Another told me that several people had left a "breakout session" she'd attended, apparently because they'd taken offense at the copious prayers. "It's a regional thing. This is the Bible Belt. You don't see this at Tea Party groups in the Southwest."

This wasn't a trivial issue. It's one thing to see pro-life evangelicals and secular libertarians marching shoulder to shoulder behind banners saying "Kill the Bill!" and "Oust the Marxist Usurper!" or displaying a portrait of Obama rouged up and kohled to look like Heath Ledger's Joker in the Batman movie *Dark Knight*. It's quite another to coop the same people for

three days in a hotel, where they must talk to one another through breakfast, lunch, and dinner. At the march on Washington, there were T-shirts proclaiming "I am John Galt" and "Atlas Has Shrugged" alongside others that said "Obama Spends—Jesus Saves," or had the legend "Yes, He Did" beneath a picture of Christ on the cross. Here at Opryland, devout, abstemious Christians were breaking bread with followers of Ayn Rand's gospel of unbridled and atheistic self-interest. The convention, designed to unite the Tea Party movement, was helping to expose fundamental differences of belief and mind-set between people who, before Nashville, had appeared as interchangeable members of a single angry crowd.

For the Saturday night banquet and Palin's speech, I was assigned a seat beside the woman who told me about people quitting a meeting because of the prayers. Had we been strangers on a plane together, we would have had nothing politically in common (she liked to refer to Obama as "the idiot"), but here we were confidential allies, in harmonious agreement about the birthers, the Marxist conspiracy, the demonization of immigrants, and the churchiness of the convention."

That evening, our prayer was led by Laurie Cardoza-Moore, the founder and president of a Christian Zionist organization called Proclaiming Justice to the Nations. We were asked to join hands with our neighbors while Moore delivered a long, impassioned appeal to God, imploring Him to compel the United States to show unwavering loyalty and devotion to the state of Israel. I felt an increasingly steady pressure on my right hand from the woman holding it as she sang out her *A-mensl*; but my left hand, lightly held by my new partner in skepticism, registered a quick double-blip from her forefinger and thumb that unambiguously said, Uh-oh. As we sat down to our steak-and-jumbo-shrimp dinner, my neighbor said, sotto voce, for my ears only, "You know, I phoned my husband last night. I told him that being here has made me realize that I am a *liberal* conservative."

Whatever cracks and fissures had begun to open beneath our feet during the convention were instantly healed by Palin's appearance on the platform. A great wave of adoration met the small, black-suited woman as she walked

^{*} After her speech, taking soft questions from the convention organizer, Palin remarked that "it would be wise of us to start seeking some divine intervention again in this country, so that we can be safe and secure and prosperous again"; the applause that met this line was intense but conspicuously scattered.

to the microphone with a sheaf of papers. The entire ballroom was willing Sarah to transport us to a state of delirium with whatever she chose to say, and perhaps our expectations at the beginning of her speech were a guarantee that we'd leave feeling rather let down at the end.

From the start, she struck me as off-form, speaking too hurriedly, sometimes jumbling the words in her script, saying that "Alaska" was a beacon of hope to the world (she meant to say "America"), and generally using a tone of voice and style of delivery that seemed too low-key for the size of the audience in the ballroom. Whoever writes Palin's speeches now is clearly not a patch on Matthew Scully, her speechwriter on the 2008 campaign. This speech lacked structure, memorability, and direction. Its best bits were Palin's slaps at Obama, like "How's that hopey-changey stuff workin' out for ya?" Most of it was a rambling *tour d'horizon* of policy issues—national security, defense, Iran, the economy, bailouts, and debt—on which Palin had little more to offer than humdrum remarks like, "So, folks, with all these serious challenges ahead, we've got private-sector job creation that has got to take place and economic woes and health care, the war on terror."

Some of what she said was inaudible in the ballroom. When she said, "We need a commander in chief!" the audience stood to applaud. Through the din, I watched Palin's lips continue to move on the giant monitor screens mounted on either side of the stage. An hour and a half later, watching a replay of the speech on C-Span, I heard the rest of the sentence: "... not a professor of law standing at the lectern." When she was speaking live, plowing through her text, I thought she must be late for her plane to Houston, where she was due to address a rally for Governor Rick Perry the next morning, and in order to get to the airport was gabbling to save every second that she could. Later, I'd see that I was wrong.

The huge standing ovation ("Run, Sarah, run!") at the end was more for the concept of Palin, her epiphanic appearance among us in the flesh, than it was for the lackluster speech she'd just delivered. Leaving the convention center, I heard no one talking about how fired up they were by what they'd heard. In the elevator, a man said, "She messed up some of her lines. She'd've been better with a teleprompter." I reached my room in time to see a reporter from C-Span interviewing a young woman in the ballroom lobby about her response to the speech. She thought about the question for a while before saying, carefully, "Well, I didn't disagree with anything she said."

Then I watched the replay of the speech on television and was surprised by how much more effective it sounded in my room than it had in life. Palin wasn't so much speaking to the convention as she was addressing the nation, in its millions of separate rooms like mine. Her rapid, self-interrupting style of delivery was meant for the small screen, where her jokes worked better and her banalities about policy had the pitch of kitchen-table conversation. It was far from a great speech, and I doubt if it won her many fresh converts, but it sounded a new note in her ever-surprising career: she was trying to find a "presidential" voice, and this was her State of the Union.

It happened that a Washington Post/ABC poll was being conducted as Palin was speaking (the convention ran from February 4 to 6, the poll from February 4 to 8). Palin's numbers were down across the board, among Republicans, Democrats, and Independents. More than 70 percent of respondents said she's unqualified for the presidency, up from 60 percent last November. Even among "conservative Republicans," only 45 percent think her qualified, down from 66 percent in November. No significant shift of opinion was observed between the sixth and the eighth. But it's the provenance of the poll that Tea Partyers will have seized on. The Washington Post and ABC News? What else would one expect of the liberal, lamestream media?

New York Review of Books, March 2010

Acknowledgments

- "Driving Home" originally appeared in the Independent on Sunday.
- "Mark Twain's *Life on the Mississippi*" first appeared as the introduction to *Life on the Mississippi*, published in 1991 by the Library of America, New York.
- "Philip Larkin," and "I'm in Heaven" first appeared in the New Republic.
- "Mississippi Water" and "Second Nature" first appeared in Granta.
- The following articles were originally published by the *New York Review of Books:* "On the Waterfront," "Walden-on-Sea," "White Warfare," "The Last Harpoon," "A Tragic Grandeur," "The Prisoners Speak," "An American in England," "Metronaturals," "American Pastoral," and "At the Tea Party."
- "Julia's City" was first published in *Edge Walking on the Western Rim*, edited by Bob Peterson and Mayumi Tsutakawa (Sasquatch Books, 1994).
- "Why Travel?" originally appeared in the Sunday Times.
- "The Waves" was first published in Vogue, "Last Call of the Wild" in Esquire, and "Seagoing" in Outside.
- "Homesteading" first appeared as the foreword to Percy Wollaston's *Homesteading: A Montana Family Album*, published by Lyons Press (1997).

"Keeping a Notebook" originally appeared in the Washington Post, "Julia and Hawaii" in the New York Times, "The Turbulent Deep" in Cruising World, "The Unsettling of Seattle" in Architectural Digest, and "Battleground of the Eye" in Atlantic Monthly.

"The Strange Last Voyage of Donald Crowhurst" was originally published as the introduction to *The Strange Last Voyage of Donald Crowhurst*, by Nicholas Tomalin and Ron Hall, and "Gipsy Moth Circles the World" as the introduction to Gipsy Moth Circles the World by Sir Francis Chichester, both published by McGraw Hill as part of their Sailor's Classics series.

"Too Close to Nature?" originally appeared in the Seattle Times.

The following articles were first published in the *Guardian:* "Surveillance Society," "Good News in Bad Times," "Election Night 2008," and "The Golden Trumpet."

"September 11: The Price We've Paid" first appeared in the *Independent*, while "Boomtown USA" and Cyber City" were originally published by the *Financial Times*.

"The Curse of the Sublime" first appeared in Playboy.

"I'm for Obama," "An Englishman in America," and "Cut, Kill, Dig, Drill" were first published in the *London Review of Books*.

"Going, Going, Gone" originally appeared in Monocle.

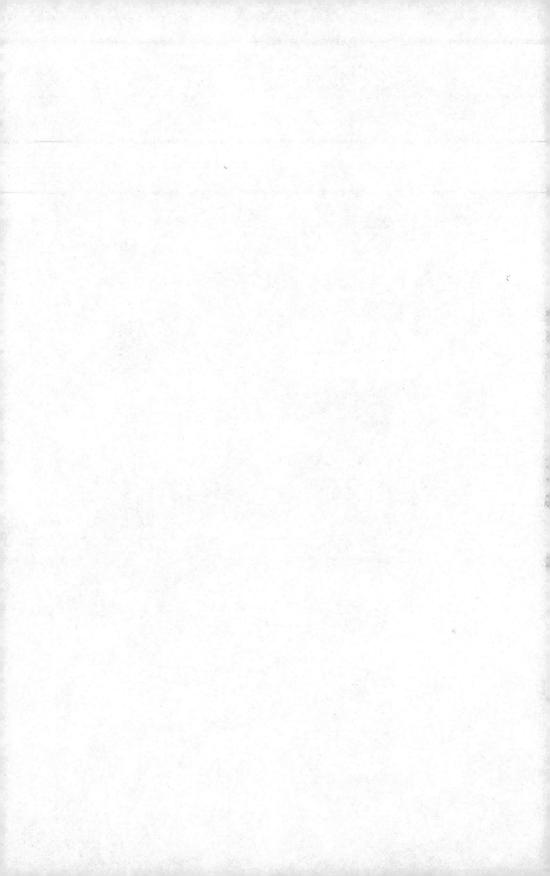

A Note on the Type

This book was set in Stempel Garamond, a font based on the type specimens of the sixteenth-century French typographer Claude Garamond. Stempel Garamond was issued by D. Stempel AG in 1925.

Composed by North Market Street Graphics, Lancaster, Pennsylvania Printing and binding by Berryville Graphics, Berryville, Virginia Designed by Michael Collica